DOCUMENTA IX

Band | Volume 1

Edition Cantz, Stuttgart
in association with
Harry N. Abrams, Inc., New York

Responsible for the exhibition
documenta und Museum Fridericianum
Veranstaltungs GmbH

Partners
Land Hessen, Stadt Kassel

Manager
Alexander Farenholtz

Authorized signatory
Frank Petri

Board of director
Oberbürgermeister Wolfram Bremeier
 (Vorsitzender)
Prof. Dr. Hans Brinckmann
Ministerpräsident Hans Eichel
Stadtverordneter Wilfried Gerke
Staatssekretär Dr. Otto Erich Geske
Staatsminsterin Prof. Dr. Evelies Meyer
Stadtverordneter Hubert Müller
Dr. Ulrich Schmidt
Stadtverordneter Wolfgang Windfuhr
Bürgermeister Ludolf Wurbs

Sponsors
Binding-Brauerei AG, Kassel
Movado Watch Deutschland GmbH, Hanau
Philips Consumer Electronics, Hamburg
Gebr. Rasch GmbH & Co., Bramsche
H. F. & Ph. F. Reemtsma GmbH & Co., Hamburg
RTL plus, Köln
TIME-LIFE International Ltd., London
RENAULT
Hessische Sparkassenstiftung, Frankfurt/M.

State subsidies
Gefördert durch die Kulturstiftung der Länder
 aus Mitteln des Bundesministers des Innern,
 Berlin, BRD
Australian Council for the Arts, Chippendale,
 Australia
Communaute Française de Belgique, Relationes
 Internationales, Brüssel, Belgien
Vlaamse Executieve, De Gemeenschapsminister
 van Cultuur, Brüssel, Belgien
Fundação Vitae, Brasilien
KIKU, Komiteen for Internationale
 Kunstudstillinger, Copenhagen, Dänemark
l'A.F.A.A. – Association Française d'Action
 Artistique, Ministère des Affaires Étrangères,
 Paris, Frankreich
Foundation I. Costopoulos, Griechenland
The British Council, London, Großbritannien
The Henry Moore Foundation, Hertfordshire,
 Großbritannien
Cultural Relations Committee, Department of
 Foreign Affairs, Dublin, Irland
The National Council of Culture and Art,
 Tel-Aviv, Israel
Ministerio degli Affari Esteri, Rom, Italien
Japanisches Kulturinstitut (The Japan Foundation),
 Köln
With the assistance of the Government of
 Canada / avec l'aide du Gouvernement du
 Canada
The Canadian Council / Conseil des Arts du
 Canada, Ottawa, Kanada
Ministerie van Welzijn, Volksgezondheid en
 Cultuur, Rijkswijk, Niederlande
Bundesministerium für Unterricht und Kunst,
 Wien, Österreich
Secretaria de Estado da Cultura, Lissabon,
 Portugal
Fundação Calouste Gulbenkian, Lissabon,
 Portugal
Fundação Luso-Americana para o
 Desenvolvimento, Lissabon, Portugal
Bildkonstnärsfonden, Stockholm, Schweden
Kulturrådet, Stockholm, Schweden
NUNSKU, Stockholm, Schweden
Svenska Institutet, Schweden
Eidgenössische Department des Inneren, Bern,
 Schweiz
USIA, United States Information Agency,
 Washington, USA
The presentation of U.S. artists at DOCUMENTA
IX is made possible, in part, through support from
the Fund for U.S. Artists at International Festivals
and Exhibitions, a partnership of the National
Endowment for the Arts, the United States
Information Agency, The Rockefeller
Foundation, and The Pew Charitable Trusts, with
administrative support from Arts International, a
division of the Institute of International Education.

Supporters / Contributors
AOK, Kassel
Arbeitsamt Kassel
Atlas Copco Compressor AB, Stockholm,
 Schweden
Bernd Behrens KG, Kassel
BMW, Kassel
Hessische Brandversicherung, Kassel
Claessens N. V., Waregen, Belgien
Computerland Kassel, Coda Vertriebs GmbH,
 Kassel
Photogravure DBL n.v.-s.a., Sint-Denijs-
 Westrem, Gent, Belgien
Jürgen Dudda Audio Service, Bergisch Gladbach
Filliers Graanstokerij, Deinze, Belgien
Glaskontor Kassel
Glaverbel N. V. – S. A., Brüssel, Belgien
HHS Planer + Architekten, Hegger, Hegger,
 Luhnen, Schleiff, Kassel
Fa. Hebel, Alzenau
Hessische Verwaltung der Staatlichen Schlösser
 und Gärten, Bad Homburg
HÜBNER Gummi- und Kunststoff-GmbH, Kassel
Indeco, Seoul, Korea
Weinbrennerei JACoBI KG, Weinstadt
Johnen und Schöttle, Köln
KEKU Rhein-Main Container-Mietsysteme,
 Groß-Gerau
Stahlbau Lamparter, Kassel
Leffers AG, Bielefeld
Panasonic Deutschland GmbH, Hamburg
Ludwig Pfeiffer GmbH, Kassel
Portlandzementwerk Dotternhausen, Rudolf
 Rohrbach KG, Dotternhausen
ProBike, Kassel
Architekturbüro Reiser & Stremme, Kassel
Sachtler AG, Garching
Fa. Schnackenberg, Wuppertal
schwann-STABILO GmbH, Nürnberg
Sharp Electronics Deutschland
Sharp Corporation, Japan
Siemens AG, Kassel
Siemens-Nixdorf Informationssysteme AG,
 Kassel
Sony Deutschland GmbH, Köln
Staff GmbH & Co. KG, Lemgo
Bernhard Starke Datensysteme GmbH, Kassel
Torbjörn Lenskog AB, Stockholm, Schweden
N. V. Gebroeders Vandekerckhove,
 Engelmunster, Belgien
VEMA, Vereinigte Malergenossenschaft, Kassel
Verband Baugewerblicher Unternehmer Hessen
e.V., Kassel
Vitra GmbH, Weil am Rhein
Zumtobel Licht GmbH, Dornbirn

Artistic direction
Jan Hoet

Team
Bart De Baere
Pier Luigi Tazzi
Denys Zacharopoulos

Advisors
Johannes Cladders
Henry-Claude Cousseau
Franz Meyer
David Ross

Secretariat
Susanne Müller

Assistance
Denise Vasseur-Oechler
Iris Vaupel

Project assistance
Sonia Becce
Luisa Borio
Isadora Brachot
Rebecca Camhi
Isabelle Dupuy
Thomasz Kocek
Martin Köttering
Sergio Risaliti
Emilia Terragni
Jari-Pekka Vanhala
Koichi Watari

Exhibition architecture
Paul Robbrecht
Hilde Daem

Press spokeswoman
Claudia Herstatt

Assistance
Jutta Damaschke
Oliver Freigang
Andrea Möller
Roland Nachtigäller
Monika Welz

Photographs
Dirk Bleicker
Benjamin Katz
Dirk Pauwels

Practical training
Brigitte Heublein

Supporting programme
Klaus Steigmeier

Assistance
Willemien Ippel
Stefan Kalmár

Evaluation
Gerd-Michael Hellstern
Martina Günther
Horst Hoffrichter
Margot Leiding-Gnau
Heidi Prael-Himmer Schnackenburg
Walter Renner

Guide service
Klaus Baum
Oliver Dörr
Monika Göbel
Thania Hafez

Organization and technical direction
Winfried Waldeyer
Thomas Büsch
Frauke Hellweg
Kathrin Krumbein
Gisela Märtz

Organization of exhibition buildings
Toos Arends
Dieter Fuchs
Thomas Martens
Heinrich Siebert
Hans Peter Tewes

Assistance
Charlotte Pollex
Silke Behling
Joachim Deutsch
Iris Mahnke
Martina Peter
Nina Pfannenstiel
Stefanie Schreck

Construction team
Sven Ahrens
Pablo Alonso
Regina Assmann
Sabine Beikert
Thomas Bernsmann
Gilbert Blumenthaler
Siegfried Böttcher
Frank Brodocz
Michael Brodocz
Dirk de Neef
Jens Engelhard
Christine Ermer
Vian Fadhil
Seamus Farrell
Martina Fischer
Karl Heinz Funk
Wibke Gerke
Philippo di Giovanni
Heino Göb
Daniel Graffe
K. F. Günther
Olaf Hackl
Martin Hast
Stefan Hasslinger
Anja Helbing
Peter Hecker
Piotr Jendrassek
Monika Jahn
Noël Joos
Sonja Karle
Kristiane Krüger
Urda Kuhn
Guido Kühn
Norman Lindner
Peter Limpinsel
Katja Mand
Richard Marshall
Andreas Martins
Wolfgang Matzat
Josephine Meckseper
Anne Möller
Nadine Moerman
Phillip Moraut
Kim Myoung-Soo
Dirk de Neef
Manfred Pernice
Jose Pinheiro
Axel Plöger
Eva Randelzhofer
Christian Rattemeyer
Uwe Richter
Georg Römmelt
Wolfgang Rosin
Carsten Saager
Hartmut Schmidt
Astrid Schneider

Anne Schreiner
Ilka Schröder
Andreas Schumacher
Markus Schwarze
Michaela Schweiger
Che Seibert
Joachim Sickinger
Janusz Siewierski
Angela Siever
Hubert de Smet
Rogerio Soares
Florian Soldner
Lars Steffens
Haluk Tas
Eva Tenschert
Frank Wahl
Sascha Weisert
Gabriele Winzen
Ignatz Wilka
Kristian Wolff
Albert Völkl
Jürgen Zähringer
Patrick de Zutter
Oliver Zwick

Restorers
Jesús del Pozo Sáiz
Barbara Decker
Dorothée Simmert
Eckhard Kneer
Bärbel Otterbeck

Technical advice and statics
Reinfried Reiser, Hartmut Stremme und Partner, Kassel
Prof. Dipl.-Ing. Heinz Jungmann, Kassel
Dipl.-Ing. Wolfgang Mehlhorn, Kassel
Matth. Meyer, Zierenberg
Prof. Dr.-Ing. F. Thiele GmbH, Kassel

Technical facilities in buildings
Klaus Dunckel
Hans Weiser
Wolfgang Schulze
Kalle Gebhard

Cleaning
Angela Damm
Elke Restifo

Administration / Organization
Gisela Artzt
Carmen Glahn
Willi Greve
Andreas Hannig
Peter Heckwolf
Barbara Heinrich
Veronika Heyne
Michaela Landgrebe
Andreas Mannsbarth
Marie-Luise Moj
Rainer Schindel
Elke Schulze
Ingeborg Wohlrab
Annette Wolter
Sigrid Zintl

Best Boy
Peter Schippmann

Insurance
ABP Behrens & Partner, Wuppertal
Mund & Fester, Hamburg

Transport
hasenkamp, Internationale Transporte, Köln

Lenders

Museum of Contemporary Art, Chicago, IL
Museum van Hedendaagse Kunst, Gent
Louisiana Museum moderner kunst, Humlebaek
Kunsthalle zu Kiel
Museum Ludwig, Köln
Westfälischer Kunstverein Münster
Stedelijk Museum, Ostende
Musée du Louvre, Paris
Fonds National d'Art Contemporain Ministère de
 la Culture, France
Museum Boymans-van Beuningen, Rotterdam
Staatsgalerie Stuttgart
Kunstmuseum Winterthur
The Elvehjem Museum of Art, University of
 Wisconsin-Madison

Galerie 1900 2000, Marcel Fleiss, Paris
ACTES, Nuits Blanche pour la Musique Noire,
 Marseille
Allen Allen & Hemsley, Sydney
American Fine Arts, Co., New York
Thomas Ammann, Zürich
Erik Andriesse, Antwerpen
Paul Andriesse, Amsterdam
Ansuric Switzerland
Galerie Arlogos, Nantes
Galerie Jean Bernier, Athen
Galerie René Blouin, Montreal
Mary Boone Gallery, New York
Jytte and Jarl Borgen, Kopenhagen
Birgit und Dieter Broska, Mainz
Galerie Bruges la Morte, Johan Vanstennkiste,
 Brügge
La Caisse des dépots et consignations, Paris
Caldic Collection, Rotterdam
Leo Castelli Gallery, New York
Linda Cathcart Gallery, Santa Monica, CA
Paula Cooper Gallery, New York
Galerie Crousel Robelin Bama, Paris

Dart Gallery, Chicago, IL
Sylviane de Decker Heftler, Paris
Jessica Diamond, New York
Rosamund Felsen Gallery, Los Angeles, CA
Galerie Konrad Fischer, Düsseldorf
Mr. and Mrs. Robert F. Fogelman, Memphis, TN
Galerie de France, Paris
Galerie Ghislaine-Hussenot, Paris
Barbara Gladstone Gallery, New York
Jay Gorney Modern Art, New York
Galerie Bärbel Grässlin, Frankfurt/M.
Mimi & Peter Haas, New York
Hess Collection, Napa, CA
Fred Hoffman, Los Angeles, CA
Max Holtzman, Inc., Rockville, Maryland
Heinrich Hunstein, Kassel
André Itten, St. Gervais, Genève
Jablonka Galerie, Köln
Jänner Galery, Wien
Annely Juda Fine Art, London
Galerie Isabella Kacprzak, Köln
Michael Klein Inc., New York
Galerie Susanna Kulli, St. Gallen
Rachel Lehmann, Lausanne
Galerie Lelong, Paris/New York
Lisson Gallery, London
Louver Gallery, New York
Luhring Augustine Gallery, New York
Philomene Magers, Bonn
Vijak Mahdavi & Bernardo Nadal-Ginard, Boston
Susan and Lewis Manilow, Chicago, IL
Marlborough International Fine Art, Vaduz
Metro Pictures, New York
Robert Miller Gallery, New York
Galerie nächst St.Stephan,
 RosemarieSchwarzwälder, Wien
Galerie Enrico Navarra, Fundacion Abramović,
 Amsterdam
Galerie Nelson, Lyon

Nerman Collection, Nelson-Atkins Museum of
 Art, Kansas City, Missouri
Mr. & Mrs. S. I. Newhouse Jr., New York
Nishimura Gallery, Tokyo
Noga Art Gallery, Herzlya, Israel
Norton Collection, Santa Monica, LA
Collection Linda Ocampo, Los Angeles, CA
Galerie Peter Pakesch, Wien
Steven Parrino, New York
Galerie Rolf Ricke, Köln
Don and Mera Rubell, New York
Saatchi Collection, London
Galerie Schmela, Düsseldorf
Karsten Schubert LTD, London
Sonnabend Gallery, New York
Galerie Pietro Sparta, Chagny
Christian Stein, Turin/Mailand
Nora & Norman Stone, New York
S. Ronald Stone
Galerie Hans Strelow, Düsseldorf
Texas Gallery, Huston, TX
The Times of India, New Delhi
Collection Barbara Toll, New York
Collection Tournereau et Bosser, Paris
Joan Wallace, New York
Galerie Michael Werner, Köln/New York
Sperone Westwater, New York
Galerie Wetering, Amsterdam
Collection Winter and Fred Hoffman,
 Los Angeles, CA
Donald Young Gallery, Seattle
Zeno X Gallery, Antwerpen
Zolla/Lieberman Gallery Inc., Chicago, IL

the artists

anonymous lenders

Thanks
to all artists
to all their assistants
to all friends
…and there are an awful lot of them…

Special thanks to:
Irene Adelman
Mohammed Ben Ali
Jean-Christophe Ammann
Tuula Arkio
John Arnstein
Patricia Ayres
Herman Balthazar
Cristina Baraldi-Cueff
Nona and Richard Barrett
Beke Laszlo
Melissa Berry
Maria Teresa Bettarini
Peter Beye
Brigitte Birke-Dexheimer
Teresa Blanch
Rom Bohez
Achiel Bonne
Peter Bormann
Cecile Bourne
Sir Alan Bowness
Dominique Bozo
Isy Brachot III
Martin Braun
Hubert Burda
Klaus Bussmann
Roberto Cerbai
Hugo Claus
College van Burgermeester en Schepenen,
Stad Gent
Enrico R. Comi
Kevin E. Consey
Sylvie Cotton
Veronique Dabin
Jan Debbaut
Johan Decavele
Marc De Cock
Norbert De Dauw
An und Laurens De Keyzer
Deutscher Baseball Verband
Luc De Vos
Robert Devriese
Jean-Paul und Charlotte Deslyper-Pannier
Patrick Dewael
Kathy De Zeger
Marie-Ange Dhondt
Norbert D'Hulst
Jean Digne
n'Dongo
Marcel Dujardin
Otto Ehnert
Silvia Eiblmayr
Marina Eliadis
Enders + Knierim
Stefan Ewald
Jürgen Fabritius
FC St. Pauli Knights
Eline Ferleu
Robert Fleck
Peter Fleissig
Carl Flore
Johannes Fluhr
Nikolai B. Forstbauer
Jean Frémon
Susanne Fritsch
Rudi Fuchs
Adelina von Fürstenberg
Hubertus Gaßner
Denise Geirlandt
Geoffrey
Heiner Georgsdorf
Suzan Ghez
Karin Girlatschek
Edythe Goodridge

Tim Guest
Irmhild Gumm
Werner Haftmann
Nicole Hantson
Marianne Heinz
Alanna Heiss
George und Marion Helft
Heinz Werner Hellweg
Paulo Herkenhoff
Herkules Baseball Club, Kassel
Hochschule für Architektur und Bauwesen,
Weimar
Hochschule für Gestaltung, Offenbach
Hochschule für Musik »Franz List«, Weimar
Astrid Holzamer
Robert Hopper
AC Hudgins
Heinrich Hunstein
Philippe Huyvaert
Piet Jaspaert
Rainer Johannes
Popsy Johnstone
Jochem Jourdan
Winfried Knierim
Hans Knoll
Christine König
Anny Kostopoulos
Königlich Holländischer Baseball Verband
Achim Kördel
KSV Hessen Kassel
Bernd und Frank Kuchinke
Huub Kuijpers
Angela Lassleben
Evelyn Lehmann
Michael Leinert
Lilian Llanes Godo
Veit Loers
Reinhard Loock
Harm Lux
Elizabeth A. Macgregor
Christine Maes
Franz Malec
Kalundi Mango
Hans Martens
Hans Werner Martin
Kai Matthieu
Matthias Matussek
Friedrich Meschede
Christian Mespreuve
Peter Graf Metternich
Viktor Misiano
Bruno Mocci
Nadine Moerman
Stéphane de Montmollin
Frederic Montornés i Dalmau
Max Moulin
Daniela Muhle
Rosaria Navas Morata
Peter Ndumbe
Louise Neri
Susanne Pagé
Christos Papoulias
Charles Penwarden
Yves Pépin
Franz Peschke
Cathrin Pichler
Stephanie Plank
Carolina Ponce de Leon
Paul Ponjaert
Chantal Pontbriand
Erhard C. Pretzell
Provinciebestuur Oost Vlaanderen
Mucke Quinckardt
Till Radevagen
Detlef Richter
Farid Rivas
Doris Rogiers
Pierre Rosenberg
Anda Rottenberg
Russische Militärkapelle, Weimar

Berenice Samyn
Knut Schäfer
Mireille Schepens
Marc Scheps
Irmgard Schleier
Marianne Schmidt
Rudolf Scholten
Sören Schöttler
Dieter Schwerdtle
Nicholas Serota
Avner Shalev
Michael Siebenbroth
Alberto Sierra
Lucas de Smet
M. Smet
Andreas Spiegel
Sportamt der Stadt Kassel
Celia Sredni de Birbragher
Staatstheater Kassel
Stadsbestuur Gent
Stadtmuseum Weimar
Liliana Stepančič
Susan Stern
Kerstin Stoll
Toni Stooss
Jonas Storsve
Anny von Stosch
Dietrich Sturm
Jiři Svestka
Harald Szeemann
Rolf S. Taher
Jack Tilton
De Toezichtscommissie v. h. MHK
Subhash M. Tusk
Christine Van Asche
Veronique Van Bever
Ernest Van Buynder
Berlinda Van Den Bossche
Georges Vander Espt
Dino Van De Velde
Rony Van De Velde
Veerle Van Durme
Gaston Van Duyse-Adam
Piet Van Eeckhaut
Peter van Houy
Rudy Van Quaquebeke
Koen Van Rouvroy
Radu Varia
Robert Verdonck
Vereniging voor het Museum van Hedendaagse
Kunst, Gent
Pierre Verger
Marcantonio Vilaca
Vincent Vlasblom
Lutz Vogel
Fred Voncken
Michael Vosberg
Michael Wagner
Hugo Weckx
Kurt Weidemann
Die Mitarbeiter der Weimarhalle
Die Mitarbeiter des Kulturamts der
Stadt Weimar
Aad Westerlaken
Henner Wincker
Bernd Wolk
Thomas Wulfen
Loretta Yarlow
Yigal Zalmona

…and to those whose names we have forgotten
here, our families and friends

DOCUMENTA IX

Kassel

June 13 – September 20, 1992

CATALOG

Editors
Roland Nachtigäller
Nicola von Velsen

Concept and Layout
Marleen Deceukelier
Sony Van Hoecke
in cooperation with the artists

Biographies and Bibliographies
Philip Willaert

English-language editor
Robert Jameson

Translations
Michael Auwers, Stefan Barmann, David Britt,
Daniele Dell'Agli, Etienne Ficheroulle, Ursula
Gräfe, Barbara Henninges, Birgit Herbst, Frank-
Alexander Hettig, Heidi Janson, Reinhard Loock,
Agnieszka Lulinska, Charles Penwarden, Michael
Robinson, Marguerite Shore, Rosmarie Waldrop,
Robert Williams

Production
Sylvia Fröhlich
Stefan Illing-Finné

Lithography
Photogravure DBL n.v.-s.a., Sint-Denijs-
Westrem, Ghent, Belgium
System-Repro, Filderstadt I

Typesetting
Fotosatz Weyhing GmbH, Stuttgart

Printing
Dr. Cantz'sche Druckerei, Ostfildern

Bookbinding
G. Lachenmaier, Reutlingen
Buchbinderei Hofmann, Darmstadt-Arheilgen

Paper
Volume I.: Salaprint HM, Papierfabrik Salach
Volume II/III: Phoenix Imperial halbmatt,
naturweiß chlorfrei, Papierfabrik Scheufelen

Published in 1992 by Edition Cantz, Stuttgart
English-language edition published in association
with Harry N. Abrams, Incorporated, New York
A Times Mirror Company

ISBN 3-89 322-381-9 (Cantz)
ISBN 0-8109-2510-9 (Abrams)

Printed and bound in Germany
CIP/Library of Congress Catalog Card Number
please see page 270

CONTENTS | VOLUME 1

Marina Abramović

Absalon

Richard Artschwager

Francis Bacon

Marco Bagnoli

Nicos Baikas

Mirosław Bałka

Matthew Barney

Jerry Barr

Lothar Baumgarten

Jean-Pierre Bertrand

Michael Biberstein

Guillaume Bijl

Dara Birnbaum

Jonathan Borofsky

Louise Bourgeois

Herbert Brandl

Ricardo Brey

Tony Brown

Marie José Burki

Jean-Marc Bustamante

Michael Buthe

Pedro Cabrita Reis

Waltercio Caldas

Pier Paolo Calzolari

Ernst Caramelle

Lawrence Carroll

Saint Clair Cemin

Tomasz Ciecierski

Tony Clark

James Coleman

Tony Conrad

Patrick Corillon

Damian

Richard Deacon

Thierry De Cordier

Silvie & Chérif Defraoui

Raoul De Keyser

Wim Delvoye

Braco Dimitrijević

Eugenio Dittborn

Helmut Dorner

Stan Douglas

Marlene Dumas

Jimmie Durham

Mo Edoga

Jan Fabre

Luciano Fabro

Belu-Simion Fainaru

Peter Fend

Rose Finn-Kelcey

FLATZ

Fortuyn/O'Brien

Günther Förg

Erik A. Frandsen

Michel François

Vera Frenkel

Katsura Funakoshi

Isa Genzken

Gaylen Gerber

Robert Gober

Dan Graham

Rodney Graham

Angela Grauerholz

Michael Gross

George Hadjimichalis

David Hammons

Georg Herold

Gary Hill

Peter Hopkins

Rebecca Horn

Roni Horn

Geoffrey James

Olav Christopher Jenssen

Tim Johnson

Ilya Kabakov

Anish Kapoor

Kazuo Katase

Tadashi Kawamata

Mike Kelley

Ellsworth Kelly

Bhupen Khakhar

Martin Kippenberger

Per Kirkeby

Harald 'elhöller

Kurt Kocherscheidt

Peter Kogler

Vladimir Kokolia

Joseph Kosuth

Mariusz Kruk

Guillermo Kuitca

Suzanne Lafont

Gustav Lange

Jonathan Lasker

Jac Leirner

Zoe Leonard

Eugène Leroy

Via Lewandowsky

Bernd Lohaus

Ingeborg Lüscher

Attila Richard Lukacs

James Lutes

Marcel Maeyer

Brice Marden

Cildo Meireles

Ulrich Meister

Thom Merrick

Gerhard Merz

Mario Merz

Marisa Merz

Meuser

Jürgen Meyer

Liliana Moro

Reinhard Mucha

Matt Mullican

Juan Muñoz

Christa Näher

Hidetoshi Nagasawa

Bruce Nauman

Max Neuhaus

Pekka Nevalainen

Nic Nicosia

Moshe Ninio

Jussi Niva

Cady Noland

Manuel Ocampo

Jean-Michel Othoniel

Tony Oursler

Panamarenko

Giulio Paolini

A. R. Penck

Michelangelo Pistoletto

Hermann Pitz

Stephen Prina

Richard Prince

Martin Puryear

Royden Rabinowitch

Rober Racine

Philip Rantzer

Charles Ray

Martial Raysse

readymades belong to everyone

José Resende

Gerhard Richter

Ulf Rollof

Erika Rothenberg

Susan Rothenberg

Ulrich Rückriem

Thomas Ruff

Stephan Runge

Edward Ruscha

Reiner Ruthenbeck

Remo Salvadori

Joe Scanlan

Eran Schaerf

Adrian Schiess

Thomas Schütte

Helmut Schweizer

Maria Serebriakova

Mariella Simoni

Susana Solano

Ousmane Sow

Ettore Spalletti

Haim Steinbach

Pat Steir

Wolfgang Strack

Thomas Struth

János Sugár

Yuji Takeoka

Robert Therrien

Frederic Matys Thursz

Niele Toroni

Thanassis Totsikas

Addo Lodovico Trinci

Mitja Tušek

Luc Tuymans

Micha Ullman

Juan Uslé

Bill Viola

Henk Visch

James Welling

Franz West

Rachel Whiteread

Christopher Wool

KeunByung Yook

Heimo Zobernig

Gilberto Zorio

Constantin Zvezdochotov

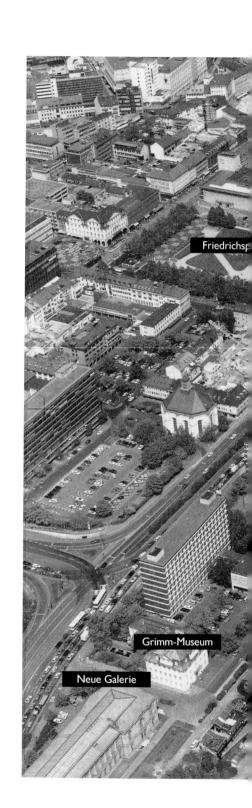

Friedrichsp

Grimm-Museum

Neue Galerie

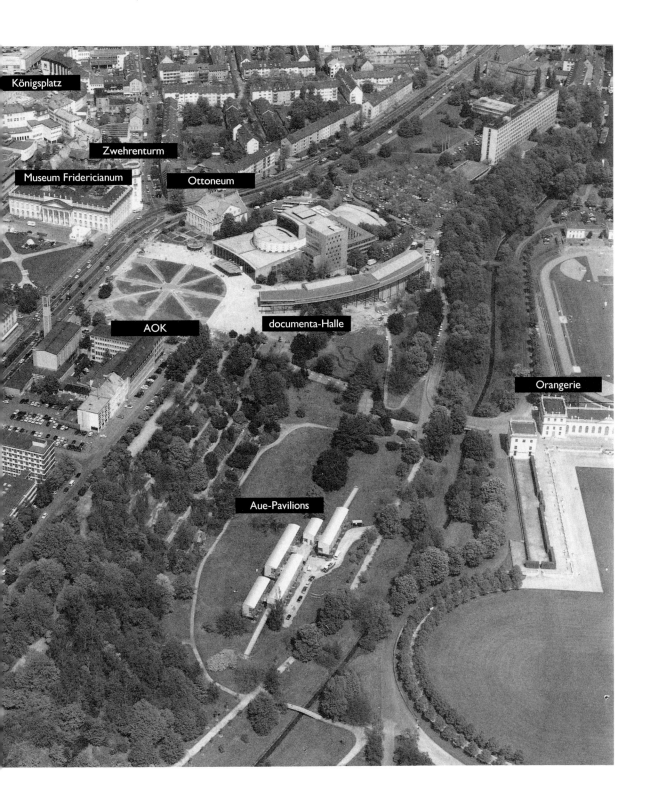

Königsplatz

Zwehrenturm

Museum Fridericianum

Ottoneum

AOK

documenta-Halle

Orangerie

Aue-Pavilions

FOREWORD

At first one only senses the change here and there, but later the feeling gets stronger and stronger, and finally it cannot be overlooked. After countless preliminary conversations, controversial discussions, after journeys round the world, an intensive search for artists and concepts, for views, assessments and rejection, it starts to take shape. Then the first artistic installations emerge on site, in squares, streets and parks. Art intervenes in the city's space, opens up showplaces for itself with different characters and atmospheres. The city, for its part, opens itself up to art. And then documenta is just *there*. The exhibition is open for 100 days. Accompanied by curiosity, tension, various expectations. Can and should all expectations be fulfilled? I think not. Every documenta is different. Each one provides new food for thought, different stimuli. There is no message required, there are no fixed criteria, no old guidelines to help an international exhibition to be recreated each time. Every documenta carries the subjective stamp of its artistic team. Documenta is simply documenta. This time it is a documenta without the Iron Curtain, a documenta in central Germany. And there is another first associated with the ninth exhibition; it is the first time the Neue documenta-Halle, built especially for the exhibition, has been used.

There are five years of work in DOCUMENTA IX. I should like to thank everyone involved for all their creativity and thought. I should like to thank the Federal Government, Hessen and the sponsors for their support. I should like to thank all the artists.

Wolfram Bremeier
Oberbürgermeister of the City of Kassel

AN INTRODUCTION

Jan Hoet

1

To write a text about an exhibition, after living with it through a gestation period of nearly three years, now seems to me like a contradiction in terms. At this moment the exhibition is becoming visible, tangible, real. Everything is in motion, though very little is finalized. Writing, for me, is always a definitive process: it establishes, freezes, creams off a concrete reality. The energy that propels me at the moment is one of movement, impetus, constant new involvements: an energy from without, not from within.

What can I write about, when so much remains to be said? Some things I would prefer to shout about; for such things, print seems altogether too quiet. I shall be expected to produce explanations, declarations of principle. But there are no true explanations or declarations, only letters and words: explanations, if you like, but not reality. Nothing but marginal notes, anecdotes, proposals.

My exhibition is an offer and a challenge; it is an invitation and an argument that can be experienced through the individual encounter with art. If a text that accompanies an exhibition is to be anything beyond self-justification – defending the work for which one has assumed such total and minute responsibility – then the only statements that count are those that direct the eye straight back to the exhibition itself.

So what should an introduction contain?

2

I might, for example, write about beauty: the physical experience of the secret of art.

Artists do not investigate the aesthetics of things: they reveal the hidden beauty, the essence, the ecstasy. Material takes on a new intensity that frees it from its physical trammels, transcends it, dissolves it into a new sensory field of reference. It is only by entering a work of art, becoming physically involved with it, that you can find the all-embracing experience that it demands. You have to be *in* the work, inside a wide open space created by the artist.

Art demands the eyes, the intellect, the body, the desires. It always relates to the body.

Just as the artist creates his work against the background of his own thoughts, his own experiences, his own intuition, and his own feeling for the body, the viewer, too, creates every work of art anew. The encounter with art begins at the point where the eyes reconstruct the artwork.

Experience is not a formal thing; it is not an image. Experience is always relative. It establishes associations with areas of life that we know already. This is not confined to experience in and with art; it equally applies to life experience. What counts is not what you expect but what you discover.

Great discoveries lie in store, not in this text but in the exhibition.

3

A story might be told, a long tale about the people and situations that I have encountered here. A story of all those little emperors who patrol the frontiers of their empires, day in, day out; kings in the tiny realms of their own responsibilities. It would be a good, long story, with plenty of surprises.

Much might be said about the antagonism between a provincial environment and a world exhibition; the clash between a petit-bourgeois craving for security and an internationally respected arena for free artistic interchange. An undertaking as hopeless as it is vital. A city gives birth to an idea, cherishes a tradition, and then is

appalled all over again, every time, by the stunning force and the creative potential that are released when that idea becomes a reality.

It would be the tale of the Sorcerer's Apprentice, and also that of Pitch Mary and Gold Mary – the folk story about the Unlucky Girl and the Lucky Girl. Somehow, one has to give all necessary support to those who are prepared to face up to the challenge of change, without at the same time totally overwhelming the unprepared. Conflict as open dialogue…

How better to conduct that dialogue than with, and in the presence of, art?

4

There is so much to be said about seeing, about how we have learned to perceive, about our experience of the world. This world has grown smaller: the 'global village' that was outlined by McLuhan now forms the horizon of our everyday lives. Almost everything is available; we have access in seconds to information, impressions and experiences of every kind. The world is atomized; the holistic vision is increasingly disappearing from our lives. Everything has become an image, mediatized. Our contacts with the world outside ourselves are concentrated in the eyes and in the immaterial experiences that they convey. No longer does the world seem alien: it has become a kind of object, a thing we think we can be sure of. Images allow parallels to appear where there was no comparability before; we feel secure because we have risk-free visual access to all phenomena, however distant. Any attacks of insecurity, anxiety and disorientation that we may suffer have been safely categorized, docketed with psychoanalytic, psychiatric and sociological names, and embedded in a system of social and psychic care. There are enough supervised free areas and domestication devices to keep every possible aberration safely within the system.

But the hold that civilization maintains on the widening cracks and fissures in our well-ordered life is becoming less and less effective. The threats and assaults of the Unknown (within and without) have become more diffuse, harder to localize, and accordingly more urgent and more absolute. In a world in which almost anything can be digitally objectivized, there is a patent need for a mediating language.

Total availability also means total inconsequence. Models with a strict inner logic, systems on the basis of a limited number of axioms, provide only a very temporary security. The compelling rationalism of the categories makes possible any coherent combination of the components. If everything can be logically connected with everything else, then truth becomes interchangeable and there-fore unimportant. At a time when experiences are becoming less and less concrete – more virtual, in fact – only total intersubjectivity, only the awareness of specific concreteness and physicality, can provide a new impetus.

What is called for is no longer the invocation of grand abstract and transcendental visions, but an acute eye for the physical components of the world around us: a new, objective relation to the world of objects (with an over-attachment to detail as its inherent negative aspect).

Reassembly of atomized experiences; reorganization beyond all scientific systems; reconstruction of an existential sensory network: this must be among the aims of art. The body must be talked about once more: not physically but emotionally; not superficially but mentally; not as an ideal but in all its vulnerability. In this respect Beuys opened a door. His work constantly demands of us that we take responsibility for our own actions.

But what is the point of writing about visions and experiences instead of having them? All the potential is there, in documenta.

5

Whatever I write, I know many people are going to read it not as what it is – a reflection – but as what it never intends to be: a conception. A concept, in the sense of standing at the beginning, framing the point of departure and setting the

course of further reflection. But for me there has only ever been one starting-point, and that is art, artists and their works: things created by inner necessity, which have sought and made a place for themselves.

Does documenta have a place of its own? In the eventful history of this exhibition, the Museum Fridericianum has been central from the start. But what was it then, and what is it now? All that was standing in 1955 was the remnants of some eighteenth-century stonework, protected by a flimsy, temporary roof. Inside, the whitewash on the exposed masonry barely covered the soot left behind by the incinerated knowledge of a once magnificent, bombed library. The thick, black plastic sheeting used in the first documenta, which formed bold accents as part of the exhibition hanging, looked like an abstract reminder of that great annihilation. The Museum Fridericianum was not a museum: it was a ruin brought to life by a grand gesture. From the ashes of the Second World War, classic modernism arose to meet the 1950s.

With more than thirty-five years of tradition behind it, this ninth documenta takes possession of a relatively well-established location. In 1987 the Museum Fridericianum was restored in accordance with building regulations and divided into fire zones; it is now on the verge of collapse from the sheer weight of concrete that has been pumped into it. Then there are the newly built documenta-Halle; the Neue Galerie, somewhat dusty but interesting; a slowly crumbling museum of natural history, with many undiscovered treasures in it; and the stoutly built temporary exhibition pavilions on the Aue.

In the beginning was non-location. More an idea than an institution, for documenta arises out of virtually nothing every time. Its premises are not really its own: they are permanent installations on temporary secondment. The logistics, the person-nel, the organization, the exhibition sites, everything has to be found from scratch. All that is permanent is the basic idea, a tradition that has acquired an economic momentum of its own, together with the history of its past realizations. It is an idea in search of a place in which to be manifested; and initially it finds this, as it always has done, at the Museum Fridericianum. From there, the threads spin out further; new buildings and spaces are discovered and insert themselves into a living topographical web of relationships. And then the spatial structure of the exhibition is suddenly there in the mind's eye, and becomes both the point of departure and the decisive, leading goal.

The ninth documenta is a documenta of places; its topography is the framework that supports it all. But it is also a documenta of artists; for they alone create the spaces within the framework. An exhibition must always take its own material circumstances as its point of departure; buildings, light, paths. It must always see and experience that, rather than look for theoretical concepts.

6

Or should I write about the artists? The many fascinating, disconcerting, powerful encounters and experiences? The artist stands at the centre: the making of the exhibition derives from an intensive engagement with his or her work. My documenta takes the artist and the artist's work as its sole point of departure. Organizing an exhibition, for me, is always a battle, a struggle for every work, an engagement to the point of physical exhaustion.

The artist has this extraordinary energy; this great expressive power; a potential that a maker of exhibitions never has. An exhibition can only profit by this energy, draw it out, make it visible, channel it and make it available to outsiders. The strength of an exhibition lies in revealing energies that are the motive forces of the world, energies that maintain life in motion, that manifest – for a single instant – beauty in its pure state.

Artists are the motors of the world; but they need the rest of the vehicle if their power is to become a propulsive force and not merely run to waste. This exhibition is intended to be a drive-belt.

7

And then someone sends in a text:

'…The earth does not seem to be the quarry of matter, to be shamelessly exploited by enlightened human reason. The earth is the origin of life, a metaphysical event like no other, to which man, even modern man, owes his origin and his continuous existence. This is proved by his own earthly body. He wears the image of life *par excellence,* the earthly sign that constantly reminds him of the maternal umbilical cord. Plato and his followers detected a metaphysical image only in the geometrically defined male body: a microcosmic mirror of the macrocosmic, rational order. They saw only the head, the seat of the rational soul, the part that moves along furthest from the earth. With eyes wide open, they remained blind to the signs of their own original ties… Art, through its metaphysical fidelity to the miracle of life, becomes what it always wanted to be, namely a maternal art…' (Sylvain De Bleeckere).

Is this a possible way to write? Can anyone – and a man, to boot – write a thing like this? And what does it mean when more and more artists seek to locate themselves where they can deal with the things of everyday life; when many works seek to locate themselves somewhere between the creation of new, mystically charged spaces and a conceptual enquiry into the fundamental, organic, 'dirty' side of life; when excrement, consumer culture, the vagina, phallic symbols, death and sweaty sex are dragged into the white purity of the classic exhibition space? Shifting things out of their accustomed contexts, references back to Duchamp, 'displacement',[1] the destabilization of one's own standpoint, are important modes of access to an everyday world that is all too readily dismissed as low and banal. But does that make it a female or – better – a maternal art?

Once again, things themselves have got to matter more than what we say about them. We live in an age of social, individual and cultural indeterminacy, in which the horizon is no longer a straight line. It manifests itself as a vague tension between heaven and earth, an indeterminate zone in which we can no longer achieve a sharp visual focus. Good and evil, above and below, true and false, blur into each other in a transitional zone that generates a bewildering state of relativity.

Experience means the world. Art that speaks on this level is always an instrument that makes things happen, arouses emotions, makes us aware of historical associations, demands a judgement. Art that alters, corrects, arouses doubts. Art that maintains contact with the earth, absorbs evil, grasps handfuls of dirt, looks death straight in the eye. Art that no longer appeals to a transfigured, metaphysical consciousness but enquires into the conditions of earthly existence – and thereby provokes us into seeing things in a new way. In this there may be a new turn of thought, a long-overdue ability to relate to the female structures of this world. That is one of the questions I would like to answer for myself through this exhibition.

8

Why am I always being asked about criteria, abstract yardsticks, good and bad taste? Art is not a matter of taste, but of choice. Choice takes courage, decisiveness. Taste remains indefinite and undecided; it always leaves a back door open. You have to be able to say Yes or No, give your reasons and examine them – and be able to make mistakes. To make a good exhibition, it is not enough to assemble a hit-list of celebrated names; there would be no coherence in that. An exhibition has a specific aim in view; it is carried along by one controlling idea. That in itself shows where the selection process must start, how successive decisions affect each other and have the power to create an inner structure. Such a structure cannot be described; you can only see it, empathize with it, experience it, reconstruct it and reinvent it in the course of the direct confrontation with the real experience.

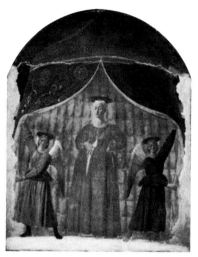

Piero della Francesca, Madonna del Parto

1 Is it possible for mathematics and art to make use of the same concepts? Where will it lead to when art refers to mathematical phenomena, and mathematics finds its way into art? The possibilities and problems of this approximation are described in a short text accompanying the first poster of Documenta IX, 'Leibniz, Newton and Displacement' (written by Dietmar Guderian): 'Between principle, chaos and catastrophe'. Artistic œuvres don't lend themselves to being summarized by a 'Leitmotive' (for example by the word displacement). However, by signalling possible starting points, for instance expression, or directly, by organizational givens, such a term can be brought into the immediate preparational stages of an exhibition. We will, here, illustrate the term 'displacement' and demonstrate its breadths by giving an example from traditional mathematics, but at the same time point out that 'displacement' cannot only have normed effects/results.

Empirical displacement: Example:
An exhibition by Reinhard Mucha in an Italian gallery: In a small, windowless room are some works in a corner. There is a door to a second room. In this room, which is painted white, there is a window that is open to the street; on the inside, there is a repetition of the 'frontispiece' picture of the first room, here, however, 'displaced' and broken up on the walls.

'Displacement' does not show up in this case only in the form of the work existing twice, but becomes empirically knowable to the viewer. He leaves the exhibition when he goes to the neighbouring room, but this one and the copy of a picture from the gallery room found here, even though spatially removed from the exhibition, does not allow avoidance.

The chalky-white ambience and the 'displaced' work there, keep him in the spiritual vicinity of the exhibition. It offers him the chance to come to an understanding while remaining within the system, even though at a distance. When leaving the exhibition he has to enter the main exhibition room for a second time: After a temporary, 'system immanent' distancing the viewer's return once more to the exhibition is guaranteed.

Displacement in Mathematics: The field of Mathematics offers a relatively easy access to the term 'displacement' in an area in which the word did not exist originally: in Infinitesimal Calculus, essentially developed by Leibniz and Newton. The drawing on the documenta poster was created during a lecture on this topic in Kassel: If we are located at a certain point of a parabola, it is at first impossible to which incline or bend the parabola has at this point. However, if we move around the curve for a short distance (displacement) to a second point the connecting straight line of both points can be described by a function. If we now return to our starting point the straight line becomes a tangent.

Meaning for DOCUMENTA IX: Even in the case of two artists working in the same spiritual neighbourhood, it is not predictable how a minimal 'displacement' onto each of them will reflect itself, and particularly how similar the results will turn out to be. The behaviour of the individual artist, his reaction to the 'displacement', is not predictable; it is even, in a mathematical sense, chaotic; the severe principle of causality (similar causes leading to similar results) no longer counts.

It is even feasible that an insignificant displacement of the artist or, rather, of his thoughts will lead to an irreversible change in his artistic balance to produce a 'creative' catastrophe (according to the mathematician Thom).

Final remarks: 'displacement' in the preparatory stages of documenta is also to be understood as an intellectual push that has its parallels in the exact sciences.

In addition to the empirical solutions, it also leaves a path open for the creative catastrophe, the invigorating chaos, especially because of the 'complex' personalities of the artists.

Lit.: D. Guderian, *Mathematik in der Kunst der letzten dreißig Jahre*, Bannstein-Verlag, Ebringen i. B., 1991.

9

I wonder, sometimes, whether I really want people to *read* what I think. I find talking more important. Dialogue means more to me than circling around a subject in a self-referential way. I need movement, the proximity of the works themselves. I want people to talk to each other, debate, argue, look outside themselves. I want them to think along with art and have experiences; I want to see the power that dwells within art become a reality within our society. I am sure that society needs art more than ever.

Art is always subversive. It calls established reality into question, upsets ingrained habits and thus creates new linguistic ground-rules, both artistic and social. Art provokes, and politics is ultimately not separable from it but a constant dialectical challenge.

Art is an attitude that stems from resistance to every kind of authoritarian ambition (conformity, prejudice, restriction), including Nazism and Neo-Nazism, which is now gaining impetus everywhere in the world. The documenta exhibition is one for which freedom is a basic, indispensable pre-condition; a place, too, in which art takes a stand against those destructive forces within society.

I believe that art intrinsically possesses this power; I believe in its potential to change things; but I have my doubts as to the power of anything I can say about political or social realities.

10

As I sit here writing my text, my thoughts constantly stray back to the exhibition, and I think about how one picture relates to another, about how the visitor is going to move between two installations, and whether the various rooms will really deploy their full potential.

This exhibition is my text; every work that is contributed is a postulate; and the discourse unfolds as one walks through the spaces. It shows how one can think in and with reality, and it shows how one does not necessarily need a blank piece of paper in order to think. It shows art.

(Translated from the German by David Britt)

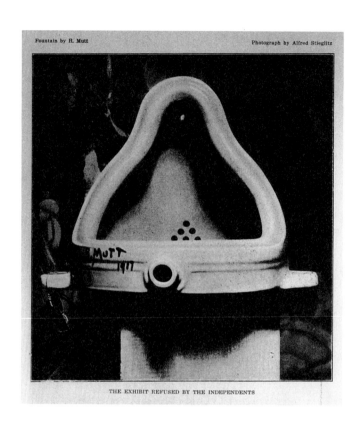

Marcel Duchamp/R. Mutt, Fountain, Readymade,
1917

THE ORIGIN OF THE WORLD
A real allegory of the work of art
and its 'taking place' in the world, today

Denys Zacharopoulos

*"We never share thoughts,
we share movements, mimetic signs,
which we then read back in terms of
thought…"*
F. W. Nietzsche, 14 (119) Spring 1888
(K. G. A. VIII, 3)

*"How would it be possible for a chrono-
logy and topology of being and non-
being to stand and fall in the play of
space and time?"*
Kostas Axelos, *Einführung in ein künftiges
Denken. Über Marx und Heidegger*, 1966

In history, any date will do. Only with regard to works of art does their signifying power vary, so that they sometimes actually become significant. Since the 19th century, the works which have marked art history have also been those works that have actively displaced its limits – the limits of sensibility, of comprehension, of reception, of discourse, of institutions and of meaning. It is these displacements that now define what is understood as the *form* of works of art, a form that is no longer to be considered as the static contour of an object, but as a dynamic set of relationships of increasing complexity and heterogeneity. This complexity and heterogeneity of the whole thus constitutes the specific dimension of works of art, which is their *autonomy* in relation to any single or univocal instance of authority other than that positively problematic notion that is *the author of the work* – the artist, not as a simple producer or genius who creates things and reproduces meanings, but rather, as the irreducible reality of the work, its necessary condition of possibility, that part of its existence which calls it into being.

What the work and the author together – and immediately – constitute, is the possibility of producing, without any pre-established or explicit rupture, 'the text and its interpretations', or (to sidestep the trap of philology) 'the text and its

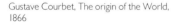

Gustave Courbet, The origin of the World,
1866

contexts'. In the secularized modern world the artist, like the citizen, simultaneously produces and establishes the letter and the spirit of his laws. Since the beginning of modern times, the uninterrupted production of the world and the constant mobility of the establishment of its laws have provided a measure of liberty – of the degree of autonomy of individuals and their works. These incessant displacements of the world's (or even worlds') limits and frontiers, mark the dates of splendour and misery in history and in art.

Mario Merz, Igloos, 1968–1985

Taking up one of its most conservative, or even reactionary, positions this century, the philosophy of law has claimed that the frontiers between different countries are given, defined, pre-established by *the unwritten law of the earth* (Carl Schmitt, *Der Nomos der Erde,* 1950). These frontiers are immovable, rooted like trees, plains and mountains in the skin of men. They shape the destiny of each race and language – the power of history whose only path leads inescapably to dictatorship and war (Carl Schmitt, *Die Diktatur,* 1921). According to this position, the immutable law of blood and earth can be threatened by *maritime law* (Recht), the law of ententes and alliances. Maritime law knows no 'natural frontiers', but only limits that have been established by free (or even 'cultural') conventions between men – products of conceptual abstraction that recognize mobile and changing contexts which, on each occasion, call for different and diverse solutions. The Manichaeism of such an ideological reduction has stamped its tragic seal on our century. Even today, we can still hear its subterranean echoes in voices which, though muffled, are no less frightening for all that. In response to such an apocalyptic claim, we can at once – and without resorting to expert analyses – insist that nearly all the important works of art created over the last two centuries clearly have their place within the scheme of maritime law rather than in the so-called law of the earth. The autonomy of works and the incessant displacement of the frontiers of sensibility and understanding, constitute the irrevocable achievement of modern art, of its works and, by the same token, of man – his growing capacity for abstraction which multiplies heteronomies into countless local institutional networks that together constitute the shifting complexity of his works.

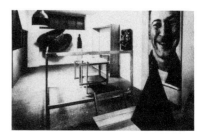

Gilberto Zorio, Canoë, 1985

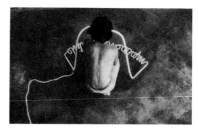

Pier Paolo Calzolari, Impazza angelo artista, 1968

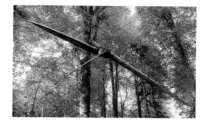

Michelangelo Pistoletto, Oggetti in meno, 1965/66

Since Newton and Kant, modern thought has abandoned the law of the earth to recognize the *a priori* not in the factual measurement of the earth (geometry), but in *space,* the necessary condition of man, of his constructions, his concepts and his thought. Since those philosophers, the infinite universe has been closer to the moving element than to the firm propositions of *geocentrism,* from which it has retained only a law of gravity and a field theory. The citizen of the world, the Kantian cosmopolitan, does not find himself 'between the earth and the world' (M. Heidegger, *Der Ursprung des Kunstwerks,* 1936), but 'projected' towards 'the starry sky above' by 'the moral law within him' (I. Kant, *Kritik der praktischen Vernunft,* 1788) – two conceptual abstractions that situate men in space with the previously unconceived duality of law and limit, in a displacement that is mutual, interactive and constant.

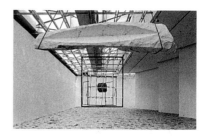

Luciano Fabro, Tautologia del pavimento, 1967/88

It was this Enlightenment vision that inspired Victor Hugo to displace the metaphor of space in *Notre-Dame de Paris* (1831), which he wrote in the middle of the 1830 revolution. In only a few dozen pages, and with the romantic and revolutionary verve of the poet, he went from the first stone used by man as a tool or home, to a condensed account of human construction in history, considering the incessant gains in space, in complexity and in meaning brought by civilization to man's architectural constructions – from the unicity of the pyramids to the rhythm of the Greek temple; from the organization of Roman constructions to the globality of Byzantine churches; from the systematics of Romanesque monasteries to the Gothic cathedral. It was the Gothic cathedral that achieved the highest degree of spatial complexity, elaborating the biggest, most composite and most diverse of totalities, both as a physical construction and as a symbolic construction of space in

Giulio Paolini, Abat-jour – Giocchi Prohibiti, 1986

Brice Marden, untitled, 1985

Niele Toroni, Empreintes de pinceau n° 50
répétées à intervalles réguliers de 30 cm, 1988

Gerhard Richter, Tote, 1988

Per Kirkeby, untitled, 1982

Joseph Kosuth, Zero & not, 1986

Bruce Nauman, Good Boy, Bad Boy, 1985

the image of the world (almost like a *Diaphane Struktur*) – and this, at the very moment, in 1456 (we must allow the poet Victor Hugo this brusque response to the needs of his method), when Gutenberg printed the first book. Since that time, the prophet has no longer gone to the mountain (refuting once and for all the law of natural frontiers), and instead the mountain has gone to the prophet. To come closer to the facts the church has ceased to occupy the symbolic centre of the world, and the book (the Bible of Gutenberg and Luther united in the fusion of the letter and the spirit of the text) has taken hold of movement and displaced itself, entering into all houses. History begins anew in another dimension, where yet more space may be gained and complexity imagined – or conceived. As early as 1831, Victor Hugo displaced the metaphor of the title *Notre-Dame de Paris* towards metonymy and claimed the complexity of the Gothic cathedral for his own book. Luckily for him, Hugo did not live to see our century, in which barbarism has burned books in the same way that it once destroyed churches. *The book,* here and from that time onwards, stood for a space as vast and open as the infinite universe of meaning and language. And, a little like Kantian man, it too hangs by a thread, standing on one side only: *its binding, its fold, its categorical imperative.* On the other side, the infinity of space and the infinity of meaning open and bathe in the same moving element: the unfolding of language and the world like the sky and stars of the cosmos – text and context produced immediately by the displacement of the limit of space, of the autonomy of the work of art, of its spatial constitution and the conceptualization of frontiers in the plurality of worlds.

In the sphere of the fine arts, it was during the same period that Gustave Courbet effected the same movement from metaphor to metonymy of space and the world with *L'Atelier* (*Painter's Studio* or *The Workshop,* 1855). Work and author leave the soil of origins (Ornans) and the place of arrival (the Salon) to project themselves into the plural being of *production, the work and exhibition* as one single mobile structure for both the world and meaning. The work is freed from all forms of equivalence to a specific place since it is both memory of that place, production of that place and place in itself, displacing all limits and frontiers into the space of the world. In this world, the world of modern man, the only possible origin is that of a woman's sex (*L'Origine du Monde* or *The Origin of the World,* 1866), that part which stands in for the whole without closing itself as totality, and which is positively unaware of any idea of a centre. *The Raft of Medusa* (1819) had grasped the advent of the secular world metaphorically as a shipwreck with a spectator (to borrow the arresting title of Hans Blumenberg's *Schiffbruch mit Zuschauer,* 1978): had grasped the concept of floating in the world of life and the infinitesimal displacement of the meaning of Dasein in the unrepresentable dramaturgy of existence in the moving space of the world. This was realized by *L'Atelier* and then by *L'Origine du Monde* as the event of the work's floating existence in the world of life, like a sudden glimmering over an abyss.

This abyss *(Abgrund),* be it that of the oceans or of sex, the place of the work or the author of the place, substantially displaces the foundation *(Grund)* of the law of the earth or of the ground of truth as origin of the work of art. It turns it towards the opening of the infinity of space, in the vertigo provoked by the dimension of the *work's* liberty and of the *individual* in the world, by their autonomy and by the gain in space as 'gain in edge'. That was how Werner Haftman put it when describing his own constitutive experience of modern art, which was to provide the intellectual framework for the first documenta. Haftman's active position in this respect contrasts with the passive resignation of Hans Sedlmayr who, faced with the possible loss of a centre in modern art (*Verlust der Mitte,* 1947) called nostalgically for a law of that earth on which cathedrals are built (*Die Entstehung der Kathedrale,* 1950).

This *gain in edge,* which is to the *loss of centre* as maritime law is to the law of the earth, should not be confused with some kind of regionalism or marginalism. It stands for a question which opens up the whole the modern world, a question

whose ramifications run through and transform both society and knowledge, from the French Revolution to Impressionism and from the Marxist revolution to psychoanalysis. A question which opens, quite simply, onto the world. This critical question seeks to calculate infinitesimal distance and proximity, the constant and pluridimensional disparity between two capital notions (because in the age of Capital questions are 'Capital' rather than 'fundamental') – the notions of *individual* and *institution*.

It is with these two notions that we must consider the set of conceptual constructions which form the conditions of possibility of our representations. Whether these constructions tend towards continuity or discontinuity, whether they seek a totality or a fragment, whether they operate by globalization or by fractalization, on each occasion the individual and the institution constitute the *passage through* the quicksands of signification. Their reversibility – and not their dialectic – unfurls the positive dynamic of modernity. At the same time, the problematic interstice between them, the fold, through which nothingness, chaos or infinity come to the surface, posits, supposes and transposes the limits of being and the world in a *topology* in which the *a-topos* (ubiquity) of the individual and the institution rest, are deposited, and oppose, becoming their *chronology* (given here as an isomorph of the topology) or, to use Nietzsche's term, their *genealogy*. The *a priori* of critical philosophy and the *as if* which both fecundates and generates it as its 'other' not only transforms space into the structure which carries every noetic abstraction, but also makes it the institutional base, the taking place of the free convention of the institution.

In this context, this base must be conceived in literal terms, as regards both its topological constitution and its chronological extension, and even its genealogy. In art, since the assassination of Marat, since the painting of the same name by David – since the coincidence of the two in time and space (the place of the event and the date – 1793), this literality has left the bureaucratic empire of the administration of meaning to offer itself – as Rimbaud said of poetry – 'literally and in every sense'. In the work of art, above all, space and time are to be taken literally, and in every sense. The gap between the individual and the institution, the experience and the work, the real and meaning, separate and touch each other at the *moment* of the *taking place* of chronology and topology. Displaced, each towards the other, each within the other, indissociably, topology and chronology *become event* – what the event consists in and what acts on the event, in one and the same place: *the work*.

Thus, in art, this constant process of displacement carries metaphor (the *analogon* or *parergon* of philosophers and of discourse) towards metonymy (the *logos* or *ergon*): meaning and the work. In a modern work of art, the passing of the individual and of the institution, the movement from one to the other, and their reversibility, take place literally. This literality does not yield, in strict terms, a 'metaphorology' (inasmuch as the tendency towards condensation is constantly deviated) or, in general, a 'hermeneutics' (insofar as the distinguishing feature of the part which stands for the whole, and which metonymy exemplifies, constantly acts on displacement, displacing it and projecting it into space/time, into the world, at the same time as it is itself constantly projected from within the world, condensed in its infinity). What this characteristic projects, and what projects it, take place, in the arts, together and in the world, and not within discourse. This base, then, taken literally, appears, posits itself and opposes in the *œuvre* of David in the space and the time between the bath-tub containing the body of Marat and, some years later (1800), Madame de Récamier's divan: *place of the body and taking place of the individual – place of meaning and taking place of the institution*. Between the assassination of Marat and the portrait of Madame de Récamier, this gap is acute and alive, projected and displaced from hand to eye, from the revolution to desire, from art to culture, from action to the body. Between liberty and privilege,

Lothar Baumgarten, Juripari (stanza di Rheinsberg), 1984

Jean-Pierre Bertrand, Le livre de sel, 1980/85

Isa Genzken, Camera, 1991

Silvie & Chérif Defraoui, Cartographie des contrées à venir, 1978

James Coleman, Box, 1977

Dan Graham, Deux cubes, l'un tourné a 45°, 1986

Ed Ruscha, SIN, 1991

Ilya Kabakov, Lew Lwowitschs, 1972/75

Louise Bourgeois, No Exit, 1988

Pat Steir, The Moon and the Wave: Courbet's Moon, 1986/87

Franz West, Liege, 1989

Max Neuhaus, Sound Installation, 1986

between violence and representation, between action and contemplation, the event and the meaning of the work, the gesture and word of the artist, live/inhabit the space and time of the world.

At the same time, the *turning* of thought in the world carries the categorical imperative and aesthetic (or critical) judgement, together, towards the constitutive intuition of man and the constituting experience of the world. This 'base' then becomes a 'turning point' between intuition and experience, between man and the world, where 'chronology' and 'topology' turn and return while displacing the gap the deadly effect of which insists and persists: the gap between the individual and the institution – a gap both problematic and constantly problematized. In the œuvre of Géricault, this gap is at work in the passage from the *The Raft of Medusa* (1819) to the portraits (faces) of the interned mental patients (1822–24), between the a-topia of subsistence and the topology of substance, between the a-topia of the event and the topology of chaos: *the limit of the body and of the taking place of the individual* – limit of meaning and taking place of the institution (prefiguring, perhaps, *The Persecution and Assassination of Jean-Paul Marat performed by the players of the asylum of Chrarenton under the director of Monsieur de Sade,* as in the key work by Peter Weiss, 1964, and its contemporaneous staging and film adaptation by Peter Brook as *Marat/Sade*).

As it comes into contact with the world, the *œuvre* – as exemplified by Géricault, holds this gap; constrains it (or even suspends it, at the same time as it is actually projected by it) between event and word, culture and art, body and madness, liberty and chaos, existence and nothingness, the unrepresentable and violence, inertia and mutism, the edge and non-place, time and space. This turning now marks the incessant displacement and constant condensation of this *limit/edge* between interiority and exteriority, between heteronomy and autonomy. The starry sky of self consciousness, the landscape and the face, taste and the sublime, critique and crisis, are given, here and now, finite in their dimensionality and infinite in their incommensurability, both terrifying and familiar at the same time.

Here, the *as if* of all *a prioris* does not introduce some form of relativism or fictionalism, but the temporal ('modern') mode in which are given both man and the world, the institution and the individual, *time* whose trace constitutes the infinitesimal gap where separation and infinity touch and move asunder, are projected and, simultaneously, project us. 'Thrown being' *(Geworfenheit)* finds itself *in the world,* projected by the world in its terrible and generous exteriority. In the image of *the book* (that perfect taking place of the dialectical suppression of subject and object), being opens itself through *the middle* (not to be confused with 'the centre') to project itself into space which, at the same time, projects it as an individual – that is to say, an indivisible unity, bound along its edge by the edge that holds its multiplicity and opens itself to the multiplicity that contains and projects it. This elusive relationship of the same to the other, before becoming a philosophical discourse, immediately posits the means of production of the world, its diaphanous structure, offering itself as the crucial question of representation and reality: their unique substance and their substance on the edge – or the fold – which holds and divides in the same movement both institution and individual.

War or peace, destruction or action, violence or work, it is on this edge and through this edge that, in an endless process of transformation, substance becomes desire and revolution, liberty and difference. Whether avant-garde or restoration, meaning or style, civilization or culture, this edge on the verge of overflow marks the 'taking place' of which the gain and loss (since you cannot have one without the other) intersect – as in the figure of the 'chiasma', the interweaving of the *visible and the invisible* (M. Merleau-Ponty, 1964); like the unknown constant of mathematics, the x: at once institution and individual between the infinitely same and the other; like genetic crossing, in which genres and species touch and move asunder, a process of mixing and hybridizing so that the individual and the world mutually yield and deliver themselves and each other; like the crossing of rail

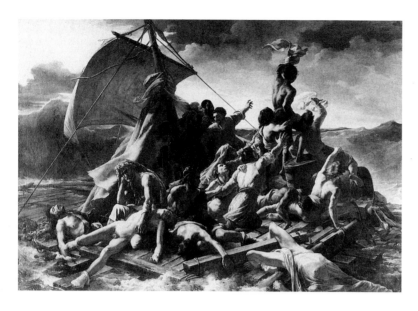

networks, sea routes, flight paths where the world is multiplied and extended, where passages and turning points ceaselessly project themselves as they institute the world and project the individual who projects them. This crossing takes place beyond any simple crossroads, beyond the principle of bifurcation of a single path which, from Platonic dialectics to the Hegelian system, demarcates virtue and vice, truth and falsehood, reality and illusion; 'for one cannot enter the same river twice', as Heraclitus said, and, at the same time, 'the road, upwards and downwards, is one and the same'.

In this world, where one never enters twice – nobody enters David's bath-tub or Géricault's raft twice – we are on the water's edge, ready to jump in, to project ourselves into it like Cézanne's *Bathers* (1870–1906). The gap between floating existence and the incessant displacement of the limit-on-the-brink-of-the-abyss, should be conceived, rather, along with all that separates and unites ('that road, upwards and downwards, one and the same') the *Waves* series by Courbet (1870–72) and the series of *Water Lilies* by Monet (1916–26): mastery of the openness of the ocean and elusive closure of the pond upon itself, recurrence of the motif and return of the movement upon itself, element in itself and moving element. Over the expanse of modern time, the substance of the world is simultaneously individuated and instituted. The opening of the abyss becomes the *apparent limit of non-place,* and also the *instituted non-place of that limit's disappearance.* The *Waves,* and later the *Water Lilies,* establish the work in the world as the edge of the abyss and as the incessant displacement of its boundary. Topology and chronology intersect imperatively and project themselves into infinity. Space and time open with the work which, in turn, opens itself to the middle of the world like that complete suppression of the dialectic of subject and object. With Courbet, the dimension of the work of art breaks definitively with the culture of the day – and indeed with the very notion of culture, to open itself to the difficult practice of the real. The eternal return of the same occurs at the same time as the momentary departure of the other. The individual and the institution are incessantly displaced towards the exteriority of a limit at the edge of the world and at the edge of meaning. From now on, it will be this displacement which will

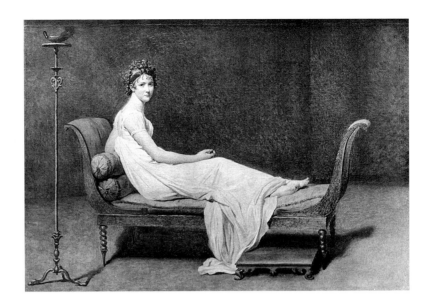

Jacques-Louis David, Madame de Récamier, 1800

project the conditions of possibility of all conceptual constructions, representations, knowledge, or society.

The *Wave* series – which precedes, accompanies and succeeds the revolution of the Commune (1871) – took up the challenge of the unrepresentable, of that density composed of contradictory, unbound forces and currents, of fluxes and accident, of which the painting can register only the symptomatic surface that hovers above and opaque and impenetrable depth. But Courbet was no Romantic. This diffuse and inconceivable force with which he grappled, as if taking up the challenge of the real in painting, cannot be thematized in terms of a nature/culture dialectic. Similarly, the questions of unrepresentable reality go beyond the problems of the subject's perception and they do not constitute the object of a phenomenology. Analysis here is never a thematic tool. On each occasion it follows the symptomatology which the object provokes and places in contradictory situations, without ever confining itself to a single level. It is open to an elusive, active complexity, a density ceaselessly condensed by the infinite displacement of experience in the order of things and situations.

As with Freud's psychoanalysis, there is no theoretical essence to Courbet's painting. Both are historic practices whose relationship to the real – and its symptomatology – constitute both their problematic and their efficacity. At the same time, for both Freud and Courbet, there is no clear demarcation between the *real* and the *as if*, so that this same real is never pre-established. It constantly eludes the representations of which it constitutes the latent content. What is manifest, then, is a kind of denial or allegory – *a real allegory,* to use the difficult term used by Courbet to refer to his *Painter's Studio* (1855). Here, the real is a density of things and situations whose depth escapes any given order or system (should we extend this symmetry to the point of imagining an isomorphic relationship between Courbet's *Atelier* and Freud's *Practice?*). As the work of the other and return of the same in the ongoing drift of the world, they take form and give themselves as the *taking place* in which gain and loss interweave beyond any dialectical principle (of pleasure or profit) in the panic-stricken overflow of the

Sigmund Freud's Couch, London

individual's secular existence and the outflow of the vertiginous impulse of being projected to the instituting exteriority of the world. If the *divan* of Madame de Récamier from the beginning of the century becomes the Freudian couch, then the bath-tub of Marat turns into a urinal, changing instantaneously from R. Mutt's *Fontaine* to Marcel Duchamp's 'ready-made' (1917). Where life is ceaselessly torn asunder and constituted, from the event to the body and from flesh to desire, the gain in edge on the inexorable *there is* (like the wave on the ocean or sex on the body) consists in a *taking place of ubiquity* and coincides exactly with the *infinitesimal gap between the essence of alienation and the substance of alterity.*

Reinhard Mucha, Das Figur-Grund Problem in der Architektur des Barock (für dich allein bleibt nur das Grab), 1985

From the moment place displaces itself from its 'soil', leaving the threshold of interiority to find itself projected towards the exteriority of the world, the contemplative conception of the individual as a 'thrown being' ceases to be able to conceive of liberty. Because liberty is outside the individual, is not given with the individual and is not its attribute property or origin, it is to be taken with the world and understood with the world. Liberty does not simply occur, it is an event and is constituted as a project. The absence of territory, the abyss of infinity in which existence floats, opens with the world at the same time as the individual conquers his autonomy in the project which displaces the limit of the thrown body. This body, its state that of 'a thing among things', is struck by the *event* (be it desire or revolution) and displaced to the edge of an instituted place, of a taking place (of liberty or difference) where, being transformed into an individual, at the same time it transforms alienation (be it social, through the object, or metaphysical, through the subject) into alterity.

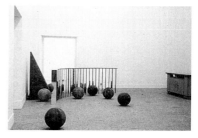

Harald Klingelhöller, Die Wiese lacht oder das Gesicht in der Wand, 1985

This *instituted taking place* is to be conceived just as much in language as in the book, as much in appearance as in the work of art, but also in the ocean as wave, with the studio as work, with sex as origin. *Origin of the world:* the double condition of existence, reversible, of the individual and the instituted taking place. It is to be taken and understood so that human beings and the world may continue to begin where they unendingly finish – but also, and most of all, so that man and the world may cease to begin where they continue to finish and begin, at last, at that same origin of the other (the other sex and the sex of the other) and have done with that same end of the same (castration of the self and/or the other: which is one and the same thing).

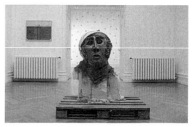

Thomas Schütte, Projet d'un monument pour A. Colas, 1988/89

L'Origine du Monde (1866) was a thought to have to have been lost at the beginning of the century, until it was exhibited at the Brooklyn Museum in 1988–1989. It is in itself sufficient to transform the obscenity of all detail into the trace of a flux and of a revolutionary force, transforming not only the history of art, but the world and life. This immanent origin of the work of art is also the origin of the human being, making this grasping of the real the new origin of history. Courbet and Freud, both strangers to humanist ideology, set man in the very place where the sex of a woman sets him: *in the World.*

Matt Mullican, Doll's Head, Dead Man, 1974

If 'any model is of value to the man who wants to learn' (letter from Courbet to Castagnary), this is because the world, and with it the practice of the real, have no model. Without either principle or origin, anarchy for Courbet goes well beyond the political theories he held so dear. Such an anarchic, *origin-less origin of the world* precedes the symbolic murder of the father which the chronological displacement of the meaning of history and the revolutionary condensation of history in the event bring into effect as the topological displacement which was to give rise to the destruction of the Vendôme column by Courbet and the Communards (the column fell when they tried to move it from the centre of Paris to the history museum). The real and the difficult practice thereof produce sense before becoming signification. If meaning is at work in the *Fort-Da* of artistic practice – in its incessant displacement between artist and individual – its reality is beyond any principle of pleasure (or profit). This opaque density of the real is there, present,

Jean-Marc Bustamante, untitled, 1987

René Daniels, Palladium, 1986

The Vendôme Columne fell down during the period of the Commune, 1871

active, an action, before any *acte manqué (lapsus)* or symbolic action. It is the great question that since Courbet and, even more, Freud, has never ceased to be posed: the question of the work and the event of which the work marks the origin, with the unthinkable end of analysis.

In Monet's series of *Water Lilies,* this unending analysis, this return of infinity into the world of life, opens the way from the conscious to the unconscious. Everything is reflection without mirage, a generalized oscillation between each point of view and each touch of colour. It is neither a dissolution of forms nor a deconstruction, but the institution of the individuation of the *non-represented* as presence, yet as a presence different from the concept of presence. There is only the *as if* of an expanse full of colours where metaphor and metonymy are superimposed and merge with each other: 'there is already something which defines the canvas as a *thick germinative and flowering mirror,* because there are the *Water Lilies* which make everything legible' (Michel Butor, *Monet ou le monde renversé,* 1975). The work is a metaphor of space, which, in its expanse, is irreducible to vision, and proceeds as if its content metonymically filled a space of presence. As space or 'field of presence' in the contemporaneity of *my* perception of the perceived object, the work is restored to the living present: 'that faraway being which is one with distance wherever it appears' is reversed in the contiguity of relational planes of its extensive displacements in the 'thickness of a medium without thing' (Maurice Merleau-Ponty, *The Phenomenology of Perception,* 1945).

The hollowness which hollows out discourse is resonant with the space of the world, pregnant throughout with the silence of a blind mimicry. In the *Water Lilies,* Monet touches, tries, gropes, before distinguishing. It is an infinite and closed world, and at the same time an idea, a project, *a-topos* and unconscious, desire, *topology.* As a round space in which 'one bathes', the space of the work attains the opacity of memory, the medium of the existence of time. Here, the work physically constitutes itself in mnemonic space, making this space visible and palpable, concave and convex at the same time, opening it to the exteriority of a consciousness *après coup.* Aspects more than images, fragments of a non-

constituted and at the same time constituting world, repressing and de-repressing existence, the *Water Lilies* move with that 'trace which makes a path' (Jacques Derrida, *Freud and the Scene of Writing,* 1966) in the world. The work, the studio, the garden, the pond, the place of exhibition are present in Monet's mind and in the world – constitutive gaps from heterotopy to autonomy. We see through the pond as we do through the Artistotelian translucence diaphanous. Like a dream of flight or diving, the *Water Lilies* take up their place above depth, not as the simple act of looking, but as the play of the world in the fullness of its glimmering. All things touch, contiguity and the work of presence become the space of the work, space per se, neither *a priori* nor a *posteriori,* but the primary experience – topological and chronological – of being brought to the world.

It was on Armistice Day, 11 November 1918, the date when the First World War came to an end, that Monet donated his *Water Lilies* to the State. Clemenceau had begun to solicit him for this work as early as 1914. Monet had spent all the war years shut away in the windowless studio he had had specially built in the garden at Giverny in 1915, having planned the site (the land and the pond, the water and the bridge, the garden and the flowers, the house and the sudio) and projected the work (like a constantly displaced confrontation between the law of the land and maritime law). As early as 1889 (centenary of the French Revolution, which brought the previous century to its end), he had begun his unremitting work to establish the conditions needed to realize his project (he even developed a complex system for numbering the colours which two successive cataract operations had rendered ever more murky to him). Right up until his death in 1926 he continued to design the space at the Louvre's Orangerie (lay-out, architecture, exhibition, place) in which his work was to take its place, while at the same time painting the series of great *Water Lilies* which, from 1916 to 1926, came to constitute the work as a whole, the work we can still admire today.

This incessant movement from one place to another which makes the work what it is, and this decisive turning point which bears the work from one place to another by giving a site to otherness in the very heart of the city, in the very heart of history (this topology and this chronology which, by coinciding, create the event), open like the fold which all of a sudden unfurls, projecting the modern world of the acropolis – the edge of the city – of Giverny to the taking place of the work in the *polis.* The work is then realized as it realizes the displacement from the interiority of the author to the exteriority of the world together with their reversibility, which becomes its praxis, the modern practice which makes of the exteriority of the world the interiority of art. This world on the edge of the abyss, emerging from the First World War, through unending, successive and simultaneous upheavals of society and mores, of representations and knowledge, is transformed by the *Water Lilies* into a haven of peace (the case is rare in the art of this century, even today: a project that simultaneously takes place and takes its place and transforms the world while being transformed by the world) by 'suspending' the individual and the institution in an endless event. Here, topology and chronology together shape the genealogy of the work of art, whose origin is the world. Origin without origin, 'endless, without horizon or edge' (as Monet told C. Roger Marx as early as 1909) because the end, the horizon and the edge are not inside the work but *take place with the work in the world.* The work *gives them place* by bringing itself into the world and the world projects them from the work of art. Desire and difference, liberty and revolution, whose end, horizon and edge form that border which is infinitely displaced from the author to the world and from the world to the work, a gain in space insofar as it is a gain in autonomy for the individual and his works. Infinite complexity, condensed in a taking place of the other and the world, the advent of which brings into play the displacement of one towards the other, of one in the other, of one and the other, indissociably.

This gain in edge by the world in its very heart, where the advent of place and the event of the work take place and mark the age, shapes the contemporaneity of the

Günther Förg (und G. B. Piranesi), Le Diaphane, 1991

Robert Gober, Bed, 1987

Mike Kelley, Installation Lumpenprole, 1991

Thomas Ruff, Portraits, 1990

James Welling, untitled, 1978/79

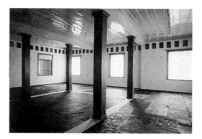

George Hadjimichalis, Topographics, surveys and other details, 1991

Helmut Dorner, Phoe, 1986/89

Mariella Simoni, Horizontal II, 1989

Christopher Wool, untitled, 1990

Herbert Brandl, untitled, 1988

Ernst Caramelle, untitled (wall painting), 1990

Adrian Schiess, Flache Arbeiten, 1990

work and of the world, their common, simultaneous, mutual and interactive taking place, their reversibility, suspension, temporality and ubiquity: desire and difference, liberty and revolution take place like a sudden glimmering over an abyss. Maritime law, which dictates nothing but participates in the play of the world above the 'Submerged Cathedral' (in the same way as Debussy's music, which displaced the limits of the world from the instrument to the resonance of sound which, like *La Mer,* becomes the free expanse and listening to the world).

Since that time, and although for some the world has continued to be a field of battle, a territory of domination, a land of blood ruled by the law of war, the modern work of art remains, in spite of the eternal chorus of sameness, the same opening, still constitutive of the world in its displacement of the essence of alienation towards the substance of alterity. Since the *Water Lilies* of Monet, but also since the dogged attempt at collocation that is Rodin's *Porte de l'Enfer* ('The Gates of Hell': 1880–1917), a work that remains suspended like a book in the middle of the world, there has been a movement towards ubiquity and the complete suppression of the dialectic of object and subject. Since that date, the artist has always been in the world and citizen of the world, just as the studio takes its place in the garden and the exhibition in the museum – be it the Louvre or the 'Hundred-day Museum'. This 'Hundred-day Museum', the documenta, was instituted in 1955, after the end of the Second World War, exactly one hundred years after Courbet's *Studio.* It too was founded by an artist, Arnold Bode. The intention was to bring about a definitive end of war through the creation of peace, of the work and of contemporary art. They all hang by the same thread, form the same fold, the same binding of the work of art whose end, horizon and edge are given by the world, taking their place in the world and taking place with the world. This thread, like an Ariadne's thread in the labyrinth of the modern world, now projects liberty and sharpens desire in a world of constant upheaval where the displacement of the limits of same and other occur on each occasion on the edge of difference, on the edge of revolution. This might be as a possible slaying of the Minotaur or like the real fall of the Vendôme column – neither *lapsus* nor symbolic action, but action in the world, action on and of the world. From this time onwards, this taking place of the act and praxis of the work become the unending event of the contemporaneity of the world (undulled by any postmodernism or pre-cataclysm). It takes place in and with it, like Brancusi's *Endless Column* (1918–38) which restores none of the old power of the centre but instead gives place to the work, to the world and to the event. (Simultaneously, from 1911 onwards, Brancusi repeatedly sought to grasp the 'Beginning of the World', which he finally accomplished in 1924.) Both base and sculpture, interior and exterior of variable dimensions, both finite and infinite, the *Endless Column* (like the universe, like the 'chiasma', the 'x', the crossing, the fold and the unfolding, the suspension and taking place of the infinite), gives rise *(gives place)* to the series while at the same time being an extraction from it, just as it is both in the studio, in the museum collection and in free space (topology and chronology interweaving and separating endlessly).

Still in the same period, Marcel Duchamp, the friend and contemporary of Brancusi, found the work in the world. The 'ready-made' became both the work's autonomy and its heterotopy, its perfect ubiquity and its pure 'taking place', where the individual and institution merge and are condensed, 'literally and in every sense' in that anarchic and originless origin of the other. With the *Large Glass* (1915–23), and up to *Etant donnés: 1 la chute d'eau, 2 le gaz d'eclairage* (1946–66), the world is simultaneously projected and contained. From *The Bride Stripped Bare by Her Bachelors, Even* (1915–23) to the sex of woman or the sex of the other, which becomes end, horizon and edge of the world, as far as its origin. The *Origin of the World,* the same as Courbet's, but also its other (Courbet's work was thought to have been lost at the beginning of the century, but its place, haven and hiding place were known to Duchamp), the 'given' origin, becomes the origin of the work of art at the same time and contemporaneously, in a double affirmation

Giovanni Battista Piranesi, 1756

and double negation. The senses, and meaning, are suspended in an event without end, horizon or edge. Because the end, horizon and edge are to be found in the world: ready-mades. The genealogy of this topology and chronology stands and falls inside and out of a *book/case* (*Boîte en Valise*, 1941). Liberty and desire, on the edge of difference, on the edge of revolution, are ceaselessly displaced with the essence of alienation towards the substance of alterity.

Marcel Duchamp left for the United States before the First World War. And whereas hundreds of other artists left for the United States at the outbreak of the Second World, Lucio Fontana left for South America, for Argentina. It was there, like Monet in his garden preparing peace, that he worked with a group of young South American artists on 'the White Manifesto' in 1945. This last great manifesto of modern art was perhaps the first to abandon the realm of ideological abstractions to make of the conceptual abstraction which art had achieved in its practices and in its autonomy, the actual origin of space and the event of its manifestation. Fontana takes art into the world of space/time, into an expanding world of waves and light, of movement and thought, where the distinction between physical and mental ceases to exist, where there is only one moving element – the play of the world. Here, individual and institution are condensed, just as the world is, and displaced to the furthest edge. It is from this edge that art and its works project the conception, the spatial concept and the event of the world in time. This event is that of the absolute contemporaneity of the *a priori* of space and of the *as if*. In this conceptualization of time, the individual and the world are instituted together in the infinite literality of the spatial concept as work. As with Courbet's *Origine du Monde,* there is a gain in space, a gain in edge, a gain in autonomy, which the work posits as its origin – literally and in every sense. Fissure or fold, passage of the other, passage to the other, once again, this anarchic, originless origin, is found at the very place of its taking place, at the place of the other, which gives place to the same. In his garden in Milan in 1955, at the foot of a tree (which bears a strange resemblance to the tree on which in 1946 Ad Reinhardt presented *How to look at Modern Art in America* as a magnificent caricature of the art world), like Monet, Lucio Fontana watered the plants. Meanwhile, on the branches, spatial concepts floated upwards toward the sky, in the world which takes place with them while at the same time enabling – *giving place* to – their autonomy, their liberty and the desire of the world which constitutes them not as some kind of possession or property, but rather as the a-topia and anarchic ubiquity of the other. This transforms itself into a world, as well as into the world's 'other', which projects the same spatial concepts – 'ready-

Auguste Rodin, A Figure from the Citiziens from Calai, 1884, in front of the Acropolis, Athen

Pedro Cabrita Reis, A casa da pobreza, 1989

Heimo Zobernig, untitled, 1990

Joe Scanlan, Potting Soil, 1989

Rodney Graham, S. Freud/Standard Edition, 1988

readymades belong to everyone, Parcelle à céder, 1990

Charles Ray, Male Mannequin, 1990

mades' or originless origins of the world, rafts of the world or *Water Lilies* of space, world and studio without end, without horizon or edge. For end, horizon and edge determine the work and the world in their absolute contemporaneity – topology and chronology, the genealogy of which is, at last, here and now, *before* the concept that is the individual conceived in his or her autonomy, in his or her desire for the other and the liberty of the self and their reversibility. It is no longer Marat in his bath-tub but Fontana, hosepipe in hand, no longer on a divan, but crouching at the foot of a tree, in the world and with the world in this infinite play of the same and the other, of the same to the other, of the same in the other, of the same and the other indissociably. Fontana's *End of God* (1966, a full century after *L'Origine du Monde*) liberates space and time to give an origin of the world without end and without origin, *here.* And it was precisely with the work *Here* (1951–65) that Barnett Newman, the notoriously anarchic and anarchist Newman, gave a place to the fold of the individual and the institution, as in a *taking place* of the work as autonomy of production of the work and of the exhibition as one single mobile structure of meaning in the studio of the world. The institution of the individual and the institution of the world are at once transformed and transforming, while at the same time displacing the limits of the body, of space, of time and of the event as a work of liberty and a liberty of the work. This autonomy is like the open place in the heart of the city that Barnett Newman planned in 1933 for New York, and which was to be completely autonomous of all institutions or law (including the police, the family and opinion), where the only form of control concerned the condition of the air and water which were to be constantly purified so that the possibility of the world and of the individual in the world should find its necessary conditions – the *a priori* and the *as if,* indissociably – conditions necessary for the emancipation of liberty, of desire, of difference, of the place of the work and place of the world – *xenotopia* in place of *xenophobia;* and this in spite of all threats, in spite of catastrophes and wars, in spite of division and disintegration, in spite of poverty and illness, in spite of persecution and genocide, in spite of censure and castration, in spite of abuse and alienation, in spite of absence and indifference, in spite of complacency and exclusion, in spite of humiliation and annihilation, in spite of exploitation and injustice, in spite of totalitarianism and extermination, in spite of boredom and incomprehension, in spite of blockage and paralysis, in spite of fraud and falsification, in spite of discord and destruction, in spite of deceit and deprivation, in spite of vain chat and stupidity, in spite of terror and repression, in spite of *arrivisme* and corruption, in spite of fear and silence, in spite of no-mans-land and separations, in spite of demagogy and lies, in spite of baseness and cowardice, in spite of fatigue and disaffection, in spite of arrogance and contempt, in spite of vulgarity and debasement, in spite of vanity and cynicism, in spite of crime and massacres, in spite of hostility and hatred, in spite of blackmail and subjection, in spite of ignorance and superstition, in spite of abasement and resignation, in spite of oppression and tyranny, in spite of inequality and inflation, in spite of lassitude and hypocrisy, in spite of intolerance and envy, in spite of impotence and death.

(Translated from the French by Charles Penwarden)

Lucio Fontana, In the Garden of his studio, Milan,
1955

Constantin Brancusi, Le commencement du
Monde, 1924

WHY AND HOW – HOW (AND WHY)

Bart De Baere

The second question is always whether the first one is the right one. I am not involved with art to find out what or why art is, but because art is. It is something like having breakfast, kissing, playing chess or seeing people.

Cake-making Though its right to exist is quite obvious to those who love art, it seems that it can only survive in society thanks to the many thoughts that defend it – or even because of this theoretical thinking. Art seems much further removed from life than cake-making or morning conversations. Further away also than music or dancing.

How and Why For three years we have worked on the reality that this catalogue is an annex to; to which this catalogue can only be fragmented reflections. So which text do you write? There were many possible titles that went through my mind; in those lost moments I could think about the text for the catalogue. In the end, I took a title from a series of popular science books for children: *How and Why*. Whether they featured skyscrapers or Indians, mushrooms or prehistoric animals, the title never seemed to fit. 'What and Why' was much more what they were about. For 'How', both the Indians and the skyscrapers stayed much too remote. They were as little flesh and blood as Little Red Riding Hood and the Wolf. Words have many hues. I like the shades of 'how', which in this text I want to introduce as David, opposed to Goliath and the Philistines, agility opposed to organized power. Goliath then, I would like to call 'why', and 'what' the Philistines; they are closely related.

Goliath Why? is What? extended to relations.
Why? organizes the passing of time. It adds and subtracts. It takes distance, observing the course of things from a removed point of view.
It disjoins a movement into rectilinear vectors, isolating inciting points, deducing their properties, measuring these by juxtaposition. It puts reaction equal to action, only happening at a different moment. It fixes down and systematizes.
Why do we live: determining a past in an effort to account for a future.

Of course they have their good sides, Goliath and the Philistines. The ultimate 'Why', as a quest for meaning, is brim-full of divergent states of mind, vitality and desperation, desolation and hope.
'What' can express a desire for empathy, a longing for insight; the absolute that is sought close to reality.
We have made a religion out of this longing, from the Enlightenment into the Romantic Era, and this religion we have reduced to dogmas. First the conventions were formulated into laws, then we forgot that those laws are only agreements.

In everyday life What? and Why? are commissioned as inhuman soldiers. To deliver us from our powerlessness, we use our ability to separate so as to want simple wants and think simple solutions.
We don't remember the cynics and now presume a cynic is someone who is convinced he knows better. We defuse Nietzsche's insurgent poetics by reducing him to the odd one out in philosophy. Philosophical nuances are spirited away as theoretical reflections so that they bother us no more.
The system can live its own life for all we care. Our Big Brother has been among us for years and it seems we don't feel that bad with him. We conform and become one more item on the list of outstanding orders, we perform and supply functions

the way an Australian rock supplies iron or an Argentinian cow meat. Simple, quick, economical.

Maybe once in a while we might try to work out for ourselves how many beans make five.

The Philistines In the Ottoneum in Kassel there is an eighteenth-century 'wood library' with more than five hundred volumes: small chests made from the wood of their respective trees, the spine from their bark and inside the branches, leaves, flowers, the fruits and even parasites that belong to names such as willow, cherry or horse-chestnut tree. Here, systemization remains filled with complexity.

When the laurel tree died that the Landgrave had his wreaths cut from, he ordered its trunk to be preserved in his cabinet of natural phenomena. The product was not severed from its origin.

Such was the past. Now, What? and its labelling of characteristics have been institutionalized. They set out the course. They formulate the demands. That is why I call 'What' the Philistines. In their hands even wood loses a big part of its corporality.

What? Science and its mechanisms, reduction and abstraction, are firmly rooted in every branch of our thinking and looking.

Even art we lift out of our own existence, so that it can be described in polished terms.

We live with art in order to live art, but in our descriptions we act as though it did not grow from, into and out of reality, as if it does not even reside in realities. As if we were angels looking at art, ghost-like beings, not quite gods but having already left our sex and shit behind, feeding on superior victuals.

So, art is neatly kept at bay from the rest. The confrontation doesn't have consequences. The danger is diverted to enjoyment. The whip should only caress. The encounter is made into a 'how do you do'.

Only rarely does a work of art emerge from a description as a knot of energies, as a juncture, as an in-between place, as a connection between realities.

Everything outside the object is a hurdle to a description-maker, because there he loses ground, in a vastness of worlds we ourselves can never wholly experience.

A work of art is a flash of lightning between the rain-clouds in the background.

We wrestle with simplistic contradictions such as 'local' and 'universal', as if there were artists who would prefer to communicate only with their immediate environment. As if Martians too should be able to appreciate our art. As if those possibilities were possible.

Of African masks or ancestral statues in European showcases, we accept that there is missing information leading to a cosmology which is never really accessible to us. Perception travelling distance, here, is seen as a fact.

Visual art is assumed to operate on a single homogeneous level. As if our culture were one solid monolithic block, with a shared backbone, shared muscles and shared ideas. As if we had an ethic or an ideology in common. Automatically, we presuppose, we share a knowledge of the foundations on which the work came into existence. Transmission and the beholder's identification are taken as a matter of course.

The work should address us directly, we imagine, and the rain-clouds we would rather forget altogether.

Why? Creativity is a European articulation of activity which has little in common with, for instance, the Japanese word 'do'. 'Do' can refer to hypercultivated ways of activity, like the tea-ceremony or bushido, a code of living for the samurai. It can also be the individual path somebody walks in doing things, which can lead one to

the passing beyond oneself and this world, to a forgetting of daily limits. In any case it has links to spirituality. It is a convention with its own distinctions and qualities. The Bantu philosophy of energy or magnificent Yoruba words such as ashe and coolness can be at the heart of an appreciation of Western art, but they can never really be my words, however much they fascinate me.

A visual thinking that has sprung from Zen Buddhism or African beliefs inevitably looks different from one based in a civilization grounded on the Word, and whose god in the beginning told his people: be fruitful and multiply and rule the earth. Those words alone make Genesis a poisoned gift for me: they command to subjugate, with the force of a childhood memory.

Creativity is our alternative, it is in the air around us: to seek the equal of the kind of divinity offered us in the story of Creation. It is implied that our attention is concentrated on whatever there is after the creator's process of creating, the tenor being that something appears out of nothing (or as good as nothing, like some dust or a rib).

The idea of the New is a direct derivative of this, a means of detection, which has now often lost contact with its origin and sense. It seems more precise to me to start from words that describe the process, such as 'proper', 'specific', 'efficient' or 'coherent'.

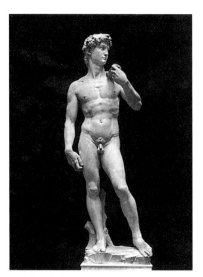

Michelangelo, David, Florence

How? It is society which delineates and reduces art. Art is a reservation: that one piece of fallow land no farmer or speculator ever wanted. It is the wasteland people now wish was heartland again, seeing harboured there what wastes away elsewhere.

It is visited mostly on Sundays, with wellies and binoculars. Probably guided.

Art never determined itself, it has just been making itself, over and over again. It never looked for its Why?, but has found itself necessary.

As it came to stand more by itself, it started to articulate its own activity as its quintessential element. The artists became increasingly aware that their activities were choices. Their How? became their existence.

The importance we attach to the name on the frame is more than a nervous tic of a categorizing society. It emanates from the essence of our appreciation of visual art, an essence that relates to the idea of man as a singular being (and representative of his kind) set down, with the first of our main reference points, in late medieval and early renaissance art.

Strictly speaking, one can say that Egyptian art is not art. When Europe developed the convention 'art' as a platform and vouchsafe for her intentions, vast areas of high culture were appropriated and equalized. Negro art, Greek art, prehistoric art, pre-columbian art. Fields of interest which could be used as sources of inspiration were reduced to a Western European mental and visual patrimony. The oba of Benin is not a king but an oba, which is more and other than a king. The distinction is sometimes, but not always recognized. Why do we call a pharaoh pharaoh and Egyptian sculpture art?

It gives me a sad, sinking feeling to hear traditional Australian aboriginal images simply proclaimed as art. Are they not visual parts of an existing (and to us hermetic) cosmology, rather than a means on their own? Are they not closer to our epics than to our visual art? Alongside what we call myths and cartography? It gives me a strange, sad feeling because proclaiming them as art seems to me a cheap bargain, paying a pittance to clear the conscience of those who can find no respect for the complexity of that culture. Declared art, they are pulled into our context, with us telling them how to behave.

All we can do is approach them and be silent or ask questions. We can approach them with whatever possibilities our looking at art gives us, but we cannot recuperate them. Few people ever see Negro masks in showcases as severed heads.

David (Minus.) Europe's power and poverty lies in the fact that it has sacrificed its social coherence to the demands of the individual. (Plus.) Europe's option has been to adapt its social structures to the potential of the singular being.
(But we're not calculating.)

Movement In the past, we imagine, everything moved more slowly.
These last few years, the Dark Middle Ages have considerably brightened. Now they seem more of an idyllic landscape, with set seasons for reaping and sowing, with a mist of silence over the land.
Not so long ago the countryside was the place you came from, and the city represented the future to go to. Now, people in the West have begun to wish themselves the opposite: country cottages, wholemeal bread, biodegradable plastics, an ecological thinking protecting an estranged origination with laws and quotas and systems. Tranquility calls.

Also in those not-so-dark Middle Ages, sociocultural changes were probably lived with exasperating intensity (changes look bigger when they are staring you in the face) but at least there was the feeling that changes were leading to a new permanence. The world was changing, but in principle it could be unchangeable. The idea of progress has tensed our appreciation of changes. We used to move away from the past, now we move away from the present.

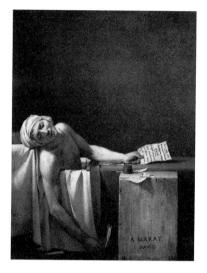

Jacques-Louis David, Marat assassiné, Brussels

We feel engulfed in a stream of never-ending mutations. More than half of all people that ever were, are now. Our society is a snake, continually shedding its skin, it is a lump of plasticine in an animation film that is now table, now chair, now person, now staircase, now swimming pool and now the sun itself. We no longer sense our spine. Every other day our bodies are made to absorb strange objects and we have to adjust our behaviour.
Movement is instability, and instability we tend to see as a problem. Someone driving a car has to concentrate on driving, someone clearing a path through the jungle has to constantly take care whether the leaves are actually leaves. And someone having to run in the dark is afraid or enjoys the danger.
We are more engrossed in the growing pains than in the possibilities. Our sizing of the changes can seldom last long enough to become enjoyable, and only rarely does the enjoyment harbour enough energy to reflect on the direction of the waves of change.
It is as if our heads are too crammed and instead of wondering we mostly just take note.

David What used to relate us to each other has become kneadable. The kinds of meals we like, the hours we are awake, the information we receive or our guiding images, our expectations, types of relationships, belief or disbelief. Morality has become so relative a thing that it has been reduced to etiquette. An artist can feel related to Zen Buddhism or to German mythology. He can describe, interpret, comment, express ideals or fantasies. No ground is firm. Thoughts are adrift. But every person can become a civilization on his own.

David becomes David the moment he distances himself from the existing models, from the hardening of conventions. He becomes David when he goes to meet Goliath and answers him with his sling and a stone from his shepherd's purse. All topical positions in society result from daring to look beyond the limits of the system. David was wearing no bronze harness.

I want to imagine David as How? because for me this is commitment to life. It is not the question of the pointing finger but that of the active hand. How? accepts the fullness of the movements within their given surroundings and concerns itself with manners of being. How? makes use of concrete examples, images, atmospheres,

attitudes. How? exists in rhythms and relations, it aims not to measure but to orientate. The attitude How? has Why? absorbed within itself, whereas Why? tries to ignore How? as much as possible.

How? has as much to do with instruction manuals as eroticism has to do with a family planning brochure.

If How? is not dissected to multiple Whats? it is a question that invites you to dance. How? is knowing your nail and your hammer but also how many times you need to hit, whether you will smash your fingers and whether the ladder is stable enough for you to have a go. In How? one is free but always a little lost.

Body There is the artist's commitment and that of the beholder. Between the two something else exists.

It is the movement that acquires a self, the How? that becomes a body. The separate existence of the term 'art' allows the artist to shape an environment in which his needs encounter their impulses. He recognizes the scale, the challenges and the orientation of his solutions, the atmosphere, the attributes…, the pace of time: even the limits are not imposed on him, the fact of his searching them out makes them possibilities.

The moment an artist acts, only activity is available to him. He becomes the horseman of his own doings. Letting some approaches disappear is as important as emphasizing others. All manner of decisions merge and chemically react with one another. They become inseparable. Desires become forms, forms desires.

And then the interaction ends. Time is locked up, the activities are resolved into their relations. The work hangs on the wall, stands in space or happens. In the history of the work of art the moment of letting go is a pivotal point. It is a symbol in the etymological sense of the word: συμβολή, the coming together.

Louise Bourgeois, Mind over Matter, 1992

DAVID AND Goliath.

LB

People The How? has many characters. It can be refined in its desire for precision or lean from desperate tension; it can be full of gentle pleasures like an afternoon stroller or passionate like an explorer. It can be Michelangelo, Brueghel, Piero della Francesca, Watteau, Matisse. It is ways of dealing with things, with the living, with their coalescence. It cannot be defined categorically, just as words describing appreciations of people, 'wise people', 'great people', 'beautiful people', 'passionate people', 'brilliant people'… cannot be categorically defined. They only come into being in a relational sense. We have a great tradition of what/why but only babytalk when it comes to the how of our movements.

Which dimension attracts us in those people we take for our models? We draw energy from what we call 'charisma'. But we are unable to specify that word. These last few months I have asked a lot of people (when I felt I could, because it is a strange question) and I am still awaiting an answer. It is an island, this word. It smells of magic, confronts us with our limitations.

Presence In a sense, art resembles charisma. Its strength is not that it is absolute but that it seems absolute, not that it weighs up the rest of the world but that it seems able to weigh up the rest of the world. Despite all of its limits, it has enough substance to make us speechless. It has the precision and nuanced certainty that makes us accept its proposition, which, for the time of our looking, lets us walk along its paths, move with its rhythm, caress its skin, think in its scale.

Thus it creates a point for orientation, and becomes an axis in space. The nightwatch is present in Amsterdam, the mystic lamb in Gent, Grünewald in Colmar, Giorgione in Castelfranco. Some works can haunt for years the space that once exhibited them. Even their memories infuse and control the space. They are more than the dark green blotch on the right-hand wall of the dining room. Works of art have weight, however ephemeral they are. They often remind me of people. When you enter a room where somebody is, you will focus on him even if he sits and keeps silent. A face, eyes, hands. Presence provides the possibility of contact.

Proposition Art is not an extension, a mirror or an imitation of life. *Kunst ist Leben.* It is life itself, a particular form of it that expresses itself in material and only exists in our time when its own time has ended. It is a form one can safely call absurd: its only activity is being itself. The fact that art is physical makes it resilient. It is autonomous, and idiosyncratic, even when used as an instrument for a larger construction.

In the past, the place of expression resided in the iconography, coincided with it, emanated from it. Now it is locked up inside its own absurdity.

Visual art is a prototype that can never be put into production. It has the enormous limitation of being irreproducible. Powerlessness arises, we say, from the impossibility of generalizing. Because generalization is still our favourite hobbyhorse, the straight line we like so much to feel between our legs.

Art is a prototype that has turned its inadequacy into its strongest weapon. It can be made public property only through the superficiality of reproductions or through the dubious truth of recollections, remnants of the moments when its own position had already been exchanged for assimilation.

From the very beginning, art has confined itself within its own limits. It occupies its place, its one place, a unique place where the atmosphere is pervaded by the rhythm of its breathing. It is a constant uncompromising witness to itself.

Because art is personal, it can never become dogmatic. It urges you back to yourself, possessing a quality one can always relate to one's own. It provokes. Art sets a tone that others can try to tune themselves to, can compare themselves to. (The statistics are right, our civilized society is paying too little attention to art to render art effective. But maybe there is a pathetically hopeful image even for this: art as a homeopathic solution.)

The Beholder Somebody passes by, the spectator. He is confronted with this one moment to which the work has abandoned its time.

Here he encounters choices, paces, materials. … Through every element he finds, through every level he seeks, he is at once encompassed by all the others. Even the missing is there. Don't you find more pure blackness in white than in black itself?

All the time, he covers parts of the distance, or assumes he covers parts of the distance.

In the end, he finds no answer, just a long series of experiences, his experiences, which he suspects … and perhaps goals, his goals, which perhaps …

Because the work does not speak, only shows itself, its tension …

Window Duchamp made his *Large Glass,* which exists in our space, which one can look through from both sides and whose imagery nevertheless remains untouchable. Classical paintings are often compared to windows on a reality, and the window still remains a useful metaphor of the relationship between the spectator and the work. One can get close to it but never inside. One can love it but this love will not be answered. One wants to experience the other side but one can experience it only through a distance. The work is complete in itself and even in his free play the beholder is directed by its manoeuvres.

(My language, incidentally, has a very beautiful word for completeness: *'volledig',* which literally means fullempty; in German it is called *'vollständig'.)*

Mysterium tremendum.

Borders We in the West have a peculiar relationship with borders. For us they are lines. You go from one piece of nature into an identical piece, but the two have different names. You move from one system into another, but everything looks the same. Somewhere there is a millimetre line. A pope once divided the world between Spain and Portugal by a line of longitude. And Africa, laid out on a map, is cut by clear, straight, edges. We put them everywhere.

The most radical border is the one we discovered between ourselves and everything outside our self. This one, we have nurtured manically in our brains. Our central idea of the individual is a consequence of this, the barrier between him and society a result, selfishness a deviation. We are permanently on the verge of solipsism. The privy is our sacred little council.

Cows This border makes our sweet life often difficult and sometimes sour. It stops us from feeling a part, has us thinking up systems for overpowering our fear and the outside world. What a danger of losing ourselves in this, of sealing off our over-sensitivity from frictions! What a mine of loneliness lies in it, and what a danger of opting for power in order to gain the feeling of control at least.

This border between me and no matter what determines us to no small degree. It goes hand in hand with the concepts and categories, those strange, hypothetical common denominators. This is their chief, their leader; maybe this is the real Goliath. And with them, the Philistines, we charm the world into submission. We have the concept 'cow' in our minds and all cows have to bend to that. Mathematics is an instrument that belongs in the workshop. Are we not losing ourselves to our skills, even in that respect compulsive consumers? Concepts are more than welcome in our homes, as long as they understand that they too are just words, words with a special training.

Loneliness The existence of words influences other words. Exoticism is our consumer behaviour towards otherness. At one time we lived among otherness, and a nymph or a river ghost could emerge from every river. Our environment was more ominous than even fairy tales admit. Now, it seems otherness is foreign. But otherness is also the unbridgeable gap between a man and his wife, a friend and her friend, between me and the table. Otherness can mean accepting our inadequacy, it can make life a constant process of communication.

Skin Me against the world is not necessarily a me as an antagonist of the world. It can also be a me yearning for the world, like we can yearn for the nearness of a woman or a man. Otherness can be made to tingle just outside the skin of our here and now, in tensed encounters where everything remains dialogue.
In this case one starts from one's own convictions, which lead to one's own actions, within a web of ever-changing connections.

Eroticism Because of our over-cultivation of the borders, the otherness between the individual and the factual world can be made hyper-sensitive, an erogenous zone.

In eroticism, thinking as a battering ram disappears. It becomes a part of activity, this activity that finds itself in being as wanting to be together, in a self-evident being. Eroticism exists beside orgasm. It is the desire to act resolvingly in the tense area between our self and the other. It is the tension between the self and the other becoming a stimulus that is experienced as a force of attraction.

and Sensuality. Western European art develops from this eroticism.
It finds its way to and beyond factuality. It favours the other, struggles with it, accustoms itself to it, wonders, seduces. It lets time merge with the events. It pleasantly surprises the other without forgetting its own necessity.
It makes love, in the uncertainty that contact always is. It makes love as a bewitching mixture of respect for the other and in the desire to communicate with it, an intertwining of listening and imposing your own movements.

It doesn't want to flaunt sensuality, doesn't celebrate it, but encounters it as a way of relating to the fascinating, aside from power, averse to exploitation, free from sentimentalism; experience without varnish.

Conventions and automatisms are there, at best, to be played with. Artists rely on their experience. They regard the gap between themselves and the other as the area in which activity can take place, a How? that is, is itself, and lets the other be the other. Distance is their breathing-space and the possibility of a point of correspondence. This is where they surrender, and encounter surrender. They are incessant lovers.

And the beholder, what does he want to do?

In art the borders are full, they are an event, they become a zone. They are places of reception.

(It is a good tradition to end a text with a quotation.)

'Let us become passers-by'
(Jesus Christ, the Gospel According to Thomas, 42)

David Hammons, Higher Goals, Harlem

Unused Notes

No answer seems to be an answer to me, except at the moment it is pronounced, when it is still linked to whatever it wants to leave behind, when its negations situate it precisely, when it is still intact because all of its aspects remain part of it. Romanticism was sharp as a cold mountain blizzard. Now it has grown clammy, a warm and cosy dressing-gown. The nihilism of Turgenev's time related to society. It was not an excuse to turn oneself away from it. Decadence was indeed wild, ardent freedom. The past often serves to build walls against the present.

The challenge today is to find propositions that do not become the umpteenth instrument to be abused. Propositions that abide in life itself, that have a flexible, reticent attitude, that have a nuance that counters manipulation. Propositions that in spite of powerlessness act in spite of the power.

Man was most likely born the minute he started accumulating means for controlling his environment. Controlling does not necessarily mean commanding and the most far-reaching means are probably the most flexible ones that call for minimum force. The old man in Dodeskaden.

Reaction is negative if it is not itself action.

Only with the Enlightenment did a door become a set of wooden panels and paint, the closing of the entrance between two rooms, with a metal knob for manipulating. Only with the Enlightenment was everything else that used to make up a door sent off into the field of poetry and similarly dysfunctional fringe areas. Only then did metaphors become just metaphors. Only then did images become just images.

If the work of art were to divulge itself, if one of its elements were to dominate, it would not be art but illustration (with its content), statement/pamphlet (with its engagement), decoration (with its form), academism (with its idea of art), design (with its function). Then there would be answers, a why? every time to which How? is subordinate. The why can be highly respectable, but there are some religious paintings none of you would ever dream of calling art. Except maybe some sociologists.

The brass-band fantasies of post-war science fiction have long lost their glory, and their adversaries have gone to sleep. Even dreams now abide by the laws of economics.

Today 'autonomy' is often confused with amputation, simulated by hermetic closure. A human being does not become autonomous by becoming 'autistic'. One can only become autonomous with and within the real.

I have a dream of Russian society regarding the members of its civilization rather in the way of fingers expressing its body and soul.

Applicants are taught how to apply for jobs.

And, more precisely, art is just as absurd as (the image of) the Zen master telling his pupil to listen to the frogs jumping into a pond.

In a body we should distinguish at least two elements, a centre (the substance) and the edges (the contacts).

Building a construction towards the other, with a combination of all possible means, slopes and preambles, and therefore with unexpected results.

The simple motto of the French Revolution was too difficult: liberty, equality, fraternity; three words where we prefer the first two. So we dropped the third one. Gold and silver was enough. Bronze could be dismissed.

Do we have an alternative for accuracy without an aim? All things purposeful we know will be recycled, simplified, used in mediocrity. A work can be shielded from this by being accurate without showing an aim; by articulating its absurdity, by playing around with its own orientation.
Inside the closed circle, freedom is rediscovered and one can afford to make one's own choices. When an answer is no longer expected, the artists can spark their convictions without danger of being misinterpreted, and play the whole gamut of their backgrounds.
Full intensity no longer willing to abandon itself to the world, secured into itself. Ourouboros. A hidden treasure in full view, but not there for the taking.
The closing of the circle is also its openness: all directions are tangents to it. One can experience it only in passing by, like the loop in a roller coaster.

With all our thoughts, we are still inside these bodies of ours that stand, hang or sit somewhere in between carrot juice, bottles of perfume and the like.

People and their eyes, making you aware that your answers to their presence are projections of your answers in their presence.
And if they do speak, it is still their eyes that show their conviction, and give you inklings of the doubts that may lie in their hearts.

Artists work out how to make a material think, how an image wants to relate to its material. Art is often very close to modelling again, to kneading, to yielding to the material and having the material yield.

The moment an artist acts, only activity is available to him/her. He/she becomes the horse(wo)man of his/her own doings.
I tend slightly more to 'him' than to 'her', because my relation with art is in first instance one with the work, and the keeping of a certain distance towards the person I feel more present in the 'he'.
In Flemish (and German) art is feminine and I do feel her attitude and action close to that. She couldn't be a he, for me. In English my only possibility now is the objectivating 'it'.

You can only understand yourself, perhaps.

Art is the impossibilities of thinking made touchable.

But does the vitality of he who abandons banality not lie in the fact that he can only do so by consorting with banality?

Play is the locomotive, seriousness the waggons. Without a locomotive, there is no activity. The load does not get anywhere. The load does not supply the coals, but makes out its necessity. A train only gets to go because the passengers want to be moved.

We prefer looking at photographs to looking at the factual world. Because they come with frames.

LANGUAGE IS A TOOL
FOR COMMUNICATION,
LIKE A CITY, OR A BRAIN.

Jimmie Durham, 1992

HEROES, KINGS AND HOPEFUL MONSTERS

Pier Luigi Tazzi

Violence

Violence shapes modern Western civilization. Here I mean violence as the overpowering of the weakest by the strongest, as a limitation imposed on the freedom of the other, as the disturbing aggression of an equilibrium, as silence imposed on another's voice, as the unexpected interruption of every level of interlocution, as the reduction of the multiplicity of possibilities of being and of movement to a single and unique possibility, as the action to which it is possible to respond in only two ways: either with silence or with reaction.

Violence provokes pain, wounds, and death.

Violence as a manifestation, expression of life or of vitality goes directly to its own ends, until, at its limits, it extinguishes the life of the other, or in any case reduces its vitality.

Modern Western civilization is steeped in violence.

As are other civilizations, in other eras and encompassing other territories.

What distinguishes modern Western civilization from the others is that the violence in it is not discerned as a necessity, but rather as a tool, as a means for pursuing an end. The means in itself, the tool, possesses no substantial qualities, but only functional characteristics. Once the goal is achieved, the tool diminishes, disappears, fades away, and is finally forgotten.

Thus by the very fact that its *importance* (mythical, symbolical, conceptual) is reduced to a functional tool, violence is theoretically excluded, to the point where it is demonized. But it is practically and continually present in all its forms in the evolutionary processes and in the axiological appraisals of the civilization to which we belong. The culture that this civilization expresses turns away from and finally condemns violence, hypothesizing its avoidability, but, in fact, habitually permitting it, from the moment that its structural insubstantiality and its functional occasionality is declared. In the end, everyone is safe, if not absolutely innocent, since 'the end justifies the means': the end is the truth, the substantial element; the means are the tools that will be thwarted, like haze in the sun, once the end has been achieved. Everyone is safe, immune, spotless, except the victims of violence itself, who have no voice, whose end that very violence has thwarted.

February 3, 1991
by train

The Rhine at Boppard

February 6, 1991
Amsterdam

Writing
Image
Books

February 8, 1991
by train
between Cologne and Basel

It's snowing

In the station, I had caught sight of the blue-jeaned cock of someone who then turned out to be ugly. But he called over a friend who was good looking.
The train has arrived. I've chosen my seat with the usual superstitious care. And the two guys from before have sat down in front of me. The face of the good looking one always wears a smile. In the end the effect is sinister.

I divert my thoughts by thinking about Milo and about Sabine and about our carnival the night before, tender, kitsch, and sentimental.
The good looking one is reading a motorcycle magazine. Now and then he looks at me and there is an opaque hardness to his glance, which is flat, like a deaf offence. His well-formed shoulders are clad in purple, he's wearing black jeans, a small precision watch, his blond hair is styled with gel. Red cheeks, a flat mouth. His eyes are set within sockets as well constructed as a piece of architecture. After Koblenz the railway passes through a city where the towers, the belfries, the wood houses have an ancient feeling. Beyond the Rhine, uniform vineyards beneath the snow. Avenarius.
Bacofix.
I have fallen asleep, and when I awaken, around Wiesbaden, he isn't there. He's gone up to a girl, a few seats ahead. While the train stops at a station and a crowd gets on, they exchange addresses. She is Dutch. He is faithful and returns to his own seat, so as not to leave the ugly one alone. His name is Dirk.
The woods south of Wiesbaden are criss-crossed by large natural paths blocked by broken trees. She resembles him and is a small lion.
I begin thinking that he smiles so often out of Swiss good manners; I deduce his nationality from the ugly physiognomy of his friend. His vigour and milk and honey complexion is a product of the milk and cheese and the mountain air. In short, I was mistaken; everything I had taken as sinister was only the result of my fantasy, distorted by the discomfort of the trip.
At the border the passengers take out their passports to show the police, who will soon get on board.
They both have German passports.

February 18, 1991
by night train
between Bologna and Venice

When we showed our sentimental photographs, in an exhibition conceived for this purpose, Lanfranco's were arranged in regular fashion, according to size: an organized and dense account where the same particular character appeared, in different periods of his life but independent from any chronological succession. One saw the change in physiognomy and in the body. Yet it wasn't a question of progressive mutations, but rather of chance variations, which had the effect of annulling time and reducing the whole to a series of multiple, simultaneous, and in

some way, all equally remote appearances. In contrast, my own photos followed a rigidly chronological progression. The dimensions were the most varied and, once assembled, they produced an unharmonious figure. Yes, the same character frequently appeared, but often, given leaps in time and the variety of the landscape backgrounds and stances, one didn't recognize him. And then there were other characters, whose images were sometimes repeated, and the protagonist, while present, was confused with the appearances of these, and in the end lost his consistency. The last image was one that depicted me in the 'magical place' that we had discovered in Le Catese; it marked an opening, a yearning youth (although at the time the photo was taken, I was already thirty-three years old).

Now that everything is over, now that the circle has closed over us, I understood how far Lanfranco's decision, then, was already inexorably tied to an idea of death.

February 24, 1992
in flight
between Frankfurt and Munich

We took off at dusk. For a moment, while we were gaining altitude, the sun tinged my face red in the reflection in the window.

I am reading a story by Paul Bowles, set in Morocco, and the images aroused by the writing congeal when they brush against memories of my experience in that land, taking on their own solidity.

Below, on the surface of the earth, the sun has already vanished beyond the horizon line. But here at this height, it still shines.

The blue of the sky toward which we are flying is preparing for night.

March 1, 1991
in flight
between Rome and Montreal

For a short while, the clustered bank of clouds opens onto the white cliffs of Dover.

I am sitting next to an immigrant from the south, made of the same erotic stuff as Jan.

He is sleeping now while we pass over the Atlantic. We were speaking earlier. He spoke in an indefinable Italian dialect and I was forced to use my language as if it were a foreign tongue. They're showing a stupid film so it will be better to try to sleep a bit, next to this creature who is alien to me in the same way a creature of another species would be, or even a creature from another world. I think I must be equally alien to him, but he's not afraid of me; his sleep is confident and tranquil. And so I too can fall asleep, and it is only in sleep that I will find with this person, so dissimilar to me.

March 9, 1991
in flight
between Ottawa and Montreal

We are following the course of the St Lawrence, partially covered with ice. Large stains of dark water are forming there on the surface. Above, the light and the shapes of the sky are forming sinuous, inhospitable, and 'surreal' figures.

without date
in flight
between London and Vienna

It is evening.

Have you ever seen the sky above the clouds?

In flight. High up. Distant.

This blue that is not even a colour: it is an impassable and joyful atmosphere, beyond everyday time, of which one only hears reports.

Forever. Death, a mere incident, an event inscribed in this stone blue of the air.

Forever, beyond time and in the moment. Below, everything, in the end, is equal, and what matters is the plus and the minus. Here there is only the vital necessity of a separation between the livable and anonymous interior, which science and technology have been able to produce, and the uninhabitable and yet so pacifying exterior in view.

The sun changes position and, penetrating the porthole window, illuminates the interior of the fuselage, where unknown voices are making a 'happy noise'. I'm under the illusion that I'm feeling its benign warmth, and on earth it is already evening. This celestial sun – no other body comes between it and our vehicle, and our 'body' has no measure, constitutes no measure – is 'my' sun. And in the same (which?) fashion, this idle talk – at this height a reduction in gravity, a rarified atmosphere, is assumed – this idle talk, for everyone and for no one, is my black box.

There will be no beaches or peaks or expanses of countryside that will be equivalent to this state, superior to anything below and timeless.

I check my watch: it's

2:57 New York

7:58 (it changed just now) in London

8:58 at home:

it's high noon, if these words can have any meaning here. The sun is to my left, burning and mild.

A trolley passes by, with things for sale, those somewhat cheap luxuries to which our century has accustomed us.

To abandon the earth in a sunset that has no equal.

My travelling companion to my right doesn't see the light that is waning beyond the curve of the earth, but he is with me and I don't forget him.

It's now 3:03 in New York.

The motors slow down. On the surface of the earth, which I see through a diaphanous and light blue substance, it must be twilight. A child whimpers in a language unknown to me.

The sun gives off a red, then pinkish glow: the blue has become more dense, and above, up high, it has just faded away.

I think I'll sleep for a bit and I wonder how night effectively 'happens'. We turn toward a mountain of clouds that seem to announce, to presage my return.

July 26, 1991
in flight
between Florence and Palermo

After Orvieto we veer toward the left. Enormous clouds: one grey, the largest ones white, stained with yellow around the edges. A boat that spins along in its own shallow wake points toward an island. Giglio? No, it is Ponza.

A voice announces that within thirty-five minutes we will be in Palermo where the temperature is 28 degrees.

September 9, 1991
Moscow

The Hotel Metropol, with so many Italians it makes you blush.

Still depressed about the 'Finland facts'. Every encounter is fraught with danger, a rap might lurk behind every pleasure. And yet the pleasure remains. One loses faith. We know that history can repeat itself, but we are not capable of resisting deception. In the moments of greatest certainty, of most open confidence, of greatest faith in one's own power, one lowers the level of one's guard, and the catastrophe takes place. The 'F.f.' have robbed me of security. The persistence of nervous tension reduces the efficacy of the most tender gifts (Viktor at the airport), and block the process of overcoming catastrophic effects. Like a good Catholic, I think that a good system would be one of narration-confession; but what is necessary is the right, appropriate interlocutor, one who, in the end, is also

complicit, if partial. And here it is still completely uncertain, dense, lost: everyone asks, in the desperation of obtaining any response at all, as if the request, being that broad, would guarantee its right. In fact, they know that the request will remain unsatisfied, but something is expected from the knowledge shown of this dissatisfaction, however meager, but, in any case, which is *no longer* sterile commiseration.

<div align="center">
without date

without locale
</div>

The borders of Europe.
Neighbouring regions, pockets of slaves.

<div align="center">
January 14, 1992

Kassel
</div>

insider instigator instil intellect

Knowledge and beauty

Knowledge serves dominion.
Beauty stimulates the desire for possession.

To establish unities of measure, to measure the world.

At the beginning, the idea is to avoid its malignity, to protect oneself, to not be crushed by its multiple presences, to resist the mass and the velocity of its stream. Then the idea is to dominate it. It is no longer sufficient to defend oneself to survive, one has to win as well. The further the extent of dominion, the more territory will be under control, and eventually, the greater the possibilities for flight or refuge, the exits and recesses through which and in which one finds safety.
But how is the zone of pleasure protected from this brutal desire to know that soft zone where the skin that separates is so thin that where there isn't a caress, there is a wound?

Or perhaps pleasure is only the primordial, original, feral state of a first impulse to dominion? And through the evolution of civilization, through the sophistication of tools, we have repressed this primordial, original, and feral state of an early successful action, brought to completion. We have pushed it into the recesses of that primordial, original, and feral memory, which now returns to us and deludes us into thinking that it is innocent, only since we know its ineffectiveness, its inexorable remoteness and unattainability. Or isn't this also a new deception? A deceptive reflection, which invites non-knowing, if every knowledge must inexorably produce other knowledge? If every figure glides by like a cloud in the sky, if every light changes colour with the passing of the hours over the grass in the meadow, if the unseized moment vanishes and, bit by bit and immediately, its loss is forgotten?

It's better then, that the burning wood in our fireplace scalds our bodies in the rigours of night, that the table be set with the mortal remains of the marvellous beast, to sate our hunger, that the mist of the cloud quenches, pouring forth from earth, satisfies our thirst.
Each time that all this interrupts our desire for continuity, let us move quickly, to avoid hearing the noise of the branches that are breaking, and to avoid being soiled by the liquids from the wounds we are producing, to avoid hearing the laments of the lives we are extinguishing.

Knowledge then; which cuts and which sews.

Beauty stimulates the desire for possession.

The exaltation of beauty we perhaps find only in societies where economic exchange is the driving force. It is not that the sensitization of beauty is uniquely a prerogative of those societies, but whenever the enjoyment of beauty is joined by the pointing of beauty, this occurs in concomitance with an acceleration of the processes of exchange. It is not that utility is disguised as beauty, not that the good becomes true in the beautiful, it is only that there is something like a distancing, a *mise-en-distance* of the beautiful. It is detached from whoever enjoys it and, loosening its ties with perceptible experience, with the senses that inform that experience, beauty is objectified, it becomes an attribute of the object, which already starts to differentiate itself. A distinction is produced between subject and object,[1] and the activity of the subject (as the only active element of the relationship) is juxtaposed with the sublime impassiveness of the object (as the element of the relationship that is more indifferent than passive). The relationship is established only beginning with the subject, while the object comes to possess its own autonomy, which transcends the relationship and leaves it out. Beauty pierces the conditions of knowledge and eludes them. But beauty, thus configured as a property of the object, is embodied in the object which nevertheless doesn't contain it, in the same manner in which the lamp contains the genie – but in any case, its opposite, beauty, liberates the object from the contingencies of its appearance – and it stimulates, solicits the desire for possession. Possession doesn't exhaust the desire for beauty, which, in fact, is inexhaustible. If one can always imagine an absolute and total knowledge, what the will to power tends toward, the desire for beauty is unexhausted. This awareness doesn't limit it. Rather it multiplies its stimuli indefinitely. And these stimulations to possess the object, objects where beauty is embodied have no end.

And yet it is only this – the sublime and absolute dazzlement of beauty – that sometimes makes the weariness of living acceptable.

The sophisticated and ferocious hedonism of the Renaissance changes according to the situation, in successive epochs, till the palpitating actuality of the present.
Having completed the planetary circumnavigation, *homo occidentalis* shows his cards:
both geographic and playing cards, of guarantee and of memory, ship's logs, eye witness accounts and *reportages,* charters and bills of exchange, pages of prayers and *cahiers des doleances,* signed confessions and declarations to a future memory.

1 leggero, attento, intatto, indifferente
(Sandro Penna)

(a) from North to South
(b) from East to West
(c) the orthogonal intersections and (d) the transversal ones
(e) short segments (f) axes (g) radial points (h) closed areas (i) deep descents
(j) wounds (k) passages (l) canals (m) routes (n) paths of air of earth of water
(o) dark zones
(p) orbital plans (q) stratifications (r) sections
(s) tinsel (t) figures
A complex navigator's book – intricate, rich, redundant, laden with noise.

(a) Universes of discourse and objects of desire
(b) Substance and functions
(c_1) Vertical emergence out of the dense mass of the exterior and the open toward the circumscribed and distinct specificity of the interior and of the cage (boxes, grids)
(c_2) Vertical descent from the clarity-transparency of thought-vision to the secret-opacity of energy-pleasure
(c_3) Horizontal movement from the indistinct state of energy-matter to the increasingly rarified distinction of function-abstraction.
(c_4) Retrograde, or transgressive, movement toward the primitive completeness, toward the totality that everything reabsorbs and gives back.
(d_1) Launching positions that augment the impact load, the capacity to leap, having calculated the distance between the poles of attraction (North-West Passage)
(d_2) Transversal slopes that provoke vertiginous slide (Nous irons a Tahiti)[2]
(e) Fords and Narrenschiff
(f) Right and left High and low
(g) Centres and peripheries
(h) Insular cultures Marginalities Monocultures
(i) Otherness Esotericisms Being elsewhere Underground
Closed rooms Burrows Subterranean spaces Thebaids Towers
Hermitages Sanctuaries Blue grottos Little people
(j) Punctum[3] Black Holes
(k) Borrowings Linguistic equivalents Translations Mirrorings
Constructive oppositions Dialectical relationships
(l) Movements (When Attitudes Become Form) Trends …-Art Styles
Patterns of intellection Codes Networks Systems of circulation
Information Information media Maps Roads Traffic systems
Checkpoints Jargons
(m) Ideologies Strategies Alliances Sympathies
(n) Intensities Frequencies
(o) Silences Voids Blanks
(p) Broad brushed narratives Episteme
(q) History and tradition Topics Techtonics
(r) Comparative criticism and analysis Hermeneutics Encyclopedia
Cultural linguistic anthropology and human sciences in general
Villages cities and metropolises
(s) Music Mass spectacularity Mass media Production for the masses
Fashion Voyages and tourism Images of the world, of the planet and of the universe
(t) The great global information system: icons and total signs

2 Paul Gauguin, Lettres

3 Roland Barthes, La Chambre claire

Art

Art, as productive practice and as a terrain offered to experience within the limits of that very experience, but beyond the limits of general production and economy (of accumulation), is given as an answer that is not requested, and yet is necessary, to the basic repression of the violence of which Western culture partakes.

And yet this is not explicit. That is, it is based on a tacit agreement. Yet the agreement ends up being so tacit, at a level of non-expression, that one might even hypothesize that it doesn't exist: no agreement, no relationship, no dialectical opposition, no programmatically determined equilibrium; only and uniquely a compresence of a series of actions (violence) and of production (art) within the same framework, but without any degree of interdependency upon one another. Or one could say, equally hopefully, in the words of Martin Heidegger: 'The struggle', which at this point becomes universal and not civil or cultural, 'is not a tear that opens wide a chasm, but the intimacy of a reciprocal coming together of the strugglers.'[4]

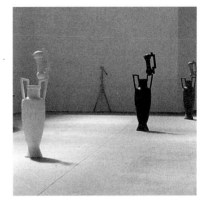

Remo Salvadori, Anfora e modello, Le Magasin, 1991

In the beginning, man, as a species, felt the need to construct the sacred circle (sacredness as the union incarnate of knowledge and beauty, incarnation as union of understanding and sensibility, as unity of the body, the indissoluble entity), as a place for gathering, concentrating, against the dispersiveness of the World, a place for securing, against the absorption of the Earth, the energy of the living, the solarity of joy. Art, as man's exclusive ethological production, has responded to this need. The here and now of art presents a momentary eternity, 'the force of the emphemeral instant… that makes the instant *stand* in its unrepeatable singularity, that frees it from the continuum of the succession of moments.'[5]

If all this is true, how is violence in its persistence, in its perseverance, connected to all this? If only it were just the absoluteness of judgement. Won't it also be the blinding light that emanates from the work of art, that obscures the other figures, and especially those closer to it? Won't it be the high sound of its voice that reduces every other and more plaintive sound to silence? Won't it be the radiant propagation of the Self, which is produced in it, annulling all otherness?

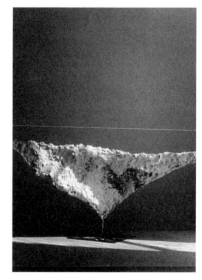

Franz West, Fontana Romana, 1988

Heroes, Kings and Hopeful Monsters

The artist-hero[6] is placed on a negative slope when full development is achieved. That is, when he comes to know the difference between the infinite, indeterminate power/potentiality-of-being and that-which-effectively-is. The artist-hero pretends to resolve, in the practical and formal process of his or her art, both power/potentiality, the open range of possibilities, and effective existence. But at the same time, the artist-hero knows himself to be able to determine something, to be in some way decisive, only in surreptitious (historical political) fashion, as it were, that has nothing to do with substance (ultra-historical). The result is the systematic annihilation of any ingenuous pretention.

The artist-hero has eliminated all dogmatism, and continues to struggle against those that still exist and resurface, and he has opened the path so that freedom is possible. But at the same time, and in so doing, he has brought about the positive possibility of the artist-king. The artist-hero knows that, far from satisfying his goal – which is Everything – he still and essentially cares about that which happens, has happened, continues to happen. The fundamental exigency of the artist-hero consists in proposing the unity between the immediate and the mediated, between the conditional and the unconditional; and immediacy has so much to do with accident that it is the result of the same mediation. The overcoming of the accidental occurs only in the work, since only within the work is that form produced which the artist-hero individuates as the force-reason that underlies that which exists.

4 Martin Heidegger, *The Origins of the Work of Art*, 1936

5 Massimo Cacciari, *L'Angelo Necessario*, 1986

6 From the proto-heroes Yves Klein and Piero Manzoni to the late-heroes Gerhard Richter, Ulrich Rückriem, and Lothar Baumgarten) – the order can be reversed, reversing the point of view from subject to horizon, from horizon to subject – through the American individualities, the New World Artists (a bridge launched into the future of the Great Spaces and of the Desert), through the Europeans of the bogs (Joseph Beuys *in primis*, but with the *secundi*, present or absent, no less influential), through the Italo-Cisalpines, through the 'heroine- ss' of the disenfranchized, Louise, Marisa, Rebecca, Marina (the Senza Terra) through…

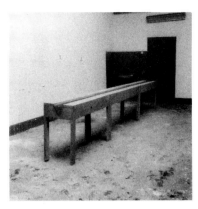

Mirosław Bałka, Dry Aqueducts, 1990

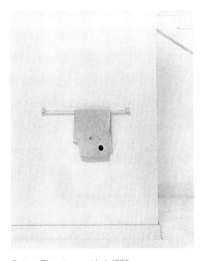

Robert Therrien, untitled, 1990

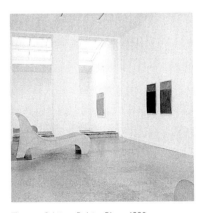

Thomas Schütte, Belgian Blues, 1990

7 Eugenio Montale, Diario del '71

Then *accident* is overcome only 'formally', but in this way its 'real' overcoming is postulated.

This qualification of the artist-hero's art as art of the negative marks the beginning of the artist-king's art as art of the positive.

Between the two there is a true passage that will be able to appear as dialectical only in an historical perspective, while in fact, it marks a compresence of differentiated attitudes, which reduces the terms of the historical distinction.

In the art of the fully developed artist-hero one finds the necessity for the 'turn' to the art of the artist-king. Its limitations don't represent its failure, but its very truth, which this art cannot find in itself, but rather in that which it heralds.

The art of the artist-hero falls silent ('…voi conoscete soltanto il grido, / un grido che si spunta / in un aria infeltrita, vi si aggiunge / e non parla.')[7] and at the same time indicates that which, from its own development, begins to grow.

The 'words' of non-knowing return to this point. The abyss opens, the doors of the void open, the secret is manifested as secret, the encumbrance of opacity returns, the resistance of non-transparency, the sensitive skin that forms an enveloping layer over the organism but doesn't detach itself from it and intimately participates in it, not rind then, but skin, not hard bark or shell, but epidermis and mucus, not garment but fabric. The face to face with vertigo that takes place here is a wonder, and this wonder gives rise to the art of the artist-kings. The positive of the artist-kings will not work as knowledge of the existent, just as the negative of the artist-heroes worked as knowledge of the conditions of the (critical) ability to know about the truth of the World and of the Earth. This art will not construct any system because it will in no way be able to fully comprise a system's rationale, its reason for being, nor will it bring it into question. But it will 'comprise' the facts of the system, it will contain them within its very nature, in its very being as such and not as another, or even *as such* and *as other,* without the *other* betraying the *such,* not even on a purely sentimental level: which means, in other words, that it will comprise the sense of its free manifestation and action. In its manifestation, the art of the artist-kings tries out and narrates the principle that has motivated it – and in the wake of which the art of the artist-heroes falls silent (making true its own negativity in this silence, in this 'cry that breaks off / in a felt-like air') – but it will never be able to possess it. The beauty in the art of the artist-kings eludes possession, dissuades one from it, when it also effectively and practically confirms it. But this is a confirmation that rests on the diffusion and, at close range, threatens the exclusivity that every aspiration to possession implies and imposes.

Therefore the positive of the artist-kings' art initiates from that which is absolutely outside 'vision', indeed from that which excludes it, which is not 'vision'. The art of the artist-kings consists in the absolute singularity of the thing.

Yet in both cases we are dealing with representation. Something is put forward. The act of putting forward relates them to each other, particularly there where that act of putting forward is not exclusive. This condition of non-exclusion is shared by both, although in absolutely different fashion. In the case of the artist-heroes, this condition corresponds to the recognition of a state of things through which one's own path can be 'heroically' opened up. In the case of the artist-kings, it corresponds to the 'sovereign' comprehension of a condition of existence within which the area of respect of one's own 'sovereign' singularity can be established. In the first case, the putting forward is realized, beginning with an assumption *(etant donné).* In the second case, the putting forward is realized *in praesentia rerum* and is manifested as a positive affirmation of the singular irreducibility of the Self.

The artist-hero's proposition offers an accessibility of the work on the part of the non-author, who in this manner comes to occupy the various positions that the work allows in the design determined by the author. An equanimity in the possibility of movement is established between author and non-author, leaving untouched the 'formal' privilege of the author vis-à-vis the non-author.

A frontality is represented, is made present in that which is put forward by the artist-king, and this frontality differentiates the positions, no longer between author and non-author, but between the Self of the subject and the Other-than-self of the work. The subject then becomes the erotic subject that, as artist, expresses the desire of the Other through the production of the work, through its construction (constructor prevails over author, participant buildability succeeds authoritativeness). Likewise the non-artist finds and recognizes in the work, in his being present, in the confrontation with the work's flagrancy, the reflection of his own position as one who desires. In both cases it is desire that is loving, and not the will to dominion and to possession.

Ettore Spalletti, Gruppo della Fonte, 1980

The frontality of the work represents and *is* the erotic act in its visible manifestation, if by erotic act one means the 'effective' and 'unconditional' encounter with the Other.

The 'real' accessibility of the work of the hero, his voyage through the surface – the work is horizontal, even in the sense in which it is established on a horizon, it presents a horizon, and 'in the final analysis' maintains the privilege of vision (we are all painters) – is juxtaposed with the frontal resoluteness of the regal work. The king doesn't travel but remains. His work is erected out of transience itself, in the moment. His work is vertical, and this verticality passes through, piercing the strata and the stratifications, removing them from their reciprocal and superimposed sedimentations, each time making them 'actual' bringing them up to the surface, the vertical surface of the artwork. The *demos* of the global village, which while not negated or excluded, is tinged and substantiated with the specifity of its thousands of names, of the kingdoms of which it is composed.

However the sovereign singularity of the work manifests a necessity, a could-not-be-anything-other-than-what-it-is. It is as if this could-not-be-anything-other-than-what-it-is, this necessary impossibility, is ignored in its dramatic implications, while it is embraced in its narrative aspects. If one wants to and is able to exercise the faculty of judgement, every time one wants to see the emperor without his clothes, and, through that faculty of judgement, if one points out his humiliating nudity, in effect one shall perceive and recognize the dark melancholy cloak that covers him, that doesn't leave him uncovered. The regal aspiration to joy, the regal desire for happiness, the solarity that the emperor represents, never completely dissolves the melancholy veil. Rather, the representative nature of his appearances comprise it, without being disturbed by it.

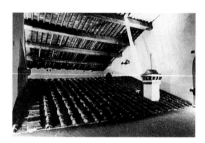

Marco Bagnoli, Golem, Dolem, Gödel, Villa Medicea dei Cento Camini, Artimino, 1981

But out of what is this veil woven? It is woven out of time. Not the historical time of the hero, the linear time that marks and measures the stages of his journey, of his voyage, but the cyclical time of birth/death. And this happens in such a way that the sovereign singularity of the artist-king isolates him and secures him in a model that is no longer a model of culture and of dominion, or a canon of beauty that is no longer well understood, but is nonetheless a model according to the highest and most orthodox tradition of the West. The model is no longer abstract and functional, economic and scientific, but practical and sentimental, concrete and substantial, corporeal and erotic. But he is still separate and protected in his own model-garment. Still not knowing, he remembers. The presence of the world is memory deposited in him and in his work. For this reason the regal presence is unconditioned indifference, in that it cannot be reduced to the given, codified system of appearances; but it is also passion, as the pathetic acceptance of the existent.

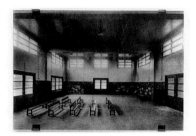

Jean-Marc Bustamante, Lumière VIII, 1991

I stands to this side and observes: the lost and hopefully salvaged voyage of the hero, his ephemeral damnation, the renewal of his departure.

I stands to that side and witnesses: the sovereign presence of transience and its force, 'the force of the ephemeral instant' in its full regality.

But where is *I*? Upon what earth does he rest? Sometimes *I* knows how to reach the next island, or what he believes to be such. But now where is he? Sometimes

Günther Förg, Der Sturz, 1984

Reinhard Mucha, Seite 35, 1985

Rodney Graham, 5 Flanders Trees, 1989

he knows where he has been and presumes he knows where he will go, what point he will be capable of reaching. But where is he now?

Sometimes *I* speaks and says: 'There is no voyage, just as there is no place. Only appearances that can be narrated, short stories, which return by night and attempt to break wakefulness into dreams (memories) or sleep (forgetfulness), where the cruelty of dawn can be avoided.'

This, then, is how the hopeful monsters arise, from the lacerations of night, from the fractures of homogeneous continuity of existence. Generated by processes of hybridization, they present indefinable outlines according to current systems of categorization.

Adventurers more than heroes, they have split the power from the potentiality-of-being, for they have tried this out at the moment of their birth; this is what has been given, at the moment of their origin. If they are, and they are as they are, it is by virtue of this schism, a schism that is not programmed, but is factual, and of which, in some fashion, they are the non-exclusive product. They are not alone and they know it, they are aware of it. Nevertheless this signifies that this state of non-solitude is anything but comforting for their survival, and in any case has nothing to do with an ideal condition of human and universal brotherhood or communion. In the same way they know that they are participating in, they are part of that-which-effectively-is. Any further consideration that goes beyond this awareness is, in the end, irrelevant. In fact, the hopeful monster first of all deals with his own effective existence. He doesn't know if his own action will determine something, but he does know that his very being is determining, if only for himself. The hopeful monster possesses true ingenuity, which resembles but is not that which generally is attributed to youth. His age is indefinable. If we should choose to consider him 'young', we could not help but wonder if his 'youth' could ever reach a stage of 'maturity'. In fact, his presumed 'youth' will be such only if the mutation that he conveys should give rise to a new species: otherwise his deformity, his deformation, will be merely the final outcome of a process of involution, or the lateral, marginal outcome of a process of evolution. And so his action, which, I repeat, is adventurous more than heroic, is dedicated to his survival. His survival before the survival of others, because in him the *I* speaks. Born out of the schism, he seems to ignore the oppositional poles that have generated him: he ignores negative and positive, vertical and horizontal, limitations and boundlessness, birth and death, but he ignores them in their value as principles, while he takes them on as tools that will enable him to safeguard his own concrete survival.

He knows his own body, as energy, but in the end doesn't distinguish between tool and substance, between function and pleasure. His relationship with history and tradition comes about less through knowledge than through experience incorporated into his own feeling. He is musician and fool, but benefits from a space of respect, which he will defend with every means, because it is the space of his life. For this reason he is careful and astute. Careful and astute particularly in what he puts forward.

He will put forward very little and will retain as much as he can. Or at least this is what he will show. And so the work will be the trace of a practice, the remains of an experience, the diagram of a journey, a score, made into pages of a text that is deliberately absent, a solid cast of something that isn't there, that one has made boldly disappear, an affectionate machine of deceptions, seemingly arrogant but made of soft flesh, humble equipment but insidious like traps...

I goes to the end of summer *(bei Sommerende)* for this landscape *(Landschaft),* fleeing the void *(die Leere),* the weight *(das Schwere),* of a vain expectation, and without any certainty, it seems to him that he is perhaps only under an illusion, that, in that fortuitous encounter, he is seeing a reflection of his own monstrosity and his own hope. (Translated from the Italian by Marguerite Shore)

Matthew Barney, Videostill: Field Dressing, 1990

Eran Schaerf, Schneider u. Sohn, *längen, kürzen,*
Rosen, Galerie Zwinger, Berlin 1992

Barnett Newman, The Moment I, 1962

COLLECTIVE MEMORY

Claudia Herstatt

DOCUMENTA IX is spread over nine buildings and a variety of open spaces. Two towers rise up from this horizontal arrangement. Both of them mirror its intentions – and at the same time fulfil them. There are no works of art visible in the glass-covered staircase of the AOK building, which dates from the 1950s. The visitor looks out of the windows into the city, the park, the landscape, onto the buildings housing the exhibition, and onto the sculptures in their grounds. And he senses something: sounds, hardly audible, which seem to permeate him. They mix with the sounds coming from outside and with those the visitor himself has brought inside. Max Neuhaus, an American, has here built a passageway between the exhibition and the world outside. It attunes the visitor to the things to come and to himself, allowing him to become receptive and quiet, slowing his pulse.

The other tower, the Zwehrenturm near the Museum Fridericianum, houses an exhibition entitled 'Collective Memory'. Just as the empty staircase is meant to be the starting-point for a visit to the exhibition, and an encounter with the unknown, so the 'Collective Memory' is intended as the conclusion. The visitor's mind is not led into contemplation or quiescence, or even to a pious devotion of august ideas; instead the viewer is encouraged to resume a confrontation with the exhibition. By means of the eight exemplary works of art the visitor is given a chance to re-enact how the curators of DOCUMENTA IX conceived the exhibition – which questions they asked themselves, which works of reference they consulted, and how they came to position all the different exhibits in an environment especially created for the purpose.

By studying the pictures, documents and texts shown in glazed cabinets placed above each other, the visitor can filter and build retrospective associations between what he has seen, passed and experienced. Not, however, in the sense of systemizing the works into categories supplied by the history of art. The names of the chosen artists (Jacques-Louis David, Paul Gauguin, Alberto Giacometti, James Ensor, Barnett Newman, Joseph Beuys, René Daniels, and James Lee Byars) easily prove that this is not a simplifying digest of the history of art using established positions. Each of these eight artists has ventured forth into unknown regions, broken out of the restricting boundaries of the conventional, and endured the nearly unbearable strain of the attempt to push the language of art beyond its own frontiers.

As representatives of revolutionary forms of art these eight works also define the engagement of the artists chosen for this documenta. That is to say, those artists who are trying to overcome art within its own system. Who fall back on the existing vocabulary and the established semiotic systems with the intent of creating something new, of extending and diversifying the expressive means of art. These artists have used the existing framework, filling it with experience reflecting their personality – both within the tower as well as outside, in the exhibition. Their understanding of art is one which presupposes the transgression of the borders of a system.

Yet the artist has to put up with and solve an inherent contradiction: the fact that borderlines need first to exist if the artist is to pass beyond them. The unease and inability which the history of art reveals in the confrontation with this reality of modern art was formulated by the American theoretician and artist Barnett Newman. In the foreword to the catalogue for the exhibition of a friend, he writes: 'The history of modern art, to label it, has been a struggle against the catalogue.' The authors of these catalogues, so he says, feel that their whole purpose lies in directing the viewers' eyes to the object represented by the work of art. The artist on the other hand is involved in a battle to free himself from these fetters. But the represented object itself is the necessary fetter.

Art and life as a permanent contradiction, taking life into art – that was the battle Barnett Newman took on, a battle which is harder than one would suppose from his remark: 'Aesthetics is for me like ornithology must be for the birds.' An inner confrontation about which his friend Thomas B. Hess said: 'The contradictions were so strong that one had to fear that this man's head would rather burst than stand the strain of so many emotions.' With the painting *Who's afraid of Red, Yellow and Blue?* (1966–67) he poses the vital question for the artist in the 20th century, the quest for the world within art.

One generation before him, the French artist Paul Gauguin had also put the more metaphysical reasoning about human existence into the title of a painting that plays a key role within his *œuvre:* 'Where do we come from? Who are we? Where are we going?.' The last part of this triple question he personally answered by stepping outside civilization. He left for the South Seas in search of an art form that was independent of the European tradition. He had no reason to doubt the beauty of Greek sculpture, but he saw a fatal flaw in the plaster of Paris casts gathering dust in the halls of the academies, 'Greek art, as beautiful as it may be,' he wrote in 1897, 'is the great mistake.'

But Tahiti was not quite paradise for him, for he was stricken by homesickness. A total separation was impossible. Gauguin still used the vocabulary of his Christian-European background, but he refreshed it with newly discovered elements taken from a strange world. He painted Madonnas who have Tahitian facial features underneath the halo, and who recline on a bed. Other pictures combine the rhythms of the European Old Masters with the statuary forms of the South Seas to make cohesive compositions.

This escape into an unknown and strange world stands in contrast to the retreat which the Belgian painter James Ensor – Gauguin's senior by twelve years – chose for himself. Working in the restricted atmosphere of the harbour town of Ostende, he created paintings whose light-toned polychromatism, faces frozen into masks, and starkly contrasting skeletons shivering with cold, provoked as much antagonism as those of the French artist.

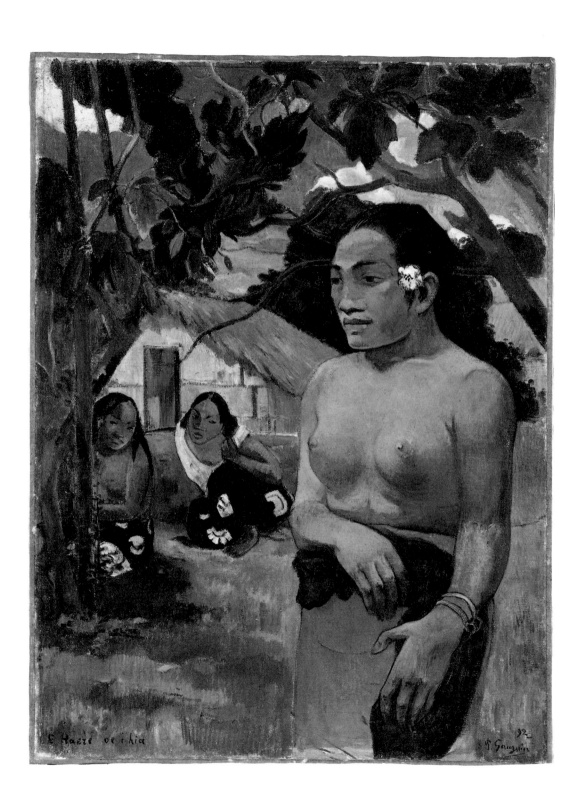

Paul Gauguin, E Haere oe i hia, 1892

Ensor's *Self-portrait with Flowered Hat* is shown in the Zwehrenturm because it comes to grips with the artist's position as an outsider. The self-critical picture dates from the year 1883 and shows the artist in three-quarter profile, looking sceptically at the observer, as one would look into the lens of a camera. Five years later, Ensor went to work on the picture once again and placed a hat with flowers and a feather on the head of his likeness. This addition makes it apparent that as an artist Ensor is declaring himself to be a fool or jester – for the others. It is a position that some modern artists are now taking up again.

James Ensor, Selfportrait with Flowered Hat, 1883

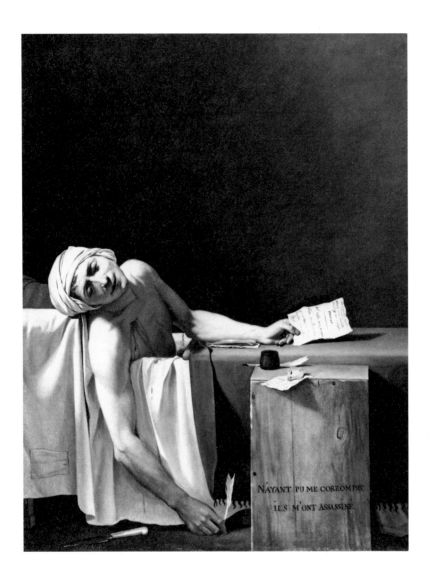

The exhibition in the tower also presents Jacques-Louis David's *The Body of Marat* – David deliberately, not Ingres. David's presentation in this context is an attempt to oppose the definition of him in the standard works of reference – as 'the representative of a declamatory and intensified formal language, the greatest classicist of French painting' – and to reveal him as one of the starting-points of modernism. The formal solution found in the picture itself is still as fresh today as it was in 1792, the year of its creation. On loan from the Louvre, it is being shown in Germany for the first time. It is not as purely a 'history piece' as one might think, and it uses Christian iconography in an astonishing manner.

Jacques-Louis David, Marat assassiné, 1792

Jungfrau:
Und siehe, ich schaue dir zu
Wie du den Marmor schlägst
Wie du formst mit der fühlenden Hand.

Ja, Liebster forme mich in Stein
Wie ich deinen Geist in die Morgenröte lenkte
Bilde mich … O, bilde mich in Stein

Wie du Helden und Götter schufst
In Wäldergängen…
Hauche meine Seele in den kühlen Stein…

Mein Herz soll kühl und ernst werden
Und mädchenhaft wie der lichte Marmor

Doch aus den steintoten Herzen
Sollen die lebenden wachsen wie die blaue Blume

Und jede Blüte soll wieder
Ein schlagendes Steinherz gebären…

Ewigkeit, Ewigkeit…
Ewigkeit…

Joseph Beuys

The murdered hero of the revolution is shown in a bath-tub. This is in itself historically correct, but it is still unusual because David places Marat in a pose typical of Christ in *pietà* paintings. In this way the figure of the murdered man turns into Man himself; the bath-tub becomes the trivial, materialistic world; the letter in Marat's hand symbolizes the artist's message to the world; and the background is a supposition about what art could be. Taken this way, the picture turns out not to be a reflection of history but a simultaneity of art and society, an abstract composition.

It is likely that none of the original audience took umbrage at the fact that the painter had placed a dead hero in something as trivial as a bath-tub. Before the Industrial Revolution art and life were not as sharply divided as they are today. The defensive mechanisms which react against implements used by man for hygenic purposes were not as differentiated – and probably not as radical either. Joseph Beuys's bath-tub, apparently soiled by grease and felt, was mistakenly scrubbed clean, and although Marcel Duchamp raised a urinal to the rank of a museum-piece, an art-critic confronted with several white porcelain bowls, which the artist David Hammons had placed in a wood near the Belgian town of Temse hardly three years ago, still asked himself if this could possibly be art.

Joseph Beuys, Drawing, n. d.

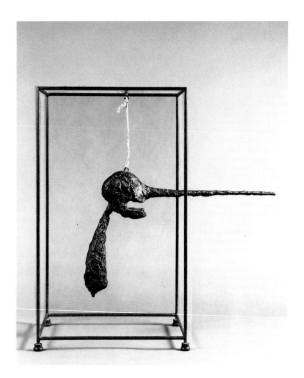

Documenta does not have this kind of fear of contact. But it is still an open question as to whether visitors will be able to build a connection through their collective memory between the provoking works of Wim Delvoye or Attila Richard Lukacs, and Jacques-Louis David's bath-tub. Possibly, as a trivial object in a beautifully executed painting, it will not even be noticed. But the internal eye of the beholder might register the image of the cover of a German magazine showing a dead politician in the bath-tub of a hotel-room. Or the photograph of a dead dog in a tin box which Jimmie Durham has made part of his contribution to DOCUMENTA IX in the Fridericianum. Even this completely emaciated, skeletal animal could be read as Christ/Marat. And here again the sentence 'ES GEHT UM DIE WURST/It's the sausage that matters', which is introduced into the work of art, serves as an irritation in an apparently familiar context.

Joseph Beuys was the great father-figure of many documentas. His presence in the form of the *Wirtschaftswerte* in the 'Collective Memory' exhibition hardly needs an explanation – it is a necessity, a prerequisite. His influence can still be felt in the work of many younger artists. Beuys, one of the outstanding artistic personalities that this century has brought forth, had the courage and energy to believe that a human being can change this world for the better. He felt called upon to answer this challenge. And he unwillingly provoked many people by adopting this stance. The viewers did not all feel activated by the contact he tried to re-establish with primeval energies, and often they felt attacked. They did not understand that

Alberto Giacometti, Le nez, 1947

Beuys did not regard any object as being beneath himself, too inferior to take unto himself, or touch in his charismatic way and thus awaken a consciousness which left him with only one possibility: to understand art as enacted reality.

Back to the exhibition, to the room housing art. This provides the starting-point for René Daniels, an artist born in 1950 in the Netherlands. His pictures often show a perspective view of an exhibition-like situation, a situation he often varies, sometimes even turning it by ninety degrees until it seems similar to a sculpture. Shrunken and multiplied, it sometimes evokes the impression of bows flitting through space. The exhibition could have expected an engaged and authoritative contribution from René Daniels, but he is suffering from the effects of a stroke and sadly he cannot work anymore. In the 'Collective Memory' the most recent of his works, which have influenced so many of his colleagues, gains remembrance for a short period of time.

Alberto Giacometti's *The Nose* is one of the sculptural contributions to this small collection – along with Beuys's work. With its formal transposition of both the acceptance of and the victory over the framework of art, it can be understood as a kind of *mode d'emploi* to the arrangement of the exhibition. Hung inside a bronze three-dimensional frame, of which only the edges are stressed, we find a head whose nose protrudes beyond the frame. The construction is the limiting framework – it could also be a cage – in which the artist is imprisoned, but out of

Joseph Beuys, Wirtschaftswerte, 1980

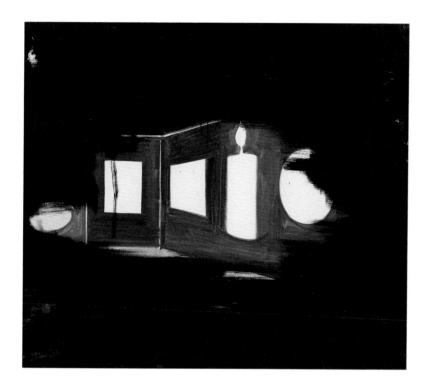

which he has a chance to escape. The head could be seen as a metaphor for the protagonist who has come to the decision to create an opening, a breathing-space, using the nose as a kind of drill.

As a way of establishing a connection with the other works in the 'Collective Memory', one could say that David provides the frame, Newman shows the transition from life to art, and that Gauguin and Ensor move even beyond that. Giacometti encapsulates all this in one sculpture that unfolds into a discourse – like a walk through the exhibition.

This is not to forget James Lee Byars, whose work is also shown in the 'Collective Memory'. His pieces seem so beautiful, so hermetic and consummate that they almost belong to the hereafter. But they thereby also set a trap in the midst of this ensemble in which closure and a hermetic attitude are concurrently threatening. Beauty takes the air which art needs to breath, and puts art under the shelter of a glass bell – a situation which calls for escape. Giacometti's *Nose* is possibly a figurative *mode d'emploi* for this escape too.

(Translated from the German by Michael Auwers)

René Daniels, untitled, 1987
James Lee Byars, The White Figure, 1990

THE ARTIST AS PERPETUAL ANTAGONIST

Joyce Carol Oates

In the human imagination, deep in that inaccessible and perhaps wordless part of consciousness of which our dreams are fleeting reflections, two forces contend for primacy. The self is divided, always in conflict. Historically, civilization is a precarious construct, its parts forever finding reasons to 'war' with one another: for it is not issues that cause war, but the desire to 'war'. As Nietzsche has said, 'In times of peace, the warlike man makes war with himself.'

There are two radically opposed currents in Western thought, which formally reflect the division in the human imagination: the first, exemplified by Parmenides of Elea, the other by Heraclitus of Ephesus.

For Parmenides, reality and truth combine in motionless, perfect Being: unitary, unchanging, absolute.

For Heraclitus, who was horrified by Parmenides' vision, fire is the primordial substance of the universe, and water is the symbol of life in perpetual flux.

Ontology and metaphysics – Being in repose, and Being in flux – here is the primary opposition from which the myriad of oppositions we call religion, politics, culture, history, aesthetics, ethics, 'morals' derive.

The great challenge for the artist is to express these warring contentions in images capacious and powerful enough to contain both.

The great challenge for the artist is to fulfill his or her destiny as the perpetual antagonist: the one who questions what others believe they believe: the one who questions even the role of art and the artists.

IDÉE DE LA FORME

Jacques Roubaud

Qu'elle soit infinie proprement, ou que son éloignement m'excède, je ne peux apprendre d'elle que par l'intermède d'un vestige, d'un effet différé, d'un vêtement, d'un renversement, d'un miroir, d'une ombre ou d'une énigme. Descort de tous plans, je ne peux la consentir cependant au hasard, ni à aucun principe qui ne sache que distinguer, ordonner ou contraindre.

Orphée l'appela Œil du Monde, parce qu'elle se tenait sur le bord unique intérieur et extérieur des choses naturelles; Empédocle Principe de Différentiation, Bruno Artiste Interne. Il existe encore bien d'autres définitions. Elle est pour moi l'Inférence Infernale (je ne la circonscris pas ainsi, je la nomme). Dès qu'est touché le papier, dès que commence la voix elle coupe, cerne, et comprime. Mais sans elle le papier ne serait pas touché, ni le moindre son émis, encore moins entendu. Défense, où partout entre la perte.

Car la forme ne peut se déclarer elle-même sans déclarer aussi l'informe, qui pourtant n'est pas séparé d'elle ni renvoyé à un autre lieu: au contraire, la forme ne peut que donner lieu à l'informe, qu'exposer, secrète, intérieure, son impropriété.

J'ai connu ces moments impeccables, brillants, où quelque chose de patent, d'aigu et de simple allait m'apparaître, prendre visage; ici l'être-soir du soir, l'être-nuit de la nuit, hors de la lumière latente autant que de l'obscurité réduite. Pourtant, je n'y pouvais rien.

Quelconque était le soleil, quelconque la terre avec toutes ses irrégularités, ses herbes et ses tuiles, ses confusions. Rouge; absorbés, semblait-il, une fois pour toutes. Mais ce moment se dispersait comme la chaleur de la pierre sous mes doigts.

Et le regard, qui passait continuellement de la tribu commune des cyprès aux traits singuliers de leur chacune présence, ne sachant plus maintenir de démarcation réelle entre eux, restait stupide.

THE IDEA OF FORM

Jacques Roubaud

Whether it be truly infinite, or simply beyond my reach, I cannot behold it but asquint, upon a vestige, a delayed effect, a garment, a reversal, a mirror, a shadow or a riddle. *Descort* of any blue-print, I can nevertheless not leave it to chance, nor to any principle that could only distinguish, order or constrain.

Orpheus called it the Eye of the World because it rests on the single inner and outer edge of natural things; Empedocles, Principle of Differentiation; Bruno, Internal Artist. There are many other definitions. For me, it is Infernal Inference (I do not circumscribe it thus, I name it). As soon as you touch paper, as soon as you clear your throat, it cuts in, comprehends, compresses. But without it, the paper would not be touched, nor the least sound uttered, let alone heard. Defence is everywhere open to loss.

For form cannot declare itself without also declaring the formless, which, however, is not separate from it nor relegated to another place: on the contrary, form cannot but give rise to the formless, cannot but expose its secret inner impropriety.

I have known flawless, brilliant moments when something evident, sharp and simple was to appear to me, was to take on a face; here, the very eveningness of evening, the nightness of night, outside the latent light as much as the diminished dark. Yet I could do nothing.

Commonplace, the sun, commonplace, the earth with all its irregularities, its grass and shingle, its confusions. Red. Absorbed, it seemed, once and for all. But the moment dispersed like the warmth of stone under my fingers.

And my eyes, which kept going back and forth between the assembled tribe of cypresses and the singular line of each tree's presence, without being able to maintain any real demarcation between them, remained stupid.

Car la forme, j'en conviens, est stupide. Substituer les arbres au ciel ne peut pas l'absoudre de ce qui lui manque, encore moins corriger le vide, hospitalité qui ne se refuse pas. Ni s'encombrer de la multiplicité difficile.

Donner des mondes en même temps et l'indication intellectuelle et l'absorption stupéfaite, gourde, ne promet à la vue aucune avenue morale, à la descendance aucun ombrage, aux sentiments aucun secours étymologique.

Il n'en est pas moins vrai qu'elle est la seule <u>manière</u>; et seule produit les exemplaires des choses, non leurs essences; par où elle évite les mômeries du sens, les catastrophes du message, comme les jongleries de la substitution. «*La manière est le nombre et l'état des choses, où chacune demeure telle qu'elle est.*»

La forme n'est que le mouvement dont elle est la forme; qu'elle ne retient pas, mais qu'elle donne en commun, pour être poésie. <u>Ainsi</u> est-elle, parce qu' ‹*ainsi est ce qu'elle peut faire de mieux*›. Il ne lui est pas arrivé d'être <u>ainsi</u> (il n'y a pas de forme ancienne); il ne lui arrivera pas d'être ainsi (il n'y a pas de forme future); elle est ‹<u>ainsi, maintenant</u>›; ‹maintenant› est la poésie.

Dans le présent infiniment mince bouge la forme, pour mettre en place le ‹maintenant› de la poésie. Là est son inférence infernale: approcher au plus près le démon du silence, qui ‹*implore notre secours*›. (D'où l'effroi, déguisé en indifférence, le recul des modernes devant la poésie.)

Elle ne dit rien; elle ‹préférerait ne pas›. Ou encore: elle ne dit qu'en disant.

For form, I agree, is stupid. Substituting trees for the sky cannot absolve it of lack, let alone correct the void, a hospitality that cannot be refused. Neither can saddling ourselves with difficult multiplicity.

To show, at the same time, both an intellectual awareness and a stupefied, dumb absorption of worlds does not promise moral avenues to sight, umbrage to descendants, or etymological support to sentiment.

For all that, it is true that form is the only <u>manner</u>, and alone produces samples of things, not essences; whereby it avoids the simpering of sense, the catastrophes of message, as well as the juggling of substitutions. *'Manner is the number and state of things where each remains as it is.'*

Form is but the movement whose form it is. Which it does not keep, but shares with all, to become poetry. <u>Thus</u> it is, because *'<u>thus</u> is what it does best'*. It has not happened to be <u>thus</u> (it has no anterior form); it will not happen to be thus (it has no future form); it is '<u>thus, now</u>'. 'Now' is poetry.

In the infinitely tenuous present, form moves to set up the 'now' of poetry. Here is its infernal inference: to come as near as possible to the demon of silence who *'implores our help'*. (Hence, in the guise of indifference, the modern terror of, and recoil from, poetry.)

It does not say anything. It 'would prefer not to'. Or again: it does not say except by saying.

Toute poésie formelle est ‹prélude non mesuré›, la forme s'y grave en <u>filigrane</u>, comme une mesure absente, comme ‹diaphane›: une lumière réfractée de l'obscur. Elle se tient au <u>lieu</u> où est la <u>mémoire</u>: j'ai dit <u>ici</u>.

La forme de poésie procède du monde irréparable. Elle ne se fonde pas de ce qui *‹ne-peut-pas-ne-pas-être›,* ni de ce qui *‹peut-ne-pas-être›,* mais de ce qui <u>à la fois</u> *‹peut- (ne-pas-(ne-pas-être))›* et *‹peut-(être-et-contr'être)›.*

(Le chinois, m'a-t-on expliqué, est capable, tout naturellement, de ces distinctions, ne confondant pas négation et contraire; mais il en existe, aussi, une logique, pour une part ancienne (le ‹pas-autre que› de Nicolas de Cuse), et pour une autre part, contemporaine-extrême (la théorie de Lawvere-Heyting)).

Quelconque était le soleil, quelconque la terre avec toutes ses contiguïtés, ses arbres, et ses murs, ses recouvrements. Rouge, noire; confondus, semblait-il, une fois pour toutes. Ce moment s'était retranché comme la chaleur de la lumière sur mes yeux.

Et mon regard, qui passait continuellement de la tribu commune des cyprès aux traits singuliers de leur chacune présence, ne sachant plus maintenir de démarcation réelle entre eux, resta stupide.

All formal poetry is an 'unmeasured prelude'. Form is carved in filigree, like an absent meter, as if 'diaphanous': a light refracted out of darkness. It is lodged in the place of memory: I have said here.

The form of poetry comes out of the irreparable world. It does not build on what *'cannot-not-be'*, nor on what *'can-not-be'*, but on what, at the same time, *-can-(not-[not-be])'* and *'can-(be-and-counter-be)'*.

(Chinese, I have been told, makes these distinctions quite naturally as it does not confuse negation and contrary. But there also exists a logic for it that is, on the one hand, very old [Nicolas de Cusa's 'not-other than'], and, on the other hand, extremely contemporary [Lawvere-Heyting's theory].)

Commonplace, the sun, commonplace, the earth with all its contiguities, its trees and walls, its coverings. Red, black. Fused, it seemed, once and for all. The moment had entrenched itself like the heat of day on my lids.

And my eyes, which kept going back and forth between the assembled tribe of cypresses and the singular line of each tree's presence, without being able to maintain any real demarcation between them, remained stupid.

(Translated from the French by Rosmarie Waldrop)

"Idée de la Forme" is the third text of a cycle in nine parts, titled "Cercles en Médita- tions" , which was published i n 1991 in the volume "La pluralité des mondes des Lewis" by Éditions Gallimard, Paris

THE CRISIS OF MARXISM AND THE CRISIS OF POLITICS

Cornelius Castoriadis

I must begin by apologizing for the title of this essay, as I am not interested in addressing the crisis of Marxism, but in addressing the crisis of politics – I mean the crisis of *emancipatory* politics. What should not be called the 'crisis' of Marxism but the wholesale *collapse* of Marxism has been obvious to me for more than thirty years.[1] The events of the last five, even the last two, years, immensely important and significant as they are in some respects, have taught us next to nothing as far as the theoretical body of Marx's work is concerned. But this collapse has opened up for us the true political question, which is this: once the oxymoronic idea that the goal or meaning of politics is dictated by some sort of 'historical necessity' is abandoned, and assuming that we do not identify politics as the management of the existing order of things or as the introduction of 'improvements' to this order, how can we discover the meaning of politics and identify the reasons *(logon didonai)* for our political choices and actions?

Before dealing with this question, however, I will briefly summarize some of the numerous points that in my view have made, and have made for quite some time, Marx's conception untenable. This is necessary even though it follows the foundering of the so-called 'Marxist-Leninist' regimes, whose invocations of Marx were of course, cruel kinds of hoax. But even if they were not, to conclude that this collapse of Marxism nullifies Marx's work is tantamount to accepting the Hegelian *Weltgeschichte ist Weltgericht* ('world history is the Last Judgement'), which means, paradoxically, to remain a Marxist.

Almost all the above points are related to the fact that Marx was deeply immersed in capitalism's ethos and assumptions, the full implications of which he never questioned. Marx believed in the centrality of economic production. He shared in the mythology of 'progress'. He was completely absorbed in the collective fantasy concerning man's rational mastery over nature, and man's mastery of himself. Marx never dissociated himself from the rationalistic scientism of his (and our own) epoch. He believed he had produced a watertight 'scientific' theory that embraced society, history and economics. This unswerving conviction mars even his best work: thus, his writings on economics, which are of lasting value as a broad sociological enquiry into the mechanisms of nineteenth-century capitalism, are untenable as economics proper, the main reason for which being that Marx transformed into a theoretical axiom that which is the (unattainable and self-contradictory) practical objective of capitalism: that labour power is (has to become) a commodity just like any other. Marx never criticized capitalist technology, nor did he criticize the ways in which capitalist work, production and factory life was organized; he only criticized their uses for capitalism's selfish ends. In addition, he was blind to the phenomenon of bureaucratic systems, and this was not accidental, for bureaucracy is not an 'economic' structure as such, it actually pertains to the structure of power.

All this was to have serious, indeed catastrophic, consequences for the workers' movement. To mention but two points: if there really is one true theory, then all dissenters from it are either wrong, or wicked, or perhaps both. The notion that there is one true theory leads, in turn, to the politically monstrous idea of orthodoxy. And, of course, orthodoxy requires its own guardians, that is, a Church or a Party machine. A Church committed to orthodoxy will always need an Inquisition, and, in turn, heretics will be burned – or, in the case of a Party, sent to the Gulag. And if the 'development of productive forces' is the supreme criterion, then Russia's 'industrialization' redeems Stalin's crimes, and the human cost in terms of its, or Stalin's, victims, can be explained away as the overhead costs of historical development.

1
See the opening chapter of my *The Imaginary Institution of Society* (Cambridge, Mass, MIT Press, and Oxford, Polity Press, 1987), first published in 1964, and my *Political and Social Writings*, 3 vols (University of Minnesota Press, 1988 and 1992).

Now, what remains if one subtracts from Marx his economics, his 'materialist' conception of history and belief in 'historical laws', and his messianic fantasy of a future society that is fully transparent to itself and spontaneously self-regulated. Apart from some acute and profound socio-historical descriptions – *The Eighteenth Brumaire,* for example, or the chapter on primitive accumulation in *Capital* – what remains is what I call 'the other element' in Marx, the element that stresses human activity, affirms that people make their own history under particular conditions – generally without realizing it – and asserts that we have to find in actual historical reality the factors that can be used to transform this same reality.

I do not wish to dwell on the lopsided specification this other element received at Marx's own hands (for whom human activity essentially meant *productive* activity), except to note that this element is, in itself, ambiguous. That people make their own history ends up by meaning – or rather, means from the outset, as *The German Ideology* makes clear – that people make tools, and by so doing they inescapably bring about everything else. That people make their own history first and foremost by creating meanings and institutions, that tools themselves *are* institutions as well as embodiments of meaning – of significations – is something that Marx never saw. Equally, the idea that history is always made under particular conditions may mean one of two things. The first is that any historical activity always takes place in a given world, in given circumstances etc., or, more concisely, under *necessary* conditions that at the same time limit it (which is obvious to the point of banality); the second is that these particular, or determinate, conditions are also *determinant,* that is to say, not only necessary but *sufficient,* which is clearly Marx's assumption and which, if true, makes of nonsense of the idea that people make their own history, implies that history itself is an immense deterministic concatenation, and that ideas of truth, of value, of choice, of responsibility are pure illusions, since their effects and ends are unknown, indeed unknowable, to those that hold them.

I prefer, therefore, to concentrate on the *political,* the 'realistic', aspect of the idea. Marx sought to break with 'utopian' thinking, and believed that he found in actual historical reality the factor that would transform this reality. As is well known, this factor is actually the proletariat, and, of course, there can be no doubt about the historical importance of the workers' movement or about the *grosso modo* legitimacy of its initial aims (I leave aside the debate with die-hard 'liberals'). But this position raises some very important questions, questions that were either avoided or laughed out of court by Marx and by the best Marxist writers that followed him. To say that a political project that involved transforming reality is worthless *unless* it can find the factors making its realization possible in socio-historical reality itself is obvious, even trivial. But Marx meant much more than that. He thought that he had found in reality all that he needed, and that there was no problem in terms of the project or in terms of the choice. Communism, he said, is not a political programme, but the actual movement that transforms social reality. If we assume this to be true, we are then left with this question: *why* should we value positively and well in advance, whatever it is that transforms reality? Why should we value positively something on the grounds that this is the dominant socio-historical trend?

Marx was able to avoid these questions because it just so happened (or happens) that the worker's movement aspired (or aspires) toward freedom, equality, justice; and who would dare to even think to question the value or the legitimacy of those aims (though Marx, of course, scorned the idea of value or legitimation)? But *we* cannot escape in the same way, either on empirical or on theoretical grounds. The briefest of reflections can only lead us to reject Marx's stand on this point, which is, after all, the primary point in any political position.

That we cannot, ought not and have not to *support* a movement just because it is 'real', or because it is the dominant socio-historical trend, hardly needs discussion. Empirically, if this were the case, we would have had to support Stalinism, or

Nazism; or, today, we would have to support the frantic course of techno-science and the 'development of productive forces' that are destroying our planet. And if someone were to insist that there are conflicting trends in reality, and thus that one is able to make choices from among them, the question would still arise – Choose on what grounds? – and it is clear that the answer could not be found in reality itself.

Both logically and philosophically, the idea that 'an actual movement that suppresses the existing social reality' is good of and in itself, *and/or* that we have to support it, presupposes a (strictly speaking, silly) postulate that is at the centre of a progressionist metaphysics of history: whatever comes after is better than what was there before. Behind this, if we remove all notions of a Divine Plan, lies the assumption that history, and Being in general, is a *cumulative* process. It is immaterial whether this cumulation is taken to be 'linear' or 'dialectic'. In either case, the future has to be 'superior' to the past, and the 'best' of the past is conserved in the present. And in both cases, the ultimate platonic fallacy that Being (or, here, Becoming) is in and of itself Good, is entailed.

This is of course a teleology (and a theology) of history, and this teleology is clearly present in Marx (as it is in bourgeois liberalism). But any teleology of history not only makes politics meaningless, it contains an internal contradiction. On the one hand, it forbids judgement of any and all specific events or instances of reality, since they all form necessary elements of the Grand Design. At the same time, however, it allows itself to pass an uninhibited, positive, judgement on the totality of the process, which is, and can only be, good. This, of course, can only be a religious, not a self-reflexive, stance.

To insist, then: the unspoken assumptions that lie behind Marx's position are equivalent to a *Sancta realitas* principle, or a belief in the rationality of the real. To be sure, the *real* is here construed to be that which in the real itself negates the real. But this only means that the real movement of negation is more real than the reality it negates. If the 'immanent critique' is *strictly* immanent, it is not a critique of reality, but part of it.

The progressionist metaphysics of history is untenable for the very same reasons that make a global teleology of history untenable. And for the reasons I have hinted at above, a total determinism is also untenable, for this is but another way of asserting that whatever is real is rational. (Deterministic scientism is only the absolute idealism of the philosophically illiterate.)

History, as well as Being, means creation as well as destruction: the creation of forms, and the destruction of forms. Therefore, any idea of cumulation or pro- gress on a total and universal level is, strictly speaking, meaningless. And creation, in and of itself, is not equivalent to value. We create history – forms of society, *œuvres,* etc. – and we have to choose from among our creations. And this very potential for choosing, for making non-trivial choices, is itself an historical creation. It does not exist for the true faithful, indeed for any individual in a 'traditional' society. The potential for choice, when it is brought to bear on forms of institution, is politics properly understood. And for the reasons mentioned above, it is this potential for choice – and thus, for kinds of politics – that Marx denies.

Why, then, discuss Marx in relation to the crisis of politics today? First of all, of course, because this very conception of Marx's, and its subsequent degeneracy and final collapse, is one of the factors that have precipitated the crisis of politics. But there is another reason. Whatever one might say of its other aspects, the work of Marx is part of the social-historical project of autonomy as it re-emerged in Western Europe in the twelfth century. It is true, as I have already said, that this work is contaminated to a lethal degree by the ethos and assumptions of capitalism. It is also true that it played a catastrophic role through its influence on both workers and intellectuals. But, equally true, it embodies one of the most radical attempts, even if it failed, to mount a critique of the existing social order. And, finally, for many countries and for many decades, it has been inextricably linked with the workers' movement, which, even if that failed in its chief aims,

brought about transformations of capitalist society without which that society would probably not have survived to become what it is today.

And now we find ourselves thus: we still adhere, and, in my view, adhere more than ever, to the project of social and individual autonomy, or, if you prefer, the project of human emancipation. We reject the Marxian insistence on 'grounding' it in the 'laws of history', or attributing it to the workers' movement if only, simply, because this movement is no more than one of the many interest groups that are fighting within rich capitalist societies. And we are left with two questions, the first of which, in my view, is easy to answer on a theoretical level, while the second has today an agonizing acuity.

The first question is this: why (in the sense of 'for what *reasons*'), does one support the project of autonomy? The answer is easy on the theoretical level because the fact that this question can be posed forces, so to speak, its own answer. If someone asks for reasons – for reasonable reasons – he or she has already entered the field of the *logon didonai,* of rendering account and reason, which in itself entails the recognition of the value of autonomy within the sphere of thinking. And it is easy to show – it is, in fact, a tautology – that autonomy within the sphere of thinking is synonymous with reason itself. It is equally easy to show that this autonomy is not an 'individual' affair, but something that is decisively conditioned by the institution of society. I do not mean this in the sense of the absence of 'external' repression, but in the sense of the internalization of institutions by the social individual making possible free and unfettered thinking. And autonomous thinking is both a precondition and a concomitant of the effective autonomy of the individual as well as of people collectively.

Clearly, this is not an argument that is directed against a true believer of any one particular religion or dogma. But, of course, a true believer should never argue: he should only show his Book. We choose to think; and therefore also to argue. Free thinking, the kernel of the project of autonomy, is a creation of our history. It is not the only one of course: the Inquisition, Stalinism and Nazism are all creations of our history too. But we *choose* autonomy against heteronomy. This choice is *made possible* by our history, but, as experience amply shows, it is not *dictated* by it. It is a choice, and as such it entails a category easily forgotten in philosophical and political discussions today: it entails *will.* Not 'voluntarism', but the capacity of self-reflexive deliberation and decision, without which even thinking itself is impossible.

So, we *will* autonomy – for ourselves and for all. And this is a *political* will and project, whereby we link ourselves with one of the essential strands whose origin is derived from ancient Greece.

But here arises the second, and much more difficult, question. As I have said, it is obvious that no political project can ignore the question of the factors that may bring about its realization. For a time one could think – as I thought myself – that the workers' movement was this factor. This idea can no longer be maintained. Marcuse thought that youth, students, marginal groups of one sort or another, would replace the workers' movement. I consider this, like Third-Worldism, to be a most awkward attempt to preserve the Marxian framework by simply substituting new social categories for the old ones. True, many new and important movements did emerge during the 1960s: ethnic minorities, youth and students, women, ecological groups. They have had a profound impact on society. But each has waned; none has managed to create a new, global, political vision.

At any rate, one has to go beyond these categories, beyond 'class thinking': *De jure,* the project of autonomy concerns the whole of society. *De facto,* ninety per cent of the population could be expected to support it.

But the present sociol historical reality is different. For forty years now, with the exception of those minority or sectional struggles I have just mentioned, there has been an unmistakable decline in social and political conflict. We have in front of us, in the rich countries, societies dominated by privatization, apathy, cynicism and the naked pursuit of consumption for its own sake. The psycho-social structure of society today is more and more *exclusively* shaped by the ethos and assumptions

of capitalism: the unlimited expansion of (pseudo-)rational (pseudo-)mastery. And it would, of course, be foolish to try to find in the 'objective contradictions' of the established system a guarantee, even an assurance, that the situation will change in this respect. Objective conditions, by themselves, mean little. Even an ecological catastrophe, in our present atmosphere of apathy and privatization, would be just as likely to bring about a new kind of fascism as to wake people up. As for the people in the poor countries, which make up eighty-five per cent of the world's population, they have, up to now, proved incapable of breaking with their traditional theocratic religious creeds, and have frequently been easy prey for military or 'socialist' tyrannies.

The project of autonomy, or emancipatory politics, is not a political endeavour that is like any other. It can only be realized through the autonomous activity of the people. And it is precisely this activity that, at present, is disturbingly absent.

Certainly, no-one can yet pass final judgement on the present socio-historical era. On the one hand, there is the apparent triumph of the capitalist ethos; while on the other, we certainly do not yet live in a world that is like fourth-century Rome or Constantinople. Islands of resistance to the prevailing order of things can be found almost everywhere.

So we can do nothing else at present but maintain our project of a transformation that will lead to a free society made up of free individuals, in the belief that our critical activity and the exemplification in our acts of the values we stand for will contribute to a revival of an emancipatory movement, one far more lucid and self-reflexive than any previously. Beyond that, one old expression at least will always retain its validity: *Hier stehen wir, wir können nicht anders* (Here we stand, we have no choice).

Frankfurt: 15 October 1990

INSIGHTS INTO THE PROCESS OF PRODUCTION – A CONVERSATION

Heiner Müller and Jan Hoet*

Hoet: Today we've also been talking about lies. I think lies are important– which is something we've also learned from mathematics. If we aren't just as proficient at lying as the mathematicians, we shall be totally written off. If mathematics is a lie…
Müller: It is, but a precise lie – which is why it gets accepted. We've got to start making our lies more precise. There are many more lies than there are truths. There's room for a wealth of variation. A lie can be anything at all – truth can't.
Stock: What part has art got to play in this edifice of lies?
Müller: Art is a lie! That's the essence of art. The starting-point of the whole thing. Art is a lie from the word go, and documenta is always an attempt to collect as many lies as possible together in one place at one time and organize them in such a way that they become productive. It's a market of lies.
Hoet: Now you're talking about art. But we also attach great importance to the lie in our own work, the work of conducting the band, as it were. That's why I have always said that I don't know what art is, because there is always an accumulation of doubts that build themselves into it. I know all about the first violinist, or the first piano-player; I know them very well. I know exactly what material they use to make a thing into art, or rather to try and make it into art: to make things that can then become art.
Müller: I'm thinking about something very similar in the theatre, for example. The theatre always becomes tedious and sterile when it becomes director's theatre. And I think this is because a director in this particular market – just so long as the theatre is hierarchically organized and there is a 'repertoire' that has to be 'sold' – if he is known for one thing, then he tries to do that thing over and over again. And so it gets more and more tedious. What really counts is doing what you *don't* know how to do. That's the essential thing in any art.
Hoet: As a strategy, even.
Müller: Yes, as a strategy. Forget what you know how to do, and do something you don't know how to do; then it will be something new.
Hoet: You always have to take a fresh look at the material and use it to make a 'construction'; not the idea institutionalizing the material, but the material working out – or bringing out – the idea.
Stock: But isn't that a theory based on incompetence?
Müller: Absolutely. Artists are incompetent; it's their duty to insist on it. Fifty years ago, perhaps, when I was twelve, I could have told anyone precisely how a play ought to be written; now it doesn't come so easily. There are so many possibilities, and every new play is a new possibility.
Hoet: Perhaps it's like this: if you take competence as your starting-point, then there's no necessity in what you do. You take an idea and a method – a system – as your starting point, instead of the compelling need that comes out of the material: the thing you can see and touch and make into something.
Müller: There's a problem there, certainly. I met a woman in New York, fifteen or twenty years ago now – she was a writer, an actress, and a violinist – and she told me that the essential thing about the American, the New York mentality was that everyone was an amateur. Anyone can do anything they want to do. This doesn't mean they really can do it, but there are no structures in place to prevent them; and this means that the distinction, or the difference, between amateurs and professionals is disappearing. And this makes it all the harder for the professionals. I remember a nice story connected with this building, the Berliner Ensemble. Brecht was always keen on bringing actors and amateurs together. So there was a production of *Chalk Circle* here. It was a lively production, and it went down very well. But it was a compromise with public taste on Brecht's part. The play was

*Excerpt from a conversation that took place in Berlin on April 1st 1992, and which was guided by Adolf Stock.

written in Hollywood, and it shows. You can argue that it's a sentimental play. But it always works, and people are moved, and that's what it's calculated to do.

On the first night, or at one of the early performances, Brecht was in a box with Peter Palitzsch, and they were looking at the audience and the set, and Palitzsch asked Brecht: 'Is this what you imagined epic theatre would be like?'

And Brecht, of course, said: 'No, it's not. Epic theatre, as I intended it, can only begin to exist when we give up perverting what should be a luxury into a profession; when there are no actors any more; when everyone has the time to be an artist or to be a part-time artist.

Stock: What part does art play in today's world? Is it an unusually skilled manner of telling lies?

Müller: No, there are plenty of other ways of defining a lie. What matters is that art is always about the impossible, desires the impossible and attempts the impossible. And politics has to work with the possible: that's the big difference. Art ought always to be disruptive of politics, and of all set positions; and for that, all it takes, very often, is a joke, a provocation.

The only difficult thing – I wouldn't like to be a visual artist at the moment. I think it's hardest for them. I don't know why, exactly.

Hoet: I think it's hardest for visual artists because in the world around them there aren't the materials for them to go on being 'disruptive'. Historically, we've got inured to everything, all kinds of judgements. Garbage doesn't bother anyone any more, nor does a technological object that's lost its credibility. Everything has been done! Everything has been defused and defined, through discourse.

Müller: I remember something that Gottfried Benn wrote in his prose cycle *Rönne*. Rönne was a fictional doctor, maybe a kind of self-portrait, and one sentence made an enormous impression on me. Rönne is sitting in a train, and there is a sentence that goes: 'Rönne looked at the motion ahead.' That is a marvellous idea: he looked at the motion ahead. I can perfectly well imagine someone coming along now and saying: 'That is my work of art: I put people onto an express train, and off it goes, and whatever they see is my picture.' The reason why this is conceivable is that there's so much more emphasis on ideas than on statements, nowadays. Statements can be delegated to someone else, very often; but an idea – there you get the idea of the Readymade, and that brings a new view of reality.

Stock: But a productive view.

Hoet: You're both talking about the vulnerable position of the artist today. And yet there are people now who don't make art any more, who say: 'We're making "something", but we're not making art.' We're making 'something', and that 'something' doesn't belong anywhere; you can't classify it or find a specific home for it. It has a reference to everything, but you can't place it once and for all; and that's why we say 'that's art, that's –'. In the past it *was* art, art was made. What Jacques-Louis David did primarily was make art.

Müller: I think art is now the process: the production, not the product. And this is the political dimension of art, too, as opposed to the idea of investing it too firmly in products.

Stock: Opposed to negotiability, as well?

Müller: Yes, that too. In one of his late interviews, Duchamp was asked, 'What are you doing at the moment?' And he answered 'Breathing'. More and more, these days, breathing is turning into an achievement in its own right, and it can perfectly well be put into an exhibition. A person actually breathing, right in the middle of the city – it's almost an artwork in itself.

Stock: Not so much a product, more a mode of existence?

Müller: Yes, a process, or a mode of existence; but you can't 'exist' without the transitory and the transitional.

Stock: But processes don't very readily lend themselves to exhibition, do they?

Hoet: You can put processes into an exhibition, within specific contexts. If you choose the right context, you can exhibit them perfectly well. All that matters is that the exhibition context embodies within itself the content of the process.

The right context for a specific work might be a church, for example. Nowadays that can be much more powerful than a museum. Or a machine shop, or a house, or some other specific context with specific processes and narratives contained within it.

Müller: Say, a church in which there's an exhibition of nothing but gigantic nude photographs. If you just exhibit them, there's nothing to it any more, it means nothing to anybody; but in a church…

Hoet: But there must be a match between what is in the processes and what is in the contexts. There has to be a dialogue.

Müller: The same thing can happen in the theatre, you just have to know more or less *who* is doing *what* for *whom* – or you have to be looking for it.

Hoet: When an artist is exploring the language of art, the best place for his work is a museum. But when he is exploring the language of the street, then the museum is not necessarily the best place at all, because there the work may very well start to look exotic, out of place.

Müller: This may be subjective, but I believe that all art is tending towards the form of theatre. There is more and more theatre in all the arts. At first glance, this looks like a turn for the worse, because there is a loss of substance or of reality, but you have to see it positively. Then you can start to put substance back into it, with and through the theatre itself. Organizationally, too, through something like documenta for example. It has an intimidating effect. People are intimidated into accepting the sheer mass of objects through the sheer extravagance of the whole thing. Which is why art always has to cost a lot of money, otherwise it's not taken seriously.

Hoet: In a way, it's all an extension of the plinth. Having a plinth used to provide art with its well-defined and articulated context. To start with, this was for the sculptor's benefit, but nowadays it's not enough.

Müller: Art now needs a mobile plinth, but it has to be one that is not identifiable as such. Once identified, it's finished, turned into something else.

Stock: So is art nowadays superior to reflection? Does a lie make a person more aware than he/she was before?

Hoet: That's the great advantage of art: not being in possession of a great truth. A great advantage, that.

Stock: That's something that needs to be spelt out; it's not by any means common knowledge.

Müller: There you have the great burden that weighs down on the concept of art, and especially so in Germany: the union of Truth, Beauty and Goodness. All nonsense, of course. Art can perfectly well be evil; it doesn't have to be good at all. Gottfried Benn said a malicious thing: he said, 'The opposite of art is well intentioned' – and mostly that's quite true. Art has nothing whatever to do with the categories of 'good' and 'evil'; there is only good art and bad art. But that's something you don't realize till much later.

Stock: What is good art? What criteria are there?

Müller: In this connection, there's a story about Shaw. A young playwright asks him how to learn to write good plays. Shaw says, 'There's only one way. You find a play that has been a success for a hundred years, or three hundred years, and copy it out by hand. That's the only way to learn.'

Hoet: That's fantastic! As an art-school teacher, I have always told the students that I don't know how a seascape ought to be painted. I don't know how 'one' should do it, but look in the museums. You can look at a seascape by Courbet, and if you don't like it choose one by James Ensor; if you don't like that, find another painting. Then go to the sea. You have to combine the two. But I can't tell anyone how to paint a seascape. That would be naive. But it sounds intellectual if you say so all the same.

Müller: And above all you can make money that way, and you get to travel.

Stock: And what's in all this for the viewer?

Müller: Yes, the viewer. The viewer exists too. I think that what the viewer can get out of it is freedom, or a little more freedom.

Hoet: Not happiness!

Müller: No, not happiness, because freedom is not necessarily happiness; it may very well be the opposite. It's being freed from a tie that also represented security: security and stupidity. Security is also stupidity. Art, if it is interesting, disturbs stupidity and thus disturbs security. Which is why aggression against art is an absolutely normal phenomenon. If there isn't any, if something new is accepted too quickly, then it probably isn't all that new, or all that interesting.

Stock: If art is a provocation, if it makes people insecure, is that the true task of art?

Müller: Task!

Stock: But you do work with the idea that art has to offer solutions?

Hoet: No, proposals! There's a big difference. Otherwise there'd be no point in it.

Müller: Brecht wanted that to be his epitaph: 'I made proposals.' Naturally no one ever accepted them, as he very well knew; but you have to make them, and then maybe somewhere, at some time, they'll be noticed and accepted.

Hoet: I have always been surprised by the lack of response, the failure to relate to Brecht, even in Germany.

Müller: In his theoretical texts, his notes, he is far more radical than he is in his own work. Of course, this has to do with the fact that all you need to write is a typewriter or a pencil and paper, but to make theatre you need an apparatus. Any apparatus consumes innovations very quickly and makes them old hat, and the bigger the apparatus the truer this is. Nobody reads Brecht. He is unknown, except when it comes to theatrical practice. But his theoretical writing is extremely interesting, and especially where he writes about things like this.

Stock: So did the East German system have to collapse before Brecht could be read in the right way?

Müller: Yes, I think it did. The basic attitude at the moment is that anything red or halfway red is dead, finished; but – it can easily happen this way – in five years' time people will be looking for something new. What I find interesting in Brecht at the moment is the stuff he wrote before 1933. Those were the most important things, and now they're becoming topical again. The future, in one sense, is now the past.

Hoet: Or the past is the vanishing-point in the perspective of the future.

Müller: This is leading a lot of visual artists into a crisis at the moment, the Art Informel people in particular…

Hoet: And that's why I devote part of this documenta to the theme of 'Collective Memory'. In the tower of the Fridericianum there will be Jacques-Louis David's painting, *The Death of Marat;* and Gauguin; and the American, Barnett Newman; and Joseph Beuys. Not as nostalgia, but as motive power.

Müller: I think that's interesting. David is interesting again…

Hoet: He's become interesting again.

Müller: … and for a remarkable reason. I can't really explain it, but I can tell in my own mind that he has started to interest me…

Hoet: I think that in the study of David there used to be too much emphasis on the consciousness of the past. But if you look closely at what he did, he brought the past into the present; he transposed it into a discourse that combined it with what the present had to offer. There are two elements in his paintings, not one; and that's what matters.

Müller: Basically, there's even a journalistic element in his pictures.

Hoet: That's right, journalistic: topical news and comment. And all this is tied in with the past. The past is not laid in front of us as a stylized product.

Müller: That reminds me of Beuys. Beuys did an exhibition of packaging from the old GDR.

Hoet: Yes, he showed the work at the museum in Ghent, and I bought it for the museum. *Economic Values,* it's called. It's not only a document – now an important one – but it's about the conflict in our existence between Reality and Art, between East and West, Beauty and Dirt, Advertising and Reality, and so on.

Müller: What's interesting about that work is the relationship, or *thinking* about the relationship, between work and leisure. This has to do with that packaging, too. I

remember a conversation I had once with a German linguist from Moscow, who told me that he was once sent out to do labour duty on a collective farm. After a few days of this, he realized that the work could be far better organized and a lot more achieved in a short time. He said as much to one old Uzbek, who was the foreman of the work-brigade – it was in Uzbekistan – and he laughed in his Asiatic way and said, 'Young man, you're young. You're intelligent. You're from Moscow. I work here, I've been working here for forty years, and maybe I shall work here for another ten, and while we're working we want to live.' There's a lot of art, from Beuys onwards, that confronts society, and the system, with this same truly provocative question.

Hoet: Courbet was already using the question, 'Where does reality begin, and where does art begin?'

Stock: Can art mediate between past and present? What are your thoughts about death in this context?

Müller: What interested me was a news item, I don't know whether it's true or not, but that doesn't matter if it leads you on to something. Anyhow, this news item said that for the last twenty years or so, for the first time in the history of the human race, there have been more people living than dead. And I think this also changes the status of art; in fact, it makes things decidedly difficult for art. It shifts the centre of gravity, because art is always partly a dialogue with the dead.

Hoet: I think that's the distinction between art and non-art. On the level of non-art, what counts is to survive, to avoid thinking about death. Survival strategies; but art is something more than a survival strategy. A survival strategy is pure culture. But I think art means no fear of death. It means a dialogue with death – and death seen as energy, not as the end. In cultural terms, death means the end: hence the need for survival strategies to compensate.

Müller: Benn said something to the effect that when the artist dies, or is dead, this means that the work has come to rest.

Stock: You seem very interested in those 1920s right-wing conservatives at the moment.

Müller: Yes, they are highly interesting. The extremes are what is interesting, because at that time there was no such thing as a functioning centre in Germany. There was no bourgeois revolution, and even the allegedly peaceful revolution that did take place was no more than an implosion: the collapse of something that had been hollowed out long before. You can't call that a revolution.

Hoet: Which is why it's so important to me to show the *Marat* in Germany. Of all politicians, I'd say the most rational was Plato. How do you think of Plato now?

Müller: He was the first person to make plans for a Dictatorship of the Intelligentsia. Absolute power to the intellectuals. And the banishment of the artists or, to be precise, the banishment of non-ornamental, non-decorative, non-celebratory art. That is quite logical. If you plan to set up a state based on the idea that reality exists only in a transcendental realm, then that's quite logical.

Which brings me to this – it may be a nonsense, but I believe that art destroys ideas; in fact, destroying ideas is its function. If ideas solidify into doctrine, then that's always dangerous. And one important function of art is the destruction of ideas.

Hoet: Absolutely right: because art deals with realities, with experiences. Art always deals with experiences, and ideas tend to divert us from material reality.

Stock: Are you abolishing the Enlightenment?

Müller: I don't know; what does Enlightenment really mean? The word always reminds me of a story that Foucault used to tell. I don't know where he got it from, but I believe him. At the time of the Jacobins, there was a congress of jurists and criminologists in St. Petersburg. And there was a French delegation, made up of Jacobins. The Russians had the problem of a huge rise in the crime rate and too few prisons. What are we to going do with all these criminals? And the French, the representatives of the Enlightenment, suggested labour camps: that is, converting criminal energy into work energy. It was completely foreign to the Russian

mentality; it was Enlightenment thinking. The consequences are clear: it was Enlightenment thinking, the Russians would never have thought of such a thing. So that was it: the invention of the Gulags by the French Enlightenment.

Stock: Is there a great yearning for unreason in the air at the moment?

Müller: No, it's not unreason at all. It's perfectly reasonable, in the sense that life itself knows better than any idea.

Hoet: This is not irrationality. People often interpret my views as irrational, but they aren't at all. Experience is not irrational.

Müller: That's it; what counts is to put ideas to the test of experience. That is art.

Hoet: Maybe the distinction lies in the priority we've all assigned to the verbal intelligence. Might it not be that verbal language is abstract in itself? And that visual art, and oral narrative traditions, have a lot more to do with experiences. The intelligence that favours oral transmission is coming to the fore again; it's no longer dismissed as secondary, but seen as something completely equal. The anthropologists are working on this, for instance.

Stock: Are these utopian ideas, or is this a reaction against intolerable pressure?

Müller: I just don't think these categories mean anything. Reason and unreason, rational and irrational: that's Enlightenment thinking. It has nothing to do with present-day reality. It's a false antithesis.

Hoet: What it is, is a relationship of tension between the two.

(…) I was always fascinated by the Eastern Bloc countries. I used to spend at least two months there every year; it was a powerfully melancholic experience, and an important one for me personally. In this physical correlative to melancholy, you learn something about depression.

Müller: The Wall always gave me the feeling that here was where the true situation was, the coagulated true situation of the world, all in this one place. It's clear that no nation can endure a thing like that; but then it was not an idea, it was a reality.

Stock: You once said: 'In the East I can work better.'

Müller: Yes, because of the pressure of experience…

Stock: Is that how it always was: melancholy in the East and happiness in the West?

Müller: What does happiness mean? I think Baudelaire came close to it when he said: 'Boredom is pain extended over time.' That is happiness. Benn said something very good, too: 'Being stupid and having work to do: that is happiness.'

Hoet: I think when you are dealing with problems that have a real cause, it's not just material issues, it's all to do with circumstances. In that situation in the Eastern countries, you could still find impulses that people could pick up on and find some kind of a way out. This is incredible, and it's a motive – and that's where art begins. I think art begins where this takes on a substantial form.

Stock: Is the East something substantial?

Hoet: No, but the experiences that people have there are.

Müller: Yes, there are more experiences.

Hoet: The problem is also, of course, that the pressure was sometimes just too great for people to find a way out. We can't escape; but there is always some kind of possibility of escape that we fail to see; it lies in art, and that is the problem.

Müller: Yes, everything in art was in a cage.

Hoet: In a cage. Everything was in a cage, morbid and sluggish.

Stock: Why did people call it 'realism'?

Müller: Because, subjectively speaking, the cage was reality.

Stock: Kassel was near the inner-German border, and it was no accident that documenta was set up there. As a place, does it seem to you a haphazard choice, or a necessary one?

Hoet: A necessary place, which I always felt to be a dead-end. And art always is in a dead-end. When you are in a dead-end, you have to come to terms with your freedom, and there are some people who can't do that.

Stock: That's from a Western point of view…

Müller: Here everything was in a constant state of anticipation. It was like being in a waiting-room. There would be an announcement: 'The train will arrive at 1815

and depart at 1820' – and it never did arrive at 1815. Then came the next announcement: 'The train will arrive at 2010.' And so on. You went on sitting there in the waiting-room, thinking, 'It's bound to come at 2105.' That was the situation. Basically, a state of Messianic anticipation. There are constant announcements of the Messiah's impending arrival, and you know perfectly well that he won't be coming. And yet, somehow, it's good to hear him announced all over again.

Hoet: Where did people get the strength to hold out for so long, to go on believing that the Messiah would fulfil their expectations? Are there reasons for this?

Müller: This is something truly remarkable, I think. This whole waiting-room mentality, the whole situation, gives you a lot more contact with the earth on which the waiting-room is built, because there is no acceleration. Acceleration can prevent or destroy experiences. When you are rooted to one spot, you experience that place; you learn all about the strata, both geological and historical. Travelling destroys experiences, and waiting to travel actually accumulates them. And, of course, there's a banality in travel – it's a kind of death – and in that sense waiting is an accrual of substance.

But what always interests me is why East German visual art is so lamentable, on the whole. It's a pity, but I'm afraid that's the way it is.

Hoet: Is there any field of the arts to which that doesn't apply?

Müller: It doesn't apply to literature. In art there really isn't much at all. The greatest artist here is Tübke. I don't like him, particularly – it's all dreadfully mannered – but that's the highest level that was achieved.

Hoet: What he does springs from an idea. Somewhere, there is a comprehensible idea that can serve to supply a method. There came a moment when a whole generation in East Germany said 'Yes' to the Academy, 'Yes' to Socialist Realism, but we must go back to the sources. For the first generation of artists who worked in that way, the primary source was Cézanne. Beautiful 'construction', constructing a beautiful abstract painting in a Cézannian way, inspired by Cézanne. Then the second generation – Tübke – said let's go further back in history, back to the Middle Ages. That was a method, but there was no real inner necessity in it at all.

Müller: Notice that this wasn't a decision, a resolve: it was a relapse. And the result of that is Mannerism, but a Mannerism that has nothing to do with the Italian kind. The figures stem from the Middle Ages; they all have a kink in them, they're broken figures.

Hoet: There's a sociological explanation for all this. You can explain a work of art in sociological, political terms; you can explain it in terms of its time, you can expound its iconography, you can describe its theme and its structure. But you can't discriminate, where beauty is concerned, because that can't be explained. In David's *Marat,* for example, you can explain the picture politically, you can talk about Robespierre, Marat, anything you like; but can't say *why* David is a great artist. Curious, really; but that's what counts. All the issues related to the time can be explained.

Müller: But not chance. That's what makes the picture.

Hoet: There is more to beauty than aesthetics.

Müller: Because beauty comes from the body.

Stock: And what made that so difficult here?

Müller: It was hard for visual artists here, because there was no material…

Hoet: Because the relation to the material was too strong.

Müller: The sole material was reality, and there were almost no translations of reality, like those there were in the West, in the developed, capitalist societies. Here there were none of those translations, those stratifications of material: the optical environment was impoverished. And that is important. This impoverishment of the optical environment. To take just one crude example: a newspaper kiosk in the East and a newspaper kiosk in the West. That was it.

Hoet: In the West you don't relate to material in the same way. It's always being distanced from us by slogans and by specific symbols of freedom, so that we are

always somehow alienated from the material.

Müller: There were virtually no sign-systems here.

Stock: But there is also such a thing as an aesthetic of poverty: the 1950s, Beuys's documenta works…

Müller: The difficulty over here was, I think, that this was just one part of Germany, and the poorer part. And for that reason you always had a guilty conscience about being poor, or a sense of inferiority. It began in politics. Perhaps you saw the first time Honecker went to the CSCE conference in Helsinki and met Helmut Schmidt – a little working-class boy facing the arrogance of a German officer. To have an aesthetic of poverty would have taken a lot more courage: for that, you need the self-confidence to say 'We are the better wild men' – and that just wasn't there. Again, it was an identity problem; the rich German and the good German. The Poles didn't have the same problem. There were no West Poles, and there was no West Czechoslovakia, no West Hungary; that was the flaw here.

Hoet: In Kassel there is a potential for articulating this East/West question, in a transitional way: bridging it. Now, it's a bridge; before, it was a dead-end: and that's a good function.

Stock: What do you think the visitors from the East are going to think of the art in Kassel?

Müller: I think you ought to take advantage of the confusion, the shock. For many of them it's going to be a shock, and a confusing one. For many of them, the first question is likely to be: 'Is that supposed to be art?' I remember a very good print-maker here who was a visiting professor at the Gesamthochschule in Kassel. He had set a theme on which all the students were to make a drawing. Then one student came up to him and said he had something already prepared. He took off his leather jacket and threw it on the ground.

'What's that?' said the artist.

The boy answered: 'That's my contribution to the theme. This was my brother's jacket; he was killed in a motorcycle accident two weeks ago.'

I think this is interesting. To the artist, this was a totally different world, a totally different civilization. The boy didn't want to draw any more; it didn't interest him, and to him *that* was the work of art. The collision is an interesting one.

If only you could find a way to turn this to advantage. Most people really are going to say: 'What is that, and what's it for? Is that art?' But they are also looking for information. There's no arrogance in this. Nobody's going to say, 'I can do that.' They're just going to wonder why such a thing is put in an exhibition, and they'll begin to think there must be some different context, one they know nothing about. There ought to be some discussions of that different context.

Hoet: But it's also quite interesting when someone does say, 'I can do that.'

Stock: The interesting thing about the sentence 'I can do that' is the self-identification. If he says 'I don't understand it', then that's the opposite, it's dismissing it.

Müller: And that's just what has to be avoided at all costs, at this moment when East and West in Germany are in collision: the danger of the East Germans relapsing into this 'I don't understand it' attitude. That's dangerous, and it's happening now through economic pressures.

Hoet: This has something to do with a German attitude, I think. A German is often scared to express his emotions impulsively or spontaneously.

In the mid-1970s there was an encyclopaedia in East Germany in which documenta was spoken of as if it were an advertisement for the capitalist world. Just as Socialist Realism flew the flag of the Eastern, Communist principle, documenta flew the flag of the capitalist principle, with Pop Art, and so on.

Stock: I get the impression that the autonomy of art was a problem in East Germany, as a result of the ties between art and politics. To what extent has that now changed?

Müller: I think the art scene here, such as it was – Prenzlauerberg, for instance – was an attempt, not at all a socialist or ideological one, to organize something that

would resemble a Bohemia. An art world, outside the established order, on the fringe. But what came out of it – and this is the problem – was the kind of attitude that said 'It doesn't matter whether this brushstroke is in the right place or not. What counts is making it really wild, against the status quo.'

The problem – and here it doesn't make the slightest difference whether we're talking about writers or visual artists – the problem is the decline of craftsmanship, of a sense of responsibility for what you are making. And that is the reverse side of all this liberation, with the discovery that anyone can make art. It doesn't have to be good art, you can sell anything.

Hoet: A great photographer once said: 'Now that everyone has a camera, the more people take photographs, the sharper the distinction between good and bad photography becomes.'

Müller: That's what we hope for. But there remains the danger, almost the disease, that nothing has to be done well any more; just so long as you have an idea, you can always sell it. The idea problem again.

Hoet: And it's this boom situation in the West that has provoked a reaction from a number of artists. A reaction that has led the artist to cultivate a direct, strong, profound relationship with the object. The danger is that the artist relates so strongly to the object – irrespective of what is produced – that you get what's called an 'overtechnical application'. In which the artist's gesture vanishes completely.

Müller: Yes, it happens in the theatre, too; there's such a thing as an 'overtrained actor'.

Hoet: That's the same thing. But I think that this relationship with the object is now the central issue; it's an important problem, now that our environment has got so much more constricted.

Müller: If I now imagine myself as a painter, or whatever, and stand in front of the canvas, or in the theatre – there I stand with my brush and I know the first stroke has to be put down somewhere, I can't calculate it, it's a matter of instinct. And the problem arises when that instinct becomes unsure.

Hoet: That's when your work becomes academic.

Müller: Yes, then your work becomes academic, or it runs wild. I learned this from Nietzsche's definition of decadence: 'Decadence is unsureness of instinct.' But how are you ever going to give young people sure instincts? How are you ever going to help them to realize that the first brushstroke truly is arbitrary, and that it takes courage. It all boils down to a question of courage; that's art.

Hoet: And risk-taking. I take risks, in the only way you ever can take risks, which is if you are sure. The risk is too great, if you don't know why you are making art.

(Translated from the German by David Britt)

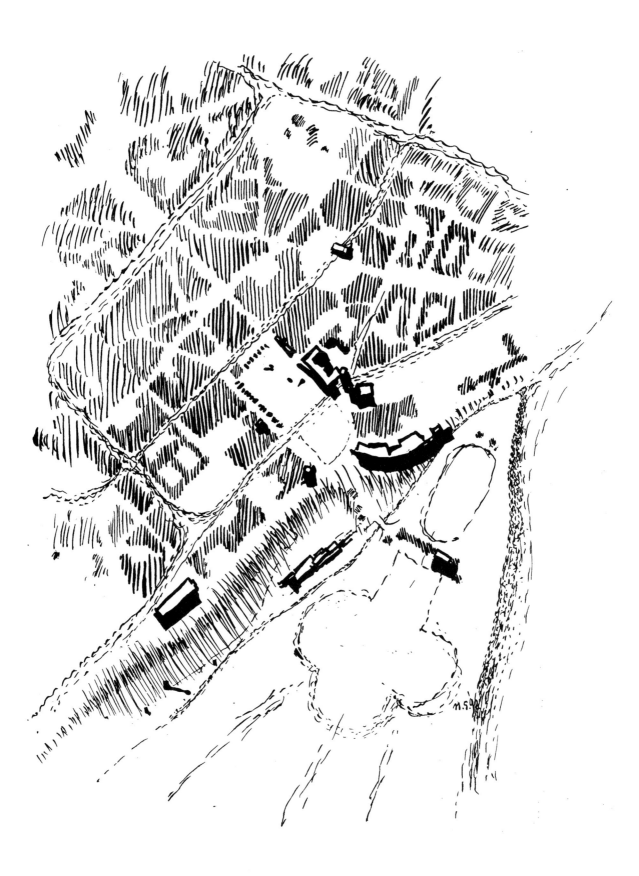

A PLACE OF ART
Brief introduction
to the exhibition's architecture
and the temporary Aue pavilions

Paul Robbrecht and Hilde Daem

Architecture relates to art in the same way that stability does to dynamism. In our minds, there *used* to be no two ways about that.

Working on this documenta has done away with that certainty. Today, at the moment of writing, the buildings have acquired their own three-dimensional shape and are awaiting the works of art that they are to host. Now, more than ever, it has become obvious that architecture too is subject to the internal dynamism of a growing body, a body that never fully matures.

In the beginning, there was the urban framework, the rough material, inside which choices had to be made and new links and traces drawn – for the ninth time. The buildings were approached in their own capacity, from within their own character, and with the meaning that they have always had within the documenta tradition. How could the compulsiveness of the façades reflecting those buildings be broken? How were the makers of documenta to exceed the relationship of documenta's urban landscape and that of the world beyond it? In an attempt to do so, a proposal by Irene Adelmann for erecting temporary structures to the Karlsaue was considered.

We systematically opened every window in every building and let shafts of light flood inside, as if trying to endow those architectonic structures with an unconditional receptivity for art.

Ever-changing light for an art whose expressions are more unpredictable than what is being expressed itself.

Knowing perfectly well that those buildings express nothing but themselves: their indisputable existence and warm materiality; for this is where the dividing line between art and architecture runs.

The Fridericianum with its palace structure, a suite of rooms and halls, re-evoked by means of massive wall chandeliers. Heavy plaster walls.

The Aue pavilions were, so to speak, designed from within the conviction that these buildings are bound to disappear. Which is why they have retained a slightly volatile aspect. Despite their ephemeral appearance, however, they will doubtless carve their own niche among the memories of a beautiful summer. A building that merges into the landscape, into the mists and the world.

Together with our assistant Hugo Vanneste, we worked on this building with the reserve but also the resoluteness of an engineer or steel constructor.

The Aue building is busy forging its own memory.

The Aue buildings are not paradigmatic for the museums; they have sprung from reflections on 'displacement' and represent a three-dimensional continuum that occasionally attaches itself to this place, a valley along the Fulda.

In this sense, the Aue pavilions are an informal and ever-changing plinth, a quickly built stage, knocked together in festive anticipation of what is about to happen, here and now. Walls as light screens.

Odd, too, that this building should host an art, such as painting, that expresses itself retinally.

April 1992

(Translated from the Dutch by Nadine Malfait)

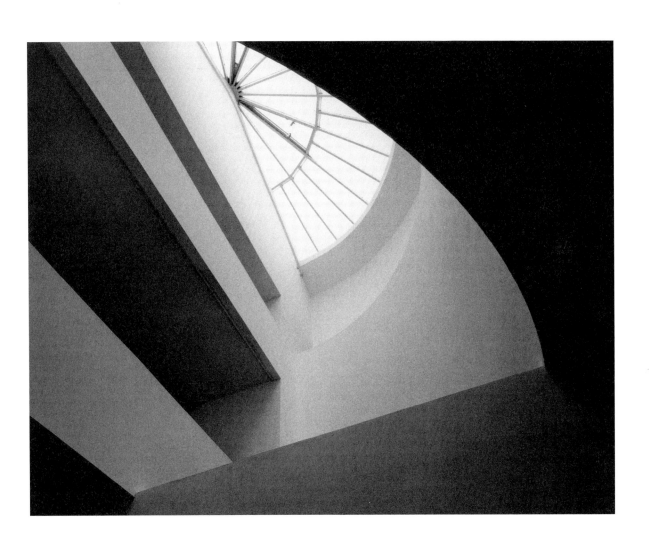

Museum Fridericianum, Kassel

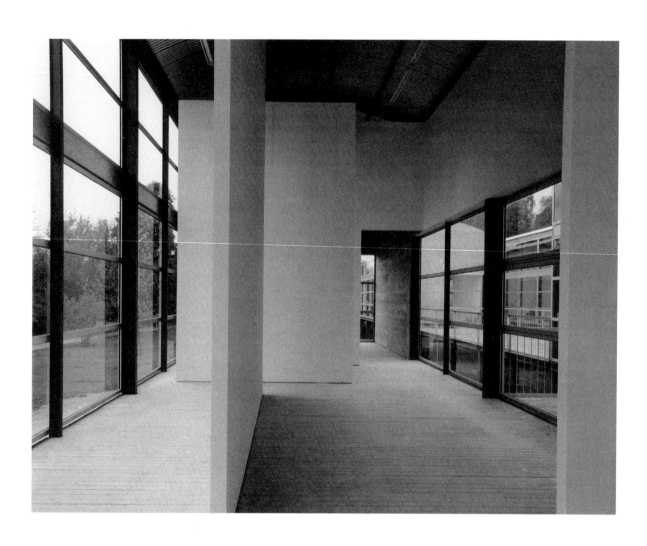

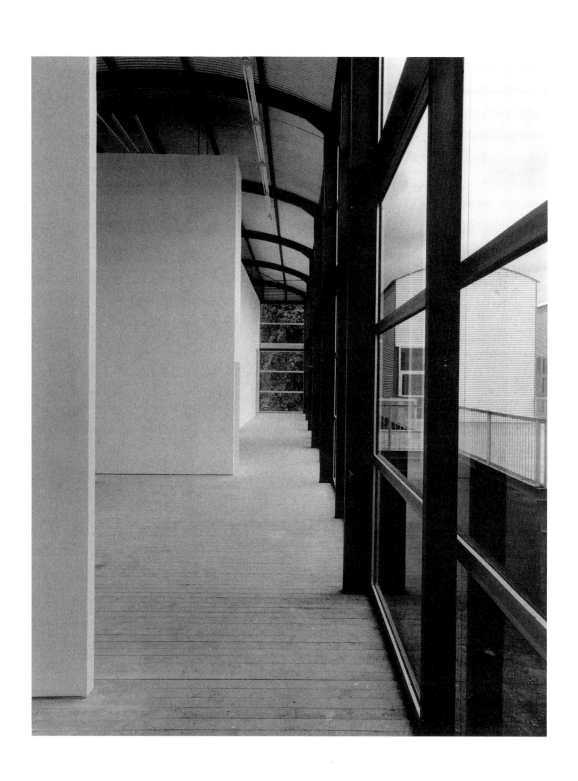

Aue-Pavilions, Kassel

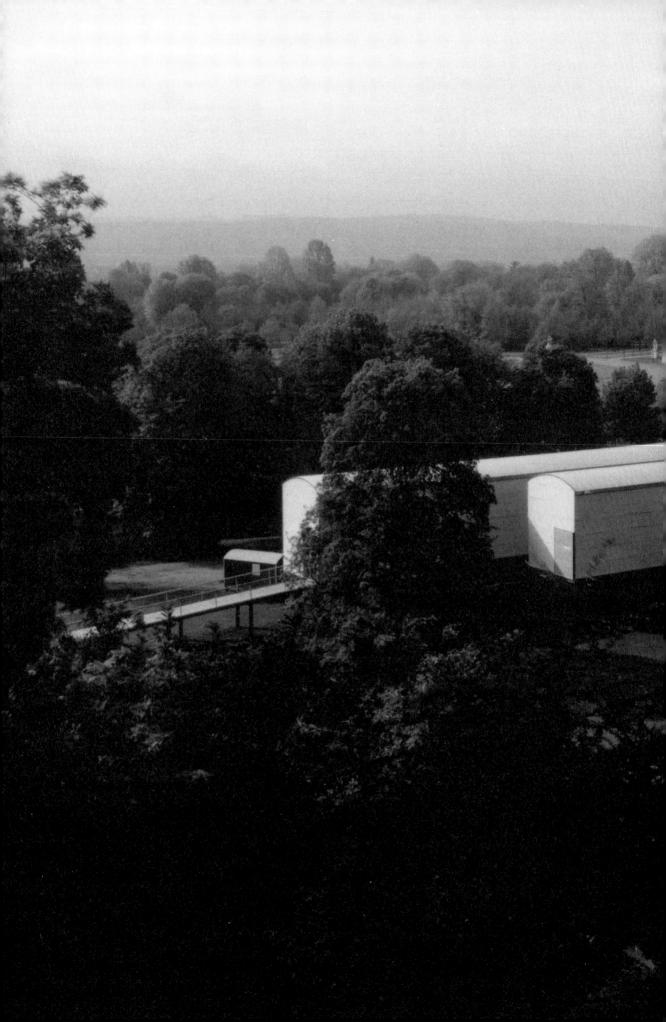

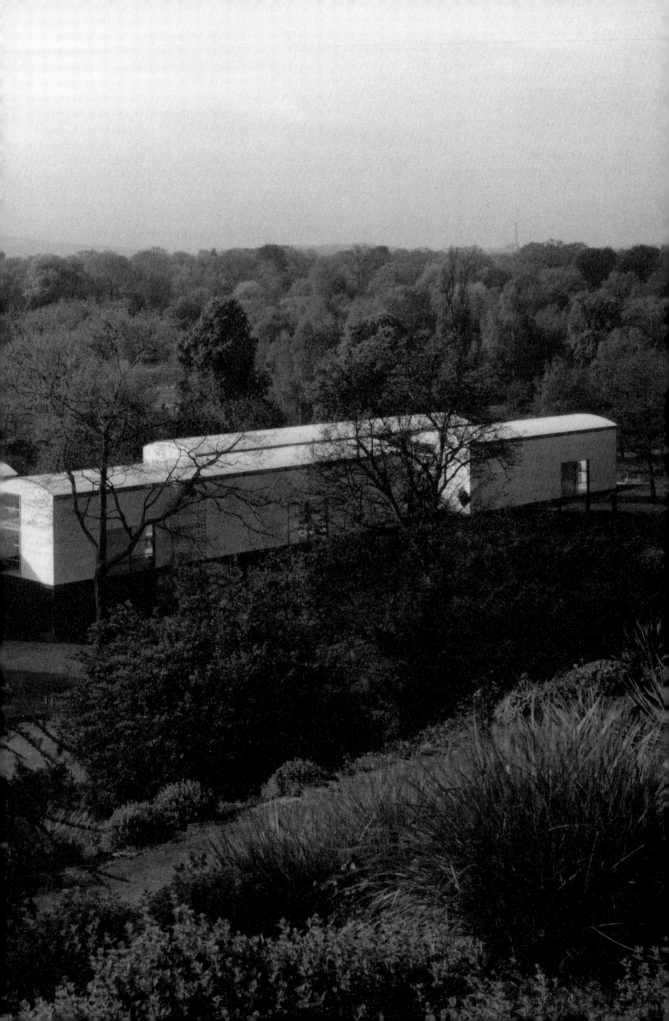

BIO- AND BIBLIOGRAPHIES

The biographic and bibliographic part of the catalogue has been compiled in close collaboration with the artists, and the structure of each entry has been adapted to their individual requirements.

The place of birth of each artist is given first, followed by their country of origin, which is indicated by the usual abbreviations. (For the former Soviet Union we have used the English abbreviation CIS.) This is followed by the year of birth and by the current place of residence and work. Next is a list of all exhibitions devoted to the individual artist, together with the corresponding catalogues and their authors. The section that details each artist's involvement in group exhibitions starts in 1987, the year of the last documenta. Here catalogues are not mentioned. Stage plays, performances and concerts have been included where they constitute an essential part of the artist's work.

The bibliography is arranged in the following order: texts and books by the artists, monographs, periodicals, films, video tapes and other media including radio and television broadcasts. Where catalogues have been listed in previous sections they are not included again in the section 'texts and books by the artist'. Monographs and other books that were published in association with an exhibtion are treated as catalogues. The periodicals are placed in alphabetical order; as with the group exhibitions, a selection was made as from 1987.

Philip Willaert

MARINA ABRAMOVIĆ

*Belgrado (YU), 1946
Lebt/Lives in Amsterdam

Einzelausstellungen | One-man exhibitions

1978 *Installation One*, Ulay/Marina Abramović, Stichting De Appel, Amsterdam · *Installation Two*, Harlekin Art, Wiesbaden · *On the way*, Audio Arts/Riverside Studio, London **1982** *Luther*, Ulay/Marina Abramović, Kabinett für aktuelle Kunst, Bremerhaven **1984** *You see what you feel/I see*, Ulay/Marina Abramović, Time Based Arts Amsterdam · *Modus Vivendi*, Institute of Contemporary Art, Boston **1985** Galerie Tanja Grunert, Köln · *Modus Vivendi: works 1980–1985*, Ulay/Marina Abramović, University Art Museum, Long Beach (Stedelijk Van Abbemuseum, Eindhoven; Kölnischer Kunstverein, Köln; Castello di Rivoli, Torino) (Kat.: T. McEvilley) **1986** *Modus Vivendi: Tuesday/Saturday*, Burnett Miller Gallery, Los Angeles · *Modus Vivendi: Tuesday*, Visual Arts Center, Cambridge, Mass. · *Nightsea Crossing: Complete Works*, Musée Saint-Pierre d'Art Contemporain, Lyon · Curt Markus Gallery, New York · Ulay/Marina Abramović, San Francisco Art Institute, San Francisco **1987** *Der Mond, die Sonne*, Centre d'Art Contemporain, Palais Wilson, Genève · Contemporary Arts Center, Cincinnati · *The Sun and the Moon*, State University, San Diego · *Project*, Michael Klein Inc., Amsterdam · Galerie René Blouin, Montréal · Michael Klein Inc., New York **1988** *China Ring*, Burnett Miller Gallery, Los Angeles · *Anima Mundi*, Galerie Ingrid Dacić, Tübingen **1989** *Boat emptying-Stream entering*, Victoria Miro Gallery, London · *The Lovers*, Stedelijk Museum, Amsterdam (Museum van Hedendaagse Kunst, Antwerpen) (Kat.: M.A., T. McEvilley, U.) **1990** *The Lovers*, Städtische Kunsthalle, Düsseldorf (Kat. cfr. Amsterdam) · *Boat emptying-Stream entering. New Works*, Galerie Ingrid Dacić, Tübingen · *Œuvres récentes*, Galerie Charles Cartwright, Paris · *Marina Abramović, Sur la Voie*, Galeries Contemporaines, Centre Georges Pompidou, Paris (Kat.: M.A., B. Marcadé, J. Martin, P. Parsy) **1991** *Four your eyes only*, De Waag, Leiden · *Departure*, Galerie Enrico Navarra, Paris

Gruppenausstellungen | Group exhibitions

1989 *Wanderers*, Galerie Charles Cartwright, Paris · *Les magiciens de la terre*, Centre Georges Pompidou, Paris · *And they see God*, Pat Hearn Gallery, New York · **1990** *The Shadow of Presence*, Galerie Charles Cartwright, Paris · *De verzameling II*, Museum van Hedendaagse Kunst, Antwerpen · *Noli Me Tangere*, Kunstmuseum, Sion · *Nature In Art*, Kunstmuseum, Wien **1991** *Das goldene Zeitalter*, Württembergischer Kunstverein, Stuttgart · Ludwig Forum für Internationale Kunst, Aachen · *Fuente*, Nieuwe Werk, Amsterdam

Performances

1976 *Relation in space*, Biennale di Venezia · *Talking about Similarity*, Singel 64, Amsterdam **1977** *Interruption in space*, Staatliche Kunstakademie, Düsseldorf · *Breathing in/Breathing out*, Studenski Kulturni Centar, Belgrado (Stedelijk Museum, Amsterdam) · *Imponderabilia*, Galleria Comunale d'Arte Moderna, Bologna · *Expansion in Space*, documenta 6, Kassel · *Relation en mouvement*, 10e Biennale de Paris, Musée d'Art Moderne de la Ville, Paris · *Relation in Time*, Studio G7, Bologna · *Light/Dark*, Internationale Kunstmesse, Köln · *Balance proof*, Musée d'Art et d'Histoire, Genève **1978** *AAA-AAA*, RTB, Liège · *Incision*, Galerie H. Humanic, Graz · *Kaiserschnitt*, Performance Festival, Wiener Reitinstitut, Wien · *Charged Space*, European Series One, Brooklyn Museum, New York · *Relation/Work*, Extract Two, Theater aan de Rijn, Arnhem (Palazzo dei Diamanti, Ferrara; Badischer Kunstverein, Karlsruhe; Harlekin Art, Wiesbaden) **1979** *The Brink*, Biennale of Sydney, Art Gallery of New South Wales, Sydney · *Go-Stop-Back.../ 1.2.3. ...*, National Gallery of Victoria, Melbourne · *Communist Body – Capitalist Body*, Zoutkeetgracht 116, Amsterdam **1980** *Rest Energy*, ROSC, Dublin **1981** *Gold found by the Artist*, Nightsea Crossing, Art Gallery of New South Wales, Sydney · *No Tango*, Sculpture Triennale, Melbourne · *Witnessing*, ANZART, The Artcenter, Christchurch (New Zeeland) · *6WF.*, The Art Gallery of Western Australia, Perth **1982** *Nightsea Crossing*, Skulpturenmuseum, Marl (Kunstakademie Düsseldorf; Künstlerhaus Bethanien, Berlin; Kölnischer Kunstverein/Moltkerei, Köln, et.al.) **1983** *Nightsea Crossing*, Museum Fodor, Amsterdam (Museum of the Ateneum, Helsinki) · *Positive Zero*, Holland Festival, Theater Carré, Amsterdam (Muziekcentrum Vredenburg, Utrecht; De Doelen, Rotterdam) · *Modus Vivendi*, Progetto Genazzano/Zattera di Babele, Genazzano **1984** *Positive Zero*, Stadsschouwburg, Eindhoven · *Nightsea Crossing*, Museum van Hedendaagse Kunst, Gent (Galerie/Edition Media, Furkapass, Furka; Städtisches Kunstmuseum, Bonn; Forum, Middelburg) **1985** *Modus Vivendi*, Kunstmuseum /Stadtheater, Bern (Saskia Theater, Arnhem) · *Nightsea Crossing*, Fundaçao Calouste Gulbenkian, Lisboa (First International Biennale, Ushimado) · *Fragillisimo* (mit M. Laub und M. Mondo), Stedelijk Museum, Amsterdam **1986** *Nightsea Crossing*, New Museum, New York (Musée Saint-Pierre d'Art Contemporain, Lyon) · *Risk in Age*, University of Baltimore, Baltimore (The House, Santa Monica)

Biliographie | Bibliography

Texte und Bücher von der Künstlerin
Texts and books by the artist
Ulay, in: O+- revue d'art contemporain, Nr. 18, 1977 · *Three performances*, Innsbruck, Galerie Krinzinger/Graz, Galerie H-Humanic, 1978 (Text: Heidi Grundman/Ulay & Marina Abramović) · *30 November/30 November, Wiebaden*, in: Kat. Harlekin Art, 1979 · *Two Performances and Detour*, Adelaide, South Australia, The Experimental Art Foundation, 1979 · *Nightsea Crossing*, in: Kat. Museum Fodor, 1983 · *Dreamtime, 1980–1981*, in: AEIUO, Bd. 5, Nr. 10/11, 1984 · *La terre est petite et bleue, je n'y suis qu'une mince crevasse*, in: Art Press, Nr. 79, 1984 · *Ulay, Marina Abramović, M. Laub and Mr. Mondo*, in: Kat. Wat Amsterdam betreft...*, Stedelijk Museum, Amsterdam, 1985 · *The Lovers*, in: Artforum, Bd. 25, 1986

Bücher | Books
Marina Abramović/Ulay Ulay/Marina Abramović Relation Work and Detour, Amsterdam, Idea Books, 1980

Periodika | Periodicals
Michel **Baudson**, *La longue marche de Ulay & Abramović*, in: Artefactum, Bd. 5, Nr. 26, 1989 · Cindy **Carr**, *Monumental Road Show*, in: Village Voice, 18. April, 1988 · Demosthenes **Davretas**, *Marina Abramović*, in: Artefactum, Nr. 42, Februar/März 1992 · Leo **Delfgaauw**, *Les investigations de Marina Abramović et Ulay*, in: Art Press, Nr. 134, 1989 · Stella **de Vries**, *Het bedwingen van de Draak/Taming the Dragon*, in: Ruimte, Bd. 6, Nr.1, 1989 · F.B. **Goy**, *Marina Abramović*, in: Journal of Contemporary Art, Nr.2, Herbst/Winter 1990 · Chrissie **Iles**, *Taking a Line for a Walk*, in: Performance Magazine, Nr. 53, April/März, 1988 · Jim **Lamoree**, *De Cultuur*, in: Haagse Post, 25. April, 1987 · Gerhard Johann **Lischka**, *Performance und performance art*, in: Kunstforum, Bd. 96, 1987 · Friedemann **Malsch**, *Kämpfer und Liebende*, in: Kunstforum, März/April, 1990 · s.n., *Gerrit Henry, Marina Abramović and Ulay at Michael Klein*, in: Art in America, Nr. 10, Oktober, 1987

Film

1976 *Relation in Space*, RAI, Roma, Alfredo di Lauri, 16 mm, Farbe/Ton, 45 Min., Venezia **1977** *Imponderabilia*, Diffusion Arte Cinomatografia, Roma, Lisa Carbone, 16 mm, Farbe/Ton, 45 Min. · *Relation in Movement*, Marina Abramović & Ulay, Hartmut Kowalke, 16 mm, Farbe/Ton, 16 Stunden, Paris · *Breathing out/Breathing in*, Ulay & Marina Abramović, Maarten Rens & Louis B. van Gasteren, 16 mm, Farbe/Ton, 22 Min., Amsterdam **1978** *Light/Dark*, Marina Abramović & Ulay , Maarten Rens und Louis B. van Gasteren, 16 mm, Farbe/Ton, 15 Min. · *AAA-AAA*, Ulay & Marina Abramović, Maarten Rens und Louis B. van Gasteren, 16 mm, Farbe/Ton, 24 Min., Amsterdam · *Incision*, Galerie H-Humanic, Cinedoc, Graz, 16 mm, Farbe/Ton, 30 Min., Graz · *Three*, Harlekin Art, Gabor Bagyoni, 16 mm, Farbe/Ton, 12 Min., Wiesbaden **1979** *Communist Body – Capitalist Body*, Marina Abramović & Ulay, Tomislav Gotovac, 16 mm, Farbe/Ton, 44 Min., Amsterdam **1980** *That Self*, Ulay & Marina Abramović, filmed by: Ruud Monster, Ton Ali Wiering, 16 mm, Farbe/Ton, 40 Min., Amsterdam **1988/89** *The Lovers . The great Wall Walk.* 16 mm, Farbe, ca. 50 Min., Murray Grigor, Photos: Douglas Campbell, The Amphis Foundation, Amsterdam

Video

1976 *Relation in Space*, s/w, Ton, 60 Min., Sony U-matic, Galleria dell Cavalino, Venezia · *Talking about Similarity*, s/w, Ton, 40 Min., Sony U-matic, Ulay & Marina Abramović, Amsterdam 1977 *Interruption in Space*, s/w, Ton, 45 Min., Sony U-matic, Kunstakademie Düsseldorf, Klaus Rinke & Ursula Wevers, Düsseldorf · *Imponderabilia*, s/w, Ton, 60 Min., Sony u-matic, Galleria Comunale d'Arte Moderna, Bologna · *Expansion in Space*, Farbe/Ton, 32 Min., Sony U-matic, Marina Abramović & Ulay, Kassel · *Relation in Time*, s/w, 2 Bänder 60 Min., Sony U-matic, Studio G7, Bologna · *Light/Dark*, Farbe/Ton, 22 Min., Sony U-matic, PAP, München · *Breathing in/Breathing out*, s/w, Ton, 22 Min., Sony U-matic, Video heads, Jack More, Belgrado · *Balance Proof*, s/w, Sony U-matic, Galerie Marika Malacorda, Musée d'Art et d'Histoire, Genève 1978 *AAA-AAA*, Farbe/Ton, 16 Min., Sony U-matic, RTB, Liège · *Incision*, Farbe/Ton 40 Min., Sony U-matic, Galerie H-Humanic, Horst Gerhard Haberl, Graz · *Kaiserschnitt*, Farbe/Ton, 35 Min., Sony U-matic, Galerie Krinzinger, Horst Gerhard Haberl, Modern Art Gallery, Wien · *Charged Space*, Farbe/Ton, 24 Min., Sony U-matic, Brooklyn Museum, New York · *Relation/Work*, s/w, Ton, 60 Min., Sony U-matic, Jan Brand & International Cultureel, Centrum, Antwerpen · *Relation/Work*, s/w, Ton, 90 Min., Sony U-matic, Palazzo del Diamanti, Ferrara · *Relation/Work*, s/w, Ton, 45 Min., Sony U-matic, Zika Dacić, Tübingen 1982 *Crazed Elephant*, U-matic, Farbe/Ton, 12 Min., Ulay & Marina Abramović, Amsterdam 1983 *City of Angels*, BVU Farbe/Ton, Ulay & Marina Abramović, Amsterdam · *Anima Mundi*, BVU Farbe/Ton, 8 Min., Continental Video, Antwerpen · *Positive Zero*, BVU Farbe/Ton, 22 Min., Continental Video, Antwerpen 1984 *The World is my Country*, BVU Farbe/Ton, 4 Min., Continental Video, Antwerpen · *Terra degli Dei Madre*, BVU Farbe/Ton, Continental Video, Antwerpen 1985 *Modus Vivendi*, BVU, Farbe/Ton, 25 Min., Continental Video, Antwerpen 1987 *Terminal Garden*, Farbe/Ton, Cambridge, Boston 1988 *Performance Anthology* (17 performances 1976–1980), Farbe/Ton, 180 mm, Amsterdam

ABSALON

** 1964*
Lebt/Lives in Paris

Einzelausstellungen | One-man exhibitions

1990 Propositions d'habitat (échelle 1:1), Galerie Aika, Jerusalem · *Cellules*, Galerie Crousel-Robelin, Paris 1991 Atelier Kasematte 7, Hamburg

Gruppenausstellungen | Group exhibitions

1987 Villa Alésia, Paris 1988 *Octobre des Arts*, Lyon · Atelier du Parvis de Beaubourg, Paris 1989 *Sous le soleil exactement*, Villa Arson, Nice · *Carte blanche à Jean de Loisy*, Credac. Ivry-sur-Seine 1990 Musée Sainte-Croix, Poitiers · *André Magnin-Choix*, Sète · *Le Cinq*, Tramway, Glasgow · *Septièmes ateliers internationaux des*

Pays de la Loire, Frac Pays de la Loire, Clisson · Galerie Anne de Villepoix, Paris · Galerie Etienne Ficheroulle, Bruxelles 1991 *Absalon, Huang Yong Ping, Didier Marcel, J.J. Rullier*, Galerie Froment & Putman, Paris · *Collection du Cap, Bordeaux · Mouvement 2*, Centre Georges Pompidou, Paris

Bibliographie | Bibliography

Periodika | Periodicals
Claire **Bernstein**, *Pas à côté, pas n'importe ou*, in: Art Press, Nr. 140, Oktober, 1989 · Jean-Pierre **Bordaz**, *Mouvement 2*, in: CNAC Magazine, Nr. 65, 15. Mai, 1991 · Brigitte **Cornand**, *Sculpture mystique ou eurodesign*, in: Actuel, März, 1991 · Virginie **Luc**, *Le cheval d'Arson*, in: Beaux-Arts Magazine, Nr. 71, September, 1989 · André **Magnin**, *Absalon, l'inversion d'un monde*, in: Art Press, Nr. 151, Oktober, 1990 · Mona **Thomas**, *Absalon*, in: Beaux-Arts Magazine, Nr. 93, September, 1991 · · Thomas **Wulffen**, *Absalon-Compartiments*, in: Kunstforum International, Bd. 166, November/Dezember, 1991 · Olivier **Zahm**, *Absalon, Andrieu, Sanchez*, in: Art Press, Nr. 144, Februar

Film
1991 *Proposition d'habitation*, 3:30 Min

RICHARD ARTSCHWAGER

**Washington (USA), 1923*
Lebt/Lives in Brooklyn

Einzelausstellungen | One-man exhibitions

1965 Leo Castelli Gallery, New York 1967 Leo Castelli Gallery, New York 1968 Galerie Konrad Fischer, Düsseldorf 1969 Galerie Rolf Ricke, Köln 1970 Eugenia Butler Gallery, Los Angeles · Galerie Onnasch, Berlin · Lo Giudice Gallery, Chicago 1972 Leo Castelli Gallery, New York · Galerie Rolf Ricke, Köln 1973 *Paintings*, Dunkelman Gallery, Toronto · *Richard Artschwager/Alan Shields*, Museum of Contemporary Art, Chicago (Kat.: C. Kord, R. A.) · *Recent Paintings*, Leo Castelli, New York 1974 *Recent Paintings*, Daniel Weinberg Gallery, San Francisco · Galerie Ileana Sonnabend, Genève 1975 *Door, Window, Table, Basket, Mirror, Rug*, Leo Castelli Gallery, New York · Jared Sable

Gallery, Toronto · Galerie Neuendorf, Hamburg · *Drawings*, Daniel Weinberg Gallery, San Francisco 1976 *Ten Years of the Black Spot*, Walter Kelly Gallery, Chicago · Castelli Graphics, New York 1977 Sable-Castelli Gallery, Toronto 1978 *Drawings*, Castelli Graphics · Texas Gallery, Houston · The Clocktower, Institute for Art and Urban Resources, New York · *Paintings and Drawings*, Morgan Gallery, Shawnee Mission, Kansas · *Zu Gast in Hamburg – Richard Artschwager*, Kunstverein, Hamburg, (Neue Galerie – Sammlung Ludwig, Aachen) (Kat.: C. Kord) 1979 *Richard Artschwager's Theme(s)*, Albright-Knox Art Gallery, Buffalo (Institute of Contemporary Art of the University of Pennsylvania, Philadelphia; La Jolla Museum of Contemporary Art, California; Contemporary Arts Museum, Houston) (Kat.: R. Armstrong, L. L. Cathcart, S. Delehanty) · *A Survey of Sculpture and Paintings from the 60s and 70s*, Leo Castelli Gallery, New York · Asher/Faure Gallery, Los Angeles 1980 *Sculpture by Richard Artschwager*, Museum of Art, Rhode Island School of Design, Providence · Daniel Weinberg Gallery, San Francisco 1981 *Paintings and Objects from 1962–1979*, Young/Hoffman Gallery, Chicago · Leo Castelli Gallery, New York 1982 *New Work*, Suzanne Hilberry Gallery, Birmingham, Michigan 1983 Mary Boone Gallery, New York · Daniel Weinberg Gallery, Los Angelos 1984 *Richard Artschwager/Matrix 82*, Matrix Gallery, University Art Museum, University of California, Berkeley (Brochure: C. Lewallen) 1985 Leo Castelli Gallery, New York · Kunsthalle, Basel (Stedelijk Van Abbemuseum, Eindhoven; Musée d'Art Contemporain, Bordeaux) (Kat.: J.-C. Ammann) · Daniel Weinberg Gallery, Los Angeles 1986 Mary Boone Gallery/Michael Werner Gallery, New York · Daniel Weinberg Gallery, Los Angeles 1987 Van Buren, Brazelton, Cutting Gallery, Cambridge · Galerie Thaddaeus Ropac, Salzburg 1988 *Drawings*, Leo Castelli Gallery, New York · Whitney Museum of American Art, New York (Museum of Modern Art, San Francisco; Museum of Contemporary Art, Los Angeles); (Kat.: R.A., R. Armstrong, R. Crone) · *His Peers and Persuasions, 1963–1988*, Daniel Weinberg Gallery, Los Angeles (Leo Castelli, New York) (Kat.: K. Kertess) 1989 Palacio de Velazquez, Madrid · Centre Georges Pompidou, Paris (Kat.: R. Amstrong) · Städtische Kunsthalle, Düsseldorf (Kat.: cfr. New York) · Leo Castelli Gallery, New York · Akira Ikeda Gallery,

Tokyo · Daniel Weinberg Gallery, Santa Monica · Galerie Metropol, Wien **1990** Galerie Ghislaine Hussenot, Paris · *R.A.: The Fourth Possibility,* Phyllis Rothman Gallery, Fairleigh Dickinson University, Madison · Donald Young Gallery, Chicago · *Destruction Paintings,* Mary Boone Gallery, New York · Galerie Metropol, Wien · Galerie Neuendorf, Frankfurt/M. (Kat.: C. Kord) · Daniel Weinberg Gallery, Santa Monica · Suzanne Hilberry Gallery, Birmingham **1991** Brooke Alexander Editions, New York · Leo Castelli Gallery, New York · Rhona Hoffman Gallery, Chicago · Elvehjem Museum of Art, University of Winconsin, Madison

Gruppenausstellungen | Group exhibitions

1987 *Drawings from the Collection of Dorothy and Herbert Vogel,* Moody Gallery of Art, University of Altoma, Houston (et al.) · *Group Show: Ti Shan Hsu, John Armleder and R.A.,* Pat Hearn Gallery, New York · *Monsters: The Phenomena of Dispassion,* Barbara Toll Fine Arts, New York · *The Great Drawing Show 1587–1987,* Michael Kohn Gallery, Los Angeles · *Biennial Exhibition,* Whitney Museum of American Art, New York · Douglas S. Cramer Foundation Gallery, Los Olivos · Donald Young Gallery, Chicago · *Artschwager, Nauman, Stella,* Leo Castelli Gallery, New York · *An Exhibition to Benefit the Armitage Ballet,* Mary Boone Gallery, New York · *A Sculpture Show,* Marian Goodman Gallery, New York · *Black and White,* Nicola Jacobs Gallery, London · documenta 8, Kassel · *Skulptur Projekte Münster,* Westfälisches Landesmuseum, Münster · *Documentarists 1987,* Land & O'Hara Gallery, New York · *Made in U.S.A.: An Americanization in Modern Art, the '50s and '60s,* University Art Museum, Berkeley (et al.) · *Dessins,* Galerie C. Issert, Paris · *Sculpture of the Sixties,* Margo Leavin Gallery, Los Angeles · *Similia/Dissimilia,* Columbia University, New York(et al.) · *A Selection of Works by the Gallery Artists Then and Now,* Flanders Contemporary Art, Minneapolis · *Hommage to Leo Castelli: Dedicated to the Memory of Toiny Castelli,* Galerie Daniel Templon, Paris · *Woodwork,* Martina Hamilton, New York · *Richard Artschwager, John Baldessari, Lothar Baumgarten, Rebecca Horn, Claes Oldenburg,* Galerie Gabrielle Maubrie, Paris · *Consonance,* ISD Incorporated, New York · *Facture,* Laurie Rubin Gallery, New York **1988** *Group Show,* Marian Goodman Gallery, New York · *Cultural Geometry,* Deste Foundation, Athinai · *Anniversary Show,* Susanne Hilberry Gallery, Birmingham · *Artschwager/Shapiro/Byars,* Kent Fine Art, New York · *Prints and Multiples,* Galerie Charles Cartwright, Paris · *Vitra Edition 1987,* Musée Rath, Genève · *Redefining the Object,* University Art Galleries, Wright State University, Dayton (Center for Contemporary Art at the Galleria, Cleveland) · *60's/80's: Sculpture Parallels,* Sidney Janis Gallery, New York · *Locations,* Tiroler Landesgalerie, Taxispalais, Innsbruck · *Richard Artschwager: His Peers and Persuasion 1963–1988,* Leo Castelli Gallery, New York · *The Multiple Object: European and American Sculptur Works made in Editions,* Bank of Boston Gallery, Boston · *Signaturen,* Museum van Hedendaagse Kunst, Gent · *Altered States,* Kent Fine Art, New York · *Flavin/Judd/Artschwager,* Galerie Tanit, München ·

Sculpture, Donald Young Gallery, Chicago · *Castelli Graphics 1969–1988,* Castelli Graphics, New York · *In Memory of Toiny Castelli,* James Mayor Gallery, London · *A Sculpture Show: A Changing Exhibition,* Marian Goodman Gallery, New York · *Artschwager/Fischl/Polke/Warhol,* PS Gallery, Tokyo · *Rendez-vous Manqués,* Galerie Gabrielle Maubrie, Paris · *Merce Cunningham Dance Company Benefit Exhibition and Art Sale,* Blum Hellman Gallery, New York · *Installation Series,* Brooke Alexander Gallery, New York · *Leo Castelli: A Tribute Exhibition,* Butler Institute of American Art, Youngstown · *Objects,* Lorence Monk Gallery, New York · *Coleccion Leo Castelli,* Fundación Juan March, Madrid · *Twenty Four Cubes,* University Gallery, Fine Arts Center, University of Massachusetts, Amherst · *The 25th Anniversary Exhibition to Benefit the Foundation for Contemporary Performance Arts, Inc.,* Leo Castelli Gallery and Brooke Alexander Gallery, New York · *Recent Acquisitions,* University Art Galleries, Wright State University, Dayton · *Information as Ornament,* Feature Gallery, Rezac Gallery, Chicago · *SMS (The Portable Museum of Original Multiples in Six Portfolios),* Reinhold-Brown Gallery, New York · *Carnegie International,* Carnegie Museum of Art, Pittsburgh **1989** *Objects of Thought,* Anders Tornberg Gallery, Lund · *R.A., John Baldessari, Jonathan Borofsky, Robert Gober, Peter Halley, Nancy Shaver,* Paula Cooper Gallery, New York · *Around the House,* Edward Thorp Gallery, New York · *Golden Opportunity: Exhibit to Benefit the Resettlement of Refugees in El Salvador,* Leo Castelli Gallery, New York · *Suburban Home Life: Tracking the American Dream,* Whitney Museum of American Art, Downtown at Federal Reserve Plaza, New York · *Abstraction in Question,* Center for the Fine Arts, Miami · *A Sculpture Show,* Marian Goodman Gallery, New York · *The Desire of the Museum,* Whitney Museum of American Art, New York · *Fairfield County, Stamford · Inside World,* Kent Fine Art, New York · *Artists' Furniture,* Harcus Gallery, Boston · *'Sitting Stance' by Richard Artschwager and 'Retor Gate' by R.M. Fischer,* The Esplanade at Rector Park, Battery Park City, New York · *A Good Read: The Book as Metaphor,* Barbara Toll Fine Arts, New York · *A Decade of American Drawing: 1980–1989,* Daniel Weinberg Gallery, Los Angeles · *From the Collection of Dorothy and Herbert Vogel,* Art Museum at Florida International University, Miami · *Leo Castelli Post Pop Artists,* Nadia Bassanes Studio d'Arte, Trieste · *Filling the Gap,* Richard Feigen Gallery, Chicago · *Bilderstreit,* Museum Ludwig, Köln · *Prospect 89,* Frankfurter Kunstverein, Frankfurt/M. **1990** *The Sixties Revisited: New Concepts – New Materials,* Leo Castelli Gallery, New York · *Selected Works from the Avant-garde,* Kent Fine Art, New York · *Two Decades of American Art: The 60s and 70s,* Nassau County Museum of Art, Roslyn · *House Prints,* Pence Gallery, Santa Monica · *The Kitchen Art Benefit,* Leo Castelli Gallery, New York · *Multiples,* Hirschl & Adler Modern, New York · *Newer Sculpture,* Charles Cowles Gallery, New York · *Sculpture,* Daniel Weinberg Gallery, Santa Monica · *A Group Show,* Marian Goodman Gallery, New York · *Group Show,* Kent Fine Art, New York · *The Practice of the Connoisseurship*

of Art, Galerie Eric Franck, Genève · *Children's AIDS Project,* Daniel Weinberg Gallery, Santa Monica · *With the Grain: Contemporary Panel Painting,* Whitney Museum of American Art at Philip Morris, New York · *Art What Thou Eat,* Edith C. Blum Art Institute, Avery Center for the Arts, Bard College, Annandale-on-Hudson, New York · *Life-Size: A Sens of the Real in Recent Art,* The Israel Museum, Jerusalem · *Semi-Objects,* John Good Gallery, New York · *Home,* Asher/Faure Gallery, Los Angeles · *The Times, the Chronicle, and the Observer,* Kent Fine Art, New York · *Life-Size,* The Israel Museum, Jerusalem **1991** *Group Show: Richard Artschwager, Richard Wilson, Cindy Sherman,* The Saatchi Collection, London · *Not on Canvas,* Asher/Faure Gallery, Los Angeles · *The Picture After the Last Picture,* Galerie Metropol, Wien · *Metropolis,* Martin-Gropius-Bau, Berlin · *To Wit: Timely Objects with Ironic Tendencies,* Rosa Esman Gallery, New York · *Franklin Furnace's 15th Anniversary Art Sale,* Marian Goodman Gallery, New York · *Expressive Drawings: European and American Art Through the 20th Century,* New York Academy of Art, New York · *Persona,* Kent Fine Art, New York · *Fond Farewell,* Nicola Jacobs Gallery, London · Galeria Weber, Alexander y Cobo, Madrid · *The Chair: From Artifact to Object,* Weatherspoon Art Gallery, Greensboro · *Objects for the ideal Home,* Serpentine Gallery, London · *Power: Its Myths and Mores in American Art, 1961–1991,* Indianapolis Museum of Art, Indianapolis (et al.) · *Pop Art,* Royal Academy of Arts, London (et al.) · Ludwig Forum für Internationale Kunst, Aachen **1992** RubinSpangle Gallery, New York · *John M. Armleder, Richard Artschwager,* Ashley Bickerton, Jan Vercruysse, Kunsternes Hus, Oslo

Texte vom Künstler | Texts by the artist
Art and reason, in: Parkett, Nr. 23, März, 1990

Periodika | Periodicals
Jack **Bankowsky**, *Richard Artschwager,* in: Flash Art, März/April, 1988 · Bernard **Blistène**, *Richard Artschwager, discours sur la méthode ou l'art de redistribuer Descartes,* in: Galeries Magazine, Februar/März, 1988 · Dan **Cameron**, *Art and Its Double,* in: Flash Art, Mai, 1987 · Bice **Curiger**, *Collaboration: Richard Artschwager,* in: Parkett, Nr. 23, März, 1990 · Peggy **Cyphers**, *Richard Artschwager,* in: Arts Magazine, September, 1990 · Arthur C. **Danto**, *On Artschwager on Art,* in: Parkett, Nr. 23, März, 1990 · Joshua **Decter**, *Richard Artschwager,* in: Flash Art, Mai, 1989 · Joshua **Decter**, *Richard Artschwager,* in: Arts Magazine, Juni, 1991 · Phillip **Evans-Clark**, *R. A.: Una mostra del Whitney Museum,* in: Domus, Mai, 1988 · Colin **Gardner**, *Artschwager: His Peers and Persuasions, 1963–1988,* in: Artforum, September 1988 · Eric **Gibson**, *Artschwager,* in: Sculpture, Mai/April, 1988 · Britta **Hueck-Ehmer**, *Skulptur/Projekte/Münster 1987,* in: Das Kunstwerk, September, 1987 · Ronald **Jones**, *Arroganz und Interpretation,* in: Wolkenkratzer, September, 1988 · Claire Wolf **Krantz**, *Richard Artschwager, Donald Young Gallery,* in: New Art Examiner, Februar, 1987 · Donald **Kuspit**, *The Critic's Way: Skulptur Projekte in Münster 1987,* in: Artforum, September, 1987 · Donald **Kuspit**, *Richard Artschwager,* in: Artforum,

April, 1988 · Joe **Lewis**, *Artschwager*, in: Contemporanea, Mai/Juni, 1988 · Rhonda **Lieberman**, *Richard Artschwager*, in: Artforum, Juni, 1991 · Roberta **Lurie**, *Richard Artschwager, Whitney Museum of American Art*, in: Craft International, April, 1988 · Steven-Henry **Madoff**, *Richard Artschwager sleight of mind*, in: Art News, Januar, 1988 · Hein-Norbert **Jocks**, *Richard Artschwager*, in: Kunstforum , September, 1989 · John **Miller**, *In the Beginning There Was Formica...*, in: Artscribe, März, 1987 · Robert C. **Morgan**, *Richard Artschwager*, in: Arts Magazine, Mai, 1989 · David **Rimanelli**, *Richard Artschwager*, in: Flash Art, Juni, 1989 · Richard **Shone**, *Richard Artschwager, Palacio Velazquez, Madrid*, in: Burlington Magazine, April, 1989 · Barry **Schwabsky**, *Richard Artschwager*, in: Flash Art, Februar, 1987 · Susan **Tallman**, *Richard Artschwager: Multiples and Their Uses*, in: Arts Magazine, Juni, 1988 · Simon **Tayor**, *Richard Artschwager at Leo Castelli*, in: Art in America, November, 1991 · John **Yau**, *Richard Artschwager*, in: Artforum, Januar, 1987 · James **Yood**, *Richard Artschwager*, in: Artforum, September, 1990

FRANCIS BACON

* Dublin (IRL), 1909
† 1992

Einzelausstellungen | One-man exhibitions

1929 7 Queensberry Mews West, London 1934 Transition Gallery, London 1951 Hanover Gallery, London 1952 Hanover Gallery, London 1953 Beaux-Arts Gallery, London · Durlacher Bros, New York (Kat.) 1954 Hanover Gallery, London 1955 Institute of Contemporary Arts, London (Kat.: M. Clarac-Serou) 1957 Rive droite, Paris (Kat.: R. Penrose, D. Sylvester) 1958 Galleria Galatea, Torino (Kat.: L. Carluccio) · Galleria dell'Ariete (Kat.: D. Sylvester, T. del Renzio) · L'Obelisco, Rome (Kat.: T. del Renzio) 1959 Hanover Gallery, London · Richard L. Feigen, Chicago 1960 Marlborough Fine Art, London (Kat.: R. Melville) 1961 University, Departement of Fine Art, Nottingham (Kat.: H. Lessore) 1962 Kunsthalle, Mannheim (Kat.) · Tate Gallery, London (Kat.: J. Rothenstein, R. Alley) · Galleria Civica d'Arte Moderna, Torino (Kat.: L. Carluccio) · Galleria d'Arte Galatea, Milano (Kat.: L. Carluccio) · Kunsthaus, Zürich (Kat.: J. Rothenstein, S. Spender) 1963 Stedelijk Museum, Amsterdam (Kat.: S. Spender) · Marlborough Fine Art (New London Gallery) (Kat.: D. Sylvester) · Graville Gallery, New York · Solomon R. Guggenheim Museum (Art Institute, Chicago) (Kat.: L. Alloway) 1964 Contemporary Arts Associates, Houston 1965 Kunstverein, Hamburg (Kat.: R. Alley) · Moderna Museet, Stockholm (Kat.: R. Alley) · Municipal Gallery of Modern Art, Dublin · Marlborough New London Gallery, London (Kat.: J. Russell) 1966 Torinelli Arte Moderna, Milano (Kat.: L. Carluccio) 1967 Marlborough New London Gallery (Kat.: M. Leiris, D. Sylvester) · Oberes Schloß, Siegen (Kat.: C. Linfert, M. Leiris, A. Bode) 1968 Marlborough-Gerson Gallery, New York (Kat.: L. Gowing) 1970 Galleria Galatea, Torino (Kat.: T. Chiaretti) 1971 Grand Palais, Paris (Städtische Kunsthalle, Düsseldorf)(Kat.: M. Lei-

ris) 1972 Galleria del Milione (Kat.: G. Bruno) 1975 Metropolitan Museum, New York (Kat.: H. Geldzahler, P. Beard) 1976 Musée Cantini, Marseilles (Kat.: G. Picon) 1977 Galerie Claude Bernard, Paris (Kat.: M. Leiris) · Museo de Arte Moderno, Mexico (J. Acha, M. Leiris) 1978 Museo de Arte Contemporaneo, Caracas (Michel L.) · Fundación Juan March, Madrid (Fundació Joan Miró, Barcelona) (Kat.: A. Bonnet Correa) 1980 Städtische Kunsthalle, Mannheim (Kat.: J. Heusinger von Waldegg) · Marlborough Gallery, New York 1983 National Museum of Modern Art, Tokyo (National Museum of Modern Art, Kyoto; Aichi Prefectural Art Gallery, Nagoya) (Kat.: M. Ichikawa, L. Gowing) 1984 Galerie Maeght Lelong (Kat.: J. Dupin, D. Sylvester) · Marlborough Gallery, New York · Thomas Gibson, London (Kat.: D. Sylvester) 1985 Tate Gallery, London (Staatsgalerie, Stuttgart; Nationalgalerie, Berlin) (Kat.: D. Ades, A. Forge, A. Bowness) 1987 *Retrospective*, Galerie Beyeler, Basel (Kat.: W. Schmalenbach) 1988 Tsentralny Dom Khudozhika, Moscow (Kat.: M. Sokolov, G. Gowrie) · *Paintings*, Marlborough Fine Art, Tokyo

Gruppenausstellungen | Group exhibitions

1987 *A School of London: Six Figurative Painters/ Eine Londoner Malerschule*, Kunstnernes Hus, Oslo (et al.) 1988 *The Magic Mirror*, Scottish National Gallery of Modern Art 1988/89 *Kopior Förfalskningar Parafraser Plagiat Plastischer Repliker, Original Reproduktioner*, Konstmuseum, Göteborg 1989 *Blasphemies Ectasies Cries*, Serpentine Gallery, London · *Auerback, Bacm, Kitaj*, Marlborough Fine Art, London 1990 Tate Galery, Liverpool

Bibliographie | Bibliography

Bücher | Books
Ronald **Alley**, John **Rothenstein**, *Francis Bacon, Catalogue Raisonné*, London, Thames and Hudson, 1964 · Alice Ann **Calhoun**, *Suspended Projections: Religious Roles and adaptable Myths in John Hawkes's Novels, Francis Bacon's Paintings, and Ingmar Bergman's Films*, PhD thesis, Department of English, University of South Carolina, 1979 · Hugh Marlais **Davies**, *Francis Bacon: the early and middle Years, 1928-1958* , PhD dissertation, Princeton University, Department of Art and Archaeology, August 1975 (New York/London 1978, Garland Publishing) · Gilles **Deleuze**, *Francis Bacon: logique de la sensation*, [Paris] 1981 (Editions de la différence) · Alexander **Duckers**, *Francis Bacon: 'Painting 1946'*, Stuttgart 1971, (Philipp Reclam jun.) · Richard **Francis**, *Francis Bacon*, London, Tate Gallery, 1985 · Lawrence **Gowing**, Sam **Hunter**, *Francis Bacon*, London, Thames and Hudson, 1989 · Michel **Leiris**, *Francis Ba-*

con, ou la vérité criante, [Paris] 1974 (Fata Morgana/Scholies) · Michel **Leiris**, *Francis Bacon, face et profil*, Paris, Albin Michel; München, Prestel-Verlag; Milano, Rizzoli; Barcelona, Poligrafa, 1983 (Üb/tr, John Weightman, *Francis Bacon, full face and in profile*, Oxford, Phaidon; New York, Rizzoli, 1983) Michel **Leiris**, *Francis Bacon*, London, Thames and Hudson; New York, Rizzoli, 1988 · John William **Nixon**, *Francis Bacon: Paintings 1959-1979: Opposites and Structural Rationalism*, PhD dissertation, University of Ulster, 1986 · John **Rothenstein**, *Francis Bacon*, Milano 1963, (Fratelli Fabbri Editori) (London, Purnell; Paris, Hachette, 1967) · John **Russell**, *Francis Bacon*, Milano , Fratelli Fabbri Editori, 1963 (London, Purnell; Paris, Hachette, 1967) · John **Russell**, *Francis Bacon*, London, Thames and Hudson, 1971 (Paris, Les Editions du Chêne; Berlin, Prophylaen Verlag; London, Oxford University Press, 1979) · Richard G. **Schreiner**, *The concrete imagination: a perspective on selected works of Francis Bacon and Edvard Munch* , EdD dissertation, Teachers College, Columbia University, 1980 · David **Sylvester**, *Interviews with Francis Bacon*, London, Thames and Hudson; New York, Pantheon Books, 1975 (*Samtal med Francis Bacon-* ,[Stockholm], Forum, [1976]; *Francis Bacon : l'art de l'impossible- entretien avec David Sylvester*, Editions Albert Skira, 1976; *Entrevistas con Francis Bacon*, Barcelona, Ediciones Poligrafa, 1977; *Interview with Francis Bacon, 1962-1979*, London, Thames and Hudson, 1980; *Gespräche mit Francis Bacon*, München, Prestel-Verlag, 1982) · Lorenza **Trucchi**, *Francis Bacon*, Milano, Fratelli Fabbri Editori , 1975 (Üb./Tr., John Shepley, London, Thames and Hudson; New York, Harry N. Abrams, 1976) · Jörg **Zimmermann**, *Francis Bacon: Kreuzigung*, Frankfurt/M., Fischer Taschenbuch, 1986

Periodika | Periodicals
Jacques **Dupin**, David Sylvester, *Francis Bacon: peinture récentes*, in: Repères, Nr. 39, 1987 · Peter **Fuller**, *Nature and raw flesh*, in: Modern Painters (UK), Bd. 1, Frühling, 1988 · Lawrence **Gowing**, *La position dans la représentation: réflexions sur Bacon et la figuration du passé et du futur*, in: Cahiers du Musée National d'Art Moderne, Nr. 21, September, 1987 · Grey **Gowrie**, *Bacon in Moscow: a small gloss on glasnost; Francis Bacon*, in: Modern Painters (UK), Vol. 1, Winter 1988–1989 · Jane Alison **Hale**, *The impossible art of Francis Bacon and Samuel Beckett*, in: Gazette des Beaux-Arts, Nr. 1431, April, 1988 · Mikhail Nikolaevich **Sokolov**, *Tragedies without a hero: the art of Francis Bacon*, in: Art Monthly (Australian), Nr. 16, November, 1988 (Ibidem, in: Art Monthly (UK), Nr. 121, Nov., 1988) · Michael **Nungesser**, *Der Mensch als Täter und Opfer: das malerische Werk von Francis Bacon*, in: Bildende Kunst, Bd. 35, 1987 · Bary **Schwabsky**, Francis Bacon: Marlborough, in: Flash Art, Nr. 136, Oktober, 1987

Film
1963 *Francis Bacon: paintings 1944-1962*, Samaritan Films (London) for Arts Council and Marlborough Fine Art, Regie: David Thompson 1964 *Francis Bacon*, Alexander Burger for Radio Télévision Suisse Romande, Regie: Pierre Koralnik

1966 *Sunday night Francis Bacon: interviews with David Sylvester,* BBC Television, Regie: Michael Gill 1971 *Francis Bacon,* ORTF, Regie: J. M. Berzosa, interv. Maurice Chapuis 1975 *Francis Bacon, Grand Palais 1971,*BBC Television, Prod.: Colin Nears, Regie/Interview: Gavin Millar · *Sides of Bacon,* London Weekend Television for *Aquarius,* Prod.: Derek Bailey, Regie: Bruce Growers, Interview: David Sylvester 1977 *Fenêtre sur… Peintres de notre temps: Francis Bacon,* Antenne 2, prod. Michel Lancelet, Regie: Georges Paumier, Interview: Michel Lancelet, Edward Behr 1984 *Après Hiroshima… Francis Bacon,* Antenne 2 *Désirs des arts,* Regie: Pierre-Andre Boutang, P. Collin, Interview: Pierre Daix · *The brutality of fact,*BBC Television *Arena,* Regie: Michael Blackwood, Prod.: Alan Yentob, Interview: David Sylvester

MARCO BAGNOLI

*Firenze (I), 1949
Lebt/Lives in Firenze

Einzelausstellungen | One-man exhibitions

1975 Galleria Paola Betti, Milano · *Dormiveglia,* Galleria Tucci Ruso, Torino · Galleria Lucrezia De Domizio, Pescara 1978 *Big Bang l L'Origine del teatro,* Galleria L'Attico, Roma · *Marina di Massa,* Galleria Lucio Amelio, Napoli · Galleria Lucrezia De Domizio, Pescara 1979 Galleria Salvatore Ala, Milano 1980 *Iperborei,* Stichting De Appel, Amsterdam · Accademia di Belle Arti Pietro Vannucci, Perugia 1981 Golem Dolmen, Dödel, Villa dei cento Camini, Artimino, Firenze 1982 Galleria Lucrezia De Domizio, Pescara 1983 Locus Solus, Genova · Galleria Mario Pieroni, Roma 1984 *Albe of Zonsopgangen,* Stichting De Appel, Amsterdam (Kat.: B. Corà) · Cappella Dei Pazzi, Opera di Santa Croce, Firenze 1985 *Vers Admirables Au-delà de l'Atmosphère,* Centre d'Art Contemporain, Genève 1986 Galleria Locus Solus, Genova 1989 Sala Ottagonale della Fortezza da Basso, Firenze 1990 Giorgio Persano, Milano · Galleria Pieroni, Roma ·

Opera, Perugia · Sacro Bosco di Bomarzo, Bomarzo · Gallerie Bruges La Morte, Brugge 1991 Galleria Giorgio Persano, Torino · Le Magasin, Grenoble

Gruppenausstellungen | Group exhibitions

1988 *Europa oggi,* Centro per l'Arte Contemporanea Luigi Pecci, Prato · *Di terra in terra,* Museo di Caltagirone, Caltagirone · *East meets West,* Convention Center, Los Angeles 1989 *Periodi di Marmo,* Rassegna Internazionale d'Arte, Acircale 1990 *Galleria,* Galleria Locus Solus, Genova · Rassegna d'Arte e Scienza, Valencia · *La Collezione 1988–90,* Centro per l'Arte Contemporanea Luigi Pecci, Prato

Bibliographie | Bibliography

Texte vom Künstler | Texts by the artist
Non Sol Antihertz, in: A.E.I.U.O., Nr. 1, September, 1980 · *Paraiperborelumenoica di Bruno Corà,* in: A.E.I.U.O., Nr. 2, Dezember, 1980 · *Orso-Panorama, Vedute (intere),* in: A.E.I.U.O., Nr. 6, Dezember 1982 · *UT quaeant laxis Resonare fibris MIra,* in: A.E.I.U.O., Nr. 5, Januar/Juli, 1982 · *Indice,* in: A.E.I.U.O., Nr. 8/9, Dezember, 1983 · *Iris,* Accademia di Brera, Milano 1987

Periodika | Periodicals
Elio **Cappucio**, *L'opera e la sua aura,* in: Tema Celeste, Nr. 22/23, Oktober/November, 1989 · Germano **Celant**,*Inespressionismo,* in: Costa & Nolan (Genova), 1988 · Germano **Celant**, *Periodi di Marmo,* in: Electa (Milano), 1989 · Viana **Conti**, *Marco Bagnoli/Locus Solus,* in: Flash Art, Juni, 1988 · Carolyn **Christov-Bakargiev**, *Marco Bagnoli,* in: Flash Art, Nr. 157, Sommer, 1990 · Fiona **Dunlop**, *M. B. et H. S.,* in: Art & Artifact, Sommer, 1991 · Mark **Kremer**, *Mozarella in carrozza,* in: Metropolis M, Nr. 5, Oktober, 1991 · Hervé **Legros**, *R. S./M. B.,* in: Art Press, Juli/August, 1991 · Alessandro **Mammi**,*Marco Bagnoli, Fortezza da Basso,* in: Artforum International, November, 1989 · Francesca **Pasini**, *Specchiarsi nel disco solaro,* in: Modo, Nr. 121, März, 1990 · Francesca **Pasini**, *Marco Bagnoli,* in: Flash Art, Nr. 155, April/Mai, 1990 · Fulvio **Salavadori**,*Lethe Re Vento,* in: Spazio x Tempo, 1987 · Cathy **Savioz**, *La Philo par L'Expérience,* in: Voir, Nr. 81, Juli/August · Pier Luigi **Tazzi**, *Marco Bagnoli,* in: Artforum International, April, 1987 · Barbara **Tosi**, *Marco Bagnoli,* in: Flash Art, 1988

NICOS BAIKAS

*Athinai (GR), 1948
Lebt/Lives in Kalamaki

Einzelausstellungen | One-man exhibitions

1982 Galerie Karen & Jean Bernier, Athinai 1986 Galerie 3, Athinai 1987 Galerie Mario Diacono, Boston 1989 Galerie H. de Buck, Gent

Gruppenausstellungen | Group exhibitions

1989 *Topos-Tomes,* Fondation Deste, Athinai · *Psychological abstraction,* Fondation

Deste, Athinai · *Europese raaklijnen,* Museum Dhondt-Dhaenens, Deurle 1990 *Carnet de voyages,* Fondation Cartier, Jouy-en-Josas

Bibliographie | Bibliograpy

Bücher vom Künstler | Books by the artist
Nicos Baikas, Greece, MALAM LTD, 1986

Periodika/Periodicals
Benoit **Angelet**, *Nicos Baikas,* in: Artefactum, Nr.17, Februar/März, 1987 · Anastasia **Manos**, *Baikas,* in: Arti, Mai/Juni, 1991 · E. **Quarantelli**, *Nicos Baikas,* in: Contemporanea, Nr. 17, 1990 · s.n., *A conversation with Nicos Baikas,* in: TEFCHOS, Nr. 2, 1989

Film
1990 *Suche nach Identität.* Vier Künstler aus Athen. Monika Bauer, Südwest 3

MIROSŁAW BAŁKA

*Warszawa (PL), 1958
Lebt/Lives in Otwock

Einzelausstellungen | One-man exhibitions

1984 *Anbetung des Kopfes des größten Kämpfers für den Frieden,* Kunstakademie, Warszawa · *Erinnerung an die Heilige Kommunion,* Zukow (Milanowek) · *Wölfe – keine Wölfe. Über den Kampf zwischen der Formel uuuu und der Formation be-be,* Installation, T.P.S.P. Galerie, Warszawa 1986 *Bumerange für den Frieden im Zimmer,* Installation und Performance Dziekanka, Warszawa · *Praecepta patris mei servivi semper,* Galerie Pokaz, Warszawa (Kat.: A. Rottenberg) 1989 *Rzeka (Fluß),* Labirynt Galerie II, Lublin (Kat.: M. Morzuch) · *Instalacja Abel (Abel-Installation),* Galerie PO, Zielona Gora · *Miroslaw Balka. Good God,* Galeria Dziekanka, Warszawa (Kat.: J. Kiliszek) · 1990 *Good God,* Dziekanka Gallery, Warszawa · Galerie Claes Nordenhake, Stockholm 1991 Stichting De Appel, Amsterdam (Kat.: C. Blase) · *April/ My Body cannot do everything I ask for,*

Galeria Foksal, Warszawa (Kat.: A. Przywara) · *IV/IX My Body cannot do everything I ask for,* Galerie Isabella Kacprzak, Köln · *XI/My Body cannot do everything I ask for,* Burnett Miller Gallery, Los Angeles

Gruppenausstellungen | Group exhibitions

1987 *Co Slychac* (Was gibt's Neues/What's New), Zaklady Norblin, Warszawa · *Il Biennale of of new Art,* Zielona Gora 1988 *B.K.K.,* Centrum voor Aktuele Kunst, Den Haag · *Polish Realities,* Third Eye Center, Glasgow · *Bruno Schulz,* SARP Galerie, Warszawa · *And Now to Sculpture,* SARP Galerie, Warszawa 1989 *Gefühle,* Dziekanka, Warszawa · *Verliese von Manhatten,* Muzeum Kinematografii, Lodz · *Mitteleuropa,* Artists Space, New York · *Dialog,* Kunstpalast, Düsseldorf (et al.) 1990 *Aperto,* Biennale di Venezia, Venezia · *Possible Worlds. Sculpture from Europe,* Institute of Contemporary Arts, Serpentine Gallery, London · Galerie Peter Pakesch, Wien 1991 *Metropolis,* Martin-Gropius-Bau, Berlin · Burnett Miller Gallery, Los Angeles · Galerie Isabella Kacprzak, Köln · Miller-Nordenhake, Köln · *Kunst, Europa* (Polen), Bonner Kunstverein, Bonn (et al.) · *Europe Unknown,* Palac Sztuki, Cracow · *Borealis V,* Kunstmuseum Pori, Finland · *Body and Body,* Kunstverein, Graz

Bibliographie | Bibliography

Periodika | Periodicals
Christoph **Blase**, *Again Everything and Everybody in Venice,* in: Kunst-Bulletin, August/Juli, 1990 · Christoph **Blase**, *Außerdem,* in: Kunst-Bulletin, Oktober, 1990 · H. **Christoph**, *Bild oder Mittagessen,* in: Profil, März, 1990 · Joanna **Kiliszek**, *Miroslaw Balka at Dziekanka Gallery,* in: Flash Art, Mai/Juni · Maria **Morzuch**, *Duration,* in: Oko I Ucho, Nr. 1, 1989 · Hans **Pietsch**, *London: Europäische Skulptur heute,* in: Art, November, 1990 · Anda **Rottenberg**, *Draught. Is Contemporary Art Decadent ? Situation Poland,* in: Nike, Nr. 16, 1987 · Anda **Rottenberg**, *Art in Many Kinds of Asylum,* in: DU, Februar, 1990 · Irma **Schlagheck**, *Polen. Aufbruch aus dem Untergrund,* in: Art, Nr. 1, Januar, 1991 · J. St. **Wojciechowski**, *Miroslaw Balka,* in: Flash Art, Nr. 130, 1990

MATTHEW BARNEY

*California
Lebt/Lives in New York

Einzelausstellungen | One-man exhibitions

1988 *Scab Action,* Video exhibition for the New York City Rainforest Alliance, Open Center, New York 1989 *Field Dressing,* Payne Whitbey Athletic Complex, Yale University, New Haven 1991 Barbara Gladstone Gallery, New York · Stuart Regen Gallery, Los Angeles

Gruppenausstellungen | Group exhibitions

1990 *Viral Infection: The Body and its Discontents,* Hallwallas Contemporary Arts Center, Buffalo (et al.) · *Drawings,* Althea Viafora Gallery, New York · *Video Library,* Andrea Rosen Gallery, New York 1991 Barbara Gladstone Gallery, New York · Stuart Regen Gallery, Los Angeles

Bibliographie | Bibliography

Periodika | Periodicals
Lois E. **Nesbitt**, *New York Fax,* in: Art Issues, September/Oktober, 1990 · David **Pagel**, *Mathew Barney,* in: Art Issues, Nr. 19, September/Oktober, 1991 · Lane **Relyea**, *Openings: Matthew Barney,* in: Artforum, Bd.30, Nr. 1, September, 1991 · Jerry **Saltz**, *Wilder Shores of Art,* in: Arts Magazine, Mai, 1991 · Greg **Schneider**, *A Sporting Subversion,* in: Artweek, Juni, 1991 · Marc **Selwyn**, *Spotlight: Matthew Barney – Personal Best,* in: Flash Art, Nr. 160, Oktober, 1991

JERRY BARR

Architect
Lebt/Lives in New York

Research Projects

Outline for the Study of the Indigenous Architecture of Ghana
Study of the Lost Cities of Africa and their Indigenous Architecture
Experimental Architecture and the Search for Energy Resources External to the Planet Earth – *The Architectural Expression of the Reorganization of Solar System*

LOTHAR BAUMGARTEN

*Rheinsberg (D), 1944
Lebt/Lives in Düsseldorf

Einzelausstellungen | One-man exhibitions

1972 Konrad Fischer, Düsseldorf 1973 Konrad Fischer, Düsseldorf 1974 Wide White Space Gallery, Antwerpen/Bruxelles · *Tropenhaus,* Botanischer Garten, Köln · *TE'NE'TE* Konrad Fischer, Düsseldorf (Kat.: L. B.) 1975 Konrad Fischer, Düsseldorf · Galerie Rolf Preisig, Basel 1976 Konrad Fischer, Düsseldorf · Kabinett für aktuelle Kunst, Bremerhaven 1978 Kunstraum, München 1979 Hallen für internationale neue Kunst, Zürich 1982 Galerie Konrad Fischer, Düsseldorf · *Die Namen der Bäume,* Stedelijk Van Abbemuseum, Eindhoven (Kat.: L. B.) 1983 *Land of the Spotted Eagle,* Städtisches Museum Abteiberg, Mönchengladbach (Kat.: L. B.) 1985 *El Dorado,* Marian Goodman Gallery, New York · Konrad Fischer, Düsseldorf · *Tierra de los Perros Mudos,* Stedelijk Museum, Amsterdam (Kat.: L.B.) · Institute of Contemporary Art, Boston 1986 *Accès aux Quais,* Musée d'Art Moderne de la Ville, Paris (Kat.) · *Wegwurf,* Museo de Bellas Artes/Jardin Botanico de Caracas, Los Caobos, Caracas · Konrad Fischer, Düsseldorf 1987 *Makunaíma,* Marian Goodman Gallery, New York (L.B.) · *Eldorado,* Kunsthalle, Bern (Kat.) · Carnegie Museum of Art, Pittsburgh · *Metro Nome,* Musée des Arts Africains et Océaniens, Paris 1988 *Terra Incognita,* Marian Goodman Gallery, New York 1990 *Carbon,* Museum of Contemporary Art, Los Angeles (Kat.: L.B.) · *Endlager/Milkyway,* Konrad Fischer, Düsseldorf 1991 *Carbon,* Marian Goodman Gallery, New York · *Baltic Window,* Museum of Contemporary Art, Helsinki 1992 *wie Venedig sehen,* Haus Esters, Krefeld (Kat.: L.B.) · *Tierra Firme,* Ivam, Centro del Carme, Valencia

Gruppenausstellungen | Group exhibitions

1987 *L'époque, la mode, la morale, la passion,* Centre Georges Pompidou, Paris/Musée des Arts Africains et Océaniens, Paris · *Skulptur Projekte Münster,* Westfälisches Landesmuseum, Münster 1988 *BiNationale: Deutsche Kunst der späten 80er Jahre,* Städtische Kunsthalle, Kunstsammlung Nordrhein-Westfalen, Kunstverein, Düsseldorf (et al.) · *Carnegie International,* Carnegie Museum of Art, Pittsburgh 1989 *Bilderstreit,* Museum Ludwig, Köln · *Acquisitations 1989,* Centre National des Arts Plastiques, Paris · *A Sculpture Show,* Marian Goodman Gallery, New York 1990 *Rhetorical Image,* New Museum of Contemporary Art, New York · *Savoir-Vivre, Savoir-Faire, Savoir-Etre,* Centre International d'Art Contemporain, Montréal · *Life-Size,* Israel Museum, Jerusalem 1991 *De woorden en de beelden/The Words and Images,* Centraal Museum, Utrecht · *Brennpunkt 2,* Kunstmuseum, Düsseldorf · *This Land,* Marian Goodman Gallery, New York · *Recent Acquisitions,* Tate Gallery, London · Museum für Moderne Kunst, Frankfurt/M. · *Carnegie International,* Carnegie Museum of Art, Pittsburgh

Bibliographie | Bibliography

Texte und Bücher vom Künstler | Texts and books by the artist
Neue Leute, in: Interfunktionen, Nr. 5, 1970 (in: Interfunktionen, Nr. 7, Nr. 9, 1970) · Vom Aroma der Namen, in: Parkett, Nr. 6, 1985 · A project for Artforum by Lothar Baumgarten, in : Artforum, März, 1988 · Sidetracks, in : Galeries Magazine, April/Mai, 1990 · Te'Ne'Te', L. Baumgarten with M. Oppitz. Konrad Fischer Gallery, Düsseldorf, 1974 · Die Namen der Bäume, Van Abbemuseum, Eindhoven, 1982 · Land of the Spotted Eagle, Abteiberg Museum, Mönchengladbach, 1983 · Señores Naturales AMERICA, Venice Biennale, 1984 · Tierra de los Perros Mudos, Stedelijk Museum, Amsterdam, 1985 · Accès aux Quais, Tableaux Parisiens, ARC Musée d'Art Moderne de la Ville de Paris, Paris 1985–86 · Makunaíma, with text "Los Advertidos" by Alejo Carpentier, Marian Goodman Gallery New York, 1987 · Carbon, with insert of stories by LB, Museum of Contemporary Art, Los Angeles, Pentti Kouri, 1990

Periodika | Periodicals
Marjorie Allthorpe-Guyton, Baltic Window, in: Artscribe, Nr. 88, September, 1991 · Jan Avgikos, Anthropological War, in: Artscribe, Nr.75, Mai, 1989 · Michèle De Angelus, Lothar Baumgarten: Carbon, in: Galeries Magazine, April/Mai, 1990 · Catherine David, Le Musée National d'Art Moderne, in: Parachute, März, 1987 · Roberto Guevara, Baumgarten, in: Arte, Sommer, 1987 · Claudia Hart, in: Artscribe, Mai, 1987 · Ken Johnson, Orinoco Defense, in: Art in America, Oktober, 1988 · Philip Monk, Lothar Baumgarten: Kunsthalle Bern, in: Parachute, Winter, 1987/88 · Craig Owens, Improper Names, in: Art in America, Oktober, 1987 · Anne Rorimer, Lothar Baumgarten in Pittsburgh: The Tongue of the Cherokee, in: Parachute, Nr. 58, Frühling, 1990 · Mauren Sherlock, The Eye and The Light, in: Art Papers, November, 1987 · René Viau, Impressions d'Afrique, in: Parachute, Dezember, 1987 · Max Wechsler, Lothar Bamgarten, in: Artforum, November, 1987

Film · Projektion | Projections

Eine Reise oder „Mit der MS Remscheid auf dem Amazonas", Projektion von 80 Dias in 12 Minuten Sequenz · Da gefällt's mir besser als in Westfalen. El Dorado, 1974–76, 32 Minuten Dia Projektion, Ton · Der Ursprung der Nacht, Amazonas-Kosmos, 1978, 102 Min., Farbe/Ton, aufgenommen zwischen 1973 und 1977 · Aristokraten des Urwalds, in progress; 1978–1979 gefilmt mit Yanomami Indians im Upper Orinnoco, Venezuela

JEAN-PIERRE BERTRAND

*Paris (F), 1937
Lebt/Lives in Paris

Einzelausstellungen | One-man exhibitions

1970 Städtische Kunstsammlungen, Ludwigshafen 1972 Galerie Sonnabend, Paris 1975 Galerie Eric Fabre, Paris 1976 Chapelle de la Salpêtrière, Paris · Fine Arts Building, New York 1977 Galerie Eric Fabre, Paris 1978 Galeria Nuovi Strumenti, Brescia 1979 C. Space, New York · Galerie Jacques Donguy, Bordeaux 1980 Galerie Eric Fabre, Paris 1981 Musée de Toulon, Toulon · Musée d'Art Moderne de la Ville, Paris (Kat.: M. C. Beaud, J. B.) 1982 Galerie Luigi Deambrogi, Milano · Galerie Camomille, Bruxelles (Kat.: J. B.) 1983 Galerie de France, Paris (Kat.: J. B.) 1984 Ecole des Beaux-Arts, Valence 1985 Galerie Christian Laune, Montpellier · Galeries Contemporaines, Centre Georges Pompidou, Paris (Kat.: C. David, D. Zacharopoulos) · Ecole Régionale des Beaux-Arts, Georges Pompidou, Dunkerque · Musée Saint-Pierre Art Contemporain, Lyon · Galerie Camomille, Bruxelles 1986 Galerie de France, Paris · Galerie Zabriskie, New York · Musée Saint-Pierre Art Contemporain, Lyon 1987 Galerie Roger Pailhas, Grenoble · Le Magasin, Grenoble (Kat.: J. B.) · Forum, Galerie de France, Zürich 1988 Galerie de France, Paris (Kat.: J. B.) 1989 Texte und Bilder/Textes et images, Kunstverein für die Rheinlande und Westfalen, Düsseldorf (Kat.: F. Deck, J. Svestka, D. Zacharopoulos) 1990 Institut Français de Naples, Napoli · Fiac, Galerie de France, Paris 1991 Ivam, Centre del Carme, Valencia

Gruppenausstellungen | Group exhibitions

1987 L'époque, la mode, la morale, la passion, Centre Georges Pompidou, Paris · Hors Tendances, Fondation Gulbenkian, Lisboa · Onze de France, Galerie Suvremene Umjetnosti, Zagreb · Quai Grands Cargo, Port de France · Vice-Versa, Het Prinsenhof, Delft · Du goût et des couleurs, Château-Lannessan-Médoc, Cnap, Paris · Voies diverses, Galeries Contemporaines, Centre Georges Pompidou, Paris · Les années 80 en France, Palais de Dolmabahce, Istanbul (Musée d'Art Moderne, Ankarra) · Collection du Musée d'Art Contemporain, Nîmes 1988 L'image de l'abstraction, Museum of Contemporary Art, Los Angeles · Eté 1988. Images et mages, Centre Culturel de l'Albigeois, Albi · Art Français du XXème siècle, Musée National d'Art Contemporain, Seoul · Fonds Régional d'Art Contemporain de Champagne-Ardenne, Châlons-sur-Marne · Art pour l'Afrique, Musée des Arts Africains et Océaniques, Paris · Inven-

taire, Musée d'Art et d'Industrie, St. Etienne · Le Faux, Fondation Cartier, Jouy-en-Josas · Clarté, Musée d'Art Moderne, Alborg · La couleur seule, Basilique de Fourvière, Lyon 1989 Reflexion 1789/1989, Museum Fridericianum, Kassel · Liberté & egalité/Freiheit und Gleichheit, Museum Folkwang, Essen (Kunstmuseum, Winterthur) · Les magiciens de la terre, Centre Georges Pompidou, Paris · Musée de la Poste, Paris · Sous le soleil exactement Nr. 2, Pas à côté, pas n'importe ou Nr. 4, Villa Arson, Nice · Grands Puits, Hôpital du Kremlin Bicêtre · Histoire de Musée, Musée d'Art Moderne de la Ville, Paris · Collection du Fnac, Château d'Oiron, Oiron · Les 100 jours de Montréal, Ciac, Montréal · De l'instabilité, vidéos Cnap, Paris · Les nourritures de l'Art, Evry-sur-Seine · Kunstverein für die Rheinlande und Westfalen, Düsseldorf 1990 Une collection pour La Grande Arche, La Défense, Paris · Tendances multiples, vidéos des années 80, Centre Georges Pompidou, Paris · Blau, Heidelberger Kunstverein, Heidelberg · Institut Français de Naples, Napoli · Aktuelle Kunst Europas, Sammlung Centre Georges Pompidou, Deichtorhallen, Hamburg · L'expérience de la couleur, Galerie de l'Ecole d'Art, Marseille · Le Diaphane, Musee des Beaux-Arts, Tourcoing 1991 Dessin et Dessein, Musée des Beaux-Arts, Mulhouse · 14 Contemporary Artists from France, Art Gallery, Ontario · Ligne de Mire No 2, Fondation Cartier, Jouy-en-Josas · Kunst, Europa (Frankreich), Kunstverein, Heilbronn (et al.) · Biennale d'Art Contemporain, Espace T. Garnier, Lyon · 30 oeuvres du Fnac, La Défense, Paris

Bibliographie | Bibliography

Texte vom Künstler | Texts by the artist
Calle Mexico, Buenos Aires, Paris, Editions de la Nepe, 1982 · Le Corridor, in: Lan, Nr. 7, Paris, 1983 · De l'Icone ou du sens de la Parole, in: Noir sur Blanc, Nr. 2, Paris, 1987 · (s. t.) in: Cahiers de Psychologie de l'Art de la Culture Nr. 13, Ecole des Beaux-Arts, Paris, 1988 · La couleur seule, l'expérience du monochrome, in: Octobre des Arts, Lyon, 1988 · Public Nr 4, 1989 · in: Kat. Réflexion, Museum Fridericianum, Kassel · in: Kat. Les magiciens de la terre, Centre Georges Pomipidou, Paris 1989 · in: Kat. Kunstverein, Düsseldorf, 1989 · Les bonheurs de l'art, in: Cahiers de la psychologie de l'Art et de la Culture, Nr. 17, 1990 · in: Kat. Ivam, Valencia, 1991

Periodika | Periodicals
Liliana Albertazzi, Tourner autour d'un aquarium, in: Art Press, Nr. 131, 1988 · M. Bouisset, La fabrique du rouge, in: Beaux-Arts, Nr. 93, September, 1991 · Catherine David, Portrait – Jean-Pierre Bertrand, in: Beaux-Arts, Nr. 52, 1987 · Catherine Grout, Jean-Pierre Bertrand, in: Artefactum, Nr. 42, Februar/März, 1992 · Catherine Millet, Jean-Pierre Bertrand, in: Art Press, Nr. 114, Mai, 1987 · Jacques Soulillon, Jean-Pierre Bertrand – Solution de continuité, in Art Press, Mai, 1989 · Guy Tortosa, Jean-Pierre Bertrand, in: Galeries Magazine, Nr. 22, 1987

Video
1989 13 ans avant l'an 2000, Video, Farbe/Ton, 13 Min., Centre Georges Pompidou; Christine Van Assche

MICHAEL BIBERSTEIN

*Solothurn (CH), 1948
Lebt/Lives in Sintra (P)

Einzelausstellungen | One-man exhibitions

1974 Galerie Medici, Solothurn 1978 Galerie Lydia Megert, Bern · Galerie Erika + Otto Friedrich, Bern (Kat.) 1979 Baak'scher Kunstraum, Köln (Kat.: M. B.) · Galerie Modulo, Lisboa · Galerie Modulo, Oporto 1980 Galerie Erika + Otto Friedrich, Bern (Kat.: M.B.) 1981 Arta, Lisboa · CAPC, Coimbra 1982 Galerie Wittenbrink, Regensburg 1983 Galerie Peter Noser, Zürich · Galerie Lydia Megert, Bern 1986 Galerie Lydia Megert, Bern 1987 Galeria Marga Paz, Madrid 1988 Galerie Xavier Hufkens, Bruxelles · Galeria Comicos, Lisboa 1989 Jay Brown Gallery, Los Angeles · Über die Apotheose des menschlichen Geistes, Kunstverein für die Rheinlande und Westfalen, Düsseldorf (Kat.: A. N. de Gusmao, J. Pinharanda, U. Stahel, J. Svestka) 1990 Galerie Tanit, München · Lang & O'Hara Gallery, New York 1991 Galeria Comicos Luis Serpa, Lisboa · Galerie Xavier Hufkens, Bruxelles · On Vernet, Landscape, the Sublime and the Beautiful, and what Relevance they might still have to Contemporary Art, Museu Nacional de Arte Antiga, Lisboa (Kat.: M. B., J. L. Porfirio) · Galeria Marga Paz, Madrid · Galerie Lüpke, Frankfurt/M. 1992 Vom Sitzen und vom Fliegen: Eine Landschaftsübersicht, Kunstmuseum, Solothurn (Kat.: M. B., A. Kamber) · Das grosse Anziehende und die unendliche Weite, Kunstverein, Salzburg

Gruppenausstellungen | Group exhibitions

1987 Offenes Ende – Junge Schweizer Kunst, Nürnberg (et al.) · Jack Tilton Gallery, New York 1988 Signaturen, Museum van Hedendaagse Kunst, Gent · Australian Biennale, Sydney, Melbourne · Künstlerbücher, Galerie Michelle Zeller, Bern · 1988, Galeria Marga Paz, Madrid · Collectie & Collecties, Museum van Hedendaagse

Kunst, Gent 1990 Arcangelo, Michael Biberstein, Ian McKeever, Galerie Barbaro, Paris · Works on Paper, Lang & O'Hara Gallery, New York · Biberstein, Lanhas, Sanches, Galeria Cortez, Lisboa 1991 Triptico, Museum van Hedendaagse Kunst, Gent · In Nebel aufgelöste Wasser des Stromes, Aargauer Kunsthaus, Aarau · Arcangelo, Michael Biberstein, Christa Näher, Galeria Mazzochi, Parma · Michael Biberstein, Alan Charlton, Galerie Tanit, Köln 1992 Geteilte Bilder: Das Diptychon in der Modernen Kunst, Folkwangmuseum, Essen · There is a Minute of a Fleeting World, Casa Serralves, Oporto · Trouvailles, Galerie Raymond Bollag, Zürich

Bibliographie | Bibliography

Periodika | Periodicals
Jan Avgikos, Michael Biberstein, in: Artforum, Dezember 1990 · Jose Luis Brea, Beautiful Tension, in: Artscribe, Nr. 88, September, 1991 · Enrico Comi, Ana Gusmao, Claudio Ratatazzi, Michael Biberstein, in: Spazio Humano, Nr. 1, 1989 · Alexandro Melo, Michael Biberstein, in: Artforum, Juni, 1989 · Andreas Neufert, Munich, in: Contemporanea, September, 1990 · Antonio Cerveira Pinto, Michael Biberstein: Between Abstraction and Meaning, in: Balcon 3, 1989 · Urs Stahel, Aber man darf Malen, in: Kunst-Bulletin, Januar, 1989

GUILLAUME BIJL

*Antwerpen (B), 1946
Lebt/Lives in Antwerpen

Installationen · Ausstellungen
Installations · exhibitions

1979 Autorijschool/Driving School, Galerij Ruimte Z, Antwerpen · Mijn politieke Inspraakruimte (Stemhok)/My Politician Involvement Space (Polling Booth), Galerij Ruimte Z 1980 Beroepsheroriëntatiecentrum/Vocational Reorientation Centre, De Warande, Turnhout (Kat.) · Chaussures Icécé/Shoe Shop, Internationaal Cultureel Centrum, Antwerpen 1981 Voyages 121/Travel Agency, 121 Art Gallery, Antwerpen · Psychiatrische Instelling/Psychiatric Hospital, Palais des Beaux Arts, Bruxelles · Suspect – Verdacht/Suspicious, Plan K, Bruxelles 1982 Eglise/Church, Pali Kao, Paris · Franklin Travel, Franklin Furnace, New York · Salon de Coiffure ARC/Hairdressing Saloon, Musée d'Art Moderne, Biennale, Paris 1983 Gym-zaal/Gymnasium, Provinciaal Museum, Hasselt · Tuindecoratiezaak/Garden Decoration Business, Museum Dhondt-Dhaenens, Deurle · Berchem Frituur/Chip Shop, Cultureel Centrum, Berchem · Relief sans titre, Montevideo, Antwerpen · Composition Trouvée, Ruimte Z, Antwerpen 1984 Occasion-Wagens/Used Car Business, Centrum Beeldende Kunst, Rotterdam · Casino, Vereniging voor het Museum van Hedendaagse Kunst, Gent · Lustrerie Média/Chandelier Booth, Galerie Média, Kunstmesse, Basel · 2 Wartesäle/2 Waitingrooms, „Die neue Tat", Aachen · Belgische Mythologie Compositie/Belgian' Mythology Composition, Dijlemolens, Leuven 1985 Reiseagentur/

Travel Agency, Hahnentorburg, Köln · Fashion-Boutique, Galerie Bilinelli, Bruxelles · La Tombe de l'Artist Inconnu/Tomb of the Unknown Artist, „Location", Bruxelles · Schietoefenbaan/Shooting Range, Apollohuis, Eindhoven · Salon Lavoir/Laundrette, Galerie Andata Ritorno, Genève · Abri-Bombe Atomique/Nuclear Fallout Shelter, Place St. Lambert, „Espace Nord", Liège · Fitnesscenter, De Beyerd, Breda · Oosterse Tapijthandel/Oriental Carpet Shop, Stedelijk Museum, Stichting De Appel, Amsterdam 1986 Herrenkleidung/Men's Wear Shop, Kölnischer Kunstverein, Köln (Kat.: L. van Damme) · Orgelstand/Organ Stand, Initiatif 1986, St. Pietersabdij, Gent · Zu Vermieten/To Rent, Furk'Art, Furka Pass · Foire d'Octobre/Trade Fair, Octobre des Arts, Lyon · Wartesaal & Konferenzzimmer/Waiting Rooms & Conference Room, Kunsthalle, Bern (Kat.: J. Lambrecht) 1987 Terracotta, Sala Uno, Roma · Theaterkamer/Theatreroom, Galerij Zeno X Gallery, RAI, Amsterdam · Informatiecentrum leger/Army Information Centre, Universiteit, Gent · Treppengeschäft/Stair Shop, Galerie Schmela, Düsseldorf · Sculpture Trouvée (buiten/outside), Beelden Buiten, Tielt · Mon Chalet/My Chalet, Zeno X Gallery, Antwerpen · Euro-Tax/Taxi Business, Intentie & Rationele Vorm, Fabriek van Dooren, Mol (Kat.) · Four American Artists, Galeria Terribile, Milano 1988 Change, Shaffy Theater, Amsterdam · Privé Solarium/Private Solarium, Galerij Lumen, Travo, Amsterdam · Voorkamer-Venster/Front-Room Window, Galerij Rumpff, Haarlem · Compositions, Espace Nord, Liège · Ein neuer Politiker/A New Politician, Kunstverein, Kassel · Miss Hamburg, Forum, Hamburg · Composites, Stadsgalerij, Heerlen · Four American Artists, Museum am Ostwall, Dortmund (RAI, Amsterdam) · Sculpture Trouvée auf einem Hügel/Sculpture Trouvée on a hill, Das gläserne U-Boot, Krems · Fami-Home, Belgisch Paviljoen, Biennale, Venezia (Kat.: J. Hoet, F. Minne, W. van Mulders) · Composition Trouvée (buiten/outside), Images et Mages, Centre Culturel de l'Albigeais, Albi · Paard-Installatie/Horse-Installation, Beelden Buiten, Kapellen · Académie de Dessin/Drawing Academy, Galerie A. Maeght, Paris · Miroirs/Mirror-booth, Galerie Wewerka, Fiac, Paris · Heiratsvermittlung Rosa/Marriage Agency, Shakespeare House, Köln · 5 Sorry's, Zeno X Gallery, Antwerpen · Passfoto Studio, Adler Zelte/Adler

Tents, Galerie Schmela (Galerie Isy Brachot, Kunstmesse, Köln) **1989** *Historique V en Sauna,* Centraal Museum, Utrecht · *Furon Store,* New Museum, New York · *Taart/Cake,* Akademie, Waasmunster · *Bügelpresse/Ironmachine-booth,* Galerie Wewerka, Kunstmesse, Frankfurt/M. · *Toning Table Centre,* Galerie Isy Brachot (Kat.: W. van Mulders), Kunstmesse, Basel · *Goldankauf/Gold Business,* Galerie Isy Brachot, Kunstmesse, Köln · *Four American Artists,* La Criée, Rennes · *Verboden te Kamperen/Camping Forbidden,* Gemeentepark, Bornem · *Sorry-Installatie/Sorry-Installation, Passages,* Waregem · *Caravan Show,* Le Magasin, Grenoble · *Compositions,* Galeria A. Murnik, Milano · *Fototentoonstelling/Photo-exhibition,* Provinciaal Museum, Hasselt · *Compositions,* Galerie Wewerka, Berlin · *Forbidden to park bicycles, Investigations,* Airport Montréal · *Composition Trouvée (buiten/outside), Öffentliche Räume,* Hamburg **1990** *Für Garderobe keine Haftung (Retroperspektive) en Sorry-Installatie,* Witte de With, Rotterdam · *Composities,* Galerie Bébert, Rotterdam · *Antiquaire/Antique Shop,* Galerie C. Burrus, Paris · Compositions, Galerie Isy Brachot, Paris · *Guiness World Record,* Edge, Newcastle · *Neuer Supermarkt/New Supermarket,* Galerie Littmann, Basel · *Stille venontwerpebn/Stillives, Ponton Temse,* Museum van Hedendaagse Kunst Gent, Temse · *Meeuwen-Installatie/Seagull-Installation, For Real Now,* Hoorn · *Four American Artists,* Museum Groningen · *Sculpture Trouvée (buiten/outside),* Tel Hai 90, Tel Hai · *Composities,* Zeno X Gallery, Antwerpen · *Posterstand/Posterbooth,* Galerie Isy Brachot, Fiac, Paris · *Compositions,* Galerie Kaess-Weiss, Stuttgart · Compositions, Gallery Nicola Jacobs, London · *Formal Wear Rental,* Koury-Wingate Gallery, New York · *Compositions,* Gallery J. Shainman, New York **1991** *Compositions, Paradoxe des Alltages,* Lenbachhaus, München (Kat.: A. Michielsen) · *Compositions, Heimat,* Galerie Wewerka & Weiss, Berlin · *Hotelrecepti/Hotelreception,* Financieel Bedrijf, Eindhoven · *Komponisten-Sterbezimmer/Composer-Memorial Room,* Galerie H. Winter, Wien · *Elefantenschädel/Elefantskull, Auf Bewährung,* Museum für das Fürstentum Lüneburg (Kat.) · *Composition Trouvée (Tombola), Anninovanta,* Bologna · *2 Composition Trouvée (buiten/outside), Que l'art Survienne,* Wien

Texte vom Künstler | Texts by the artist
A Project for Artforum: 'Sorry', in: Artforum, Januar, 1989 · G. Bijl, P. Groot, R. Houkes, *Shopping,* in: Museumjournaal, '34 2/3, 1989

Bücher | Books
20 Foto's, Antwerpen, Edition A.D.D., 1988 · *An Intro To Creative Visualization,* Zedelgem, Ed. Passages 3/1, Kunst & Projecten, 1989 · *Für Garderobe keine Haftung,* Rotterdam, Ed. Witte de With, 1990

Periodika | Periodicals
Carine **Bienfait,** *Guillaume Bijl,* in: Art et Culture, April, 1989 · Jan **Braet,** *Ik laat zien mijn tijd,* in: Knack, Nr. 18, 1987 · Giulio **Ciavoliello,** *Guillaume Bijl,* in: Flash Art, Nr. 143, 1988 · Carolyn **Christov-Bakargiev,** *Guillaume Bijl,* in: Flash Art, Nr. 135, 1987 · Leontine **Coelewij,** *Guillaume Bijl,* in : Metropolis M, Nr. 9/1, 1988 · Bert **Janssen,** *Guil-*

laume Bijl, in: Metropolis M, April/Mai, 1989 · Fredrick **Leen,** Thomas **Wulffen,** *Reproduktion, Rekonstruktion, Typus,* in: Kunstforum, Bd. 91, 1987 · Kim **Levin,** *Belgian fakirs,* in: Village Voice, Nr. 29, 1989 · Uma **Nag,** *Madhu Prasad ki Ajeeb Kahani,* in: Museumjournaal, Nr. 34, 2/3, 1989 · Saul **Ostrow,** *Guillaume Bijl,* in: Arts Magazine, Januar, 1992 · Carl-Friedrich **Schröer,** *Duchamp für großes Orchester,* in: Art, Nr. 7, Juli, 1991 · Barbara **Straka,** *Guillaume Bijl: Del objeto de Arte a amercancia,* in: Balcon, Nr. 5/6, 1990 · Pier Luigi **Tazzi,** *Guillaume Bijl,* in: Artforum, Oktober, 1987 · Christiane **Vielhaber,** *Kunst-Konsum pur oder der schöne Schein der Dinge,* in: Wolkenkratzer, Nr. 2, 1987 · Giorgio **Verzotti,** *Guillaume Bijl – Una giganttesca ricostruzione golosamente kitsch,* in: Flash Art, Nr. 154, 1990

Film · Video
Ik laat zien het decor van mijn tijd, 16 mm Film, Video-Edition, V. Vlasblom, Stichting Aktuele Kunst Nederland, Amsterdam · Dokumentarfilm, *Guillaume Bijl,* Karel Schoeters, BRT Produktion, 1989

DARA BIRNBAUM

*New York (USA)
Lebt/Lives in New York

Einzelausstellungen | One-man exhibitions

Vorführungen | Screenings
1977 Artists Space, New York **1978** The Kitchen Center for Video and Music, New York · Centre for Art Tapes, Halifax, Nova Scotia · Franklin Furnace, New York · Artists Reading Series, Franklin Furnace (mit/with Suzanne Kuffler), New York **1979** Multidisciplinary Program, P.S. 1, New York **1980** *Local TV News Analysis for Cable Television* (mit/with Dan Graham), Television by Artists, A Space, Toronto · Anna Leonowens Gallery, The Nova Scotia College of Art and Design, Halifax, Nova Scotia · The Kitchen Center for Video and Music, New York The Collective for Living Cinema, New York · Air Gallery, London **1981** Pacific Film Archives, University Art Museum, Berkeley · *Video Viewpoints,* Museum of Modern Art, New York **1982** *Video in Person,* Pittsburgh Film Makers Cooperative, Pittsburgh · The Sixth Annual Chinsegut Film/Video Conference, Redington Beach, Tampa · *Video ? Vous avez dit video ?,* Musée d'Art Moderne, Liège · Museum van Hedendaagse Kunst, Gent **1983** Musée d'Art Contemporain, Montréal **1984** Le Coin du Miroir, Dijon · *The New American Filmmakers Series,* Whitney Museum of American Art, New York · *Currents* and *Prime Time,* The Institute of Contemporary Art, Boston · Anthology Film Archives, New York · Rencontres Video Internationales de Montréal-Video 84, Galerie Graff, Montréal · *Dara Birnbaum – Retrospective Screening,* ICA Cinematheque/Videotheque, London **1985** *1. Internationale Video Biennale,* Retrospective, Wien · L'American Center, Retrospective, · *Video/Television/Media: Dara Birnbaum,* Meet the Makers, Donnell Library, New York · *Talking Back to the Media,* Time Based Art, Retrospective Screening, Amsterdam · Donnell Media Center, New York Public Library, New York **1986** New Television, WNET-TV,

Channel 13, New York · Retrospective Screening, Kunsthaus, Zürich · *Videowochen im Wenkenpark,* Retrospective Screening, Basel **1987** *1987 American Film Institute Maya Deren Winners for Independent Film and Video,* Retrospective Screenings, American Film Institute Festival, Washington DC (Los Angeles) · Artbreak, MTV Networks, Inc. · New Television, WNET-TV, New York and WGBH-TV, Boston · Video Feature, International Center for Photography, New York · *Learning From Performers,* Visiting Artist Lecture Series, Harvard University, Cambridge · *Artists in Collaboration,* Visiting Artist Lecture Series, The High Museum of Art and The Atlanta College of Art, Atlanta · *Video Art: Testament to Inner Grace or Meditated Channel?,* Video Icons and Values Conference, Boston University, Department of Religion and the Humanities Foundation, Boston **1988** *Many Charming Landscapes: The Video Tapes of Dara Birnbaum, Artist-In-Person,* Pacific Film Archives, Berkeley · *Liquid Perception,* International Center of Photography, The New Picturemakers, New York **1989** *Rio Videowall,* Rio Shopping and Entertainment Center, Atlanta · *Sessao Especial Com a Presenca de Dara Birnbaum,* Forum de Arte Contemporanea, Lisboa · *Video Texte,* 707 e.V., Frankfurt · *Dara Birnbaum...From Appropriation to the Sublime,* School of Art Institute of Chicago, Video Department Visiting Artist Screening Series, Chicago **1990** *Dara Birnbaum: Retrospektiivi,* Kuopio Videofestvalit, Helsinki/Kuopio – Videowall, Main Rail Station, Helsinki · *Videotaiteilija Dara Birnbaum Luennoi Taiteestaan,* Kuvataideakatemia, Helsinki · Josh Baer Gallery, New York · Rhode Island School of Design Sculpture Department, Visiting Artist Lecture Series: Dara Birnbaum, Providence · Kuopio Videofestivaaltit 1990, Helsinki/Kuopio **1991** *Tiananmen Square: Break-In Transmission,* Rhona Hoffman Gallery, Chicago · *Dara Birnbaum: Canon: Taking to the Street/Part One,* Rena Branstein Gallery, San Francisco · *Dara Birnbaum: Damnation of Faust Trilogy,* Ivan Doughertly Gallery, Sydney · Retrospective Screening; Australian International Video Festival, Sydney (Kat.) · Ivam, Centre del Carme, Valencia (Kat.)

Gruppenausstellungen | Group exhibitions

Vorführungen | Screenings
1987 *L'époque, la mode, la morale, la passion,* Centre Georges Pompidou, Paris · *Implosion: A Postmodern Perspectiv,* Moderna Museet, Stockholm · *Non In Codice,* Galleria Pieroni, Roma · *The Arts for Television,* The Museum of Contemporary Art/The Temporary Contemporary, Los Angeles · *Selections from the Video Study Collection: 1968–87,* The Museum of Modern Art, New York · *Japan 1987,* Video Television

Festival, Spiral Gallery, Tokyo · The Second Australian Video Festival, Sydney · documenta 8, Kassel · World Wide Video Festival, Kijkhuis, Den Haag · Video CD '87, 3rd International Biennial, Yugoslavia · Video de Femmes, Saint Gervais, Maison des Jeunes et de la Culture, Genève · The French Programme, Revision: Art Programmes of European Television Stations, Stedelijk Museum, Amsterdam 1988 American Landscape Video: The Electronic Grove, The Carnegie Museum of Art, Pittsburgh (et al.) · New Works, 1988 National Video Festival, American Film Institute, Los Angeles · Film/Video Arts: 21 Years of Independents, Museum of Modern Art, New York · 1988: The World of Art Today, The Milwaukee Art Museum, Milwaukee · TV: For Real, Halle Sud, Genève (et al.) · Twilight, Festival Belluard-Bollwerk, Fribourg · Festival International du Nouveau Cinéma et de la Vidéo de Montréal, 17e Edition, Montréal · Dallas Video Festival, Dallas · 3rd International Festival of Films by Women Directors, produced by CineMatrix, Seattle · Articulations: Picturing Woman, Long Beach Museum of Art, Long Beach · Special Effects, Video Feature, International Center of Photography, New York · Video Transformations, ICI Travelling Exhibition 1988/91 · Landscape of the Imagination, New American Makers, Opera Plaza Cinema, San Francisco · Has Cynism Replaced Meaning in Art ?, Symposium Panel Member, School of Visual Arts, New York 1989 American Landscape Video, Newport Harbor Art Museum, Newport Harbor · Image World: Art and Media Culture, Whitney Museum of American Art, New York · Video Scan: An Introduction to Vieo Art, Madison Art Center, Madison · Video-Skulptur: Retrospectiv und Aktuell 1963–1989, Kölnischer Kunstverein und DuMont Kunsthalle, Köln (et al.) · Escultura Contemporanea Americana: Sinais de Vida & Video Drive-In, Encontres Luso-Americanos de Arte Contemporanea, Fundacao Calouste Gulbenkian, Lisboa · Forum de Arte Contemporana, Lisboa · A Forest of Signs, The Museum of Contemporary Art/The Temporary Contemporary, Los Angeles · Femmes Cathodiques, Festival International de Vidéo, Palais de Tokyo, Centre Audiovisuel Simone de Beauvoir, Paris · Berlin Film Festival, Video Section, Berlin · 3. Videonale Bonn · Internationale Videokunst 1986–1988, Neuer Berliner Kunstverein, Berlin/Artothek und Video-Forum, Berlin · Making Their Mark: Women Artists Move Into the Mainstream, 1970–85, Cincinatti Art Museum (et al.) · The Arts for Television, Museum of Modern Art, New York · What Does She Want, Current Feminist Art from the First Bank Collection, Carlton Art Gallery, Carlton College and Woman's Art Registry of Minnesota, Minneapolis · Sequence/(con)Sequence: (sub)versions of photography in the 80's, Video Section, Bard College, New York · Video Tape Gallery, 235 Media and Pentagon/Gallery Pentagon, Köln · Beyond Survival: Old Frontiers/New Visions, Ceres Gallery in association with NYFAI/Woman's Center for Learning, New York 1990 The Decade Show: Frameworks of Identity in the 1980's, Museum of Contemporary Hispanic Art/The New Museum of Contemporary Art/The Studio Museum, Harlem, New York · Video Poetics, Long Beach Museum of Art, Long Beach · Women's Caucus For Art, 1990 National Conference; Breaking the

Codes: Women, Technology and Art (panel and screening Video Artists Showcase) · What's on TV, The Brooklyn Museum, New York · 13th Annual Mill Valley Film Festival, Videofest, Mill Valley · Premieres, 4. Videonale, Bonner Kunstverein, Bonn · Works by Women, Dallas Video Festival, Dallas · The Alternative Voice, Video Drive-In, The Public Art Fund/Central Park, Summer Stage and The Video Data Bank, New York · Life-Size, The Israel Museum, Jerusalem 1991 Josh Baer Gallery, New York · Arte & Arte, Museo d'Arte Contemporanea, Castello di Rivoli, Torino · Collision: Video Art and Popular Culture, The Savannah College of Art and Design, Savannah · The Pleasure Machine: Recent American Video, Milwaukee Art Museum, Milwaukee · Time Festival, Installation and Retrospective Screening, Museum van Hedendaagse Kunst, Gent · The 15th Annual Atlanta Film/Video Festival, Atlanta · Highlights of the 15th Annual Atlanta Film/Video Festival, The Tulla Foundation Gallery, Atlanta · La Mondiale de Films et Vidéos, Quebec · Inaugural Exhibition, The Irish Museum of Modern Art, Dublin · Canon: Taking to the Street/Part I, Arts Festival of Atlanta's Video Art Competition, Atlanta · Charming Landscape, Mixed Signals; a cable series produced by the New England Foundation for the Arts, Cambridge · Video in the Gallery: Realities, American Museum of the Moving Image, Astoria · Moving Light: Seeing and Believing, Kohler Arts Center, Sheboygan · 27the Chicago International Film Festival · 20th Montreal International Festival of New Cinema and Video · MultiMediale 2, Zentrum für Kunst und Medientechnologie, Karlsruhe · XII Festival International de la Vidéo et des Arts Electroniques, Locarno

Bibliographie | Bibliography

Texte und Bücher von der Künstlerin
Texts and books by the artist
Projekte | Projects
Special Artist', Porfolio, Send, Nr. 9, Frühling, 1984 · Playground (The Damnation of Faust), in: Zone, Nr. 1/2, 1985 · Every Color TV Needs a Revolution, TV Guides, New York, Ed. Barbara Kruger, Kuklapolitan Press, 1985 · Wonder, Wonder Woman, in: Telos, Nr. 9, März/Mai, 1987 · Rough Edits: Popular Image Video, Nova Scotia, Ed. Benjamin H.D. Buchloh, Press of the Nova Scotia College of Art and Design, 1987 · Out of the Blue, in: Artforum, Bd. 26, Nr. 7, März, 1988 · Photo Essay, in: City Lights Review, Nr. 2, 1988 · Cover Art. Masochism, New York, Zone Books, 1989 · Out of the Blue, in: Discourses: Conversations in Postmodern Art and Culture, New York, Ed. Russell Ferguson, William Olander, Marcia Tucker, Karen Fiss, The New Museum of Contemporary Art, Cambridge, The MIT Press, 1990 · The Wondering of Context, in: Real Life Magazine, Nr. 20, 1990 · Overlapping Signs for War/After War, in: War After War, San Francisco, Ed. Amy Scholder, City Lights Publishers, 1990 · Yearbook, in: Jahresring, Nr. 38, München, Ed. Kasper König/Hans-Ulrich Obrist, Verlag Silke Schreiber, 1991 · The Rio Experience: Video's New Architecture Meets Corporate Sponsorship, in: Illuminating Video: An Essential Guide to Video Art, New York, Ed. Doug Hall/Sally Jo Fifer, Bay Area Video Coalition, 1991

Bücher | Books
Every TV needs revolution, Gent, IC Series, Imschoot, 1992

Periodika | Periodicals
Robert Barry, Wonder, in: Art Forum International, Sommer, 1989 · Robert Beck, An Interview with Dara Birnbaum, in: Media Arts, Bd. 2, Nr. 5/6, Winter/Frühling, 1990 · Johannes Birringer, The Damnation of Culture in Postmodern Video Sculpture, in: Tema Celeste, Bd. 26, 1990 · Cristiana Cilli, Fuochi Fatui Nel Castello, in: Noi Donne, Bd. 4, April, 1991 · Regina Cornwell, Art in the Agora, in: Art in America, Bd. 79, Februar, 1991 · Guido Curto, Rivoli Fills a Castle with Art, in: The Journal of Art, April, 1991 · Dieter Daniels, Review of Rough Edits, in: Kunstforum, Nr. 98, Januar/Februar, 1989 · Dieter Daniels, Video-Wand im Öffentlichen Raum Atlanta, USA, in: Kunstforum, Nr. 98, Januar/Februar, 1989 · Peter Frank, Los Angeles, in: Contemporanea, Bd. 3, Nr. 6, Sommer, 1990 · Davidson Gigliotti, The Allure of the Electronic: The Changing Vocabulary of Video and Sculpture, in: Afterimage, Bd. 17, Nr. 8, März, 1990 · S. Paul Gorney, Dara Birnbaum, in: Juliet Art Magzine, Nr. 36, April/Mai, 1988 · Susan Hapgood, Dara Birnbaum, in: Contemporanea, Bd. 3, Nr. 5, Mai, 1990 · Kathryn Hixson, Dara Birnbaum, in: Flash Art, Bd. 24, Nr. 158, Mai/Juni, 1991 · Andrea Liss, History Reconceptualized, in: Artweek, 10. Januar, 1987 · Dara Meyers-Kingsley, Beyond Toontown: What's on TV?, in: Independent Film & Video Monthly, Juli, 1991 · Robert Morgan, Review of Rough Edits, in: High Performance, Nr. 44, Winter 1988 · Lois E. Nesbitt, Review, in: Artscribe, Bd. 81, Mai, 1990 · Dena Shottenkirk, Reviews, in: Artforum, Bd. 28, Nr. 8, April 1990 · Magaret Tiberio, Not My Twentieth Century, in: Visions (Boston), Film/Video Foundation, Sommer, 1991 · Christopher L. Tyner, The Home Forum. Light at the end of the tape, in: The Christian Science Monitor, 17. März, 1988

Video

1978 Technology/Transformation: Wonder Woman, Farbe, Stereo, 7 Min. (Also available 16 mm. Kinescope) · (A)Drift of politics (Laverne & Shirley), Farbe, Stereo, 3 Min., loop 1979 Kiss the Girls: Make Them Cry, Farbe, Stereo, 6 Min. 50 Sek., Musik: Dori Levine, Spike, Allan Scarthe 1980 remy/Grand central: Trains and Boats and Planes, Farbe, Stereo, 5 Min., Musik: Radio Fire Fight (Jules Baptiste, Lefferts Brown), Mudd Club, Glenn Branca: Symphony, Nr. 1, The Performing Garage 1982 PM Magazine(Installation), Hudson River Museum, New York documenta 7 Kassel (Additional panel displays produced by the The Milwaukee Art Museum, The Minneapolis College of Art and Design) · PM Magazine/Acid Rock, Farbe, Stereo, 4 Min. 20 Sek., Musik: Dara Birnbaum, Simeon Soffer (One of four simultaneous video/music channels created for documenta 7) · Fire!/Hendrix, Farbe, Stereo, 3 Min. 20 Sek., Musik: Jimi Hendrix, VideoGram International, Ltd. 1983 Damnation of Faust: Evocation, Farbe, Stereo, 10 Min. 2 Sek. Musik: Joshua Fried, Sonic Youth, (c)Neutral Records, (p)LGW Music, John Zieman 1984 Damnation of Faust (installation), Dara Birnbaum, John Zieman, The Luminous Image, Stedelijk Museum, Amsterdam 1985

Damnation of Faust: Will-O'-the Wisp, Farbe, Stereo, 5 Min. 46 Sek., Musik: Paul Jacobs, Mike Nolan · *Will-O'-the Wisp (installation),* Carnegie International Committee, Pittsburgh **1987** *Damnation of Faust: Charming Landscape,* Farbe, Stereo, 6 Min. 30 Sek. Musik: The Picasso's (Keith James and Mike Nolan) · *Artbreak,* Farbe, Stereo, 30 Sek., MTV Networks, Inc. **1989** *Rio Videowall (installation),* Farbe, Rio Shopping/Entertainment Complex, Atlanta, Ackerman & Co., Real Estate Developers **1990** *Canon: Taking to the Street. Part One: Princeton University – Take Back the Night,* Farbe, Stereo, 10 Min. 10 Sek., Music: The Picasso's (Keith James, Mike Nolan), Audio Composition, Mix: Harmonic Ranch, New York (Brooks Williams) · *Tiananmen Square: Break-In Transmission (installation),* Farbe, Josh Baer, New York/Rhona Hoffman Gallery, Chicago **1991** *Canon: Taking to the Street. Part Two: Rutgers University – 1988 National Student Convention*

JONATHAN BOROFSKY

*Boston (USA), 1942
Lebt/Lives in New York

Einzelausstellungen | One-man exhibitions

1973 Artists Space, New York **1975** Paula Cooper Gallery, New York **1976** Wadsworth Atheneum, Hartford (Kat.: M. Rosenthal) · Paula Cooper Gallery, New York **1977** Art Gallery, University of California, Irvine **1978** Protetch-McIntosh Gallery, Los Angeles · Thomas Lewallen Gallery, Los Angeles · University Art Museum, Berkeley · Corps de Garde, Groningen · Museum of Modern Art, New York **1979** Paula Cooper Gallery, New York · Halle für Internationale Neue Kunst, Zürich (Kat.) · Portland Center for Visual Arts, Oregon **1980** Paula Cooper Gallery, New York · Hayden Gallery, Massachusetts Institute of Technology, Cambridge **1981** Contemporary Arts Museum, Houston (Kat.: L. L. Cathart) · Galerie Rudolf Zwirner, Köln · Kunsthalle, Basel (Institute of Contemporary Arts, London) (Kat.: J.-C. Ammann, J. B.,

S. Nairne, J. Simon) **1982** *Werkers,* Museum Boymans-van Beuningen, Rotterdam · Museum van Hedendaagse Kunst, Gent · *Prints from Gemini G.E.L. and Simca,* Paula Cooper Gallery, New York · Gemini G.E.L., Los Angeles · Erika und Otto Friedrich Galerie, Bern **1983** Kunstmuseum, Basel (Städtisches Museum, Bonn; Kunstverein, Hamburg; Kunsthalle, Bielefeld; Mannheimer Kunstverein, Mannheim; Moderna Museet, Stockholm) (Kat.: C. Geelhaar, D. Koepplin) · Akron Art Institute · Gemini G.E.L., Los Angeles · Paula Cooper Gallery, New York **1984** The Israel Museum, Jerusalem (Kat.) · Museum of Art, Philadelphia (Whitney Museum of American Art, New York; University Art Museum, Berkeley; Walker Art Center, Minneapolis, The Corcoran Fallery of Art, Washington DC) (Kat.: R. Marshall, M. Rosenthal) · Moderna Museet, Stockholm (Kat.: R. Armstrong, O. Granath, D. Koepplin) · *Dreams & Compulsions,* Lowe Art Museum , University of Miami, Coral Gables · Louisiana Museum, Humlebaek · Carl Solway Gallery, Cincinnati · *J. B.: Chattering Men,* Garden Court, Seattle Art Museum · Galerie Watari, Tokyo · Städelsches Kunstinstitut/ Städtische Galerie, Frankfurt/M. **1985** Gemini G.E.L., Los Angeles **1986** *Currents 33,* Saint Louis Art Museum · Gemini G.E.L., Los Angeles · Arthur M. Sackler Museum, Harvard University Art Museum, Cambridge · *Prints from Gemini G.E.L.,* Paula Cooper Gallery, New York · Heath Gallery, Atlanta · *Currents 9: Jonathan Borofsky Drawings,* Teweles Gallery, Milwaukee Art Museum, Milwaukee/Des Moines Art Center (Kat.: D Sobel) **1987** Galerie Watari, Tokyo · *Fish With Ruby Eye,* The Cathedral of St. John the Divine, New York · Tokyo Metropolitan Art Museum, Tokyo/The Museum of Modern Art, Shiga (Kat.: R. Marshall) · *Dessins,* Galerie Yvon Lambert, Paris **1988** *Zeichnungen und Druckgrafik,* Galerie Albrecht, München · Paula Cooper Gallery, New York · Nelson-Atkins Museum of Art, Kansas City **1989** *New Prints and Unique Screenprints,* Gemini G.E.L., Los Angeles · *A One man Show,* Galerie Saqqarah, Gstaad **1990** *Forms of Nature,* Paula Cooper Gallery, New York · *Man with a Briefcase at No.,* Gemini G.E.L., Los Angeles · Galerie Yvon Lambert, Paris · *Recent Work,* Glenndash Gallery, Los Angeles **1991** Galeria La Maquina Espanola, Madrid · *New Print & Sculpture Editions,* Gemini G.E.L., Los Angeles · *Heart and Mind,* Galerie Albrecht, München · *Pieces of Infinity,* Paula Cooper Gallery, New York · *Heart and Mind,* Portikus, Frankfurt/M · *Prints and Multiples, 1982–1991,* Hood Museum of Art, Hannover · *Pieces of Infinity,* Paula Cooper Gallery, New York · Galleri Wallner Fersens, Malmö **1992** Paula Cooper Gallery, New York

Gruppenausstellungen | Group exhibitions

1987 *L'époque, la mode, la morale, la passion,* Centre Georges Pompidou, Paris · *State of the Art,* Institute of Contemporary Arts, London (et al.) · *California Figurative Sculpture,* Palm Springs Desert Museum, Palm Springs · *Arco,* Lisboa/Madrid · *Cinéma du Réel: 9ème festival Internationale de Films Ethnographiques et Sociologiques,* Centre Georges Pompidou, Paris · *The Great drawing Show 1587–1987,* Michael Kohn Gallery, Los Angeles · *Art That Moves,* Laguna Gloria Art Museum, Austin · *Drawings,* Sylvia Cordish Fine Art, Balti-

more · *The Smorgon Family Collection of Contemporary American Art,* La Jolla Museum of Contemporary Art, (et al.) · *From the Collection of Sol LeWitt,* The Wadsworth Atheneum, Hartford · *Artists from the Paula Cooper Gallery,* Galerie EMI Valentin de Carvalho, Lisboa · *Borofsky, Disler, Pichler: Zeichnungen,* Galerie Albrecht, München · *A Century of Modern Sculpture,* Dallas Museum of Art (et al.) · *The Remergent Figure: Seven Sculptors,* Storm King Art Center, Mountainville · *Berlinart 1961–1987,* Museum of Modern Art, New York · *Art Against Aids: A Benefit Exhibition,* Paula Cooper Gallery, New York · *Alternate Routes to the Permanent Collection,* Whitney Museum of Modern Art, New York · *Drawings from the Eighties,* Carnegie Mellon University Art Gallery, Pittsburgh · *Avant-garde in the Eighties,* County Museum of Art, Los Angeles · *Schizofrenia,* Josh Baer Gallery, New York · *Prints from Presses,* University Art Galleries, Creative Arts Center, Wright State University, Dayton · *Anniversary Exhibition: Painting 1977–1987,* National Museum of Art, Osaka · *Contemporary Cutouts,* Whitney Museum of American Art/Fairfield County, Stanford · *Changing Group Exhibition,* Paula Cooper Gallery, New York **1988** *On Track,* Nova Building, Olympic Arts Festival, Calgary, Alberta · *Committed to Print,* Museum of Modern Art, New York · *Master Drawings,* Janie C. Lee Master Drawings, New York · *The Multiple Image,* Bank of Boston Gallery, Boston · *New Art on Paper,* The Philadelphia Museum of Art · *1988: The World of Art Today,* Art Museum, Milwaukee · *Eleven Artists from Paula Cooper,* Mayor Rowan Gallery, London · *Waterworks Project,* R.C. Harris Water Filtration Plant, Ontario · *Objects,* Lorence Monk Gallery, New York · *Lost and Found in California: Four Decades of Assemblage Art,* Shoshana Wayne Gallery, Los Angeles · *Painting and Sculpture,* Akira Ikeda Gallery, Tokyo · *Motorized Sculpture,* Freedman Gallery, Albright College, Reading · *SoHo at Duke,* Duke University, Durham · *20th Century Drawings from the Whitney Museum,* Whitney Museum of American Art, New York · *Druckgrafik und Fotografie,* Galerie Albrecht, München · *Art of the 1980's: Artists from the Eli Broad Family Foundation Collection,* Kresge Art Museum, Michigan State University, East Lansing (et al.) · *25th Anniversary Exhibition for the Benefit of the Foundation for Contemporary Performance Arts, Inc.,* Leo Castelli, New York/Brooke Alexander, New York **1989** *Selections from the Fredrick R. Weisman Art Foundation,* Frederick S. Wight Art Gallery, Los Angeles · *Words,* Tony Shafrazi Gallery, New York · *Group Exhibition,* Paula Cooper Gallery, New York · *Materials + Spirit,* Davis/ McClain Gallery, Houston · *Menschen-Gesichter Werke auf Papier, 1901–1989,* Galerie Raymond Bollag, Zürich · *Open Mind,* Museum van Hedendaagse Kunst, Gent · *Art in Place: Fifteen Years of Acquisitions,* Whitney Museum of American Art, New York · *A decade of American Drawing 1980–1989,* Daniel Weinberg Gallery, Los Angeles · *(N) Akt wie Adam und Eva...,* Galerie Raymond Bollag, Zürich · *Colleccion de Dibujos,* Galeria La Maquina Espanola, Madrid · *Encore II: Celebrating Fifty Years,* Contemporary Arts Center, Cincinnati · *Drawings as Itself,* National Museum of Art,

Osaka · *Immaterial Objects*, Whitney Museum of American Art (et al.) · *41st Annual Academy-Institute Purchase Exhibition*, American Academy and Institute of Arts and Letters, New York · *Contemporary Icons and Explorations: The Goldstrom Family Collection*, Mint Museum, Charlotte · *The 1980s: Prints from the Collection of Joshua P. Smith*, National Gallery of Art, Washington DC · *Visualizations on Paper: Drawings as a Primary Medium*, Germans van Eck, New York **1990** *Heroes of Contemporary Art*, Galerie Saqqarah, Gstaad · *Divergent Styles: Contemporary American Drawing*, University Gallery, College of Fine Arts, University of Florida, Gainsville · *Contemporary Art in New York: 1950's-1980's*, IMP Hall, Osaka · *The Readymade Boomerang*, Biennale of Sydney, Art Gallery of New South Wales, Millers Point · *Stained Sheets/Holy Shroud*, Krygier/Landau Contemporary Art, Santa Monica · *Numbering*, Art Gallery of Hamilton, Hamilton · *Drawings*, Richard Kuhlenschmidt Gallery, Los Angeles · *Achievement of Gemini G.E.L.*, Seibu Department Stores, Tschukashin Store, Osaka (et al.) · *Indianapolis Collects: The Second Exhibition*, Herron Gallery, Center for Contemporary Art, Indianapolis · *The Kitchen Art Benefit*, Castelli Graphics, New York · *Downtown Kinetic*, USX Tower, Pittsburgh · Paula Cooper Gallery, New York · *Word as Image: American Art 1960–1990*, Art Center, Milwaukee (et al.) · *The 80s: A Post Pop Generation*, Southern Alleghenies Museum of Art, Loretto · *In Memory of James 1984–1988: The Children's Aids Project*, Daniel Weinberg Gallery, Santa Monica · *Pharmakon '90*, Nippon Convention Center, Tokyo · *Heads*, BlumHelman Gallery, New York · *Imagination und Realität: Werke auf Papier 1910–1989*, Galerie Raymond Bollag, Zürich · *Pulse 2: Report on a Phenomenom*, University Art Museum, Santa Barbara · *Home*, Asher Faure, Santa Monica · *Heroes of Contemporary Art*, TransArt Exhibitions, Köln **1991** *20 Century Collage*, Margo Leavin Gallery, Los Angeles · *To Portray*, Barbara Krakow Gallery, Boston · *Image and Likeness*, Whitney Museum of American Art, New York · *The 1980's: A Selected View from the Permanent Collection*, Whitney Museum of American Art, New York · *Not on Canvas*, Asher Faure, Los Angeles · *I Love Art*, Watari-um, Tokyo · *Biennale de Sculpture*, Monte Carlo, Monaco · *Words & # s*, Museum of Contemporary Art, Wright State University, Dayton · *Watercolor across the Ages*, Gallery at Bristol-Myers, Squibb, Princenton · *De Persona*, Oakland Museum, Oakland · *Masterworks of Contemporary Sculpture, Painting and Drawing, the 1930's to the 1990's*, Bellas Artes, Santa Fe · *De woorden en de beelden/The words and images*, Centraal Museum, Utrecht · *Metropolis*, Martin-Gropius-Bau, Berlin · *Compassion and Protest*, Museum of Art, San Jose · *Second Annual Sculpture at Gateway*, Prudential Insurance Co. of America, Newark · *The Artist's Hand: Drawings from the Bankamerica Corporation Art Collection*, Museum of Contemporary Art, San Diego · *Portraits on Paper*, Robert Miller Gallery, New York · *In Public: Seattle 1991*, Security Pacific Gallery, Seattle · *Small Sculpture in an Inner Space*, Bellas Artes, Santa Fe · *Immaterial Objects*, Whitney Museum of American Art Downtown at Federal Reserve Plaza, New York · *Devil on the Stairs: Looking back on the Eighties*, Institute of Contemporary Art, Philadelphia (et al.) · *Collage au XXème Siècle*, Musée d'Art Moderne et d'Art Contemporaine, Nice · Kunstmuseum, Basel · *Sculptors' Drawings*, Bellas Artes, Santa Fe **1992** *Yvon Lambert collectionne*, Musée d'Art Moderne de la Communauté de Lille, Villeneuve D'Ascq · Kunstforum, Rottweil

Bibliographie | Bibliography

Texte vom Künstler/Texts by the artist
Strike: A Project by Jonathan Borofsky, in: Artforum, Februar, 1981 · *Prisoner*, in: Artforum, März, 1988

Bücher | Books
Counting 3287718–3311003, Köln/Frankfurt/M., Verlag der Buchhandlung Walther König/Portikus, 1991

Periodika | Periodicals
Jean-Christophe **Ammann**, *Borofsky's Hammering Man*, in: Kunst-Bulletin, Oktober, 1989 · Maria **Campitelli**, *Jonathan Borofsky*, in: Juliet, Juni, 1990 · *Ballerina Clown*, *Jonathan Borofsky*, in: Artspace, Bd. 14, Nr. 3, März/April, 1990 · Laura **Cottingham**, *Jonathan Borofsky*, in: Flash Art, Sommer, 1990 · Gabi **Czöppan**, *Wer hat Angst vorm schwarzen Mann*, in: Pan, Nr. 9, 1991 · Joshua **Decter**, *Review*, in: Flash Art, Sommer, 1988 · Giacinto Di **Pietrantonio**, *Jonathan Borofsky: Portikus*, in: Flash Art, Oktober, 1991 · Xavier **Girard**, *Jonathan Borofsky. Age Pièce*, in: Art Press, Nr. 134, März, 1989 · Jane **Hart**, *Substantive Spirit, Jonathan Borofsky's Projections*, in: Cover, Mai, 1990 · Eleanor **Heartney**, *The Expanded Readymade*, in: Art in America, September, 1990 · Eleanor **Heartney**, *Jonathan Borofsky at Paula Cooper*, in: Art in America, Oktober, 1990 · Yaso **Kobayashi**, *Forum on Pharmakon '90*, in: Mizue, Sommer, 1990 · Richard **Kostelanetz**, *Art in Motion: The Aesthetics of technology*, in: The Journal of the Art, November, 1990 · Donald **Kuspit**, *Jonathan Borofsky, Paula Cooper Gallery*, in: Artforum, September, 1988 · Donald **Kuspit**, *Jonathan Borofsky*, in: Artforum, Sommer, 1990 · Christopher **Lyon**, *Review*, in: Artnews, Oktober, 1988 · Robert **Mahoney**, *Pygmalion à Disneyland: l'histoire de l'art et l'histoire de la mécanique chez Jonathan Borofsky*, in: Artstudio, Nr. 22, Herbst, 1991 · Ben **Marks**, *Jonathan Borofsky's Ballerina Clown*, in: Artspace, März/April, 1990 · Carlo **McCormick**, *Exits and Entrances*, in: Artforum, Januar, 1988 · George **Melrod**, *Jonathan Borofsky*, in: Artnews, September, 1990 · Friedhelm **Mennekes**, *Die Stadt, die Kunst, die Religion*, in: Kunst und Kirche, April, 1987 · Annemarie **Monteil**, *Basel*, in: Contemporanea, November, 1989 · Peter **Plagens**, *Los Angeles: Two for the Show*, in: Art in America, Mai, 1987 · Sam **Saggs**, *Big Fish, Big Pond*, in: Artnews, Mai, 1987 · Ingris **Shaffner**, *Jonathan Borofsky*, in: Artscribe, Sommer, 1990 · Buzz **Spector**, *Stained Sheets/Holy Shroud*, in: Art Issues, Oktober, 1990

LOUISE BOURGEOIS

*Paris (F), 1911
Lebt/Lives in New York

Einzelausstellungen | One-man exhibitions

1945 *Paintings by Louise Bourgeois*, Bertha Schaefer Gallery, New York **1947** Norlyst Gallery, New York **1949** *Late Work 1947 to 1949: 17 Standing Figures*, Peridot Gallery New York **1950** *Sculptures*, Peridot Gallery, New York **1953** *Drawings for Sculpture and Sculpture*, Peridot Gallery, New York · Allan Frumkin Gallery, Chicago **1959** *Sculpture by Louise Bourgeois*, Andrew D. White Art Museum, Cornell University, New York **1963** *Recent Drawings by Louise Bourgeois*, Rose Fried Gallery, New York **1964** *Recent Sculpture*, Stable Gallery, New York **1974** *Sculpture 1970–1974*, 112 Greene Street, New York **1978** *Triangles: new Sculpture and Drawings, 1978*, Xavier Fourcade Gallery, New York · *New York*, Hamilton Gallery, New York **1979** *Sculpture 1941–1953. Plus one new Piece*, Xavier Fourcade Gallery, New York · *Matrix/Berkeley 17*, University of California, Art Museum, Berkeley **1980** *Sculpture: the middle Years 1955–1970*, Xavier Fourcade Gallery, New York · *The Iconography of Louise Bourgeois*, Max Hutchinson Gallery (Kat.: J. Gorovoy) **1981** *Femme maison*, The Renaissance Society, Chicago (Kat.: S. Ghez, J. P. Marandel) **1982** Robert Miller Gallery, New York · *First Retrospective*, Museum of Modern Art, New York (Contemporary Arts Museum, Houston; Museum of Contemporary Art, Chicago; Akron Art Museum, Akron) **1984** Daniel Weinberg Gallery, Los Angeles · Daniel Weinberg Gallery, San Francisco · Robert Miller Gallery, New York **1985** Serpentine Gallery, London · Maeght-Lelong, Zürich · *Retrospektive 1947–1984*, Maeght-Lelong, Paris **1986** *Eyes*, The Doris Freedman Plaza, New York · Robert Miller Gallery, New York · *Sculptures and drawings*, Texas Gallery **1987** *Paintings from the 1940's*, Robert Miller Gallery, New York · Yares Gallery, Scottdale · *Sculpture 1947–1955*, Gallery Paule Anglim, San Francisco · *Paintings and Drawings*, Janet Steinberg Gallery, San Francisco **1987/89** *Louise Bourgeois*, The Taft Museum, Cincinnati (The Art Museum at Florida International University, Miami; Laguna Gloria Art Museum, Austin; Gallery of Art, Washington University, St. Louis; Henry Art Gallery, Seattle; Everson Museum of Art, Syracuse) (Kat.: S. Morgan) **1988** *Drawings 1939–1987*, Robert Miller Gallery, New York (Kat.: R. Storr) · *Sculpture by Louise Bourgeois*, Laguna Gloria Art Museum, Austin · *Works on Paper 1939–1988*, Museum Overholland, Amsterdam **1989** *Sculpture*, Robert Miller Gallery, New York · *Progres-*

sions and Regressions, Galerie Lelong, New York · Works from the 50's, Sperone-Westwater Gallery · Dessins 1940/86, Galerie Lelong, Paris · 100 Zeichnungen 1939–1989, Galerie Lelong, Zürich · Selected Works 1946–1989, Rhona Hoffman Gallery, Chicago · Works from the Sixties, Dia Art Foundation, Bridgehampton · Recent Sculpture by Louise Bourgeois, Art Gallery of York University, Canada · Frankfurter Kunstverein, Frankfurt/M. (Kat.: P. Weiermair, L. R. Lippard, R. Storr, R. Krauss, T. McEvilley) 1990 Recent Work 1984–1989, Riverside Studios, London (Kat.: Z. Shearman, S. Morgan) 1991 Kunstmuseum, Bern · Rijksmuseum Kröller-Müller, Otterlo (cfr. Kat.: Frankfurter Kunstverein) · L'oeuvre gravée, Galerie Lelong, Zürich 1992 Galerie Karsten Greve, Paris

Gruppenausstellungen | Group exhibitions

1987 Black and White, Museum of Modern Art, New York · Whitney Biennal, New York · Von Chaos und Ordnung der Seele, Psychiatrische Klinik der Universität, Mainz · L'Etat de Choses I, Kunstmuseum, Luzern · Assemblage, Kent Fine Art, New York · Group Show, Galerie Maeght Lelong, New York · Sculptors' Drawings, Blum Helman, New York · 22 artists: the friends of Louise Tolliver Deutschman, Kent Fine Art, Paris · The 100 Days of Contemporary Art of Montreal 1987: stations, Montréal International Centre of Contemporary Art, Quebec · Lust one the Seven Deadlies, M-13 Gallery, New York · Black, Siegeltuch Gallery, New York · Sculpture from Surrealism, Zabriskie Gallery, New York · After Pollock: Three Decades of Diversity, Ianetti-Lanzone Gallery, San Francisco · La femme et le surréalisme, Musée Cantonal des Beaux-Arts, Lausanne · Undercurrents: Rituals and Translations, Grossman Gallery, School of the Museum of Fine Arts, Boston · Process and Product: the Making of Contemporary Masterwork, Edith C. Blum Art Institute , The Bard College Center, Annandale-on-Hudson, New York · Drawn out: an Exhibition of Drawings by Contemporary Artists, Kemper Gallery, Kansas City · Boundaries: Works on Paper, Sander Gallery, New York · Contemporary Sculpture, George Dalsheimer Gallery, Baltimore · Sculpture, Galerie Lelong, New York · Sculpture, Pat Hearn Gallery, New York · In Defense of Sacred Lands, Harcus Gallery, Boston · The Quality of Line, The Forum, St. Louis 1988 Sculpture: Works in Bronze, Carl Schlosberg Fine Arts, Sherman Oaks · Enduring Creativity, Whitney Museum of American Art, Fairfield County · The Politics of Gender, The QCC Art Gallery, Queensborough Community College, New York · Enchantment/Disturbance, The Power Plant, Toronto · Figure as Subject: the Revival of Figuration since 1975, Whitney Museum of American Art, New York (et al.) 1989 Les magiciens de la terre, Centre Georges Pompidou, Paris · Prospect, Frankfurter Kunstverein, Frankfurt/M. · Bilderstreit, Museum Ludwig, Köln · Towards Form, Greenberg Wilson Gallery, New York · Quality of Line, The Forum, St. Louis · Sculptors Drawings, David Beitzel Gallery, New York · A Decade of American Drawings: 1980–1989, Daniel Weinberg Gallery, Los Angeles · Representing the 80's, Simon Watson Gallery, New York · Lines of Vision: Drawings by Contemporary Women, Hill-

wood Art Gallery, Long Island University, Greenvale (et al.) · Art in Place: 15 Years of Acquisitions, Whitney Museum of American Art, New York · Exhibition of Masterworks, Riva Yares Gallery, Scottsdale · Marble: a contemporary aesthetic Sculptur, California Museum of Science and Industry, Loker Gallery, Los Angelos · Making their Mark: Woman Artists move into the Mainstream 1970–85, Cincinnati Art Museum, Eden Park (et al.) · Sculptors' Drawings, John C. Stoller & Co., Minneapolis · Acquisitions 1989, Centre National des Arts Plastiques, Paris 1991 Die Hand des Künstlers, Museum Ludwig, Köln · Art of the Forties, Museum of Modern Art, New York · Pulsio, Fundació Caixa de Pensions, Barcelona · Dislocations, Museum of Modern Art, New York 1992 Psycho, Kunsthall, New York

Bibliographie | Biobliography

Bibliographie/Bibliography in: Kat. Frankfurter Kunstverein, Frankfurt/M./Kat. Kröller-Müller, Ottolo 1990

Texte und Bücher von der Künstlerin
Texts and books by the artist
He disappeared into complete silence (Gedichte und Zeichnungen), in: The Harvard Advocate Special Translation Issue, Sommer 1982 · In the works – leading artists reflect on their creations for the coming season…, in: The New York Magazine, 11. September, 1988 · (statement by the artist), in: CAA Newsletter, Bd. 14, Nr. 1, Frühjahr, 1989

Bücher | Books
Donald Kuspit, Bourgeois, (Interview Louise Bourgeois), New York, Elisabeth Avendon Editions/Vintage Contemporary Artists, 1988 · Lucy R. Lippard, Louise Bourgeois: from the inside out, in: From the center: feminist essays on women's art, New York, E. P. Dutton, 1976 · Jean Revol, La sculpture: état des lieux, hommage à Louise Bourgeois, in: La Nouvelle Revue Française, 1. November, Nr. 406, Paris, La Nouvelle Revue Française, 1986 · Christiane Meyer-Thoss, Louise Bourgeois, Konstruktionen für den freien Fall – Designing for Free Fall, Zürich, Ammann Verlag, 1992

Periodika | Periodicals
Robert Atkins, Louise Bourgeois, in: 7 Days, 19. April, 1989 · Ruth Bass, New York? New York!, in: Art-Talk, Juni/Juli, 1989 · Bibeb, De ogen zijn er altijd, worden steeds belangrijker in mijn werk. Ogen zijn overal. Ogen liegen niet, in: Vrij Nederland, Nr. 43, 29. Oktober 1988 · Francesco Bonami, Dislocation, the Place of Installation, iin: Flash Art, Nr. 162, Januar/Februar, 1992 · Manuel J. Borja-Villel, Louise Bourgeois' défi, in: Parkett, Nr. 27, 1991 · Jamie Brunson, An art of personal exorcism, in: Artweek, Bd. 18, Nr. 39, November 1987 · Holland Cotter, Dislocating the Modern, in: Art in America, Nr. 1, Januar, 1992 · Jean Fremon, Louise Bourgeois, in: New Observations, Nr. 50, September, 1987 · Paul Gardner, Louise Bourgeois makes a sculpture, in: Artnews, Sommer, 1988 · Paul Gardner, Sculpture's grandes dames, in: Signature, Juni, 1987 · Paul Gardner, Louise Bourgeois, in: Contemporanea, Bd. 2, Nr. 7, 1989 · Gregory Galligan, Strangle sane, in: Art International, Sommer, 1988 · Ron Glowen, Louise Bourgeois comes into her own/Trajec-

tions of a long career, in: Artweek, Nr. 43, 17. Dezember 1988 · Amy Golany, Ann Sutherland, Elaine A. King, Sculpture by women in the eighties, in: Dialogue, Mai/Juni, 1987 · Barbara Goodstein, In the galleries, in: Art & Antiques, Oktober 1989 · Therese Grisham, Louise Bourgeois – volcanic charm, in: Artsfocus, Bd. 3, Nr. 5, Januar, 1989 · Josef Helfenstein, Der Macht der Intimität/The power of intimacy, in: Parkett, Nr. 27, 1991 · Kay Heymer, Long standing singular figure, in: Flash Art, Bd. 24, Nr. 158, Mai/Juni, 1991 · Nancy Jones, Lives of the artists, in: New York Woman, Mai, 1989 · Alain Kirili, The passion for sculpture – a conversation with Louise Bourgeois, in: Arts, Bd. 63, Nr. 7, März, 1989 · Donald Kuspit, Louise Bourgeois – where angels fear to tread, in: Artforum, März, 1987 · Kay Larson, New York, Dislocations, in: Galeries Magazine, Nr. 46, Dezember 1991/Januar 1992 · Kate Linker, Louise Bourgeois, in: Artforum, April, 1988 · Miranda McClintic, Sculpture today, in: Art & Auction, Mai, 1988 · Marisa Melchers, Waar eindigt het ritueel where Does the Ritual End?, in: Ruimte, Nr. 3/4, 1991/1992 · Christiane Meyer-Thoss, Ich bin eine Frau ohne Geheimnisse/I am a woman with no secrets – statements by/von Louise Bourgeois, in: Parkett, Nr. 27, 1991 · Robert C. Morgan, Eccentric abstraction and post-minimalism, in: Flash Art, Nr. 144, Januar/Februar, 1989 · Stuart Morgan, Taking cover: Louise Bourgeois interviewed by Stuart Morgan, in: Artscribe, Januar/Februar, 1988 · Mignon Nixon, Pretty as a picture/Bildschön: Louise Bourgeois' fillette, in: Parkett, Nr. 27, 1991 · Ann Pollak, National sculpture conference: works by women comes to Cincinnati, in: Art Academy News, Nr. 6, Februar, 1987 · Nancy Princenthal, Bourgeois with a vengeance, in: Sculpture, Juli/August, Bd. 8, Nr. 4, 1989 · Barbara Rose, sex, rage & Louise Bourgeois, in: Vogue, September, 1987 · Edward Rubin, The seduction of 57th Street, in: Manhattan Arts, Nr. 3, Mai, 1989 · Carolyn Treat, Louise Bourgeois: „Art is a guarantee for sanity, in: Museumjournaal, Nr. 6, 1991 · Phyllis Tuchman, Life begins at sixty-something, in: The Journal of Art, Nr. 4, April, 1989 · Pamela Wye, Louise Bourgeois, in: Arts Magazine, Januar, 1992 · Karen Wilkin, At the Galleries, in: Partisan Review, 3, 1989 · John Yau, New York, in: Contemporanea, Nr. 5, Juli/August, 1989

HERBERT BRANDL

*Graz (A), 1959
Lebt/Lives in Wien

Einzelausstellungen | One-man exhibitions

1981 Forum Stadtpark (mit/with Gerwald Rockenschaub), Graz · Secession Klubgalerie (mit/with Gerwald Rockenschaub), Wien 1982 Galerie Peter Pakesch, Wien (Kat.: W. Drechsler) 1983 Galerie Thaddaeus Ropac (mit/with Gerald Obersteiner), Linz · Galerie Luigi Deambrogi, Milano · Galerie Peter Pakesch (mit/with Gilbert Bretterbauer), Wien 1984 Neue Galerie Landesmuseum Joanneum, Graz (Kat.: K. Jungwirth, W. Skreiner) · Galerie Thomas Borgmann, Köln 1985 Galerie Peter Pakesch, Wien (Kat.: M. Faber-

Drechsler, P. Weibel) · Galerie Jean Bernier (mit/with Otto Zitko), Athinai · Galerie Emilio Mazzoli, Modena (Kat.) 1986 Galerie Michael Haas, Berlin (Kat.) · Galerie Peter Pakesch, Wien (Kat.: P. Pakesch) 1987 Galerie Borgmann-Capitain, Köln · Galerie Eugen Lendl (mit/with Franz West), Graz 1988 Galleria Giorgio Persano (mit/with Franz West), Torino · Galerie Peter Pakesch, Wien (Kat.: E. Schlebrügge) · Die Ernte des Tantalos (mit/with Franz West), Galerie Peter Pakesch, Wien 1989 Galerie Grässlin-Ehrhardt (mit/with Franz West), Frankfurt/M. (Kat.: G. Herald) · Galleria Giorgio Persano, Torino 1990 Galerie Peter Pakesch, Wien · Galerie Grässlin-Ehrhardt, Frankfurt/M. · Museum van Hedendaagse Kunst, Gent (Kat.) 1991 Kunsthalle, Bern (Kat.: U. Loock) · Galerie Grässlin-Ehrhardt, Frankfurt/M. · Obalne Galerije, Piran (Kat.: D. Ronte, P. Weibel) 1992 Jack Tilton Gallery, New York

Gruppenausstellungen | Group exhibitions

1987 Galerie Zwirner, Köln · Luoghi dell Atopia, Parco Ducale, Parma · Österreichisches College, Forum Alpach · Aktuelle Kunst in Österreich, Europalia, Museum van Hedendaagse Kunst, Gent · Malerei – Wandmalerei, Grazer Kunstverein, Stadtmuseum, Graz · Various Artists, Vienna Austria 1987, Unge Kunstneres Samfund, Oslo · Im Rahmen der Zeichnung – Im Laufe der Zeichnung, Secession, Wien 1988 Biennale der Europäischen Grafik, Heidelberg · Internationale Triennale für Originalgraphik, Grenchen · Malermacht, Bregenz · Aus Wien, Positionen des Aufbruchs, Bonn · Graphische Sammlung Albertina, Wien · Galerie Peter Pakesch, Wien 1989 I Triennal de Dibuix Joan Miró, Fundacio Miró, Barcelona · Landscapes, Galerie Bruges la Morte, Brugge · Biennale São Paulo · Popocatepetl, Galeria Juana de Aizpuru, Madrid · Kunst der letzten 10 Jahre, Museum für moderne Kunst, Wien · Arbeiten auf Papier, Galerie Grässlin-Ehrhardt, Frankfurt/M. 1990 Musée de l'Art moderne de la Ville, Paris · Querdurch, Bratislava, Kosice Jänner Galerie, Wien · Vienne aujourd'hui, Musée de Toulon, Toulon · Kunst der 80er Jahre, Neue Galerie am Landesmuseum Joanneum, Graz · Le Diaphane, Musée des Beaux-Arts, Tourcoing · De Pictura, Bruges la Morte, Brugge 1991 Junge Kunst aus Österreich, Ham-

burger Kunstverein in den Deichtorhallen, Hamburg · Wien – 1900, Wien – 1990, Liljevachs Konsthall, Stockholm · Un musée en voyage. La collection de la Neue Galerie Graz, Musée d'Art Contemporain, Lyon · Atelier del Sur, El Cabrito La Gomera, Islas Canarias · Sensualité, sensibilité, purisme, Couvent des Cordeliers, Paris · Das Jahrzehnt der Malerei, Kunstforum, Wien (et al.) · Körper und Körper, Grazer Kunstverein im Stadtmuseum, Steirischer Herbst, Graz

Bibliographie | Bibliography

Bücher vom Künstler | Books by the artist
Das kleine schwarze Buch, Galerie Peter Pakesch, Wien, 1985

Periodika | Periodicals
Helmut Draxler, Herbert Brandl, in: Flash Art, Nr. 133, April, 1987 · Luk Lambrecht, Brandl, Frandsen, Herold, Heyvaert, Kocherscheidt, in: Metropolis M, Nr. 5, Oktober, 1991 · Ulrich Loock, Herbert Brandl, in: Noema, Nr. 15, 1987 · Peter Nesweda, In Search of a Lost Paradise, in: Arts Magazine, Dezember, 1991 · Achille Bonito Oliva, Herbert Brandl, in: Kunstforum, Mai/Juni, 1987

RICARDO BREY

*La Habana (C), 1955
Lebt/Lives in Gent

Einzelausstellungen | One-man exhibitions

1980 Luna Llena, Casa de la Cultura de Jaruco, La Habana 1981 El Origen de las Especies, Museo Nacional de Bellas Artes, La Habana 1985 New Art from Cuba, Long Island, New York 1987 Sobre la tierra, Centro Wilfredo Lam, La Habana · Sobre la tierra, Galeria Khalo – Coronel, Ciudad de Mexico 1991 Galerie Baronian, Bruxelles

Gruppenausstellungen | Group exhibitions

1987 Biennal de São Paulo, São Paulo · Visiones del Paisaje, Galeria Universidad de los Andes, Mérida · Tres Artistas Cubanos, Colateral a la Biennal Bantu, Zaire (et al.) 1988 Signs of Transition: 80's art from

Cuba, Museum of Contemporary Hispanic Art, New York · Made in Havana, Arts Gallery, New South Wales · Raices en Accion, Museo Carrillo Gil, Ciudad de Mexico (et al.) 1989 Made in Havana, Museum of Contemporary Art, Brisbane (et al.) · Biennal de La Habana, Museo Nacional de Bellas Artes, La Habana 1990 Kuba O.K. Aktuelle Kunst aus Kuba/ Arte actual de Cuba, Städtische Kunsthalle Düsseldorf/ Centro de Desarollo de las Artes Visuales, Cuba · Ponton Temse, Museum van Hedendaagse Kunst Gent, Temse

Bibliographie | Bibliography

Periodika | Periodicals
Ruffo Caballero, Misteriosa Cultura de la Eficacia, in: Revolucion y Cultura, Juli/August, 1991 · Erena Hernandez, El unico sitio, in: Revolucion y Cultura, September, 1988 · Gerardo Mosquera, Mito Concepto y poesia en Brey, in: Brecha, a III, Nr. 116, 29. Januar, 1988

Video
1991 Brey, Enrique Alvarez, Februar 1991, 15 Min.

TONY BROWN

*Peterborough (GB), 1952
Lebt/Lives in Montréal

Einzelausstellungen | One-man exhibitions

1982 National Gallery of Canada, Musée des Beaux-Arts du Canada, Ottawa 1983 Ydessa Gallery, Toronto 1984 49th Parallel, New York 1985 Ydessa Gallery, Toronto 1986 Winnipeg Art Gallery, Musée des Beaux-Arts, Winnipeg (Kat.: B. Ferguson, A. Kroker, S. Madill) 1987 Centre d'Art Contemporain du Domaine de Kerguéhennec, Locmine (Kat.: A. Guzman) · Galerie Arlogos, Nantes · London Regional Art Gallery, London (Ontario) 1988 De Vleeshal, Middelburg (Kat.: J. Lamoureux) 1990 Galerie Arlogos, Nantes 1991 Living in the Hot House, The Art Gallery of York University, Toronto (Kat.: M. Gagnon, J. Sans) · Chapelle Henri IV, Renard Poitiers · National Gallery of Canada, Musée des Beaux-Arts du Canada, Ottawa

Gruppenausstellungen | Group exhibitions

1987 Stichting De Appel, Amsterdam · Musée d'Art Contemporain, Montréal · Opening Exhibition, National Art Gallery, Ottawa 1989 Architecture and Imagination, Fort Asperen · Machinations, Gallery Christiane Chassay, Montréal 1990 Ateliers de la Fondation Cartier, Jouy-en-Josas

Bibliographie | Bibliography

Periodika | Periodicals
Françoise **Bataillon**, *Tony Brown – Domaine de Kerguéhennec et Galerie Arlogos*, in: Artpress, November, 1987 · Bruce **Ferguson**, *Unnatural Acts*, in: Canadian Journal of Political and Social Theory, 1987 · Antonio **Guzman**, *Tony Brown: sculptures et chimères*, in: Mars, Nr. 20, Winter, 1987/1988 · Arthur **Kroker**, *Synapse Lapse*, in: Canadian Journal of Political and Social Theory, 1987 · Anne **Tronche**, *Tony Brown*, in: Opus International, Januar/Februar, 1988

MARIE JOSÉ BURKI

*Biel (CH)
Lebt/Lives in Bruxelles

Einzelausstellungen | One-man exhibitions

1989 Kunstverein, Freiburg (Kat.: L. Adert) · Shedhalle, Zürich (Kat.: H. Lux) 1991 IMEREC, Marseille · Galerie Rachel Lehmann, Genève 1992 *Videaux*, Le Creux de l'Enfer, Centre d'Art Contemporain, Thiers (Kat.: L. Léchot)

Gruppenausstellungen | Group exhibitions

1986 *Von Bildern*, Kunsthalle, Bern · Centre Culturel Suisse, Paris 1987 *Wind im Getriebe*, Galerie Grita Insam, Wien · Centre d'Art Contemporain, Genève 1988 *19&&*, Le Magasin, Grenoble · Centre d'Art Contemporain, Genève 1989 Le confort moderne, Poitiers · Swiss Intitute, New York · Zeno X Gallery, Antwerpen 1991 *Extra muros*, Musée des Beaux-Arts, La Chaux-de-fonds (et al.) 1992 Galerie Bruges la Morte, Brugge

Bibliographie | Bibliography

Periodika | Periodicals
Lysiane **Léchot**, *Deux et deux dont quatre*, in: Faces (Genève), Nr. 10, 1988 · Friedemann **Malsch**, *Marie José Burki, Eric Lanz, Videoinstallationen, Musée de Carouge*,

in: Kunstforum, Bd. 98, 1989 · Johan **Pas**, in: Forum International, Nr. 1, 1990

Videovorführungen | Videoscreenings
1984 Einhorn Kunst und Video, Basel/Elac, Lyon 1985 Fri-Art, The Kitchen, New York · Internationales Video Festival, Locarno (Unesco Preis) · Elac, Lyon · Erste internationale Video Woche, Genève · VIPER, Luzern 1986 Kunstmuseum, Bern · Alliance videoart, Valladolid · *Videonale* ORF, Wien · Foundation Danaé, Paris · 2. Videonale, Bonn · Frauen Video, MJC Saint-Gervais, Genève · *Höhenluft Videoszene Schweiz*, Kunstverein, Köln · Internationales Video Festival, Madrid 1987 S-8 und Video Festival von Québec, Montréal · World Wide Festival, Kijkhuis, Den Haag · Video Biennale, Barcelona · Kunsthaus, Zürich · Ars Electronica, Linz · Internationales Video Festival von Ljubljana · Filmer à tout prix III, Bruxelles · Zweite internationale Video Woche Genève · U-Media, Umea 1988 Le Magasin, Grenoble · Le Cargo, Grenoble · Frauen Video Festival, Montréal · 3. Videonale, Bonn (2. Preis) · Festival de la création vidéo, Clermont-Ferrand · European Media Art festival, Osnabrück · Video und Kino Festival, Taormina · Fernsehen der Deutschen und Rätoromanischen Schweiz 1989 European Media Art Festival, Osnabrück · Rassegna Internationale del Video d'Autore, Taormina · DRS, Schweiz 1991 *Silence elles tournent*, Montréal · Semaine internationale de vidéo, Genève 1992 World Wide Video Festival, Kykhuis, Den Haag · Kunstmuseum, Bern

JEAN-MARC BUSTAMANTE

*Toulouse (F), 1952
Lebt/Lives in Paris

Einzelausstellungen | One-man exhibitions

1982 Galerie Baudoin Lebon, Paris 1984 Galerie Crousel – Hussenot, Paris* 1986 Galerie Bärbel Grässlin, Frankfurt/M.* · Galerie Philip Nelson, Villeurbanne* · Musée Saint-Pierre, Lyon* 1987 Galerie Micheline Szwajcer, Antwerpen* 1988 Galerie Ghislaine Hussenot, Paris 1989 Galerie Joost Declercq, Gent · Kunsthalle, Bern (Kat.: A. Cueff, U. Loock) 1990 Museum Haus Lange, Krefeld (Kat.: J. Heynen) · Stichting De Appel, Amsterdam (Kat.: S. Bos) · Galerie Paul Andriesse, Amsterdam · *Paysages, intérieurs*, Musée d'Art Moderne de la Ville, Paris (Kat.: A. Cueff, S. Pagé) 1991 Galerie Marga Paz, Madrid · *Oeuvres Récentes/ Stationnaire II*, Galerie Ghislaine Hussenot · Galerie Samia Saouma, Paris 1992 Stedelijk Van Abbemuseum, Eindhoven

Gruppenausstellungen | Group exhibitions

1987 *L'époque, la mode, la morale, la passion*, Centre Georges Pompidou, Paris* · documenta 8, Kassel · *Die große Oper oder die Sehnsucht nach dem Erhabenen*, Bonner Kunstverein, Bonn 1989 *Fonds National d'Art Contemporain, Acquisitions 1988*, Centre National des Arts Plastiques, Paris · *Un art de la distinction*, Abbaye Saint André, Centre d'Art Contemporain, Meymac · *De Afstand*, Witte de With, Rotterdam · *Camera Works*, Galerie Samia Saouma, Paris · Institute of Contemporary Arts,

London · *Weitersehen*, Museum Haus Lange und Haus Esters, Krefeld · *La collection des oeuvres photographiques du Musée de la Roche-sur-Yon*, La Roche-sur-Yon · *Le Diaphane*, Musée des Beaux-Arts Tourcoing 1990 *Possible Worlds. Sculpture from Europe*, Institute of Contemporary Arts, Serpentine Gallery, London 1991 *Vanitas*, Galerie Crousel Robelin Bama, Paris · *Metropolis*, Martin-Gropius-Bau, Berlin · *Lieux Communs, Figures Singulières*, Musée d'Art Moderne de la Ville, Paris · *Collection du Musée de Bordeaux – Capc*, Bordeaux (* 1983–1987 Bazilebustamante)

Bibliographie | Bibliography

Bücher | Books
Stationnaire's, Galerie Philip Nelson, Lyon/ Yves Gevaert, Bruxelles, 1991

Periodika | Periodicals
Paul **Andriesse**, *Photographs by Jean-Marc Bustamante*, in: Kunst & Museumjournaal, Nr. 2, 1990 · José Luis **Brea**, *Jean-Marc Bustamante*, in: Artscribe, Sommer, 1991 · Anne **Barclay Morgan**, *Jean-Marc Bustamante at Ghislaine Hussenot and Samia Saouma*, in: Art in America, Nr. 2, Februar, 1992 · Jean-François **Chevrier**, *Jean-Marc Bustamante. Le lieu de l'Art*, in: Galeries Magazine, Februar/März, 1990 · Tony **Godfrey**, *Report from Paris 1*, in: Art in America, Oktober, 1989 · Hans-Rudolf **Heust**, *Jean-Marc Bustamante*, in: Artscribe, November/Dezember, 1989 · Mark **Kremer**, *Saskia Bos*, in: Galeries Magazine, Mai, 1990 · Marie Christine **Loriers**, *Jean-Marc Bustamante – Géométries fines*, in: Techniques et Architecture, Dezember 1991/Januar 1992 · Jérôme **Sans**, *Jean-Marc Bustamante*, in: Flash Art, Sommer, 1988 · Edna **Van Duyn**, *Een inventaris van herinneringen: Bustamante in Krefeld*, in: Archis, Nr. 3, 1990

MICHAEL BUTHE

*Sonthofen/Allgäu (D), 1944
Lebt/Lives in Köln, Marrakech

Einzelausstellungen | One-man exhibitions

1968 Galerie Ricke, Kassel 1969 Galerie Ricke, Köln · Von-der-Heydt-Museum, Wuppertal 1970 Galerie Kuhn, Aachen · Kabinett für aktuelle Kunst, Bremerhaven · Galerie Renée Ziegler, Zürich · Galerie Ernst, Hannover 1971 *Hommage an die Sonne*, Galerie Toni Gerber, Bern · Galerie Möllenhoff, Köln 1972 Galerie Möllenhoff, Köln · Galerie Volante Toni Gerber, Kabul 1973 Galerie Onze, Bruxelles · *Le Dieu de Babylone*, Kunstmuseum, Luzern · Galerie Pablo Stähli, Luzern · *Eine Reise in den Orient*, Galerie Oppenheim, Köln · Galerie Volante Toni Gerber, Kabul · Galerie Volante Toni Gerber, Kathmandu · Galerie Volante Toni Gerber, Kala Pattar 1974 *Benin-Serie*, Galerie Loeb, Bern · Galerie Vandres, Madrid · Galerie Oppenheim, Köln 1975 Galerie Magers, Bonn · *Zarathustra*, Oppenheim Studio, Köln · Galerie Abis, Berlin 1976 *Musée du Echnaton*, Künstleratelier, Köln · Forum Kunst, Rottweil 1977 Galerie ak, Frankfurt/ M. · *Tarahumaras*, Städtisches Museum Schloß Morsbroich, Leverkusen · *Hommage an einen Prinzen aus Samarkand*, Kunstmuseum, Düsseldorf 1978 Galerie Gerhild Grolitsch, München · Städtische Galerie, Ravensburg 1979 *Les Voyages de Marco Polo*, Galerie Toni Gerber, Bern · *Les Voyages de Marco Polo*, Galerie Bama, Paris · Galerie 't Venster, Rotterdam · *Du bist der Wind – ich bin das Feuer*, Harlekin Art, Wiesbaden 1980 *Die endlose Reise der Bilder*, Museum Folkwang, Essen (Kat.: M. Buthe, Z. Felix) · Kunstverein, Kassel 1981 Galerie Munro, Hamburg · Bernier Gallery, Athinai · Galerie Bama, Paris · *Il Ritorno d'Ulisse in Patria*, Galerie Toni Gerber, Bern · *Aus Selbstbildnissen*, Galerie Nächst St. Stephan, Wien 1982 Galerie Krinzinger & Forum für aktuelle Kunst, Innsbruck · Art in Progress, München · Galerie Baronian/Lambert, Gent · Gallery Holly Solomon, New York 1984 *Inch Allah*, Museum van Hedendaagse Kunst, Gent (Kat.: J. Hoet, J.Poetter) · Museum Villa Stuck, München · Galerie Munro, Hamburg · Galerie Bama, Paris 1985 Galerie Moderne Kunst Dietmar Werle, Köln · Galerie Toni Gerber, Bern · Galerie Bama, Paris 1986 Galerie Schmela, Düsseldorf · Galerie Munro, Hamburg · Galerie Bama, Paris · *Die Sonne von Taormina*, Graphisches Kabinett des Museum Ludwig, Köln (Kat. A. M. Fischer) 1987 *Tü pronse jö swie un jeune Barbar?*, Galerie Moderne Kunst Dietmar Werle, Köln 1988 *Kouki & Ramses*, Louisiana Museum of Modern Art, Humlebaek (Kat.: H. Crenzien), Galerie Pablo Stähli, Zürich · Galerie Munro, Hamburg · *Primavera Pompeijana*, Württembergischer Kunstverein, Stuttgart (Kat.: T. Osterwold, J. Schulze, N. Smolik, S. von Wiese) · *Der Vorfall mit dem Körbchen*, Galerie Moderne Kunst Dietmar Werle, Köln · Galerie Crousel-Robelin, Paris 1990 Nationalgalerie, Berlin (Kat.: B. Murphy, B. Schmitz) · Obalne Galerije, Piran 1991 *Totes Meer*, Galerie Moderne Kunst Dietmar Werle, Köln · Galerie Munro, Hamburg · Galerie Heike Curtze, Wien

Gruppenausstellungen | Group exhibitions

1987 *Die Gleichzeitigkeit des Anderen*, Kunstmuseum, Bern · Bonner Kunstverein, Bonn · *Exotische Welten – Europäische Phantasien*, Württembergischer Kunstverein, Stuttgart · Ausstellung afrikanischer zeitgenössischer Kunst, Rabat/Marokko 1988 *Biennale of Sydney* 1989 *Refigured Painting – The German Image*, Solomon R. Guggenheim Museum, New York (et al.) · *Open Mind*, Museum van Hedendaagse Kunst, Gent · *Triennale Fellbach für Kleinplastik*, Fellbach · *Akademierundgang 1950–1968*, Verbindungsbüro Nordrhein-Westfalen, Bruxelles 1991 *Erwerbungen der Graphischen Sammlung Staatsgalerie Stuttgart 1983–1990*, Staatsgalerie, Stuttgart · *Fuente*, Nieuwe Kerk, Amsterdam · *Das goldene Zeitalter*, Württembergischer Kunstverein, Stuttgart · *Versamelde werken, een hommage aan Ulises Carriou*, Centrum Beeldende Kunst, Groningen

Bibliographie | Bibliography

Texte und Bücher vom Künstler
Texts and books by the artist
Freunde/Friends, Düsseldorf, Mediacontacts, 1971 · *Lukretia begann damals gerade von der Küste weg zu ziehen*, Luzern, Edition Stähli, 1971 · *Die wunderbare Reise des Saladin Ben Ismael*, Köln, Lamuv Verlag, 1977 · *Hommage an einen Prinzen aus Sarmarkand*, in: Skulptura in Deo Fabuloso, München, Verlag Silke Schreiber, 1977/1983 · *Der Vortrag über die Schönheit des absoluten Positivismus le dernier Empire*, Museum Folkwang, Essen 1980 · *Sefhcekarramregnat etoile*, Leporello, Fotos Dietmar Werle, Kassel, Bärenreiter Verlag, 1980

Monographie | Monography
Stephan **von Wiese**, *Michael Buthe, Skulptura in Deo Fabulosa*, München, Verlag Silke Schreiber, 1983

Periodika | Periodicals
Jürgen **Glaesemer**, *Das Schönste ist, daß man überhaupt lebt*, in: Kunstforum, Bd. 93, 1988 · Juliane **Schulze**, *Le dernier secret de fatima*, in: Kunstforum, Bd. 93, 1988

PEDRO CABRITA REIS

*Lisboa, 1956
Lebt/Lives in Lisboa

Einzelausstellungen | One-man exhibitions

1986 *Da ordem e do Caos*, Comicos Gallery, Lisboa 1987 *Anima et Macula*, Galerie Cintrik, Antwerpen 1988 *A sombra na agua*, Comicos Gallery, Lisboa · *Cabeças, Arvores e Casa*, Roma e Pavia Gallery, Oporto 1989 *Melancolia*, Bess Cutler Gallery, New York (Kat.: A. Melo) 1990 *Alexandria*, Convento de S. Francisco, Beja (Kat.: P. C. R.) · Contemporary Art Foundation, Amsterdam (Kat.) · *A Casa dos Suaves Odores*, Galeria Comicos, Lisboa 1992 Galerie Andreas Binder, München

Gruppenausstellungen | Group exhibitions

1987 *Lusitanies, aspect de l'art contemporain portugais*, Centre Culturel de l'Albigeois, Albi · *Tendencias dos anos 80*, Centro de Arte de S. Joao, Madeira 1988 *Um olhar sobre a Arte Contemporanea Portuguesa*, Casa de Serralves, Oporto 1989 *Cabrita Reis, Jan Van Oost, Lili Dujouri, Ulrich Horndash*, Comicos Gallery, Lisboa · *Complex Objects*, Galeria Marga Paz, Madrid 1990 *Ponton Temse*, Museum van Hedendaagse Kunst Gent, Temse · *Cabrita Reis, Gerardo Burmeister, Nancy Dwyer, Stephan Huber*, Galeria Pedro Oliveira, Roma/Pavia, Oporto · *Carnet de voyages – 1*, Fondation Cartier, Jouy-en-Josas · *Cabrita Reis, Rui Sanches. Arte Portugues Contemporaneo I*, Fundacion Luis Cernuda, Sala de Exposiciones, Sevilla · *Ultima Frontera, 7 artistes portuguesos*, Centro de Arte Sta. Monica, Barcelona 1991 *Metropolis*, Martin-Gropius-Bau, Berlin · Galeria Juana De Aizpuru, Sevilla

Bibliographie | Bibliography

Texte vom Künstler | Texts by the artist
Un texto de Cabrita Reis, in: Spazio Umano, April 1988

Periodika | Periodicals
Pascal **Cornet**, *Het Kunstcircuit in Porto en Lissabon*, in: Kunst & Cultuur (Bruxelles), Jg. 13, September, 1991 · David **Galloway**, *Metropolis: crossroads or cul-de-sac?*, in: Art in America, Nr. 7, Juli, 1991 · Alexandro **Melo**, *Cabrita Reis*, in: Flash Art (It.), Sommer, 1988 · Alexandro **Melo**, *Quelques artistes contemporains portugais*, in: Art Press, Nr. 131, Dezember, 1988 · Alexandro **Melo**, *Pedro Cabrita Reis: Thougt Passion*, in: Artscribe, Sommer, 1991 · Norbert **Messler**, *Berlin: Metropolis*, in: Artforum, Nr. 10, 1991 · Luis **Francisco**

Perez, *Pedro Cabrita Reis*, in: Balcon, Nr. 3, 1988 · Joao **Pinharanda**, *Las lineas de partida*, in: Lapiz, Nr. 70, 1990 · Joao **Pinharanda**, *Windows on a decade*, in: Lapiz, Madrid, Nr. 70, Sommer, 1990 · Michael **Tarantino**, *Pedro Cabrita Reis*, in: Artforum, Nr. 5, Januar, 1991

WALTERCIO CALDAS

*Rio de Janeiro (BR), 1946
Lebt/Lives in Rio de Janeiro

Einzelausstellungen | One-man exhibitions

1973 *Objetos e Desenhos*, Museu de Arte Moderna, Rio de Janeiro 1974 *Objetos e Desenhos*, Galeria Luiz Buarque/Paulo Bittencourt 1975 *Esculturas, Objetos e Desenhos*, Museu de Arte, São Paulo · *Esculturas*, Galeria Luiza Strina, São Paulo 1976 *Esculturas e Objetos*, Museu de Arte Moderna, Rio de Janeiro 1979 *Objetos*, Galeria Luiza Strina, São Paulo 1980 *Instalaçao*, Galeria Saramenha, Rio de Janeiro · *Instalaçao*, Espaço ABC/FUNARTE, Rio de Janeiro 1982 *Esculturas e Objetos*, Gabinette de Arte, São Paulo · *Instalaçao*, Faculdade de Filosofia da UFRJ, Rio de Janeiro 1983 *Instalaçao*, Gabinette de Arte Raquel Arnaud, São Paulo 1984 *Esculturas*, GB-ARTE, Rio de Janeiro 1986 *Esculturas*, Paulo Klabin Galeria, Rio de Janeiro/Gabinette de Arte, São Paulo 1988 *Esculturas*, Galeria Sergio Milliet/Funarte, Rio de Janeiro · *Esculturas*, Paulo Klabin Galeria, Rio de Janeiro 1989 *Esculturas*, Gabinette de Arte Raquel Arnaud, São Paulo 1990 Galeria 110 Contemporanea, Rio de Janeiro · Pullitzer Gallery, Amsterdam 1991 Gabinette de Arte Raquel Arnaud, São Paulo · Stichting Het Kanaal, Kortrijk (Kat.: R. Brito)

Gruppenausstellungen | Group exhibitions

1987 *Arte e Palavra*, Forum de Ciência e Cultura, Rio de Janeiro · *A Ousadia da Forma*, Shopping da Gavea, Rio de Janeiro · *Imaginaros e Singulares*, Bienal de São Paulo · *Arte Imagica*, Museu de Arte Contemporânea, São Paulo · *Art Brésilien du 20e. siècle*, Musée d'Art Moderne de la Ville, Paris · *Works on Paper*, CDS Gallery, New York · *Ao Colecionador*, Museu de Arte Moderna, Rio de Janeiro 1988 *Expressao e*

Conceito Anos 70, Galeria G. Chateaubriand, Rio de Janeiro · *Modernidade*, Museu de Arte, São Paulo · *Arte Hoje BB*, Ribeirao Preto, São Paulo · *Papel no Espaço*, Galeria Aktuel, Rio de Janeiro 1989 *Rio Hoje*, Museu de Arte Moderna, Rio de Janeiro · *Caminhos*, Rio Design Center, Rio de Janeiro · *Nossos Anos 80*, GB Arte, Casa de Cultura Laura Alvim · *10 Escultores*, Gabinette de Arte Raquel Arnaud, São Paulo · *Bienal de São Paulo*, 1990 *Transcontinental*, Ikon Gallery, Birmingham/Cornerhouse, Manchester · 1992 *America*, Museum voor Schone Kunsten, Antwerpen

Bibliographie | Bibliography

Bücher vom Künstler | Books by the artist
Walterico **Caldas**, *Manual da ciência popular*, Rio de Janeiro, Funarte Ed., 1982

Bücher | Books
Ronaldo **Brito**, *Aparelhos de Waltércio Caldas*, Rio de Janeiro, GBM Editora, 1979

Periodika | Periodicals
Fernando **Cochiarali**, *Visao de um tempo suspenso*, in: Galeria (São Paulo), Nr. 17, 1989 · Oswaldo **Costa**, *Brazil's vital and active art scene*, in: The Journal of Art, September/Oktober, 1989 · Leyla **Leone**, *Interview with the artist*, in: Journal a Critica, Februar, 1992 · Edward **Liffingwell**, *Report from Brazil. São Paulo diary*, in: Art in America, Januar, 1989 · Angela **Pimento**, *Campo de Provas*, in: Revista Veja, November, 1991 · Sonia **Salzstein Goldberg**, *Desocupaçses de espaço*, in: Guia das Artes Plasticas, Nr. 8 (São Paulo), 1988 · Geris **Smith**, *The mental Carpenter of Rio*, in: Artnews, Oktober 1991

Film
1986 *Apaga-te Sésamo*, Regie: Miguel rio Branco, Produktion: Rioartes/Estudioline · *Software*, Regie: Ronaldo Tapajos, s.d.

PIER PAOLO CALZOLARI

*Bologna (I), 1943
Lebt/Lives in Fermignano

Einzelausstellungen | One-man exhibitions

1965 Sala Studio Bentivoglio, Bologna (Kat.: P.P.C., A. Napoletano) 1966 Sala Studio Bentivoglio, Bologna 1969 Galleria Sperone, Torino 1970 Galleria Sperone, Torino · Galerie Sonnabend, Paris 1971 Galerie Sonnabend, Paris · Sonnabend Gallery, New York 1972 Galleria Lucio Amelio, Napoli 1973 Galerie Folker Skulima, Berlin · Musée Galliera, Festival d'Automne, Paris 1974 Galleria Toselli, Milano · Galerie Baecker, Bochum 1975 Galleria De Domizio, Pescara · Galleria Marinucci-Russo, Torino · Galleria Multipli, Torino · Galleria Paolo Betti, Milano 1976 Galleria Toselli, Milano · Galleria Deambrogi-Cavellini, Milano · Nuovi Strumenti, Brescia · Galleria Forma, Genoa 1977 Galleria Tucci Russo, Torino · Museo Aragona Pignatelli, Napoli · Studio Cavalieri, Bologna 1978 Galleria Fata, Bologna · Galleria Sperone, Roma · Galleria Ala, Milano · Jean & Karen Bernier Galleria, Athinai (Kat.: D. Zacharopoulos) 1979 Galleria Mazzoli, Modena · Galleria Tucci Russo, Torino · Ink, Zürich · Galerie Bernier-Russo, Köln · Galerie Jean & Karen Bernier, Athinai

1980 Galleria LP 220, Torino · Galleria De Crescenzo, Roma · Cantieri Navali – Luigi Deambrogi, Venezia · Galleria Il Caprivorno, Venezia 1981 Galleria Mazzoli, Modena · Galerie Eric Fabre, Paris · Galerie Schurr, Stuttgart 1982 Galerie Knoedler, Zürich 1983 Galleria Deambrogi, Milano · Galleria Ferrari, Verona 1984 Galerie de France, Paris (Kat.: D. Zacharopoulos) · Galerie Jean Bernier, Athinai · Galerie Peter Pakesch, Wien (Kat.: D. Ronte) 1986 Galleria Giorgio Persano, Torino (Kat.: P. Volponi) · Galleria Civica, Modena (Kat.: A. Borgogelli, G. Calzolari, A. Cueff, C. David, P. Javault, L. Rogozinski) 1988 Barbara Gladstone Gallery, New York · Galleria Giorgio Persano, Torino 1989 Galerie Szwajcer, Antwerpen · Galleria Giorgio Persano, Milano · Galerie Jean Bernier, Athinai 1990 Galerie Rudolf Zwirner, Köln · Galleria Rossana Ferri, Modena (Kat.: M. Bertoni) 1991 Galerie Ghislaine Hussenot, Paris · Galleria Gentili, Firenze · Galleria Giorgio Persano, Torino

Gruppenausstellungen | Group exhibitions

1987 *Collection Sonna*, Reina Sophia, Madrid · François Lambert Galleria, Milano · Stadtmuseum, Graz · *Collection Sonnabend*, Capc, Bordeaux · *De l'Arte Povera dans les collections publiques françaises*, Musée Savoirien, Chambery, Lille/La Roche-sur-Yon · Barbara Gladstone Gallery, New York 1988 *Pier Paolo Calzolari, Jenny Holzer, Joseph Kosuth, Mario Merz, Bruce Nauman, Keith Sonnier*, Barbara Gladstone Gallery, New York · *Sonnabend Collection*, Hamburger Bahnhof, Berlin (et al.) 1989 *Sigmund Freud's apartment*, Freudhaus, Wien · *Pier Paolo Calzolari, Ulrich Rückriem, Gilberto Zorio*, Galeria Soledad Lorenzo, Madrid 1990 *Ambiente Berlin*, Biennale di Venezia, Venezia · *Le Diaphane*, Musée de Beaux Arts, Tourcoing · Galleria In Arco, Torino · *Nature (artificielle)*, Paris 1991 *Selection*, F.A.E. (Edelman), Musée d'Art Contemporain, Pully-Lausanne Museum Industriekultur, Nürnberg · *Enter Null, Kunsteis Kälte Kultur*, Stadtmuseum, München · Galleria Giorgio Persano, Torino

Performances · Aktionen | Actions

1966/67 *Il filtro Benvenuto all'angelo*, Studio Bentivolgio, Bologna 1968 *Senza titolo* 1970 *1 e secondo giorno come gli orienti sono due*, Galleria Sperone, Torino 1972/73/74 *Canto Sospeso*, Dezember 1972 (25. Min.), Bologna; Galerie Skulima (35. Min.), Berlin; Musée Galliéra (55. Min.), Paris · Galleria Toselli (60. Min.), Milano 1973 *The Glass reflects*, Berlin 1975 *Avere pallido il viso avere bianco il viso*, Galleria Lucrezia De Domizio, Pescara · Studio Paola Betti, Milano 1976 *Il Treno*, Galleria Franco Toselli, Milano 1977 *Luogo persona tempo ognuno dei quali influisce summ'altro*, Galle-

ria Tucci Russo, Torino 1978 *Appunti dei getsemani,* Galleria Tucci Russo, Torino

Bibliographie | Bibliography

Text vom Künstler | Text by the artist
Per Tema Celeste, in : Tema Celeste, Juli/August, 1987

Bücher | Books
Germano **Celant**, *Pier Paolo Calzolari,* Torino, Ed. Urbina, 1988

Periodika | Periodicals
Bruno **Corà**, *Pier Paolo Calzolari Trasformazioni iniziatiche verso la luce,* in : New Art International, März, 1989 · Daniel **Soutif**, *La famille peuvre,* in: Artstudio, Nr. 13, Sommer, 1989 · Denys **Zacharopoulos**, V. **Karcayannis**, *Le Diaphane, a concept, a collection, an exhibition, a place,* in: Arti, Bd. 3, Januar/Februar, 1991

Filme | Films
1968 Operator Gianni Castagnoli: super 8, s/w, 12 Min. · 1970 super 8, s/w, 16 Min. 1970 super 8, s/w, 6 Min. 1970 super 8, Farbe, 9 Min. · 1971 super 8, Farbe, 3 Min. 30 Sek. 1971 super 8, Farbe, 3 Min. 30 sec. 1972 super 8, s/w, 15 Min. 1972 super 8, s/w, 3 Min. 1972 super 8, s/w, 3 Min. 1972 super 8, s/w, 30 Min. 1973 doppelt, super 8, Farbe, 25 Min. 1973 doppelt, super 8, Farbe, 20 Min. 1973 super 8, Farbe, 12 Min. 1973 super 8, Farbe, 15 Min. 1971 Operator identifiziert 16 mm, s/w, 3 Min. 1974 Operator: Renato Gozzano, doppelt, super 8, Farbe (nicht montiert)

Video
Operator P. P. Calzolari, s/w, 15 Min., 1972 · Operator G. Schum, s/w, 15 Min., 1969 · s/w, 15 Min., 1971

ERNST CARAMELLE

*Hall (A), 1952
Lebt/Lives in Frankfurt/M.

Einzelausstellungen | One-man exhibitions

1975 Project Inc., Cambridge 1976 Zentrum Mozartgasse, Wien 1977 Galerie Maier, Kitzbühel 1978 Galerie Krinzinger, Innsbruck · Galerie Marika Malacorda, Genève 1979 Galerie Buades, Madrid · Galerie Nächst St. Stephan, Wien 1981 *Blätter,* Frankfurter Kunstverein, Frankfurt/M. (Kat.: J.-C. Ammann, T. Bayrle, P. Weiermair, D. Zacharopoulos) 1982 Kunsthalle, Basel · Stampa, Basel · Galleria Luigi Deambrogi, Milano · Galerie Marika Malacorda, Genève 1984 Galerie Hubert Winter, Düsseldorf/Wien · Petersen Galerie, Berlin 1986 Jack Tilton Gallery, New York (Kat.: P. Weiermair) · Kunst-

halle, Bern (Kat.: U. Loock) · Galerie Erika + Otto Friedrich, Bern · Karin Bolz Galerie, Mühlheim/R. 1987 Galerie Bama, Paris · Galerie Zeitkunst, Innsbruck · Galerie Cora Hölzl, Düsseldorf · Stichting De Appel, Amsterdam 1988 Galerie Nächst St. Stephan, Wien 1989 Galerie Erika + Otto Friedrich, Bern · Galerie Marika Malacorda, Genève · Musée départemental de Rochechouart (Kat.: G. Tosatto) · Museum Schloß Hardenberg, Velbert · Galerie Susanna Kulli, St. Gallen 1990 Gallery Shimada, Yamaguchi · Galerie Crousel-Robelin, Paris · Museum Haus Lange, Krefeld (Kat.: J. Heynen) · Nationalgalerie, Berlin 1991 University Art Museum, Berkeley 1992 Christin Burgin Gallery, New York · Crousel-Robelin, Paris

Gruppenausstellungen | Group exhibitions

1987 Museum Haus Lange, Krefeld · *Een keuze,* Kunst Rai, Amsterdam · *Malerei-Wandmalerei,* Stadtmuseum, Graz · *Actuele Kunst in Oostenrijk,* Museum van Hedendaagse Kunst, Gent · Japanisches Kulturinstitut, Köln 1988 Freizone Dorotheergasse, Wien · *In Situ,* Secession, Wien · Kunstmuseum, Düsseldorf · Germanisches Nationalmuseum, Nürnberg 1989 Kunstverein, Hamburg · Mücsarnok, Budapest · Stiftung für konstruktive und konkrete Kunst, Zürich · *Acquisitations 1989,* Centre National des Arts Plastiques, Paris 1990 *The Readymade Boomerang,* Biennale of Sydney, Art Gallery of New South Wales, Millers Point · *Weitersehen,* Museum Haus Lange und Haus Esters, Krefeld · Musée d'Art Moderne de la Ville, Paris · Musée des Beaux-Arts, Tourcoing 1991 Museum des 20. Jahrhunderts, Wien · Christine Burgin Gallery, New York · Kunsthalle, Bremen

Bibliographie | Bibliography

Bücher | Books
Zwei Arbeiten, Innsbruck, Galerie Krinzinger, 1978 · *Josef Troma schläft heute,* Frankfurt, Patio Verlag, 1978 · *Two pieces of each work,* Madrid, Galerie Buades, 1979 · *Jänner, Februar, März..,* Wien, Galerie Nächst St.Stephan, 1979 · *Forty Found Fakes,* New York, Thomas Way & Co., 1979 · *Blätter,* Frankfurt/M., Frankfurter Kunstverein, 1981 · *Öch könn jetzt nöt röden,* Hannover, Verlag Zweitschrift, 1981 · *Detail einer Totalansicht,* Berlin, Rainer Verlag, 1984 · *Katalog Galerie Hubert Winter ,* Wien/Düsseldorf, 1984 · *Marginalien,* Berlin, Petersen Galerie, 1984 · *Publication,* New York, Jack Tilton Gallery, 1986 · *Ernst Caramelle,* Kunsthalle Bern, 1986 · *Ernst Caramelle,* Musée départemental de Rochechouart, 1989 · *After Image,* Velbert, Museum Schloß Hardenberg, 1989 · *Grandeur nature,* Paris, Musée d'Art Moderne de la Ville, 1990 · *Ernst Caramelle,* Krefeld, Museum Haus Lange, 1990 · *Ernst Caramelle, Panorama der Retrospektiven,* Berlin, Rainer Verlag, 1990

Periodika | Periodicals
Jérome **Baratelli**, *Ernst Caramelle: abstraite, oui entre autres,* in: Opus International, Nr. 103, Winter, 1987 · Isabelle **Graw**, *One found take,* in: Wolkenkratzer Art Journal, Nr. 1, Januar/Februar, 1987

LAWRENCE CARROLL

*Melbourne (AUS), 1954
Lebt/Lives in New York

Einzelausstellungen | One-man exhibitions

1988 Stux Gallery, New York (Kat.: R. Pincus-Witten) · Stux Gallery, Boston 1989 Stux Gallery, New York · Galerie Ryszard Varisella, Frankfurt/M. 1990 Stux Gallery, New York (Kat.: T. R. Myers) 1991 Rontgen Kunst Institut, Tokyo · Baudoin Lebon, Paris 1992 Galerie Beaumont, Luxembourg 1993 Städtisches Museum Abteiberg, Mönchengladbach

Gruppenausstellungen | Group exhibitions

1987 P.S. 22, New York · *Miniatures,* Stux Gallery, New York · City Without Walls, Newark, New York · Sweet Briar College, Virginia · Gallery 503 Broadway, New York · Gallery 3, Hoboken · Bronx Museum, New York · Queens Museum, Flushing, New York · Phillip Stansbury Gallery, New York 1988 *The New Poverty,* Myers/Bloom Gallery, Los Angeles · *Art At the End of the Social,* Rooseum, Malmö · *Off White,* Diane Brown Gallery · Stux Gallery, New York · Karl Bornstein Gallery, Santa Monica 1989 *Einleuchten,* Deichtorhallen, Hamburg · De Rozeboomkamer, Beeld-en-Route Foundation, Diepenheim · *Pre-Pop/Post-Appropriation,* Stux Gallery, New York · Holtegaard Museum, Vedaek · Stux Gallery, New York · Galerie Ryszard Varisella, Frankfurt/M. 1990 Galerie Ghislaine Hussenot, Paris · Musée des Beaux-Arts, Bruxelles · Baltimore Sales and Rental Gallery, Baltimore · Galerie Schmela, Düseldorf · Mayor Rowan Gallery, London · *All Quiet on the Western Front?,* Galerie Antoine Candau, Paris 1991 Galerie Krinzinger, Wien 1992 *Dealing with Art,* Künstlerwerkstatt Lothringerstraße, München

Bibliographie | Bibliography

Periodika | Periodicals
Michael **Archer**, *I Don't Like Eggs: Janet Green, British Collector, On Art And The World,* in: Artscribe, Sommer, 1990 · Joshua **Decter**, *Pre-Pop/Post-Appropriation, Stux,* in: Flash Art, Nr. 146, Mai/Juni, 1989 · Michael **Ellenberger**, *Lawrence Carroll – Galerie Baudoin-Lebon,* in: Art Press, Mai, 1991 · Donald **Kuspit**, *Lawrence Carroll – Stux Gallery,* in: Artforum, Januar, 1990 · Robert **Mahony**, *Lawrence Carroll,* in: Arts, Januar, 1990 · Terrey **Myers**, *Lawrence Carroll's Boxes,* in: Arts Magazine, Dezember 1988 · Tricia **Collins**, Richard **Milazzo**, *Post-Appropriation and the Romantic Fallacy,* in: Tema Celeste, Nr. 21, Juli/

September, 1989 · Tricia **Collins**, Richard **Milazzo**, *Translations,* in: Juliet Magazine, Nr. 45, Dezember, 1989 · Tricia **Collins**, Richard **Milazzo**, *From Kant to Kitsch and back Again,* in: Tema Celeste, Januar/Februar, 1991 · Terry R. **Myers**, *Lawrence Carroll's Boxes,* in: Arts Magazine, Bd. 63, Nr. 4, Dezember, 1988 · Robert **Pincus-Witten**, *Entries: Concentrated Juice & Kitschy Kitschy Koons,* in: Arts Magazine, Februar, 1989 · David **Rimanelli**, *Pre-Pop/Post-Appropriation at Stux Gallery,* in: Artforum, Mai, 1989 · Stephan **Schmidt-Wulffen**, *Lawrence Carroll,* in: Kunstforum, Bd. 105, Januar/Februar, 1990 · Jude **Schwendenwien**, *Pre-Pop/Post-Appropriation,* in: Tema Celeste, April/Juni, 1989 · Robert P. **Vifian**, *Lawrence Carroll,* in: Galeries Magazine, April/Mai, 1991

SAINT CLAIR CEMIN

*Cruz Alta (BR), 1951
Lebt/Lives in Paris/New York

Einzelausstellungen | One-man exhibitions

1979 Galeria Projecta, São Paulo · Galeria Guinard, Porto Alegre **1980** The White Room, Hasselt **1981** Galeria Guinard, Porto Alegre · Galeria Projecta, São Paulo **1982** Galeria Projecta, São Paulo · The Red Bar, New York **1984** Beulah Land, New York **1985** Daniel Newburg Gallery, New York **1986** Daniel Newburg Gallery, New York **1987** Massimo Audiello Gallery, New York **1988** Daniel Weinberg Gallery, Los Angeles · Sperone Gallery, Roma · Rhona Hoffman Gallery, Chicago (Kat.: T. Collins, R. Milazzo) **1989** Massimo Audiello Gallery, New York · Daniel Weinberg Gallery, Los Angeles **1990** Anders Tornberg Gallery, Lund · Massimo Audiello Gallery/Sperone Westwater, New York · Galerie Thaddaeus Ropac, Paris **1991** Witte de With, Rotterdam (Kat.: S. C. Cemin) · Baumgartner Galleries, Washington DC · Hirshhorn Museum and Sculpture Garden, Smithsonian Institute, Washington DC · Daniel Weinberg Gallery, Santa Monica · Baumgartner Galleries, Washington DC (Kat.: D. Kuspit) **1992** Robert Miller Gallery, New York

Gruppenausstellungen | Group exhibitions

1987 *The Antique Future,* Massimo Audiello Gallery, New York · *Extreme Order,* Lia Rumma Gallery, Napoli · *Atlantic Sculpture,* Art Center College of Design, Pasadena · *The Ironic Sublime,* Galerie Albrecht, München · *Gallery Group Show,* Massimo Audiello Gallery, New York · *The New Poverty,* John Gibson Gallery, New York · *Similia/ Dissimilia,* Columbia University, New York (et al.) **1988** *Artschwager: His Peers and Persuasions 1963–1988,* Daniel Weinberg Gallery, Los Angeles (et al.) · *Off White,* Diane Brown Gallery, New York · *Art at the End of the Social,* The Frederick Roos Museum, Malmö · *The BiNational: American Art of the Late'80s,* Institute of Contemporary Art, Museum of Fine Arts, Boston (et al.) · *New Poverty II,* Meyers/Bloom Gallery, Santa Monica · *Saint Clair Cemin, Joel Fischer, Joel Otterson, Jon Kessler,* Massimo Audiello Gallery, New York **1989** *Horn of Plenty,* Stedelijk Museum, Amsterdam · *Melancholia,* Galerie Grita Insam,

Wien · *The Silent Baroque,* Galerie Thaddaeus Ropac, Salzburg · *Biennial Exhibition,* Whitney Museum, New York · *Objet/ Objectif,* Daniel Templon Gallery, Paris **1990** *Specific Metaphysics,* Sandra Gering Gallery, New York · *The Last Laugh: Humor, Irony, Self-Mockery and Derision,* Massimo Audiello Gallery, New York · *Saint Clair Cemin, Richard Prince and Meyer Vaisman,* Arthur Roger Gallery, New Orleans · *The Last Decade – American Artists of the 80's,* Tony Shafrazi Gallery, New York · *Culture in Pieces: Other Social Objects,* Beaver College Art Gallery, Glenside · Galerie Thaddaeus Ropac, Paris **1991** *Between Intuition and Reason: Saint Clair Cemin and Jonathan Lasker,* Grossman Gallery, School of the Museum of Fine Arts, Boston · *Desplazamientos: Aspectos de la identidad y las culturas,* Centro Atlantico de Arte Moderno, Las Palmas · *Anni Novanta,* Galleria Comunale D'Arte Moderna, Bologna · *Little Things Mean A Lot,* Momentary Modern, Amsterdam · *Contemporary Sculpture after 1970,* Fondation Daniel Templon, Frejus · *Anni '80: Artisti a New York,* Museo d'Arte Moderna e Contemporanea, Trento · *Altrove/fra immagine e identità, fra identità e tradizione,* Museo d'Arte Contemporanea Luigi Pecci, Prato

Bibliographie | Bibliography

Periodika | Periodicals

Tsipi **Ben-Haim**, *Saint Clair Cemin,* in: Sculpture, März/April, 1988 · Marja **Bosma**, *Horn of Plenty,* in: Contemporanea, Mai, 1989 · Dan **Cameron**, *Shifting Tastes,* in: Art & Auction, Nr. 2, September, 1991 · Elizabeth **Broadrup**, *Commissions: Saint Clair Cemin, Mercury Fountain, Reston, Virginia,* in: Sculpture, Nr. 5, September/Oktober, 1991 · Matthew **Collings**, *Posthumous Meaning,* in: Artscribe, September/Oktober, 1987 · Tricia **Collins**, Richard **Milazzo**, *Tropical Codes: Neue Kunst aus New York,* in: Kunstforum, Dezember 1987/Januar 1988 · Tricia **Collins**, Richard **Milazzo**, *Tracit Disruptions. Saint Clair Cemin,* in: Tema Celeste, November/Dezember, 1990 · Lynne **Cooke**, *Saint Clair Cemin,* in: Artscribe, März/April, 1988 · Holland **Cotter**, *Report fron New York: A Bland Biennial,* in: Art in America, September, 1989 · Kirby **Gookin**, *Between States of Being. Saint Clair Cemin,* in: Tema Celeste, September, 1989 · Isabelle **Graw**, *The American BiNational,* in: Flash Art, Januar/Februar, 1989 · Elizabeth **Hayt-Atkins**, *Quaesto Facti: The Sculpture of Saint Clair Cemin,* in: Arts, Dezember, 1990 · Eleanor **Heartney**, *Saint Clair Cemin at Massimo Audiello,* in: Artnews, Januar, 1988 · Kathryn **Hixon**, *Saint Clair Cemin,* in: Arts, Februar, 1989 · Memory **Holloway**, *Long-Distances Runners,* in: Art International, Bd. 24, Nr. 159, Sommer, 1991 · Christoph **Horst**, *Ratlos Schön,* in: Profil, Nr. 14, 3. April, 1989 · Gary **Indiana**, *Future Perfect,* in: Village Voice, 10. März, 1987 · Steven **Kaplan**, *Head, Heart and Hands,* in: Artfinder, Frühling, 1987 · Donald **Kuspit**, *Saint Clair Cemin,* in: Artforum, Dezember, 1990 · Kim **Levin**, *Saint Clair Cemin,* in: Village Voice, 24. November, 1987 · Markus **Liz**, *St. Clair Cemin,* in: Sculpture, September/Oktober, 1989 · Robert **Mahoney**, *St. Clair Cemin,* in: Arts, Januar, 1988 · Robert **Mahoney**, Saint Clair Cemin, *in: Arts,* September, 1989 · Carlo **McCormick**, *Saint Clair Cemin,* in: Art-

forum, Januar, 1987 · Pat **McCoy**, *The Antique Future,* in: Art International, Sommer, 1987 · George **Melrod**, *Saint Clair Cemin,* in: Artnews, Dezember, 1990 · David **Pagel**, *Blending Metaphor and Allegory,* in: Artweek, 22. April, 1989 · Lucio **Pozzi**, *Ceminal Art,* in: Artforum, Mai, 1988 · Meyer Raphael **Rubinstein**, *Saint Clair Cemin,* in: Flash Art, Nr. 155, November/Dezember, 1990 · Stephan **Schmidt-Wulffen**, *Similia/Dissimilia,* in: Flash Art, Oktober/November, 1987 · Mark **Woodruff**, *The Antique Future: Articulating the Void,* in: New Art Examiner, Juni, 1987

TOMASZ CIECIERSKI

*Crakow (PL), 1945
Lebt/Lives in Warszawa

Einzelausstellungen | One-man exhibitions

1977 Galeria Zapiecek, Warszawa **1978** Galeria Krytykow, Warszawa **1980** Jack Visser Gallery, Amsterdam **1981** Galeria Krytykow, Warszawa · Galeria MDM, Warszawa **1984** Wetering Galerie, Amsterdam **1985** Nouvelles Images, Den Haag **1986** Wetering Galerie, Amsterdam · Foksal Gallery, Warszawa **1987** Pracownia Dziekanka , Warszawa · Wetering Galerie, Amsterdam **1988** Wetering Galerie, Amsterdam · Foksal Gallery, Warszawa (Kat.: A. Morawinska) **1990** Muzeum Sztuki, Lòdz (Kat.: R. Stanislawski) **1991** Galerie des Arènes, Musée d'Art Contemporain, Nîmes (Kat.: Ch. Besson) **1992** Foksal Gallery, Warszawa · Galerie Hans Strelow, Düsseldorf · Wetering Galerie, Amsterdam

Gruppenausstellungen | Group exhibitions

1987 *Bienal de São Paolo,* São Paolo · *Aspetti dell'arte in Polonia dal 1945 al 1986,* Palazzo Venezia, Roma **1988** *Polish Realities,* Third Eye Centre, Glasgow **1989** *Art Frankfurt,* Galeria Foksal, Frankfurt/M. · *Kunst Rai,* Wetering Gallery, Amsterdam · *Polska malirska tvorba '80 ze sbirek Narodniho muzea ve Vratislavi,* Mestska Galerie, Karlovy Vary · *Supplements, Contemporary Polish Drawing,* Muzeum Sztuki, Lodz-John Hansard Gallery, Southampton **1990** *The Art of the Sixties,* Muzeum Akademii Sztuk Pieknych, Warszawa · *Junge Zeitgenössische Kunst aus Polen,* Sankt Augustin, Bonn **1991** *XX century collection of art from Museum of Art,* Lodz · Zacheta

Gallery, Warsawa · *Kunst, Europa (Polen)*, Kunstverein, Bonn (et al.) · *Eye Shot*, Nicolaj Gallery, Kobenhavn · *Positionen Polen*, Künstlerhaus Bethanien, Berlin

Bibliographie | Bibliography

Periodika | Periodicals
D. Jarecka, *Poklady*, in: Szkice, Nr. 8, 1988

TONY CLARK

*Canberra (AUS), 1954
Lebt/Lives in St. Kilda Victoria

Einzelausstellungen | One-man exhibitions

1982 Art Projects, Melbourne (Kat.: T. C) 1983 Art Projects, Melbourne (Kat.: T. C.) · Roslyn Oxley9 Gallery, Sydney 1985 Australian Centre for Contemporary Art, Melbourne 1987 Roslyn Oxley9 Gallery, Sydney · Bellas Gallery, Brisbane 1988 Roslyn Oxley9 Gallery, Sydney 1989 Institute of Modern Art, Brisbane (Kat.: T. C.) 1990 Bellas Gallery, Brisbane · Store 5, Melbourne 1991 City Gallery, Melbourne · Roslyn Oxley9 Gallery, Sydney · Store 5, Melbourne

Gruppenausstellungen | Group exhibitions

1987 *From Field to Figuration*, National Gallery of Victoria, Melbourne · *Young Australians*, Budget Collection, National Gallery of Victoria, Melbourne · *Bohemia*, Linden Gallery, Melbourne · *The Golden Shibboleth*, 200 Gertrude Street, Melbourne · *A New Romance*, Australian National Gallery, Canberra 1988 *Stories of Australian Art*, Commonwealth Institute, London/Usher Gallery, Lincolnshire 1989 *Art and Nature*, Flaxman Gallery, London · *A Question of Belief*, Contemporary Artspace, Adelaide 1990 *Believe, Scenery for a solo dance performance by Shelley Lasica*, City Gallery, Melbourne (et al.) · *Out of Asia*, Heide Park and Art Gallery · *Inland*, Australian Centre for Contemporary Art, Melbourne · *Group Show*, Roslyn Oxley9 Gallery, Sydney 1991 *Early and recent work by 8 Contemporary Artists*, City Gallery, Melbourne

Bibliographie | Bibliography

Texte vom Künstler | Texts by the artist
in: Kat. Architectura Picta, George Paton Gallery, 1984 · *Ormond College Welcomes New Art*, Ormond College, 1987 · *The Palace of Italian Civilization*, in: Art and Australia, Herbst, 1988 · *Posterity Will Judge*, in: Tension, Sommer, 1989 · *De Chirico Com 'é'*, in: Photofile, Sommer, 1990 · *Architectural Subjects*, in: Store 5, 1991 · *Howard Arkley*, Monash University Gallery, 1991 · *Acquinas*, Rosebud, 1991

Periodika | Periodicals
Carolyn **Barnes**, *Inland*, in: Art & Text, Winter, 1991 · Roger **Benjamin**, *White exits: ›Our of Asia‹*, in: Art Monthly, September, 1990

JAMES COLEMAN

*Ballaghaderreen (IRL), 1941
Lebt/Lives in Dublin

Einzelausstellungen | One-man exhibitions

1965 Molesworth Gallery, Dublin 1967 Design Studio, Amsterdam 1970 Studio Marconi, Milano 1972 Galleria Toselli, Milano 1973 Studio Marconi, Milano · David Hendriks Gallery, Dublin 1974 Cork Arts Society Gallery, Cork · Galerie 't Venster, Rotterdam · Ulster Museum, Belfast · Studio Lia Rumma, Napoli 1975 Studio Marconi, Milano (Kat.: R. Luccio) 1978 Galway Arts Festival, Galway · Projects Arts Centre, Dublin 1979 Galleria Schema, Firenze 1980 *A video installation*, Nigel Greenwood Gallery, London · Douglas Hyde Gallery, Trinity College (Becket Room), Dublin · University College Galway Art Gallery, Galway · Nigel Greenwood Gallery, Metropolitan Wharf, London 1981 Franklin Furnace, New York · Project Arts Centre, Dublin 1982 · John Hansard Gallery, University of Southampton, Southampton · *Retrospective*, Douglas Hyde Gallery, Dublin (Ulster Museum, Belfast) (Kat.: J. Fisher) · Nigel Greenwood Gallery, London · *Ignotum per Ignotius*, Lantaren Theater, Rotterdam (Shaffy Theater, Amsterdam; Concordia Theater, Enschede; Toneelschuur Theater, Haarlem; Witte Theater, Ijmuiden) 1983 Whitechapel Art Gallery, London · *The enigma of the hero in the work of James Coleman*, The Orchard Gallery, Londonderry (Kat.: J. Fisher) · Auditorio de Arquitecura, Esbal, Lisboa · Teatro Estudio Citac, Coimbra 1984 David Bellman Gallery/Art Metropole, Toronto · Douglas Hyde Gallery, Dublin · Zona, Firenze 1985 *Selected works*, The Renaissance Society, Chicago (Kat.: M. Newman, A. Rorimer) · Dunguaire Castle, Co. Clare, Galway 1986 Institute of Contemporary Arts, London (cfr. *Selected works*, Chicago, 1985) 1987 Rüdiger Schöttle Galerie, München · Galerie Johnen & Schöttle, Köln 1988 Galerie des Beaux-Arts, Bruxelles 1989 List Visual Arts Center, MIT, Boston · Musée d'Art Moderne de la Ville, Paris (Kat.: J. Coleman, F. Migayrou) · Stedelijk Van Abbemuseum, Eindhoven (Kat.: J. Debbaut, F. Lubbers) 1990 Art Gallery of York University, Ontario (Kat.: D. Tuer) · Galerie Micheline Szwajcer, Antwerpen · Galerie des Beaux-Arts, Bruxelles 1991 Marian Goodman Gallery, New York · Lisson Gallery, London · Musée d'Art Contemporain, Lyon · One Five, Antwerpen

Gruppenausstellungen | Group exhibitions

1987 *Uit het Oude Europa*, Stedelijk Museum, Amsterdam · *The Analytical Theatre, New Art from Britain*, ICI, New York (et. al.) · *Dark/Light*, Mercer Union YYZ Gallery, Toronto 1988 *Michael Asher/James Coleman*, Artists Space, New York · *Rosc '88*, Guiness Hop Store, Royal Hospital, Kilmainham, Dublin 1989 *Theatre Garden Bestiarium*, Institute of Contemporary Arts, P.S.1., Long Island City, New York · *A Photo Show: a Selection*, Marian Goodman

Gallery, New York · *Cultural and Commentary*, Hirshhorn Museum, Washington DC 1990 *A new Necessity*, First Tyne International, Queensway North, New Castle · *Culture and Commentary*, Hirshhorn Museum, Washington DC · *Lignes de mire*, Fondation Cartier, Jouy-en-Josas · *65–75 Aspetti e Pratiche dell'Arte Europea*, Castello di Rivara, Torino · Marian Goodman Gallery, New York · Galerie des Beaux-Arts, Bruxelles · *Le Diaphane*, Musée des Beaux-Arts, Tourcoing · *Irish Art*, The European Dimension 1991 *The Projected Image*, Museum of Modern Art, San Francisco · *Inheritance and Transformation*, The Irish Museum of Modern Art, Dublin · *Places with a Past*, Spoleto Festival, Charleston · Marian Goodman Gallery, New York · *Carnegie International*, Carnegie Museum of Art, Pittsburgh

Bibliographie | Bibliography

Periodika | Periodicals
Lieven van den **Abeele**, *From the Europe of old*, in: Artefactum, Nr. 22, 1988 · Fiona **Dunlop**, *Contemporary Visions of Utopia*, in: Art International, Nr. 12, Herbst, 1990 · Liam **Gillick**, *Time Flies*, in: Artscribe, Nr. 88, September, 1991 · Luk **Lambrecht**, in: Artscribe, Nr. 79, Januar/Februar, 1990 · Christian **Leigh**, *James Coleman*, in: Artforum, Nr. 3, November, 1988 · Frank **Lubbers**, *The Illusion of Reality in the Work of James Coleman*, in: Kunst & Museum Journal, Nr. 4, 1990 · Friedemann **Malsch**, *James Coleman*, in: Artefactum, Nr. 39, Juni/Juli/August, 1991 · Tony **Reveaux**, *Fleeting Phantoms: The Projected Image at SFMOMA*, in: Artweek, 28. März, 1991 · Dieter **Schwarz**, *Charon*, in: Parkett, Nr. 25, September, 1990

TONY CONRAD

*Concord/New Hampshire (USA), 1940
Lebt/Lives in Buffalo

Einzelausstellungen | One-man exhibitions

1967 Yale University 1969 New York University 1971 Millenium Film Workshop, New York · Museum Modern Art, New York · Whitney Museum of American Art, New York 1972 Abaton-Kino, Hamburg · Albright College, Reading · Arsenal, Berlin · Cinémathèque Suisse, Lausanne · Collectif Jeune Cinéma, Paris · documenta 5, Kassel · Forum für aktuelle Kunst, Innsbruck · Freiburg University, Freiburg · Galerie Friedrich, München · The Kitchen, New York · London Filmmakers‹ Cooperative · Millenium Film Workshop, New York · Osterreichisches Filmmuseum, Wien · Undependent Film Center, München · X-Screen, Köln · Yale University 1973 Antioch College, Yellow Springs · The Kitchen, New York · Millenium Film Workshop, New York · SUNY, Binghamton · Syracuse University 1974 Carnegie Institute Museum of Art, Pittsburgh · Harvard University · Media Study/Buffalo · Millenium Film Workshop, New York · SUNY, Binghamton · SUNY, Buffalo · Walker Art Center, Minneapolis · Wright State University, Dayton 1975 Minneapolis College of Art and Design · SUNY, Buffalo · Walker Art Center, Minneapolis · Whitney Museum of American Art, New York 1976 Berks Film-Makers‹ Coope-

rative, Reading · Kent State University · Millenium Film Workshop, New York · NAME Gallery, Chicago · Pittsburgh Film-Makers · Sarah Lawrence College **1977** Boston Film and Video Foundation · CEPA Gallery, Buffalo · *documenta 6*, Kassel · Hallwalls, Buffalo · The Kitchen, New York · Media Study/Buffalo · SUNY, Buffalo **1978** Bard College · Eye Music, San Francisco **1978** Bard College · Eye Music, San Francisco · Mills College, San Francisco · Mills College, Oakland · Oasis, Los Angeles · Film Forum, Pasadena · Art Institute, San Francisco · San Francisco State College · SUNY, Buffalo · SUC, Buffalo · SUC, Fredonia · Survival Arts Media, Jamestown · UCSC Los Angeles · University Museum, Berkeley (Pacific Film Archives) · Visual Studies Workshop, Rochester **1979** Artspace, Peterboro · *Beau Fleuve*, Paris/Lyon/Marseille · Gallery 219 (installation), SUNY, Buffalo · Hallwalls Gallery (installation), Buffalo · Hallwalls Gallery (performance), Buffalo · The Kitchen (performance: *New Music New York*), New York · Ohio State University, Columbus · P.S. 1 (performance: *New Music Performances at P.S. 1*) · SUNY Film and Video Festival, New Paltz · Workspace, Albany **1980** The Cinematheque, San Francisco Art Institute · Collective for Living Cinema, New York · The Kitchen Center (performance), New York · LAICA (performance), Los Angeles · Museum of Modern (Video: *Projects: Video XXXII*), New York · Pacific Film Archive · Film Forum, Pasadena · Rhino Records (audiotapes), Los Angeles · UCSD (performance, film program in faculty show) **1981** Antioch College · Detroit Film Project, Focus Gallery, Detroit · Media Study/Buffalo · Toledo Media Project, University, Toledo **1982** Boston Film/Video Foundation, Boston · Kent State University · Real Art Ways, Hartford · SUNY/Binghampton · SUC, Brockport **1983** Anthology Film Archives · Artists Present Artists (performance), New York · City Center, Denver · Point Blank (media, audiotape, six shows), New York · Rocky Mountain Film Center, Boulder · School of the Art Institute, Chicago **1984** The Catskill Center for Photography, Woodstock · CEPA Gallery, Buffalo · Creative Time (performance), New York · Hallwalls, Buffalo · Millenium Film Workshop, New York · Tonawanda Council on the Arts, North Tonawanda **1986** *Suburban Discipline + Fun* (Installation/Video), The Artists Gallery, Buffalo · SUNY Film/Video Festival (Video) · Boston Film/Video Foundation (Video) **1987** *Video Viewpoints*, Museum of Modern Art, New York **1988** *Meet the Makers*, Donell Library, New York · Rierson Technical Institute, Toronto · Collective for Living Cinema, New York · SUNY (Dept. of Media Study), Buffalo, · *Tony Conrad Early Minimalism*, SUC, Buffalo · *Early Minimalism: February 1965* (Solo Performance with tape), Herbert F. Johnson Museum, Cornell University **1989** Nova, Loyola University, New Orleans **1990** *Video Visions*, WNY Analytical Society **1991** Video Retrospective, The Kitchen, New York

Gruppenausstellungen | Group exhibitions
Seminare · Vorträge | Lectures · Performance

1987 *Network Society and Personal Pluralism* (Seminar), Japan 87 Film/Video Festival, Tokyo · *Network Society and Personal Pluralism*, Museum of Modern Art, New York · Super Seminar, SUNYAB Dept. of Art

and History · *Paradox and Alternative Media*, Keynote Address, Media Alliance Annual Conference, Borough of Manhattan Community College/CUNY · *Fighting Illegability in Japan* (lecture), Squeaky Wheel Media Coalition, Buffalo **1988** *Infermental 7*, Buffalo (et al.) · Great Lakes Film and Video Festival, Milwaukee · *Waterfront Video*, Dortmund · *Other Versions (Perversions)*, Artists Space, New York · Forty-Second Western New York Exhibition, Albright-Knox Art Gallery, Buffalo · Residency and video Production workshop, Rierson Polytechnic institute, Toronto · *Jam Session*, Hallwalls, Buffalo · *Media Buff: Media Art in Buffalo, New York* (Installation, lecture), The Herbert F. Johnson Museum of Art, Cornel University · *Exit Post Modernism: The Ground Floor*, Media Alliance Conference, American Film Institute · *Post Currents*, SUNY, Buffalo · New Music America Festival (performance): *Early Minimalism: March 1965*), Miami · *Media Migration: Videotapes by Filmmakers*, Cinematheque, San Francisco · 4ème Manifestation Internationale Vidéo et de Télévision, Montbeliard · European Media Arts Festival, Osnabrück · *Eyes on the Arts*, Letchworth Cable Access Program · *The Other Sex*, Hallwalls, Buffalo **1989** *The Battle of the Nile* (performance), Katharina Cornell Theater, SUNY, Buffalo · The Relative Violin Festival, Berlin · *Forget the Big Idea*, Collective for Living Cinema, New York · *Cinder(ella)s*, Pfeiffer Theater, Buffalo · *Songbooks* (performance), The Clocktower, New York · *What to Do When Your Old Tapes Don't Play Anymore*, Fast Rewind: The Archaeology of Moving Images, Rochester · Media and Education: 1989 National Alliance of Media Arts Centers Conference, Rochester · Western New York 1989, Albright-Knox Art Gallery, Buffalo · *Forget the Big Idea-Recent Video from Buffalo*, Collective for Living Cinema, New York · *Optical Pop: Opening the Mind's Eye*, Harvard Film Archives · The 11th Annual San Francisco Art Institute Film and Video Festival, San Francisco · *Infermental 9*, Wien · *The Tragedy of Structuralism*, Music Gallery, Toronto · *Infermental 9*, Berlin Film Festival (et al.) **1990** Panelist on play by Richard Mennen, Alleyway Theater, Buffalo · Pannelist on *Video Witness* program at Hallwalls, Buffalo · Museum of Modern Art, New York · *History*, Hallwalls, Buffalo · Public Access Cable Television (PACT), Museum of Science, Buffalo · *Traversals: Instructions to the Double*, Museum of Art, Long Beach (et al.) · Panelist at *Common Ground*, New York Foundation for Arts, The Arts Council of Buffalo, Erie County · Panelist/speaker, Media Alliance Annual Conference, Ithaca · Panelsit/speaker, *The Controversy, SUNY, New Paltz* (sponsored: University wide Programma in the Arts) **1991** *In Western New York, 1991*, Albright-Knox Art Gallery, Buffalo · *Infermental 9*, Buffalo (et al.) · *Video Witnesses, 1991*, Hallwalls, Buffalo · Première gala: film program of four short works, Big Orbit Gallery, Buffalo · Panelist *The First Amendement Goes to War*, SUNY, Buffalo, The Kiva · *Mind and Body Control*, Chicago Filmmakers · Panelist, *On Censorship*, Alumni Association, SUNY, Buffalo

Kabel-Fernsehen | Cable Television

1991/92 *Studio of the Streets*, special edition; also visiting artists on series *Insight in Media*, Lockport Cable Commision, Lockport · »*Artwaves*«, Lafayette Square, TCI Cable Channel 32, Buffalo · Program: *Studio of the Streets* co-poducer), TCI Cable Channel 32, Buffalo · »*8 mm News*«, Lafayette Square, New Diaries (Parts I, III), *Riddle of the Mysterious Missing Station*, *Delivering Petitions to david Rutecki*, *Bicycle Safety Announcement*, *Public Access Policy Board Meetings*

Ton | Sound

1963 *Flaming Creatures* **1964** *Chumlum* **1965** Incidental music for Ronald Travel's *Shower* **1973** Taped realization of new Theater Strategy Festival

Bibliographie | Bibliography

Texte und Bücher vom Künstler
Texts and books by the artist
Inside the Dream Syndicate, et alia, in: Film Culture, Nr. 41, 1966 · *Three Loops for Performers and Tape Recorders* (1961 composition excerpt), in: John Cage, *Notations*, New York, Something Else Press, 1969 · *Filmmaker's Statement*, Experimental Film Symposium catalog, Oxford, Ohio, Miami University, 1975 · *Shadow File*, in: Kat. Luminous Realities, Dayton, Ohio, Wright State University, 1975 · *Non-Linguistic Extensions of Film and Video*, in: Quarterly Review of Film Studies, 1, Nr. 3, August, 1976 · *A Few Remarks Before I Begin*, in: The Avant-Garde Film, Ed. P. Adam Sitney, New York, N.Y.U. Press, 1978 · *Diegesis and Violence in Narrativity*, in: Phos, 1, Nr. 2 (1978), SUNY, Buffalo · *At Last, Real Movies: Super-8 Cinema from New York*, in: The Journal, Nr. 27, Los Angeles, LAICA, Juni/Juli, 1980 · *Knowing with Television*, in: Kat. Afterimage, 1983 · *The Eye and the Asshole: Otto Mühl and the Extremes of Vienna, 1960*, in: The Underground Film Bulletin, Nr. 5, 1986 · *L'Intégral*, Trans, Yann Beauvais, Deke Dusinberre, Musique, Cinémathèque Française, Paris, 1986 · *Integer: Bulldozing a foundation in the culturesque of sound, media and performance*, in: Cinematography, San Francisco Cinematheque, Bd. 2, 1986 · *The Longest Wave/Joe Gibbons*, in: Kat. Living in the World Super 8: The Last Frontier, s.d. · *Old Open-Reel Videotape Restoration*, in: Hallwalls circular to the field, März, 1987 · *Can Artists Work with Advanced Technologies*, in: The Squealer (Buffalo), Mai, 1987 · *A Propaedeutic for Active Viewing*, in: Media Active, Sommer, 1987, in: The Squealer, Februar, 1987 · *Paradox and Altenative Media: Marketing Social Criticism, Institutionalizing Artistic Independance, (Dis)Organizing for Alienation*, in: Image News, Atlanta: Image Film/Video Center, Januar, 1988; in: Media Alliance, NYC, Media Alliance, November/Dezember, 1987 · *Open Reel Videotape Restoration*, in: The Independant, Foundation for Independant Video and Film, Nr. 10, 1987 · *Literature and Revolution*, in: The Squealer, Nr. 9, 1987 · *Theory – The People's Foe*, in: New Observations, Nr. 44, s.d. · *Catching Video at Home and Abroas*, in: Kat. Infermental 7, Buffalo, Hallwalls, 1988 · *Network Society and personal Pluralism*, in: The Squealer,

Januar/Februar, 1988 · *Exit Post-Modernism: The Ground Floor,* in: The Squealer, Januar/Februar, 1989 · *Early Minimalism: Works for Solo Violin with Strings,* in: Inventionen ›89, Berlin, Festival Neuer Musik, Akademie der Künste, Berlin, 1989 · *Dolomite: Having No Trust in Readers,* in: Kat. Media Ruff : Media Art of Buffalo, New York, Ithaca, Herbert F. Johnson Museum of Art, 1988 · *Catching Up to Video at Home and Abroad/Early Minimalism: February 1965,* in: Kat. Ars Electronica 1988, Linz, LIVA, 1988 · *Armor -Piercing Electronics Art Incoming at UB: Post Currents/A gallery of Electronic Art,* in: The Squealer, Dezember 1988/Januar 1989 · *Duke, Duke, Duke, Duke of Erl: Grahama Weinbren and Roberta Friedman, The Erl King,* in: The Squealer, Nr. 5/6, 1989 · *Polar Strategies,* in: The Squealer, Januar/Februar, 1990 · *Video as Opposition: Remodeling Postmodern Media,* in: Motion Picture III, Winter 1989/1990 · *Censorship Nostalgia: The Artpark Bust, A Season Later,* in: The Squealer, Februar, 1991

Bücher | Books
T.C., D. **Hartline,** *Flexagons,* RIAS Monograph, Baltimore, Maryland, Research Institute for Advanced Study, 1962 · T.C., Barbara **Broughel,** *The Animal,* Buffalo, 1984

Video | Film
1987 *The Poetics of TV* (A Trilogy), 24 Min. **1988** *Redressing Down,* video, 18 Min. · *That Faraway Look,* video, 25 Min. · *Paroptikon,* video installation **s.d.** *Cinders,* Scene V, video, Janusz Glowacki's play **1990** *No Europe,* video, mit Chris Hill, 14 Min. · *Safe Arca,* mit Julie Zando, film installation, Studies Workshop, Rochester · *True Stories Window,* 15 Buffalo artists, First Night, Buffalo · *Teletheory,* Gregory Ulmer, SUNY, Buffalo · *Crash Music,* SUNY, Buffalo (documentation of lecture by Arthur & Mary Louise Kroker), SUNY, Buffalo **1991** Authorized to Surrender, compilation: *Sanapshot History, The Subject is Sex(un)less: Spotting Gender, Praxis Spaces, The Science of Observing* · *Bicycle Safety Announcement,* co-prod. Richard Wicks, 16 Min. · *The Flicker,* Video, 23 Min. (1966/1991) · *Lafayette Square,* Cable TV doc., 27 Min. · *Long-shot/run/dead* (in progress, 1986-), Part I (copleted), 11 Min. · *Lookers* (in progress, 1984-), Pilot segment, 3 Min. · *Studio of the Streets,* programs I – XLII, TCI Channel 32, mit Cathy Steffan · Group productions in collaboration with the 8 MM News Collective, Nine half-hour program: *New Diaries, Riddle of the Mysterious Missing Station, Delivering Petitions to David Rutecki, Public Access Policy Board Meetings, Bikes Not Bombs, Wind/Solar Energy Fair · Alert,* First Night Buffalo, M&T Bank Windows, M&T Plaza

PATRICK CORILLON

*Knokke (B), 1959
Lebt/Lives in Liège/Paris

Einzelausstellungen | One-man exhibitions

1985 Galerie du Cirque Divers, Liège **1986** *Que Reste-t-il...,* Centre Wallon d'Art Contemporain **1987** *Vie et Mort des Noms d'Artistes,* Musée d'Art Moderne, Liège **1988**

Galerie Etiennne Ficheroulle, Bruxelles · Galerie Véga, Liège-Plainevaux **1989** Galerie Etienne Ficheroulle, Bruxelles · Studio Marconi 17, Milano · *Gare de Courtrai, 150 ans,* Stichting Het Kanaal, Kortrijk · *Hubert D...,* Musée d'Art Contemporain, Dunkerque **1990** Parcours dans le parc de la Fondation Cartier, Jouy-en-Josas · Galerie Albert Baronian, Bruxelles **1991** Galerie Tanya Rumpff, Haarlem · Galerie des Archives, Paris **1992** Studio Marconi, Milano · Produzentengalerie, Hamburg · Galerie Albert Baronian, Bruxelles

Gruppenausstellungen | Group exhibitions

1988 *Kunst Rai,* Galerie Véga, Amsterdam · *Vraiment Faux,* Fondation Cartier, Jouy-en-Josas **1989** Galerie Tanya Rumpff, Haarlem · *Les Grâces de la Nature,* Frac – Pays de Loire, Clisson · *Evitez de réveiller vos correspondants,* Galerie 't Venster, Rotterdam · *Fables et Récits,* La Basse, Levallois-Perret, Paris · *Atlantique,* Galerie Chambre Blanche, Québec **1990** *Collection Georges et Stéphane Uhoda,* Palais des Beaux-Arts, Charleroi · *La Collection,* Vereniging voor het Museum van Hedendaagse Kunst, Gent · Centre d'Art Contemporain de Guérigny, Nevers · Galerie Jean-François Dumont, Bordeau · *Zoersel 90,* Museum van Hedendaagse Kunst, Zoersel · *Cent ans d'art Belge,* Grande Arche de la Défense, Paris · *La Collection II,* Museum van Hedendaagse Kunst, Antwerpen · Galerie Nouvelles Images, Den Haag · *Eurégio,* Aquarium de Liège · *Belgique, une nouvelle génération,* Frac – Pays de Loire, Clisson · Galerie Air de Paris, Nice · Galerie Bitter-Larkin, New York · Galerie Jean-François Dumont, Bordeaux · Ancienne Etablissemnet Sacré, Liège · *Au Commencement,* Centre d'Art Contemporain de Guéigny, Nevers **1991** *Affinités Sélectives VIII,* Palais des Beaux-Arts, Bruxelles · *Escales,* Ile de Milliau, Côtes d'Armor · *Night Lines,* Centraal Museum, Utrecht · *Top 50,* Espace Lyonnais d'Art Contemporain, Lyon · *Kunst Europa,* (Belgien) Kunstverein für die Rheinlande und Westfalen , Düsseldorf (et al.) · *La Collection III,* Museum van Hedendaagse Kunst, Antwerpen · *Top 50,* ELAC, Lyon · Espace Lulay, Liège · *Signes de Belgique,* Fine Arts Museum, Paipei (el al.) · *Mit Worten ein Bild bereiten,* Ludwig Forum, Aachen (et al.) ·

Grandes Lignes, Gare de l'Est, Paris · Shedhalle, Zürich **1992** *Il faut construire L'Acienda,* CCC, Tours · Galerie Jean Bernier, Athinai · *Hexapla,* Galerie Equilibrist, Sint Niklaas · *Selectie Belgische Kunstenaars voor DOCUMENTA IX,* Museum Dhondt-Dhaenens, Deurle

Bibliographie | Bibliography

Texte und Bücher vom Künstler
Texts and books by the artist
Que Reste-t-il, Identités, 1986 · *Vie et Mort des Noms d'Artistes,* Véga, 1987 · *Livre Bleu,* Ficheroulle, 1989 · *Antoine Wiertz,* in: Beaux-Arts Magazine, Mai, 1989 · *The Transparency Effect,* in: Flash Art, November/Dezember, 1990 · *Le Rapport Langston,* in: Beaux-Arts Magazine, Dezember, 1990 · *Le Musée Jacques Lizène,* in: Artefactum, Februar/März, 1991 · *Der Streit um den Patroklos,* in: Jahresring, Nr. 38, Oktober, 1991 · *Souvenir du Passage d'Oskar Serti sur L'Ile Milliau,* Côtes-d'Armor, 1991

Periodika | Periodicals
Nicolas **Bourriaud,** *Patrick Corillon,* in: Artefactum, Nr. 38, April/Mai, 1991 · Marie-Ange **Brayer,** *Quelques notes sur P.C.,* in: Art & Culture, Nr. 9, Mai, 1990 · René **Debanterlé,** *Patrick Corillon, Sculpteur des deux espaces,* in : Artefactum, Nr. 26, November/Dezember, 1988 · Edith **Doove,** *Mit Worten ein Bild bereiten,* in: Artefactum, Nr. 43, Februar/März, 1992 · Anthony **Iannacci,** *Patrick Corillon,* in : Artforum, Dezember, 1989 · Bernard **Marcadé,** *Patrick Corillon éthologue de l'art,* in : Art Press, Nr. 160, Sommer, 1991 · Meyer Raphael **Rubinstein,** *Patrick Corillon,* in : Art in America, September, 1991 · Eric **Troncy,** *Patrick Corillon,* in : Flash Art, Nr. 159, Sommer, 1991 · Christine **Vuegen,** *Literatuur en sculptuur bij Patrick Corillon,* in : Kunstbeeld, Oktober, 1990

Film · Video
Jacinthe, RTBf, 1988

DAMIAN

*Bucarest (RO), 1922
Lebt/Lives in Paris

Einzelausstellungen | One-man exhibitions

1942 Ateneul, Bucarest **1943** Sala Dalles, Bucarest **1945** Ateneul Român, Bucarest **1952** Galerie Arnaud, Paris **1953** Galerie Arnaud, Paris **1957** Galerie Stadler, Paris · Leo Castelli Gallery, New York **1958** Galerie Stadler, Paris · Galerie 22, Düsseldorf **1959** Galleria dell'Ariete, Milano **1960** Galerie Michel Warren, New York **1961** Galerie des Beaux-Arts, Bruxelles **1962** Galerie Stadler, Paris · Cordier-Warren Inc., New York · Neue Galerie im Künstlerhaus, München **1963** Robert Fraser Gallery, London **1964** Galerie Stadler, Paris (Kat.: P. Restany) **1965** *Les vingt-cinq pyramides de Damian,* Galerie Stadler, Paris **1968** Galerie Stadler, Paris (Kat.: R. Varia) **1969** *Cinq constructions de Damian,* Galerie Stadler, Paris **1970** Städtisches Museum, Trier **1972** *Les grandes constructions,* Musée d'Art Moderne de la Ville, Paris (Kat.: J. Lassaigne, R. Varia) **1974** *Galaxy,* Neue Galerie – Sammlung Ludwig,

Aachen (Kat.: G. C. Argan, W. Becker, S. Dali, R. Varia) 1975 *20 desenhos para 5 monumentos fantasticos,* Museo do Arte Moderna, Rio de Janeiro (Kat.: R. Varia) 1976 *The Hill,* Solomon R. Guggenheim Museum, New York (Kat.: R. Varia) 1978 Galerie Stadler, Paris · *3 peintures, 8 dessins,* Galerie Denise René, Paris (Kat.: R. Varia) 1979 Galerie Der Spiegel, Köln · Galerie Nouvelles Images, Den Haag (Kat.: H. D.) 1980 *Le Projet de San Francisco,* Centre Georges Pompidou, Paris (Kat.: P. Hulten, R. Varia) · Bank of America/The Art Institute of San Francisco, San Francisco · Galerie Stadler, Paris · Galerie Denise René, Paris 1981 Galerie Raphael, Frankfurt/M. 1983 *Les symboles du lieu, l'habitation de l'homme,* Grand Palais, Paris (Les Cahiers de L'Herne, Nr. 44 : J. P. Faye, G. Liicanu, P. Sollers, C. Tacou, R. Varia) 1984 Galerie Nouvelles Images, Den Haag 1986 Galerie Gilbert Vrownstone, Paris · Elisabeth Frank Gallery, Knokke (Kat.: J. Parvulesco) 1987 Galerie Raphael, Frankfurt/M. 1990 Galerie Jacqueline Moussion, Paris (Kat.: R. Varia) 1991 Galerie Jacqueline Moussion, Paris

RICHARD DEACON

*Bangor, Wales (GB), 1949
Lebt/Lives in London

Einzelausstellungen | One-man exhibitions

1978 *Studio Exhibition,* 52 Acre Lane, London 1980 *Spring Programme,* The Gallery, 52 Acre Lane, London 1981 Sheffield City Polytechnic Gallery, Sheffield 1983 Lisson Gallery, London · Orchard Gallery, Londonderry (Kat.: L. Cooke) 1984 Riverside Studios, London · Chapter Gallery, Cardiff · Fruitmarket Gallery, Edinburgh (Le Nouveau Musée, Lyon-Villeurbanne) (Kat.: M. Newman) 1985 Donald Young Gallery, Chicago (mit/with Tony Cragg) · *Five Recent Sculptures,* Tate Gallery, London (Kat.: R. Francis) · Le Centre International du Verre, Aix-en-Provence · *Sculptors' Drawing* (mit/with Jacky Winsor), Margarete Roeder Fine Arts, New York · *Blind, Deaf and Dumb: An Installation in Collaboration with Richard Roger and John Tchalenko,* Serpentine Gallery, London 1986 Marian

Goodman Gallery, New York · Interim Art, London · Galerie Arlogos, Nantes (Kat.: M. Enrici) · *For Those Who Have Eyes: Richard Deacon Sculpture 1980–85,* Aberystwyth Arts Center (et al.) (Kat.: R. Deacon) 1987 Lisson Gallery, London · Bonnefantenmuseum, Maastricht (Kunstmuseum Luzern; Fundació Caixa de Pensions, Madrid; Museum van Hedendaagse Kunst, Antwerpen) (Kat.: A. van Grevenstein, C. Harrison, M. Kunz) 1988 Marian Goodman Gallery, New York (Kat.: P. Schjeldahl) · *3 Sculptures,* Ecole des Beaux-Arts, Macon · *Prints and Drawings,* Lisson Gallery, London · Carnegie Museum of Art, Pittsburgh, (Art Gallery of Ontario, Toronto) (Kat.: J. Caldwell, L. Cooke, R. D., M. Newman, P. Schjeldahl) · *Richard Deacon. Distance no Object,* Museum of Contemporary Art, Los Angeles · *Sculpture in the Garden,* Tate Gallery, London 1989 Whitechapel Art Gallery, London · *Metal and Wood,* Bonnefantenmuseum, Maastricht (Kat.: R. D.) · Marian Goodman Gallery, New York/Lisson Gallery, London (Kat.: P. Schjeldahl) · Kunstmuseum, St. Gallen · *New Sculpture,* Art Centre, Plymouth · *Richard Deacon. 10 sculptures 1987/89,* Musée d'Art Moderne de la Ville, Paris (Kat.: S. Pagé, J. Sans) 1990 *Richard Deacon. Nye Arbeider/New Works,* Kunsternes Hus, Oslo (Kat.: R. D.) · *Sculpture,* Marian Goodman Gallery, New York · Galleria Locus Solus, Genova · Moderna Galerija, Mala Galerija, Ljubljana (Kat.: M. Newman) 1991 *Drawings 1974–91,* Mead Gallery, University of Warwick, Coventry · *Skulpturen und Zeichnungen,* Museum Haus Lange und Haus Esters, Krefeld (Kat.: J. Heynen), Galerie Konrad Fischer, Düsseldorf · *Foursome,* Lisson Gallery, London 1992 *Three recent works,* Lisson Gallery, London

Gruppenausstellungen | Group exhibitions

1987 *Skulptur Projekte Münster,* Westfälisches Landesmuseum, Münster · *Casting An Eye,* Cornerhouse, Manchester · *A Quiet Revolution: British Sculpture since 1968,* Museum of Contemporary Art, Chicago (et al.) · *Current Affairs: British Painting and Sculpure in the 1980's,* Museum of Modern Art, Oxford (et al.) · *Juxtapositions, Recent Sculpture from England and Germany,* P.S. 1, New York · *British Art of the 1980's: 1987,* Liljevalchs Konsthall, Stockholm (et al.) · *Anderer Leute Kunst,* Museum Haus Lange, Krefeld 1988 *Schlaf der Vernunft,* Museum Fridericianum, Kassel · *British Now: Sculpture et Autres Dessins,* Musée d'Art Contemporain, Montréal · *Starlit Waters: British Sculpture,* Tate Gallery, Liverpool · *Britannica: 30 Years of Sculpture,* Musée des Beaux-Arts André Malraux, Le Havre (et al.) · *From the Southern Cross: Biennale of Sydney,* Art Gallery of New South Wales, Sydney · *Rosc '88,* Guinness Hope Store, Dublin · *Made to Measure,* Kettle's Yard, Cambridge · *Something Solid,* Cornerhouse, Manchester · *Art in the Garden: The Glasgow Garden Festival,* Glasgow · *Six Sculptors,* St. Louis Art Museum, St. Louis 1989 *Britse sculptuur 1960/1988,* Museum van Hedendaagse Kunst, Antwerpen 1990 *Weitersehen,* Museum Haus Lange und Haus Esters, Krefeld · *For a Wider World,* The British Council, London · *Terskel I/Threshold I,* Museet for Samtidskunst, Oslo · *Frank Auerbach, Lucian Freud, Richard Deacon,* The Saatchi

Collection, London · *Reiner Bergman, Richard Deacon, Imi Knoebel,* Philippe Casini, Paris · *Now for the Future,* Hayward Gallery, London · *Robin Collyer, Richard Deacon, Richard Monnier,* Galerie Arlogos, Nantes · *Affinities and Intuitions,* Art Institute of Chicago, Chicago · *A Group Show,* Marian Goodman Gallery, New York · *New Works for different Places: Four Cities Project,* Arts Centre, Plymouth · *British Art Now: A Subjective View,* Setegaya Museum, Tokyo (et al.) 1991 *Inheritance and Transformation,* New Museum of Contemporary Art for Ireland, Dublin · *La Sculpture contemporaine après 1970,* Fréjus · *Carnegie International,* Carnegie Museum of Art, Pittsburgh · *Jean Marc Bustamante, Richard Deacon, Katharina Fritsch, Ettore Spalletti, Jan Vercruysse,* Galleria Locus Solus, Genova · *Acht Entwürfe für die Landspitze,* Städtische Galerie, Nordhorn

Bibliographie | Bibliography

Texte und Bücher vom Künstler
Texts and books by the artist
Stuff Box Object, November 1970-December 1970, I first met Paul..., Published by St. Martin's School of Art, 1972 (re-ed. and publ. Chapter Arts Centre, Cardiff, 1984) · *Presentation to the Department of Design* (with Peter Venn), Royal College of Art, 1975 · *Notes on a Piece of Sculpture,* in: Journal of the Royal College of Art, Nr. 1, Januar, 1977 · *Notes on a Painting by Poussin,* Royal College of Art, 1977 · *The Department of Environment Media,* in: Journal of the Royal College of Art, Nr. 2, 1977 · *Richard Layzell at Acme,* in: Artscribe, Nr. 8, 1977 · *David Pye,* in: Artscribe, Nr. 10, Februar, 1978 · *Martin Smith, Forms Around a Vessel,* in: Crafts, Nr. 53 · *Catalogue Statement,* The South Bank Show, London, 1982 · *Sara Radstone, Ceramics,* in: Crafts, Nr. 62 · *Richard Slee, Katherine Virgils,* BBC Newsletter, Mai/Juni, 1984 · *Statements: Richard Deacon,* in: Link, Nr. 39, Juli/August, 1984 · *Carol McNicoll, An Appreciation* (Kat.), Crafts Council, 1985 · *Richard Deacon Talking About For Those Who Have Ears No. 2 and other works,* Patrons of New Art, London, 1985 · *Sculpture and National Identity* (Kat.), Sonsbeek, 1986 · *Meaning Making, Making Meaning. Recent Works by Anne Lydiate* (Kat.), Ikon Gallery, Brimingham, 1987 · *Introduction,* in: (Kat.) Casting An Eye, Cornerhouse, Manchester, 1987

Periodika | Periodicals
Brook **Adams,** *Richard Deacon at Marian Goodman,* in: Art in America, Januar, 1987 · Juan Vincente **Aliaga,** *Richard Deacon, Metafora y estructura del objeto,* in: Lapiz, Nr. 41, 1987 · Michael **Anderson,** *Richard Deacon at the Museum of Contemporary Art,* in: Art Issues, April, 1989 · Barry **Barker,**

Richard Deacon, Lisson Gallery London, in: Flash Art, Bd. 135, Sommer, 1987 · Mary Rose **Beaumont**, *Beyond Tradition: Sculpture Since Caro,* in: Art & Design, Februar, 1987 · Mary Rose **Beaumont**, *Richard Deacon,* in: Arts Review, April, 1987 · Christiane **Bergob**, *Brief aus London,* in: Kunstforum, Juni/Juli, 1987 · Patricia **Bickers**, *In the Mind's Eye,* in: Art Monthly, Mai, 1987 · Christoph **Blase**, *Schlaf und Stress der Vernunft,* in: Wolkenkratzer Art Journal, Nr. 3, 1988 · Monica **Bohm-Duchen**, *Lijn, Ackling, Wentworth, Deacon,* in: Art Monthly, Mai, 1987 · Paul **Bonaventura**, *An Introduction to Recent British Sculpture,* in: Artefactum, September/Oktober, 1987 · David **Carrier**, *Richard Deacon in Pittsburgh,* in: Arts Magazine, Nr. 2, Oktober, 1988 · Richard **Cork**, *Richard Deacon,* in: Art & Design, Nr. 11/12, 1987 · John **Cornall**, *Very Like a Whale: Meaning in the Sculpture of Richard Deacon,* in: Alba, Nr. 6, Winter, 1987 · David **Deitcher**, *Art on the Installation Plan,* in: Artforum, Nr. 5, Januar 1992 · Régis **Durand**, *Richard Deacon le grand „fabricateur",* in: Art Press, Bd. 134, März, 1989 · Michel **Enrici**, *Richard Deacon: Un Pan de Labeur, Inestimable,* in: Galeries Magazine, Bd. 30, April/Mai, 1989 · William **Feaver**, *Richard Deacon,* in: Vogue, März, 1987 · Jan **Foncé**, *Richard Deacon,* in: Artefactum, Bd. 25, September/Oktober, 1988 · Paul **Frédérick**, *Richard Deacon: un exercice d'auto-critique d'art,* in: Artstudio, Bd. 10, Herbst, 1988 · John **Furse**, *TSWA: Plymouth Update,* in: Art Monthly, Nr. 141, November, 1990 · Pierre **Giquel**, *Exposition Richard Deacon, Galerie Arlogos, Nantes,* in: Art Press, Februar, 1987 · Brian **Hatton**, *Richard Deacon Whitechapel, London,* in: Flash Art, Mai/Juni, 1989 · Judith **Higgins**, *Britain's New Generation,* in: Art News, Dezember, 1987 · Heinz-Norbert **Jocks**, *Weitersehen,* in: Kunstforum, Bd. 111, Januar/Februar, 1991 · Olivier **Kaeppelin**, *L'agoni au jardin,* in: 303: La Revue des Pays de la Loire, Nr. 13, 1987 · Jane **Lee**, *Glasgow Garden Festival,* in: Art Monthly, September, 1988 Adrian **Lewis**, *Interpreting Contemporary Art,* in: Artscribe, April, 1991 · Michael **Phillipson**, *Richard Deacon at Interim Art,* in: Artscribe, Januar/Februar, 1987 · Jörg **Restorff**, *Richard Deacon,* in: Kunstforum, Juli/August, 1991 · Junichi **Shioda**, *Here's to Art! The Spirit of John Bull,* in: Geijutsu Shincho, Oktober, 1990 · Richard **Shone**, *London, Whitechapel. Sculpture by Richard Deacon,* in: Burlington Magazine, Februar, 1989 · Mona **Thomas**, *Richard Deacon: Portrait,* in: Beaux-Arts, Nr. 66, März, 1989 · Paul **Usherwood**, *Deacon and Wodiczko on Tyneside,* in: Art Monthly, Februar, 1991

THIERRY DE CORDIER

*Oudenaarde (B), 1954
Lebt/Lives in Schorisse

Einzelausstellungen | One-man exhibitions

1987 Galerie Joost Declercq, Gent · De Lege Ruimte, Brugge 1988 Galleria Grazia Terrible, Milano 1989 Galerie des Beaux-Arts, Bruxelles 1991 Galerie des Beaux-Arts, Bruxelles

Gruppenausstellungen | Group exhibitions

1987 *Skulptur Projekte Münster,* Westfälisches Landesmuseum, Münster · *Copers, De Cordier, Geys, Lohaus, Matthys, Van Isakker, Wery,* Elac, Lyon 1988 *Armoede, Toeval, Vergankelijkheid,* Broeltorens, Kortrijk · *Images et mages,* Centre Culturel de l'Albigeois, Albi · *Crucifixion Malheureuse,* Puycelsi 1989 *Einleuchten,* Deichtorhallen, Hamburg · *Open Mind,* Museum van Hedendaagse Kunst, Gent 1990 *Weitersehen,* Museum Haus Lange und Haus Esters, Krefeld · *Artisti della Fiandra,* Palazzo Sagredo, Venezia 1991 *1951–1991, Een tijdsbeeld,* Palais des Beaux-Arts, Bruxelles · *Un détail immense,* Palais des Beaux-Arts, Charleroi · *L'Art en Belgique Flandre et Wallonie au XXè siècle,* Musée d'Art Moderne de la Ville, Paris · *Inscapes,* Stichting De Appel, Amsterdam · *Espacio Mental,* Ivam, Centre del Carme, Valencia 1992 *Letters,* Christine Burgin Gallery, New York · *Selectie Belgische Kunstenaar voor DOCUMENTA IX,* Museum Dhondt-Dhaenens, Deurle

Performances

1985 *Performance,* Museum van Hedendaagse Kunst, Gent 1988 *J'ai décidé de couper ma langue,* Piazza del Duomo, Milano

Bibliographie | Bibliography

Bücher vom Künstler | Books by the artist
Ecrits, ou Les petites pensées d'un philosophe auto-didacte, Bruxelles, Yves Gevaert, Editeur, 1991

Periodika | Periodicals
Lieven Van den **Abeele**, *Hortus Conclusus ou comment l'artiste belge cultive son jardin intérieur,* in: Artstudio, Nr. 18, Herbst, 1990 · Bart De **Baere**, *Thierry de Cordier, Wereldverbeteraar,* in: Metropolis M, Februar/März, Nr. 1, 1989 · Jan **Braet**, *Onmenselijk menselijk. Stellingname over kommunikatie door jonge Belgische kunstenaars in de Brusselse Beaux-Arts Galerij,* in: Knack, 31. August, 1988 · Nathalie **Ergino**, *Thierry de Cordier,* in: Beaux-Arts, Dezember, 1990 · Luk **Lambrecht**, *Vervreemding,* in: Knack Weekend, 11. April, 1989 · Arlette **Lemonnier**, *La juste valeur*

des choses, in: Art & Culture, Februar, 1989 · Bert **Popelier**, *de Cordier,* in: Kunst & Cultuur, März, 1989 · Riki **Simons**, *Thierry de Cordier stuurt berichten aan zichzelf de wereld in,* in: Avenue, April, 1990 · Michael **Tarantino**, *Thierry de Cordier,* in: The Bulletin, 30. März, 1989 · Michael **Tarantino**, *Thierry de Cordier. Galerie des Beaux-Arts,* in: Artforum, Sommer, 1989 · Piet **Vanrobaeys**, *Thierry de Cordier. Emigratie naar het innerlijke. Over de nietigheid van de mens in het universum en over de zinloosheid van het zijn,* in: Artefactum, November/Dezember 1990/Januar 1991

SILVIE & CHÉRIF DEFRAOUI

*St. Gallen/Genève (Ch), 1935/1932
Leben/Live in Vufflens-Le-Château

Einzelausstellungen | One-man exhibitions

1975 Galerie Gaëtan, Genève 1976 *Jardins éxotique,* Galerie Gaëtan, Genève (Kat.: S. & C. D.) · *Estuaire,* Galerie Arte Arena, Zürich · *Lieux de mémoire,* Centre d'art contemporain, Cité Universitaire, Genève 1977 *Perquisicion: el tango,* Galerie »G«, Barcelona · *Archétypes & artifices,* Galerie Cadaquès, Cadaquès 1978 *Rooms,* Centre d'art contemporain, Genève · *La Route des Indes,* Galerie Quadrum, Lisboa 1979 *Cartographie des contrées à venir,* Musée Soares dos Reis et Centre d'art contemporain, Porto · *Performances secrètes,* Centre d'art contemporain, Genève 1981 *Indices de variation,* Raum für aktuelle schweizer Kunst, Luzern · *Les instruments de divination,* Centre d'art contemporain, Genève 1982 Galerie Med a Mothi, Montpellier 1983 Metronom, Barcelona · *Conversations sur un radeau,* Galerie Grita Insam, Wien (Kat.: S. & C. D. 1984 *Elementare Begegnungen,* Galerie Corinne Hummel, Basel 1985 *Figures,* Musée cantonal des Beaux-Arts, Lausanne (Kat.: D. Zacharopoulos) · Galerie Marika Malacorda, Genève 1986 *Et si la terre perdait son pouvoir d'attraction,* Fondació Juan Miró, Barcelona · *La Querelle des Images,* Centre d'art contemporain, Midi-Pyrénées, Toulouse (Kat.: S. & C. D., D. Zacharopoulos) 1987 *Bilderstreit,* Kunsthalle, St. Gallen (Kat.: C. Schatz) · *Orient/Occident,* La Criée, Halle d'art contemporain, Rennes (Centre d'art contemporain/Musée Rath, Genève) (Kat.: J. Benzakin, P. L. Tazzi) 1988 Centre d'art culturel Suisse, Paris · Galerie Arlogos, Nantes · Galerie Rosenberg, Zürich 1989 *Oosten/Westen,* Museum van Hedendaagse Kunst, Antwerpen (Kat.: P. L. Tazzi, D.Zacharopoulos) · Centre de Création Contemporaine, Tours 1990 Galerie Grita Insam, Wien · Vleeshal, Middelburg (Kat.: F. Vande Veire) · Galerie Rosenberg, Zürich · Villa Arson, Nice (Kat.: H. R. Reust) · Galerie Insam-Gleicher, Chicago · Galerie Albert Baronian, Bruxelles 1991 Kölnischer Kunstverein, Köln · Stadtgalerie, Saarbrücken (Videobänder S. & C. D.) · Kunstverein, St. Gallen

Gruppenausstellungen | Group exhibitions

1987 *Périgrinations,* Musée de Vence · *Quai des Pêcheurs, 12 expositions individuelles,* Artel, Strasbourg · *Cinq pièces avec vue,* (Installation »La nuit les chambres sont plus grandes«), 2ème semaine in-

ternationale de la video, Genève **1988** *Sculptures de chambre,* Galerie Marilena Bonomo, Bari (et al.) · *Swiss video Festival,* Swiss Institute, New York · Galerie Rosenberg, Zürich · *7ème Salon d'art contemporain,* (Installation, »La traversée du Siècle«), Bourg-en-Bresse · *Schriftzeichen-Bildformen,* Galerie Ernesto + Krips, Köln **1989** *Triennale Fellbach,* (Kleinplastik in der Schweiz), Fellbach · *Chefs-d'oeuvres du Musée cantonal des Beaux-Arts. Regards sur cent tableaux,* Musée cantonal des Beaux-Arts, Lausanne · *Taormina Arte,* (Installation), Taormina, Sicilia · *Dimension: Petit, l'art suisse entre petite sculpture et objet,* Musée Cantonal des Beaux-Arts, Lausanne · *Unikat und Edition Künstlerbücher in der Schweiz,* Helmhaus, Zürich · *Fictions,* Aéroport international de Mirabel, Montréal **1990** *Noli me tangere,* Musée de Sion · *Le Diaphane,* Musée des Beaux-Arts, Tourcoing **1991** *Tabula rasa,* Fontana de la Justice, Bienne · *Autrement dit,* La Planche, Fribourg · *Furor/Parkett,* Vieille Charité, Marseille · *Swiss Dialectic,* The Renaissance Society, Chicago · *Argusauge,* Königsplatz, München

Performances

1975 *Le piu ricche nazioni del mondo...,* Biennale di Venezia, Venezia **1976** *L'art dans l'information, l'information dans l'art,* Biennale d'art suisse, Musée cantonal des Beaux-Arts, Lausanne **1977** *Copier/Recopier, une anthologie photographique...,* Galerie Gaëtan, Genève; Gesamthochschule, Kassel; Biennal de São Paulo (Prix Arrudo-Perreira) · Western-Front, Vancouver **1978** *Une espace parlé,* Galerie Gaëtan, Genève **1979** *Les vitrines,* Galerie Gaëtan, Genève **1980** *16 Lehrstücke: ich habe alles fotografiert,* Fotoforum, Gesamthochschule, Kassel **1981** *Lieux en transit,* Galerie Gaëtan et Ecole supérieure d'art visuel, Genève **1982** *La querelle des images,* vidéo-collage pour la Télévision suisse romande; Raum für aktuelle schweizer Kunst, Luzern; Filiale, Basel **1983** *Akustische Bilder,* Kunstmuseum, Bern **1984** *Fragments de films et de vidéos,* ateliers média mixtes S. & C. Defraoui, Kunstmuseum, Luzern **1987** *Quand voir c'est faire,* Palais de l'Athenée, Genève

Bibliographie | Bibliography

Texte und Bücher von den Künstlern
Texts and books by the artists
Lieux de mémoire, in: Kat. Centre d'art contemporain, 1975 · *Chronologiques,* in: Skira Annuel, 1975 · *Mythographie,* Genève, Ed. Galerie Gaëtan, 1976 · *Los misterios de barcelona,* Genève, Ed. Gaëtan, 1976 · *Perquisition: el tango,* Cadaquès, Ed. Galerie Cadaquès, 1977 · *Puerto de cadaquès,* Coll. »Les vrais itinéraires et les faux points de vue«, Cadaquès, Ed. Galerie Cadaquès, 1977 · *Barcelona en General,* Barcelona, Ed. Galerie G, 1977 · *Place of memory No. VIII,* in: Kat. Europe in the Seventies, The Art Institute, 1977 · *D'un jardin à l'autre,* in: Kat. Le jardin, lectures et relations, Musée Royal des Beaux-Arts, Bruxelles, 1977 · *Performances secrètes,* Genève, Ed. centre d'art contemporain, 1978 · *Mercedes/Benz,* in: Kat. Masculin/Féminin, Trigon 79, Neue Galerie, Graz, 1979 · *Instruments de divination,* in: Furor, Nr. 1, 1980 · *Instrumente zum Hellsehen* (Fragmente deren Formen

den Sinn bestimmen), in: Photo-noPhoto, Kunstverein, Mannheim, 1981 · *Fragments d'entretien I,* (Mirages automatiques...), ESAV, 1981 · *Conversations sur un radeau,* Genève, Ed. Centre d'art contemporain, 1982 · *Anlass zur Unruhe,* in: Photo recycling Photo, Kassel, Ed. Universität Kassel, 1982 · *Les formes du récit,* in: Kat. Tartar Gallery, Edinburgh, 1983 · *Fragments d'entretien II,* (Visions en mouvement), Ed. ESAV, 1984 · *Images sous tension,* in: Kat. Ed. Pro Helvetia, Zürich, 1984 · *Films et vidéo-collagen,* in: Video & Filme aus Genf, Basel, Ed. Einhorn, 1984 · *Lettre à Ulrich Loock,* in: Kat. Von Bildern, Kunsthalle, Bern, 1986 · *Fragments d'entretien IV,* in: 2ème semaine internationale de vidéo, Genève, 1987 · *Le point sur l'écran,* in: Genlock, Genève, 1987 · *La fontaine de la Justice,* in: Kat. Tabula rasa, Bienne, 1991 · *Dix questions à une jeune artiste,* in: Gespräche Interview Texte, in: Kat. Charmer, Räume, Kunst an Ort, Zug, 1991 · *Fragments d'entretien V,* in: Das offene Kunststadium, Bern, Benteli Verlag, 1991 · *Übergang,* in: Kat. Argusauge, München, 1991

Bücher | Books
Periodika | Periodicals
Liliana **Albertazzi,** *Silvie & Chérif Defraoui, ORIENTE/OCCIDENTE?* in: Contemporanea, Nr. 7, 1989 · Liliana **Albertazzi,** *Silvie et Chérif Defraoui,* in: Lapiz (Barcelona), Nr. 57, März, 1989 · Lynda **Barckert,** *Silvie and Chérif Defraoui,* in: Artscribe, November/Dezember, 1990 · Patrick **Beurard,** *Silvie et Chérif Defraoui, entre orient des géométries et occident des figures,* in: Opus International, Nr. 105, Herbst, 1987 · Kathryn **Hixson,** *Silvie and Chérif Defraoui,* in: Arts Magazine, November, 1990 · Patrick **Jeavault,** *Silvie et Chérif Defraoui,* Centre culturel suiss, in: Art Press, Nr. 124, 1988 · Elisabeth **Lebvici,** *Silvie et Chérif Defraoui,* in: Beaux-Arts Magazine, Nr. 54, Februar, 1988 · Lysianne **Lechot,** *Silvie et Chérif Defraoui,* in: Beaux-Arts Magazine, Nr. 65, Februar, 1989 · Gloria **Moure,** *Silvie et Chérif Defraoui,* in: Artforum, Oktober, 1987 · Corinne **Schatz,** *Silvie et Chérif Defraoui, La Querelle des Images,* in: Artefactum, Nr. 19, 1987 · Corinne **Schatz,** *Silvie et Chérif Defraoui,* in: Artis (Bern), November, 1991 · Max **Wechsler,** *Silvie & Chérif Defraoui, ORIENTE/OCCIDENTE?* in: Arena (Madrid), Nr. 7, 1989 · Max **Wechsler,** Roman Hollen-

stein, Jean-Luc Daval, *Silvie et Chérif Defraoui,* in: Kunstforum, Bd. 106, März/April, 1990

Filme/Films · Video

1975 *Chronologie,* film Installation, S8, Centre d'Art Contemporain, Genève **1976** *Estuaire,* film Installation, S8, Galerie arte Arena, Zürich **1977** *Lieux de mémoire, Room,* film Installation, S8, Galerie G, Barcelona · *Perquisition, el tango,* film Installation, S8, Cadaquès, Galerie Cadaquès · *Barcelona en general,* film Installation, S8, Galerie G, Barcelona **1979** *La Route des Indes,* Film Installation, S8, Centre d'Art Contemporain, Oporto (Kat.: S. & C. Defraoui) · *Cartographie des contrées à venir,* 16 Min., Farbe **1980** *Les formes du récit,* 9 Min., Farbe **1981** *Les instruments de divinations,* Video Installation, Centre d'Art Contemporain, Genève · *Les instruments de divination,* 60 Min., Farbe **1983** *Mirador,* 12 Min., Farbe **1985** *Les cariatides I,* Fridericianum, Kassel, Video Installation **1986** *Les cariatides II,* Höhenluft, Video Installation, Köln · *Homme-Femme-Serpent,* 11 Min., Farbe **1987** *La nuit les chambres sont plus grandes,* Video Installation, semaine internationale de la vidéo, Genève **1988** *La traversée du siècle,* Video Installation, Musée Rath, Genève **1991** *Exposition/Surexposition,* 17 Min., Farbe · *Le jour les chambres sont plus petites,* Video Installation, Galerie Baronian, Bruxelles

RAOUL DE KEYSER

*Deinze (B), 1930
Lebt/Lives in Deinze

Einzelausstellungen | One-man exhibitions

1965 Galerie Drieghe, Wetteren · Galerij Kaleidoskoop, Gent **1966** Galerie Les Contemporains, Bruxelles **1967** Celbeton, Denderdmonde · Galerie M.A.S., Deinze **1968** Galerij Kaleidoskoop, Gent **1969** Galerie Les Contemporains, Bruxelles (Kat.: J. Dypréau) **1970** Galerie Denise-Emmanuel, Bruxelles · Korrekelder, Brugge · Galerie Richard Foncke, Gent · Koninklijk Museum voor Schone Kunsten, Antwerpen · Groninger Museum, Groningen (Frans Halsmuseum/De Hallen, Haarlem; Noordbrabants Museum, 's Hertogenbosch) (Kat.: P. Vries, Roland Jooris) **1971** Plus-Kern, Gent **1972** Galerij Ado, Bonheiden · Grafiek 50, Wakken · Plus-Kern, Gent **1973** Aksent, Waregem · Provinciaal Begijnhof, Hasselt **1974** Stedelijk Van Abbemuseum, Eindhoven · De Mangelgang, Groningen **1975** Aksent, Waregem · Elsa von Honolulu Loringhoven Galerie, Gent · Neue Galerie, Atrium, Aachen **1976** De Mangelgang, Groningen · Grafiek 50, Wakken **1977** Galerie Drieghe, Wetteren · Wittepoppetoren, Hasselt **1978** Galerie Jeanne Buytaert, Antwerpen · Galerie Jean Leroy, Paris · Museum van Hedendaagse Kunst, Gent **1979** Galerie Waalkens, Finsterwolde · Das Belgische Haus, Köln (Kat.: R. Jooris) **1980** Galerie Declercq, Knokke · Galerie Jeanne Buytaert, Antwerpen · Internationaal Cultureel Centrum, Antwerpen (Kat.: W. V. Mulders, H. Van Pelt) **1982** Kunsthandel Lambert Tegenbosch, Heusden/Maas · Galerie Richard Foncke, Gent **1983** Vereniging Aktuele Kunst Gewad, Gent **1984** Villa des Roses, Gent **1985** Dam

43, Middelburg · Galerij Drieghe, Wetteren · Galerij Ado, Bonheiden **1986** Museum Dhondt-Dhaenens, Deurle (Kat.: B. D. Baere) · Palais des Beaux-Arts, Bruxelles (Kat.: K. J. Geirlandt) · Kunsthalle (mit : Guillaume Bijl, Jan Vercruysse, Lili Dujourie), Bern (Kat.: U. Loock, B. Cassiman) **1987** Vereniging voor het Museum van Hedendaagse Kunst, Gent (Kat.: O. Hamerlynck) · Villa des Roses, Gent · CIAP, Hasselt · De Lege Ruimte, Brugge · Plus-Kern, Bruxelles **1988** Galerij Minnen, Dessel · Galerie Basket, Middelburg · Bellamy 19, Vlissingen (Kat.: R. Jooris) · Zeno X Gallery, Antwerpen **1989** Groeningemuseum, Brugge · Zeno X Gallery, Antwerpen **1990** Wewerka & Weiss Galerie, Berlin · Museum van Deinze en de Leiestreek, Deinze (Kat.: R. Jooris) · **1991** Zeno X Gallery, Antwerpen · Kunsthalle, Bern · Portikus, Frankfurt/M. (Kat.: U. Loock, K. König, U. Wilmus, D. De Vos, P. Robbrecht) · Kunstverein, Arnsberg **1992** Wewerka & Weiss Galerie, Berlin · Galerie Rüdiger Schöttle, Paris

Gruppenausstellungen | Group exhibitions

1987 *Na Beervelde,* Provinciaal Museum voor Moderne Kunst, Oostende **1988** *Na Beervelde,* Museum Van Bommel-Van Dam, Venlo **1990** *Beeldenstorm 1990,* De Beyerd, Breda · *Artisti della Fiandra,* Palazzo Sagredo, Venezia · *Ponton Temse,* Museum van Hedendaagse Kunst Gent, Temse · *De Collectie Alsnoch,* Provinciaal Museum, Hasselt · *De Verzameling II,* Museum van Hedendaagse Kunst, Antwerpen · Galerie Peter Pakesch, Wien **1992** *Selectie Belgische Kunstenaars voor DOCUMENTA IX,* Museum Dhondt-Dhaenens, Deurle

Bibliographie | Bibliography

Bücher | Books
Roland Jooris, *Raoul de Keyser: het samengaan van gegeven en schilderij,* Tielt, Visueel, 1972 · Roland Jooris, *Raoul De Keyser, nota najaar '73,* Deinze, De Muyter, 1973 · Roland Jooris, Wijnand Sengers, *Raoul de Keyser 1979–1985,* Bruxelles, Museumfonds, 1986 · Dirk De Vos, *Raoul de Keyser, Malmédy series 1981–1983, een keuze voor het Groeningemuseum* (Brugge), Astene, 1989

Periodika | Periodicals
Jan Braet, *Onder de apebroodboom,* in: Knack, 19. Juli-25. Juli, 1989 · Dirk De Vos,

Raoul De Keyser. Confrontatie Bogart – De Keyser – Swimberghe – Van Severen, in: Stedelijke Musea Brugge, Informatiebulletin, Jg. 8, Nr. 1, Januar, 1988 · Roland Jooris, *Raoul De Keyser, een portret,* in: Ons Erfdeel, Jg. 30, Nr. 3, Mai/Juni, 1987 · Ilse Kuycken, *Meester van het afwegen,* in: Knack, Jg. 21, Nr. 22, 29. Mai – 4. Juni, 1991 · Luk Lambrecht, *Raoul De Keyser,* in: Forum International, Bd. 2, Nr. 10, November/Dezember, 1991 · Wijnand Sengers, *Een keuze uit het bulletin van nieuwe teken- en schilderkunst,* in: Metropolis M, Nr. 1, 1990

WIM DELVOYE

*Wervik (B), 1965
Lebt/Lives in Gent/Bruxelles

Einzelausstellungen | One-man exhibitions

1986 Plus-Kern, Bruxelles **1988** Galerie Riekije Swart, Amsterdam · Galleria Andrea Murnik, Milano · Galerie Plus-Kern, Bruxelles **1989** Galerie Bébert, Rotterdam **1990** Jack Tilton Gallery, New York · Galleria Andrea Murnik, Milano **1991** Sonnabend Gallery, New York · Galerie Faust, Genève · Art Gallery of New South Wales, Sidney · Castello di Rivoli, Rivoli (Kat.: G. Verzotti)

Gruppenausstellungen | Group exhibitions

1987 *Plus-Kern 1969–1986,* Vereniging voor het Museum van Hedendaagse Kunst, Gent **1988** *Confrontatie & Confrontaties,* Museum van Hedendaagse Kunst , Gent · *Zin en Beeld,* Museum Het Kruithuis, 's Hertogenbosch **1989** *Six Flemish Artists,* Jack Tilton Gallery, New York · *The European Avantgarde,* Freedman Gallery, Buffalo · *Groeten uit Utrecht,* Centraal Museum, Utrecht · Museum van Hedendaagse Kunst, Gent · *Haut Pays-Bas,* Halle Sud, Genève · *Exuberantie,* Groninger Museum, Groningen **1990** *Avec,* Centre d'Art Contemporain A.P.A.C., Nevers · *Blau, Farbe der Ferne,* Heidelberger Kunstverein, Heidelberg · *Aperto,* Biennale di Venezia, Venezia · *Artisti della Fiandra,* Palazzo Sagredo, Venezia (Museum van Hedendaagse Kunst, Gent) · *Belgique, une nouvelle Génération,* FRAC/Pays de Loire, Clisson · *Zoersel '90,* Zoersel · *Confrontationes,* Museo Español de Arte Contemporaneo, Madrid **1991** *Kunst, Europa (Belgien. Niederlande. Luxemburg)* Kunstverein für die Rheinlande und Westfalen, Düsseldorf (et al.) · *Anni Novanta,* Galleria Comunale d'Arte Moderna, Bologna · *Buchstäblich,* Van der Heydt-Museum, Wuppertal/Kunsthalle Barmen, Wuppertal-Elberfeld · *Desplaziamentos,* Cientro Atlantico de Arte Moderno, Las Palmas de Gran Canaria · *Altrove,* Museo de Arte Contemporanea, Prato **1992** *Selectie Belgische Kunstenaars voor DOCUMENTA IX,* Museum Dhondt-Dhaenens, Deurle

Bibliographie | Bibliography

Periodika | Periodicals
Nicolas Bourriaud, *Wim Delvoye,* in: Galeries Magazine, Nr. 41, Februar/März, 1991 · Germano Celant, *The Inside Skinside,* in: Artforum International, Sommer, 1991 · Gretchen Faust, *Wim Delvoye,* in: Arts Magazine, April, 1991 · Luigi Meneghelli, *Wim Delvoye,* in: Flash Art, Juni/Juli, 1991 · Michael

O'Rourke, *Wim Delvoye,* in: Arts Magazine, Mai, 1990 · Dirk Pultau, *Wim Delvoye,* in: Artscribe International, November/Dezember, 1989 · Dirk Pultau, *Wim Delvoye,* in: Arena Internacional de Arte, Dezember, 1989 · Jos Vandenbergh, *Wim Delvoye,* in: Flash Art, November/Dezember, 1989 · Piet Vanrobaeys, *Wim Delvoye,* in: Artefactum, Juni/Juli, 1989 · Gorgio Verzotti, *And our Carnival Bones…,* in: Artforum, September, 1990

BRACO DIMITRIJEVIĆ

*Sarajevo (YU), 1948
Lebt/Lives in London/Paris

Einzelausstellungen | One-man exhibitions

1958 Galerija RU Djuro Djakovic, Sarajevo **1969** Galerija SC, Zagreb (Kat.: B. D.) **1970** Galerija 212, Belgrado · Aktionsraum, München **1971** Modern Art Agency, Napoli · Galerija Suvremene Umjetnosti, Zagreb **1972** Situation Gallery, London · Galerie Konrad Fischer, Düsseldorf **1973** Museum of Contemporary Art, Zagreb (Kat.: B. D., C. Tisdall) · Situation Gallery, London **1974** Galleria Gian Enzo Sperone, Torino · Galleria Françoise Lambert, Milano **1975** Palais des Beaux-Arts, Bruxelles · Städtisches Museum Mönchengladbach (Kat.: J. Cladders) · Robert Self Gallery, London · Museum of Temporary Art, Albiolo · Sperone Gallery, New York **1976** Galerie René Block, Berlin · Galleria Gian Enzo Sperone, Torino · *Tale of an artist and a castle,* Kabinett für aktuelle Kunst, Bremerhaven (Kat.: B.C.) **1977** Robert Self Gallery, Newcastle · Nuovi Strumenti, Brescia · Galleria Civica d'Arte Moderna, Modena · Galerie Hetzler + Keller, Stuttgart **1978** Centre d'Art Contemporain, Genève · Ecart, Genève · Galerie MTL, Bruxelles **1979** Stedelijk Van Abbemuseum, Eindhoven (Kat.: R. H. Fuchs) · Museum and Schloßpark Charlottenburg, Berlin · London Underground Stations · Badischer Kunstverein, Karlsruhe (Kat.: M. Schmalriede, M. Schwarz) · Kunsthalle, Tübingen (Kat.: C. Weyergraf) · Institute of Contemporary Arts, London (Kat.: S. Kent) **1980** Tvornica Peter Velebit, Belgrado **1981** *New Culture-*

scapes, Waddington Galleries, London (Kat.: D. Brown) 1982 Galerija Roman Petrović, Sarajevo (Kat.: J. Denegri) · Deweer Art Gallery, Otegem (Kat.: J. Hoet) 1983 Zooloski vrl/Zoologischer Garten, Sarajevo 1984 Museum Ludwig, Köln (Kat.: A. Morris, E. Weiss) · Kunsthalle, Bern · Galerie Ingrid Dacić, Tübingen · Galerie Marika Malacorda, Genève 1985 Tate Gallery, London (Kat.: D. Brown) · Galerie Philomene Magers, Bonn 1986 Galerie Ingrid Dacić, Tübingen 1987 Galerie de Paris, Paris · Le Consortium, Dijon · Hilman Hollan Fine Arts, Atlanta · Wilhelm Hack Museum, Ludwigshafen 1988 Halles d'Art Contemporain, Rennes · Galerie Arlogos, Nantes · Outdoor Retrospective 1968–88, Interim Art, London · Galerie Ingrid Dacić, Tübingen · Gallery Nicole Klagsbrun, New York · Galerie Albert Baronian, Bruxelles · Galerie de Paris, Paris · Institute of Modern Art, Brisbane · Queensland Art Gallery, Brisbane · Triptychos Post Historicus, Direction Régionale des Affaires Culturelles, Limousin (Kat.: J. Benzakin, G. Tortosa) 1990 Pat Hearn Gallery, New York · Nicole Klagsbrun, New York · Galerie Ingrid Dacić, Tübingen · Galerij Ronny van de Velde, Antwerpen (Kat.: J. Watkins) 1991 Galerie de Paris, Paris · Galerie Arlogos, Nantes · Winnipeg Art Gallery, Winnipeg · Galeria Benet Costa, Barcelona 1992 Galerie de Paris, Paris

Gruppenausstellungen | Group exhibitions

1987 Fondation Lucio Amelio, Grand Palais, Paris · Vis à Vis, Musée St. Denis, Reims · Monument, Middelheim Park, Antwerpen · 16 artistes dans 16 châteaux, Médoc, Bordeaux · Forum, Middelburg · Perspectives cavalières, Tourcoing 1988 Kunst der letzten 20 Jahre, Städtische Galerie, Karlsruhe · Bezugspunkte 1938–88, Steirischer Herbst, Graz · Mnemosyne oder das Theater der Erinnerung, Schloß Herrnsheim, Worms · Hommage/Demontage, Neue Galerie Aachen/Museum des 20. Jahrhunderts, Wien · Balkon mit Fächer, Akademie der Künste, Berlin/Dumont Kunsthalle, Köln 1989 Sous le soleil, Villa Arson, Nice · Prospect 89, Kunstverein, Schirn Kunsthalle, Frankfurt/M. · Les Magiciens de la terre, Centre Georges Pompidou, Paris · Natura naturata, Josh Baer Gallery, New York · 2000 Jahre, Die Gegenwart der Vergan-

genheit, Bonner Kunstverein, Bonn · Hic Sunt Leones, Zoo, Torino 1990 Biennale di Venezia · Casino fantasma, PS 1, New York · Life Size, The Israel Museum, Jerusalem · Rhetorical Image, New Museum of Contemporary Art, New York · Art conceptuel, formes conceptuelles, Galerie 1990–2000, Paris 1991 Heimat, Galerie Wewerka Weiss, Berlin · Photoprojekt, München · Scuola d'obbligio, Pescara · History as a fiction, Meyers/Bloom Gallery, Santa Monica · Oeuvres originales, Frac – Pays de la Loire, Clisson

Bibliographie | Bibliography

Texte und Bücher vom Künstler
Texts and books by the artist
Why do I point like Pollock, Brief, Belgrado, 1972 · Three Museum Exhibitions, Galerija Nova, Zagreb · Tractatus Post Historicus, Tübingen, Ed. Dacić, 1976 · Self portraits after Rembrandt and Miguel Perez, Genève, Centre d'Art Contemporain & Ecart Publications, 1978 · Voyage autour de ma chambre, in : Artforum, Dezember, 1989 · Nobel Prize Stories, Paris, Ed. de Paris, 1992

Periodika | Periodicals
Judith Aminiff, Dix ans de post histoire: Tractatus Post Historicus Revisited, in: Des Arts, Nr. 1, winter, 1986/1987 · Lynn Gumpert, Accidental History, in: Art in America, Juni, 1991 · Elisabeth Hayt-Atkins, Braco Dimitrijević, in: Art News, September, 1990 · Zelimir Koscevic, Interview with Braco Dimitrijević, in: Nike, Mai/Juni, 1989 · Jorinde Seydel, Braco Dimitrijević: Post Historical Dimension, in: Forum International, Bd. 3, Nr. 12, März/April, 1992 · Daniel Soutif, Braco Dimitrijević, in: Artforum, Mai, 1988 · Mona Thomas, Portrait: Braco Dimitrijević, in: Beaux-Arts Magazine, März, 1990 · Jonathan Watkins, Braco Dimitrijević, in: Flash Art, September, 1988 · Olivier Zahm, Braco Dimitrijević, La Beauté sera Contemporaine, in: Art Press, Nr. 144, Februar, 1990

Film · Video
1957 Braco Dimitrijević – Young Painter, News Reel Production, 18 mm, 18 Min. 1971 Tihoun Simeie in South America, 16 mm, 4 Min. 1981 Culturescapes, H. Schneebeli, 16 mm, 8 Min., London 1983 4 Culturescapes, Video/U-matic, 12 Min. 1985 Triptychos, Post Historicus, Tate Gallery, D. Moujan, Video/U-matic, Film, 16 mm, 10 Min., London

EUGENIO DITTBORN

*Santiago (RCH), 1943
Lebt/Lives in Santiago

Einzelausstellungen | One-man exhibitions

1974 22 events for Goya, painter, National Museum of Fine Arts, Santiago · Goya versus Brueghel, Carmen Waugh Gallery, Santiago 1976 On Chilean Painting, History, Epoca Gallery, Santiago 1977 End of the Runway – Paintings and Horor Lists, Epoca Gallery, Santiago 1978 On Chilean Painting, History-End of the Runway, Contemporary Art Center, Pereira (Colombia) 1980 Impaintings, Offset and Silk-

screens, Sur Gallery, Santiago 1981 Oil Change, A spillage of 350 liters of burn lubricant over the surface of the Tarapaca desert, Tarapaca · To read and write, Sur Gallery, Santiago · Don't look a gift horse in the mouth, A saying written on a horse, Santiago 1984 20 Airmail Paintings, Cali Museum of Modern Art, Cali (Colombia) · From another Periphery, Airspace, Sydney 1985 From another Periphery, George Paton Gallery, Melbourne · 6 Airmail Paintings, Bucci Gallery, Santiago · 12 Airmail Paintings, Sur Gallery, Santiago · 15 Airmail Paintings, Chameleon Gallery, Hobart, Tasmania 1986 17 Airmail Paintings, Adelaide Festival, Adelaide · One Whole Day in my Life, Remittance to the Sydney Biennal, Bucci Gallery 1987 14 Airmail Paintings, College Gallery, South Australian School of Art, Adelaide · 14 Airmail Paintings, Institute of Modern Art, Brisbane 1988 20 Airmail Paintings, Cultural Center of the Municipality of Miraflores, Lima, Peru 1989 La Casa, the Letter, the House, Kinok Film Shooting Stage, Santiago · La Casa, the Letter, the House, Australian Centre for Photography, Sydney · VI History of the Human Face (Black and Red Camino), Kinok Film Shooting Stage, Santiago 1990 8 Airmail paintings coming back from Cuenca, London, Sydney and Berlin, Kinok Film Shooting Stage, Santiago · La Casa, The Letter, The House, Linden Gallery, St. Kilda, Melbourne (Canberra School of Art Gallery, Canberra; Experimental Art Foundation, Adelaide · Encuentro regional sobre formacion y promocion de las artes plasticas en America Latina y el Caribe, Ana Julia Rojas Theater, Caracas, Venezuela 1992 8 Airmail Paintings, Gabinette de Arte Raquel Arnaud, São Paulo

Gruppenausstellungen | Group exhibitions

1987 A Marginal Body, Australian Centre for Photography, Sydney 1988 2 Airmail Paintings, Cali Museum of Modern Art, Cali · Airmail Paintings, Latitude 53 Gallery, Alberta, Canada · Airmail Paintings, New York Latin American Triennal, New York · A Marginal Body, Camberra Contemporary Art Space, Camberra (et al.) 1989 Cirugia plastica, Staatliche Kunsthalle, Berlin · One Airmail painting, Second Cuenca International Painting Biennial, Cuenca (Ecuador) 1990 Transcontinental, Ikon Gallery/Birmingham – Cornerhouse/Manchester · Latinarcta 90, Montréal · Nearness and Distance, Walter Philips Gallery, Banff, Canada 1991 Airmail Installation, Fundacion Santillana, Santillana Del Mar, Spain · 2

Airmail Paintings, The Showroom, London · *The Interrupted Life,* The New Museum of Contemporary Art, New York · *One Airmail Painting,* The Museum of Contemporary Art, Sydney · *Airmail Installation,* IV La Habana Biennale, La Habana · *3 Airmail Paintings,* I.C.I., Buenos Aires · **1992** *Flandres y America,* Koninklijk Museum voor Schone Kunsten, Antwerpen

Bibliographie | Bibliography

Texte und Bücher vom Künstler
Texts and books by the artist
Definitley Transitory, (co-author Ronald Kay), s.l., Espacio Siglo Veinte Editiones, 1978 · *Strategies and Projections of The National Visual Arts Activities in The Eighie,* s.l., Grupo Camara Chile Editions, 1979 · *End of the Runway,* s.l., Galeria Epoca Editiones, 1977–81 · *Photo Finish,* s.l., Self Edition, 1981–82 · *La Feliz Del Eden,* s.l., Self Edition, 1984

Bücher | Books
Eugenio **Dittborn**, Gonzalo **Millan**, Gonzalo **Munoz**, Pablo **Oyarzun**, Nelly **Richard**, *Pinturas Postales de Eugenio Dittborn,* Santiago de Chile 1985, Francisco Zegers, 1985

Filme | Films · Video
(Videography)
1981 *What we saw on the summit of the Corona Mountain,* 20 Min., Farbe, NTSC, 3/4 of an inch **1982** *The History of Physics,* 18 Min., Farbe, NTSC, 3/4 of an inch **1986** *Five Preliminary Sketches for the History of Music,* 33 Min., Farbe, NTSC, 3/4 of an inch · *Pieta,* 8 Min., Farbe, NTSC, 3/4 of an inch **1989** *The Physics of History,* 4 Min., Farbe, NTSC, 3/4 of an inch **1990** *The Crusoe,* 17 Min., Farbe, NTSC, 3/4 of an inch

HELMUT DORNER

*Gengenbach/Baden (D), 1952
Lebt/Lives in Düsseldorf

Einzelausstellungen | One-man exhibitions

1983 *Zeichnungen,* Galerie Ricke, Köln **1984** Kunst- und Museumverein, Wuppertal **1985** *Skulpturen 1981–1985,* Ulmer Museum, Ulm (Kat.: D. Bauerle, H.-M. Huckert) · *Skulpturen,* Galerie Philippe Casini, Paris **1987** Raum für Malerei, Köln · Galerie Grässlin-Ehrhardt, Frankfurt/M. **1988** Galerie Konrad Fischer, Düsseldorf · Galerie Philippe Casini, Paris **1989** Galerie Philip Nelson, Lyon **1990** Museum Haus Esters, Krefeld · Kunsthalle, Bern (**1991** Musée d'Art Contemporain, Nîmes) (Kat.: U. Loock, A. Schaumann, D. Zacharopoulos) · Galerie Karlheinz Meyer, Karlsruhe **1991** Galerie des Arènes, Nîmes

Gruppenausstellungen | Group exhibitions

1987 *23. Ausstellung,* Galerie Grässlin-Ehrhardt, Frankfurt/M. **1988** *La raó revisada,* Fundació Caixa de Pensions, Barcelona · Galerie Philip Nelson, Lyon **1989** *I Triennal de Dibuix Joan Miró,* Fundacio Miró, Barcelona **1990** *Weitersehen,* Museum Haus Lange und Haus Esters, Krefeld · *Le Diaphane,* Musée des Beaux-Arts, Tourcoing · *De Pictura,* Galerie Bruges la Morte, Brugge

Bibliographie | Bibliography

Periodika | Periodicals
Alain **Cueff**, *Helmut Dorner – Galerie Nelson,* in: Artforum International, Bd. 7, März, 1990 · Julian **Heynen**, *Helmut Dorner,* in: Beaux-Arts Magazine, Bd. 91, Juni, 1991 · Luk **Lambrecht**, *Helmut Dorner,* in: Forum International, Bd. 6, Januar/Februar, 1991 · Helga **Meister**, *Helmut Dorner – Museum Haus Esters,* in: Kunstforum, Juni/Juli, 1990 · Stephan **Schmidt-Wulffen**, *Reason Revised,* in: New Art International, Bd. 1, 1989

STAN DOUGLAS

Lebt/Lives in Vancouver (CDN)

Einzelausstellungen | One-man exhibitions

1983 *Slide Works,* Ridge Theatre, Vancouver **1985** *Panoramic Rotunda,* Or Gallery, Vancouver **1986** *Onomatopoeia,* Western Front, Vancouver **1987** *Stan Douglas: Perspective '87,* Art Gallery of Ontario, Toronto (Kat.: B. Fischer) **1988** *Television Spots,* Artspeak Gallery, Vancouver (Kat.: S. D., D. Ferguson) · *Television Spots/Overture,* Galerie Optica, Montréal · *Samuel Beckett: Teleplays,* Vancouver Art Gallery, Vancouver · *Television Spots/Subject to a Film,* Contemporary Art Gallery, Vancouver (Kat.: M. Nichols, S. D.) **1989** *Subject to a Film/Television Spots,* XYZ Gallery, Toronto **1991** *Monodrama,* Jeu de Paume, Paris · *Trois Installations cinématographiques,* Ambassade du Canada, Paris **1992** *Monodramas and Loops,* UBC Fine Arts Gallery, Vancouver (Kat.: C. David, S. D., J. Fiske, S. Watson)

Gruppenausstellungen | Group exhibitions

1988 *Behind the Sign,* Artspeak Gallery, Vancouver · *Made in Camera,* VAVD Editions, Stockholm **1989** *Foto Kunst,* Staatsgalerie, Stuttgart · *Biennial Exhibition of Canadian Art,* National Gallery of Canada, Ottawa · *Or Gallery Exchange,* Cold City Gallery, Toronto **1990** *Art and Public Discourse,* Galerie d'art Essai/Galerie du Cloître, Rennes (et. al.) · *Aperto,* Biennale di Venezia, Venezia · *Issues in Contemporary Video,* Meendel Art Gallery, Saskatoon · *Sydney Biennale,* Art Gallery of New South Wales, Sidney · *Renactments,* The Power Plant, Toronto **1991** *Schwarze Kunst: Konzepte zur Politik und Identität,* Neue Gesellschaft für bildende Kunst, Berlin · *Northern Lights,* Canadian Embassy, To-

kyo · *Work,* Norman Mackenzie Art Gallery, Regina · *Passage de l'image (Video Programm),* Centre Georges Pompidou, Paris · *The Projected Image,* Museum of Modern Art, San Francisco

Bibliographie | Bibliography

Texte und Bücher vom Künstler
Texts and books by the artist
Goodbye Pork-Pie Hat. Samuel Beckett: Teleplays, in: Vanguard, November, 1988 · *Shades of Masochism: Samuel Beckett's Teleplays,* Australia: Photophile, Herbst, 1990 · *Public Art in a Nutshell,* paper delivred at *Politics of the Image,* Dia Center for the Arts, New York, November, 1990 · *Joanne Tod and the Final Girl,* in: Joanna Tod (Toronto/Saskatoon: The Power Plant/Mendel Art Gallery); rpt. abr. Parachute, Nr. 65, Januar/Februar, 1991 · *Introduction,* in: Vancouver Anthology: The Institutional Politics of Art, Stan Douglas, ed., Vancouver, Talonbooks, 1991

Periodika | Periodicals
Jo-Anne **Birnie Danzker**, *The Beauty of the Weapons,* in: Canadian Art, Herbst, 1989 · Peter **Culley**, *Dream as Dialectic: Two Works by Stan Douglas,* in: Vanguard, September/Oktober, 1987 · Peter **Culley**, *Window Dressing,* in: Vanguard, April/Mai, 1988 · Peggy **Gale**, *Stan Douglas: Perspective '87,* in: Canadian Art, Frühling, 1988 · Monika **Gagnon**, *Reenactments: Between Self and Other,* in: C Magazine, Sommer, 1990 · Mark **Harris**, *Stan Douglas: Television Spots,* in: C Magazine, Nr. 21, Frühling, 1989 · Karen **Henry**, *Television Spots,* in: Parachute, Nr. 51, Juni/August, 1988 · David **Joslit**, *Projected Identities,* in: Art in America, November, 1991 · Michael **Lawlor**, *Camera Works,* in: Parachute, Nr. 47, Juni/August, 1987 · Tony **Reveaux**, *Fleeting Phantoms: the Projected Image at SFMOMA,* in: Artweek, 28. März, 1991 · Jean **Tourangeau**, *Sins of Experience,* in: Vanguard, Dezember 1986/Januar 1987 · Jane **Young**, *Broken Muse,* in: C Magazine, Nr. 13, Frühling, 1987 · Arne **Zazlove**, *Samuel Beckett's Teleplays,* in: C Magazine, Nr. 23, Herbst, 1989

MARLENE DUMAS

*Kaapstad (ZA), 1953
Lebt/Lives in Amsterdam

Einzelausstellungen | One-man exhibitions

1979 Galerie Annemarie de Kruyff, Paris 1980 Galerie Lambelet, Basel 1983 *Unsatisfied Desire,* Galerie Paul Andriesse, Amsterdam 1984 *Ons Land Lichter Lager Dan De Zee,* Centraal Museum, Utrecht · *The Artist as a Young Girl,* Galerie Flatland, Utrecht 1985 *The Eyes of the Night Creatures,* Galerie Paul Andriesse, Amsterdam (Kat.: M. D.) · Galerie Barbara Jandrig, Krefeld (Kat.: M. D.) 1987 *The Private versus the Public,* Galerie Paul Andriesse, Amsterdam (Kat.: M. D.) 1988 *Nightmares,* Galerie Wanda Reiff, Maastricht · Galerie Stampa, Basel · *Waiting (for meaning),* Kunsthalle, Kiel (Kat.: U. Bischoff, M. D., J. C. Jensen, M. van Nieuwenhuyzen) · *Waiting (for meaning),* Galerie Paul Andriesse, Amsterdam 1989 *The Question of Human Pink,* Kunsthalle, Bern (Kat.: M. D.) 1990 *Couples,* Museum Overholland, Amsterdam (Kat.: M. D.)· *The Origin of the Species,* Staatsgalerie Moderner Kunst, München 1991 *Außer Reichweite von Kindern,* Galerie Stampa, Basel · *The Origin of the Species II,* Galerie Paul Andriesse, Amsterdam · Presentatie van een opdracht voor het Psychiatrisch Centrum het Hooghuys, Etten-Leur 1992 Galerie Isabella Kacprzak, Köln · Stedelijk Van Abbemuseum, Eindhoven (Kat.: J. Rebbaut, S. Klein Essing, M. Vos) · *In Situ/Ardi Poels,* Maastricht

Gruppenausstellungen | Group exhibitions

1987 *Art from Europe,* Tate Gallery, London · *Een keuze/A Choice,* KunstRai, Amsterdam · *Century 87. Kunst van nu ontmoet Amsterdams verleden/Today's Art face to face with Amsterdam's past,* Amsterdam · *Hollands Landschap,* Museum Overholland, Amsterdam · *Century Art,* Amsterdam · *Hommage aan Pasolini,* Gemeentemuseum, Arnhem 1989 *Bilderstreit,* Museum Ludwig, Köln · *Prospect 89,* Frankfurter Kunstverein, Frankfurt/M. · *6 Dutch Artists,* Fruitmarket Gallery, Edinburgh 1990 *De uitputting van de muze,* W 139, Amsterdam · *Zelfportretten,* Galerie Tanya Rumpff, Haarlem · *Inconsolable,* Louver Gallery, New York · *Bevrijdingen. Joods Historisch Museum,* Amsterdam 1991 *De woorden en de beelden/The Words and Images,* Centraal Museum, Utrecht · *Forbidden Games,* Jack Tilton Gallery, New York · *Inscapes,* Stichting De Appel, Amsterdam · *The interrupted Life,* New Museum, New York · *Individu: Duiding, verboden verbindingen + twijfelachtige verbanden,* Internationaal Cultureel Centrum, Antwerpen · *Glück Auf,* Zeche Rheinpreussen, Schacht V, Moers

Bibliographie | Bibliography

Texte von der Künstlerin
Texts by the artist
(Statements), in: Dutch Art + Architecture Today, Nr. 12, Dezember, 1982 · *Some qualities I Exhibit,* in: Kat. Junge Kunst aus den Niederlanden. Form und Expression, Sonderschau Kunstmesse, Basel, 1982 · *The Lava – Edge,* hg. vom Museum Fodor Amsterdam anläßlich der Ausstellung: Reyjavik – Amsterdam, ter weerszijden van de meridiaan, The Living Art Museum, Reykjavik, 1983 · A Fortune for the Mermaid, in: Kat. Restrisiko, Bonnefanten Museum, Maastricht, 1983 · *On words and Images,* in: Kat. Im Toten Winkel, Kunstverein & Kunsthaus, Hamburg, 1984 · *Unsatisfied Desire and the untrustworthy Language of Art,* in: Kat. 5th Biennale of Sydney, 1984 · *Vindsulor, maleri, skulptur och video i Holland,* in: Kat. Konsthallen Göteborg, Göteborg, 1984 · *Notites,* in: Fodor, Juli/August, Jg. 4, Nr. 4, 1985 · *Laat deze beker aan mij voorbijgaan,* in: Kat. Het avondmaal, Leeuwarden, 1985 · *Fear of Babies,* Texte zur Mappe: Fear of Babies, (fünf Lithos), Amsterdam, 1986 · *The Intuition of Danger,* in: Kat. Innovation und Tradition, Badischer Kunstverein, Karlsruhe, 1986 · *Blinde vlekken,* in: de Rijksakademie, Nr. 3, November, 1987 · *Give 'em enough rope,* in: Kat. A Priori Tekenen, Stichting Makkom, 1987 · *The loss of soul,* in: Kat. Nightfire, Stichting De Appel, Amsterdam, 1988 · *2 liefdesnoties, tijdloos,* en *3 katernotites, Amsterdam 1983,* en *2 taalnotities, Amsterdam 1985,* in: Ander werk, Arnhem, KAAP, 1988 · *From one dirty place to another,* in: Galerie, Galerie Paul Andriesse, Amsterdam, November, 1989 · *The Body Guard,* in: Kat. Kapriolen, Kunstverein, München, 1989 · *De aarde is plat,* in: De Balie/De Rijksakademie, Jg. 4, Nr. 11, 1989 · *The Origin of the Species,* in: Kat. The Origin of the Species, Staatsgalerie Moderner Kunst, Bayerische Staatsgemäldesammlungen, München, 1990 · *Couples,* in: Kat. Couples, Museum Overholland, Amsterdam, 1990 · in: Tirade, Oktober/November, 1990 · *Tussen God, Kunst en Waanzin; een boekbespreking door Marlene Dumas van Renaissance, drie teksten van Luce Irigaray,* in: Ruimte, Jg. 7, Nr. 3, 1990 · *It is not 'the Imaginary' we need neither is it 'the Museum' we desire,* in: Metropolis M, Nr. 3, 1991 · *Het gesprek,* in: Arti, Jg. 2, Nr. 7, 1991 · *De muze is uitgeput,* in: de uitputting van de muze, April, 1991 · *Brief,* Projekt voor het Hooghuys, Ettenleur, 1991 · *Writing about Art,* Symposium Stedelijk Van Abbemuseum, Eindhoven, 1991 · *The Body Guard. Dressed in Exposure,* in: Kunst & Museumjournaal, Bd. 2, Nr. 4, 1991

Bücher | Books

Marlene Dumas en Stichting één op één, Amsterdam, Stichting één op één, 1987 · *The Body Guard Dressed in Exposure,* in: Kunst & Museumjournaal, Bd. 2, Nr. 4, 1991

Periodika | Periodicals

T. Baker, *Art from Europe and Art and Language,* in: The Face, Juni, 1987 · E. Beck, *Marlene Dumas, Kunsthalle Bern,* in: Artnews, Bd. 88, Nr. 10, Dezember, 1989 · Ulrich Bischoff, *Marlene Dumas – The Question of Human Pink,* in: Das Kunstwerk, Dezember, 1989 · M. Bosma, *Marlene Dumas, Talking to strangers,* in: Dutch Heights, September, Nr. 3, 1990 · Jan Braet, *Altijd Mis,* in: Knack, 1. April, 1992 · D. Cooper, *Report from Amsterdam, Art on the Amstel,* in: Art in America, Oktober, 1987 · Paul Groot, *Marlene Dumas,* in: Artforum, März, 1989 · Piet de Jonge, *The Subjective as Object,* in: DA + AT, Juni, 1987 · Jim Lamoree, *Geboren worden, dood gaan en...,* in: Haagse Post, 19. Dezember, 1987 · Chr. Murken-Altrogge, *Die Freiheit, sich malend sichtbar zu machen, Das weibliche Aktselbstbildnis des 20. Jahrhunderts,* in: Kunst und Antiquitäten, Nr. 11, November, 1990 · M. Roskam, *Marlene Dumas Museum Overholland,* in: Flash Art, Nr. 152, Mai/Juni, 1990 · I. Schaffner, *Snow White in the wrong Story, Paintings and Drawings by Marlene Dumas,* in: Arts Magazine, März, 1991 · A. Tilroe, *Marlene Dumas,* in: Arena, Nr. 1, Februar, 1989 · Philip Urspring, *Marlene Dumas, 'The Question of Human Pink',* in: Nike, Nr. 10/11, 1989 · Martijn van Nieuwenhuyzen, Mathilde Roskam, *Names in bold,* in: Artscribe, März/April, 1987 · Martijn van Nieuwenhuyzen, *Marlene Dumas,* in: Flash Art, Nr. 136, Oktober, 1987 · J. Withers, *Notices,* in: Vogue, April, 1987

JIMMIE DURHAM

*Washington/Arkansas (USA), 1940
Lebt/Lives in Cuernavaca

Einzelausstellungen | One-man exhibitions

1967 University Texas, Austin · Adept Gallery, Houston 1971 Circa Gallery, Genève · Centre des Rencontres, Genève 1972 Circa Gallery, Genève · Abelin Gallery, Zürich · Ecole des Beaux-Arts, Genève 1985 Alternative Museum, New York (Kat.: J. D.) · 22 Wooster Gallery, New York 1986 John Jay College, New York 1988 Matt's Gallery, London (Kat.: J. D.) · Orchard Gallery, Derry (N. Ireland) (Kat.: J. D.) 1989 *The Bishop's Moose and the Pinkerton Men,* Exit Art, New York (Kat.: L. Camnitzer, P.Colo, J. Fischer, L. R. Lippard, J. Ingberman) 1990 Exit Art Show, Western Washington Unversity, Bellingham 1991 Museum of Civilization, Hull (Quebec) · University of Colorado, Boulder · The Luggage Store, San Francisco 1992 Nicole Klagsbrun, New York

Gruppenausstellungen | Group exhibitions

1987 *We, The People,* Artists Space, New York · *The Law and Order Show,* John Weber Gallery, New York · *The Soaring Spirit,* Morris Museum, Morristown, New York · *Rider with no Horse,* American Indian Gallery, New York 1988 *Re-Visions,* Walter Phillips Gallery, Bonf, B.C. · *Acts of Faith,* The Art Gallery Cleveland State University, Cleveland 1990 *Holy Wars,* Exit Art, New York · *Savoir Faire, Savoire Vivre, Savoir Etre,* Centre International d'Art Contemporain, Montréal 1991 Orchard Gallery, Derry (Northern Ireland) · *The Interrupted Life,* The Museum of Contemporary Art, New York · *The Subversive Stitch,* Simon Watson, New York

Performances

1964 *My Land,* Alley Theater, Houston 1969–1972 Various street performances, Genève 1983 *Thanksgiving, PS 122,* New York

1984 *A Trick,* 22 Wooster Gallery, New York
1985 *Manhattan Give-away,* Franklin Furnace Gallery, New York 1986 *The Death of Paul Smith,* Minor Injury Gallery, New York 1987 *I want to say something,* La Mama Theater, New York · *One of twelve actors in »colorschemes«,* a film by Shu Lea Cheang, New York 1988 *Four scenes for the British Army,* Orchard Gallery, Derry 1989 *Hermeneutical Consideration of the Bishops Moose,* Exit Art, New York 1990 *Crazy For Life,* Dance Theater Workshop (DTV), New York (*The Decade Show*) · *The Self-Taught Artist,* Exit Art, New York · *Catskills Giveaway,* Art Awareness Lepington, New York 1991 *Savage,* Time Festival, Museum van Hedendaagse Kunst, Gent

Bibliographie | Bibliography

Texte vom Künstler | Texts by the artist
Columbus Day (poems), Minnesota, West End Press, 1983 · *Poesiealbum,* Berlin, Verlag News Lebon, 1985 · *Ni Go Tlunh A Doh Ka,* in: Kat. We are always turning around on purpose, State University of New York, Old Westbury, New York 1986 · *Russell means is Wrong,* in: The Washington Post, 20. März, 1986 · *Savage attacks on White Women, as usual,* in: Kat. We, The People, Artists Space, New York 1987 · *Those dead Guys for a hundred Years,* in: I Tell You Now, autobiographical essays by native American writers, Lincoln, Ed. Brian Swann & Arnold Krupat, 1987 · *The Ground has been Covered,* in: Artforum, Sommer, 1988 · *Here at the center of the World,* in: Third Text, 1988 · *A central margin,* in: Kat. The Decade Show, Museum of Contemporary Hispanic Art/The New Museum of Contemporary Art/The Studio Museum, Harlem 1990 · *Cowboy S – M,* in: New Observations, Nr. 80, November/Dezember, 1990 · *White Water rafting,* in: Kat. Savoir Faire, savoir Vivre, Savoir Être, Centre International d'Art Contemporain de Montréal, 1990 · *On The Edge of Town,* in: The Journal of the College Art Association, 1991 · *Cowboy and...,* in: Third Text, 1991 · *Transcendance,* in: The Journal of the College Art Association, 1992 · *Amerikaner oder der ›andere‹,* in: Kunstforum International, Mai/Juni, 1991

Periodika | Periodicals
Susan **Canning,** *Jimmie Durham,* in: Art Papers, Vol. 14, Nr. 4, Juli/August, 1990 · Jean **Fisher,** *The Health of the People is the Highest Law,* in: Third Text, Nr. 2, Winter 1987/1988 · Ann **Friedman,** *Word Power,* in: Reflex, Mai, 1990 · Elisabeth **Hess,** *Who Is Jimmie Durham,* in: Village Voice, 2. Dezember, 1989 · Amelia G. **Jones,** *Jimmie Durham: Exit Art,* in: Artscribe, März, 1990 · Desa **Philippi,** *Jimmie Durham Matt's Gallery,* in: Artscribe, Nr. 74, März/April, 1989 · Calvin **Reid,** *Jimmie Durham,* in: Art in America, Mai, 1990 · John **Rushing,** in: New Art Examiner, Februar, 1991

MO EDOGA

Lebt/Lives in Mannheim

JAN FABRE

*Antwerpen (B), 1958
Lebt/Lives in Antwerpen

Einzelausstellungen | One-man exhibitions

1978 *Bic-Dweilen en Wetspotten,* Jordaenshuis, Antwerpen 1979 *Wetskamer,* Galerij Workshop, Antwerpen 1980 *Mond-Oog-Oor Arts,* Galerij Workshop, Antwerpen 1981 *Bic-Art Room,* Salon Odessa, Leiden 1982 *Money and Art, Art and Money,* Gallery School of Visual Arts, New York 1984 *Vrienden,* Provinciaal Museum, Hasselt (Kat.: L. Van Damme) 1985 *Tekeningen,* Museum van Hedendaagse Kunst, Gent (Kat.: J. Hoet) · *De vervalsing van het geheime feest/The Forgery of the Secret Feast,* New Math Gallery, New York (Kat.) 1987 *Het Uur Blauw,* De Selby, Amsterdam (Kat.: W. Hayes) 1988 *Modellen '77–'85,*

Deweer Art Gallery, Otegem (Kat.) · *Hé wat een plezierige zottigheid!,* Galerie Ronny Van de Velde, Antwerpen (Kat.: B. Verschaffel) · *Der Blaue Raum,* Künstlerhaus Bethanien, Berlin · Belgisches Haus, Köln (Kat.: W. Hayes) · *Insecten en Ruimte,* Museum Overholland, Amsterdam (Kat.: B. Verschaffel) 1989 *Sculpturen,* De Selby, Amsterdam · *Eén sculptuur/vijf tekeningen,* Deweer Art Gallery, Otegem (Kat.: J. Coucke) · *Tekeningen, Modellen & Objekten,* Provinciaal Museum voor Moderne Kunst, Oostende (Kat.: W. Van den Bussche, K. De Coster, J. Coucke, M. van der Jagt) · *Risbe, Modeli & Objekti,* Moderna Galerija, Ljubljana (Kat.: K. De Coster, J. Coucke, E. Hrvatin, M. van der Jagt, L. Stepanicic) · Jack Tilton Gallery, New York (Kat.: D. Kuspit, M. Welish) · *Knipschaarhuis,* Gallery Jack Tilton, New York (Kat.: D. Kuspit) 1990 *Das Geräusch,* Kunsthalle, Basel (Kat.: U.-B. Frei) · *Som,* Centre de Arte Moderna, Lissabon · *Tivoli,* Galerie Ronny Van de Velde, Antwerpen/ Mechelen · *Fabre's Insects,* Palais des Beaux Arts, Bruxelles 1991 *Zwei Objekte,* Schirn Kunsthalle, Frankfurt/M. 1992 Kunstverein, Hannover (Museum of Contemporary Art, Helsinki) (Kat.: B. Verschaffel)

Gruppenausstellungen | Group exhibitions

1987 *From the Europe of Old,* Stedelijk Museum, Amsterdam 1988 *Signaturen,* Museum van Hedendaagse Kunst, Gent · *Theaterbeelden,* Fort Asperen, Asperen · *Collectie & Collectie,* Museum van Hedendaagse Kunst, Gent · *Porkkana,* Finnish Museum of Contemporary Art, Helsinki · *Die Leere mit Bedacht gefüllt,* Gesellschaft für aktuelle Kunst, Bremen · *Four Belgium Artists,* Jack Tilton Gallery, New York · *documenta 8,* Deweer Art Gallery, Otegem 1989 *Open Mind,* Museum van Hedendaagse Kunst, Gent · *Anniversary Show,* Galerie Deweer, Otegem · *Dubbeltalent,* Hessenhuis, Antwerpen 1990 *Artisti della Fiandra,* Palazzo Sagredo, Venezia · *Hommage to Vincent van Gogh,* Gemeentemuseum, Den Haag 1991 *Metropolis, Martin-Gropius-Bau,* Berlin · *Irony by Vision,* Watari-Um, Tokyo · *Bienal de São Paulo* · *Facts and Rumours,* Witte de With, Rotterdam · *Wanderlieder,* Stedelijk Museum, Amsterdam · *Fotografija,* Moderna Galerija, Ljubljana 1992 *TransForm,* Kunstmuseum Basel, Basel · *The another world,* Art Tower Mito, Tokyo · *Selectie Belgische Kunstenaars voor DOCUMENTA IX,* Museum Dhondt-Dhaenens, Deurle

Performances

1976 *Avondmaal,* Antwerpse haven, Antwerpen · *Ik neem alles serieus maar niet tragisch,* Cultureel Centrum, Antwerpen · *Hier leeft mijn...,* Offerandestraat, Antwerpen · *Red Lines performance,* Antwerpse straten, Antwerpen 1977 *Lange Beeldekens – Jan Fabre straat,* Lange Beeldekensstraat 240, Antwerpen · *Window Performance,* Offerandestraat, Antwerpen 1978 *My Body, my Blood, my Landscape,* Lange Beeldekensstraat 240, Antwerpen · *Vincent van Gogh – Jan Fabrehuis,* Lange Beeldekensstraat 240, Antwerpen · *Buy by Jan Fabre,* Gallery Van Eck, Antwerpen 1979 *Money Performance,* Ankerrui Theater, Antwerpen · *Creativity* School H.H., Turnhout · *West-World Project,* Stedelijk Museum, Amsterdam (Centre Georges Pompi-

dou, Paris) (et al.) · *Wetspotten fossielen*, Omganckstraat, Antwerpen · *Billus later*, Mott Street Gallery, New York 1980 *Will Doctor Fabre cure you?*, Galerij Workshop, Antwerpen · *The Rea(dy)make of the performance ›Money‹*, Ankerrui Theater, Antwerpen · *Ilad of the Bic-Art*, Stichting De Appel, Amsterdam · *Money (Art) in Culture*, Rijksuniversiteit, Communicatie en Wetenschap, Gent · *After Art*, Helfaer Theatre, Milwaukee · *Sea-Salt of the Fields*, Marquette University, Philosophy Dept., Milwaukee · *Creative Hitler Act*, St. Louis University, Milwaukee · *American Works and Window Performance*, Galerij Blanco, Antwerpen 1981 *Ilad of the Bic-Art, the Bic-Art room*, Salon Odessa, Leiden · *This ain't Work, this is Evolution*, Cultureel Centrum, Antwerpen · *Art as a Gamble, Gamble as an Art*, School of Visual Arts, New York · *T.Art*, Washington University, Philosophy Dept., St. Louis · *Performance X, l'Art est ennui cultivé*, Cairn, Paris · *The interim-art works of Jan Fabre*, Peperstraat 37, Groningen 1982 *It's Kill or Cure*, Franklin Furnace, New York

Theaterproduktionen | Theatre Productions

1980 *Theatre written with a K is a tomcat/ Theater geschreven met een ›K‹ is een kater*, Ankerrui Theater, Antwerpen 1982 *This is theatre like it was to be expected and foreseen/Het is theater zoals te verwachten en te voorzien was*, Stalker, Bruxelles · 1983 *Een theatervoorstelling omtrent acteren waarin enkele personen verenigd zijn die mogelijk het acteren in twijfel trekken*, Labaratoire de Manipulation de Chémie Générale, Leuven 1984 *De macht der theaterlijke dwaasheden*, Teatro Carlo Goldoni, Biennale di Venezia, Venezia 1987 *The Dance Sections*, Staatstheater, documenta 8, Kassel 1988 *Prometheus-Landschaft*, Künstlerhaus Bethanien, Berlin 1989 *Das Interview das stirbt*, Theater am Turm, Frankfurt/M. · *Der Palast um vier Uhr morgens... A.G.*, Theater am Turm, Frankfurt/M. · *Die Reinkarnation Gottes*, Theater am Turm, Frankfurt/M. 1990 *Das Glas im Kopf wird vom Glas* (Opera), De Vlaamse Opera, Antwerpen · *The Sound of one Hand clapping* (Ballet), Ballett Frankfurt, Städtischen Bühnen, Frankfurt/M. 1991 *Sweet Temptations*, Wiener Festwochen, Wien · *Zij was en zij is, zelfs*, Felix Meritis, Amsterdam 1992 *Silent Screams, Difficult Dreams* (Opera), Staatstheater, documenta 9, Kassel

Bibliographie | Bibliography

Texte und Bücher vom Künstler
Texts and books by the artist
Hé wat een plezierige zotigheid!, Antwerpen, Ronny Van de Velde Gallery, 1988 · *Fabre's book of insects*, Gent, Imschoot Uitgevers, 1991 · *8 mm Films*, Gent, Museum van Hedendaagse Kuns, 1991 · *Tivoli*, Antwerpen, Jan Sack, 1992

Bücher | Books
Kathy Acker, Germano Celant, Jan Fabre, Robert Mapplethorpe, *The Power of theatrical Madness Fabre*, London, Institute of Contemorary Arts, 1986 · *Jan Fabre, Video, Performances, Theater-projekten, Lezing-performances, Live-installaties, Workshops, Televisie-werken*, Antwerpen, EPO, [1985] · Miguel Romero, Emil Hrvatin,

The Dance Sections, Gent, Imschoot Uitgevers, 1990

Periodika | Periodicals
Felix Schnieder-Henninger, *Die Stunde blau: Prometheus Landschaft*, in: Wolkenkratzer Art Journal, September/Oktober, 1988 · Erno Vroonen, *The Drawings of Jan Fabre*, in: Artefactum, Nr. 21, November 1987/Januar 1988

Filme | Films · Video

Film
1981 *Negatief*, 8 mm., 17 Min., Farbe 1982 *Portraits*, 8 mm., 30 Min., s/w 1987 *Blue Sunday*, 16 mm., 160 Min., Farbe, Produktion: Troubleyn, Antwerpen 1988 *Hé wat een plezierige zottigheid!*, 16 mm., 10 Min., s/w & Blau, Produktion: Ronny Van de Velde, Antwerpen 1990 *Tivoli, 35 mm., Farbe, Ton, 10 Min.*, Produktion: Jan Sack, Antwerpen 1991 *This magnificent Silence*, 35 mm., Farbe, Ton, 240 Min., Produktion: Allarts, Amsterdam

Television
1984 *De macht der theaterlijke dwaasheden*, Rob Klassman, VPRO, Hilversum, 80 Min. 1985 *Portret Jan Fabre*, Annie Declerck, BRT, Bruxelles, 38 Min. 1986 *Fabre's Madness*, Isso Miura, NHK, Tokyo, 60 Min. 1987 *De danssecties*, Rob Klaasman, VPRO, Hilversum, 80 Min. 1990 *Damens en Heren Jan Fabre*, Bart Verschaffel, Jef Cornelis, BRT, 83 Min. 1991 *Ein junger Mann als Künstler*, Ernest Grandits, ORF, Wien, 60 Min. 1992 *Difficult Dreams*, BRT, Bruxelles, 25 Min.

LUCIANO FABRO

*Torino (I), 1936
Lebt/Lives in Milano

Einzelausstellungen | One-man exhibitions

1965 Galleria Vismara, Milano (Kat.: L. F.) 1967 Galleria Notizie, Torino (Kat.: C. Lonzi) 1968 *Davanti, dietro, destra, sinistra, (Tautologie)*, Galleria Notizie (Kat.: L. F., C. Lonzi, S. Vertone, M. Volpi Orlandini) 1969 Galleria la Salita, Roma · Galleria de Nieubourg, Milano (Kat.: L. F.) 1970 *Bekleidung*, Aktionsraum, München 1971 Galleria Bor-

gogna, Milano (Kat.: S. Vertone) · Galleria Notizie, Torino (Kat.: S. Vertone) · Galleria del Leone, Venezia · 1973 *Letture parallele I*, Galleria Borgogna, Milano (Kat.: L. F.) 1974 *Ogni ordine è contemporaneo d'ogni altro ordine*, Galleria Notizie, Torino (Kat.: L. F.) · Galleria del Cortile, Roma · *Ogni ordine è contemporaneo d'ogni altro ordine*, Galleria Sperone Fischer, Roma · Modern Art Agency, Napoli · *Lectures parallèles II*, Salle Simon I Patino, Genève (Kat.: L. F.) 1975 *Allestimento teatrale (Cubo di specchi)*, Bagno Borbonico, Pescara · *Iconografie*, Galleria Area, Firenze · *Letture parallèle III. Coreografie*, Galleria Christian Stein, Torino (Kat.: L. F.) 1976 Galleria del Cortile, Roma · *A e na roba massa granda par podei pensala*, Incontri Internazionali d'Arte, Roma 1977 *Attaccapanni*, Galleria Framart, Napoli (Kat.: L. F., A. Izzo) 1978 *Io*, Galleria II, Roma · *Tu*, Galerie Paul Maenz (Kat.: P. Maenz) 1979 *Il giudizio di Paride*, Galleria Mario Pieroni, Roma 1980 *Letture parallele IV*, Padiglione d'Arte, Milano (Kat.: L. F.) · *Habitat delle erbe*, Galleria Christian Stein, Torino (Kat.: G. Risso) · *Iconografie*, Salvatore Ala Gallery, New York · *1 – 100*, Galleria Toselli, Milano 1981 *Habitat 1962*, Galleria Mario Pieroni, Roma · *Sehnsucht*, Museum Folkwang, Essen (Kat.: W. Beeren, L. F., Z. Felix) · *Duister kristal: Luciano Fabro – Pier Paolo Pasolini*, Museum van Hedendaagse Kunst, Gent (Kat.: L. F., Z. Felix, J. H.) · Museum Boymans-van Beuningen, Rotterdam (Kat.: cfr. Folkwang Museum, Essen) 1982 *La foglia*, Saman Gallery, Genova · *Italia a pennello*, Galleria Banco – Massimo Minini, Brescia 1983 Neue Galerie – Sammlung Ludwig, Aachen · *Italia vota*, Galleria Minini, Milano · Pinacoteca Comunale, Ravenna (Kat.: J.-C. Ammann, M. Bandini, R. Barilli, A. B. Oliva, B. Brock, T. Catalano, G. Celant, B. Corà, L. F., Z. Felix, P. Fossati, A. van Grevenstein, P. Groot, M. Grüterich, L. L. Ponti, C. Lonzi, D. Palazzoli, A. Pohlen, L. Rogozinski, G. Salerno, J. de Sanna, T. Trini, L. Vergine, M. Volpi) 1984 *Deutschland*, Galerie Paul Maenz, Köln (Kat.: P. Maenz) 1985 *Il Belgio*, Galerie Micheline Szwajcer, Antwerpen 1986 Galleria Christian Stein, Milano 1987 *Landscapes*, The Fruitmarket Gallery, Edinburgh (Kat.: L. F.) · *Etat*, Musée d'Art Moderne de la Ville, Paris (Le Nouveau Musée, Villeurbanne) (Kat.: L. F.) · *Obélisques*, Galerie Pietro Sparta, Chagny 1988 *Effimero/Ovaie*, Galleria Christian Stein, Torino · *Luciano Fabro con tre nudi che scendono le scale*, Galleria Mario Pieroni, Roma · *C'est la vie*, Palais des Beaux-Arts, Bruxelles · *Basta la vista/Eierstöcke*, Kunstverein, München 1989 *Troubadours*, Galerie Elisabeth Kaufmann, Basel · Castello di Rivoli, Torino (Kat.: L. F., M. Francis, R.H. Fuchs, J. Gachnang, J. R. Lane, W. Oechslin, J. De Sanna, D. Soutif) · *Nord, Sud, Est, Ovest giocano a Shanghai*, Napoli (Kat.: B. Corà, L. F., G. L. Buontempo) · *Two nudes descending a staircase dancing the Boogie-Woogie*, SteinGladstone Gallery, New York · *L'infinito*, Galerie Micheline Szwajcer, Antwerpen 1990 Fundació Joan Miró, Barcelona (Kat.: L. F., M. Rowell) · *Computers*, Galleria Christian Stein, Milano 1991 *Ogni ordine è contemporaneo d'ogni altro ordine*, Museo Casa Bianca, Malo · *Die Zeit. Werke 1963–1991*, Kunstmuseum, Luzern (Kat.: L. F., M. Schwander) · Galerie Elisabeth Kaufmann, Basel 1992 Galerie Durand-Dessert, Paris · Museum of Moderen Art, San Francisco

Gruppenausstellungen | Group exhibitions

1987 *Arte povera 1965–1971*, Galerie Durand-Dessert, Paris · *Giovanni Anselmo, Alighiero Boetti, Luciano Fabro, Giulio Paolini, Giuseppe Penone, Michelangelo Pistoletto*, Galleria Locus Solus, Genova · Galerie Roger Pailhas, Marseille · *Skulptur Projekte Münster*, Westfälisches Landesmuseum, Münster · *Inside-Outside*, Museum van Hedendaagse Kunst, Antwerpen · *Italie hors d'Italie*, Musée des Beaux-Arts, Nîmes · *Standing Sculpture*, Castello di Rivoli (Torino) · *Regenboog*, Stedelijk Van Abbemuseum, Eindhoven · *Nightfire*, Stichting De Appel, Amsterdam · *Memoria del video.* Padiglione d'Arte Contemporanea, Milano · *Beelden Enbandieren*, Fort Acquoy, Asperen **1988** *Christian Boltanski, Luciano Fabro, Rebecca Horn, Bruce Nauman*, Galerie Elisabeth Kaufmann, Zürich · *Mnemosyne oder das Theater der Erinnerung*, Schloß Herrnsheim (Worms) · *Academia*, Bonnefantenmuseum, Maastricht · Galerie Elisabeth Kaufmann, Basel · Galerie René Blouin, Montréal · *Carnegie International*, Carnegie Museum of Art, Pittsburgh · *Biennale*, Sydney **1989** *Italian art in the 20th century*, Royal Academy of Arts, London · *Verso l'arte povera.* Padiglione d'Arte Contemporanea, Milano · *Sculptures*, Margo Leavin Gallery, Los Angeles · *Bilderstreit*, Museum Ludwig, Köln · **1990** *Past, Present, Future*, Tate Gallery, London · *Anselmo, Chamberlain, Fabro, Flavin, Judd, Kounellis, Long, Merz, Nauman*, Lawrence SteinGladstone Gallery, New York · *Twintig/twenty posters: Hommage aan/ Homage to Vincent Van Gogh 1853–1890/ 1990*, Rijksmuseum Vincent Van Gogh, Amsterdam · *Energieën*, Stedelijk Museum, Amsterdam · *Casino fantasma*, Ca'Vendramin Calergi, Venezia · *Affinités sélectives VII. Luciano Fabro, Michel Verjux*, Palais des Beaux-Arts, Bruxelles **1991** *La collection*, Château de Roche-Chouart · *La sculpture contemporaine après 1970*, Fondation Daniel Templon, Fréjus **1992** *Territorium Artis*, Kunst- und Ausstellungshalle der Bundesrepublik Deutschland, Bonn · *Platzverführung*, Stuttgart · Kunsthalle, Basel

Bibliographie | Bibliography

Vollständige Bibliographie/Complete Bibliography in: Kat. *Die Zeit. Werke 1963–1991*, Kunstmuseum Luzern 1991

Texte vom Künstler | Texts by the artist
Selezione di scritti, in: Data, Nr. 1, 1 September, 1971 · *Testi*, in: Flash Art, Nr. 72/73, März/April, 1977 · *Didascalie delle opere*, in: Flash Art, Nr. 72/73, März/April, 1977

Bücher vom Künstler | Books by the artist
Apologhi, 1969–1978 · *Attaccapanni*, Tori-

no, 1978 · *Lettere ai Germani, Milano, 1979* · *Regole d'arte*, Casa degli Artisti, Milano, 1980 · *Aufhänger*, Köln, 1983 · *Luciano Fabro, Lavori 1963–1986*, Torino, 1987 · *Luciano Fabro, Travaux – Entretiens*, Paris, 1987 · *Testi*, in: Sottotraccia, Nr. 4/5, Roma, 1988 · *Kunst wird wieder Kunst. Arte torna arte*, Bern/Berlin, 1990 · *L'Art redevient l'Art. Kunst wordt terug Kunst*, Bruxelles

Interviews
Achille **Bonito Oliva**, *Conversazione con A.B.O.*, in: Achille Bonito Oliva, Dialoghi d'Artista, Mailand 1984 · Jan **Braet**, *Na de regen gaat een bloem open*, in: Knack, 18.Mai 1988 · Jan **Braet**, De kunst keert terug naar de kunst. in: Knack, 7.–13. Juni 1989 · Jan **Braet**, *Een sterk gebaar in een onbenullige vorm*, in: Knack, Nr. 20, 19.–25. Dezember 1990 · Germano **Celant**, *Intervista*, 27.6.1971 (nicht veröffentlicht/not published) · Stefano **Chiodi**, *Situazioni del senso*, in: Digraphe, Nr. 54, Dezember 1990 · Bruno **Corà**, *Un Habitat geometrico*, in: A.E.I.U.O., Nr. 7, 1983 (dt. in: L. F.: Kunst wird wieder Kunst) · Carla **Lonzi**, Discorsi, in: marcatré, Nr. 19–22, April 1966 · Francesca **Pasini**, *Prometeo irradiato*, in: Il Manifesto, Oktober 1986 · Francesca **Pasini**, *Luciano Fabro*, in: Flash Art, Sommer 1989 · Lisa Licitra **Ponti**, *colloquio con LLP*, Milano 9. 10. 1984, in: Domus, Nr. 656, Dezember 1984 · Jole De **Sanna**, *Natura no*, in: Fabro, Lavori, Turino 1986 · Margit **Rowell**, *Questioni di identità*, in: Kat. Fondació Joan Miró, Barcelona 1990

Periodika | Periodicals
Renat **Casarin**, *Luciano Fabro*, in: Tema Celeste, Nr. 19, Januar/Februar, 1991 · Germano **Celant**, *Luciano Fabro. The image that isn't there*, in: Artforum, Oktober, 1988 · Gillo **Dorfles**, *Luciano Fabro*, in: Vogue, Mai, 1987 · Vera Vita **Gioia**, *Luciano Fabro*, in: Arts Magazine, November, 1989 · Patrick **Javault**, *Luciano Fabro. De l'image à la forme*, in: Art Press, Nr. 115, Juni 1987 · Ken **Johnson**, *Luciano Fabro at SteinGladstone*, in: Art in America, Nr. 2, Februar, 1990 · G. **Jovane**, *Italiana 50–86. Da Valencia a Madrid*, in: Segno, Nr. 61, Januar 1987 · Donald **Kuspit**, Max Wechsler, Pier Luigi Tazzi, Ida Rein, *The critics' way. Münster, Rhineland-Westphalia*, in: Artforum, September, 1987 · Jacinto **Lageira**, Luciano Fabro, *Le miroir des sens ou quelques tautologies sur l'expérience esthétique*, in: Artstudio, Nr. 13, Sommer, 1989 · Lisa Licitra **Ponti**, *Acrobazie di Fabro*, in: Domus, Nr. 686, September, 1987 · Adalgisa **Lugli**, *La sfidadel castello*, in: Casa Vogue, Juni, 1989 · Robert **Mahoney**, *Luciano Fabro*, in: Arts Magazine, Nr. 7, Februar, 1990 · Johannes **Meinhardt**, *Luciano Fabro*, in: Zyma, Nr. 5, November/Dezember, 1991 · W.J.T. **Mitchell**, *The Pictorial Turn*, in: Artforum, Nr. 7, März, 1992 · Francesca **Pasini**, *Verso l'Arte povera*, in: Flash Art, Nr. 149, April/Mai, 1989 · Francesca **Pasini**, *Luciano Fabro*, in: Flash Art, Sommer, 1989 · Francesca **Pasini**, *Luciano Fabro*, in: Artforum, Nr. 5, Januar, 1991 · Giacinto Di **Pietrantonio**, *Luciano Fabro*, in: Flash Art, Nr. 159, Dezember 1990/Januar 1991 · Floriana **Piqué**, *Luciano Fabro*, in: Flash Art, Nr. 152, Oktober/November, 1989 · Floriana **Piqué**, *Torino anni settanta*, in: Flash Art, Nr. 162, Juni/Juli, 1991 · Francesco **Poli**, *Luciano Fabro tra realtà e rappresentazione*, in: Carte d'arte,

Nr. 6, Dezember, 1989 · M. Raphael **Rubinstein**, *Milano. Luciano Fabro*, in: Art News, Nr. 1, Januar, 1991 · Daniela **Salvioni**, *Arte povera de Barbara Gladstone New York*, in: Flash Art, Sommer, 1987 · Jole De **Sanna**, *Luciano Fabro*, in: Contemporanea, Nr. 5, Juli/August, 1989 · Jole De **Sanna**, *Luciano Fabro. Separate and in action*, in: Arti, Nr. 3, Januar/Februar, 1991 · Heinz **Schütz**, *Luciano Fabro*, in: Kunstforum, Bd.96, August/Oktober, 1988 · Riki **Simons**, *Luciano Fabro en de uitkomsten van een denkproces*, in: Avenue, 7. Juni, 1988 · Daniel **Soutif**, *La famille pauvre*, in: Artstudio, Nr. 13, Sommer, 1989 · Anna Stuart **Tovini**, *Luciano Fabro*, in: Tema Celeste, Nr. 10, Januar/ März, 1987 · Elisabeth **Vedrenne-Careri**, *Points de suspension*, in: Beaux-Arts, Nr. 75, Februar, 1990 · Daniel **Wiener**, *Luciano Fabro dancing to dense cultural allusions*, in: Flash Art, Nr. 150, Januar/Februar, 1990 · Daniel **Wiener**, *Luciano Fabro*, in: Flash Art, Nr. 155, April/Mai, 1990 · Adachiara **Zevi**, *Luciano Fabro. Atto non d'intelletto ma di senso*, in: L'architettura, Nr. 403, Mai, 1989

BELU-SIMION FAINARU

*Bucurest (RO), 1959
Lebt/Lives in Haifa/Antwerpen

Einzelausstellungen | One-man exhibitions

1981 Installation im Schutzbunker eines öffentlichen Hauses/Installation in the bombshelter of a public house, Haifa **1984** *From around a lake*, Midway Gallery, Chicago **1986** *Bluegarden for Sun Lovers (Tchelgan)*, Janco-Dada Museum, Ein-Hod · *The Flautist's Longings*, Mabat Gallery, Tel-Aviv **1988** *Sculpture works*, X+ Gallery, Knokke · *The Unity of a Broken Wing*, Internationaal Cultureel Centrum, Antwerpen **1989** *Crystal Night Souvenirs*, Avantgarde Gallery, Antwerpen · *Tzad Mizrah*, Musée d'Art Moderne, Bruxelles **1990** *Travail au Noir*, Ficheroulle Art Gallery, Bruxelles · *The Heart Needs More Room to Breathe*, Equilibrist Gallery, St. Niklaas · Vereniging voor het Museum van Hedendaagse Kunst, Gent **1991** Hugo Minnen Gallery, Dessel · Sara Levy Gallery, Tel-Aviv **1992** Museum of Israeli Art, Ramat-Gan · Noga Art Gallery, Hertzlia

Gruppenausstellungen | Group exhibitions

1987 *Tel-Hai '87: International Sculpture Meeting*, Tel-Hai · *Inside-Outside: An Aspect of Contemporary Sculpture*, Museum van Hedendaagse Kunst, Antwerpen 1988 *The New Generation in Israeli Art*, The Israel Museum, Jerusalem · *Drawings*, Avantgarde Gallery, Antwerpen 1989 *Light Exhibition*, Savolina (Finl.) 1990 Sara Levy Gallery, Tel-Aviv · Helan Art Foundation, Bornem 1991 Transit Gallery, Leuven · *The Presence of the Absent – The Empty Chair in Israeli Art*, Genia Schreiber University Art Gallery, Tel-Aviv University, Tel-Aviv · Noga Art Gallery, Herzlia · *Rooms*, Artists' House, Jaffa – Tel-Aviv · Tel-Aviv Museum, Tel-Aviv 1992 *Nomadism in Israeli Art*, Israel Museum, Jerusalem · *The Artist as a Channel*, The Art Gallery of Haifa, Haifa · National Museum of Art, Seoul · *Time Sculpture, Time Photography*, The Studio Borohov Art Gallery, Tel-Aviv · Sara Levy Gallery, Tel-Aviv · The Art Gallery, University of Haifa, Haifa

PETER FEND

*1950
Lebt/Lives in New York

Ausstellungen | Exhibitions

1978 *Earthnet : An Economic System*, Caltech, Baxter Art Museum, Pasadena 1979 *Iron Lung : Towards an other architecture, AROOM DEFIN ED NOTBY WALLS BUTBY APUMP*, Peter Nadin Gallery, New York/Milano 1980 *World Space*, Peter Nadin Gallery, New York · *Ruhrgebiet Projekt*, Duisburg · *Time Square Show*, architectural proposal for midtown Manhattan · *Public Policy : Architectural Propositions*, artists and architects from New York, Los Angeles, Germany · The Offices of Fend, Fitzgibbon, Holzer, Nadin, Prince & Winters, New York; Los Angeles; London 1981 *New York/New Wave*, P.S. 1, New York 1982 *Global System*, Chase Manhattan Placa, New York · *Art of the State*, The Kitchen, New York · *Natural History*, Grace Borgenlicht Gallery 1983 *Image/Process*, The Kitchen, New York ·

SPACE FORCE, aspects of OECD, Kunsthalle, Düsseldorf · *The 1984 Show*, Ronald Feldman, New York 1984 *Kunst und Medien*, Kunsthalle Berlin · *Via Saterllite*, Amerika Haus, Köln · *International Show*, Baskerville & Watson, New York 1985 *Bacino Torbido*, Museo Santa Barbara, Calabria · *German Art 1945 – 1985*, Nationalgalerie, Berlin 1986 Surveillance, LACE, Los Angeles · *Beach Party*, Corporate Crime, various sites in CA 1987 *The New Poverty*, John Gilbert Gallery, New York · *documenta 8*, Kassel · Computer Images of Architects, New York · SIPRI Yearbook, Stockholm International Peace Research Institute 1988 *Peter Fend*, with *Middle East Conference Room*, Scott Hanson Gallery, New York · *International Landscape*, Galerie Christoph Duerr, München · *Body*, OECD, American Fine Arts, New York · KunstRai, Amsterdam · *Art at the End of the Social*, Rooseum, Malmö · *The New Poverty II*, Meyers Bloom Gallery, Los Angeles 1989 *Completion of the War*, American Fine Arts, New York · *Global Natural Ressource Monitoring and Assessments*, United Nations Environment Program Conference, Venezia. · Video Works, Galleri Nordanstad-Skarstedt, Stockholm · *California Project*, Terrain, San Francisco · *International Landscape*, XPO Gallery, Hamburg · Competition Diomede, *architectural project finalist*, New York (et al.) 1990 *News Room Frankfurt*, Pavilion, Ryszard Varisella, Frankfurt · *Einheiten*, Ryszard Varisella, Frankfurt · Soirées at Emmanuel Perrotin, Paris : Gulf, Japan · *Die Totenstadt : City of the Dead*, OECD, Tanja Grunert, Köln · *Städte als Körper : Cities as Bodies*, City Bild OECD, Esther Schipper, Köln · *Progretoo Adriatico : Administration of the Adriatic*, Ocean Earth OECD, Le Casa D'Arte, Milano · *Kleine Fragen*, selected photos of sculpture project apparently by German secret police, Galerie Christian Nagel, Köln · *In The Beginning*, Cleveland Center for Contemporary Art · *News Room New York*, American Fine Arts, New York · *News Room Amsterdam*, Museum Fodor, Amsterdam · Golfe Nouveau, soirée/exposition, Emmanuel Perrotin, Paris · *Reconnaissance*, Simon Watson Gallery, New York · *Around the World*, P.S. 1, New York 1991 *Trivat Test Site*, Gallery Transplant, American Fine Arts, New York · *Europa*, Kunstraum Daxer, München · *City of the Dead II*, Galerie der Künstler, München · *Heimaten*, video surveillance of Black Sea, in subway system, Wien · *News Room Amsterdam*, press conference in Den Haag and presentation at Fotomuseum München · Assemblée Nationale, Paris · *Teorici Americano*, Ottagano, Milano · Frac Corse, Corsica · *Incognito*, Curt Marcu Gallery, New York · *News Room Stockholm*, Galleri Nordenstad-Skarstedt · *Beach Party: a New World Order – Common Wealth*, American Fine Arts, New York · La Salle du Monde, Hopital Ephémère, Paris 1992 *News Room Sarajewo* · *Souvenir de l'avenir*, Frac des Pays de la Loire, Clisson (et al.) · *Albania and Los Angeles*, parallel projects, at Malibu Invitational, Malibu · *Noordzee*, HDTV installation at Florida, Den Haag: co-copyrighted with Dutch and Swiss scientists · *Espace Circulant/Room Spin*, Galerie Roger Pailhas, Paris · *Out of Yugoslavia, A New*, Riverside Studios, London · *Beach Party Deutschland*, Esther Schipper, Köln · *Hacienda*, CCC, Tours

Bibliographie | Bibliography

Texte vom Künstler | Texts by the artist
Administration of the Adriatic, in: Flash Art, November/Dezember, 1990 · *Desert Flood*, in: New Observations, Nr. 82, Februar/März, 1991 · *The State of the Art – the Art of the State*, in : Fotogeschichte, Nr. 43, 1992

Periodika | Periodicals
Jul. Cric. **Corp.**, *Peter Fend*, in : Juliet, Nr. 49, 1990 · Alan **Jones**, *Thinking Big. Peter Fend's World Beach Party*, in : Arts Magazine, November, 1991 · Jutta **Koether**, *Die verdrängte Dimension jeder Kunst*, in: Zyma, Nr. 5, November/Dezember, 1990 · Jérôme **Sans**, *Construction and Development. A Conversation with Peter Fend*, in : Arts Magazine, November, 1991 · Gregor **Schwering**, Christoph **Marx**, *Manifeste für die Zukunft*, in: Zyma, Nr. 5, November/Dezember, 1990 · Raimund **Stecker**, *Ökologische Kunst und politische Krise*, in: FAZ, September, 1990

ROSE FINN-KELCEY

*Northampton (GB)
Lebt/Lives in London

Einzelausstellungen | One-man Exhibitions
(Performances – Installations)

1970 Railway line site, Flag installation alongside the Euston Line at Berkhamstead 1972 Battersa and Bankside Power Stations, London. *Power for the People* flags flown from both buildings 1974 Midland Gallery, Nottingham 1983 Performance of *Glory*, The Serpentine Gallery, London 1984 Performance of *Flaming Cheek* · Vacated performance and installation *Black and Blue – The Button Pusher's View of Paradise*, Matt's Gallery, London 1988 Extended version of *Bureau de Change installation*, Matt's Gallery, London 1992 Installation *Infinite Turbulence*, Chisenhale Gallery in collaboration with Edge 92, London

Gruppenausstellungen | Group exhibitions
(Performances – Installations)

1987 *New Works Newcastle* (Installation *Bureau de Change*), Laine Gallery, Newcastle (et al.) · *Depicting History* (Installation *Bureau de Change*), Mappin Gallery, Sheffield · *Depicting History* (Installation of *Fallen Totem*), City Art Gallery, Leeds 1988 *Depicting History* (Installation of *Fallen Totem 2*), Rochdale Art Gallery, Rochdale · *Something Solid* (Installation of *Pool*), Corner House, Manchester · *The Maginot Line*, Gala Benefit, Riverside Studios, London 1989 *The Tree of Life*, The Corner House, Manchester (et al.) · *The Suitcase Show* (Installations *When Your Ship Comes In*), Harris Museum, Preston (et al.) 1990 *Landscapes* (*Bar Doors*, site-specific work), Houston International Festival, Texas · *Signs of the Times* (a decade of time-based work in Britain, 1980–1990), Museum of Modern Art, Oxford · *Rhetorical Image* (International version of *Bureau de Change*), New Museum of Contemporary Art, New York · *A New Necessity* (Site-specific installation *Openings*), Tyne International for the Garteshead Garden Festival, Gateshad 1991 *Shocks to the System*, Royal Festi-

val Hall, London · Amnesty International Auction, Bonhams Showroom, London 1992 *Edge 92,* International season of performance and installation work, London/Madrid (Site-specific installation for Madrid) · The Angel Row Gallery (Installation), Nottingham

Bibliographie | Bibliography

Periodika | Periodicals
Marjorie **Allthorpe-Guyton**, *Bureau De Change,* in: Performance Magazine, Frühjahr, 1988 · Guy **Brett**, *Depicting History For Today,* in: Art Monthly, Oktober, 1988 · Edith **Decker**, *Signs of the Times,* in: Kunstforum, März/April, 1991 · Patrick **Finnegan**, *(Interview),* in: Contemporanea, September/Oktober, 1988 · Liam **Gillick**, *A New Necessity,* in: Artscribe, September/Oktober, 1990 · Sarah **Kent**, *Sign Of The Times,* in: Time Out, Oktober, 1990 · Sotiris **Kyriacon**, *(review),* in: Artscribe, März/April, 1991 · Kim **Levin**, *Art that Intervenes,* in: Village Voice, Dezember, 1990 · Roger **Wollen**, *Confrontations/New Work Newcastle,* in: Art Monthly, Juli, 1987

Video
1982 *Cut-Out,* video documentation of a performance at the 4th International Symposium of Performance Art, Lyon 1984 *Glory,* World-Wide Video Festival, Holland, San Sebastian Film and Video Festival, Locarno and Montréal Video festivals. Included in *Recent British Video* at the ICA Videotheque, A Space Toronto, The Kitchen, New York, International Exhibition of Women's Art in Wien, The British Art Show, Metro Cinema (et al.) 1992 *Suit of Lights – unfinished video work*

Film
1992 Film documentary of *Bureau de Change,* produced and edited by Nick Collins

FLATZ

*Dornbirn (A), 1952
Lebt/Lives in München/Berlin

Einzelausstellungen | One-man exhibitions

1980 Galerie Rüdiger Schöttle, München · Galerie Konrad Fischer, Düsseldorf 1981 Kunstforum der Städtischen Galerie im Lenbachhaus, München (Kat.: H. Friedel, J. Johnen) · Galerie Max Hetzler, Stuttgart 1982 Büro Orange, Siemens München (mit/

with Günther Förg)1988 Forum, Kunstmesse Hamburg, Galerie Christoph Dürr, München 1989 *Werkschau 1972–1989,* Künstlerhaus Palais Thurn und Taxis, Bregenz (Galerie Mosel und Tschechow, München) (Kat.: T. Dreher, F., V. Loers) · Kunstraum Wuppertal · Evangelische Akademie, Schloß Hofgeismar, Kassel 1990 Palast der Jugend, Leningrad (Kat.: V. Loers, R. Metzger) · Siemens Führungskreis Haus Witzleben, Feldafing (mit Florian Aicher) (Kat.: F. Aicher/F., U. Bischoff, R. Metzger) 1991 Kunstverein, München (Kat.: T. Dreher, Z. Felix, F., R. Scala, G. Schöllhammer, G. F. Schwarzbauer) · *Flatz – Klimawechsel,* Galerie im Scharfrichterhaus, Passau · *Ich bin schon eher eine Ratte...,* Ars Electronica, Linz

Gruppenausstellungen | Group exhibitions

1987 *Möbel als Kunstobjekt,* Künstlerwerkstätten Lothringerstrasse 13, München · *Portraits (1780–1980),* Voralberger Landesmuseum, Bregenz 1988 *Arbeit in Geschichte-Geschichte in Arbeit,* Kunsthaus und Kunstverein, Hamburg · *Ausgesuchte Videos,* Galerie Christoph Dürr, München · *Broken Neon,* Galerie Christoph Dürr, München (et al.) · *International Landscape,* Forum Stadtpark, Graz (et al.) · *(W)Orte,* Galerie der Künstler, München 1990 *Picture of Rock,* Kunsthallen Brandts Klaederfabrik, Odense (et al.) · *Zeitbezüglich,* 6. Kunstwoche Dillingen, Kunstverein, Dillingen 1991 *Münchner Räume, Modelle neuer Innenarchitektur,* Stadtmuseum München · *Krieg und Fotografie,* Galerie der Künstler, München · *Ars Electronica, Out of Control,* Brucknerhus, Linz · *Soft Targets-Visionen im Raum,* Künstlerwerkstätten Lothringerstraße 13, München

Performances · Aktionen | Actions

1974 *Modenschau,* Hotel Steirer Hof, Graz 1975 *Palais Liechtenstein,* Palais Liechtenstein, Feldkirch · *Zum 3. Jahrestag,* Ortsgebiet Rankweil · *Zum österreichischen Nationalfeiertag,* Hauptplatz Graz · *Teppich,* Akademie der bildenden Künste, München 1977 *Schläge,* Großer Vortragssaal des Wirtschaftsförderungsinstitutes, Bludenz 1978 *Handtuch,* Internationales Performancefestival, Belgrado · *Lebensraum,* Performance and Body, Lublin · *Der letzte Schliff,* Internationales Performancefestival, Wien · *Wallroll,* 3 Performer, Warszawa; Performances 79, Lenbachhaus, München 1979 *Sandsack,* Europa 79, Stuttgart · *Treffer,* Europa 79, Stuttgart · *Walltouch II,* Akademie der bildenden Künste, München 1980 *Walltouch III,* Museum Moderner Kunst, Wien · *Schwarzbauersekunden,* Gesamthochschule Wuppertal · *Blackout,* Berner Galerie, Bern (Kat.: G. F. Schwarzbauer) 1982 *Lovestories,* Sage und Schreibe, Literaturfestival, München

Demontagen
1987 *Demontage I,* Schock und Schöpfung, Ritterwerke München · *Demontage II,* Galerie Galerico, Rosenheim · *Demontage III,* Prozessionstheater München · *Demontage IV,* Möbel als Kunstobjekt, Künstlerwerkstätten Lothringerstr. 13, München · *Demontage V,* Combinale, Alabamahalle München 1988 *Demontage VI,* 10-jähriges Jubiläum, Hotel Chelsea, Köln 1989 *Demontage VII,* Kunstraum Wuppertal 1990 *Demontage VIII,* Prospekt Fantanka, Leningrad · *De-*

montage IX, Alte Synagoge, Tiflis 1991 *Demontage X,* Kunstverein München · *Demontage XI,* Ars Elecronica, Brucknerhaus, Linz 1992 *Demontagen IX–XII,* Im Freihaus, Wien

Bibliographie | Bibliography

Texte vom Künstler | Texts by the artist
Intentionen und Medium, in: Kunstforum, Bd. 36, 1979 · *Applaus für Mary Lou,* in: Prinz, Nr. 10, Oktober, 1989 · *Das Millionenspiel,* in: Applaus, Nr. 4, April, 1990

Periodika | Periodicals
Christoph **Blase**, *Kunst plus Kunst. Die Kunst mit den reproduzierenden Medien,* in: Artis, September, 1989 · Gabi **Czöppan**, *Mit Micky-Maus in Leningrad,* in: PAN, Nr. 8, 27. Juli, 1990 · Henry **Gerlach**, Katrin **Schauffele**, *Fressen, Ficken, Fernsehen,* in: Accent, Nr. 7, Juli, 1989 · Eric **Hansen**, *Should Art be an Imitation of Ads? Eric Hansen looks to the fast-moving world of the shaven-headed artist Wolfgang FLATZ,* in: The European Weekend, 2/4 November, 1990 · Christa **Hausler**, *Im Streiflicht der Geschichte,* in : Bodenseehefte, Nr. 7, Juli, 1989 · Justin **Hoffmann**, *Munich. Wolgang FLATZ. Mosel & Tschechow,* in: Artforum International, Oktober, 1989 · Justin **Hoffmann**, *FLATZ: Unternehmen Leningrad,* in: Kunstforum International, Bd. 108, Juni/Juli, 1990 · Justin **Hoffmann**, *FLATZ in the USSR,* in: Artscribe, September/Oktober, 1990 · Rainer **Metzger**, *Wolfgang FLATZ, Mosel & Tschechow,* in: Flash Art, Nr. 147, Juli/August, 1989 · Rainer **Metzger**, *Gespräch mit Iwan. Das »Unternehmen Leningrad« von Wolfgang FLATZ,* in: Applaus, Nr. 7, Juli, 1990 · Karlheinz **Schmid**, *FLATZ nach Leningrad,* in: Kunst Intern, Newsletter, Nr. 9, 31. März, 1990 · s.n., *Wolfgang FLATZ,* in: Art, Nr. 6, Juni, 1988 · s.n., *Heldentod,* in: Miss Vogue, Mai, 1989

Videoperformances
1977 *Schläge,* s/w-Kamera, s/w-Monitor · 1978 *Lebensraum,* Videoüberwachungskamera und Kontrollmonitor 1979 *Treffer,* 2 s/w-Kameras, 2 Rekorder, 2 s/w-Monitore 1980 *Walltouch III,* Videoüberwachungska-

mera, 2 Monitore · *Blackout*, Videoüberwachungskamera, Monitor **1991** *Demontge XI*, Videokamera, 1 Kontrollmonitor

Videoinstallationen, -skulpturen
Videoinstallations, -sculptures
1980 *2 & eine voneinander scheinbar wirklich unabhängige Situationen*, 2 U-matic-Rekorder, 2 61-cm-Farbemonitore, ein Tisch, zwei Stühle, Video Farbe, 2x60 Min. **1981** *Toni Marlboro*, U-matic-Rekorder, Farbfernsehgerät, U-matic-Endloskasette, Fernsehliegesessel, Teppich, Knabbertischchen mit Knabbergebäck, Bier und halbgefülltes Bierglas, Fernsehrollwagen mit gerahmten Kunstdruck **1984** *Friseursalon Rosana*, Erster Video-Friseursalon, Closed-Circuit-Installation **1985** *Model America*, VHS-Player, Farbmonitor, VHS-Endloskasette, Eisenstuhl, 2 Wassereimer **1991** *Schläge*, VHS-Player, Monitor, s/w-Video auf Endloskasette, Stahlrohrsessel · *Demontage VII*, VHS-Player, Podest, Farbmonitor, VHS-Endloskassette, Jacke »FLATZ-Syndikat« · *Demontage IX*, VHS-Player, Podest, Farbmonitor, VHS-Endloskassette, Hanfseil

Videobänder | Videotapes
1975 *Eine Minute oder vier Ansichten einer Person*, s/w, 1 Min. · *15 Minuten oder Wie schnell verliert man seine Identität*, s/w, 15 Min. · *30 Minuten auf Sendung*, s/w, 30 Min. · *Teppich*, s/w, 12 Min. **1977** *Kameraliebe*, s/w, 12 Min. · *Schläge*, s/w, 15 Min. **1978** *Handtuch*, s/w, 3 Min. · *Lebensraum*, s/w, 3 Min. · *Der letzte Schliff*, s/w, 4 Min. **1979** *Wallroll*, Farbe, 2 Min. · *Treffer*, s/w 6 Min. **1980** *Walltouch II*, s/w, 80 Sek. · *2 & eine voneinander scheinbar wirklich unabhängige Situationen*, Farbe, 2x60 Min. **1981** *Toni*, Farbe, 7 Sek. Endlosspot, Band aus der Videoinstallation »Toni Marlboro« · *Toni Tausendschön*, Farbe, 3 Min. 39 Sek. **1982** *Und sie bewegten sich doch nicht oder Die Sprache ihrer Bilder hat versagt*, Farbe und s/w, 12 Min. **1987** *Demontage II*, Farbe, 30 Min. · *Demontage V*, Farbe, 4 Min. **1988** *Demontage VI*, Farbe, 6 Min. 10 Sek. · *Demontage VII*, Farbe, 15 Min. **1989** *Demontage VIII*, Farbe, 10 Min. **1990** *Demontage VIII*, Farbe, 10 Min. **1991** *Demontage IX*, Farbe, 15 Min. · *A Portrait*, Farbe, 25 Min. · *Demontage X*, Farbe, 25 Min. · *Demontage XI*, Farbe, ca. 12 Min.

Rundfunk · Fernsehen | Radio · Television
Schweizer Rundfunk, SRG 1, FLATZ – Porträt, Interview zu *Performance – Art*, 26. Juni, 1978 · TV Weiss-Blau, FLATZ – Porträt, Interview, 28. Mai, 1985; Redaktion: Dorothée May · Bayerische Rundfunk, Zündfunk, FLATZ, Porträt, Interview, 18. Dezember, 1988 · RTL-Plus, Kul-Tour, FLATZ – Werkschau 1972–1989 in der Galerie Mosel & Tschechow, 10. April, 1989; Redaktion: Piet Klein · BBC, The Late Show, Interview, 14. Dezember, 1989; Redaktion: John Whiston · ZDF, Aspekte, FLATZ – *Unternehmen Leningrad*, Porträt, 27. April, 1990; Redaktion: Wolfram Cornelissen · ORF, FS 2; Kultur-Journal, FLATZ: *Unternehmen Leningrad*, Porträt, 29. April, 1990 · Sowjetisches Fernsehen, 600 Sekunden, FLATZ – Ausstellung *Unternehmen Leningrad*, Porträt, 30. April, 1990 · Lenfilm, UdSSR, Flatz, Interview, 2. Mai, 1990; Redaktion: Victor M. Izvekov · Georgisches Fernsehen, UdSSR, Flatz, Interview, 23. Juni, 1990; Redaktion: Laly Andronicachvily · Radio Xanadu,

FLATZ, Interview zur Ausstellung *Unternehmen in der UdSSR*, 22. Juli, 1990 · Bayerische Rundfunk, Zündfunk, FLATZ, Porträt, Interview, 11. August, 1990 · NDR, Bayern 3, Bayerisch Rundschau, FLATZ, Porträt, Interview, 13. März, 1991

FORTUYN/O'BRIEN

Lebt/Lives in Amsterdam

Einzelausstellungen | One-man exhibitions

1984 *Bon Voyage Voyeur – a view over the ocean, part one: Den Haag*, Galerie van Kranendonk, Den Haag · *Bon Voyage Voyeur – A View over the Ocean, Part Two: New York*, Artists' Space, New York · *Fortuyn/O'Brien – The Reflex*, Museum Fodor, Amsterdam **1985** Galerie The Living Room, Amsterdam · *Beelden in de koepel – Fortuyn/O'Brien*, Gemeentemuseum, Arnhem **1987** *Fortuyn/O'Brien*, Luhring, Augustine & Hodes Gallery, New York **1988** *Fortuyn/O'Brien – Merry Christmas*, Galerij Joost Declercq, Gent · *Fortuyn/O'Brien – The Twentyfour Men in White*, Maison de la Culture, Saint-Etienne (Kat.: F/O, P. Groot, P. Javault, P. L. Tazi) · *Fortuyn/O'Brien*, Galleria Locus Solus, Genova **1989** *Fortuyn/O'Brien – Regard en coulisse*, Galerie Roger Pailhas, Marseille · *Fortuyn/O'Brien*, Galerie The Living Room, Amsterdam **1991** Galerie Roger Pailhas, Paris · *The Living Room*, Galerie The Living Room, Amsterdam · *Marblepublic*, Stedelijk Museum, Amsterdam (Kat.: W. Beeren, F/O, C. Gould, P. L. Tazzi)

Gruppenausstellungen | Group exhibitions

1987 *National and International Studio Programs 1986–1987*, P.S. 1, The Clocktower, New York · *D'Ornamentation*, Daniel Newburg Gallery, New York · *Selections from XVI*, Damon Brandt Gallery, New York · *Die große Oper – oder Die Sehnsucht nach dem Erhabenem*, Bonner Kunstverein, Bonn (et al.) · *Nightfire*, Stichting De Appel, Amsterdam **1988** *L'Inventaire*, Manufrance, Saint-Etienne · *La giovane scultura olandese*, Palazzo Sagredo, Venezia · *Aperto 88*, Biennale di Venezia, Venezia · *Beelldentuin/Sculture Garden*, Rijksmuseum Kröller-Müller, Otterlo · *Eléments Manifestes*, Galerie Roger Pailhas, Marseille · *Eh! bien prenons la plume*, Arti et Amicitiae, Amsterdam **1989** *Theatergarden Bestiarium*, P.S. 1, The Clocktower, New York (et al.) · *Tekens van Verzet*, Museum Fodor, Amsterdam · *Kapriolen – Zeitgenössische Kunst aus den Niederlanden*, Künstlerwerkstatt Lothringerstrasse, München · *Beelldentuin/Sculpture Garden*, Gemeentemuseum, Arnhem · *Territoires d'artistes Paysages verticaux*, Musée du Quebec, Quebec **1990** *Galleria*, Galleria Locus Solus, Genova · *Pelago – un progeto*, Commune di Pelago, Pelago · *Paleistuin/Beelldentuin*, Paleistuin, Den Haag · *Art meets Science and Technology in a changing Economy*, Museum Fodor, Amsterdam · *Dujouri, Fortuyn, Houshiary, Kapoor, Beelden van afweezigheid tekens van verlangen*, Rijksmuseum Kröller-Müller, Otterlo · *Tempels, Zuilen, Sokkels*, Cultureel Centrum De Werf, Aalst **1991** *14 A3* (mit/with Bas Wit-

lox), Galerie van den Berge, Goes · *Ars Usu*, Gemeentemuseum, Den Haag

Bibliographie | Bibliography

Texte und Bücher von der Künstlerin
Texts and books by the artist
Uitnodiging/Invitation, in: Kat. Beelden/Sculpture 1983, Rotterdamse Kunst Stichting, Rotterdam, 1983 · *De vervalste tijdsgeest – Galerij 1984*, in: Museumjournaal, Nr. 2, Jg. 28, 1983 · *Personalia – Portret – Zelfportret van een stad*, in: brochure/leaflet Forum Skulptuur 1983, Middelburg, 1983 · *(statement)*, in: verslag/report Forum Skulptuur 1983, Middelburg, 1984 · *Bon Voyage Voyeur – Gedachten over skulptuur/Bon Voyage Voyeur – Some thoughts about sculpture*, Amsterdam, artist's publication, 1984 · *(statement)*, in: brochure/leaflet International projects: Holland-Fortuyn/O'Brien, Artists' Space, New York, 1984 · *(statement)*, in: Kat. Philosophies on the art process, Stichting Makkom, Amsterdam, 1984 · *(statement)*, in: Kat. Beelden aan de Linge, Reflex, Utrecht, 1984 · *Alchemy and mico-electronics (lecture)*, Symposium Under the influence of mercury, Scheepvaart Museum, Amsterdam (not published), 19. Oktober, 1984 · *Luchtkasteel*, in: De Appel, Nr. 2, 1984 · *Kunstenaarsbijdrage/artist's project*, in: Fodor (leaflet), Nr. 9, Jg. 3, August/September, 1984 · *(statement)*, in: Kat. Beelden op de Berg 4, Belmonte Arboretum, Wageningen, 1985 · *Domestic sculpture*, in: Kat. Sonsbeek 86, Arnhem, Bd. II, 1986 · *Poker*, in: CODE, (Amsterdam), Nr. 6, Februar, 1987 · *Ambiguïteiten*, in: Museumjournaal, Nr. 5/6, Jg. 32, 1987 (published in: R. Cramigni/P. Tazzi, *PELAGO*, Firenze) · *Leda and the swan and the ugly duckling*, in: Kat. Nightfire, De Appel, Amsterdam, 1987 · *The foot and the trowel*, in: Kat. La giovane scultura olandese, RBK, Den Haag, 1988 · *Tuinen*, in: Museumjournaal, Nr. 5/6, Jg. 33, 1988 · *Het bestaan van de muis die op het dak liep en de goudvis zwemmend in zijn glazen kom...*, in: Antje von Graevenitz (ed.), '(ander werk)', kaAP, Arnhem, 1988 · *Artists Investigation*, in: Flash Art News, Nr. 143, November/Dezember, 1988 · *(cover)*, in: Haagse Post, Nr. 51/52, Dezember, 1988 · *6 augustus 1988*, in: Beeld, Nr. 1/2, Jg. 4, Januar, 1989 · *Scala*, in: Ch. Dercon, *Theatergarden Bestiarium Jardin-Theatre*, Cambridge, Massachutes, The MIT Press, 1989 (R. Grammigni, P. Tazzi, *PELAGO*, Firenze) · *Les yeux en coulisse*, in: Kat. Bestiarium Jardin – Theatre, Entrepot-Galerie du Confort Moderne, Poitiers, 1989 · *De wil van het beeld*, in: R. Schimmel, A. Vos (Red./Ed.), *de wil van het Beeld*, Nijmegen, Virtu IBK, 1989 · *The promters box* (trailers for the film), Prod. Stichting Actuele Kunstdocumentatie, 1989 · *(kunstenaarsbijdrage/artist's project)*, in: Kat. Dujouri, Fortuyn/O'Brien, Houshiary, Kapoor: Images of absence -signs of desire, Rijksmuseum Kröller-Müller, Otterlo

Periodika | Periodicals
Caroline **Christov-Bakargiev**, *Fortuyn/O'Brien*, in: Flash Art, September/Oktober, 1989 · Viana **Conti**, *Fortuyn/O'Brien*, in: Flash Art (It.), Nr. 147, Dezember, 1988 · Lynne **Cooke**, *New York – A distanced View*, in: Artscribe International, Nr. 61, 1987 · Thomas **Dreher**, *KAPRIOLEN – Zeitgenössische Kunst aus den Niederländen*,

in: Wolkenkratzer Art Journal, Nr. 4, Juli/August, 1989 · Christine Dubois, *The materialisation of intimacy,* in: Parachute, Nr. 56, 1989 · Paul Groot, *Fortuyn/O'Brien,* in: Kunstforum, März/April, 1990 · Catherine Grout, *Vice Versa – dutch art in France,* in: Dutch Art + Architecture Today, Nr. 24, Dezember, 1988 · Eleanor Heartney, *New York – Fortuyn/O'Brien,* in: Art News, Dezember, 1987 · Frank-Alexander Hettig, *Fortuyn/O'Brien,* in: Forum International, Nr. 10, November/Dezember, 1991 · Frank-Alexander Hettig, *Fortuyn/O'Brien,* in: Kunstforum, Bd. 116, November/Dezember, 1991 · Patrick Javault, *Fortuyn/O'Brien – Oeuvres en echo,* in: Art Press, Nr. 121, Januar, 1988 · Jack Kankowsky, *New York – Fortuyn/O'Brien,* in: Flash Art, November/Dezember, 1987 · Jhim Lamoree, *De liefde voor het berispelijke,* in: Haagse Post, Nr. 51/52, 24. Dezember, 1988 · Kate Linker, *New York – A distanced View,* in: Artforum, Januar, 1987 · Nancy Princenthal, *Fortuyn/O'Brien at Luhring, Augustine & Hodes,* in: Art in America, Jg. 75, Nr. 11, 1987 · Pier Luigi Tazzi, *If you go down in the woods today,* in: Artforum, Mai, 1989 · Jonathan Turner, *Fortuyn/O'Brien,* in: Art News, Januar, 1992 · Camiel van Winkel, *Fortuyn/O'Brien: MARBLEPUBLIC,* in: Archis, Oktober, 1991 · Giorgio Verzotti, *Fortuyn/O'Brien – Maison de la culture, Saint-Etienne,* in: Flash Art, Nr. 142, Oktober, 1988 · Arno Vriends, *Fortuyn/O'Brien,* in: Art Press, 1991

Video
1984 *Much ado about nothing,* Prod. Magriet de Moor, Bussum, 1984

Filme | Fims
The prompters box, 88

GÜNTHER FÖRG

*Füssen (D), 1952
Lebt/Lives in Areuse

Einzelausstellungen | One-man exhibitions

1974 *6 Graue Bilder,* Akademie der bildenden Künste, München 1977 *8 Bilder,* Akademie der bildenden Künste, München 1980 Rüdiger Schöttle, München 1981 Galerie van Krimpen, Amsterdam 1982 Büro Orange, München · Galerie Kubinski, Stuttgart 1983 Schaufenster Nr. 34, München · Galerie Ursula Schurr, Stuttgart · Galerie van Krimpen, Amsterdam · Rüdiger Schöttle, München · studio f, Ulm · Kunstmarkt Köln, Galerie Max Hetzler, Köln 1984 Galerie Max Hetzler, Köln · Ausstellungsraum Fettstraße 7a, Hamburg · Galerie van Krimpen, Amsterdam · Kunstraum, München · Galerie Tanja Grunert, Stuttgart 1985 Galerie Erhard Klein, Bonn · Galerie Heinrich Ehrhardt, Frankfurt/M. · Galerie Max Hetzler, Köln · Galerie Micheline Szwajcer, Antwerpen · CCD Galerie, Düsseldorf · *Tekeningen,* Galerie van Krimpen, Amsterdam · Annette Gmeiner Galerie, Kirchzarten · Stedelijk Museum, Amsterdam 1986 Kunsthalle, Bern (Kat.: U. Loock) · Galerie Borgmann-Capitain, Köln · Westfälischer Kunstverein, Münster (Kat.: P. Groot) · Galerie Vera Munro, Hamburg · Galerie Grässlin-Ehrhardt, Frankfurt/M. · Galerie Achim Kubinski, Stuttgart · Galerie Max Hetzler, Köln · Galerie Peter Pakesch, Wien · La Monnaie, Bruxelles · Galerie Roger Pailhas, Marseille 1987 Galerie van Krimpen, Amsterdam · Museum Haus Lange, Krefeld (Maison de la Culture et de la Communication, St. Etienne; Gemeentemuseum, Den Haag) ((Kat.: B. E. Buhlmann, M. Wechsler) · Reinhard Onnasch Galerie, Berlin · Maison de la Culture et de la Communication, St. Etienne (Kat.: F. Migayroux) · La Criée, Rennes · *Kunst im Auditorium,* Gesellschaft für Strahlen- und Umweltforschung, München · Galerie Crousel-Robelin, Bama, Paris · Galerie Dürr, München 1988 Galleria Pieroni, Roma (Kat.: P. L. Tazzi) · Luhring, Augustine & Hodes Gallery, New York · Galerie Max Hetzler, Köln · Anders Tornberg Gallery, Lund · Luhring, Augustine & Hodes Gallery, New York · Karsten Schubert Ltd., London · Interim Art, London · Galerie Pierre Hubert, Genève · The Renaissance Society, Chicago 1989 Newport Harbor Art Museum, Newport Beach · Museum of Modern Art, San Francisco · Milwaukee Art Museum, Milwaukee · *Gesamte Editionen/The complete editions,* Museum Boymans-van Beuningen, Rotterdam (Kat.: L. Horn, K. Schampers) · Galerie Gisela Capitain, Köln · Castello di Rivoli, Rivoli (Torino) · Rüdiger Schöttle, München · Neue Galerie am Landesmuseum Joanneum, Graz 1990 *8 Holzschnitte,* Maximilian Verlag, Sabine Knust, München · Wiener Secession, Wien (Kat.: E. Köb, Ferdinand Schmatz) · *Günther Förg: stations of the cross,* Galerie Max Hetzler, Köln · The Renaissance Society, Chicago · *Monotypien 1989,* Museum van Hedendaagse Kunst, Gent · Galerie und Edition Artelier, Graz · *Günther Förg: Hellenistischer und römischer Marmorkopf,* Galerie Erika und Otto Friedrich, Bern · Galerie Peter Pakesch, Wien · Luhring Augustine Gallery, New York · Austellungsraum Galerie Max Hetzler, Köln · The Chinati Foundation, Marfa · Museum Fridericianum, Kassel (Museum van Hedendaagse Kunst, Gent · Museum der Bildenden Künste, Leipzig · Kunsthalle, Tübingen) (Kat.) 1991 Galleria Stein, Milano · Galleria Stein, Torino · Wiener Secession, Wien · Galerie Lendl, Graz · Galerie Gisela Capitain, Köln · Galerie Ursula Schurr, Stuttgart · Galerie Friedrich, Bern · Museum of Contemporary Art, Tokyo · Musée d'Art Moderne de la Ville, Paris · Van Krimpen/Art & Project, Amsterdam · Galerie R. Urmel, Gent · Lorence Monk Gallery, New York 1992 *Bilder,* Galerie Rüdiger Schöttle, München · Galerie & Edition Artelier, Graz · Kunstver-

ein, München · Maximilianverlag – Sabine Knust, München · Galerie und Edition Artelier, Frankfurt/M.

Gruppenausstellungen | Group exhibitions

1987 *Wechselströme,* Kunstverein, Bonn · *Blow-up Zeitgeschichte,* Württembergischer Kunstverein, Stuttgart (et al.) · *Der reine Alltag,* Galerie Christoph Dür, München · *Tekenen 87,* Museum Boymans-van Beuningen, Rotterdam · *Werkgruppen: Arbeiten auf Papier,* Galerie Nächst St. Stephan, Wien · *Der Stolz in der Sentimentalität – Kunst mit Fotografie,* Galerie Ralph Wernicke, Stuttgart · *Denkpause,* Karsten Schubert Ltd./Interim Art, London · *Günther Förg, Blinky Palermo, Imi Knoebel,* Luhring, Augustine & Hodes Gallery, New York · *Säulen,* Galerie Silvia Menzel, Berlin · *Room enough,* Sammlung Schürmann-Suermondt /Ludwig Museum, Köln · *Malerei-Wandmalerei,* Kunstverein, Graz · *Multiples,* Galerie Daniel Buchholz, Köln · *Säulen-Zeilen,* Galerie Westersingel/Rotterdamse Kunststichting, Rotterdam · *Günther Förg, Hubert Kiecol, Günther Tuzina. Drawings,* David Nolan Gallery, New York · *Eighty. Les peintres d'Europe,* Parc des Expositions du Wacken, Strasbourg · *Förg, Kiecol, Mucha, Schütte,* Galleria Lia Rumma, Napoli · Galerie Peter Pakesch, Wien · *Boundaries, works on paper,* Sander Gallery, New York 1988 *Förg, Kiecol, Rückriem, Tuzina,* Galerie van Krimpen, Amsterdam · *Schlaf der Vernunft,* Museum Fridericianum, Kassel · *Furniture as art,* Museum Boymans-van Beuningen, Rotterdam · *Arbeiten auf Papier: Federle, Förg, Kiecol, Knoebel, Ungers,* Galerie Schurr, Stuttgart · *Pyramids,* ICC, Berlin (et al.) · *Beelden in de stad,* Museum Boymans-van Beuningen, Rotterdam · *Another objectivity,* Institute of Contemporary Arts, London · Rüdiger Schöttle, München · *Presi X incantamento,* Padiglione d'Arte Contemporanea, Milano · Galerie Peter Pakesch, Wien · Carnegie International, Pittsburgh · *La raó revisada,* Fundació Caixa de Pensions, Barcelona (et al.) · *Drawings,* Luhring, Augustine & Hodes Gallery, New York · *Arbeit in Geschichte – Geschichte in Arbeit,* Kunsthaus, Hamburg · *Das Licht von der anderen Seite. Teil II Fotografie,* Galerie Monika Sprüth, Köln · *Complexity and Contradiction,* Scott Hanson Gallery, New York · *B.R.D. – Abstract tendencies in new German art,* Karl Bomste in Gallery, Santa Monica · *Blow-up,* Kunstmuseum, Luzern · *Vor aller Augen (Kunst im öffentlichen Raum),* Kunstverein, Graz · *The multiple Objekt,* Bank of Boston Gallery, Boston · *The Quality of Line,* The Forum, Saint Louis · *New Prints from Germany,* Art Museum, Saint Louis · *Das Licht von der anderen Seite,* PPS Gallery, Hamburg · *Kölner Künstler fotografieren,* Sammlung F. C. Gundlach, Hamburg (et al.) 1989 Luhring, Augustine & Hodes, New York · *Pyramiden,* Galerie Jule Kewenig, Frechen · *Another Objectivity,* Centre National des Arts Plastiques, Paris (et al.) · *Arbeiten auf Papier,* Galerie Meyer Hohmeister, Karlsruhe · Rhona Hoffman Gallery, Chicago · Galerie Peter Pakesch, Wien · Aschenbach Galerie, Amsterdam · *Günther Förg, Christina Iglesias, Ettore Spalletti, Jan Vercruysse, Franz West, Christopher Wool,* Galerie Joost Declercq, Gent/Max Hetzler, Köln /Luhring Augustine, New York/Peter Pa-

kesch, Wien/Marga Paz, Madrid/Mario Pieroni, Roma · *Bilderstreit,* Museum Ludwig, Köln · *Das Medium der Fotografie ist berechtigt, Denkanstösse zu geben,* Sammlung F.C. Gundlach/Kunstverein, Hamburg · *Figures,* Galerie Municipake d'Art, Saint-Pries · Furkart, Furkapasshöhe · *2000 Jahre. Die Gegenwart der vergangenen Zeit,* Kunstverein, Bonn · *Just to look at,* Museum van Hedendaagse Kunst Gent, Stadsgalerij, Heerlen · *Einleuchten,* Deichtorhallen, Hamburg 1991 *Metropolis,* Martin-Gropius-Bau, Berlin · *AnniNovanta,* Galleria Comunale d'Arte Moderna, Bologna · *To Return to Base,* Deweer Art Gallery, Otegem · *Fotografija,* Moderna Galerija, Ljubljana

Bibliographie | Bibliography

Texte vom Künstler | Texts by the artist
Untitled, 1986, in: Artscribe, November/Dezember, 1986 · *Projekt für Krefeld, 1987,* in: Parkett, Nr. 12, März, 1987

Bücher | Books
Günther Förg, Verzeichnis der Arbeiten seit 1973, München, Christoph Dürr Verlag, 1987 · *Günther Förg, Grosse Zeichnungen,* Köln, Galerie Gisela Capitain, 1990

Periodika | Periodicals
Delène **Ainarda,** *Günther Förg,* in: Tema Celeste, Nr. 19, Januar/März, 1989 · Jörg Uwe **Albig,** *Das neue Zeitalter der Fotografie,* in: Art, Nr. 1, Januar, 1987 · Christoph **Blase,** *Die Brillanz der neuen Fotokunst,* in: Artis, Nr. 3, März, 1987 · Christoph **Blase,** *Kunst plus Kunst,* in: Artis, Mai, 1987 · Christoph **Blase,** *Der reine Alltag und die kleine Unterschied,* in: Wolkenkratzer, Nr. 3 Mai/Juni, 1987 · Ralph. C. **Bond,** *Classical and contemporary,* in: Orange Coast Magazine, März, 1989 · Achille **Bonito Oliva,** *Neo-Europe (West),* in: Flash Art, März/April, 1988 · Donna **Brookman,** *Artist as maker,* in: Artweek, 17. Juni, 1989 · Carolyn **Christov-Bakargiev,** *(Interview),* in: Flash Art, Nr. 150, Juni, 1989 · Holland **Cotter,** *Günther Förg at Luhring, Augustine & Hodes,* in: Art in America, Juli, 1988 · Gabriella **Daleso,** *Günther Förg, Galleria Pieroni,* in: Nike, Nr. 23, März/Juni, 1988 · Dorothea **Dietrich,** *(Interview),* in: The Print Collector's Newsletter, Juli/August, 1989 · Doris von **Drateln,** *The Carnegie Museum of Art,* in: Kunstforum, Bd. 96, Januar/Februar, 1989 · Helmut **Draxler,** *Die Raumhaut, der Austausch und die Analogie,* in: Noema, Nr. 3, Mai/Juni, 1989 · Wolfgang Max **Faust,** *Der Künstler als exemplarischer Alkoholiker,* in: Wolkenkratzer, Nr. 3, Mai/Juni, 1989 · Nikolai B. **Forstbauer,** *Ich bin Maler,* in: Zyma, Nr. 5, November/Dezember, 1990 · Colin **Gardner,** *Günther Förg at Newport Harbor Art Museum,* in: Artforum, Sommer, 1989 · Nancy **Grimes,** *(Ohne Titel/Without title),* in: Artnews, Nr. 10, 1987 · Catherine **Grout,** *Fonctions du regard,* in: Flash Art, April, 1987 · Patrick **Javault,** *L'espace de Günther Förg en thèmes,* in: Art Press, Nr. 115, 1987 · Donald **Kuspit,** *Totalitarian space,* in: Artis, Sommer, 1989 · Gregorio **Magnani,** *A choice – KunstRai 1987, Amsterdam,* in: Flash Art, Oktober, 1987 · Norbert **Messler,** *Günther Förg,* in: Noema, September/Oktober, 1988 · John **Miller,** *Günther Förg, Reinhard Mucha, Bernd un Hila Becher at Luhring, Augustine & Hodes Gallery,* in: Artscribe, März/April, 1987 · Frédéric **Migayrou,** *Günther*

Förg, Galerie Roger Pailhas, Marseille, in: Neue Kunst in Europa, Nr. 17, 1987 · Robert **Morgan,** *(Ohne Titel/Without title),* in: Arts Magazine, Dezember, 1988 · Michel **Nuridsany,** *Rentrée 1987: les forces de l'habitude,* in: La Vie des Arts, 15. September, 1987 · David **Pagel,** *Günther Förg at Newport Harbor Art Museum,* in: Artscribe, Sommer, 1989 · Michel **Phillipson,** *Denkpause – Karsten Schubert, Interim Art, London,* in: Artscribe, September/Oktober, 1987 · Peter **Plagens,** *Under western eyes,* in: Art in America, Januar, 1989 · Renate **Puvogel,** *Günther Förg: Museum Haus Lange, Krefeld,* in: Kunstforum, Mai/Juni, 1987 · Daniela **Salvioni,** *(Ohne Titel/Without title),* in: Flash Art, Sommer, 1988 · Christoph **Schenker,** *(Ohne Titel/Without title),* in: Flash Art, Nr. 144, Januar/Februar, 1989 · Karlheinz **Schmid,** *Moderne Kunst, die immer ihr Geld wert ist,* in: Impulse, Nr. 12, Dezember, 1987 · Stephan **Schmidt-Wulffen,** *(Interview),* in: Flash Art, Nr. 144, Januar/Februar, 1989 · Heinz **Schütz,** *Transformation und Wiederkehr,* in: Kunstforum, Bd. 95, Juni/Juli, 1988 · Heinz **Schütz,** *Günther Förg,* in: Kunstforum, Bd. 117, 1992 · Domenico **Scudero,** *(Ohne Titel/Without title),* in: Notizie e recensioni sull'attività artistica a Roma, April/Mai, 1988 · Domenico **Scudero,** *Design in the here and now,* in: Sottotraccia, Nr. 6, 1988 · Domenico **Scudero,** *Una progettualità nell'odierno: Günther Förg,* in: Sottotraccia, Nr. 6, 1988 · **s.n.,** *Il tempo ciclio,* in: Tema Celeste, Februar, 1987 · **s.n.,** *Cinque poesie di Enrico Comi,* in: Spazio Umano/Human Space, Nr. 1, 1988 · Pier Luigi **Tazzi,** *Günther Förg, Praefartio cum figuris,* in: Halle Sud, Nr. 19, 1988 · Van **Veelen,** *De kleren van een te vroeg oud geworden keizer,* in: Va Dias, 10. Oktober, 1988 · Giorgio **Verzotti,** in: Flash Art, November/Dezember · Torsten **Wallraf,** *Blow-up,* in: Noema, Januar/Februar, 1988 · Regina **Wyrwoll,** *Revidierte Vernunft?,* in: Artscribe, Januar/Februar, 1989

ERIK A. FRANDSEN

*Randers (DK), 1957
Lebt/Lives in Bruxelles

Einzelausstellungen | One-man exhibitions

1981 Galerie Hexeringen (mit/with Christian Lemmerz), Kobenhavn 1983 *Mordet pa Greenwich* (mit/with Lars Norgard), Galleri Specta, Århus (Kat.) · *Lunatique,* Eeklo 1984 *16 tegninger,* Galleri Sub-Set, Kobenhavn · *Cordelia,* Tranegarden, Gentofte (Kat.: E.A.F., C. Lemmerz) 1985 *Den topologiske pyjamas,* Galleri Spectra, Århus (Kat.) · *Livet er hardt ved os/Martyrium Simplex,* Eks-skolens Forlag, Kobenhavn (Kat.: E.A.F.) 1986 *Retrograd Amnesi/Ingen vej tilbage,* Horsens Kunstmuseum Lunden, Horsens (Kat.: C. Lemmerz) · *Codex: SANG (Osram),* Galleri Prag, Hellerup (Kat.) · *Titel : Lyset derude – det er elektrisk,* Himmerlands Kunstmuseum, Års (Kat.) 1987 *Recent Works,* Galleri Spectra, Århus (Kat.) · *Osmose,* Galleri Prag, Hellerup (Kat.: T. Boberg, C. Lemmerz, P.S.M.) · *La Verdad,* London Bar, Barcelona (Kat.) 1988 *Frandsen BC,* Horsens Kunstmuseum Lunden (Kat.: C. Hagedorn-Olsen) · *Blokader,* Galleri Prag, Kobenhavn (Kat.) · *La Verdad 2,* Galleri Spectra, Århus · *Skandia,*

Sygehus Kunstforening, Sonderborg · Galleri Spectra, Århus 1989 *Grundbilleder,* Århus Kunstmuseum · Galleri Spectra, Århus (Kat.) 1990 *U.T.,* Galleri Mikael Andersen, Kobenhavn (Kat.) · *Scandia,* Sonderborg Syggehus's Kunstforening, Sonderborg (Kat.) 1991 Den kongelige Kobberstiksamling, Satens Museum for Kunst, Kobenhavn · *Epeisodion,* Kunstmuseum, Randers (Kat.: F. Terman Frederiksen) · Museum van Hedendaagse Kunst, Gent (Kat.: B. De Baere) · *Tegninger,* Statens Museum for Kunst, Kobenhavn (Kat.: V. Knudsen) 1992 Zeno X Gallery, Antwerpen

Gruppenausstellungen | Group exhibitions

1987 *De danske »vilde«,* Nordens Hus, Island · *De danske »vilde«,* Nordens Hus, Fæoerne · *Eighty. Peintres d'Europe ,* Strasbourg · *Nye billeder i 80'erne,* Statens Museum for Kunst, Kobenhavn 1988 *Danemark 88. Ateliers en Liberté. 17 Artistes Danois,* Fondation Cartier, Paris · *Dansk Kunst,* Galleri F. 15, Moss · London Bar, Barcelona · *2+2+2,* Musée des Beaux-Arts, Rennes 1989 *Bonde, Carstensen, Frandsen,* Kunstmuseum, Århus 1990 *Tatec,* Bucharest · *Tatec,* Lyon 1991 *Tegninger,* Zeno X Gallery, Antwerpen

Bibliographie | Bibliography

Bücher vom Künstler | Books by the artist
Thorvaldsen og det Japanske perspektiv, Kobenhavn, Forlaget Vrst, 1982 · *Linol de lux,* Kovenhavn, Forlaget Væst, 1984

Periodicals | Periodika
Luk **Lambrecht,** *Brandl, Frandsen, Herold, Heyvaert, Kocherscheidt,* in: Metropolis M, Nr. 5, Oktober, 1991

Film · Video
1984 *Fut, Fut, Schatzi, Fut,* Super 8, (M. Lars Norgard, Christian Lemmerz), 15 Min. 1986 *Doren,* Super 8 (mit/with Sonny Tronborg, Lars Norgard, Christian Lemmerz), 9 Min. 1990 *Runien 1,* Video (mit/with Charly Jensen), 6: 30 Min. · *Rumnien* (mit/with Charly Jensen), 20 Min.

MICHEL FRANÇOIS

*Sint-Truiden (B), 1956
Lebt/Lives in Bruxelles

Einzelausstellungen | One-man exhibitions

1980 *Appartement à louer,* Galerie ERG, Bruxelles 1983 *Araignées,* Fondation de la Tapisserie, Tournai 1984 Zeno X Gallery, Antwerpen 1986 Zeno X Gallery, Antwerpen 1987 Galerie La Planita, Roma 1988 Vereniging voor het Museum van Hedendaagse Kunst, Gent · Galerie Christine et Isy Bra-

chot, Bruxelles (Kat.: T. Ledoux) · Musée d'Art Moderne, Bruxelles **1989** Galerie Camille von Scholz, Bruxelles · *Het Latijnse Noorden in vier scènes (mit/with Babis Kandilaptis, Ann-Veronica Janssens, Johan Muyle)*, Provinciaal Museum, Hasselt **1990** Galerie Michel Vidal, Paris · Galerie des Beaux-Arts, Bruxelles (Kat.: M. F.) **1991** Galerie Lumen Travo, Amsterdam · Vereniging voor het Museum van Hedendaagse Kunst, Gent

Gruppenausstellungen | Group exhibitions

1987 *Belgica*, Roma · Jeune Sculpture, Paris · Beeldhouwerssymposium, Jan Van Eyk Academie, Maastricht · *Dialogue d'Art*, Le Botanique, Bruxelles · *Clair Obscur*, Bernard Villers, Bruxelles · Galerie Christine et Isy Brachot, Bruxelles **1988** Zeno X Gallery, Antwerpen · *5 Artistes Belges*, Madrid · *De verzameling*, Museum van Hedendaagse Kunst, Antwerpen · Casa Frolo, Venezia · *De l'animal et du végétal*, Van Reekum Museum, Apldoorn · Galerie A. Maeght, Paris-Montrouge · *Etats limites, archives de passions*, Espace 251 Nord, Liège **1989** Galerie Michel Vidal, Paris · *Incidents Parcours*, Palais des Beaux-Arts, Bruxelles · *De Integrale*, Atelier Steel, Brugge · *Anamnèse*, Galerie Métropole de Belgique, Bruxelles · *De Rozeboomkamer*, Diepenheim · *Transatlantique*, Le Botanique, Bruxelles **1990** Galerie Michel Vidal, Paris · *Taal en Geometrie*, Stedelijk Museum, Amsterdam · *Transatlantique*, Le Botanique, Bruxelles · *Le périférique et le merveilleux*, Espace 251 Nord, Liège **1991** *1951–1991, een tijdsbeeld*, Paleis voor Schone Kunsten/Palais des Beaux-Arts, Bruxelles · *Un détail immense*, Palais des Beaux-Arts, Charleroi · *Von der Wiederholung Träume zur Realität*, Galerie Grita Insam, Wien · *Les voies de la culture européenne*, Narodna Gallery, Bratislava · Hôtel de Ville, Bruxelles · *De Collectie alsnoch*, Provinciaal Museum, Hasselt · Zeger Reijers Multiples, Rotterdam · Galerie des Beaux-Arts, Bruxelles **1992** *Jean-Marie Bijtebier, Michel François, Jean-Pierre Temmerman, Ludwig Vandevelde*, Galerie Schröder, Mönchengladbach · *Selectie Belgische Kunstenaars voor DOCUMENTA IX*, Museum Dhondt – Dhaenens, Deurle

Bibliographie | Bibliography

Periodika | Periodicals
Marie-Ange **Brayer**, *Michel François*, in: Art & Culture, Dezember, 1990 · Emanuelle **Dubuisson**, *Michel François*, in: Kiosque, Dezember, 1990 · Isabelle **Lemaitre**, *Michel François. Corp et Compression*, in: Artefactum, April/Mai, 1991 · Michael **Tarantino**, *Grand Inventory*, in: The Bulletin, 10. Januar, 1991 · Michael **Tarantino**, *Michel François*, in: Artforum, April, 1991 · Ysbrand van **Veelen**, *Michel François*, in: Flash Art, Oktober, 1991 · Christine **Vuegen**, *Dubbelzinnig spel van Michel François*, in: Kunstbeeld, Dezember 1990/Januar 1991

VERA FRENKEL

*Bratislava (CS)
Lebt/Lives in Toronto/Ontario (CDN)

Einzelausstellungen | One-man exhibitions

Installationen | installations
Aktionen | Performances
1971 *Vera Frenkel, Métagravure*, National Gallery of Canada, Ottawa (Kat.) **1974** *String Games: Improvisations for Inter-city Video*, Bell Canada Teleconferencing Studios, Montréal/Toronto; playback at Galerie Espace 5, Montréal (Kat.: V. F.) · *Kill Poetry, Masks/Barriers, Retinue*, performance works in *Words/Movement/Music*, with composer Peter Perrin, St. Lawrence Hall, Toronto **1976** *The Big Book & Related Works*, The Gallery, Stratford (Kat.: R. Arn, V. F.) **1979** *Lies & Truths: Mixed Format Installations*, Vancouver Art Gallery, Vancouver (Kat.: G. M. Dault, V. F.) · *Signs of a Plot: A Text, True Story & Work of Art* (video installation), A Space, Toronto · *Listening to Video* and *Her Room in Paris* (sound and video installations), York University Downtown Gallery, Toronto **1982** *Likely Stories* (installations with video), Agnes Etherington Art Centre, Kingston (Kat.: V. F.) · *In Search of the True-Blue Romance* (video installation), Artculture Resource Centre, Toronto **1983** *The Screening Room* (video installation), Main Gallery, Minneapolis College of Art & Design, Minneapolis **1985** *Vera Frenkel: Les Bandes Vidéo/The Videotapes*, National Gallery of Canada, Ottawa (Kat.: B. Grenville, L. Steele) **1986** *Attention: Lost Canadian* (sound work, installation and computer-generated video, Canada Pavilion, Expo '86, Vancouver **1987** *Trust Me It's Bliss: The Hugh Hefner/Richard Wagner Connection* (Multidisciplinary performance), Hefner Hall (Playboy Mansion), Chicago **1989** *Mad for Bliss* (Multidisciplinary performance), Music Gallery, Toronto **1990** *Metro-Centre Messiah* (installation), Squires Foyer, Newcastle Polytechnic, Newcastle (Kat.: V. F.) · *Messiah Speaking* (animation), Piccadilly Circus Spectacolor Board, London

Gruppenausstellungen | Group exhibitions

1987 *Jeu d'Histoire/Play of History*, The Power Plant, Toronto · *The Lunatic of One Idea*, Square One Mall, Mississauga, Ontario **1988** *The Business of Frightened Desires: Or the Making of a Pornographer*, in: Edge '88, A.I.R. Gallery, London · *The Fukui International Video Biennale* (installation), Fukui **1990** *Nine from Toronto*, Newcastle

Polytechnic Art Gallery, Newcastle upon Tyne (et al.) **1991** *Media, War & the New World Order*, CIAC, Montréal

Ausgewählte Vorführungen, Projekte, Vorträge
Selected Screenings, Projects, Public Lectures

1980 *Image Orthicon Festival*, Music Gallery, Toronto **1981** *Neo-Narrative Tapes*, Long Beach Museum, Long Beach · *Women's Film & Video Festival*, Amsterdam · *Video/Video*, in the Festival of Festivals, Toronto **1982** Koffman Union, Minneapolis, performance/screening, *Projected Parts*, Art Gallery of Ontario, Toronto **1983** *Performance Video: A Ten Year Survey*, Museum of Modern Art, New York · *The Second Link: Viewpoints on Video*, Walter Philiips Galery, Banff · *When Words Become Works*, Walker Art Centre, Minneapolis, performance, *Some Enchanted Evening or Other: The Story of the World*, and, Great George Street Gallery, Charlottetown, P.E.I. **1984** *The Last Screening Room*, London Video Arts, named after and inaugurated by Vera Frenkel's *The Last Screening Room: A Valentine* · Kijkhuis Annual Video festival, den Haag · *Axes of Sexuality*, Walter Phillips Art Gallery, Banff · *British/Canadian Video Exchange*, London Video Arts/A Space **1984** The Holland Festival · First International Video Biennale, Wien · *Cinémama Festival*, Montréal · *Tenth Anniversary Juried festival*, Long Beach Museum **1985** *Text for, Artists/Critics*, YYZ Symposium, with/mit Brian Boigon, Ian Carr-Harris, Stan Denniston, Bruce Grenville; Ed. , André Jodoin **1986** *Video as a Social Tool*, Video Inn, Vancouver · *Romance, Exile and other Household Words* (lecture), Ontario College of Art, Ontario **1987** *The Center for New Television*, Chicago · *Piccadilly Video Festival*, London **1988** Galerie Donguy, Paris · *The 2nd Fukui International Video festival*, Fukui (Kat.) · *The Showroom*, London, in *Aurora Borealis* **1989** *International Experimental Film Congress*, University of Toronto/Art Gallery of Ontario, Toronto **1990** *Video Positive Festival*, Liverpool · *Technologies et Imaginaires: Art Cinema/Art Video/Art Ordinateur*, Vidéothèque de Paris, Paris (Kat.) **1991** *Silence, Elles Tournent*, festival of Women's film & Video, Montréal (Kat.)

Bibliographie | Bibliography

Texte und Bücher von der Künstlerin
Texts and books by the artist
The New School of Art: insight – explosions, in: artscanada, Bd. 35, Nr. 4, 1. Dezember, 1968 · *A week at the Centre*, in: artscanada, Bd. 36, Nr. 3, 1. Juni, 1969 · *POCA and the visual arts: between officers – a view of the campaign*, in: artscanada, Bd. 36, Nr. 6, 1. Dezember, 1969 · *Image Spaces,*

poems & drawings by Vera Frenkel, Toronto, Roundstone Press, 1971 · The Third Locked Room: Remembering Albert Dumouchel, in: artscanada, Bd. 28, Nr. 2, 1. April 1971 · notes on gifts, in: artscanada, Bd. 37, Nr. 6, 1. Dezember, 1971 · Art, Love & Politics: a preamble, in: artscanada, Bd. 34, 1. März, 1977 · Art, Love & Politics: Benign Ignorance, in: artscanada, Bd. 34, Nr. 2, 1. Mai, 1977 · Art, Love & Politics: Deals, in: artscanada, Bd. 34, Nr. 3, 1. Oktober, 1977 · Art, Love & Politics: After Dignity, in: artscanada, Bd. 35, Nr. 1, 1. Februar, 1978 · Discontinuous Notes on and After a Meeting of Critics by One of the Artists Present, in: artscanada, Bd. 38, 1. März, 1981 · Stranger in a Stranger Land, in: Impressions 12, Nr. 28/29, März, 1982 · An Ordering Madness The 40th Venice Biennale, in: Vanguard Magazine, Dezember 1982/Januar 1983 · The Cornelia Lumsden Archive: Can Truth Prevail?, in: Museums by Artists, Art Metropole, Eds. AA Bronson, Peggy Gale, 1983 · Ruling Fictions: The Small & Large Betrayals that Haunt us Once Again, text for Vestiges of Empire, Camden Arts Centre, London, 1984 (photo-text version in: C Magazine, Januar, 1985) · The Art of Denial/ The Practice of pain, in: Kat. Issues of Censorship, A Space, Toronto, 1985 · Lost Art: A Cargo Cult Romance, in: Videoguide, Issue 37, Bd. 8, Nr. 2, 1. Januar, 1986 · I Can Tell You Simply, in: The Event Horizon: Hope, Sexuality, Social Space, Mediation, Toronto, Coach House Press, 1986 · Berlin's Beuys, in: Art Monthly, Juni, 1988

Periodika | Periodicals
Nik Houghton, Sex, Fleas and Or-Phelia: Vera Frenkel and Ulrike Rosenbach at the AIR, in: Independent Media (London), 1. November, 1988 · John Kaplan, Critical text feeds on cultural fantasy, in: Now Magazine (Toronto), 7. September, 1989 · John Bently Mays, Sex was just the preamble, in: The Globe & Mail, 8. September, 1989 · John Bently Mays, Award announcement – Canada Council Molson Award – Incorrigible Vera Frenkel, in: The Globe & Mail, 3. Februar, 1990

Video
videography
1974 String Games: Improvisations for Inter-City Video (four- channel work; nine hours duration) 1977 No Solution – Suspense Thriller #2: Introduction to Some of the Players, 22 Min. 1978 No Solution – A Suspense Thriller #5: Signs of a Plot: A Text, True Story & Work of Art, 60 Min. 1979 The Secret Life of Cornelia Lumsden (#1): Her Room in Paris, 60 Min. 1980 The Secret Life of Cornelia Lumsden (#2): »... And Now, The Truth! (A Parenthesis), 31 Min. 1981 Stories from the Front (& the Back): A True Blue Romance, 60 Min. 1984 The Contraband Tape, 60 Min. 1986 Lost Art: A Cargo Cult romance, 28 Min. 1987 Censored: or the making of a pornographer, 25 Min. 1990 This is your Messiah Speaking, 9:40 Min.

KATSURA FUNAKOSHI

*Morioka City/Iwate Prefecture (J.), 1951
Lebt/Lives in Tokyo

Einzelausstellungen | One-man exhibitions

1982 Gallery Okabe, Tokyo 1985 Nishimura Gallery, Tokyo (Kat.: S. Oshima) 1988 Nishimura Gallery, Tokyo (Kat.: K. F., T. Sakai) 1989 Comme des Garçons, Tokyo · Arnold Herstand Gallery 1990 Nishimura Gallery, Tokyo 1991 Nishimura Gallery, Tokyo · Annely Juda Fine Art, London (Kat.: M. Vaizey)

Gruppenausstellungen | Group exhibitions

1988 Contemporary Japanese Sculpture: The Rotunda Exchange Square, Hong Kong · Biennale di Venezia· Naghimura Gallery, Tokyo 1989 Sculpture Now, Gallery of Tokyo Department Store Nihonbashi, Tokyo · Art Exciting '89, The Museum of Modern Art, Saitama · Sculpturesque Image, Gallery Haku, Osaka · Against Nature, Japanese Art in the 80's, San Francisco Museum of Modern Art, San Francisco (et al.) · Bienal de São Paulo 1990 Transformation of Material and Space, Kanagawa Prefectural Hall Gallery, Yokohama · Toyama Now '90, The Museum of Modern Art, Toyama · Inside Eye The 1st – 1990, Tokyo Ginza Art Center, Tokyo (et al.) · New Wave of Wood Sculpture, Hokkaido Asahikawa Museum of Art · Japanische Kunst der 80er Jahre, Frankfurt Kunstverein, Frankfurt/M. (et al.) 1991 Against Nature – Homecoming Exhibition, ICA, Nagoya · A Current of Contemporary Art in Japan – Sculpture, The Museum of Modern Art, Tayoma

Bibliographie | Bibliography

Texte und Bücher vom Künstler
Texts and books by the artist
in: Atelier, Mai, 1983 · Oto no aru shigoto ba (Artist's studio with sounds), in: Geijutsu Shincho, Dezember, 1987 · Funakoshi Katsuro: dessin kara kibori e, in: Mizue, Nr. 947, Sommer, 1988 · The day I go to the forest, Tokyo, Ryutaro Adachi, 1992

Periodika | Periodicals
Vittorio Fagone, New Art in the New Japan, in: Contemporanea, Juli, 1988 · Julia Fendrick, Contemporary Japanese Sculpture: Artifice vs Nature, in: Sculpture, Januar/

Februar, 1991 · Friedrich Geyhofer, Japanische Kunst der 80er Jahre in Wien, in: Wiener, Februar, 1991 · Eleanor Heartney, Funakoshi at Herstand, in: Art in America, April, 1990 · Eleanor Heartney, Mixed messages, in: Art in America, April, 1990 · Jürgen Hohmeyer, Schatten im Bild, in: Der Spiegel, 4. Juli, 1988 · Seiichi Hoshino, New Age of Contemporary Sculpture, in: Arts Magazine, Bd. 1, Oktober, 1988 · Janet Koplos, Sculpture: The Premier Contemporary Art, in: Winds, 1988 · Janet Koplos, Through the Looking Glass, in: Art in America, Juli, 1989 · Constance Lewallen, (interview), in: View, August, 1990 · Constance Lewallen, My Etching Diary, in: 21st Century Prints, April, 1991 · s.n., Funakoshi Katsura: From Dessin to Sculpture, in: Mizue, Sommer, 1988 · s.n., (Ohne Title/untitled), in: Atelier, Juni, 1989 · Christine Tanblyn, Against Nature – Japanese Art in 80's, in: Art News, September, 1989

ISA GENZKEN

*Bad Oldesloe (D), 1948
Lebt/Lives in Köln

Einzelausstellungen | One-man exhibitions

1976 Galerie Konrad Fischer, Düsseldorf 1978 Kabinett für aktuelle Kunst, Bremerhaven 1979 Museum Haus Lange, Krefeld (Kat.: B. Pelzer) 1980 Galerie Max Hetzler, Stuttgart 1981 Galerie Konrad Fischer, Düsseldorf 1983 Galerie Mario Pieroni, Roma (Kat.: R. H. Fuchs) 1985 Galerie Van Krimpen, Amsterdam 1986 Galerie Fred Jahn, München (Kat.: P. Groot) · Galerie Konrad Fischer, Düsseldorf · Galerie Jean Bernier, Athinai 1987 Galerie Harald Behm, Hamburg · Galerie Daniel Buchholz, Köln · Galerie Mario Pieroni, Roma (mit/with Gerhard Richter) (Kat.: P. Groot) 1988 Galerie Ghislaine Hussenot, Paris · Galerie Daniel Buchholz, Köln · Rheinisches Landesmuseum, Bonn (Kat.: J. van Adrichem, K. Honnef, D. Schwarz) 1989 Kunstmuseum, Winterthur (cfr. Bonn, 1988) · Museum Boymans-van Beuningen, Rotterdam (cfr. Kat. Bonn, 1988) · Galerie Daniel Buchholz, Köln · Jack Shainman Gallery, New York 1990 Galerie Varisella, Frankfurt/M. · Galerie Meert Rhioux, Bruxelles · Ognuno ha bisogno di una finestra, Galleria Mario Pieroni, Roma 1991 Arbeiten auf Papier 1987–91, Galerie Fred Jahn, Stuttgart · Galerie Jürgen Bekker, Hamburg 1992 The Renaissance Society, Chicago · Portikus, Frankfurt/M. · Galerie Daniel Buchholz, Köln

Gruppenausstellungen | Group exhibitions

1987 Skulptur Projekte Münster, Westfälisches Landesmuseum, Münster · Mathematik in der Kunst der letzten dreißig Jahre, Wilhelm Hack Museum, Ludwigshafen · Floor for a Sculpture – Wall for a Painting, Stichting De Appel, Amsterdam · Juxtapositions: Recent Sculpture from England and Germany, P.S. 1, New York · Brückenschlag, Fürstenwall 228, Düsseldorf · Zeichnungen von Bildhauern, Museum am Ostwall, Dortmund · Daniel Newburg Gallery, New York 1988 Biennale of Sydney, Art Gallery of New South Wales, Sydney · Goethe-Institut, Rotterdam · Beelden in de stad/Sculpture in the city, Rot-

terdam · *Made in Cologne*, DuMont-Halle, Köln **1989** *Sei Artisti Tedeschi*, Castello di Rivara, Torino · *Zeitzeichen*, Stationen Bildender Kunst in NRW, Ministerium für Bundesangeleigenheiten, Bonn (et al.) · *Själen Omfattar Kroppen*, Galerie Nordenhake, Stockholm · *Isa Genzken, Susana Solano, Amikam Toren, John Wikins*, Anthony Reynolds Gallery, London · *Einleuchten*, Deichtorhallen, Hamburg **1990** *Berlin März 1990*, Wiensowski & Harbord, Berlin · *Echange De Procédes*, Ecole supérieure d'art visuel, Genève · *Berlin März 1990*, Kunstverein, Braunschweig · *Get well soon*, Robbin Lockett Gallery, Chicago · *Le choix des femmes*, Le Consortium, Dijon · *Zur Sache selbst*, Museum, Wiesbaden · *Le Diaphane*, Musée des Beaux-Arts, Tourcoing **1991** *El Sueno De Egipto*, El Centro Cultural/Arte Contemporaneo, Polanco · *Espacio Mental*, Ivam, Centre del Carme, Valencia · *This Land*, Marian Goodman Gallery, New York · Galerie Van Krimpen, Amsterdam · *Proiezion I*, Castello di Rivara, Torino · *Karl Schmidt-Rottluff Stipendium. Isa Genzken, Jürgen Bordanowicz, Wolfgang Luy*, Städtische Kunsthalle, Düsseldorf

Bibliographie/Bibliography

Bücher | Books
Isa Genzken, Köln, Verlag der Buchhandlung Walther König, 1992

Periodika | Periodicals
Jan van **Adrichem**, *Nostalgic Modernism. Isa Genzken*, in: Tema Celeste, Oktober-Dezember, 1989 · Jean-Pierre **Bordaz**, *Imi Knoebel, Isa Genzken, Gerhard Merz: Affinitäten zur Architektur/Imi Knoebel, Isa Genzken, Gerhard Merz: Affinities with Architecture*, in: Parkett, Nr. 31, 1992 · René **Denizot**, *Isa Genzken – The War Beyond The War*, in: Galeries Magazine, Oktober/November, 1990 · Kirby **Gookin**, *Isa Genzken-Jack Shainman* Gallery, in: Artforum International, März, 1990 · Susanne **Helfferich**, *Zum Beton gefunden*, in: Die Welt, 21. August, 1987 · Jutta **Koether**, *Isa Genzken*, in: Artforum International, September, 1988 · Edith **Krebs**, *Isa Genzken*, in: Noema, Nr. 4, 1989 · Luk **Lambrecht**, *Een verzegelde bron*, in: Knack, 24. Mai, 1989 · Luk **Lambrecht**, *Isa Genzken*, in: Knack, September, 1990 · Luk **Lambrecht**, *Isa Genzken*, in: Forum International, November/Dezember, 1990 · Anja **Lösel**, *Lieber wahr als edel*, in: Art, Nr. 9, 1987 · Renate **Puvogel**, *Isa Genzken*, in: Artefactum · Jürgen **Raap**, *Isa Genzken*, in: Kunstforum International, Bd. 95, 1988 · Calvin **Reid**, *Isa Genzken*, in: Arts, März, 1990 · Paul

Robbrecht, *De plaats van de Kunst*, in: Vlees en beton 8, 1987 · Karlheinz **Schmid**, *Beton mit Beton überlisten*, in: Artis, Jg. 41, Januar, 1989 · Ilske von **Schweinitz**, *Isa Genzken*, in: Zyma, Nr. 5, Dezember 1991/Januar 1992 · Michael **Tarantino**, *Isa Genzken – Galerie Meert Rihoux*, in: Artscribe, Januar/Februar, 1991 · Susanne **Triebel**, *Zurück zum Beton*, in: Szene Hamburg, Nr. 9, 1987 · Rainer **Unruh**, *Isa Genzken „Vom 23. Stock aus"*, in: Kunstforum, Bd. 113, Mai/Juni, 1991

GAYLEN GERBER

*McAllen/Texas (USA), 1955
Lebt/Lives in Chicago

Einzelausstellungen | One-man exhibitions

1980 One Illinois Center, Chicago **1985** van Straaten Gallery, Chicago **1987** Grey Art Gallery and Study Center, New York · University, New York **1988** Wolff Gallery, New York · Robbin Lockett Gallery, Chicago **1989** Galerie Nächst St. Stephan-Rosemarie Schwarzwälder, Wien (Kat.) · Robbin Lockett Gallery, Chicago **1990** Le Casa d'Arto, Milano (Kat.: K. Hixson) · Wolff Gallery, New York · Shed Halle, Zürich · Robbin Lockett Gallery, Chicago (Kat.) **1992** The Renaissance Society, Chicago (Kat.: J. Avgikos)

Gruppenausstellungen | Group exhibitions

1987 *New Chicago: Quiet and Deliberate*, Tangeman Fine Arts Gallery, University of Cincinnati, Cincinnati · *Nourishment*, Beacon Street Gallery, Chicago · Center for Contemporary Art, Chicago · *Wet Paint*, Robbin Lockett Gallery, Chicago · *July*, Wolff Gallery, New York · *Invitational*, Damon Brandt Gallery, New York · *The Non-Spiritual in Art/Abstract Painting*, 341 West Superior, Chicago · van Straaten Gallery, Chicago **1988** *Drawings*, Robbin Lockett Gallery, Chicago · *Looking Out*, Rockford Art Museum, Illinois · *Tim Ebner, Gaylen Gerber, Allan McCollum*, Ricky Renier Gallery, Chicago **1989** *Problems with Reading Rereading*, Rhona Hoffman Gallery, Chicago · *Material Matters*, Arts Center Gallery, College of DuPage, Glen Ellyn · *Chicago Works: Art from the Windy City*, Bruce

Gallery, Edinboro University of Pensylvania · *Mediated Knot*, Robbin Lockett Gallery, Chicago · *Prima Vision*, Milano Internazionale D'Arte Contemporanea, Milano · *Mentalitäten und Konstruktionen in Arbeiten auf Papier*, Galerie Nächst St. Stephan – Rosemarie Schwarzwälder, Wien · *Drawings*, Wolff Gallery, New York **1990** *Strategies for the last Painting*, Wolff Gallery, New York/Feigen Gallery, Chicago · *Drawings*, Nathalie Karg Gallery, New York · *Drawings*, Paula Allen Gallery, New York **1991** *David Cabrera, Gaylen Gerber, Mitchell Kane*, Trans Avant-Garde Gallery, San Francisco · Galeria Anselmo Alvarez, Madrid **1992** Galerie Nächst St. Stephan – Rosemarie Schwarzwälder, Wien · *Works on Paper*, Curt Marcus Gallery, New York · *Abstrakte Malerei zwischen Analyse und Synthese*, Galerie Nächst St. Stephan-Rosemarie Schwarzwälder, Wien · *From America's studio: Drawing new Conclusions*, Betty Rymer Gallery, School of the Art Institute of Chicago, Chicago

Bibliographie | Bibliography

Periodika | Periodicals
Lynda **Barkert**, *Chicago: Gaylen Gerber*, in: New Art Examiner, Oktober, 1989 · Michael **Bonesteel**, *Medium Cool: New Chicago Abstraction*, in: Art in America, Nr. 12, Dezember, 1987 · Daniel **Brown**, *New Chicago: Quiet & Deliberate*, in: Dialogue, Nr. 4, Juli/August, 1988 · Joshua **Decter**, *Reviews*, in: Arts Magazine, Nr. 1, September, 1990 · Alison **Gamble**, *The Myths that Work: Beneath the Surfaces of Chicago Art*, in: New Art Examiner, Mai, 1989 · Kathryn **Hixson**, *Cool, Conceptual, Controversial*, in: New Art Examiner, Nr. 9, Mai, 1988 · Kathryn **Hixson**, *Gaylen Gerber*, in: Arts Magazine, Nr. 2, Oktober, 1989 · Kathryn **Hixson**, *Reviews: Gaylen Gerber*, in: Arts Magazine, Nr. 3, November, 1989 · Kathryn **Hixson**, *The Subject is the Object: The Legacies of Minimalism*, in: New Art Examiner, Mai, 1991 · Kathryn **Hixson**, *Gaylen Gerber in Neutral*, in: Flash Art, Nr. 159, 1991 · Richard **Kalina**, *Gaylen Gerber at Jamie Wolff Gallery*, in: Tema Celeste, Nr. 26, Juli/Oktober, 1990 · Peter **Muhr**, *Reviews: Vienna*, in: Flash Art, Nr. 151, März/April, 1990 · Laurie **Palmer**, *Problems with Reading Rereading*, in: Artforum, Nr. 1, 1989 · Joseph **Scanlan**, *Problems with Reading Rereading*, in: Artscribe, Nr. 77, September/Oktober, 1989 · Joe **Scanlan**, *Focus on Painting*, in: The Renaissance Society at The University of Chicago Newsletter, Winter, 1992

ROBERT GOBER

*Wallingford (USA), 1954
Lebt/Lives in New York

Einzelausstellungen | One-man exhibitions

1984 *Slides of a Changing Painting*, Paula Cooper Gallery, New York **1985** Paula Cooper Gallery, New York · Daniel Weinberg Gallery, Los Angeles **1986** Daniel Weinberg Gallery, Los Angeles **1987** Galerie Jean Bernier, Athinai (Kat.: D. Robbins) · Paula Cooper Gallery, New York **1988** The Art Institute, Chicago · Tyler School of Art, Temple **Denizot**, Ulrich **Loock**, in: Galeries Magazine, Dezember, 1990/Januar 1991 · Jim **Drobnick**,

University, Elkins Park (Kat.: P. Colombo) · Galerie Max Hetzler, Köln · Galerie Gisela Capitain, Köln 1989 Paula Cooper Gallery, New York 1990 Museum Boymans-van Beuningen, Rotterdam (Kunsthalle, Bern) (Kat.: U. Loock, K. Schampers, T. Fairbrother) · Galeria Marga Paz, Madrid 1991 Galerie Nationale du Jeu de Paume, Paris (Kat.)

Gruppenausstellungen | Group exhibitions

1987 *Extreme Order,* Galleria Lia Rumma, Napoli · *Art Against Aids: A Benefit Exhibition,* Paula Cooper Gallery, New York · *Avant-garde in the Eighties,* Los Angeles County Museum of Art, Los Angeles · *The Great Drawing Show 1587–1987,* Michael Kohn Gallery, Los Angeles · *Artists from Paula Cooper Gallery,* Galeria EMI-Valentim de Carvalho, Lisboa · *Group Exhibition,* Crousel-Hussenot, Paris · *New York Art Now (Part 1),* The Saatchi Collection, London · *Drawn Out: An Exhibition of Drawings by Contemporary Artists,* Kemper Gallery, Kansas City Art Institute 1988 *Cultural Geometry,* DEKA Foundation, Athinai · *Real Inventions/Invented Functions,* Laurie Rubin Gallery, New York · *Utopia Post Utopia (Untitled Installation conceived by Robert Gober),* Institute of Contemporary Art, Boston · *Works on Paper,* Curt Marcus Gallery, New York · *Sculpture Parallels,* Sydney Janis Gallery, New York · *Artschwager: His Peers and Persuasions (1963–1988),* Daniel Weinberg Gallery, Los Angeles (et al.) · Galerij Micheline Szwajcer, Antwerpen · *Robert Gober, Christopher Wool,* 303 Gallery, New York · *New York Art Now (Part II),* The Saatchi Collection, London · *Biennale di Venezia · The BiNational. American Art of the Late 80's,* Institute of Contemporary Art, Museum of Fine Arts, Boston (et. al.) · *Furniture as Art,* Museum Boymans-van Beuningen, Rotterdam · *Eleven Artists from Paula Cooper Gallery,* Mayor Rowan Gallery, London · *Art at the End of th Social,* Rooseum Gasversgaten, Malmö · *Innovations in Sculpture,* The Aldrich Museum, Ridgefield · *Dan Flavin, Robert Gober, Yves Klein,* 303 Gallery, New York · *In the Making/Drawings by Sculptors,* The Sculpture Center, New York · *New Works by Ashley Bickerton, Robert Gober, Peter Halley, Jeff Koons, Richard Prince, Meyer Vaisman, Chistopher Wool,* Daniel Weinberg Gallery, Los Angeles · *Sculpture: Inside Outside,* Walker Art Center, Minneapolis (et al.) 1989 *Einleuchten,* Deichtorhallen, Hamburg · *Horn of Plenty/Hoorn van overuloed,* Stedelijk Museum, Amsterdam · *Biennial Exhibition,* Whitney Museum of American Art, New York · *Pre-Pop/Post-Appropriation,* Stux Gallery, New York · Paula Cooper Gallery, New York · *A Decade of American Drawing 1980–1989,* Daniel Weinberg Gallery, Los Angeles · *Coleccion de Dibujos,* Galeria La

Maquina Espanola, Madrid · *Ludwig Wittgenstein,* Wiener Sezession, Wien · *Gober, Dujouri, Horndash, Muñoz, van Oost,* Wolff Gallery, New York · *Gober, Halley, Kessler, Wool: Four Artists from New York,* Kunstverein München · *Graduate Exhibit,* Starr Library, Special Collections, Middlebury College, Middlebury Vermont · *Filling in the Gap,* Feigen, Inc. Chicago · *Dream Reality,* The School of Visual Arts Gallery, New York · *Hybrid Neutral, Modes of Abstraction and the Social,* Richard F. Brush Art Gallery, St. Lawrence University, Canton · *Another Focus,* Karsten Schubert Ltd., London · *Robert Gober and Bruce Nauman,* Galerij Micheline Szwajcer, Antwerpen 1990 *The Readymade Boomerang,* Biennale of Sydney, Art Gallery of New South Wales, Sydney · *Culture and Commentary,* Hirshhorn Museum, Washington DC · *Objectives. The new Sculpture,* Newport Harbor Art Museum, Newport Beach · *Life -Size,* The Israel Museum, Jerusalem · *The Clinic,* Simon Watson, New York · *Editionen,* Galerie Gisela Capitain, Köln · *Günther Förg, Kenji Fujita, Robert Gober, Georg Herold, Jon Kessler, Liz Larner, Zoe Leonard,* Luhring Augustine, New York · *New Work: A New Generation,* San Francisco Museum of Modern Art, San Francisco · *Status of Sculpture,* l'Espace Lyonnais d'Art Contemporain, Centre d'Echanges de Perrache, Lyon (et al.) · *Drawings,* Burnett Miller Gallery, Los Angeles · *White Colums Twentieth Anniversary Benefit Exhibition,* White Columns, New York · *The Kitchen Art Benefit,* Curt Marcus Gallery and Castelli Graphics, New York · Paula Cooper Gallery, New York · Barbara Gladstone Gallery, New York · *Sculpture,* Daniel Weinberg Gallery, Santa Monica · *In Memory of James 1984–1988: The Children's AIDS Project,* Daniel Weinberg Gallery, Santa Monica · *The thing itself,* Feature, New York · *Half-Truths,* Parrish Art Museum, Southampton, New York · *The Last Decade: American Artists of the 80's,* Tony Shafrazi Gallery, New York · *Culture in Pieces, Other Social Objects,* Beaver College Art Gallery, Glenside · *Meeting Place: Robert Gober, Liz Magor, Juan Muñoz,* The Art Gallery of York University, Toronto (et al.) · *Que Overdose,* Mincher/Wilcox Gallery, San Francisco · *The Andrew Glover Youth Program Benefit Exhibition,* Josh Baer Gallery, New York · *Act Up Auction For Action,* Paula Cooper Gallery, New York · *Home,* Asher Faure, Los Angeles · *Blood Remembering,* Newhouse Center for Contemporary Art, Staten Island 1991 *Metropolis,* Martin-Gropius-Bau, Berlin · Galerie Max Hetzler, Köln · *Katharina Fritsch, Robert Gober, Reinhard Mucha, Charles Ray, Rachel Whiteread,* Luhring Augustine, New York · *Objects for the Ideal Home,* Serpentine Gallery, London · *Rocking Horses,* Lorence Monk Gallery, New York · *Forbidden Games,* Jack Tilton Gallery, New York · *Something Pithier and more Psychological,* Simon Watson, New York · *Biennial Exhibition,* Whitney Museum of American Art, New York · *Object Lessons,* Portland Art Museum, Portland · *Home For Jun,* Contemporary Theatre and Art, New York · *Strange Abstraction,* Tokyo Museum of Contemporary Art, Tokyo · *La Sculpture Contemporaine: après 1970,* Fondation Daniel Templon, Musée Temporaire, Fréjus · *Robert Gober, Cady Noland, Christopher Wool,* Galerie Max Hetzler, Köln · *True to Life,* 303 Gallery, New York · *The Lick of the*

Eye, Shoshana Wayne Gallery, Santa Monica · *Larry Clark, Robert Gober, Mike Kelley, Jeff Koons, Cady Noland, Richard Prince, Cindy Sherman, Christopher Wool,* Luhring Augustine Hetzler, Santa Monica · *Selections from the Elaine and Werner Dannheisser Collection: Painting and Sculpture from the '80s and '90s,* Parrish Art Museum, Southampton · *Devil on the Stairs: Looking on the Eighties,* Institute of Contemporary Art, Philadelphia · *Contemporary Collectors,* San Diego Museum of Contemporary Art, La Jolla 1992 Rubin-Spangle Gallery, New York

Bibliographie | Bibliography

Texte vom Künstler | Texts by the artist
in: Journal of Contemporary Art, Herbst/Winter, 1988 · *Cumulus,* in: Parkett, Nr. 19, 1989 · *Six Drawings,* in: The Paris Review, Nr. 109, s.d. · *Hanging Man, A Conversation between T. Bush, R. Gobert, N. Rifkin,* in: Parkett, Nr. 27, März, 1991

Periodika | Periodicals
Brooks **Adams,** *Artschwager et Gober: d'étranges cousins,* in: Artstudio, Nr. 19, Winter, 1990 · Marjorie **Allthorpe-Guyton,** *NY Art Now: The Saatchi Collection, London,* in: Flash Art, November/Dezember, 1987 · Jan **Avgikos,** *Tell Them It Was Wonderful,* in: Artscribe, März/April, 1990 · Mary Rose **Beaumont,** *Eleven Artists from Paula Cooper,* in: Arts Review, 3. Juni, 1988 · Maurice **Berger,** *Are Art Museums Racist?,* in: Art in America, September, 1990 · Lucie **Beyer,** *Förg, Kiecol, Meuser, Hütte, Zobernig, Koons, Kessler, Gober,* in: Flash Art, Februar/März, 1987 · Michael **Boodro,** *Art Takes Shape,* in: HG, Mai, 1988 · Susan **Boone,** *The Finishing Touch,* in: Home, Dezember, 1988 · Gregg **Bordowitz,** *Against Heterosexuality,* in: Parkett, Nr. 27, März, 1991 · Petra **Bosetti,** *Sieben Säcke Katzenstreu,* in: Art, Mai, 1990 · Nicolas **Bourriaud,** *Ludwig Wittgenstein and Twentieth Century Art,* in: Galeries Magazine, Dezember, 1989 · Dan **Cameron,** *Art and Its Double: A New York Perpective,* in: Flash Art, Mai, 1987 · Dan **Cameron,** *Robert Gober,* in: Galeries Magazine, Nr. 45, Oktober/November, 1991 · Dan **Cameron,** *Robert Gober,* in: Galeries Magazine, Oktober/November, 1991 · Maria **Campitelli,** *Robert Gober,* in: Juliet, Nr. 39, Dezember 1988/Januar 1989 · Elio **Cappuccio,** *The Work and Its Aura,* in: Tema Celeste, Januar/März, 1990 · Tricia **Collins,** Richard **Milazzo,** *Post-Appropriation and the Romantic Fallacy. Gober, Etkin, Shaver and Carroll,* in: Tema Celeste, Nr. 21, Juli/September, 1989 · Tricia **Collins,** Richard **Milazzo,** *Sinking to the Bottom of Discourse. René Ricard,* in: Tema Celeste, Juli/Oktober, 1990 · Tricia **Collins,** Richard **Milazzo,** *From Kant to Kitsch and back Again,* in: Tema Celeste, Januar/Februar, 1991 · Lynne **Cooke,** *Aperto Ma Non Troppo,* in: Art International, Herbst, 1988 · Regina **Cornwell,** *Martin Friedman,* in: Contemporanea, Sommer, 1990 · Michael **Corris,** *The Status of Sculpture, ICA,* in: Artscribe, Januar/Februar, 1991 · Jean-Pierre **Criqui,** *Robert Gober. Jeu de Paume,* in: Artforum , Bd. 30, Nr. 5, Januar, 1992 · Catherine **David,** *Recent Ruins,* in: Kunst Nu, Nr. 1, 1992 · Jeffrey **Deitch,** *Mera and Donald Rubell,* in: Galeries, Oktober/November, 1989 · Jeffrey **Deitch,** *Psychological Abstraction,* in: Flash Art, Novemb./Dezemb., 1989 · J. **Drobnick,**

In Pieces, Of Pieces: Robert Gober, in: Parachute, Nr. 64, Oktober/November, 1991 · Wolfgang Max **Faust**, *Now New York New (An Interview with Dan Cameron with Material on the Current Art Scene),* in: Wolkenkratzer Art Journal, Januar/Februar, 1988 · Patrick **Finnegan**, *Culture & Commentary,* in: Contemporanea, Sommer, 1990 · Nikolai B. **Forstbauer**, *Robert Gober. Hanging Man – Sleeping Man,* in: Zyma, Nr. 5, November/Dezember, 1990 · Peter **Frank**, *From anti-form to the new objecthood,* in: Artspace, September/Oktober, 1990 · Peter **Frank**, *Los Angeles Letters,* in: Contemporanea, Dezember, 1990 · David **Galloway**, *Metropolis: Crossroads of Cul-de-Sac?,* in: Art in America, Juli, 1991 · Paul **Gardner**, *Collecting Art of the Eighties,* in: Contemporanea, September/Oktober, 1988 · Amy **Gerstler**, *Fancy Work,* in: Art Issues, März/April, 1990 · Craig **Gholson**, *Robert Gober,* in: Bomb, Herbst, 1989 · Deborah **Gimelson**, *Elaine & Werner Dannheisser,* in: Galeries Magazine, April/Mai, 1991 · Nancy **Grimes**, *Whitney Biennial,* in: Tema Celeste, Juli/September, 1989 · Pam **Hansford**, *The Readymade Boomerang,* in: Artscribe, September/Oktober, 1990 · Eleanor **Heartney**, *Homeward Unbound,* in: Sculpture, September/Oktober, 1989 · Eleanor **Heartney**, *Art in the '90s: A Mixed Prognosis,* in: New Art Examiner, Mai, 1990 · Eleanor **Heartney**, *The Expanded Readymade,* in: Art in America, September, 1990 · Josef **Helfenstein**, *The Powe of Intimacy,* in: Parkett, Nr. 27, März, 1991 · Elizabeth **Hess**, *Artbeat,* in: Village Voice, 31. Oktober, 1989 · Elizabeth **Hess**, *Upstairs, Downstairs,* in: Village Voice, 30. April, 1991 · Jan **Hoet**, *1992 Documenta: Museum of Feelings,* in: Edges, Nr. 3, Dezember, 1990 · Viola **Hopkins Winner**, *Culture and Commentary: An Eighties Perspective,* in: Artnews, September, 1990 · Gary **Indiana**, *The Torture Garden,* in: Village Voice, 27. Oktober, 1987 · Gary **Indiana**, *Success. Robert Gober,* in: Interview, Mai, 1990 · Elizabeth **Janus**, *Robert Gober,* in: Tema Celeste, März/April, 1991 · Bill **Jones**, *Stunted Brides and Fascinating Hardware,* in: Arts Magazine, Sommer, 1990 · Ken **Johnson**, *Cleaning House,* in: Art in America, Januar, 1990 · Ken **Johnson**, *Generational Saga,* in: Art in America, Juni, 1991 · David **Joselit**, *Investigating the Ordinary,* in: Art in America, Mai, 1988 · Roberto **Juarez**, *Selected Similarities,* in: Bomb, Winter, 1987 · Lewis **Kachur**, *Sculpture's Unbounded Range,* in: Arts International, Herbst, 1989 · Steven **Kaplan**, *Head, Heart and Hands,* in: Artfinder, Frühjahr, 1987 · Jutta **Koether**, *Group Show – Max Hetzler,* in: Artscribe, März/April, 1987 · Jutta **Koether**, *Robert Gober,* in: Artforum, Februar, 1989 · Francine A. **Koslow**, *Collins and Milazzo: Curators of Commodities Brokers,* in: Contemporanea, Dezember, 1989 · Donald **Kuspit**, *Breakfast of Duchampians,* in: Contemporanea, Mai, 1989 · K. **Larson**, *Whitney Biennial,* in: Galeries Magazine, Juni/Juli, 1991 · Christian **Leigh**, *Home is Where the Heart Is,* in: Flash Art, März/April, 1989 · James **Lewis**, *Home Boys,* in: Artforum, Oktober, 1991 · Lisa **Liebman**, *The case of Robert Gober,* in: Parkett, Nr. 21, 1989 · Sylvère **Lothringer**, *Third Wave, Art and the commodification of Theory,* in: Flash Art, Mai/Juni, 1991 · Catharine **Lumby**, *Sydney Biennial,* in: Flash Art, Sommer, 1990 · Steven Henry **Madoff**, *Sculpture, A New Golden Age?,* in: Artnews, Mai, 1991 ·

Gregorio **Magnani**, *Venice Biennial,* in: Flash Art, Oktober, 1988 · Robert **Mahony**, *Real Inventions/Invented Functions,* in: Arts Magazine, Mai, 1988 · Robert **Mahony**, *Reviews,* in: Contemporanea, Februar, 1990 · Paula **Marincola**, *Robert Gober, Tyler School of Art Gallery,* in: Artforum, Mai, 1988 · Thomas **McEvilley**, *New York: The Whitney Biennial,* in: Artforum, Sommer, 1991 · Bernardo **Mercuri**, *Prospect 89,* in: Tema Celeste, Juli/September, 1989 · Norbert **Messler**, *Robert Gober at The Museum Boymans-van Beuningen,* in: Artforum, November, 1990 · Norbert **Messler**, *Berlin: Metropolis,* Artforum, Sommer, 1991 · Terry R. **Meyers**, *Reviews,* in: Flash Art, Januar/Februar, 1990 · Terry R. **Meyers**, *Robert Gober,* in: Flash Art, Nr. 156, Juni/Juli, 1990 · Catherine **Millet**, *Interview with Alfred Pacquement,* in: Art Press, Juni, 1991 · Robert C. **Morgan**, *New York in Review,* in: Arts, Mai, 1989 · Robert **Nickas**, *Art and Its Double,* in: Flash Art, Februar/März, 1987 · Luis Francisco **Perez**, *El Arte y su Doble,* in: Tema Celeste, April/Juni, 1987 · David **Pagel**, *Vexed Sex,* in: Art Issiues, Februar, 1990 · Dennis **Phillips**, *Tre Poesie,* in: Spazio Umano, Nr. 1, 1989 · Robert **Pincus-Witten**, *Entires: Electrostatic Cling or the Massacre of Innocence,* in: Artscribe, Sommer, 1987 · Kevin **Power**, *Art and Its Double,* in: Flash Art, Februar/März, 1987 · Nancy **Princenthal**, *Robert Gober at Paula Cooper,* in: Art in America, Dezember, 1987 · Nancy **Princenthal**, *Rooms With a View,* in: Sculpture, März/April, 1990 · Renate **Puvogel**, *Robert Gober at Galerie Hetzler, Galerie Gisela Capitain,* in: Artscribe International, Mai, 1989 · Meyer Raphael **Rubinstein**, Daniel **Weiner**, *Robert Gober,* in: Flash Art, Januar/Februar, 1988 · Hans Rudolf **Reust**, *Robert Gober,* in: Artscribe, Januar/Februar, 1991 · Jeffrey **Rian**, *Past Sense, Present Sense,* in: Artscribe International, Januar/Februar, 1989 · Jerry **Saltz**, *Notes on a Sculpture,* in: Arts Magazine, Dezember, 1989 · Jerry **Saltz**, *Strange Fruit,* in: Arts Magazine, September, 1990 · Joe **Scanlan**, *Metropolis – Martin Gropius,* in: Art Issues, Sommer, 1991 · Peter **Schjeldahl**, *Cutting Hedge,* in: Village Voice, 30. April, 1991 · Christoph **Schenker**, *Robert Gober, Museum Boymans-van Beuningen, Kunsthalle Bern,* in: Flash Art, Januar/Februar, 1991 · Mira **Schor**, *You can't leave home without it,* in: Artforum, Oktober, 1991 · Maureen P. **Sherlock**, *Arcadian Elegy. The Art of Robert Gober,* in: Arts Magazine, September, 1989 · Joan **Simon**, *Robert Gober: Oeuvres Nouvelles,* in: Art Press, Nr. 162, Oktober, 1991 · Noemi **Smolik**, *Robert Gober,* in: Kunstforum, Bd. 3, 1991 · Caroline **Smulders**, *Le corps en miettes de Robert Gober,* in: Beaux-Arts, November, 1991 · Deborah **Solomon**, *A Downtown Aesthetic,* in: Architectural Digest, November, 1989 · Nancy **Spector**, *Robert Gober: Homeward-Bound,* in: Parkett, Nr. 27, März, 1991 · Nancy **Stapen**, *BiNational,* in: Artnews, Dezember, 1988 · William F. **Stern**, *Sculpture Inside Outside,* in: Cite, Frühjahr/Sommer, 1989 · Paul **Taylor**, *Spotlight: Cultural Geometry,* in: Flash Art, Mai/Juni, 1988 · Sue **Taylor**, *Garden City,* in: Art in America, Dezember, 1988 · Robert **Vitale**, *Review,* in: New Art Examiner, Januar, 1988 · Matthew **Weinstein**, *The House of Fiction,* in: Artforum, Februar, 1990 · John **Yau**, *Official Policy,* in: Arts, September, 1989

DAN GRAHAM

*Urbana (USA), 1942
Lebt/Lives in New York

Einzelausstellungen | One-man exhibitions

1969 John Daniels Gallery, New York **1970** The Mezzanine, Nova Scotia College of Art, Halifax · Anna Leonowens Gallery, Nova Scotia College of Art, Halifax **1972** Gallery A 402, California Institute of the Arts, Valenica · Project Inc., Cambridge · Galleria Toselli, Milano · Protech-Rivkin Gallery, Washington, DC · Lisson Gallery, London (Kat.) · Fourth Flour Gallery, Halifax, Nova Scotia **1973** Galleria Schema, Firenze · Galerie Zwirner, Köln · Galerie MTL, Bruxelles **1974** Lisson Gallery, London · Royal College of Art, London · Galerie 17, Paris · Galleria Marilena Bonomo, Bari **1975** Griffiths Art Centre, St. Lawrence University, Canton, New York · Internationaal Cultureel Centrum, Antwerpen · Palais des Beaux-Arts, Bruxelles · John Gibson Gallery, New York · Modern Art Agency, Napoli **1976** Kunsthalle, Basel (Kat.) · Galleria Banco, Brescia · Galerie Anne-Marie Verna, Zürich · Institute of Contemporary Arts, London · Galerie Vega, Liège · Samangallery, Genova · Salle Patino, Genève · Sperone Westwater Fischer, New York **1977** Museum van Hedendaagse Kunst, Gent · Studio Terelli, Ferrara · *Articles,* Stedelijk Van Abbemuseum, Eindhoven (Kat.) · Galerie René Block, Berlin · *Video Piece for two Glass Building,* Leeds Polytechnic Gallery, Leeds **1978** Museum of Modern Art, Oxford · Corps de Garde, Groningen **1979** Galerie Locus Solus, Genève · Center for Art Tapes, Halifax, Nova Scotia · Paola Betti, Milano · Galerie Rüdiger Schöttle, München · Franklin Furnace Gallery, New York **1980** P. S. 1, Long Island City, New York · Museum of Contemporary Art, Lisboa · City of Los Angeles, Central Library, Los Angeles · Museum of Modern Art, New York · Galerie Rüdiger Schöttle, München **1981** *Building and Signs,* Lisson Gallery, London · *Building and Signs,* The Renaissance Society, Chicago (Kat.) · *Building and Signs,* Durand-Dessert, Paris · *Video at 30th Street Station,* Institute of Contemporary Art, University of Pennsylvania, Philadelphia · Center for the Arts, Mühlenberg College, Allentown **1982** Galerie Durand-Dessert, Paris · Plan B, Tokyo · Anna Leonowens Gallery, Halifax, Nova Scotia · Parachute, Montréal · Johnson State College, Johnson · Hotel Wolfers, Bruxelles · Gewad, Gent **1983** Walter Phillips Gallery, Banff Centre for Art, Alberta David Bellman Gallery, Toronto · Amelia A Wallace Gallery, College of New York State, Old Westbury, New York · *Pavilions,* Kunsthalle, Bern (Kat.) **1984** Galleria del Cavallino, Venice · Todd's, New York · Marianne Desan Gallery, Chicago **1985** Art Gallery of Western Australia, Perth (Kat.) **1986** Cable Gallery, New York · *Dan Graham and Sol LeWitt,* Lisson Gallery, London · Kijkhuis, Den Haag (Kat.) · Galerie Durand-Dessert, Paris · Galerie Johnen & Schöttle, Köln · Galerie Rüdiger Schöttle, München · Storefront for Art and Architecture, New York **1987** Marian Goodman Gallery, New York · *Video/Cinema,* Fruitmarket Gallery, Edinburgh (Kat.) · Centro d'Arte Reina Sofia, Madrid (Kat.) · Le Consortium, Dijon · Musée d'Art Moderne de la Ville, Paris (Kat.) **1988**

Pavilions, Kunstverein, München (Kat.) · Kunsthalle, Kiel (Kat.) 1989 *Pavilions des enfants,* Galerie Roger Pailhas, Marseille 1990 The Yamaguchi Prefectural Museum of Art, Yamaguchi (Kat.) · *Photographs 1965–1985,* Marian Goodman Gallery, New York · *Zeichnungen und Fotografien 1965–68,* Galerie Bleich Rossi, Graz (Kat.) 1991 *Pavilion/Sculptures,* Galerie Roger Pailhas, Marseille · Margo Leavin Gallery, Los Angeles · Galerie Fenster, Frankfurt/M. · Galerie Rüdiger Schöttle, München · *Photographs,* Le Case d'Arte, Milano · Castello di Rivara, Torino (Kat.) · *Roof Project,* Dia Center for the Arts, New York · *Pavilions/Sculptures,* Fondation pour l'Architecture, Bruxelles · Galerij Micheline Szwajcer, Antwerpen · Galleria Mario Pieroni, Roma 1992 *Pavilion Sculptures and Photographs,* Lisson Gallery, London

Gruppenausstellungen | Group exhibitions

1988 *Selected Photographs from the Donnelley Collection,* Barbara Gladstone Gallery, New York · *Balkon mit Fächer,* Akademie der Bildenden Künste, Berlin · *New Urban Landscape,* World Financial Center, New York · *Cascade/Vertical landscapes,* Tom Cugliani Gallery, New York · *Cultural Geometry,* Deste Foundation for Contemporary Art, Athinai · *Neo-Classicism,* Loughelton Gallery, New York · *Group-Show,* Marian Goodman Gallery, New York · *Immaculate Beginnings,* Althea Viafora Gallery, New York · *Material Ethics,* Milford Gallery, New York · *Skulptur Projekte Münster,* Landesmuseum, Münster · '77 – '87, Centre Georges Pompidou, Paris · *Artist and Decoration,* Daniel Newburg Gallery, New York · *Biennial Exhibition,* Whitney Museum of American Art, New York · *The Viewer as Voyeur,* Whitney Museum of American Art, New York · *Non in Codice,* Galeria Mario Pieroni/The American Academy, Roma · *Future of Storefront,* Storefront for Art and Architecture, New York · *Group Exhibition,* Marian Goodman Gallery, New York · *Schema,* Baskerville and Watson, New York · *Aspects of Conceptualism in American Work,* Avenue B Gallery, New York · *1967: At the Crossroads,* Institute of Contemporary Art, University of Pennsylvania, Philadelphia 1989 *Wittgenstein,* Wiener Sezession, Wien (et al.) · *Image World. Arts and Media Culture,* Whitney Museum of American Art, New York · *L'art conceptuel, une perspective,* Musée d'Art Moderne de la Ville, Paris · Frac, Poitou-Charentes, Poitiers · *The Presence of Absence. New Installations,* University of Illinois, Chicago (et al.) · *Theatergarden Bestiarium,* P.S. 1 Museum, The Institute for Contemporary Art, Long Island City, New York (et al.) · *Effets du Miroir,* Gare de Paris-Austerlitz, Paris · *Outdoor Projects,* Ulla Klot, Hamburg · *Les graces de la Nature,* Pays de la Loire, Clisson · *Per-*

spektivismus, Bleich-Rossi Galerie, Graz · *A Group Exhibition,* Marian Goodman Gallery, New York · *Künstlerische Fotografie der 70er und 80er Jahre,* Galerie Schurr, Stuttgart · *Skulpturen für Krefeld,* Museum Haus Lange und Haus Esters, Krefeld · *The Silent Baroque,* Galerie Thaddaeus Ropac, Salzburg · *Exactement pas à Côté 3,* Villa Arson, Nice · *Pas à Côté, Pas n'importe ou' 4,* Villa Arson, Nice · *A Photo Show – A Selection,* Marian Goodman Gallery, New York · Ralph Wernicke, Stuttgart · *Photographies 1969–1989,* Galerie Chantal Boulanger, Montréal · *Spazio Humano,* Galeria Comico, Lisboa · *The Children's Pavilion, Dan Graham and Jeff Wall,* Collection Frac, Rhône-Alpes/Roger Pailhas Gallery 1990 *Conceptual Art. Conceptual Forms,* Gallery 1900–2000/Gallery de Roche, Paris · *Interventions,* Art Gallery of Ontario, Toronto · *Pas n'importe ou ' sous le soleil 5,* Villa Arson, Nice · *Some Seventies Work,* Marian Goodman Gallery, New York · *A New Necessity.* National Garden Festival, Newcastle · *Affinities and Intuitions,* Art Institute of Chicago, Chicago · *The New Urban Landscape,* The World Fiancial Center, New York · *The Children's Pavilion, Dan Graham and Jeff Wall,* Marian Goodman Gallery, New York/Galerie Roger Pailhas, Paris 1991 *Carnegie International,* Carnegie Museum of Art, Pittsburgh · *Diaporama des expositions de la galerie,* Galerie Roger Pailhas, Paris · *Nouvel Espace,* Galerie Durand-Dessert, Paris · *Juste en Dessous 6,* Villa Arson, Nice · *Video Events,* Tom Cugliani Gallery, New York · *1969,* Daniel Newburg Gallery, New York · *Acquisitions,* Galerie Roger Pailhas, Marseille · *Enclosures and Encounters: Architectural Aspects of Recent Sculpture,* Storm King Art Center, New York · *A Group Show,* Marian Goodman Gallery, New York · *L'art Conceptuel des années 70 à aujourd'hui,* Galerie Rüdiger Schöttle, Paris · *Little Things Mean a Lot (Slize it Down to Size),* Warmoesstraat 12, Amsterdam · *A Dialogue about Recent American and European Photography,* Museum of Contmporary Art, Los Angeles · Castello di Rivara, Torino · *La Revanche de L'Image,* Galerie Pierre Huber, Genève · *Inscapes,* Stichting De Appel, Amsterdam

Performances · Aktionen | Actions

1969 *Lax/Relax,* Nova Scotia College of Art, Halifax · *Income (outflow),* Dwan Gallery, New York · *Coulisse,* with Acconci and Nauman, Paula Cooper Gallery, New York 1970 *TV Camera/Monitor Performance,* Nova Scotia College of Art, Halifax · *Lax/Relax,* Video Camera/Monitor Performance, *and Like,* University Loeb Student Center, produced by John Gibson 1971 *Body* (mit/with Acconci, Nauman, Serra, Snow, Oppenheim), University Loeb Student Center, produced by John Gibson · *Like,* Nova Scotia of Art, Halifax · *Project for a local cable TV,* Nova Scotia, Halifax 1972 *TV Camera/Monitor Performance,* Lisson Gallery, London · *Intention Intentionality Sequence I,* Lisson Gallery, London · *Intention Intentionality Sequence II,* Protech-Rivkin Gallery, Washington, DC · *Intention Intentionality Sequence III,* Project Inc., Cambridge · *Two Conciousness Projection(s),* Galeria Tosselli, Milano · *Two Consciousness Projection(s),* Lisson Gallery, London · *Two Conciousness Projection(s),* and *Past Future Split Attention,* 98 Green Street Loft, New

York 1973 *Two Consciousness Projection(s),* Galerie Rudolf Zwirner, Köln 1974 2 Royal College of Art, London · *Two Consciousness Projection(s),* Kunst Bleibt Kunst Projekt '74, Köln 1975 *Performer/ Audience Sequence,* San Francisco Art Institute · *Performer/Audience Sequence,* Hallwalls, Buffalo, New York · *7,* and *Nude: Two Consciusness Projection(s),* Nova Scotia, Halifax 1976 *Two Consciousness Projection(s),* and *Performer/Audience Sequence,* Salle Simon I, Patino, Geneva · *Two Consciousness Projection(s),* School of The Art Institute of Chicago, Chicago · *Performer/Audience Sequence,* Artist's Space, New York · *Performer/Audience Sequence,* New Gallery, Institute of Contemporary Art, London 1977 *Lax/Relax, past Future Split Attention,* Franklin Furnace, New York · *Sex Projection* and *Performer/ Audience/Mirror,* P.S. 1, Long Island, New York · *Identification Projection,* Leeds Polytechnic, Leeds · *Performer/Audience/ Mirror* and *Identification Projection,* Stichting De Appel, Amsterdam · *Sex Projection,* Ecart Galerie, Geneva; Stichting De Appel Amsterdam 1978 *Performer/Audience/Mirror* and *Past Future Split Attention,* Video Free America, San Francisco 1979 *Performer/Audience/Mirror,* Riverside Studios, London 1980 *New Wave and Feminism,* Intitute of Contemporary Arts, London · *Eventworks,* Massachusetts College of Art, Boston 1981 *La Cité et La Banlieue,* Centre George Pompidou, Paris · *Performer/Audience/Mirror,* Frankfurter Kunstverein, Frankfurt/M.

Bibliographie | Bibliography

Texte und Bücher vom Künstler
Texts and books by the artist
detumescence, in: National Tatler, 1966 · *Homes for America,* in: Artsmagazine, 1966 · *Muybridge Moments,* in: Artsmagazine, Februar, 1967 · *The Book as Object,* in: Artsmagazine, Mai, 1967 · *Schema,* in: Aspen, Nr. 5/6, 1967 · *Carl Andre,* in : Artsmagazine, Bd. 42, 1967 · in: Kat. Dan Flavin, Museum of Contemporary Art, Chicago, 1968 · *Oldenburg's Monument,* in: Artforum, Januar, 1968 · *Eisenhower and the Hippies,* in: 0 to 9, Winter, 1968 · in: End Moments, New York, Ed. Dan Graham, 1969 · *Dean Martin/Entertainment as Theatre,* in: Fusion, Herbst, 1969 · *Some Implications and Observations,* in: Art and Language, Nr. 7, 1969 · *Two Parallel Essays,* in: Artists and Photographs, Multiples Inc., 1969 · *Two Sculptures,* in: Kat. Sol Lewitt, Gemeentemuseum, Den Haag, 1970 · *Pieces,* in: Interfuntionen, Nr. 5, 1970 · *Performance as Perceptual Process,* in: Interfunktionen, Nr. 7, 1971 · *TV Camera/Monitor Performance,* in: Radical Software, Herbst, 1971 · *Film Prices by Dan Graham,* in: Studio International, Mai, 1972 · *Interview and various Documentations,* in: Artitiudes, 1972 · *TV Camera/Monitor Perfrmace,* in: TDR, Juni, 1972 · Dan Graham, Tomasso Trini, *Dan Graham I/Eye,* in: Domus, Februar, 1983 · *Various Pieces,* in: Interfunktionen, Nr. 9, 1973 · *Intentional Intentionality Sequence,* in: Artsmagazine, April, 1973 · *Scheme (1965),* in: Schema Informazione, 1973 · *Magazine/Ads* and *Income Piece,* Deurle, November, 1973 · *Two Consciousness Projections,* in: Artsmagazine, April, 1974 · *The Book as Object,* in: Interfunktionen, Nr. 11, 1974 · *Notes on Income (Out-*

flow) Piece, in: Interfunktionen, Nr. 11, 1974 · *The Glass Divider, Light and Social Division, Vieo Feedback*, in: + − 0, Nr. 14, September, 1986 · *Dean Martin (Entertainment as Theatre)*, in: Tracks, Nr. 1/2, Frühling, 1977 · *Public Space/Two Audiences*, in: Art Actuel, Skir Annual, 1977 · *Response to query by Philippe Sers on What Does Duchamp Mean to you Today? Do you Consider Him to Already Belong to The Past*, in: Connaissance des Arts, Nr. 29, Januar, 1977 · Dan Graham, Lisa Pontia Licitra, *Dan Graham: Architectural Model and Photographs*, in: Domus, Mai, 1979 · *Art in Relation to Archtecture/Architecure in Relation to Art*, in: Artforum, Februar, 1979 · *Notes on Public Space/Two Audiences*, in: Aspects, Nr. 5, Winter, 1979 · *Punk: Political Pop/Funk als Propaganda*, in: Überblick, Nr. 3, März, 1979 · *Videoarbeit für Schaufenster*, in: Zweitschrift, Nr. 4/5, 1979 · *Art in Relation to Architecture/Architecture in Relation to Art*, in: Artforum, Februar, 1979 · *Two Untitled Pages*, in: Artforum, Februar, 1980 · *Aesthetics: Impermanent Art and the Seventies Audience*, in: Artforum, Januar, 1980 · *The Destroyed Room of Jeff Wall*, in: Real Life, März, 1980 · *Signs*, in: Artforum, April, 1981 · *Future Dread*, in: ZG, Nr. 7, 1981 · *Video-Performance-Architecture*, in: Art Present, Nr. 9, Frühjahr/Sommer, 1981 · *Not Post-Modernism*, in: Artforum, Dezember, 1981 · *New Wave Rock en het Feminiene*, in: Museumjournaal, 1981 *Bow Wow Wow*, in: Real Life, New York Sommer, 1981 · *Semiosex: New Wave and Feminin*, in: Life, Nr. 6/7, 1982 · *My Religion*, in: Museumjournaal, Nr. 7, 1982 · *McLaren's Children*, in: ZG, Nr. 7, Sommer, 1982 · *Cinema/Project*, in: Museumjournaal, Nr. 6, 1982 · *Theatre, Cinema, Power*, in: Parachute, Sommer, 1983 · *The End of Liberalism II*, in: Image: The Unnecessary, 1983 · *Sur Gordon Matta-Clark*, in: Artpress, Juni/August, 1983 · *Europäischer Archetypus und amerikanischer Kommerzrealismus*, in: Kunstforum, Oktober, 1983 · *On John Knight's Journals Work*, in: Kat. John Knight, LAICA, 1984 · *On John Knight's Journals Work*, in: The Journal, Los Angeles, 1984 · *Darcy Lange: Work and Music*, in: New Observations, Nr. 29, 1985 · *An American Family*, in: New Observations, Nr. 31, 1985 · *Rock My Religion*, in: Video by Artists II, Art Metropole, Toronto, 1985 · in: Kat. Gordon Matta-Clark, Museum of Contemporary Art, Chicago, 1985 · *Gordon Matta-Clark*, in: Parachute, Mai/Juni, 1986 · *Public Space/Two Audiences*, in: Museumjournaal, Nr. 3/4, 1986 · *Kunst als Design/Design als Kunst*, in: Museumjournaal, Nr. 3/4, 1986 · Dan Graham, Robin Hurst, *Corporate Arcadias*, in: Artforum, Nr. 22, Dezember, 1987 · *Design comme Art/Art comme Design*, in: Des Arts, Nr. 5, Winter, 1986 · *Legacies of Critical Practice in the 1980's*, in: DiaArt Foundation: Discussion in Contemporary Culture, Nr. 1, New York, 1987 · *Rock my Religion*, in: Terminal Zone, Published by Fareed Armaly, Köln, 1988 · *Semiosex: Women in Rock*, in: R.O.O.M., published by Fareed Armaly, Köln, 1989 · *Video in Relation to Architecture*, in: Illuminating Video: An essential guide to video art, Aperture in association with Bay Area Video Coalition, New York, Los Angeles, 1990 · *Garden and Theater as Museum*, in: Theatergarden Bestiarium, The MIT Press, Cambridge, Massachusetts; London, 1990 · *Cinema, in: Splinter*, Nr. 4,

Oktober, 1991 · *Skateboard Pavilion*, in: Jahresring 38, Verlag Silke Schreiber, München, 1991

Bücher | Books
Dan Graham. Performance, New York, John Gibson Gallery, 1970 · *Dan Graham-.Some Photographic Projects*, New York, John Gibson Gallery, 1970 · *1966*, New York, John Gibson Gallery, 1970 · *Dan Graham. Textes*, Galerie 17, Paris, Daled, Bruxelles, 1974 · *Dan Graham. For Publications*, Los Angeles, Otis Art Institute, 1975 · *Dan Graham. Video-Architecture-Television*, New York, New York University Press, 1979 · *For Publication*, New York, Marian Goodman Gallery, 1991

Periodika | Periodicals
Liliana **Albertazzi**, *Jeff Wall and Dan Graham*, in: Lapiz, Nr. 59, 1989 · P. **Ardenne**, A. **Barak**, *Dan Graham. Fondation pour l'architecture*, in: Art Press, Juli/August, 1991 · Carolyn **Christov-Bakargiev**, *Dan Graham and Jeff Wall*, in: Flash Art, Nr. 147, Sommer, 1989 · Roger **Denson**, *Review*, in: Tema Celeste, April/Juni, 1990 · Chris **Dercon**, *Interview*, in: Forum International, Nr. 9, September/Oktober, 1991 · Thomas **Dreher**, *Dan Graham. Sculptural models as bridgeable historical metaphors*, in: Artefactum, Nr. 30, 1989 · Jean-Paul **Fargier**, *Maman Cube*, in: Le Journal Cahiers, Nr. 72, April, 1987 · Cathrine **Fayet**, *Review*, in: Opus, Nr. 103, Winter, 1977 · Robert **Fleck**, *Dan Graham at Roger Pailhas*, in: Flash Art, Oktober, 1991 · Susan **Fruedenheim**, *Suburban Hamlets*, in: Artforum, Mai, 1987 · John **Griffith**, *Deconstruction deconstructed*, in: Art & Design, Nr. 314, 1988 · Paul **Groot**, *Bolwerken zijn houdbaar, illusies niet: Over onder meer het pittoreske; of de rehabilitatie van een verloren gewaand genre I*, in: Museumjournaal, 1989 · Hans **Hagen**, *1987 Biennale Exhibition: Film and Video*, in: Artforum, September, 1987 · Brian **Hatton**, *Dan Graham: Present Continuous*, in: Artscribe, Winter, 1991 · Brian **Hatton**, *Conversation with Dan Graham*, in: Galeries Magazine, Nr. 46, Dezember 1991/Januar 1992 · Eleanor **Heartney**, *Review*, in: New Art Examiner, November, 1987 · J. **Hoberman**, *Sympathy For The Devil*, in: Village Voice, 2. Juni, 1987 · B. **Hueck-Ehmer**, *Skulptur-Projekte Münster 1987*, in: Das Kunstwerk, September, 1987 · Richard **Ledes**, *The Children's Pavilion*, in: Artscribe, Mai, 1990 · Kate **Linker**, *Review*, in: Artforum, Februar, 1987 · Robert **Linsley**, *Critical Realism Revisited*, in: C, Dezember, 1989 · John **Miller**, *In the Beginning there was Formica*, in: Artscribe International, März/April, 1987 · John **Miller**, *Review*, in: Artscribe, Mai, 1988 · **Piguet**, *Dan Graham. Sol Lewitt. Vladimir Skoda*, in: Flash Art, Mai, 1987 · Barry **Schwabsky**, *Spotlight: Non in Codice*, in: Flash Art, Mai, 1988 · Dena **Shottenkirk**, *Review*, in: Artforum, März, 1990 · Robert **Smithson**, *Interview*, in: Noema, Nr. 29, März/April, 1990 · Nancy **Spector**, *The Children's Pavilion. Jeff Wall's and Dan Graham's Collaborative Project*, in: Canadian Art, Sommer, 1990 · Michael **Tarantino**, *La Collection Herbert: La Recherche sans Compromis d'Anton et Annick Herbert*, in: Parachute, Nr. 54, 1989 · Walter **Thompson**, *Review*, in: Art in America, Dezember, 1987 · Paul **Wood**, *Review*, in: Artscribe, November, 1987

Film
Dan Graham. Static at Riverside Studios, London, Audio Arts Tape Edition, 1980

RODNEY GRAHAM

*Vancouver (CDN), 1949
Lebt/Lives in Vancouver

Einzelausstellungen | One-man exhibitions

1979 *Camera Obscura*, (installation), Abbotsford · *Illuminated Ravine*, (installation), Simon Fraser University, Burnabay 1986 Galerie Johnen & Schöttle, Köln 1987 Art Gallery of Ontario, Toronto, Ydessa Gallery, Toronto 1988 Christine Burgin Gallery, New York · Galerie Philip Nelson, Lyon · Galerie Johnen & Schöttle, Köln · Vancouver Art Gallery, Vancouver (Kat.: J. Wall) 1989 Stedelijk Van Abbemuseum, Eindhoven (Kat.: J. Debbaut, F. Lubbers) · Galeria Marga Paz, Madrid · Galerij Micheline Szwajcer, Antwerpen · *Books and Writings by Rodney Graham*, Yves Gevaert, Bruxelles 1990 *Books*, Lisson Gallery, London · *Parsifal*, Galerie Johnen + Schöttle, Köln · Christine Burgin Gallery, New York 1991 Maison de la Culture et de la Communication, St. Etienne · Galerie Rüdiger Schöttle, Paris 1992 Galerie Philip Nelson, Lyon (mit/with Ken Lum) · Galerij Micheline Szwajcer, Antwerpen · *Les Dernières Merveilles de la Science*, Yves Gevaert, Bruxelles

Gruppenausstellungen | Group exhibitions

1987 *Skulptur Projekte Münster*, Westfälisches Landesmuseum, Münster · *Non in Codice*, Galleria Pieroni/Accademia Americana, Roma · *Dan Graham, Rodney Graham, Robert Smithson, Jeff Wall*, Christine Burgin Gallery, New York · *Kunst mit Photographie*, Gallerie Ralph Wernicke, Stuttgart · *Cinema Objects*, Stichting De Appel, Amsterdam · Cash/Newhouse Gallery, New York · *Rodney Graham and James Welling*, Coburg Gallery, Vancouver 1988 *Rodney Graham, Robert Kleyn, Jeff Wall*, Studio Casoli, Milano · *Theatregarden Bestiarium*, P.S. 1, New York (et al.) · *Drawings*, Cable Gallery, New York · *Essential Form*, Walter Philips Gallery, Banff · *Facsimile*, De Zaak, Groningen · *Made in Camers*, Gallery Sten Eriksson, Stockholm · Galerij Micheline Szwajcer, Antwerpen 1989 *Prospect 89*, Frankfurter Kunstverein, Frankfurt/M. · Galerie Ralph Wernicke, Stuttgart · *Wiener Diwan: Sigmund Freud heute*, Museum Moderner Kunst, Wien · *A Good Read : The Book as Metaphor*, Barbara Toll Gallery, New York 1990 *Weitersehen*, Museum Haus Lange und Haus Esters, Krefeld · Centro Atlantico de Arte Moderno, Las Palmas de Gran Canaria · *Figures et Lectures*, Galerie Samia Sãouma, Paris · *Centre* International d'Art Contemporain, Montréal · *Rodney Graham, Inn Wallace*, Galerie Rüdiger Schöttle, München · *HanneDarboven, Rodney Graham, Antonio Muntadas, Lawrence Weiner*, Galerie Marga Paz, Madrid 1991 Christine Burgin Gallery, New York · *Rodney Graham, Stephen Prina, Christopher Williams*, S.L. Simpson Gallery, Toronto · *Real Allegories*, Lisson Gallery, London 1992 *Camaras Indiscretes*, Centre d'Art Santa Monica, Barcelona · *The Last Days*, Salas del Arenal, Sevilla

Artscribe International, Sommer, 1987 · R. **Kleyn**, *Method, method*, in: C Magazine, Nr. 2, Juni, **1989** · Donald **Kuspit**, u.a., *The Critic's Way*, in: Artforum, Nr. 1, September, 1987 · G. **Lebredt**, *A Piece of Poe*, in: Vanguard, Nr. 2, April/Mai, 1988 · G. **Lebredt**, *Cleft/Rodney Graham, Ydessa Gallery, Toronto*, in: C Magazine, Nr. 17, März, 1988 · R. **Linseley**, *In Pursuit of the Vanishing Subject: James Welling and Rodney Graham*, in: C Magazine, Nr. 16, Winter, 1987–1988 · E. **Ramsay**, *Rodney Graham, James Welling*, in: Vanguard, Nr. 1, Februar/März, 1987 · A. **Rodante**, *Non in Codice*, in: Tema Celeste Magazine, Dezember 1987/Februar 1988 · Barry **Schwabsky**, *Non in Codice*, in: Flash Art, Nr. 138, Januar/Februar, 1988 · F. **Wagemans**, *Gelukkig en prettig geconditioneerd, een keuze door Fred Wagemans*, in: Haagse Post, 12. Mai, 1988 · S. **Watson**, *Zweimal Canada Dry : Sechs Künstler aus Vancouver*, in: Wolkenkratzer Art Journal, Nr. 2, März/April, 1988

Bibliographie | Bibliography

Texte und Bücher vom Künstler
Texts and books by the artist
Lenz, Vancouver, Rodney Graham, 1983 (10 Exempl.) · *Lenz* (Prospekt), Vancouver, Rodney Graham, 1983 (210 Exempl.) · *Die Gattung Cyclamen*. Installation für Westfälisches Landesmuseum, Münster, 1987 (24 Exempl.) · *The System of Landor's Cottage*, Bruxelles, Yves Gevaert/ Toronto, The Art Gallery of Ontario, 1987 (250 Exempl.) · *The System of Landor's Cottage*, Bruxelles, Yves Gevaert/Toronto, The Art Gallery of Ontario, 1987 (4 Exempl.) · *Projects*, Facsimile Nr. 38/39, VII, Groningen, De Zaak, 1988 · *Cours de linguistique Générale*, Bruxelles, Yves Gevaert, 1988 · *Vathek*, Bruxelles, Yves Gevaert, 1989 (2 Exempl.) · *La Veranda [La Véranda]*, 2 Bänder, Bruxelles, Yves Gevaert, 1989 (100 Exempl.) · *Nouvelles Impressions d'Afrique*, Bruxelles, Yves Gevaert/ New York, Christine Burgin Gallery, 1989 (2 Exempl.) · *Images qui succèdent à la contemplation d'objets d'un grand éclat ou même d'objets bien éclairés*, Bruxelles, Yves Gevaert/New York, Christine Burgin Gallery, 1989 · *Alice's Adventures in Wonderland*, Bruxelles, Yves Gevaert, 1989 · *Casino Royale*, Bruxelles, Yves Gevaert, 1989 (15 Exempl.) · *Freud Supplement (170A-170D)*, Christine Burgin Gallery, New York; Yves Gevaert Bruxelles; Galerie Nelson, Lyon; Galerie Johnen & Schöttle, Köln, 1989 (100 Exempl.) · *Parsifal – One signature*, Bruxelles, Yves Gevaert/Köln, Galerie Johnen & Schöttle, 1989 (12 Exempl.) · *Parsifal – Transformation Music*, Bruxelles, Yves Gevaert/Köln, Galerie Johnen & Schöttle, 1989 (2 Exempl.) · *Parsifal (1882 – 38, 969, 364, 735)*, Köln, Galerie Johnen & Schöttle, 1990 (40 Exempl.) · *Shorter Notice*, Vancouver, Or Gallery Society, 1990 (50 Exempl.) · *Shorter Notice*, Vancouver, Or Gallery Society, 1990 (450 Exempl.) · *Freud et le cas Katharina: Deux sources pour un élément possible de fiction*, Bruxelles, Yves Gevaert/Emile Van Balberghe, 1991 (300 Exempl.)

Periodika | Periodicals
C. **Christov-Bakargiev**, *Something Nowhere*, in: Flash Art, Nr. 140, Mai/Juni, 1988 · Marie-Ange **Brayer**, *Rodney Graham*, in: Forum International, Nr. 10, November/Dezember, 1991 · E. **Heartney**, *Sighted in Münster*, in: Art in America, Nr. 9, September, 1987 · R. **Jones**, *Group Show Cash/Newhouse*, in:

ANGELA GRAUERHOLZ

*Hamburg (D), 1952
Lebt/Lives in Montréal

Einzelausstellungen | One-man exhibitions

1984 Centre Vu, Québec **1985** Galerie Art 45, Montréal · Agnes Etherington Art Centre, Queens University, Kingston (Kat.: M. Townsend) **1986** Stride Gallery, Calgary · Anna Leonowens Gallery, Nova Scotia · College of Art and Design, Halifax **1987** Centre Culturel, Université de Sherbrooke, Sherbrooke · Galerie Art 45, Montréal **1988** The Photographers Gallery, Saskatoon · Centre Vu, Québec **1989** Galerie Art 45, Montréal · La Galerie du Musée, Musée du Québec, Québec **1990** Mercer Union, Toronto (Kat.: J. Lamoureux, C. Simon) **1991** Westfälischer Kunstverein, Münster (Kat.: F. Meschede, C. Pontbriand) · Centre Culturel Canadien, Paris · *Timeframe: Angela Grauerholz and Michèle Waquant*, Presentation House, Vancouver (Kat.: K. Henry)

Gruppenausstellungen | Group exhibitions

1987 *Paysage*, Dazibao, Montréal **1988** *The Historical Ruse: Art in Montréal*, Power Plant, Toronto · *Paysage*, Contemporary Art Gallery, Vancouver (et al.) **1989** *Taking Pictures*, Presentation House, Vancouver · *Tenir l'image à distance*, Musée d'Art Contemporain, Montréal · *Montréal 89*, Aspects de la photographie québécoise contemporaine, CREDAC, Ivry · *Printemps québécois*, Théâtre de Caen, Caen · *The Zone of Conventional Practice and Other Real Storie*, travelling exhibition organized by Cheryl Simon and Galerie Optica · *Territoires d'artistes: Paysages verticaux*, La Galerie du Musée, Musée du Québec, Québec **1990** *Sydney Biennial*, Sydney **1991** *Unnatural Traces – Contemporary Art from Canada*, Barbican Art Gallery, London · *Un archipel de désir: les artistes québécois et la scène internationale*, Musée du Québec, Québec · *Memory Works: Postmodern Impulses in Canadian Art*, London Regional Art and Historical Museums, London (et al.) · *Media War – Media Guerre/New World Order*, Centre international d'art contem-

porain de Montréal, Montréal · *The Photographic Image*, 49th Parallel, Gallery for Contemporary Canadian Art, New York

Bibliographie | Bibliography

Periodika | Periodicals
Serge **Bérard**, *Angela Grauerholz – Art 45*, in: Parchute, Nr. 40, 1985 · Claire **Gravel**, *L'extase photographique. Quelques photographes montréalaises*, in: Vie des Arts, Nr. 136, September, 1989 · Lesley **Johnstone**, *Paysages – Dazibao*, in: Vanguard, Nr. 4, September/Oktober, 1987 · Chantal **Pontbriand**, *Tunnel of Light. A Canadian Art Portfolio by Angela Grauerholz*, in: Canadian Art, Nr. 4, Winter, 1988 · Chantal **Pontbriand**, *Le Regard vertigineux de l'ande*, in: Parachute, Juli/August/September, 1991 · Randy **Saharuni**, *Angela Grauerholz – Art 45*, in: C Magazine, Nr. 15, Herbst, 1987 · Beth **Seaton**, *Angela Grauerholz – Mundane Re-Membrances*, in: Parachute, Nr. 56, Oktober/November/Dezember, 1989 · Cheryl **Simon**, *The Déjà Vu of Angela Grauerholz*, in: Vanguard, April/Mai, 1986

MICHAEL GROSS

*Tiberia (Il), 1920
Lebt/Lives in Haifa

Einzelausstellungen | One-man exhibitions

1964 Haifa Museum of Modern Art, Haifa **1971** Museum of Modern Art, Rio de Janeiro **1974** Rina Gallery, New York **1975** Julie M. Gallery, Tel-Aviv · Worcester Art Museum, Massachusets **1977** Israel Museum, Jerusalem (Kat.: Y. Fischer) · Tel-Aviv Museum,

Tel-Aviv (Kat.: Y. Fischer) 1978 Printer's Gallery, Jerusalem 1980 Mishkan Leomanut, Museum of Art, Ein-Harod (Kat.: Mordechai Omer) 1981 Hillel Gallery, Jerusalem (Kat.: Mordechai Omer) 1983 Dvir Intrator **Gallery,** Tel-Aviv (Kat.: Mordechai Omer) 1987 Dvir Intrator **Gallery,** Tel-Aviv (Kat.: Mordechai Omer) 1988 Dvir Intrator Gallery, Tel-Aviv (Kat.) · *Strong Emphasis,* Israel Museum, Jerusalem 1989 The Haifa Museum od Modern Art, Haifa

Gruppenausstellungen | Group exhibitions

1987 *Six Israel Artists,* Helsinki Kunsthalle, Helsinki 1989 *Upon one of the Mountains,* The Tel-Aviv University Gallery 1990 *Contemporary Israel Art from the collection of Joseph Hackmey,* Municipal Museum, Mexico (et al.) 1991 *Ten Israel Artists,* Museum of Art, São Paulo · *Mountains Round About,* Jerusalem in Israeli printmaking from the Seventies and the Eighties (et al.) · *Israeli Contemporary Sculpture/Place and Mainstream,* Hara Museum of Contemporary Art, Tokyo

GEORGE HADJIMICHALIS

*Athinai (GR), 1954
Lebt/Lives in Athinai

Einzelausstellungen | One-man exhibitions

1977 ORA Cultural Center, Athinai 1981 ORA Cultural Center, Athinai 1985 *Painting,* Galerie 3, Athinai · *A Parallel Life,* Galerie 3, Athinai 1991 *Synaxi Marocias: Topographics, Surveys, and Other Details,* The Tokos Megaron, Inspectorate of Byzantin Antiquities of Eastern Macedonia and Thrace, Kavala

Gruppenausstellungen | Group exhibitions

1991 *Ideas for the Greek Pavilion,* Biennale of Architecture, Venezia

Bibliographie | Bibliography

Texte und Bücher vom Künstler
Texts and books by the artist
George Hadjimichalis, Dionysis Kapsalis, *Fotis Kontoglu : A Painter of Greek Modernism,* in : O Polites, Nr. 24, Januar/Februar, 1979 · Apostolos Doxiadis, *A Parallel Life,* Athinai, Agra Publications, 1985 · Haralambos Barkirtes, George Hadjimichalis, *Synaxi Maroneas,* Athinai, Agra Publications, 1991

Bücher | Books
Periodika | Periodicals
Kyrillos **Sarris,** *George Hadjimichalis. Defining the Terms of the Problem,* in : Arti, Bd. 7, November/Dezember, 1991

DAVID HAMMONS

*Springfield (USA), 1943
Lebt/Lives in Harlem (New York)

Einzelausstellungen | One-man exhibitions

1971 Brockman Gallery, Los Angeles 1974 Fine Arts Gallery, Los Angeles 1975 *Greasy Bags & Barbeque Bones,* Just Above Midtown, New York 1976 *Dreadlock Series,* Just Above Midtown, New York 1977 *Nap Tapestry: Wire & Wiry Hair,* Neighbourhood Art Center, Atlanta 1980 *The Window,* The New Museum, New York 1982 *Higher Goals,* public installation, Harlem 1986 Just Above Midtown, New York 1989 Exit Art, New York 1990 Jack Tilton Gallery, New York (Kat.: V. V. Gioia) · Retrospective exhibition, Institute of Contemporary Art, P.S. 1, Long Island City, New York 1991 *Rousing the Rubble* (Retrospective), San Diego Museum of Contemporary Art, San Diego (ICA, Philadelphia) (Kat.: S. Cannon, T. Finkelpearl, A. Heiss, K. Jones) 1992 Künstlerhaus Bethanien, Berlin

Gruppenausstellungen | Group exhibitions

1987 *Arts Festival of Atlanta,* Atlanta 1988 *Art as a Verb,* Maryland Institute College of Art, Baltimore · *Out of the Studio: Art with Community,* P.S. 1, Queens, New York 1989 *19 Sixties – A cultural Awakening Reevaluated 1965–75,* California Afro-American Museum · *The Blues Aesthetic,* Washington Project for the Arts, Washington, DC · *The City/The Spirit,* Paula Allen Gallery, New York · *Committed to Print,* Museum of Modern Art, New York · *Art as a Verb,* The Studio Museum in Harlem/Met Life Gallery, New York · *Strange attractions, Signs of Chaos,* The New Museum of Contemporary Art, New York 1990 *The Decade Show,* Studio/New Museum/MOCA, New York · *Just Pathetic,* Rosamund Felsen Gallery, Los Angeles · *Exotism – Art of Incorporation,* Zilkha Center for the Arts, Middletown · *Rewriting History,* Kettles Yard, Cambridge · *Black USA,* Museum Overholland, Amsterdam · *Works on Paper,* Paula Allen Gallery, New York · *Casino Fantasma,* P.S. 1, Venice · *Annual Exhibition,* American Academy, Roma · *Ponton Temse,* Museum van Hedendaagse Kunst Gent, Temse · *Who Counts? Assessing the 1990 Census,* Randolph Gallery, Chicago 1991 *Dislocations,* Museum of Modern Art, New York · *Places With a Past,* Spoleto Festival U.S.A., Charleston · *Heimat,* Wewerka & Weiss Galerie, Berlin · *In Public: Seattle 1991,* Seattle Arts Commision, Seattle Washington · Security Pacific Gallery, Seattle Washington 1992 *Carnegie International,* Carnegie Museum of Art, Pittsburgh

Performances · Aktionen | Actions

1978 *Abstract Crashing,* The Studio Museum, Harlem, New York 1979 *Evening Glow,* Central Park, New York 1983 *Blizzard Ball Sale,* Cooper Square, New York 1986 *Doll Shoe Salesman,* Astor Place, New York

Bibliographie | Bibliography

Periodika | Periodicals
Maurice **Berger,** *Interview with David Hammons,* in: Art in America, September, 1990 · Maurice **Berger,** *Rassismus in US-Museen,* in: Kunstforum, Nr. 113, Mai/Juni, 1991 · Iwona **Blazwick** & Emma **Dexter,** *Rich in Ruins/Ruinenreich,* in: Parkett, Nr. 31, 1992 · Francesco **Bonami,** *Dislocation, the Place of Installation,* in: Flash Art, Nr. 162, Januar/Februar, 1992 · Dan **Cameron,** *Good-Bye to All That?,* in: Art & Auction, Januar, 1991 · Lynne **Cooke,** *Yo,* in: Parkett, Nr. 2, 1992 · Holland **Cotter,** *Dislocating the Modern,* in: Art in America, Nr. 1, 1992 – Joshua **Decter,** *New York in Review,* in: Arts Magazine, Oktober, 1989 · John **Farris,** *Is it reel or is it memorex: out of his window/Is it reel or is it memorex: durch sein Fenster,* in: Parkett, Nr. 32, 1992 · Elizabeth **Hess,** *Train of Thought,* in: Village Voice, 30. Juni, 1989 · Elizabeth **Hess,** *Getting His Due,* in: Village Voice, 1. Januar, 1991 · Kelly **Jones,** *Interview: David Hammons,* in: Art papers, Nr. 4, Juli/August, 1988 · Kay **Larson,** *David Hammons,* in: Galeries Magazine, Nr. 41, Februar/März, 1991 · Kay **Larson,** *New York, Dislocations,* in: Galeries Magazine, Nr. 46, Dezember 1991/Januar 1992 · Kay **Larson,** *Dirt Rich,* in: New York Magazine, 14. Januar, 1991 · Kay **Larson,** *David Hammons,* in: Galeries Magazine, Februar/März, 1991 · Lizette **Lefelle-Collins,** *Between traditions,* in: Visions, Winter, 1989 · Louise **Neri,** *No Wonder/Kein Wunder,* in: Parkett, Nr. 32, 1992 · Lois E. **Nesbitt,** *David Hammons: Nobody's Champion,* in: Artscribe, Sommer, 1991 · Bojana **Pejic,** *Heimat,* in: Artforum, Sommer, 1991 · Calvin **Reid,** *Chasing the Blue Train,* in: Art in America, September, 1989 · Calvin **Reid,** *David Hammons, guide du hipster dans l'Amérique noire,* in: Art Press, Nr. 168, April 1992 · Evelyn **Schels,** *Schwarz und stolz im Getto,* in: Pan, Nr. 1, 1992 · Robert Farris **Thompson,** *Hammons' Harlem Equation: Four Shots of Memory, Three Shots of Avant-garde/Hammons' Harlem Gleichung: vier Schuß Erinnerung, drei Schuß Avant-*

garde, in: Parkett, Nr. 31, 1992 · Francis De **Vuono,** *David Hammons,* in: Artnews, März, 1991

GEORG HEROLD

*Jena (D), 1947
Lebt/Lives in Köln

Einzelausstellungen | One-man exhibitions

1977 *Präsentationen der ersten »Latte«,* Hamburg 1978 *Läser,* Hamburg 1979 *Altes Gerippe – mieses Getitte,* Künstlerhaus, Hamburg · *Latte in Watte,* Hamburg · *Mode Nervo,* Künstlerhaus, Hamburg · Galerie Arno Kohnen, Düsseldorf 1982 *Goethe-Latte,* Galerie Gugu Ernesto, Köln · *Geile Feile, Feile Geile,* Galerie Arno Kohnen, Düsseldorf · *Der Bügelmeister,* Galerie Arno Kohnen, Düsseldorf 1983 *Ein Kreuzweg,* Galerie Klein, Bonn 1984 *P.F.U.I. Diffusa della Cultura,* Galerie Max Hetzler, Köln · *Dachlattenprofile,* Ausstellungsraum Fettstraße 7a, Hamburg 1985 Galerie Max Hetzler, Köln · *Unschärferelation, Realismus* Studio der Neuen Gesellschaft für Bildende Kunst, Berlin (Kat.: R. Speck, B. Straka) · Galerie Susan Wyss, Zürich · *Wäscheleine verkehrtrum,* Galerie Petersen, Berlin 1986 *Fotografie aus Schande,* CCD Galerie, Düsseldorf · *Kampf dem Dekubitus,* PPS Galerie, Hamburg · Galerie Ralph Wernicke, Stuttgart · *1:1,* Westfälischer Kunstverein, Münster (Kat.: F. Heubach) 1987 Galerie Borgmann-Capitain, Köln · *Das Heil in der Kunst,* Galerie Peter Pakesch, Wien · Richard Foncke Gallery, Gent · Galerie Max Hetzler, Köln · *Schrauben, Nägel, Öfen, Knöpfe, Juwel,* Kunstraum München e.V., München · Galerie Christoph Dürr, München · Städtische Kunsthalle, Düsseldorf · *Tafel der Wahrheit,* Galerie Klein, Bonn 1988 Galerie Grässlin-Ehrhardt, Frankfurt/M. · Galerie Susan Wyss, Zürich · Koury/Wingate Gallery, New York · Galerie Wanda Reiff, Maastricht · Richard Foncke Gallery, Gent · University Gallery of Massachusetts, Amherst · Galerie Silvia Menzel, Berlin · Galeria Juana de Aizpuru, Madrid 1989 Karsten Schubert Ltd., London · Interim Art, London · Daniel Weinberg Gallery, Los Angeles · Anders Tornberg Gallery, Lund · Galerie Massimo di Carlo, Milano · Lawrence Oliver Gallery, Philadelphia · Galerie Juana de Aizpuru, Sevilla · *Multiples,* Galerie Gisela Capitain, Köln · Kunsthalle, Zürich (Kat.: Ch. Schenker) 1990 Galerie Max Hetzler, Köln · Robbin Lockett Gallery, Chicago · Museum of Modern Art, San Francisco · *Geld spielt keine Rolle,* Kölnischer Kunstverein, Köln (Kat.: B. Groys, M. Stockebrand) · Richard Foncke Gallery, Gent · Galerie Lucio Amelio, Napoli · *Multiples,* Maximilian Verlag, Sabine Knust, München · *Promised,* Thea Westreich Associates, New York · Koury Wingate Gallery, New York · *White Sheets and Promises,* Luhring Augustine Gallery, New York · Air de Paris, Nice · Galerie Erhard Klein, Bonn · Galerie Sylvana Lorenz, Paris 1991 Carnegie Museum of Art, Pittsburgh · Museum van Hedendaagse Kunst, Gent · Dallas Museum of Art, Dallas · Richard Foncke Gallery, Gent · Paley Wright, Interim Art Limited, London · Luhring Augustine Hetzler, Santa Monica 1992 Galerie Juana de Aizpuru, Madrid

Gruppenausstellungen | Group exhibitions

1987 *Skulptur Projekte Münster,* Westfälisches Landesmuseum, Münster · *Room enough – Sammlung Schürmann,* Suermondt-Ludwig Museum, Aachen · *Similia-Dissimilia,* Columbia University, New York (et al.) · *Broken Neon,* Steirischer Herbst 87, Forum Stadtpark, Graz · *Res publica: Ideen und Konzepte für öffentliche Kunst,* Galerie Sonne, Berlin 1988 *BiNationale,* Städtische Kunsthalle, Kunstsammlung Nordrhein-Westfalen, Kunstverein für die Rheinlande und Westfalen, Düsseldorf (et al.) · *Georg Herold, Joseph Beuys, Martin Kippenberger, Sigmar Polke u. a.,* Luhring Augustine & Hodes Gallery, New York · *Ansichten,* Westfälischer Kunstverein, Münster 1989 *Elegies,* Galerie Baudoin Lebon, Paris · *Object of Thought,* Anders Tornberg Gallery, Lund · The Renaissance Society, Chicago · Galerie Templon, Paris · Karsten Schubert Ltd., London · Koury Wingate, New York · *Bilderstreit,* Museum Ludwig, Köln · *Über Unterwanderungen,* Galerie Sophia Ungers, Köln · *What is Contemporary Art?,* Rooseum, Malmö · *Das Medium der Fotografie ist berechtigt, Denkanstösse zu geben,* Sammlung F. C. Gundlach, Hamburg (et al.) · *Neue Figuration – Deutsche Malerei 1960–88,* Kunstmuseum, Düsseldorf (et al.) · Galerie Christine et Isy Brachot, Bruxelles · *Refigured Painting: The german Image 1960–88,* Solomon R. Guggenheim Museum, New York (et al.) · *2000 Jahre – Die Gegenwart der Vergangenheit,* Bonner Kunstverein, Bonn · *Ausstellung zum 50. Todestag von Sigmund Freud,* Sigmund Freud-Haus, Wien · *Junge Rheinische Künstler II,* Kölnische Rückversicherungsgesellschaft, Köln · *Künstlerische Fotografie der 70er und 80er Jahre,* Galerie Ursula Schurr, Stuttgart 1990 *Just Pathetic,* Rosamund Felsen Gallery, Los Angeles · *About Round – Round About,* Anders Tornberg Gallery, Lund · *Artistes De Colonia,* Centre D'Art Santa Monica · *Prints and Multiples,* Luhring Augustine Hetzler Gallery, Santa Monica · *Günther Förg, Kenji Fujita, Robert Gober, Georg Herold, John Kessler, Liz Larner, Zoe Leonard,* Luhring Augustine Gallery, New York · *New Work: A New Generation,* San Francisco Museum of Modern Art, San Francisco · *Multiples,* Hirsch & Adler Modern, New York · *Le désenchantement du monde,* Villa Arson, Nice · *Ponton Temse,* Museum van Hedendaagse Kunst Gent, Temse · *Changing Summer Show,* Karl Bornstein Gallery, Santa Monica · *Painting alone,* Pace Gallery, New York · Galerie Max Hetzler, Ausstellungsraum Alsdorfer Straße, Köln · *Small Works,* Koury Wingate, New York · Interim

Art Ltd., London · *Rose ist eine Rose ist eine Rose...,* Barbara Gross Galerie, München (et al.) 1991 *Metropolis,* Martin-Gropius-Bau, Berlin · *Berlin Paris Bar,* Artcurial, Centre d'Art Plastique Contemporain, Paris · Perry Rubenstein Gallery, New York · *Gullivers Reisen,* Galerie Sophia Ungers, Köln · Luhring Augustine Gallery, New York · *176 Tage W.A. Mozart in Mannheim,* Reiss-Museum der Stadt Mannheim, Mannheim 1992 *Platzverführung,* Stuttgart

Bibliographie | Bibliography

Periodika | Periodicals
Michael **Archer,** *Werner Büttner, Georg Herold, Albert Oehlen at the ICA,* in: Artscribe, März/April, 1987 · Jan **Avgikos,** *Gift of the Artist,* in: Artscribe, Januar/Februar, 1990 · Fritz **Balthaus,** *Georg Herold. Dingens,* in: Artefactum, Nr. 40, September/Oktober, 1991 · Françoise **Bataillon,** *Broken neon – Galerie Sylvana Lorenz,* in: Artpress, Mai, 1988 · Ernest **Beck,** *Georg Herold – Kunsthalle Zürich,* in: Artnews, April, 1989 · Enrico R. **Comi,** *On Similia/Dissimilia,* in: Spazio Umano/Human Space, Nr. 4, 1987 · Wilfried **Dickhoff,** *Members only,* in: Artforum, Nr. 5, Januar, 1988 · Stephen **Ellis,** *The boys in the Bande,* in: Art in America, Dezember, 1988 · Andreas **Franzke,** *New german Sculpture,* in: Art & Design. German Art Now, 1989 · Kirby **Gookin,** *A Phoenix Built from the Ashes,* in: Arts Magazine, März, 1990 · Isabelle **Graw,** *Atlantisches Bündnis,* in: Wolkenkratzer Art Journal, Nr. 1, Januar/Februar, 1988 · Isabelle **Graw,** *Ein Ausflug in marktbeherrschte Zonen,* in: Artis, November, 1988 · Claudia **Herstatt,** *Wieder muß das Publikum wandern,* in: Art, Nr. 9, September, 1990 · Justin **Hoffmann,** *Georg Herold – Christoph Dürr/ Kunstraum,* in: Artscribe, Mai, 1988 · Jutta **Koether,** *Sculptures: Koury Wingate,* in: Artscribe, Mai, 1988 · Edith **Krebs,** *Georg Herold – Kunsthalle Zürich,* in: Noema, Nr. 22, 1989 · Luk **Lambrecht,** *Brandl, Frandsen, Herold, Heyvaert, Kocherscheidt,* in: Metropolis M, Nr. 5, Oktober, 1991 · Friedemann **Malsch,** *Georg Herold '1:1',* in: Kunstforum, Bd. 87, Januar/Februar, 1987 · Friedemann **Malsch,** *Georg Herold at Westfälischer Kunstverein,* in: Artscribe, März/ April, 1987 · Friedemann **Malsch,** *Georg Herold – Borgmann-Capitain, Köln,* in: Noema, Nr. 11, April/Mai, 1987 · Friedemann **Malsch,** *»Nothing Final – The Scupltural Principle -Flight into Mania«. Thoughts on the Role of Form and Material in Georg Herold's Work,* in: Parkett, Nr. 15, 1988 · Friedemann **Malsch,** *Über Unterwanderung,* in: Kunstforum, Bd. 103, September/ Oktober, 1989 · Friedemann **Malsch,** *Die Ziegelbilder,* in: Kunstforum, Bd. 100, 1989 · Eileen **Neff,** *Georg Herold – Lawrence Oliver Gallery,* in: Artforum, Januar, 1990 · Alfred **Nemeczek,** *Weh' dem, der es wissen möchte: Similia/Dissimilia, Kunsthalle Düsseldorf,* in: Art, Nr. 10, Oktober, 1987 · Saul **Ostrow,** *Köln,* in: Bomb, Frühjahr, 1987 · Karlheinz **Schmid,** *Moderne Kunst, die immer ihr Geld wert ist,* in: Impulse, Nr. 12, Dezember, 1987 · Peter **Plagens,** *German Exchange,* in: Art in America, April, 1989 · Jürgen **Raap,** *Georg Herold,* in: Kunstforum, Bd. 109, August/Oktober 1990 · Andrew **Renton,** *Georg Herold – Karsten Schubert/ Interim Art, London,* Flash Art, Nr. 146, Mai/Juni, 1989 · S.D. **Sauerbier,** *Georg Herold – Kölnischer Kunstverein,* in: Noema, Nr.

32, September/Oktober, 1990 · S. D. Sauerbier, *Bill in Kauf*, in: Noema, Januar/Februar/März, 1991 · Carl Friedrich Schröer, *Querdenker mit Sinn für das Absurde*, in: Art, Nr. 7, Juli, 1990 · Sabine Schütz, *Similia/Dissimilia*, in: Kunstforum, Bd. 91, Oktober/November, 1987 · Jude Schwendenwien, *Sculpture – Koury-Wingate*, in: Artnews, Sommer, 1988 · Dina Sorensen, *Georg Herold*, in: Arts Magazine, Januar, 1991 · Andrew Wilson, *Georg Herold – Paley Wright Gallery, London*, in: Forum International, Nr. 11, Januar/Februar, 1992

GARY HILL

*Santa Monica (USA), 1951
Lebt/Lives in Seattle

Einzelausstellungen/One-man exhibitions

1971 Polaris Gallery, Woodstock 1973 Woodstock Artist's Association, Woodstock, New York 1974 South Houston Galleria, New York 1976 Anthology Film Archives, New York 1978 Rochester Memorial Art Galleria, Rochester, New York 1979 The Kitchen Center for Music, Video and Dance, New York · Everson Museum, Syracuse, New York 1980 Media Study, Buffalo, New York · *Video Viewpoints*, Museum of Modern Art, New York 1981 The Kitchen Center for Music, Video and Dance, New York · And/Or Galleria, Seattle · Anthology Film Archives, New York 1982 Galerie H at ORF, Steirischer Herbst, Graz · Long Beach Museum of Art, Long Beach 1983 American Cultural Center, Paris · Internationaal Cultureel Centrum, Antwerpen · Whitney Museum of American Art, New York · Monte Video, Amsterdam 1985 Scan Gallery, Tokyo 1987 *Cinq pièces avec vue*, Centre Genevois de Gravure Contemporaine, Genève · Museum of Contemporary Art, Los Angeles · Los Angeles Contemporary Exhibitions, Los Angeles · Cornish College of the Arts, Seattle · 2nd Seminar on International Video, St. Gervais, Genève 1988 Western Front, Vancouver · Video Wochen, Basel · Elac Art Contemporain, Lyon 1989 Kijkhuis, Den Haag · Beursschouwburg, Bruxelles · Musée d'Art Moderne, Villeneuve d'Ascq (Kat.: J.-P. Fargier, G.

Quasha) · Pacific Film Archives, San Francisco 1990 *And Sat Down Beside Her*, Galerie des Archives, Paris (Kat.: R. Mittenthal) · *Other Word Sand Images*, Video Galleriet, Huset Galleri, Glyptoteket (Kat.: A. Dorph Christoffersen, P. Borum, R. Bellour, G. Hill) · Galerie Baudoin Lebon, Paris 1991 *Core Series*, Galerie des Archives, Paris · *Between Cinema and a Hard Place*, OCO, Espace d'Art Contemporain, Paris

Gruppenausstellungen | Group exhibitions

1987 *documenta 8*, Kassel · *L'époque, la mode, la morale, la passion*, Centre Georges Pompidou, Paris · *Mediated Narratives*, Institute of Contemporary Art, Boston · *Video Discourse: Mediated Narratives*, La Jolla Museum of Contemporary Art, San Diego · *Avenues of Thought: Cultural and Spiritual Abstractions in Video*, Rutgers University, Newark · *The Situated Image*, Mandeville Gallery, University of California at San Diego · *15th Avenue Studio 2: The Mechanics of Contemplations*, Henry Art Gallery, University of Washington, Seattle · *The Arts for Television*, Museum of Contemporary Art, Los Angeles/Stedelijk Museum, Amsterdam · *Computers and Art*, Everson Museum of Art · *Infermental VI*, Western Front, Vancouver 1988 *Infermental VII*, Buffalo · *Degrees of Reality*, Long Beach Museum of Art, Long Beach · *Art Video American*, Credac, Paris · *As Told To*, Walter Philip Galleria, Banff, Alberta · *4th International Manifestation of Video and TV*, Montbéliard · *London Film Festival*, London · *The World Wide Video Festival 3*, Kijkhuis, Den Haag · *3. Videonale*, Bonn 1989 *Biennial Exhibition*, Whitney Museum of American Art, New York · *Video-Skulptur retrospektiv und aktuell 1963–1989*, Kölnischer Kunstverein, Köln 1990 *Passage de l'image*, Centre Georges Pompidou, Paris · *Energieën*, Stedelijk Museum, Amsterdam

Bibliographie | Bibliography

Periodika | Periodicals
Robert Mittenthal, *Between Seeing and Being Seen. Video Event: Gary Hill's Catastrophe*, in: Reflex, Nr. 6, November/Dezember, 1989

Video
1973 *The Fall*, 11 Min., (s/w) 1974 *Air raid*, 6 Min. (s/w) · 1975/75 *Rock City Road*, 12 Min. · 1975 *Earth Pulse*, 6 Min. · 1976 *Improvisations with Bluestone*, 6:00 Min. · *Mirror Road*, 6 Min. 1977 *Bathing*, 4:25 Min. 1978 *Windows*, 8 Min. · *Electronic Linguistics*, 3:45 Min. (s/w) · *Sums & Differences*, 8 Min. (s/w) · *Mouth Piece*, 1 Min. · *Full Circle*, 3:25 Min. · *Primary*, 1:40 Min. · *Elements*, 2 Min. (s/w) 1979 *Objects with Destinations*, 3:40 Min. · *Equal Time*, 4:00 · *Picture Story*, 7 Min. · *Soundings*, 17 Min 1980 *Processual Video*, 11:30 Min. (s/w) · *Schwarz/Weiß/Text*, 7 Min. (s/w) · *Commentary*, 0:40 Min. · *Around & About*, 4:45 Min. · *Videograms*, 13:25 Min. (s/w) · 1982 *Happenstance (part one of many parts)*, 6:30 Min. (s/w) 1984 *Why Do Things Get in an Muddle? (Come on Petunia)*, 32 Min. 1985 *Tale Enclosure*, 5:30 Min. · *URA Aru (The backside exists)*, 28 Min. 1986 *Meditations*, 4:45 Min. 1987/88 *Incidence of Catastrophe*, 43:51 Min. 1989 *Site Recite (a Prologue)*, 4 Min.

PETER HOPKINS

*1952
Lebt/Lives in Stamford/Connecticut

Einzelausstellungen | One-man exhibitions

1982 ARC/Raw Space, Chicago 1986 American Fine Arts, Co., New York 1987 American Fine Arts, Co., New York 1988 American Fine Arts, Co., New York 1989 American Fine Arts, Co., New York 1990 Galerie Ryszard Varisella, Frankfurt/M. 1991 Marc Jancou Galerie, Zürich · American Fine Arts, Co., New York · Palm Beach Community College Projects Gallery, Museum of Art, Palm Beach, Florida 1992 Galerie Sophia Ungers, Köln · Patrick De Brock, Antwerpen

Gruppenausstellungen | Group exhibitions

1987 *True Pictures*, John Good Gallery, New York · American Fine Arts, Co., New York · *The Art of the Real*, Galerie Pierre Huber, Genève 1988 Craigh Cornelius Gallery, New York · *Coup de Coeur*, Galerie Pierre Huber, Genève · *Primary Structures*, Galerie Gilbert Brownstone, Paris · *Photomannerism*, Lawrence Oliver Gallery, Philadelphia 1989 *Chaos*, Chicago · *Buena Vista*, John Gibson Gallery, New York 1990 *The (Un) Making of Nature*, Whitney Museum Downtown, New York · Galerie Tanja Grunert, Köln 1991 *Bildlicht. Malerei zwischen Material und Immaterialität*, Museum Moderner Kunst, Wien · *Gullivers Reisen*, Galerie Sophia Ungers, Köln 1992 *Für die Galerie-Dealing with Art*, Künstlerwerkstatt Lothringerstraße, München

Bibliographie | Bibliography

Periodika | Periodicals
Brooks Adams, *Shock of the Mundane*, in: Vogue, März, 1990 · Joshua Decter, *(Review)*, in: Flash Art, Januar/Februar, 1992 · Kirby Gookin, *Peter Hopkins*, in: Artforum, Februar, 1990 · Paula Marincola, *Photomannerism*, in: Artforum, Februar, 1988 · Robert Nickas, *Entropy and the New Objects*, in: El Paseante, Oktober, 1988 · Klaus Ottmann, in: Bijutsu-Techno, Oktober, 1987 · Klaus Ottmann, *Photomannerism*, in: Flash Art, Oktober, 1987 · Klaus Ottmann, *True Pictures*, in: Flash Art, Februar/März · Sabine Vogel, *(Review)*, in: Artscribe, September/Oktober, 1990 · Mathew Welnstein, *(Review)*, in: Artforum, Januar, 1992 · John Zinsser, *Peter Hopkins at American Fine Arts*, in: Art in America, Februar, 1990

REBECCA HORN

*Michelstadt (D), 1944
Lebt/Lives in Bad König/Berlin

Einzelausstellungen | One-man exhibitions

1972 *Performance, vidéo et dessins,* Galerie René Block, Berlin · Kunstverein, Hannover 1974 *Projekt 74,* Kunsthalle/Kunstverein, Köln 1975 Galerie Nächst St. Stephan, Wien (Kat.) · Saman Galleria, Genova · Anthology Fim Archives, New York · Kunstverein, Hamburg · Biennale, Paris · Berliner, Berlin Festwochen 1976 René Block Gallery, New York (Kat.) · *Paradieswitwe,* Publikation des gleichmaliges Buch Paradieswitwe, Saman Galleria, Genova · Galerie H, Graz (Kat.) 1977 *Travaux de 1968 à 1977 – Die Aktionobjekte in ihren Reisekoffern,* Kölnischer Kunstverein, Köln (Haus am Waldsee, Berlin) (Kat.: Z. Felix, M. Grüterich, R. H., L. R. Lippard) · *Die ungleichen Zwillinge,* Galleria Salvatore Ala, *Milano* · Kunsthalle, Baden-Baden (Kat.: R. H) 1978 *Der Eintänzer,* Kestner-Gesellschaft, Hannover (Kat.: R. H) · Saman Galleria, Genova · Salvatore Ala Gallery, New York · Kunstverein, Münster 1979 Stedelijk Van Abbemuseum, Eindhoven · Salvatore Ala Gallery, New York · Kunstverein, Münster · Kunstpreis der Böttcher-Strasse, Bremen 1980 Spoleto Festival, Spoleto · Forum Design, Linz 1981 *La Ferdinanda – Sonate für eine Medici-Villa,* Staatliche Kunsthalle, Baden-Baden (Kat.: R. H.) · Stedelijk Museum, Amsterdam · Saman Galleria, Genova 1982 Vereniging Aktuele Kunst Gewad, Gent · Galerie Hans Mayer – Denise René · Galerie Chantal Crousel (Projektion der Filme »Der Eintänzer«), Paris · Kestner-Gesellschaft, Hannover 1983 Galerie Eric Franck, Genève · Centre d'Art Contemporain, Genève (Kunsthaus Zürich, Zürich; John Hansard Gallery/University of Southampton, Soutampton;Serpentine Gallery, London; Museum of Contemporary Art, Chicago, 1984) (Kat.: B. Curiger, R. H., T. Stoos) · 1985 *The Golden Waterfall,* Galerie Eric Franck, Genève · *Promenades,* Parc Lullin, Genthod, Genève · Fiac, Galerie Eric Franck, Paris 1986 *The Gold Rush,* Marian Goodman Gallery, New York · Hayward Gallery, London · *Nuit et jour sur le dos du serpent à deux têtes,* Musée d'Art Moderne de la Ville, Paris (Kat.: S. Pagé, K. Schmidt, M. Mosebach) · *Wien-Fluss 86,* Wiener Secession, Wien 1987 *Rebecca Horn – Drucksache,* Galerie Konrad Fischer, Düsseldorf · *Zeichnungen Objekte,* Galerie Elisabeth Kaufmann, Zürich · *A Sculpture Show,* Marian Goodman, New York · *Nachtvuur,* Stichting De Appel, Amsterdam 1988 *Films et oeuvres,* Galerie Susan Wyss, Zürich · *An Art Circus,* Marian Goodman Gallery, New York · *A Rather Wild Flirtation,* Galerie de France, Paris 1989 Gemeentemuseum, Arnhem (Kat.) · Galerie Elisabeth Kaufmann, Basel · *Missing Full Moon,* Artsite Gallery, Bath (Kat.: L. Cooke) · Galerie Konrad Fischer, Düsseldorf 1990 *Diving through Buster's Bedroom,* Museum of Contemporary Art, Los Angeles (Kat.: G. Celant, B. W. Ferguson, R. H., E. A. T. Schmidt), Galerie Taché/mit Galerie Eric Franck, Genève, Barcelona · Gallery Marian Goodman, New York 1991 Galerie Franck + Schulte, Berlin · Galerie de France, Paris · Museum für Gegenwartkunst, Kunstmuseum, Basel · Galerie Elisabeth Kaufmann, Basel · Marian Goodman Gallery, New York 1992 Tate Gallery, London · Musée des Beaux-Arts, Nantes 1993 Guggenheim Museum, New York

Gruppenausstellungen | Group exhibitions

1987 *Skulptur Projekte Münster,* Westfälisches Landesmuseum, Münster · *Die Gleichzeitigkeit des Anderen,* Kunstmuseum, Bern · *Stations 3rd 100 Days of Contemporary Art,* Montréal · *Les Mécaniciens de l'Imaginaire,* La Cité des Sciences et de l'Industrie, La Villette, Paris · *Manierismus subjektiv,* Forum für aktuelle Kunst, Innsbruck · *Manierismus subjektiv,* Galerie Krinzinger, Wien · *Uit het oude Europa,* Stedelijk Museum, Amsterdam · *Reason and Emotion in Contemporary Art,* The Royal Scottish Academy, Edinburgh 1988 *The Multiple Object,* Fine Arts Planning Group, Boston · Bank of Boston Gallery, Boston · *Waterworks,* Toronto · Rosc '88, Dublin · St. Louis Museum, St. Louis · Galerie Elisabeth Kaufmann, Zürich · *Scultures da Camera,* Galleria Bonomo, Bari · *Sculture da Camera,* Contemporary Art Museum, Utrecht · *Sculture da Camera,* Festival of the Two Worlds, Spoleto · *Sculture da Camera,* Desde Foundation, Athinai · The Carnegie Museum of Art, Pittsburgh · Galerie de France, Paris · Marian Goodman Gallery, New York 1989 *Acquisitations 1989,* Fonds National d'Art Contemporain, Centre National des Arts Plastiques, Paris · *Electricity in Art,* Mayor Rowan Gallery, London · Galerie Elisabeth Kaufmann, Basel · *Blickpunkte,* Musée d'Art Contemporain, Montréal · Marian Goodman Gallery, New York · *Departures: Photography 1924 – 1989,* Hirschl & Adler, New York 1990 *The Readymade Boomerang,* Biennale of Sydney, Art Gallery of New South Wales, Sydney · *Territory of Desire,* Louvre Gallery, New York · Galerie Silia Menzel, Berlin · Marian Goodman Gallery, New York · Centre d'Art du Domaine de Kerguéhennec, Bignan · Dany Keller Galerie, München · *Die Endlichkeit der Freiheit,* Berlin · Galerie Sophia Ungers, Köln · Anthony Reynolds Gallery, London · Vrej Baghoomian Gallery, New York 1991 *Arte & Arte,* Castello di Rivoli, Rivoli (Torino) · Pascal de Sarthe Gallery, Los Angeles · Marian Goodman Gallery, Los Angeles · Galeria Weber, Alexander Y Cobo, Madrid · Josh Baer Gallery, New York

Bibliographie | Bibliography

Texte von der Künstlerin
Texts by the artist
Dialogo della Vedova Paradisiaca, Genova, Samanedizioni, 1976 · *Reflections from the innermost-earth to the outermost-constellations: a project for Artforum by Rebecca Horn,* in: Artforum, Nr. 7, März, 1988 · *Rebecca Horn Buster's Bedroom,* Zürich, Parkett Publishers, 1991

Bücher | Books
Baum **Timothy,** *Rebeccabook I,* New York, Nadada, 1976

Periodika | Periodicals
Anne **Bendheim,** *Rebecca Horn,* in: The Contemporary, Nr. 2, Sommer, 1990 · Nicolas **Bourriaud,** *Les machines malade de Rebecca Horn,* in: Artstudio, Nr. 22, Herbst, 1991 · Dan **Cameron,** *Horn's dilemma: the art of Rebecca Horn,* in: Arts Magazine, Nr. 3, November, 1987 · Bice **Curiger,** *Gentle transference,* in: Parkett, Nr. 13, August, 1987 · Demosthenes **Davvetas,** *The bird in Rebecca's Horn's work,* in: Parkett, Nr. 13, August, 1987 · Mary Ellen **Haus,** *Rebecca Horn,* in: Tema Celeste, Nr. 19, Januar/März, 1989 · Renate **Puvogel,** *Ohne Titel,* in: Parkett, Nr. 15, Februar, 1988 · Daniel **Soutif,** *Trickery and display,* in: Parkett, Nr. 13, August, 1987

Film
1970 *Einhorn,* 12 Min., Super 8 mm, Farbe 1971 *Schwarze Hörner,* 15 Min., Super 8 mm · *Körperfarbe* (Malaktionen), Super 8 mm · *Mata Hari,* weisz 1/weisz 2/Yoni/ schwarz 1/schwarz 2 · 1972 *Performances 1,* 16 mm, 22 Min. 1973 *Performances 2,* 16 mm, 45 Min., Sound 1974 *Flamingos* (nicht beendet) · Berlin (10.110.1974 – 28.1.1975) – Übungen in neuen Stücken – *Unter dem Wasser schlafen und Dinge sehen, die sich weiter Ferne abspielen,* 16 mm, 40 Min., Sound 1975 *Paradieswitwe,* 16 mm, Sound 1976 *Die Chinesische Verlobte,* New York, 16 mm, Ton, Farbe 1978 *Der Eintänzer,* New York, 16 mm, Farbe, 45 Min. 1978 *Der Eintänzer,* New York, 16 mm, farbe, 45 Min. (Drehbuch: R.H.) 1981 *La Ferdinanda – Sonate für eine Medici-Villa,* Artimino, 35 mm, Farbe, 90 Min.

Video
1972 *Conversation 1,* New York, 1/1 Zoll, s/ w, 30 Min., *Conversation 2, Conversation 3 · Transformation,* New York, 1/2 Zoll, s/w, 30 Min. 1973 *Exercices,* New York, 1/2 Zoll, s/w, 30 Min. · *Bleistiftmaske,* Hamburg, 1/2 Zoll, s/w, · *Performances,* Hamburg, 3/4 Zoll, s/w, 30 Min. 1974 *Mit beiden Händen gleichzeitig die Wände berühren,* Blinzeln, 3/4 Zoll, s/w, 30 Min. · *Zwischen den feuchten Zungenblättern,* 3/4, s/w, 30 Min. · *Mit zwei Scheren gleichzeitig Haare schneiden,* 3/4 Zoll, s/w, 30 Min. · *Berlin– übungen in neun Stücken,* 3/4 Zoll, s/w, 40 Min. 1975 Video-Installation mit zwei Bändern: *Paradieswitwe 1, Paradieswitwe 2,* 3/4 Zoll, Farbe, 30 Min. 1976 *Die Chinesische Verlobte,* New York, 3/4 Zoll, s/w, 30 Min. · *übung zu: Der Eintänzer,* New York, 3/4 Zoll, s/w, 30 Min.

RONI HORN

*New York (USA), 1955
Lebt/Lives in New York

Einzelausstellungen | One-man exhibitions

1975 Brown University, Providence 1978 bYale University, New Haven 1980 Kunstraum, München (Kat.: H. Kern) · Clocktower, Institute for Art and Urban Resources, New York (Kat.) 1983 Glyptothek Museum, München · Kunstforum, Lenbachhaus Museum, München · Kunstraum, München (Kat.: B. Hammann, L. Horn, H. Friedel) 1984 Galerie Heinz Herzer, München 1985 Burnett Miller Gallery, Los Angeles 1986 Galerie Maeght Lelong, New York · Neuberger Museum, Purchase · Burnett Miller Gallery, Los Angeles 1987 Galerie Maeght Lelong, New York · Galerie Maeght Lelong, Paris 1988 Winston Gallery, Washington · Galerie Lelong, New York/Paris (Kat.: J. Gilbert-Rolfe) · Germans Van Eck, New York · Detroit Institute of Arts, Detroit · Susanne Hilberry, Birmingham · Mario Diacono Gallery, Boston (Kat.: M. Diacono) · Chinati Foundation, Marfa · 1989 Jay Gorney Modern Art, New York · Galerie Annemarie Verna, Zürich · Paula Cooper Gallery, New York 1990 Leo Castelli Gallery, New York · Museum of Contemporary Art, Los Angeles (Kat.: K. Kerstess) · Margo Leavin Gallery, Los Angeles · Paula Cooper Gallery, New York 1991 Westfälischer Kunstverein, Münster (Städtisches Museum Abteiberg Mönchengladbach) 1992 Jablonka Galerie, Köln (Kat.: R. H. Fuchs, H. Kersting)

Gruppenausstellungen | Group exhibitions

1987 Galerie Maeght Lelong, New York · Thomas Segal Gallery, Boston · Similia-Dissimilia, Columbia University, New York (et al.) · Lead, Hirsch and Adler Moder, New York (et al.) 1988 Susanne Hilberry Gallery, Detroit · Zola Lieberman Galllery, Chicago III · The Inscribed Image, Lang-O'Hara Gallery, New York · AVA, Los Angeles County Museum of Art, Los Angeles (et al.) · Works on Paper, Pamela Auchincloss Gallery, New York 1989 Prospect 89, Frankfurter Kunstverein, Frankfurt/M. · Nonrepresentation, Anne Plumb Gallery, New York · Prospect 89, Kunstverein, Frankfurt/M. 1990 Annemarie Verna Gallery, Zürich · Sculptor's Drawings, Baltimore Museum of Fine Arts, Baltimore · Lead and Wax, Stepehen Wirtz Gallery, San Francisco · The Children's AIDS Project, Daniel Weinberg Gallery, Los Angeles 1992 RubinSpangle Gallery, New York

Bibliographie | Bibliography

Bücher von der Künstlerin
Books by the artist
Bluff Life, Vol. I of To Place, New York, Peter Blum Ed., 1990

Periodika | Periodicals
Kenneth Baker, The Atomized Self, in: Art Coast (Santa Monica), März/April, 1989 · Kenneth Baker, Physical Precision : Notes On Some Recent Sculpture, in: Artspace, September/Oktober, 1990 · Jeremy Gilbert-Rolfe, Non-Representation in 1988: Meaning-Production Beyond the Scope of the Pious, in: Artforum, Mai, 1988 · Jeremy Gilbert-Rolfe, Roni Horn: pair objects I, II, III, in: Repères, Nr. 43, 1988 · Jeremy Gilbert-Rolfe, The Current State of Non-Representation, in: Visions, Art Quarterly (Los Angeles), Frühjahr, 1989 · Kirby Gookin, (Review), in: Artforum, Mai, 1988 · Ken Johnson, (Review), in: Art in America, April, 1989 · Kim Levin, Choices, in: Village Voice, 23. Februar, 1988 · Friedhelm Mennekes, New York, New York, in: Kunst und Kirche, Nr. 4, 1987 · Stuart Morgan, (Review), in: Arts Magazine, Mai, 1987 · Chuch Nicholson, A Magical Sense of Place, in: Artweek, Mai, 1990 · Meg O'Rourke, The Weight of the World, in: Arts Magazine, November 1991 · Stephan Schmidt-Wulffen, Similia/Dissimilia, in: Flash Art, November/Dezember, 1987 · Buzz Spector, Roni Horn, in: Art Issues, Nr. 13, September/Oktober, 1990

GEOFFREY JAMES

*St. Asaph, Clwyd/Wales (GB), 1942
Lebt/Lives in Montréal

Einzelausstellungen | One-man exhibitions

1971 Sir George Williams University, Montréal 1975 Yajima/Galerie, Montréal 1978 Yajima/Galerie, Montréal 1981 Photograph Gallery, New York 1982 Yajima/Galerie, Montréal 1983 Yarlow-Salzman Gallery, Toronto · Panoramic Photographs, Nova Scotia College of Art and Design, Halifax 1984 Entrances and Exits, Queen's University, Kingston 1985 I Giardini Italiani, Palazzo Braschi, Roma (Kat.: I. Pizzetti) · Centre International de Recherche, de Création et d'Animation, Villeneuve-les-Avignon · Italian Gardens, University of Kent, Canterbury 1986 Landscape with Ruins, Royal Institute of British Architects, Heinz Gallery, London (Kat.: J. Harris, G.J.) · Coburg Gallery, Vancouver · University of palermo · Genius Loci, Canadian Museum of Contemporary Photography (The Graham Foundation for Advanced Studies in the Fine Arts, Chicago; The Edmonton Art Gallery, The Greater Victoria Art Gallery, the School of Architecture; University of Texas, Houston; the Norman Mackenzie Art Gallery, Regina) (Kat.: M. Langford) 1987 Galerie René Blouin, Montréal 1988 Italian Journeys, Twining Gallery, New York 1989 Equiniox Gallery, Vancouver 1990 Galerie René Blouin, Montréal · Equinox Gallery, Vancouver · Verticale, Québec City

Gruppenausstellungen | Group exhibitions

1987 Clasical Concerns, Twining Gallery, New York · Elementa Naturae, Musée d'Art Contemporain, Montréal · Divers Secrecies, Presentation House, Vancouver · Toronto, Le Nouveau, Nouveau Monde, Maison de L'Architecture, Paris (et al.) 1988 Jan Turner Gallery, Los Angeles 1989 Twining Gallery, New York · Contemporary Canadian Photography, Budapest · Anamnese, Dazibo, Montréal 1990 Works for the Garden, Blum Helman Gallery, Los Angeles · The Shaping of Nature, Oakville Galleries, Oakville 1991 Galerie René Blouin, Montréal · Corriger Les Lieux, Dazibo, Montréal · Archipels de Désir, Musée du Québec

Bibliographie | Bibliography

Texte und Bücher vom Künstler
Texts and books by the artist
in : Kat. Transparent Things, The Artist's Use of the Photograph, Can. Council Art Bank, 1975 · in: Kat. Entrance & Exits Legacy, The Garden as Theatre, Agnes Etherington Art Centre, Queen's University, Kingston, 1984 · Morbid Symptoms, Princeton, Princeton Architectural Press, 1986, in: Kat. Toronto, Le Nouveau, Nouveau Monde, Maison de L'Architecture, Paris, 1989 · La Campagna Romana, Montréal, Ed. René Blouin, 1991 · Introduction, in: 13 Essays on Photography, Ottawa, Canadian Museum of Contemporary Photography, 1991 · Afterword, in: The Italian Garden, New York, Harry N. Adams, 1991

Periodika | Periodicals
Peggy Gale, Morbid Symptoms & Genius Loci, in: Canadian Art, Sommer, 1987 · Monique Mosser, Geoffrey James: de l'esprit des lieux, in: Beaux-Arts, Mai, 1988 · Petra Rigby Watson, (Review), in: C Magazine, Winter, 1991

OLAV CHRISTOPHER JENSSEN

*Sortland (N), 1954
Lebt/Lives in Berlin

Einzelausstellungen | One-man exhibitions

1979 Galleriet, Oslo 1980 Galleri 1, Bergen 1983 Hammarlunds Kunsthandel, Oslo 1984 Galleri Cassandra, Drobak · 1985 Demoralisert landskap, Galleri Riis, Oslo (Kat.: S. Andersen, S. Wyller) 1987 Galleri 16 (Galleri Lars Bohman), Stockholm · Tegninger, Galleri Riis, Oslo 1988 Galerie Artek, Helsinki · Galerie Dörrie & Priess, Hamburg · Ventetid/Wartezeit, Galleri Riis, Oslo (Kat.: S. Andersen, S. Gudmundsson) 1989 Anders Tornberg Gallery, Lund · Grafiske, Galleri Riis, Oslo 1990 Galleri Riis, Oslo (Kat.: S. Andersen, D. v. Drateln, E. Kittelsen) · Galleri Eklund, Umeä · Galleri Lars Bohman, Stockholm 1991 Galerie Dörrie & Priess, Hamburg · Galleri Artek, Helsinki

Gruppenausstellungen | Group exhibitions

1987 *Borealis III,* Malmö Konsthall, Malmö 1988 *8 fra Norge,* Henie-Onstadt Kunstsenter, Oslo · *5 nordiske temperament,* Rooseum, Malmö 1989 *Det gronne morke,* Nordisk Kunstsentrum, Helsinki 1990 *Northlands,* Museum of Modern Art, Oxford (et al.) · Trinity College, Dublin 1991 *Blue Transparency,* Moderna Museet, Stockholm (et al.) · *Arbeiten auf Papier,* Dörrie & Priess Galerie, Hamburg

Bibliographie | Bibliography

Bücher vom Künstler | Books by the artist
Olav Christopher Jenssen. Episodes. An essay and a selection of drawings by Gertrud Sandqvist, Münster, Ed. Holger Priess, Ulrich Dörrie, Kleinheinrich Verlag, 1991

Periodika | Periodicals
Altii Kuusamo, *En tunne maisemiani,* in: Taide, Nr. 4, 1988 · Gertrud Sandqvist, *Scandinavia on the edge between twilight and minimalism,* in: Art News, September, 1989 · Gertrud Sanqvist, *Olav Christopher Jenssen (Galleri Lars Bohman),* in: Tema Celeste, Juli/Oktober, 1990 · Asmund Thorkildsen, *Norway-Some prsonality – few trends,* in: Flash Art, März/April, 1991

TIM JOHNSON

*Sydney (AUS), 1947
Lebt/Lives in Sydney

Einzelausstellungen | One-man exhibitions

1970 *Off the Wall,* Gallery A, Sydney 1971 *Installation as Conceptual Scheme,* Inhibodress, Sydney 1972 *Diary, Voyeur, Fittings, Disclosures, etc.,* Pinacotheca, Melbourne 1973 University of Queensland, Brisbane 1974 Gallery A, Sydney 1976 Erskine Street Gallery, Sydney 1977 Gallery A, Sydney 1979 Mori Gallery, Sydney 1982 *Wheel of Life,* Mori Gallery, Sydney 1984 *The Drunken Boat,* Mori Gallery, Sydney (Kat.) 1985 *Co-ordinates,* Mori Gallery, Sydney · *Conceptual Painting,* Union Street Gallery, Sydney 1986 *Esoteric Landscape,* Mori Gallery, Sydney · *Languish,* Institute of Modern Art, Brisbane 1987 *Papunya Revisted,* Bellas Gallery, Brisbane · Tolarno Gal-

leries, Melbourne · Mori Gallery, Sydney 1988 Bellas Gallery, Brisbane · Pomeroy Gallery, London · Mori Gallery, Sydney 1989 Bellas Gallery, Brisbane · Tolarno Galleries, Melbourne 1990 Mori Gallery, Sydney · Bellas Gallery, Brisbane 1991 Tolarno Galleries, Melbourne · Chapman Gallery, Canberra · *Armageddon,* Mori Gallery, Sydney 1992 Bellas Gallery, Brisbane

Gruppenausstellungen | Group exhibitions

1987 *Shadow of Reason,* Institute of Modern Art, Brisbane · *Young Australians,* National Gallery of Victoria, Melbourne · *A New Romance,* Drill Hall, Australian National Gallery, Canberra · *In Print Vol 1 Artist Books,* Power Gallery, University of Sydney, Sydney 1988 *Stories of Australian Art,* Commonwealth Institute, London · *Creating Australia: 200 Years of Art 1788–1988,* State Galleries · *A Changing Relationship,* S.H. Ervin Gallery, Sydney · *Contemporary Australian Art to China 1988–89,* Beijing (et al.) · *The Caddy Collection,* Watters Gallery, Sydney · *Prints by Twenty-Five Australian Artists,* Australian National Gallery, Canberra · *Covering the Ground,* Contemporary Art Space Gallery, Adelaide 1989 *Inhibodress 1970–1971,* Institute of Modern Art, Brisbane (et al.) · *Cosmos,* City Gallery, Melbourne · *Sets and Series: Recent Australian Prints from the Collection,* National Gallery of Victoria, Melbourne · *Red,* Mori Gallery, Sydney 1990 *Paraculture,* Artists Space, New York · *Art Frankfurt,* Frankfurt/M. · *Out of Asia,* Heide Gallery, Melbourne/ Regional Galleries · *Architecture of Light,* Mori Gallery, Sydney · *L'été Australian à Montpelier,* Montpelier · *Balance,* Queensland Art Gallery, Brisbane · Art Dock, Nouema, New Caledonia 1991 Chicago Art Fair, Chicago · *Artists Make Books,* Linden Gallery, Melbourne · *Off the Wall,* Monash University, Melbourne · *Rivers,* Australian Centre for Contemporary Art, Melbourne · *Microcosm,* Gary Anderson Gallery, Sydney · *Via Crucis,* Mori Annexe, Sydney · *Multiples,* Museum of Contemporary Art, Sydney · *Steam,* Perpecta Satellite Exhibition, The Rocks, Sydney

Bibliographie | Bibliography

Texte vom Künstler | Texts by the artist
Papunya Tula: Aboriginal Art of the Western Desert, Sydney, Macquarie University, 1980 · *John Nixon Art Notes,* Tension, 1980 · *Aboriginal Land Rights Exhibition,* Sydney, Paddingtion Town Hall, 1981 · *The Papunya Painters,* in: Express, Us and European Edition, 1984 · *Koori Art '84,* Artspace, Sydney, 1984 · *Chance Technology,* in: On The Beach (Sydney), Nr. 7/8, 1985

· *An Impossible Vision,* in: On The Beach (Sydney), Nr. 9 , 1985 · *Theoretical Force,* Biennale of Sydney, 1986 · *Travel Songs,* in: Tension (Melbourne), Nr. 9, 1986 · *Space,* in: Third Degree (Sydney), Nr. 3, 1986 · *Tim Johnson,* in: On The beach (Sydney), Nr. 11? 1987 · *Paying the Rent,* in: Stories of Australian Art, London, 1988

Bücher vom Künstler | Books by the artist
Cambridge to London, Sydney, Tim Johnson, 1970 · *Spare Parts,* Sydney, Tim Johnson, 1971 · *Fittings,* Sydney, Tim Johnson, 1971 · Tim Johnson & Vivien Johnson, *Text for out of the Gallery Installation as Conceptual Scheme,* Sydney, Tim Johnson, 1971 · *Public Fitting,* Sydney, Tim Johnson, 1972 · *Disclosure,* Sydney, Tim Johnson, 1972 · *Be an Artist,* Sydney, Tim Johnson, 1973 · *Schooltime,* Sydney, Tim Johnson, 1973 · *Coincidence,* Sydney, Tim Johnson, 1974 · *Alienation,* Sydney, Tim Johnson, 1976 · *You,* Sydney, Tim Johnson, 1976 · *Be an Artist,* Sydney, Tim Johnson, 1976 · *E.S.P.,* Adelaide, Experimental Art Foundation, 1976 · *Notes on Painting,* Sydney, Tim Johnson, 1977 · *The Drunken Boat,* Sydney, Mori Gallery, 1983 · *Electric Tribal,* Sydney, Tim Johnson, 1984 · *Songs 1985,* Sydney, Tim Johnson, 1985

ILYA KABAKOV

*Dnjepropetrowsk (CIS), 1933
Lebt/Lives in New York

Einzelausstellungen | One-man exhibitions

1985 Galerie Dina Vierny, Paris · *Am Rande,* Kunsthalle, Bern (Kat.: B. Groys, I. K., J. Martin) · Galerie Dina Vierny, Paris 1988 *Vor dem Abendessen,* Grazer Kunstverein, Graz (Kat.: I. K.) 1989 *10 Personen (Zimmer),* Institute of Contemporary Arts, London · *10 Characters,* Ronald Feldman Fine Arts, New York (Kat.) · *Who are These Little Men?,* Institute of Contemporary Art, Philadelphia · *Ten Characters,* Riverside Studios, London · *Das Schiff – Die Kommunalwohnung,* Kunsthalle, Zürich · *Ausstellung eines Buches,* Daadgalerie, Berlin (Kat.: B. Groys) · Stichting De Appel, Amsterdam · *Before Supper,* Kunstverein, Graz (Kat.) · Neue Galerie, Schloß Gotzental · *10 Characters,* Portikus, Frankfurt/M. (Kat.) · *Who Are These Little Men?,* Gallerie de France, Paris (Kat.) 1990 *7 Ausstellungen eines Bildes,* Kasseler Kunstverein, Kassel (Kat.: B. Groys, I. K.) · *The Ship, An Installation,* Neue Galerie, Museum Ludwig, Aachen · *Four Cities Project,* Orchard Gallery, Derry (Kat.) · *Rhetorical Image,* The New Museum of Contemporary Art, New York · *Selection from Ten Characters,* Hirshhorn Museum, Washington DC (Kat.) · *He Lost His Mind, Undressed, Ran, Away, Naked,* Ronald Feldman Fine Arts, New York (Kat.) 1991 *Die Zielscheiben,* Galerie Peter Pakesch, Wien · *Meine Heimat (Die Fliegen),* Wewerka & Weiss Galerie, Berlin (Kat.) · Sezon Museum of Modern Art, Nagano · *I. K., Yuri Kuper,* Ateliers Municipaux d'Artistes, Marseille/La Criée, Halle d'Art Contemporain, Rennes (Kat.) · *I. K., John Scott,* The Power Plant, Toronto 1992 *Das Leben der Fliegen,* Kölnischer Kunstverein, Köln (Kat.: B. Groys, I. K.)

Gruppenausstellungen | Group exhibitions

1987 *Der Künstler und die Gegenwart*, Ausstellungsräume an der Kaschirkoje-Chaussee, Moskva · *Das Objekt I*, Malaja Grusinskaja, Moskva · *Wohnstätte*, Vereinigung Eremitage, Moskva · *Direct from Moscow!*, Phyllis Kind Gallery, New York · *Gegenwartkunst aus der Sowjetunion: Ilya Kabakov und Iwan Tschuikow*, Museum für Gegenwartkunst, Basel · *Fiac '88*, Galerie de France, Paris **1988** *Ich lebe – Ich sehe, Künstler der achtziger Jahre in Moskva*, Kunstmuseum, Bern · *Russian Avantgarde and Soviet Contemporary Art*, Sotheby's Auktion, Moskva · *Erik Bulatov, Wladimir Jankilewskij, Ilya Kabakov und Oleg Wasiljew*, Kupferstichkabinett, Staatliche Kunstsammlung, Dresden · *Sowjetkunstheute*, Museum Ludwig, Köln **1989** *Behind the Ironic Curtain*, Phyllis Kind Gallery, New York · *The Green Show*, Exit Art, New York (et al.) · *Le Bateau*, Elac, Art Contemporain, Lyon · *Kosuth's Show*, Freud House, Wien · *The Beautiful '60's in Moscow*, The Genia Schreiber University Art Gallery, Tel-Aviv University, Tel-Aviv · *Les Magiciens de la Terre*, Centre Georges Pompidou, Paris · *Post Utopia: Painting and Installations by Soviet Conceptualists: Bulatov, Kabakov, Komar & Melamid*, S.E. Massachusetts University, N. Dartmouth **1990** *Rhetorical Image*, The New Museum, New York · *Works on Hanji Paper*, Seoul Art Festival, Seoul · *The Green Show*, The Dunlop Art Gallery, Regina · *The Quest for Self Expression: Painting in Moscow and Leningrad 1965–1990*, Columbus Museum of Art, Columbus (et al.) · *In the U.S.S.R. and Beyond*, Stedelijk Museum, Amsterdam · *At Last Freedom*, Daadgalerie, Berlin · *Particular Histories*, Ronald Feldman Fine Arts, Moskva · *Soviet Contemporary Art 1990*, Alpha Cubic Gallery, Tokyo · *Between Spring and Summer: Soviet Conceptual Art in the Era of late Communism* (et al.) · *Adaption & Negation of Socialist Realism*, Aldrich Museum of Contemporary Art, Ridgefield · *The Readymade Boomerang*, Biennale of Sydney, Art Gallery of New South Wales, Sydney · *Soviet Art*, Museo d'Arte Contemporanea Luigi Pecci, Prato **1991** *Kunst Europa (Sowjetunion)*, Kunstverein, Hannover (et al.) · *Trans/Mission*, Rooseum, Center for Contemporary Art, Malmö · *Sowjetische Kunst um 1990*, Städtische Kunsthalle, Düsseldorf (et al.) · *Dislocations*, Museum of Modern Art, New York · Ludwig Forum für Internationale Kunst, Aachen · *Soviet Contemporary Art. From Thaw to Perestroika*, Art Museum, Setagaya · *Wanderlieder*, Stedelijk Museum, Amsterdam · Art Fair, Montréal · *Schwerelos*, Große Orangerie im Schloß Charlottenburg, Berlin · *Zero Gravity*, Henry DeFord III Gallery, Long Island City · *Carnegie International*, Carnegie Museum of Art, Pittsburgh · *Fiac Art Fair*, Paris · *Devil on the Stairs: Looking back on the Eighties, Institute of Contemporary Art, Philadelphia* (et al.) · *Soviet Art Around 1990*, Israel Museum, Jerusalem · *In Public: Seattle 1991*, Security Pacific Gallery · *Biennial of Cetinje*, Cetinje · *Next Stop Tarakanovo*, Paris North Railroad Station, Paris · *Words without Thoughts Never to heaven Go*, Centraal Museum, Utrecht · *Night Lines*, Centraal Museum, Utrecht (outdoor) · *Paintings from the Bible*, The Bible Society, Frankfurt/M. (et al.) · *Perspectives of Conceptualism*, University of Hawaii Art Gallery, Honolulu (et al.) **1992** *Just Pathetic*, American Fine Arts, Co., New York · *EX USSR*, Groninger Museum, Groningen

Bibliographie | Bibliography

Bücher | Books

Boris **Groys**, *Ilya Kabakov, Die Kunst des Fliehens*, Wien/München, Carl Hanser Verlag, 1991

Periodika | Periodicals

Michael **Archer**, *Invisible Yearnings: The TSWA Four Cities Project*, in: Artscribe, Nr. 85, Januar/Februar, 1991 · Robert **Atkins**, *MoMA's New Man*, in: New Art Examiner, Nr. 7, März, 1991 · Jan **Avgikos**, *Vienna – Gift of the Artist, Bergasse 19.*, in: Artscribe, Januar/Februar, 1990 · Marius **Babias**, *Die Endlichkeit der Freiheit*, in: Kunstforum, Bd. 110, November/Dezember, 1990 · Godfrey **Barker**, *Grisha Who*, in: Art News, Nr. 7, September, 1988 · Francesco **Bonami**, *Dislocations – The Place of Installation*, in: Flash Art, Nr. 162, Januar/Februar, 1992 · Markus **Brüderlin**, *Ilya Kabakov: Gallery Pakesch*, in: Artforum, Nr. 10, Sommer, 1991 · James **Bustard**, *This Year's Carbegie International More International, More Self Aware, Less Doctrinaire*, in: The Art Newspaper, Nr. 10, Juli/September, 1991 · Diane **Calder**, *Between Spring and Summer*, in: High Performance, Nr. 53, Frühling, 1991 · Shaun **Caley**, *To Russia With Love*, in: Flash Art, November/Dezember, 1989 · K. **Carry**, *Ilya Kabakov*, in: Art and Auction, Nr. 7, Februar, 1987 · Robin **Cembalest**, *The Man Who Flew Into Space*, in: Artnews, Nr. 5, Mai, 1990 · Holland **Cotter**, *Dislocating the Modern*, in: Art in America, Bd. 80, Nr. 1, Januar, 1992 · Arthur **Danto**, *Dislocationary Art*, in: The Nation, Bd. 254, Nr. 1, Januar, 1992 · David **Deitcher**, *Art on The Installation Plan*, in: Artforum, Nr. 5, Januar, 1992 · Doris von **Drateln**, *Biennale de Venise 1988*, in: Galeries, Nr. 26, August/September, 1988 · Gretchen **Faust**, *Ilya Kabakov ›Ten Characters‹*, in: Nike Magazine, Juli/August, 1988 · Peter **Funken**, *Heimat*, in: Kunstforum, Bd. 103, Mai/Juni, 1991 · Jamey **Gambrell**, *Notes on the Underground*, in: Art in America, Nr. 11, November, 1988 · Jamey **Gambrell**, *Moscow Conceptualism*, in: Artics, Bd. 1, 1989 · Jamey **Gambrell**, *Perestroika Shock*, in: Art in America, Februar, 1989 · Jamey **Gambrell**, *Report from Moscow: The Perils of Perestroika*, in: Art in America, Nr. 3, März, 1990 · Jamey **Gambrell**, *Russian Art to Rutgers*, in: Art in America, Nr. 6, Juni, 1991 · Kirby **Gookin**, *Ilya Kabakov*, in: Artforum, Nr. 1, September, 1989 · Alex **Gregory**, *Sotheby's Goes to Moscow – Interview with Simon de Pury*, in: The Art Journal, Nr. 9, November, 1991 · Boris **Groys**, *Im Banne der Supermaschine: Die Künstler in Moskva und New York,* in: Durch (Graz), 1989 · Boris **Groys**, *Kunst und Widerstand im Sowjetreich*, in: Pan, Nr. 2, 1991 · James **Hall**, *Rooms with a View*, in: Arena, Frühling, 1989 · Howard **Hampton**, *Public Ennemies: Ronald Reagan Conquers the Martians*, in: Artforum, Bd. 29, Nr. 8, April, 1991 · Eleanor **Heartney**, *Ilya Kabakov at Ronald Feldman Fine Arts*, in: Art in America, Nr. 9, September, 1988 · Eleanor **Heartney**, *The Green Show*, in: Art in America, Nr. 3, März, 1990 · Eleanor **Heartney**, *Korea Opens the Door*, in: Art in America, Nr. 4, April, 1991 · Eleanor **Heartney**, *Reviews: Dislocations, MOMA*, in: Artnews, Nr. 1, Januar, 1992 · Elizabeth **Hess**, *White Cube Crumbling*, in: Village Voice, 5. November, 1991 · Memory **Holloway**, *New York: MoMA Moves to More Contemporary Pastures*, in: Art International, Frühling/Sommer, 1991 · Bill **Jeffries**, *Fast Forward*, in: Canadian Art, Nr. 3, Herbst, 1991 · Heinz-Norbert **Jocks**, *Sowjetische Kunst um 1900*, in: Kunstforum, Bd. 103, Mai/Juni, 1991 · Pat **McCoy**, *Ilya Kabakov*, in: Tema Celste, Nr. 17–18, Oktober/Dezember, 1988 · Claudia **Jolles**, Wiktor **Misiano**, *(interview)*, in: Flash Art, Nr. 137, November/Dezember, 1987 · Claudia **Jolles**, *Ilya Kabakov – Die Kraft der Erinnerung*, in: Kunst-Bulletin, Nr. 3, 1992 · Richard **Kostelanetz**, *Soviet Art Then and Today*, in: The Journal of Art, Bd. 3, Nr. 3, Dezember, 1990 · Ilse **Kuijken**, *Alle macht aan de vliegen*, in: Knack, 11. März, 1992 · Konstantin K. **Kuzminsky**, in: Art of Russia and the West, Nr. 1, März, 1989 · Kay **Larson**, *New York, Dislocations*, in: Galeries Magazine, Nr. 46, Dezember 1991/Januar 1992 · Innesa **Levkova-Lamm**, *Ilya Kabakov*, in: Contemporanea, Nr. 4, November/Dezember, 1988 · Kim **Levin**, *Choices*, in: Village Voice, 23. Januar, 1990 · Kim **Levin**, *Slouching Toward the Millenium*, in: Village Voice, 19. März, 1991 · Giorgij **Litichevsky**, Andrej **Royter**, *From Moscow*, in: Flash Art, Mai/Juni, 1988 · Victoria **Lyn**, *Sydney Biennale*, in: Arts Magazine, Nr. 2, Oktober, 1990 · Robert **Mahoney**, *The Green Show*, in: Flash Art, Nr. 151, März/April, 1990 · Paula **Marincola**, *Philadelphia Reviews*, in: Contemporanea, Nr. 4, April, 1990 · Pat **McCoy**, *Ilya Kabakov*, in: Arts Magazine, Bd. 64, Nr. 8, April, 1990 · Kathrin **Meier-Rust**, *Soz Art und Postmoderne*, in: Du, Nr. 8, 1988 · Johannes **Meinhardt**, *Malmö: Trans/Mission*, in: Artforum, Nr. 4, Dezember, 1991 · Viktor **Misiano**, *Moscow Letter*, in: Contemporanea, Nr. 24, Januar, 1991 · Stuart **Morgan**, *Kabakov's Albums*, in: Artscribe, Nr. 75, Mai, 1989 · Myroslava **Mudrak**, *Soviet Art Today: Vitality and Expression*, in: Artnews, Nr. 10, Dezember, 1990 · Lois **Nesbitt**, *Ilya Kabakov*, in: Artforum, Nr. 8, April, 1990 · Bojana **Pejic**, *Heimat*, in: Artforum, Nr. 10, Sommer, 1991 · Robert **Roos**, *A Sign in the Night*, in: Nike, Mai/April, 1991 · Meyer Raphael **Rubinstein**, *David Humphrey, Ilya Kabakov – ›David and Goliath‹*, in: etc. Montréal, Nr. 5, Herbst, 1988 · Peter **Schjeldahl**, *Art Trust*, in: The Village Voice, Nr. 38, 17. September, 1991 · Mira **Schor**, *You Can't Leave Home without It*, in: Artforum, Nr. 2, Oktober, 1991 · Harry **Schwalb**, *Reviews: Carnegie International*, in: Artnews, Nr. 1, Januar, 1992 · Henning **Sietz**, *The Market for Soviet Artists*, in: Contemporanea, Nr. 22, Dezember, 1990 · Owen **Smith**, *On Looking Through Western Eyes*, in: Reflex, Nr. 5, Juli/August, 1990 · Ingrid **Sommar**, *Postmodern Power Station*, in: Artnews, Nr. 8, Oktober, 1991 · s.n., *Kabakov at Wewerka*

and Weiss Gallery, in: Flash Art, Nr. 158, Mai/Juni, 1991 · Marie Thérèse Suermann, *Zu den Alben von Ilya Kabakov*, in: Nike, Nr. 24, Juli/August, 1988 · Ilyan Tsentsipert, *Brushing Up*, in: Moscow Magazine, Februar, 1990 · Margarita Tupitsyn, *From Sots Art to Sovart*, in: Flash Art, November/Dezember, 1988 · Victor Tupitsyn, *Ilya Kabakov*, in: Flash Art, Nr. 51, März/April, 1990 · Brigitte van der Sande, *Een alledaagse metafysicus*, in: De Appel, Nr. 2, 1990 · Angela Vetesse, *Eric Bulatov Ilya Kabakov*, in: Flash Art, Januar/Februar, 1988 · Giorgio Verzotti, *Doppel Jeopardy*, in: Artforum, Nr. 3, November, 1990 · Richard W. Walker, *Vasari Diary – Gavel Glasnost*, in: Art News, Sommer, 1988 · Richard W. Walker, *The making of a Market*, in: Art News, März, 1989 · Richard Woodward, *Vasari Diary – Other Pkaces, Other Rooms*, in: Art News, Nr. 7, September, 1988 · Jeff Wright, *Ilya Kabakov*, in: Cover, Nr. 2, Februar, 1990 · Thomas Wulffen, *The Old Guard and...*, in: Apollo, Januar, 1990

ANISH KAPOOR

* Bombay (IND), 1954
Lebt/Lives in London

Einzelausstellungen | One-man exhibitions

1980 Patrice Alexandre, Paris 1981 Coracle Press, London 1982 Lisson Gallery, London · Walker Art Gallery, Liverpool 1983 *Anish Kapoor. Beeldhouwwerken,* Galerie 't Venster, Rotterdam (Kat.: M. Newman) · *Feeling into form/Le sentiment de la forme, la forme du sentiment,* Walker Art Gallery, Liverpool/Le Nouveau Musée, Lyon (Kat.: M. Livingstone) · Lisson Gallery, London 1984 Barbara Gladstone Gallery, New York 1985 Lisson Gallery, London · Kunsthalle, Basel (Stedelijk Van Abbemuseum, Eindhoven) (Kat.: J.-C. Ammann, A. Coomaraswamy, A. von Grevenstein) 1986 Kunstnernes Hus, Oslo (Kat.: L. Cooke, A. Malmedal) · Barbara Gladstone Gallery, New York · Stedelijk Van Abbemuseum, Eindhoven · *Recent sculpture and drawings,* University Gallery, Fine Arts Center, University of Massachusetts, Amherst (Kat.: H. Posner) · Albright-Knox Gallery, Buffalo (Kat.: H. Raye) 1987 *Works on Paper 1975–1987,* Ray Hughes Gallery,

Sidney (MOMA, Brisbane) 1988 Lisson Gallery, London 1989 Barbara Gladstone Gallery, New York · Kohji Ogura Gallery, Nagoya (Kat.: P. L. Tazzi) · *Void Field,* Lisson Gallery, London 1990 *Biennale di Venezia* Kat.: M. Allthorpe-Guyton, T. McEvilly) · *Drawings,* Barbara Gladstone Gallery, New York · *Drawings,* The Tate Gallery, London (Kat.: J. Lewison) · Le Magasin, Grenoble 1991 Palacio de Velazquez, Madrid · Kunstverein, Hannover · IV Biennale, Ushimado · International Art Festival, Ushimado · 1992 San Diego Museum of Contemporary Art, San Diego (Des Moines Art Center, Des Moines, Iow; Museum of Contemporary Art, Chicago; The Power Plant, Toronto)

Gruppenausstellungen | Group exhibitions

1987 *Inside-Outside,* Museum van Hedendaagse Kunst, Antwerpen · *Juxtapositions: Recent Sculpture from England and Germany,* P.S. 1, New York · *British Art of the 1980's: 1987,* Liljevalchs Konstall, Stockholm (et. al.) 1987 *Similia – Dissimilia,* Kunsthalle, Düsseldorf (et. al.) 1988 *Europa oggi/Europe now,* Museo d'Arte Contemporanea Luigi Pecci, Prato · *La couleur seule,* Musée d'Art Contemporain, Lyon · *Britannica. 30 Ans de sculpture,* Musée des Beaux-Arts André Malraux, Le Havre (et. al.) · *Starlit Waters. British Sculpture 1968–88,* Tate Gallery, Liverpool · *Viewpoint,* British Art in the 1980s, British Council, Koninklijke Musea voor Schone Kunsten van België, Bruxelles · *Minos Beach Art Symposium,* Minos Beach Hotel, Crete · *Carnegie International,* Carnegie Museum of Art, Pittsburgh · *British Now: sculpture et autres dessin,* Musée d'Art Contemporain de Montréal 1989 *Britse sculptuur 1960/1988 British sculpture,* Museum van Hedendaagse Kunst, Antwerpen 1990 *Affinities and Intuitions,* Art Institute of Chicago, Chicago · *Dujourie, Fortuyn/O'Brien, Houshiary, Kapoor, Beelden van afwezigheid tekens van verlangen,* Rijksmuseum Kröller-Müller, Otterlo · *La Collezione 1988–90,* Museo d'Arte Contemporanea Luigi Pecci, Prato · *For a Wider World,* The British Council, London 1991 *Trans/Mission,* Rooseum, Center for Contemporary Art, Malmö · *British Art Now : A Subjective View,* The British Council, Setagaya Museum, Tokyo (et. al.) · *Made of Stone,* Galerie Isy Brachot, Bruxelles · Gallery Shirakawa, Kyoto · *Anish Kapoor & Ban Chiang,* Galerie Feuerle, Köln · *La Sculpture Contemporaine après 1970,* Fondation Daniel Templon, Fréjus · *Rhizome,* Gemeentemuseum, Den Haag

Bibliographie | Bibliography

Periodika | Periodicals
Marjorie Allthorpe-Guyton, *Anish Kapoor, Lisson Gallery,* in: Artforum, März, 1990 · Paul Bonaventura, *An introduction to recent British sculpture,* in: Artefactum, September/Oktober, 1987 · Doris von Drateln, *Ein Gespräch mit Anish Kapoor,* in: Kunstforum International, 1990 · Anish Kapoor, Sylvie Primard, Pier Luigi Tazzi, *Mother as a mountain,* in: Artforum, September, 1989 · David Lee, in: Arts Review, April, 1988 · Rupert Martin, *The Journey from an earthly to a Heavenly Body,* in: Flash Art, Sommer, 1988 · Ameena Mer, *Anish Kapoor,* in: BOMB, Nr. 30, Winter, 1989 · Caroline Mulders, *Anish Kapoor. Vers la dématéria-*

lisation de l'objet, in: Art Press, Nr. 152, November, 1990 · Akio Obigane, *Anish Kapoor,* in: Atelier, Nr. 755, Januar, 1990 · Paul Overy, *Lions & Unicorn: The Britishness of Postwar British Sculpture,* in: Art in America, Nr. 9, September, 1991 · Andrew Renton, *Anish Kapoor, Lisson,* in: Flash Art, Nr. 151, März, 1990 · s.n., *Anish Kapoor,* in: Lapiz, Nr. 42, 1987 · s.n., *XLIV Venice Biennale 1990,* in: Visual Arts News, The British Council, Nr. 31, Januar, 1990 · Justin Spring, *Anish Kapoor, Barbara Gladstone Gallery,* in: Artforum, Dezember, 1990 · Stéphanie du Tan, *Pigments of the Imagination,* in: The Journal of Art, Nr. 2, November, 1990 · Liliane Touraine, *Anish Kapoor,* in: Artefactum, Nr. 38, April/März, 1991 · Stephen Westfall, *Anish Kapoor, Barbara Gladstone Gallery,* in: Flash Art, Nr. 147, Sommer, 1989

KAZUO KATASE

* Shizuoka (J), 1947
Lebt/Lives in Kassel

Einzelausstellungen | One-man exhibitions

1973 Tamura Gallery, Tokyo 1974 Muramatsu Gallery, Tokyo 1975 Städtische Galerie, Wolfsburg (Kat.: K. Hoffmann) 1976 Galerie Apex, Göttingen 1977 Baack'scher Kunstraum, Köln (Kat.: K. Hoffmann) · Agora Studio, Maastricht · Studio Kausch, Kassel · Galerie Lehmann, Düsseldorf 1978 Galerie Erika + Otto Friedrich, Bern (Kat.: K. Hoffmann) · Galerie Falzik, Neuenkirchen · Kunstverein Kassel 1979 Aktionscenter Kassel 1980 Harlekin Art, Wiesbaden (Kat.) 1981 Fotoforum, Kassel · *Negativraum-Positivraum,* Aktionscenter, Kassel (Kat.: H. Thiel) 1982 Städtische Museum, Göttingen (Kat.: H. Thiel) · Galerie vor Ort, Hamburg 1983 Kunstverein Heidelberg (Kat.: H. Gerkke, V. Rattemeyer) 1985 Kunstforum, Städtische Galerie im Lenbachhaus, München (Kat.: H. Friedel) · Galerie Brigitte March, Stuttgart · Werk-Galerie, Bonn 1986 Galerie Juana Mordo, Madrid (Kat.: H. Friedel) · Wewerka Galerie, Berlin 1987 Wewerka Galerie, Hannover · Galerie Monschhauer, Köln 1988 Kunstverein für die Rheinlande und Westfalen, Düsseldorf (Kat.) · Kunstverein Kassel · Kunstverein Wolfsburg (Kat.: K. Hoffmann) · Zeno X Gallery, Antwerpen · Adelhauser Kloster, Freiburg i. Br. 1989 *Nachtblumen,* Shedhalle, Zürich (ICC, Antwerpen) (Kat.: C. Leopardi, H. Lux, H. van Leuven) · Kunstverein, Arnsberg · Stadhuis, Almere (Kat.: T. van Gestel) · Wewerka Galerie, Berlin · Le Magasin, Grenoble (Kat.: J. Hoet, F. Kaiser, H. Liesbrock) 1990 Galerie Thomas Carstens, Barcelona · John Gibson Gallery, New York · Galerie Wanda Reiff, Maastricht 1991 New Museum of Contemporary Art, New York · Wewerka & Weiss Galerie, Berlin · Oriel Gallery, Cardiff

Gruppenausstellungen | Group exhibitions

1987 *Oktogon,* Museum, Wiesbaden · *Beelden-Land '87,* Winschoten · *Furkart '87,* Furka-Pasz · *Botschaften,* Kunsthalle, Wilhelmshaven · *Zeitgeist Architektur,* Kunstverein Wolfsburg 1988 *Kunst für Europa, Deutsche Kunst heute,* Bruxelles · Fort a/d Drecht, Amsterdam · *Publik Concepts,*

Forum-Messe, Hamburg 1989 *Kompositionen – Inszenierung,* Wewerka Galerie, Berlin · *Wortlaut,* Galerie Schüppenhauer, Köln · *Inszenierte Fotografie, Foto-Raum-Installation,* Kulturamt, Neuss · *Kunst im öffentlichen Raum,* Kulturbehörde Hamburg · *Japan 89,* Museum van Hedendaagse Kunst, Gent 1990 *Blau: Farbe der Ferne,* Heidelberger Kunstverein · *Trans-Europe Express,* John Gibson Gallery, New York 1991 *Heimat,* Wewerka & Weiss Galerie, Berlin · *Ecclipse of the Earth,* The New Museum of Contemporary Art, New York · *Auf Bewährung,* Museum für das Fürstentum Lichtenstein · *Radicalchip – Kazuo Katase: Sunken Horizon,* Japan Festival UK/Wales, Oriel Gallery, Cardiff · *Rhizome,* Gemeentemuseum, Den Haag

Bibliographie | Bibliography

Periodika | Periodicals
Paolo **Bianchi,** in: Kunstforum, Nr. 100, April/ Mai, 1989 · Beatrice von **Bismarck,** in: Noemea Art Magazin, Nr. 28, Januar/Februar, 1990 · Jan **Braet,** in: Knack, November, 1989 · Michael **Hübl,** in: Kunstforum, Nr. 103, September/Oktober, 1989 · Edith **Krebs,** in: Noema Art Magazine, Nr 23, April/Mai, 1989 · Roman **Kurzmeyer,** *Neue Kunst in Europa,* in: Nike, Oktober/November, 1987 · Heinz **Liesbrock,** in: FAZ Magazin, Nr. 25, 30. Januar, 1988 · Heinz **Liesbrock,** in: Kunstforum, Nr. 93, Februar/März, 1988 · Masaschi **Ogura,** in: Atelier Fine Arts Magazine (Tokyo), März, 1990 · Kar-Heinz **Schmid,** in: Faz Magazin, Nr. 472, 17. März, 1989 · Martin **Tschechne,** in: Art, Das Kunstmagazin, Nr. 9, September, 1989

TADOSHI KAWAMATA

*Hokkaido (J), 1953
Lebt/Lives in Tokyo

Einzelausstellungen | One-man exhibitions

1979 Lunami Gallery, Tokyo · Tamura Gallery, Tokyo · Maki Gallery, Tokyo 1980 Gallery Kobayashi, Tokyo 1981 ASG, Nagoya · Studio 37, Kyoto · Gallery K, Tokyo 1982 Gallery

Haku, Osaka · Kaneko Art Gallery, Tokyo 1983 TEN Gallery, Fukuoka · Kaneko Art Gallery, Tokyo 1984 Hillside Gallery, Tokyo · Kaneko Art Gallery, Tokyo 1985 Laboratory, Sapporo · P.S. 1 Studio, New York · Kaneko Art Gallery, Tokyo 1986 Area Deux Gallery, Fukuoka · Kamithori Gallery, Kumamoto · Kaneko Art Gallery, Tokyo · Hillside Gallery, Tokyo 1987 Galeria Unidade Dois de Arte, São Paulo · Kaneko Art Gallery, Tokyo · Hillside Gallery, Tokyo 1988 Storefront for Art and Architecture, New York · Galerie Van Mourik, Rotterdam · Hillside Gallery, Tokyo · Hillside Gallery, Tokyo 1989 Mercer Union, Toronto · Kodama Gallery, Osaka · Galerie Brenda Wallace, Montréal · Hillside Gallery, Tokyo 1990 Annely Juda Fine Art, London · Hillside Gallery, Tokyo 1991 Kaneko Art Gallery, Tokyo · Hillside Gallery, Tokyo · Galerie Brenda Wallace, Montréal 1992 *Kawamata projects Maquettes,* Koolama Gallery, Osaka

Gruppenausstellungen | Group exhibitions

1987 *documenta 8,* Kassel · *Art in Japan since 1969; Mono-ha and post Mono-ha,* Seibu Museum of Art, Tokyo · Biennal de São Paolo · *Vision-Dream-Image,* Kaneko Art Gallery, Tokyo 1988 *The New Urban Landscape,* World Financial Center, Battery Park City, New York · *Projekt Worldfax 88: Fax The Art,* Kunstraum, Neuss 1989 *Drawing as itself,* National Museum of Art, Osaka · *Japan 1989 (Europalia),* Museum van Hedendaagse Kunst, Gent 1990 *A new Necessity,* First Tyne International, Queensway North, New Castle · *A Primal Spirit,* Hara Museum Arc, Gumma (et al.) · *The Game of Manners,* Contemporary Art Gallery of Art Tower Mito, Mito · *Onvoltooid Tegenwoordige Tijd,* Centraal Museum, Utrecht · *Garden of Charity to Urban Arcadia,* Urban Centre, New York · *New Works or New Spaces, Into the Nineties,* Wexner Center for the Visual Arts, Columbus 1991 *Tokyo Art Expo '91,* Tokyo International Trade Center, Tokyo · *Out of Site,* P.S. 1, New York · *Landscapes, The Houston International Festival,* Houston · *A Primal Spirit,* Modern Art Museum, Forth Worth/The National Gallery, Ottawa · *Sapporo Contemporary Arts 1991,* Recent Gallery, Sapporo · *Ushimado International Biennale,* Ushomado

Projekte | Projects

1979 *By Land,* Tama Riverside, Tokyo 1980 *Project Work in Takayama,* Takayama School of Architecture, Gifu 1982 *Takara House Room 205,* Apartment project, Tokyo 1983 *Oteman, Wada-So,* Apartment project, Fukuoka · *Project Work in Saitama,* Museum of Modern Art, Saitma · *Slip in Tokorozawa,* Apartment project, Saitama · *Tetra House N-3 W-26,* Apartment project, Tetra House Commities, Sapporo (Kat.: Kazuhiro Endo, Iori Manabe, Tomoya Sato, Tomoo Shibahashi 1984 *Ginza Network,* Tokyo Gallery, Jewellery Shop Olphe, Gallery Kobayashi, Kaneko Art Gallery, Tokyo · *Okaido Installation,* PH Studio, Okaido Merchants' Association, Matsuyama · *Under Construction,* PH Studio, Art Front Gallery, Tokyo 1985 *Limelight Project,* New York · P.S. 1 Project, P.S. 1, Asian Cultural Council, New York 1986 *Spui,* construction site project, Gemeentemuseum, Den Haag 1987 *La Maison des Squatters,* construction site

project, Ecole des Beaux-Arts, Grenoble · *Destroyed Church,* documenta 8, Kassel · *Nove de Julho Cacapava,* construction site project, São Paulo 1988 *Fukoroi,* construction site project, Aka-Renga Final Commitee, Shizoka · *Hien-So,* Sagacho Exhibit Space, Kyoto 1989 *Colonial Tavern Park,* Mercer Union, Toronto · *Begijnhof Sint Elisabeth,* Kanaal Art Foundation, Kortrijk (Kat.: G. Bekaert, M. Tarantino, C. de Zegher)

Bibliographie | Bibliography

Texte und Beiträge vom Künstler
Texts and contributions by the artist
in: Graphication (Fuji Xerox Co.), November, 1981 · in: Graphication (Fuji Xerox Co.), Januar, 1982 · in: Dia (Mitsubishi Industry Inc.), März, 1982 · *Europe, Japan, Tokyo, and then Sapporo,* in: Dokusho Hokkaido, 15. Juli 1983; Kat.: Tetra House 326 Project No 1 · *Analogy of City,* in: Kat. Slip in Tokorozawa, 1983 · *A Gapped Chair,* in: Kat. Slip in Tokorozawa, 1983 · *Space Work,* in: Hokkaido Shimbun Newspaper, 27. August, 1983 · *Endo's House: Tetra House N-3 W-26 – Project Working Process Memo,* in: Kat. Tetra House 326 Project No. 1, 1983 · *Making subject than making artwork,* in: Chuo Koron, Nr. 1183, September, 1984 · *Workshop at The Hague,* in: Hokkaido Shimbun Newspaper, 4. Oktober, 1986 · *Birds' Nest, in the City Development,* in: The Mainichi Newspapers, 20. Oktober, 1986 · Hermes (Iwanami Shoten), Illustrations, 1987 · Sogetsu (Sogetsu Publishing), Nr. 176, Illustrations, 1988 · *About the 'Akarenga Final',* in: Kat. Akarenga Final (Hiroko Osugi), 1988 · *From Destruction to Construction,* Anouncement of One-man Exhibition, Storefront for Art and Architecture), Mai, 1988 · *Growing of Art in the city,* in: Kukan (Gakushu-Kenkyu-sha), Nr. 3, Mai, 1989 · *Ruin as the beginning: Roosevelt Island,* in: Hermes (Iwanami Shoten), Nr. 23, Februar, 1990 · *Drawing '90: Beguinage Project at Kortrijk,* in: Yomiuri Shimbun Newspapers, Nr. 40857, 3. März, 1990 · *Japanese Contemporary Art Exhibition in Abroad,* in: Yomiuri Simbun Newspapers, Oktober, 1990 · *Prologue,* in: Kat. Field Work (On the table), 1991 · *Temporary Structures,* in: Kat. Kawamata: Temporary Structures (Kyotot Shoin Publishing), 1991 · *Contemporary Art and Art Museum,* in: Gendai no Me (National Museum of Modern Art, Tokyo), September, 1991

Periodika | Periodicals
Dore **Ashton,** *Documenta of What,* in: Art Magazine (Art Digest), September, 1987 · Geert **Bekaert,** *Tadashi Kawamata's ontmoetingen in gent en Kortrijk,* in: Archis, Dezember, 1989 · Jan **Braet,** *Het Kawamataprojekt,* in: Knack, 13. Dezember, 1989 · Dan

Cameron, *Documenta 8 Kassel*, in: Flash Art, Oktober, 1987 · Mario De Candida, *Giovani e giapponesi*, in: TrovaRoma, Januar, 1987 · Peter Clothier, *A Primal Spirit*, in: Artspace, September/Oktober, 1990 · Sylvie Comte, *Empreintes sur le quartier brerriat*, in: Quartier, 1987 · Michel Ellenberger, *Tadashi Kawamata, Batisseur du provisoire*, in: Art Press, Nr. 153, 1990 · Adele Freedman, *Fastforward*, in: Canadian Art, Nr. 3, Herbst, 1989 · Edward Fry, Fumio Nanjo, *Collapse of Post-Modernism*, in: Subaru, Nr. 10, September, 1987 · Jeann C. Fryer-Kohles, *Review: 'New Works for New Spaces: Into The Nineties*, in: New Art Examiner, März, 1991 · Ichiro Hariu, *Kassel's Documennta and Out-door Sculpture Exhibition in Münster*, in: Sogetsu, Nr. 173, 1987 · Brian Hatton, *Review/Tadashi Kawamata, Annely Juda*, in: Artscribe, September/Oktober, 1990 · Eleanor Heatney, *Report from New Castle, Cultingham Engaged Public Art*, in: Art in America, Oktober, 1990 · Junji Ito, *Yokohama Art Blues*, in: Nikkei Image Climate Forecast, April, 1988 · Tomoya Kitahashi, *Escape from Post-Modern*, in: Brutus, Nr. 149, 15. Januar, 1987 · Janet Koplos, *Review*, in: Art in America, Mai, 1988 · Janet Koplos, *Mono-ha and the power of materials*, in: New Art Examiner, Juni, 1988 · Janet Koplos, *Material Meditation*, in: Art in America, März, 1991 · Bernard Marcelis, *Tadashi Kawamata*, in: Art Press, Nr. 144, Februar, 1990 · Nancy Marmer, *Documenta 8: The Social Dimension ?*, in: Art in America, September, 1987 · Makoto Murata, *Christo and Tadashi Kawamata*, in: Kokoku (Hakuhodo), Januar/Februar, 1988 · Fumio Nanjo, *From the site of Documenta 8*, in: Sunaru (Shu-ei-sha), September, 1987 · Fumio Nanjo, *World Art Report*, in: Atelier, Nr. 727, 1987 · Lois E. Nesbitt, *New Work for New Spaces: Into the Nineties*, in: Newsline, Dezember 1990/Januar 1991 · Hirosi Noda, *The newest technic: wood*, in: Atelier (Atelier Shuppan-sha), Nr. 722, April, 1987 · Philip Peters, *Tadashi Kawamata*, in: Artefactum, Nr. 24, Juni/August · Patricia C. Phillips, *Added Attraction*, in: Artforum International, Mai, 1989 · James Roberts, *Review*, in: Artscribe, Nr. 70, Sommer, 1988 · Gimme Shelter, *New Urban Landscape*, in: Design (U.S.A.), Januar, 1989 · Yukiko Shikata, *Document of Documenta Exhibition*, in: Brutus, 1. September, 1987 · Motoaki Shinohara, *Trans Art Map*, in: Yuriika (Seido-sha), Nr. 2, Februar, 1990 · Shaw Smith, *Documenta 8*, in: New Art Examiner, Nr. 2, Oktober, 1987 · Naoyuki Takashima, *Japan Modern Art Communication*, in: Wacoa, Nr. 7, 1987 · Naoyuki Takashima, *Return to System of Painting*, in: Nikkei Image Climate Forecast (Nihon Keizai Shimbun-sha), Nr. 2, Oktober, 1987 · Naoyuki Takashima, *Kawamata Annual*, in: Mono Magazine (K.K. World Photo Press), Nr. 4, 2. Februar, 1988 · Naoyuki Takashima, *Destroyed Church*, in: Asahi Journal, Nr. 1492, 7. August, 1987 · Sven Thielmann, *Kunst für die Welt-Kunst für's Volk*, in: Prinz, Juli/August, 1987 · Thomas West, *Republic of Ready-Mades*, in: Art International, Herbst, 1987

MIKE KELLEY

*Detroit (USA), 1954
Lebt/Lives in Los Angeles

Einzelausstellungen | One-man exhibitions

1981 Mizuno Gallery, Los Angeles 1982 Metro Pictures, New York 1983 Rosamund Felsen Gallery, Los Angeles · Hall Walls, Buffalo 1984 Metro Pictures, New York · Rosamund Felsen Gallery, Los Angeles 1985 Rosamund Felsen Gallery, Los Angeles 1986 Metro Pictures, New York 1987 *Vintage Works: 1976–1986*, Rosamund Felsen Gallery, Los Angeles 1988 The Renaisance Society, Chicago · Metro Pictures, New York 1989 Rosamund Felsen Gallery, Los Angeles · *Why I Got Into Art Vaseline Muses*, Jablonka Galerie, Köln · *Pansy Metal/Clovered Hoof*, Metro Pictures, New York · Galerie Peter Pakesch, Wien · Jablonka Galerie, Köln · Pacific Film Archive, University Art Museum, University of California, Berkeley · *Pansy Metal/Clovered Hoof*, Robbin Lockett Gallery, Chicago 1990 Metro Pictures, New York · Rosamund Felsen Gallery, Los Angeles (Kat.: R. Rugoff) · Galerie Ghislaine Hussenot, Paris 1991 Hirshhorn Museum, Washington, DC · Jablonka Galerie, Köln · *Obras Recientes*, Galeria Juana de Aizpuru, Madrid · *Lumpenrolle*, Galerie Peter Pakesch, Wien 1992 Alma Pater, Portikus, Frankfurt/M. (Kat.)

Gruppenausstellungen | Group exhibitions

1987 *Schema*, Baskerville & Watson Gallery, New York · Group Exhibition, Saxon-Lee Gallery, Los Angeles · *Biennial Exhibition*, Whitney Museum of American Art, New York · Toyama Now 87, Museum of Modern Art, Toyama · *1987 Phoenix Biennial*, Art Museum, Phoenix · *Contemporary Diptychs: Divided Visions*, Whitney Museum of American Art, New York · *Head Sex*, Feature, Chicago · *Nothing Sacred*, Margo Leavin Gallery, Los Angeles · *L.A. Hot and Cool*, M.I.T. List Visual Arts Center, Cambridge · *Avant-Garde in the Eighties*, County Museum of Art, Los Angeles · *Cal Arts. Skeptical Belief(s)*, The Renaissance Society, Chicago 1988 *Striking Distance*, Museum of Contemporary Art, Los Angeles

(et al.) · *Awards in the Visual Arts 7*, Los Angeles County Museum of Art, Los Angeles (et al.) · *Recent Drawings*, Whitney Museum of American Art, New York · *Monster with three Heads*, Don Soker Contemporary Art, San Francisco · *Lost and Found in California: Four Decades of Assemblage Art*, James Corcoran Gallery, Santa Monica (et al.) · *New Works on Paper*, Rosamund Felsen Gallery, Los Angeles · *Art Against Aids*, Pacific Design Center, Los Angeles · Metro Pictures, New York · *Cultural Participation*, a Group Material installation, DIA Art Foundation, New York · *Aperto*, Biennale di Venezia, Venezia · *Graz 1988*, Grazer Kunstverein, Stadtmuseum, Graz · *The Bi-National. American Art of the Late 80's*, Institute of Contemporary Art, Museum of Fine Arts, Boston (et al.) 1989 *Prospect 89*, Frankfurter Kunstverein, Frankfurt/M. · *A forest of Signs. Art in the crisis of representation*, Los Angeles · *Biennal Exhibition*, Whitney Museum of American Art, New York · *A Decade of American Drawing 1980–1989*, Daniel Weinberg Gallery, Los Angeles · *Mike Kelley, Judd Pfaff, Keith Sonnier*, Susanne Hilberry Gallery, Birmingham · *Jennifer Bolande, Tim Ebner, Mike Kelley, Ken Lum*, Robbin Lockett Gallery, Chicago · *They See God*, Pat Hearn Gallery, New York · Metro Pictures, New York · *The Images of American Pop Culture Today III*, organized by U.S.S.O. Co. Ltd. for La Foret Art Museum, Tokyo · *Filling in the Gap*, Feigen & Co., Chicago · *Künstlerische Fotografie der 70er un 80er Jahre*, Galerie Schurr, Stuttgart · *Erotophobia*, Simon Watson, New York · *No Stomach*, Installation, San Diego · *Jessica Diamond, Allen Ruppersberg, Mike Kelley*, Christine Burgin Gallery, New York 1990 *Past & Present – Selected Works by Gallery Artists*, Rosamund Felsen Gallery, Los Angeles · *Stained Sheets/Holy Shroud*, Krygier/Landau Contemporary Art, Santa Monica · *The Thing Itself*, Feature, New York · *Prints and Multiples*, Luhring Augustine Hetzler, Los Angeles · *Drawings: Werner Büttner, Mike Kelley, Martin Kippenberger, Robert Longo, John Miller*, Metro Pictures, New York · *Jessica Diamond, Mike Kelley*, Interim Art, London · *Editionen*, Galerie Gisela Capitain, Köln · *Mike Kelley, Tim Rollins + K.O.S., Meyer Vaisman*, Jay Gorney Modern Art, New York · *Re: Framing Cartoons*, Loughelton Gallery, New York · Galerie Ghislaine Hussenot, Paris · *Word as Image*, Milwaukee Art Museum, Milwaukee (et al.) · *The Children's Aids Project: A Benefit Exhibition*, Daniel Weinberg Gallery, Los Angeles · *Le désenchantement du monde*, Villa Arson, Nice · *Figuring the Body*, Museum of Fine Arts, Boston · *Viewpoints towards the 90's: Three Artists from Metro Pictures*, Seibu Contemporary Art Gallery, Tokyo · *Sculpture*, Daniel Weinberg Gallery, Los Angeles · *The Kitchen Art Benefit*, Leo Castelli/Castelli Graphics & Curt Marcus Gallery, New York · *Semi-Objects*, John Good Gallery, New York · *Just Pathetic*, Rosamund Felsen Gallery, Los Angeles · *Heart and Mouth*, Fahey/Klein Gallery, Los Angeles · *Lotte or the Transformation of the Object*, Grazer Kunstverein, Graz (et al.) · *Total Metal*, Contemporary Arts Forum, Santa Barbara · *Suttering*, Stux Gallery, New York 1991 *Metropolis*, Martin-Gropius-Bau, Berlin · *Anni Novanta*, Galleria Comunale d'Arte Moderna, Bologna · *Telekinesis*, Mincher/Wilcox Gallery, San Francisco ·

Idiosyncrasies in the Expanded Field, Postmasters, New York · *Savage Garden*, Fundació Caixa de Pensions, Barcelona · *California Artists: William T. Wiley, Mike Kelley, Brad Dunning*, Aldrich Museum of Contemporary Art, Ridgefield · *Carroll Dunham, Mike Kelley, Cindy Sherman*, Metro Pictures, New York · *Enclosure*, Los Angeles Municipal Art Gallery, Los Angeles · *Flux Attitudes*, Hallwalls, Buffalo, New York · *Something Pithier and More Psychological*, Simon Watson, New York · Interim Art, London · *Poets/Painters Collaborations*, Brooke Alexander Editions, New York · *Biennal Exhibition*, Whitney Museum of American Art, New York · *Individual Realities*, Sezon Museum of Art, Tokyo (et al.) · *Someone or Somebody*, Meyers/Bloom Gallery, Santa Monica · *The Kelly Family*, Esther Schipper, Köln · *Body Language*, Lannan Foundation, Los Angeles · *The Lick of the Eye*, Shoshana Wayne Gallery, Santa Monica · *Objects for the Ideal Home*, Serpentine Gallery, London **1992** Kunsthalle, Basel

Performances · Vorträge | Lectures

1978 *Poetry in Motion*, Los Angeles Contemporary Exhibitions, Los Angeles · *Dream Lover*, audio tape; The Poetics, C.L.O.S.E. Radio Art Series, KPFK, Los Angeles (Mike Kelley, Tony Oursler, Don Krieger) · *Indiana*, Los Angeles Contemporary Art, La Jolla · *A Big Question*, California State University, Los Angeles **1979** *The Monitor and he Merrimac*, Foundation for Art Resources, Los Angeles, in conjunction with the collaborative exhibition with David Askevold : „The Poltergeist" · Los Angeles Institute of Contemporary Art, Los Angeles, in conjunction withe exhibition *Sound* **1980** *Three Valleys*, Foundation for Art Resources, Los Angeles · *The Parasite Lily*, performed at Los Angeles Contemporary Exhibitions, Los Angeles as part of the performance festival : Public Spirit : Live Art L.A.: California Institute of the Arts, Valencia; University of California, San Diego; The Kitchen, Center for Video, Music and Dance, New York; University of Michigan, Ann Arbor **1981** *The Monitor and the Merrimac*, Hallwalls, Buffalo · *Meditation on a Can of Vernors*, Los Angeles Contemporary Exhibitions, Los Angeles **1982** *Confusion*, University of California, San Diego; Film in the Cities, Minneapolis · *The Artist in Television*, Telesatellite Conference held at the University of California, Los Angeles: live interactive performance with Michael Smith, Los Angeles/New York **1983** *Confusion*, Pilot 1 Theater, Los Angeles · *Monkey Island*, Beyond Baroque Literary/Arts Center, Venice · *X-C*, Beyond Baroque Literary/Arts Center, Venice; collaboration with Tony Oursler · Reading, Hall Walls, Buffalo **1984** *The Sublime*, Museum of Contemporary Art, Los Angeles · *Godzilla on the Beach*, Beyond Baroque Literary/Arts Center, Venice; collaboration with Bruce and Norman Yonemoto · Reading, Anti Club, Los Angeles **1985** Reading, The Permanent Contemporary Gallery, Los Angeles · Reading, Artist Space, New York · *Monkey Island Part Two*, Los Angeles Municipal Art Gallery Theater, part of *Artificial Intelligence in the Art, Nr. 1 brainworks*, a symposium in conjunction with the exhibition *Los Angeles/Styrian Autumn*, Los Angeles, Municipal Art Gallery, Los Angeles and Steirischer Herbst,

Graz **1986** *The Peristaltic Airwaves*, live radio performance, KPFK, Los Angeles, co-produced by High Performance Magazine & KPFK · *Plato's Cave, Rothko's Chapel, Lincoln's Profile*, Artist Space, New York **1989** *Theory, Garbage, Stuffed Animals, Christ*, Beyond Baroque, Venice · *Pansy Metal/Clovered Hoof*, A dance presentation of silk scarf series in collaboration with Anita Pace. Sponsored by Rosamund Felsen Gallery at private residence in Los Angeles **1991** *3 Blowhards and A Little Lady*, Beyond Baroque, Venice

Bibliographie | Bibliography

Texte und Bücher vom Künstler
Texts and books by the artist
The Runaway Wheel, in: Journal, Los Angeles Institute of Contemporary Art, März, 1979 · *The Parasite Lily*, in: High Performance, Nr. 11/12, 1980 · *The Poltergeist*, in: Journal, Los Angeles Institute of Contemporary Art, September, 1980 · *Monkey Island*, in: Lightworks, Februar, 1981 · *The Monitor and the Merrimac*, in: High Performance, Nr. 14, 1981 · *Conserve Energy*, in: Los Angeles Herald Examiner: California Living Magazine, in conjunction with *A Meeting of Medial*, by Christopher Knight, 22. November, 1981 · *Meditation on a Can of Vernors'*, in: High Performance, Nr. 17/18, 1982 · *Monkey Island*, in: Cave Canem, Artist's Anthology, September, 1982 · *The Spot Syndrom* (mit/with Erika Beckman), in: New Observations, New York, 1984 · *Slow Boat to Lesbos*, in: Barney Magazine, 1984 · *Ajax*, in: Journal, Los Angeles Institute of Contemporary Art, Frühling, 1984 · *Urban Gothic*, in: Spectacle, Nr. 3, 1985 · *Excerpts From: Plato's Cave, Rothko's Chapel, Lincoln's Profile*, in: L.A.I.C.A. Journal, Herbst, 1985 · *Plato's Cave, Rothko's Chapel, Lincoln's Profile*, New City Editions in association with Artists Space, 1986 · *Three projects by Mike Kelley at the Renaissance Society at the University of Chicago: Half a Man, From My Institution to Yours, Pay for your Pleasure*, in: WhiteWalls, Nr. 20, Herbst, 1988 · *Foul Perfection. Thoughts on Caricature*, in: Artforum, Januar, 1989 · *Mekanïk Destruktïw Kommandoh: Survival Resaerch Laboratories ans popular Spectacle*, in: Parkett, Nr. 22, 1989 · *Theory, Garbage, Stuffed Animals, Christ (Dinner Conversation Overheard at a Romantic French Restaurant)*, in: Forehead, Vol. II, 1989 · *Reconstructed History*, Köln/New York, Galerie Gisela Capitain/Thea Westreich, 1991

Periodika | Periodicals
Todd **Alden**, Terry R. **Myers**, *Total Metal*, in: Arts, Februar, 1991 · Jan **Avigkos**, *The Binational, ICA Boston*, in: Artscribe, Sommer, 1989 · David **Bernardi**, *Mike Kelley, The ABC's of Perversion*, in: Flash Art, Nr. 162, Januar/Februar, 1992 · Donald **Britton**, *Mike Kelley*, in: Art Issues, Nr. 15, Dezember 1990/Januar1991 · Dan **Cameron**, *Pop 'n' Rock*, in: Art Issues, November, 1989 · Dan **Cameron**, *Changing Priorities in American Art*, in: Art International, Frühling, 1990 · Shaun **Caley**, *Spotlight: A Forest of Sign*, in: Flash Art, November/Dezember, 1989 · Jean-François **Chevrier**, *Mike Kelley*, in: Galeries Magazine, Nr. 45, Oktober/November, 1991 · Peter **Clotier**, *L.A.: Outward Bound*, in: Artnews, Dezember, 1989 · Leontine **Coelewij**, *New Kids On The Block*, in: Metropolis

M, Nr. 5, Oktober, 1991 · Hunter Holland **Cotter**, *Eight Artists Interviewed*, in: Art in America, Mai, 1987 · Holland **Cotter**, *A Bland Biennial*, in: Art in America, September, 1989 · **Drohojowska**, *The 80's: Stop Making Sense*, in: Artnews, Oktober, 1989 · Hunter **Drohojowska**, *Contemporary Arts's Crisis of Representation*, in: The Journal of Art, September/Oktober, 1989 · Trevor **Fairbrother**, *Mike Fucking Kelley*, in: Parkett, Nr. 32, 1992 · Fred. **Fehlau**, *Review*, in: Flash Art, März/April, 1988 · Jeremy **Gilbert-Rolfe**, *The Price of Goodnss*, in: Artscribe, November/Dezember, 1989 · Laura **Gottingham**, *Mike Kelley*, in: Tema Celeste, Juli/Oktober, 1990 · Scotte **Gutterman**, *World Chronicle – New York*, in: Art International, Nr. 12, Herbst, 1990 · Richard **Hawkins**, *Just Pathetic*, in: Art Issues, November, 1990 · Eleanor **Heartney**, *Mike Kelley, Metro Pictures*, in: Artnews, November, 1988 · Eleanor **Heartney**, *Who's Afraid of the Whitney Biennial*, in: Art News, Sommer, 1989 · Gerrit **Henry**, *Mike Kelley*, in: Contemporanea, September, 1990 · Elizabeth **Hess**, *Coming Up Empty*, in: Village Voice, 9. Mai, 1989 · Kathryn **Hixon**, *Mike Kelley*, in: Arts Magazine, Nr. 3, November 1988 · John **Howell**, *Mike Kelley. Plato's Cave, Rothko's Chapel, Lincoln's Profile*, in: Artforum, Mai, 1987 · David **Humphrey**, *Hair Piece*, in: Art Issues, Februar, 1990 · David **Humphrey**, *Stained, Sheets/Holy Shroud*, in: Arts, Dezember, 1990 · Ronald **Jones**, *Mike Kelley, Metro Pictures*, in: Flash Art, Nr. 12, Februar/März, 1987 · Susan **Kandel**, *Heart in Mouth*, in: Arts, Februar, 1991 · Jutta **Koether**, *C-Culture and B-Culture*, in: Parkett, Nr. 24, 1990 · Gary **Kornblau**, *Review*, in: Art Issues, März/April, 1990 · Christian **Leigh**, *L.A. Hot and Cool – The Eighties*, in: Artforum, April, 1988 · Kim **Levin**, *Dogs and Babies*, in: Village Voice, 8. Mai, 1990 · James **Lewis**, *Beyond Redemption*, in: Artforum, Sommer, 1991 · Bernard **Marcadé**, *The World's Bad Breath/Der Mundgeruch der Welt*, in: Parkett, Nr. 32, 1992 · Christoph **Marx**, *Mike Kelley*, in: Zyma, Nr. 1, Januar, 1992 · Norbert **Messler**, *Mike Kelley. Galerie Jablonka*, in: Artforum, Sommer, 1989 · Michael **Nash**, *Video Poetics: A Contemporary Survey*, in: High Performance, Nr. 37, 1987 · Lois E. **Nesbitt**, *Not a pretty sight. Mike Kelley make us pay for our pleasure*, in: Artscribe, September/Oktober, 1990 · Kathy **O'Dell**, *Mike Kelley at Artists Space*, in: Art in America, Mai, 1987 · Peter **Pakesch**, *Graz 88*, in: Spazio Umano, 1988 · Laurie **Palmer**, *Mike Kelley. Renaissance Society*, in: Artforum, September, 1988 · Peter **Plagens**, *Under Western Eyes*, in: Art in America, Januar, 1989 · Lane **Relyea**, *Wild Kingdom/Über das Scheitern*, in: Parkett, Nr. 32, 1992 · David **Rimanelli**, *Mike Kelley*, in: Artforum, September, 1990 · Ralph **Rugoff**, *Review*, in: Artscribe, Mai, 1988 · Wade **Saunders**, Craig Gholson, *Los Angeles*, in: Bomb, Nr. 22, Winter 1988 · Peter **Schjeldahl**, *The New Low*, in: Village Voice, 13. November, 1990 · Julie **Sylvester**, *Talking Failure*, in: Parkett, Nr. 32, 1992 · Paul **Taylor**, *Mike Kelley*, in: Interview, April, 1990 · Paul **Taylor**, *Mike Kelley, Toying with Second-Hand Souvenirs*, in: Flash Art, Bd. 22, Oktober 1990 · Matias **Vliegener**, *Heart in Mouth*, in: Art Issues, Nr. 16, Februar/März, 1991

ELLSWORTH KELLY

*Newburgh (USA), 1923
Lebt/Lives in New York

Einzelausstellungen | One-man exhibitions

1951 Galerie Arnaud, Paris 1956 Betty Parsons Gallery, New York 1957 Betty Parsons Gallery, New York 1958 Galerie Maeght, Paris 1959 Betty Parsons Gallery, New York 1961 Betty Parsons Gallery, New York 1962 Arthur Tooth Gallery, London 1963 Betty Parsons Gallery, New York (Washington Gallery of Modern Art, Washington DC) 1964 Institute of Contemporary Art, Boston (Galerie Maeght, Paris) 1965 Ferus Gallery, Los Angeles · Sidney Janis Gallery, New York · Galerie Adrien Maeght, Paris (Galerie Rikke, Kassel) 1966 Ferus Gallery, Los Angeles 1967 Sidney Janis Gallery, New York · Irving Blum Gallery, Los Angeles 1968 Sidney Janis Gallery, New York · Irving Blum Gallery, Los Angeles 1971 Dayton's Gallery, Minneapolis (Sidney Janis Gallery, New York) (Kat.) 1972 Galerie Denise René und Hans Mayer, Düsseldorf (Kat.) · Albright-Knox Gallery, Buffalo 1973 Leo Castelli Gallery, New York · *Elsworth Kelly Retrospective,* Museum of Modern Art (Pasadena Art Museu, Pasadena; Walker Art Center, Minneapolis; The Detroit Institute of Arts, Detroit) 1975 Leo Castelli Gallery, New York · Blum Helman Gallery, New York 1977 Leo Castelli Gallery, New York · Blum Helman Gallery, New York · Blum Helman Gallery, New York 1979 Blum Helman Gallery, New York · *Ellsworth Kelly: Recent Painting and Sculpture,* Metropolitan Museum of Art, New York · *Paintings and Sculptures, 1963–1979,* Stedelijk Museum, Amsterdam; Musée National d'Art Moderne, Centre Georges Pompidou, Paris/ Staatliche Kunsthalle, Baden-Baden/Hayward Gallery, London (Kat.: B. Rose) 1981 Leo Castelli Gallery, New York · Blum Helman Gallery, New York 1982 Leo Castelli Gallery, New York · Blum Helman Gallery, New York · *Sculpture,* Whitney Museum of American Art, New York/The Saint Louis Art Museum, St. Louis (Kat.: P. Sims, E. Rauh

Pulitzer) 1984 Leo Castelli Gallery, New York (Kat.: E. K.) · Blum Helman Gallery, New York · Margo Leavin Gallery, Los Angeles (Kat.: E. K.) 1985 Leo Castelli Gallery, New York · Blum Helman Gallery, New York 1986 Blum Helman Gallery, New York 1987 *Works on Paper,* Fort Worth Art Museum, Fort Worth/Museum of Fine Arts, Boston/ Art Gallery of Ontario, Toronto/San Francisco Museum of Modern Art, San Francisco/ Nelson-Atkins Museum of Art · *A Print Retrospective,* The Detroit Institute of Arts, Detroit (et al.) 1988 Blum Helman Gallery, New York (Kat.: R. Storr) 1989 Leo Castelli Gallery, New York · Blum Helman Gallery, New York (Kat.: B. Rose) · *Works on Paper,* Museum Overholland, Amsterdam 1990 Leo Castelli Gallery, New York · Gallery Kasahara, Osaka · Portikus, Frankfurt/M. · *Artists's Choice: Ellsworth Kelly – Fragmentation and the Single Form* (video), Museum of Modern Art, New York (Kat.: E. K.) 1991 *At Right Angles,* Margo Leavin Gallery, Los Angeles (Kat.: R. Bernstein) 1992 *The French Years, 1948–54,* Galerie Nationale du Jeu de Paume, Paris (Westfälisches Landesmuseum, Münster; National Gallery of Art, Washington, DC) · Galerie Templon, Paris

Gruppenausstellungen | Group exhibitions

1988 *La couleur seule l'expérience du monochrome,* Musée St. Pierre, Lyon · *Red Yellow and Blue,* Kunstmuseum, St. Gallen (et al.) · 1989 *Prospect 89,* Frankfurter Kunstverein, Frankfurt/M. · *Einleuchten,* Deichtorhallen, Hamburg · *Bilderstreit,* Museum Ludwig, Köln · *Abstraction, Geometry, Painting: Selected Geometric Abstract Painting in America Since 1945,* Albright-Knox Art Gallery, Buffalo 1990 *Polyptiques,* Musée du Grand Louvre, Paris 1991 *Die Hand des Künstlers,* Museum Ludwig, Köln · *Carl Andre, Ellsworth Kelly, Richard Long,* Anthony d'Offay Gallery, London · *Schwerelos,* Große Orangerie Schloß Charlottenburg, Berlin 1992 RubinSpangle Gallery, New York

Bibliographie | Bibliography

Texte und Bücher vom Künstler |
Texts and books by the artist
Ellsworth Kelly: A Calendar for 1992, London, Anthony d'Offay, 1991

Bücher | Books
E. C. **Goosen,** *Ellsworth Kelly,* in: Derrière le Miroir, Nr. 110, October, Paris, Maeght Editeur, 1958 · Dale **McConathy,** *Ellsworth Kelly,* in: Derrière le Miroir, Nr. 149, November, Paris, Maeght Editeur, 1964 · Diane **Waldman,** *Ellsworth Kelly: Drawings, Collages, Prints,* Greenwich, Connecticur, New York Graphic Society, 1971 · John Coplans, *Ellsworth Kelly,* New York, Harry N. Abrams, 1973 · E.C. **Goossen,** *Ellsworth Kelly,* New York, The Museum of Modern Art, 1973 · Elizabeth C. **Baker,** *Ellsworth Kelly: Recent Paintings and Sculptures,* New York, The Metropolitan Museum of Art, 1979 · Diane **Upright,** *Ellsworth Kelly: Works on Paper,* New York, Harry N. Abrams in association with The Fort Worth Art, 1987 · Richard H. **Axsom,** *The Prints of Ellsworth Kelly,* New York, The American Federation of Arts, Hudson Hills Press, 1987 · Trevor **Fairbrother,** *Ellsworth Kelly: Seven Paintings*

(1953–55/1987), Boston, Museum of Fine Arts, 1987 · Gottfried **Böhm,** *Ellsworth Kelly, Yellow Curre,* Stuttgart, edition cantz, 1992

Periodika | Periodicals
Paul **Cummings,** *Interview: Ellsworth Kelly Talks With Paul Cummings,* in: Drawing, Bd. 13, Nr. 3, September/Oktober, 1991 · Charles **Hagen,** *The Shape of Seeing, Ellsworth Kelly's Photographs,* in: Aperture, Nr. 125, Herbst, 1991 · Ann **Hindry,** *Ellsworth Kelly: une investigation phénomènologique sur pans de couleur,* in: Art Studio, Nr. 16, 1990 · Ann **Hindry,** *Ellsworth Kelly,* in: Art Studio, März, 1992 · Jean **Leering,** *De Keuken van Kelly,* in: Elsevier, 15. Juli, 1989 · Robert **Storr,** *Ellsworth Kelly,* in: Art Press, März, 1992 · Paul **Taylor,** *Ellsworth Kelly,* in: Interview Magazine, Mai, 1991 · Ulrich **Wilmes,** *Ellsworth Kelly,* in: Künstler, Nr. 14, München, 1991

BHUPEN KHAKHAR

*Bombay (IND), 1934
Lebt/Lives in Baroda

Einzelausstellungen | One-man exhibitions

1965 Jehangir Art Gallery, Bombay 1970 Kunika Chemould Art Gallery, New Delhi 1972 Chemould Gallery, Bombay 1976 Black Partridge Gallery, New Delhi 1979 Arthony Stokes Gallery · Hester von Royen Gallery, London 1981 Chemould Art Gallery, Bombay 1982 Urja Art Gallery, Baroda 1983 Chemould Art Gallery, Bombay · Contemporary Art Gallery, Ahmedabad · Knoedler Gallery, London 1985 Huthesingh Visual Art Centre, Ahmedabad · Kunika Chemould Art Gallery, New Delhi · Chemould Art Gallery, Bombay 1986 Galeries Contemporaines, Centre Georges Pompidou, Paris (Kat.: U. Beier, D. Bozo, B. K., J. Maheu, J. Walla) · Gallery Watari, Tokyo 1990 Chemould Art Gallery, Bombay

Gruppenausstellungen | Group exhibitions

1989 *India Contemporary Art,* World Trade Centre Club, Amsterdam · Chemould Art Gallery, Bombay

Bibliographie | Bibliography

Texte und Bücher vom Künstler
Texts and books by the artist
Written several Gujarati Short Stories, published in Gujarati Journals · Editor of »Vrishchik« magazine with Shri Gulam Sheikh, dedigned bookjackets for Gujarati short stories, essays & poetry · *Mojila Manilai,* a play stayed in Bombay, Baroda, Ahmedabad, 1989

Periodika | Periodicals
Timothy **Hyman,** *New Figuration in India: the Baroda school and Bhupen Khakhar,* in: Art International, Nr. 10, Frühling, 1990

Film · Video
Interview, ITV, London Festival, 1982 · *Messages from Bhupen Khakar,* film made by Arts council of Great Britain · *Figures of Thought,* film by Arun Khopkar on three artists: Bhupen Khakhar, Vivan Sundaram, Nalini Malani, 1989

MARTIN KIPPENBERGER

*Dortmund (D), 1953
Lebt/Lives in Köln

Einzelausstellungen | One-man exhibitions

1979 *Knechte des Tourismus* (mit/with Achim Schächtele), Café Einstein, Berlin · *Kommen, Kucken, Kaufen*, Künstlerhaus, Hamburg (Kat.) 1981 *Kippenberger in Nudelauflauf sehr gerne*, Galerie Petersen, Berlin · *Lieber Maler, male mir*, Neue Gesellschaft für Bildende Kunst -Realismusstudio 14, Berlin (Kat.) · *Ein Erfolgsgeheimnis des Herrn A. Onassis*, Galerie Max Hetzler, Stuttgart · *Dialog mit der Jugend*, Galerie Achim Kubinski, Stuttgart 1982 *Das Leben ist hart und ungerecht*, Forum Kunst, Rottweil (Studio F, Ulm) (Kat.: J.-C. Ammann, I. Barfuss/T. Wachweger, W. Büttner) · *Kiste Orgon bei Nacht* (mit/with A. Oehlen), Galerie Max Hetzler, Stuttgart · Galerie Silvio Baviera (mit/with A. Oehlen), Cavagliano/Tessin· *Fiffen, Faufen, Ferfaufen*, Studio F · *Capri bei Nacht* (mit/with A. Oehlen), Galerie Tanja Grunert, Stuttgart · *Türe bei Nacht*, (mit/with A. Oehlen), Dr. Dacić, Tübingen · 1983 *Abschied vom Jugendbonus! Vom Einfachsten nach Hause*, Galerie Dany Keller, München (Kat.) · *Endlich 2*, Galerie Erhard Klein, Bonn (Kat.: M.K., B. Schaub) · *Gibt's mich wirklich?*, Galerie Max Hetzler, Stuttgart · *Kennzeichen eines Unschuldigen*, Galerie Rudolf Zwirner, Köln · *Song of Joy* (mit/with Wilhelm Schürmann), Neue Galerie – Sammlung Ludwig, Aachen · *James Dean* (mit/with A. Oehlen), Buchhandlung Welt, Hamburg · *Frauen im Leben meines Vaters* (mit/with A. Oehlen), Galerie Klein, Bonn 1984 *4 Bilder*, Gerald Just, Hannover · Galerie Max Hetzler, Köln · *One ten eight four*, Ausstellungsraum Fettstraße 7a, Hamburg · *Schock aus heißt das Spiel*, Galerie Peter Pakesch, Wien · *Hoch und Tief I 81/82*, Michael Schwarz, Braunschweig · *Abschied vom Jugendbonus Teil II* (mit/with A. Oehlen), Galerie Thomas Borgmann, Köln 1985 *Wie komm' ich in Kriegszeiten mit Knochenbruch und Futurismus klar?*, Galerie Ascan Crone, Hamburg · *Hoe kom ik in vredestijd met botbreuken en futurisme klaar*, Galerie Van Beveren, Rotterdam · *Selling America & Buying El Salvador*, Metro Pictures, New York · Galerie Silvio Baviera, Zürich · Galerie Max Hetzler, Köln · *Helmut Newton für Arme – Selbstbeschmutzende Nestwärme bis '84*, CCD Galerie, Düsseldorf · *Podria prestarte algo, pero con eso note haria ningún favor*, Galerie Leyendecker, Santa Cruz, Tenerife · *Acht Ertragsgebirge und drei Entwürfe für Müttergenesungswerke*, Galerie Heinrich Ehrhardt, Frankfurt/M. · *Endlich 3*, Galerie Erhard Klein, Bonn (Kat.: M. K., M. Oehlen) · *Money Forever (Hunger)*, Galerie Bärbel Grässlin, Frankfurt/M. 1986 *Nur Angst vor Frauen, die Samt tragen (Seidene Schlüpfer sind keine Ausrede für hautfarbene BHs)*, Oldenburger Kunstverein · *23 Vierfarben-Vorschläge für die Modernisierung des Rückenschwimmers*, Galerie Engels, Köln · *40 Millionen für ein Hallöchen* (mit/with A. Oehlen), Galerie Ascan Crone, Hamburg · *Miete Strom Gas*, Hessisches Landesmuseum, Darmstadt (Kat.: B. Brock, D. Diedrischen, M. Prinzhorn, J.-K Schmidt) · *Endlich 1*,

Galerie Erhard Klein, Bonn (Kat.) · *Sand in der Vaseline*, CCD Galerie, Düsseldorf (PPS Galerie, Hamburg) (Kat.: M. K. A. Oehlen)· *Von der Partykellermalerei zur Kneipenkunst*, Galerie Wanda Reiff, Maastricht 1987 *Petra*, Galerie Gisela Capitain, Köln (Kat.) · *Fräulein Fischer*, Galerie Norballe, Kopenhagen · *Peter – Die russische Stellung*, Galerie Max Hetzler, Köln · *Einfach geht der Applaus zu Grunde*, Galerie Grässlin-Ehrhardt, Frankfurt/M. (Kat.) · *Peter 2*, Galerie Peter Pakesch, Wien (Kat.)· *Sorry III*, Metro Pictures, New York · *Les tableaux primés et une maison sans titre*, Galerie Sylvana Lorenz, Paris · *Reise nach Jerusalem*, Galerie Bleich-Rossi, Graz · *Pop in*, Forum Stadtpark, Graz· *Werken op papier*, Ado Gallery, Bonheiden · *Per Pasta ad Astra*, Ado Gallery, Antwerpen 1988 Galleria d'arte, Silvio R. Baviera, Cavigliana · *Nochmal Petra*, Kunsthalle, Winterthur (Kat.) · Galerie Juana de Aizpuru, Sevilla 1989 Galerie Max Hetzler, Köln (Galerie Carrée, Villa Arson, Nice; Galerie Luhring Augustine Hetzler, Santa Monica; Metro Pictures, New York) (Kat.: C. Bernard, A. R. Penck)· *Input-Output*, Galerie Gisela Capitain, Köln (Kat.) · *Die Hamburger Hängung, Umzüge 1957–1988, Fallende Flüge*, Galerie Gisela Capitain, Köln · *Ballon-Bilder*, Galeria Juana de Aizpuru, Sevilla · *The Side Up*, Amraser Straße, Innsbruck · *Investigations. Not to Be the Second Winner – Part Two*, ICA, University of Pennsylvania, Philadelphia · *Disco Bombs*, Julie Sylvester, New York · *Multi Pack Corner/Angst* (mit/with M. Oehlen), Amraser Straße, Innsbruck · *Collages*, David Nolan Gallery, New York · *Bei Nichtgefallen Gefühle zurück*, Halle Süd, Genève · *Que calor II*, Museo de Arte Contemporaneo, Sevilla (Kat.) · *D.E. d.A.7*, Fettstraße 7a, Zürich · *VIT 89*, Galerie Max Hetzler, Köln 1990 *Casa Anti Magnetica*, Galerie Sylvana Lorenz, Paris · *We Were Anchored At The Coast Of Zanzibar And Had A Manifesto On Board*, Galleri Nordanstad-Skarstedt, Stockholm · *Jetzt geh ich in den Birkenwald, denn meine Pillen wirken bald*, Anders Tornberg Gallery, Lund · Galerija Studentskog kulturnog centra, Beograd (Kat.) · Luhring Augustine Hetzler Gallery, Santa Monica · *Heimweh Highway 90*, Fundació Caixa de Pensions, Barcelona · *Ein Handvoll vergessener Tauben*, Galerie Grässlin-Ehrhardt, Frankfurt/M. · *Hotel Hotel zum Letzten*, Jänner Galerie, Wien · *Unlängst verlängerte Originale*, Galerie Gisela Capitain, Köln · *Allestismento mostra Sognatore americano in Italia*, Studio Marconi, Milano · Galerie Peter Pakesch, Wien 1991 *In and Out Carnation*, Galerie Semia Sãouma, Paris · *Heavy Mädel*, Pace/Mcgill Gallery, New York · *Put your eye in your mouth*, Museum of Modern Art, San Francisco (Kat.) · *Only heavy*, Luhring Augustine Hetzler Gallery, Santa Monica · *Tiefes Kehlchen*, Wiener Festwochen, Wien · *Kippenblinkys*, David Nolan Gallery, New York · *William Holden Company on Tour*, Galerie Wewerka & Weiss, Berlin · *The beginning was a retrospective*, Karsten Schubert Ltd., London · *Heavy Burschi*, Kölnischer Kunstverein, Köln (Kat.) · *Dieter von der Ruhr*, Galerie Klein, Bonn

Gruppenausstellungen | Group exhibitions

1987 *Berlinart 1961–1987*, The Museum of Modern Art, New York (et al.) · *Room Enough – Sammlung Schürmann*, Suermondt-Ludwig-Museum, Aachen · *Eighty · Les Peintres d'Europes*, Parc des Expositions du Wacken, Strasbourg · *Fotografie*, Groninger Museum, Groningen · *Broken Neon*, Steirischer Herbst, Forum Stadtpark, Graz 1988 Luhring Augustine & Hodes Gallery, New York · *Made in Cologne*, DuMont Kunsthalle, Köln · *Der Hang zur Architektur in der Malerei der Gegenwart*, Deutsches Architekturmuseum, Frankfurt/M · *B.R.D. – Abstract Tendencies in New German Art*, Karl Bornstein Gallery, Santa Monica· *Arbeiten mit Photographie aus Köln*, Kölnischer Kunstverein, Köln · *New Prints from Germany*, Art Museum, St. Louis 1989 *Object of Thought*, Anders Tornberg Gallery, Lund (Kat.) · *Neue Figuration – Deutsche Malerei 1960–88*, Kunstmuseum, Düsseldorf (et al.) · *Refigured Painting : The German Image*, The Toledo Museum of Art, Toledo (et al.) · *I Triennal de Dibuix Joan Miró*, Fundació Joan Miró, Barcelona · *Contemporary Illustrated Books*, Brooke Alexander Editions, New York · *Künstlerische Fotografie der 70er un 80er Jahre*, Galerie Ursula Schurr, Stuttgart · Galleri Nordanstad-Skarstedt, Stockholm 1990 *Drawings*, Metro Pictures, New York · *About Round – Round About*, Anders Tornberg Gallery, Lund · *Artistes De Colonia*, Centre d'Art Santa Monica, Barcelona· *Contemporary German Photography*, david Nolan Gallery, New York · *Prints and Multiples*, Luhring Augustine Hetzler Gallery, Santa Monica · *Le Désenchantement du Monde*, Villa Arson, Nice (Kat.) · *3 Tage Umhausen*, Umhausen · *Artificial nature*, Desta Foundation, Athinai · *Pharmakon '90*, Nippon Convention Center, Nakuhari Messe, Nakase · *Rockens Billeder*, Kunsthalle Brandts Klaedefabrik, Odense · *Camera Works*, Galerie Samia Sãouma, Paris 1991 *Once again the world is flat*, Galeria Juana de Aizpuru, Madrid · *Gulliver's Reisen*, Galerie Sophia Ungers, Köln · Galleri Nordanstad-Skarstedt, Stockholm · *Buchstäblich*, Von der Heydt-Museum, Wuppertal

Bibliographie | Bibliography

Texte und Bücher vom Künstler
Texts and books by the artist
Al vostro servizio, Hamburg, 1977 · *Vom Eindruck zum Ausdruck. 1/4 Jahrhundert Kippenberger*, Berlin, Verlag Pikasso's Erben, 1979 · *Sehr gut, Berlin*, Martin Kippenberger, 1979 · *19 Gedichte 1 Geschichte 1 kl. Stapel graues Papier 15 Männer 1 Superporter anbei*, Essen, Existens Verlag, 1980 · *Frauen*, Berlin, Merve Verlag, 1980 · *Was auch immer sei Berlin bleibt frei*, Berlin, 1981 · *Durch die Pubertät zum Erfolg*, Berlin, Rainer Verlag, 1981· *Kippenberger! 25. 30. 53 – 25. 2. 83 Abschied vom Jugendbonus! Vom Einfachsten nach Hause*, München/Köln, Martin Kippenberger & Dany Keller, 1984 · *No Problem No problème*, Stuttgart, Ed. Patricia Schwarz & Galerie Kubinski, 1986 · *Was könnt ihr dafür?*, Köln, Ed. Daniel Buchholz, 1986 · *67 Improved Papertigers – Not Afraid of Repetition*, New York, Ed. Sylvester, 1987 · *Café Central. Skizze zum Entwurf einer Romanfigur*, Hamburg, Meterverlag, 1987 · *Psychobuildings*, Köln, Walther König,

1988 · *Die Welt des Kanarienvogels,* Forum Stadtpark Graz, 1989 · *Kippenbergerweg 25-2-53, Plakate 1,* Köln, Verlag der Buchhandlung Walther König, 1989 · *Hotel, Hotel,* Köln, Verlag der Buchhandlung Walther König, 1992

Bücher | Books
Martin Kippenberger, Köln, Taschen, 1991

Periodika | Periodicals
Brooke **Adams,** *Martin Kippenberger at Max Hetzler,* in : Art in America, Nr. 11, November, 1987 · Stefan, **Banz,** *Martin Kippenberger – Kunsthalle Winterthur,* in : Noema, Nr. 21, November/Dezember, 1988 · Saskia **Bos,** *L'art doit se libérer du passé,* in : Art Press, Nr. 126, Juni 1988 · Merlin **Carpentier,** *Martin Kippenberger,* in : Artscribe, Nr. 80, März/April, 1990 · Diedrich **Diedrischen,** *I'll Buy That,* in : Parkett, Nr. 19, März, 1989 · Stephen **Ellis,** *The Boys in the band,* in : Art in America, Nr. 12, Dezember, 1988 · Patrick **Frey,** *Whereof One Cannot Speak, Thereof One Should Not be Silent,* in : Parkett, Nr. 19, März, 1989 · Isabelle **Graw,** *Reworking History,* in : Flash Art, Nr. 149, November/Dezember, 1989 · Martin **Hentschel,** *Martin Kippenberger – Galerie Max Hetzler,* in : Artforum, Bd. 26, Nr. 2, Oktober, 1987 · Justin **Hoffmann,** *Martin Kippenberger – Peter Pakesch,* in : Artscribe, Nr. 68, März/April, 1988 · Friedemann **Malsch,** *Martin Kippenberger – Peter,* in : Kunstforum, Bd. 91, Oktober/November, 1987 · Stephan **Schmidt-Wulffen,** *Martin Kippenberger : Max Hetzler, Cologne,* in : Flash Art, Nr. 137

PER KIRKEBY

*Kobenhavn (DK), 1938
Lebt/Lives in Leaso-Westero,
Hellerup-Kobenhavn, Frankfurt/M.

Einzelausstellungen/One-man exhibitions

1964 Hoved-Bibliothek, Kobenhavn **1965** Den Fries Udstillingsbygning, Kobenhavn · *Euklids Raum,* Galerie Jensen, Kobenhavn **1967** Galerie 101, Kobenhavn **1968** Jysk Kunstgalerie, Kobenhavn · Fyns Stiftsmuseum, Odense **1969** Jysk Kunstgalerie, Kobenhavn **1972** *Karlsons Klister 1,* Daner Galleriet, Kobenhavn · Tranegaarden, Kobenhavn · Gentofte Kunstbibliothek, Museumausstellung, Kobenhavn · Galleri Olsen, Kredericia **1973** Galerie St. Petri, Lund **1974** Haderslev Museum, Haderslev · Galerie Michael Werner, Köln **1975** *Karlsons Klister II,* Daner Galleriet, Kobenhavn · *Retrospektive mit Zeichnungen und graphischen Blättern,* Statens Museum for Kunst, Kobenhavn **1976** Galerie Cheap Thrills, Helsingfors · Ribe Kunstmuseum, Ribe **1977** *Fliegende Blätter,* Museum Folkwang, Essen (Kat.: T. Andersen, P. K., F. Zdenek) **1978** Galerie Sven Hansen, Kobenhavn · Galerie Michael Werner, Köln · Kunstraum München e.V., München (Kat.: H. Kern, P. K.) **1979** Kunsthalle, Bern (Kat.: J. Gachnang, T. Kneubühler) · Århus Kunstmuseum, Århus **1980** Galerie Heiner Friedrich, München · Galerie Fred Jahn, München · Galerie Helen van der Meij, Amsterdam · Galerie Michael Werner, Köln (Kat.: R. H. Fuchs, J. Gachnang) **1981** Museum Ordupgaardsamlingen, Kobenhavn

(Kat.: H. Finsen, R. H. Fuchs, P. K.) · Galerie Fred Jahn, München · Himmerlands Kunstmuseum, Års **1982** *„Semele" Serie,* Galerie Michael Werner, Köln (Kat.: A. R. Penck) · Galerie Springer, Berlin · Painters Gallery, Helsingfors (Helsinki) · *Neue Bilder und Atlas Serie,* Galerie Ascan Crone, Hamburg (Kat.: M. Warnke) · Gallery Nigel Greenwood, London · Stcdclijk Van Abbemuseum, Eindhoven (Kat.: R. H. Fuchs, J. Gachnang, P. K.) · Galerie Fred Jahn, München · Taidemaalant, Helsingfors (Helsinki) **1983** *Zeichnungen 1964–1982,* Daadgalerie, Berlin (Kat.: R. Block, J. Gachnang, P. K.) · *Bilder aus der Berliner Zeit,* Galerie Springer, Berlin (Kat.: P. K.) · *6 Kobertryk,* Galerie Susanne Ottensen, Kobenhavn (Kat.: E. Fischer) · Galerie Sabine Knust, München · Galerie Gillespie-Laage-Salomon, Paris · Galerie Heinrich Erhardt, Madrid · Galerie Michael Werner, Köln · Galerie Ascan Crone, Hamburg · *Kinalampeakvareller,* Vejle Kunstmuseum, Vejle (Kat.: S. Miss, P. K.) · *Samenslutingen af Danske Kunstforening,* Kobenhavn (Kat.: P. K.) **1984** Musée d'Art Moderne, Strasbourg (Kat.: M. J. Geyer, P. K.) · *Acht Bronzeplastiken 1981–1983,* Galerie Michael Werner, Köln (Kat.: A. Franzke) · Skitmuseum, Koge · Boibrino Gallery, Stockholm · Galerie Thaddaeus J. Ropac, Salzburg · Galerie Ulysses, Wien (Kat.: J. Gachnang) · *Sechs Bilder,* Galerie Michael Werner, Köln (Kat.: P. K.) · *Malerier,* Himmerlands Kunstmuseum, Års (Kat.: P. Ronde Moller) · Anders Tornberg Gallery, Lund · *Übermalungen 1964–1984,* Kunstraum, München (Kat.: L. Horn, P. K.) · Kunstverein, Braunschweig (Kat.: D. Blume, A. Franzke, W. Bojescul, J. Klein) **1985** *Zeichnungen und Aquarelle 1979–82,* Galerie Fred Jahn, München · *Bilder, Zeichnungen, Skulpturen,* Galerie Heinrich Erhardt, Frankfurt/M. · *Paintings, Sculpture, Films,* Fruitmarket Gallery, Edinburgh/Douglas Hyde Gallery (Kat.: T. Andersen) · *Skulpturen,* Den Fries Udstillingsbygningen, Kobenhavn (Kat.: P. Laugesen) · *Skulpturen und Bilder,* Galerie Knödler, Zürich (Kat.: A. von der Borch) · *Malerier,* Himmerlands Kunstmuseum, Års · *Bilder und Skulpturen,* Galerie Ascan Crone, Hamburg · *Sculptures/Peinture,* Galerie Gillespie-Laage-Salomon, Paris · *Recent Painting & Sculpture,* Whitechapel Art Gallery, London (Kat.: T. Godfrey, P. K., N. Serota) **1986** *Grafik,* Galerie Mühlenbusch, Düsseldorf · Galerie Gillespie-Laage-Salomon, Paris · *5 Filme von Per Kirkeby,* Kunstmuseum, Bern · *7 grafiske arbeider i blandinsteknikk,* Galleri Riis, Oslo · *Großformatige Zeichnungen 1977,* Galerie Michael Werner (Kat.: P. K.) · *Grafische Arbeiten,* Galerie Meta Linde, Lübeck · *Diagrammer,* Himmerlands Kunstmuseum, Års (Kat.: P. Ronde Moller, P. K.) · *Salzburg Bilder und sieben Skulpturen,* Galerie Thaddaeus J. Ropac, Salzburg (Kat.: P. K.) · Mary Boone/Michael Werner Gallery, New York (Kat.: P. Schjeldahl) · *Skulptur und Druckgrafik,* Städtisches Museum Abteiberg, Mönchengladbach (Kat.: T. Andersen, J. Gachnang, D. Stemmler, H. Kersting, P. K.) · *Radierungen,* Maximilianverlag/Sabine Knust, München · Galerie Michael Werner, Köln (Kat.: P. K.) · *Paintings & Sculpture,* Pamela Auchincloss Gallery, Santa Barbara · *Skulptur – Projekt für Münster,* Westfälisches Landesmuseum, Münster (Kat.: K. Bussmann, P. K., F. Meschede) **1987** *Bilder und Zeichnungen,* Galerie Maeght-Lelong, Zürich (Kat.: R. H. Fuchs, C.A. Haenlein, P.

K.) · *Bilder und Skulpturen,* Kunstverein, Freiburg · *Retrospektive,* Museum Ludwig, Köln (Kat.: T. Andersen, A. Franzke, S. Gohr, P. Schjeldahl) · *Baksteensculptuur/Bachstein-Skulptur,* Museum Boymans-van Beuningen, Rotterdam (Kat.: W. Crouwel, P. K., K. Schampers) **1988** *Neue Arbeiten,* Galerie Michael Werner, Köln (Kat.: P. Schjeldahl) **1989** *Bilder und Skulpturen,* Galerie Lelong, Zürich (Kat.: F. Meschede) · *Radierungen 1990,* Maximilian Verlag/Sabine Knust, München **1990** Neue Galerie am Landesmuseum Joanneum, Graz (Kat.: K. Jungwirth, W. Skreiner) · Galerie Michael Werner, Köln (Kat.: S. Gohr) · *Maleri/Paintings – skulptur/sculptures – teckningar/drawings – böcker/books – film/films 1964–1990,* Moderna Museet, Stockholm (Kat.: S. Gohr, A. Hejlskov Larsen, L. Morell, C. Norrested, P. Schjeldahl, A. Schnack, B. Springfeldt) **1991** *Utvalgte tegninger 1983–1985,* Galleri Riis, Oslo · Philippe Guimiot, Bruxelles (Kat.: E. Devolder) · **1992** Kestner Gesellschaft, Hannover **1992** Michael Werner, Köln · Le Magasin, Grenoble · *Bilder – Arbeiten auf Papier 1981–84,* Galerie im Scharfrichterhaus, Passau · *A portfolio of six lithographs,* Maximilian Verlag – Sabine Knust, München

Gruppenausstellungen | Group exhibitions

1987 *Arco 87 – Internationale Ausstellung für moderne Kunst,* Palacio de Cristal, Madrid · *Skulptur Projekte Münster,* Westfälisches Landesmuseum, Münster · *New edition prints by Marc Chaimowicz, Enzo Cucchi, Per Kirkeby, Brice Marden, David Salle, Adrian Wiszniewski,* Nigel Greenwood Gallery, London · *Drawing, tekenen, dessin, zeichnen 87,* Museum Boymans-van Beuningen/Centrum beeldende Kunst/Kunststichting, Rotterdam · *Accrochage,* Galerie Michael Werner, Köln · *L'état des choses,* Centre de Création Contemporaine, Tours · *Frauenbilder,* Galerie Michael Werner, Köln · *Eté 1988. Images et mages,* Centre Culturel de l'Albigeois, Albi **1988** *Zeitlos,* Hamburger Bahnhof, Berlin **1989** *Bilderstreit,* Museum Ludwig, Köln · *Europese raaklijnen,* Museum Dhondt-Dhaenens, Deurle **1991** *Brennpunkt 2,* Kunstmuseum, Düsseldorf · *Seoul International Art Festival,* The National Museum of Modern Contemporary Art, Seoul · *Die Hand des Künstlers,* Museum Ludwig, Köln · *Acht Entwürfe für die Landspitze,* Städtische Galerie, Nordhorn **1991** *Das goldene Zeitalter,* Württembergischer Kunstverein, Stuttgart · *In Nebel aufgelöste Wasser des Stromes,* Aargauer Kunsthaus, Aarau

Bibliographie | Bibliography

Texte und Bücher vom Künstler
Texts and Books by the artist
Per Kirkeby Litt, (Gedichte) Nykobing Mors, Privatdruck, Morso Kunstforening, 1965 · *Bla 5,* Kobenhavn, Edition Panel 13/3, 1965 · *Copyright,* (Gedichte) Kobenhavn, Borgens Forlag, 1966 · *2,15,* (Roman) Kobenhavn, Borgens Forlag, 1967 · *I orkennen moder Maigret entropien,* Kobenhavn, Borgens Forlag, 1968 · *Bla, Tid,* (Fluxus 1968, für Henning Christiansen) Kobenhavn, Panel 13, 1968 · *Billedforklaringer,* (Essays) Kobenhavn, Borgens Forlag, 1968 · *Landskaberne,* (Bildroman) Kobenhavn, Jysk Kunstgalerie, 1969 · *Ornamentet er noget som er frataget tiden det er ren*

udstraeking fastlagt og stabilt, (Gedichte) Kobenhavn, Borgens Forlag, 1969 · *Bla, Ornament,* Kobenhavn, Borgens Forlag, 1969 · *Personerne,* (Bildroman) Kobenhavn, Jysk Kunstgalerie, 1970 · *Jüngling auf der Wanderschaft,* (Gedichte) Kobenhavn, Borgens Forlag, 1970 · *Handlingen,* (Bildroman) Kobenhavn, Jysk Kunstgalerie, 1971 · *Haendelser pa rejsen,* (Essays) Kobenhavn, Svend Hansen Forlag, 1972 · *Veijret,* (Bildroman), Svend Hansen Forlag, 1972 · *2 digte,* Kobenhavn, Borgens Forlag, 1973 · *Flyvende Blade,* (Fliegende Blätter) Kobenhavn, Borgens Forlag, 1974 · *Gron, Ornament,* Kobenhavn, Privatdruck, 1974 · *Under duebla himmel gra skyer hvide segl,* (Bildroman) Kobenhavn, Permild & Rosengreen, 1975 · *Et billedudvalg,* Kobenhavn, Forlaget Sommerko & Daner Galleriet, 1975 · *Perspektivet,* (Gedichte) Kobenhavn, Borgens Forlag, 1976 · *Die Ausstellung,* in: Kat. Arme & Beine – 5 Dänische Künstler, Kunstmuseum, Luzern, 1976 · *Naturens Blyant,* (Essays) Kobenhavn, Borgens Forlag, 1978 · *Rejser,* (Gedichte) Kobenhavn, Forlaget Swing, 1978 · *Serie,* (Bildroman) Kobenhavn, Privatdruck, 1978 · *Naturstudiet,* Kobenhavn, Borgens Forlag, 1979 · *Billeder af Haderslev, Haderslev,* Jacob Clausen, 1979 · *Klee und die Wikinger,* in : Kat. Paul Klee, Kunsthalle, Köln, 1979 · *Tegninger,* Kobenhavn, Brondums Forlag, 1980 · *Isolation af delen,* Kobenhavn, Brondums Forlag, 1980 · *Bravura,* Kobenhavn, Borgens Forlag, 1981 (dt. Ausgabe: *Bravura, Ausgewählte Essays,* Bern – Berlin, Verlag Gachnang & Springer, o.J.) · *Tegninger II,* Kobenhavn, Brondums Forlag, 1982 · *Den fortsatte tekst,* Kobenhavn, Brondums Forlag, 1982 · *Tegninger III,* Kobenhavn, Brondums Forlag, 1983 · *Kommentarer,* Kobenhavn, Brondums Forlag, 1983 · *Henvisninger,* Kobenhavn, Brondums Forlag, 1983 · *Skulpturer,* Kobenhavn, Brondums Forlag, 1984 · *Naturhistorie,* Kobenhavn, Borgens Forlag, 1984 · *Atlas,* s.l., Eks-skolens Forlag, 1984 · *Kommentarer II,* Kobenhavn, Brondums Forlag, 1985 · *Udviklingen,* Kobenhavn, Borgens Forlag, 1985 · *Skulpturer II,* Kobenhavn, Brondums Forlag, 1986 · *Kommentarer III,* Kobenhavn, Brondums Forlag, 1987 · *Edvard Weie,* s.l., Blondal, 1988 · *Efterbilleder,* Kobenhavn, Borgens Forlag, 1988 · *Kommentarer IV,* Kobenhavn, Brondums Forlag, 1989 · *Maletid,* Kobenhavn, Borgens Forlag, 1989 · *Zeichnungen,* Kobenhavn/Münster, Brondums Verlag/Kleinheinrich, 1989 · *Manet,* s.l., Blondal, 1990 · *Van Gogh. Een Jubileumjaar,* in: Kunst & Museumjournaal, Nr. 2, 1990 · *Fortgesetzter Text. Hinweise,* Bern – Berlin, Verlag Gachnang & Springer, o.J. · *Kristallgesicht,* Bern – Berlin, Verlag Gachnang & Springer, o.J. · *Rodin – La porte de l'enfer,* Bern – Berlin, Verlag Gachnang & Springer, o.J. · *Nachbilder,* Bern – Berlin, Verlag Gachnang & Springer, 1991 · *Natural History and Evolution,* Haags Gemeentemuseum, 1991

Illustrierte Bücher | Illustrated books
Thoreau, Walden, Kobenhavn, Forlaget Rhodos, 1972 · H.C. **Andersen,** *The little Mermaid,* Brondum, 1984

Bücher | Books
Troels **Andersen,** *Per Kirkeby – Werkverzeichnis der Radierungen 1977–1983,* Bern – Berlin, Verlag Gachnang & Springer, o.J.

Periodika | Periodicals
Gregory **Galligan,** *Per Kirkeby, the Ludwig Museum Retrospective: the landscape intensified by a light that will not last,* in: Arts Magazine, Nr. 2, Oktober, 1987 · François **Grundbacher,** *Wenn die Kunst fehl am Platze ist,* in: Kunst-Bulletin 2, Februar, 1987 · Isabelle **Lemaitre,** *(Reviews) Per Kirkeby,* in: Forum International, Nr. 9, September/Oktober, 1991 · Bernard **Lamarche-Vadel,** *Per Kirkeby: du sol au paysage,* in: Art Press, Nr. 134, März, 1989 · Peter **Schjeldahl,** *Effeto Kirkeby,* in: Tema Celeste, Nr. 10, Januar/März, 1987 · s.n., *Per Kirkeby* (Sonderheft/Special Kirkeby edition), in: Terksel/Threshold, Tidsskrift utgitt/periodical published by Museet for Samtidskunst/ The National Museum of Contmporary Art, Oslo, Jrg. 1, Nr. 3, 15. Dezember, 1990 · Tineke **Reijnders,** *Per Kirkeby Has made a Sculpture for Amsterdam,* in: Kunst & Museumjournaal, Nr. 2, 1990 · s.n., *Per Kirkeby, Künstler aus Dänemark: Ich liebe meine Melancholie,* in: Kassel Kulturell, Nr. 11, November, 1991

Film
1968 *Brigitte Bardot,* Fernsehproduktion/ TV-production, s/w, 16 mm, 20 Min., Texte: Hans-Jorgen Nielsen **1969** *Stevns Klint og Moens Klint,* Fernsehproduktion/TV-production, s/w, 16 mm, 40 Min., Kamera: Thor Adamsen, Musik: Henning Christiansen · *Fortllinger I,* N8, Farbe, 65 Min., priv. · *Fortllinger II,* N8, Farbe, 12 Min., priv. · *Gronlandsfilm I,* S8, Farbe, Kassette, 23 Min., Musik: Henning Christiansen **1970** *Gronlandsfilm II,* S8, Farbe, Kassette, 120 Min., 1969, forsvunnet · *Dyrehaven-den romantiske skov,* Farbe, 35 mm, 40 Min., · *Dracula I,* N 8, Farbe, 60 Min., priv. · *Dracula II,* N8, Farbe, 50 Min., priv. · *Fndelos,* 16 mm, Farbe, 90 Min., Kamera: Ole John, Musik: Henning Christiansen **1971** *Tri piger og en gris,* Farbe, 16 mm, 90 Min., In Zusammenarbeit mit/In cooperation with: Elisabeth Terkelsen, Lene Adler Petersen, Ursula Reuter Christiansen, Kamera: Teit Jorgensen, Produktion: Per Mannstaedt-Statens Film Central (SFC) · *Mexico,* N8, Farbe, 50 Min., priv. · *Den gamle Maya,* S8, Farbe, 120 Min., priv., mit/with: Michael, Teit Jorgensen **1972** *Wilhelm Freddie,* s/w, 16 mm, magnetlyd, 120 Min., Kamera: Gregers Nielsen, Filminstitutes Workshop · *Og myndighederne sagde stop,* Farbe, 16 mm, 90 Min., Kamera: Teit Jorgensen, Ton: Peter Sakse,

Schnitt: Grete Moldrup, Musik: Jens Hendriksen, Produktion: Per Maenstaedt/Statens Film Central (SFC)und DR · *Gronlandsfil III,* S8, Farbe, 110 Min., priv. · *Sklmen fra Bukhara,* S8, f, 110 Min., priv. **1974** *En erindring om et besog hos en lacandonfamilje i regnskoven i Mexico,* Farbe, 16 mm, 20 Min., Ohne Ton, Kamera: Teit Jorgensen, Per Kirkeby **1975** *Normannerne,* Farbe, 35 mm, 90 Min., mit/with: Poul Gernes, Kamera: Teit Jorgensen, Ton: Jan Juhler, Ausstattung/Decor: Peter Hojmark, Kostüme: Jette Termann, Schnitt: Maj Soya, Produktion: Nina Crone/Crone Film **1977** *Asger Jorn,* Farbe, 16 mm, 60 Min., Kamera: Teit Jorgensen, Ton: Jan Juhler, Schnitt: Grete Moldrup, Produktion: Vibeke Windelov/Statens Film Central (SFC) **1980** *Geologi er det egentlig videnskab – en simpel film,* 16 mm, f, 1, 42 Min., 1980, Statens Film Central (SFC) · *Carl Brummer,* 16 mm, Farbe, 6 Min.,, priv. · *Thorvaldsen I,* 16 mm, Farbe 16 min., priv **1989** Ekspeditionen, 16 mm, Farben, 1, 30 Min., priv.

HARALD KLINGELHÖLLER

*Mettmann (D), 1954
Lebt/Lives in Düsseldorf

Einzelausstellungen | One-man exhibitions

1981 Galerie Rüdiger Schöttle, München · P.S. 1, New York **1982** Galerie Schmela, Düsseldorf **1984** Galerie Konrad Fischer, Düsseldorf **1985** Galerie Rüdiger Schöttle, München **1986** Galerie Micheline Szwajcer, Antwerpen · Westfälisches Landesmuseum, Münster (Kat.: F. Meschede) · Galerie Philip Nelson, Lyon **1987** Galerie Bernier, Athinai **1988** Galerie Konrad Fischer, Düsseldorf · Galerie Micheline Szwajcer, Antwerpen · Museum Haus Esters, Krefeld/Kunsthalle, Bern (Kat.: J. Heynen, U. Loock, D. Zacharopoulos) **1989** Galerie Ghislaine Hussenot, Paris · Galerie Bernier, Athinai **1990** Galerie Philip Nelson, Villeurbanne/Lyon · Stedelijk Van Abbemuseum, Eindhoven (Kat.: B. Cassiman, D. Zacharopoulos) (The Whitechapel Art Gallery, London) **1991** Galerie Konrad Fischer, Düsseldorf **1992** *Skulpturen,* Portikus, Frankfurt/M.

Gruppenausstellungen | Group exhibitions

1987 *Wechselströme*, Bonner Kunstverein · *Skulptur Projekte Münster*, Westfälisches Landesmuseum, Münster *Juxtaposition*, P.S. 1, New York **1988** *Cultural Geometry*, Deka Foundation, Athinai · *BiNationale*, Städtische Kunsthalle, Kunstsammlung Nordrhein-Westfalen, Kunstverein für die Rheinlande und Westfalen, Düsseldorf (et al) · Galerie Philip Nelson, Villeurbanne/ Lyon · *L'inventaire*, Manufrance, St. Etienne · *la raó revisada*, Fundació Caixa de Pensions, Barcelona **1989** *Einleuchten*, Deichtorhallen, Hamburg **1990** *Weitersehen*, Museum Haus Lange und Haus Esters, Krefeld **1991** *Buchstäblich*, Van der Heydt-Museum, Wuppertal/Kunsthalle Barmen/ Wuppertal Elberfeld · Galeria Marga Paz, Madrid · *In anderen Räumen*, Museum Haus Lange und Haus Esters, Krefeld

Bibliographie | Bibliography

Bücher | Books
Blaue Blume, Krefeld, Kaiser Wilhelm Museum, 1984

Periodika | Periodicals
Alain **Cueff**, *Harald Klingelhöller le langage à l'oeuvre*, in: Art Press, Nr. 158, Mai, 1991 · Christian **Huther**, *Harald Klingelhöller*, in: Kunstforum, Bd. 177, 1992

Video
1990 *Zur Konfiguration von ›Fallen‹* (mit M. Kreyssig) VHS, 20 Min., Eindhoven

KURT KOCHERSCHEIDT

*Klagenfurt (A), 1943
Lebt/Lives in Wien

Einzelausstellungen | One-man exhibitions

1968 Galerie Heide Hildebrand, Klagenfurt **1970** Galerie Würthle, Wien **1972** Galerie Würthle, Wien (Kat.) **1973** Ganggalerie im Rathaus, Graz · Galerie Grünangergasse, Wien · *Bilder/Zeichnungen/Radierungen*,

F. A. Morat, Freiburg i.Br. (Kat.: K. K.) **1976** Kulturhaus, Graz · *Zeichnungen 1971–1976*, Sammlung F. A. Morat, Freiburg i.Br. (Kat.: K. K.) **1977** Galerie Schapira & Beck, Wien · Galerie Heike Curtze, Düsseldorf. **1978** *Zeichnungen 1976/1977*, Galerie Bloch, Innsbruck · Galerie Schloß Rosenberg, Zell am See **1980** *Bilder und Zeichnungen 1979/1980*, Galerie Klewan · *Bilder und Zeichnungen 1980*, Galerie Heike Curtze, Düsseldorf **1981** *Neue Bilder und Zeichnungen*, Galerie Heike Curtze, Wien **1983** Galerie Klewan, München · Galerie Albrecht, Oberplanitzing/Bozen **1984** *Neue Bilder und Zeichnungen*, Galerie Heike Curtze – Galerie Krinzinger, Düsseldorf/ Wien – Innsbruck (Kat.: D. Ronte) **1985** *Bilder 1984/85*, Reinhard Onnasch Galerie, Berlin **1986** *Trumm und Splitter*, Reinhard Onnasch Galerie, Berlin (Kat.: K. K.) · *Handläufe*, Galerie Heike Curtze, Wien (Kat.) · *Bilder 1976–1986*, Morat-Institut, Freiburg i.Br., Wien, Graz, Salzburg, Karlsruhe, Eindhoven (Kat.: G. Boehm, W. Drechsler, R. H. Fuchs, D. Ronte) **1987** Galerie Schloß Rosenberg, Zell am See **1988** *Bilder 1986–1987*, Morat-Institut, Freiburg i.Br. (Kat.: A. Vowinckel) **1990** *Ölbilder und Arbeiten auf Papier*, Galerie Heike Curtze, Wien (Kat.) · *Neue Bilder*, Galerie Springer, Berlin **1991** *Bilder 1988–1990*, Galerie Schneider, Freiburg i.Br. (Kat.) · *Werken op doek en hout/Arbeiten auf Leinwand und Holz*, Museum van Hedendaagse Kunst, Gent (Kat.: H. Scharnagl) **1992** Wiener Secession, Wien (Kat.: A. Krischanitz, C. Reder) · *Neue Bilder und Graphik*, Galerie Springer, Berlin

Gruppenausstellungen | Group Exhibitions

1989 Nykytaidetta Harallasta **1990** Art Prospective, Genève · *Vienne Aujourd'hui*, Musée de Toulon, Toulon · *Querdurch*, Bratislava **1991** Das Jahrzehnt der Malerei, Kunstforum, Wien (et.al.)

Bibliographie/Bibliography

Texte und Bücher vom Künstler
Texts and books by the artist
Einige Anleitungen zum besseren Verständnis der Malerei (1968), in: Protokolle, Nr. 1, 1971 · *Kunst und Klima*, in: Protokolle, Nr. 2, 1971 · *Das Zeichen in tropische Ländern*, in: Protokolle, Nr. 1, 1976, in: Kat. Von Anderswoher, Burg Schlaining im Burgerland, 1981 · *Il Privilegio, La fattoria-studio di Kurt Kappa Kocherscheidt a Burgenland*, Gran Bazaar, Harper's Italia, Juni/Juli, 1984 · *Maler an die Baufront*, in: Wiener Bauplätze Verschollene Träume – Angewandte Programme, Wien, Verlag Löcker, 1986

Bücher | Books
Otto Breicha, *Vorwort*, in : Kocherscheidts erweitertes Tierleben (Mappe), Wien, 1969 · Oswald Oberhuber/Kristian Sotyriffer, *Beispiele, Österreichische Kunst von Heute*, Wien/München, Edition Tusch im Verlag Schroll, 1971 · Reinhard Priessnitz, *Gerümpel und die Probleme seiner Katalogisierung*, sl., sd. · *Kurt Kocherscheidt*, Bern, Editions Benteli/Kurt Kocherscheidt, 1990 · *Kurt Kocherscheidt*, Salzburg/Wien, Residenz Verlag, 1991

Periodika | Periodicals
Luk **Lambrecht**, *Brandl, Frandsen, Herold, Heyvaert, Kocherscheidt*, in: Metropolis M, Nr. 5, Oktober, 1991

PETER KOGLER

*Innsbruck (A), 1959
Lebt/Lives in Wien

Einzelausstellungen | One-man exhibitions

1984 Galerie Hummel, Basel · Galerie Krinzinger, Innsbruck **1985** Anna Friebe Galerie, Köln · Galerie XPO, Hamburg · Gracie Mansion Gallery, New York **1986** Galerie Krinzinger, Innsbruck **1987** Anna Friebe Galerie, Köln · Atelier, Graz **1988** Galerie Karin Sachs, München **1991** Galerie Karin Sachs, München · Galerie 60, Feldkirch

Gruppenausstellungen | Group exhibitions

1987 *8 Künstler aus Österreich*, Kunstverein, Aachen · *Europalia 87*, Museum van Hedendaagse Kunst, Gent **1989** *Ein anderes Klima*, Kunsthalle, Düsseldorf · *Brennpunkt Wien*, Kunstverein, Bonn/Kunstverein, Karlsruhe · *The Flag Projekt*, Antwerpen · *Bezugspunkte 38/88*, Steirischer Herbst, Graz · *Open Mind*, Museum van Hedendaagse Kunst, Gent · *Optik der Objekte*, Kunstsalon, Graz · *Kunst der letzten 10 Jahre*, Museum Moderner Kunst, Wien · *Wien Möbel, Sezession, Wien · Biennale Istanbul*, Istanbul · *Common Market*, Richard Kuhlenschmidt Gallery, Los Angeles **1990** *Anatomy*, Galerie Krinzinger, Wien · *3 Tage Umhausen · Insbruck-Grenoble*, Maison de la Culture, Grenoble **1991** *Kurator*, Kunsthalle, Innsbruck

Bibliographie | Bibliography

Periodika | Periodicals
Klaus **Ahrens**, *Bilder aus Bits und Bytes*, in: Stern, Nr. 43, 1987 · Gerhard **Bachleiter**, *Peter Kogler*, in: Nike, Nr. 39, Juli/August/ September, 1991 · Markus **Brüderlin**, *Positionen der neuen Geometrie in Wien*, in: Kunstforum, Mai/Juni, 1987 · Helmut **Drax-**

ler, *Peter Kogler,* in: Kunstforum, Mai/Juni, 1987 · Helmut **Draxler,** *Die Optik der Objekte,* in: Noema, Nr. 1, April, 1989 · Andrea **Schurian,** *Aus dem Computer gekommen,* in: Parnass, Nr. 2, 1988 · Sabine **Schütz,** *Peter Kogler,* in: Noema, Nr. 11, April/Mai, 1987 · **s.n.,** *Peter Kogler,* in: Nike, Mai/Juni, 1988

VLADIMIR KOKOLIA

*Brno (CS), 1956
Lebt/Lives in Veverské

Einzelausstellungen | One-man exhibitions

1982 Young Artists Gallery, Brno **1983** Regional Museum, Ivancice **1984** University Club, Brno **1985** Krenova Gallery, Brno · Gallery of The Union of Youth, Praha **1986** M Gallery, Valasske Mezirici · Palace of Culture, Praha · Lidovy dum Hall, Praha · Ekko Centrum, Utrecht **1987** Medical Resaerch Centre, Brno · Na bidylku Gallery, Brno **1988** Small Gallery, Brno · Palace of Culture, Zilina · Gallery of The Town of Cadca, Cadca · Young Artists Gallery, Opava · Museum of The Town Zlin, Zlin (Kat.: I. Sedlacek) **1989** Opatov Gallery, Praha · New Gallery of The Union of Czech Writers · Young Artists Gallery, Praha · Kleine Humboldtgalerie, Berlin · OKO Gallery, Amsterdam · Barbakanegalerie, Leipzig · KPCK Gallery, Bratislava (Kat.: Z. Bartosova, V.K.) **1990** Delta Gallery, Praha · Gallery V predsali, Blansko (Kat.: J. Valoch) · Benar Gallery, Litvinov · Holzer Gallery, Villach **1991** *Narcis and Echo : Conjunction,* Headlands Center for the Arts, San Francisco · Le Pont Neuf, Paris · Regional Gallery, Roudnice

Gruppenausstellungen | Group exhibitions

1987 *Rockfest 87,* Palace of Culture, Praha · *Confrontation of Young Artists VI,* Vysocany, Praha · *The Grotesque in Czech Art,* Museum of The Capital of Prague, Praha **1988** *Rockfest 88,* Palace of Culture, Praha · *Young Czech Art,* Altenberg · *Fifteen Artists, Young Czech Generation of Eighties,* Museum of The Capital of Prague, Praha **1989** *5th Biennial of Young Moravian Artists,* House of Art, Brno · *Young Czech Artists,* University, Heidelberg · *Expressionism,* Regional Museum, Hradec Kralové · *Objects,Sculptures and Installations,* Technical Museum, Praha · *Smile, Joke and Grimace,* Palace of Culture · *Young Artists at Variance,* Vysocany, Praha · *Contemporary Czech Painters,* Warszawa · *Rockfest 89,* Palace of Culture, Praha · *Young Studios,* Gallery of The Town, Most · *Dialogue Prague/Los Angeles,* Young Artists Gallery, Praha · *Palais des Expositions,* Lyon · *Young Studios,* Mlada Fronta Gallery, Praha · *Con Amore,* Sovinec · *A description of One Struggle – Czech Avantgard of the Eighties,* Regional Museum, Roudnice · *Art for America,* Prague Market Hall, Praha **1990** *Sommer Atelier,* Deutsche Messe, Hannover · Entrepot Gallery, Poitiers · *David, Divis, Kokolia,* Painted House Gallery, Trebic · *Nine Prague Artists,* Lisboa · *Postmodernism,* Museum of Applied Arts, Praha · *Contemporary Czech Drawing,* Moravian Gallery, Brno · *Czech and Slovak Artists 1968/90,* Art Défense, Paris · Poriginal Gallery, Pori · *Stalin Monument,* Totalitarian

Zone, Praha · *Three artists from Bohemia,* P.S. 1, New York · *A.N. 90,* Köln · *Prague in Eindhoven,* Fabrik Gallery, Eindhoven · *Unofficial,* Nasau County Museum · *Expressions,* Third Eye Centre, Glagow · Czech Cultural Centre, Budapest · *New Accessions,* Gallery of Zlin, Zlin · *Brno Circle,* Young Artists Gallery, Praha · *Czech Contemporary Painting,* Wolker Hill Art Center, Seoul · *Czech Alternative,* ULUV Gallery, Praha · Folk Art Museum, Straznice · *Inoffiziell Kunst der Tschechoslowakei 69–89,* Regensburg · *Tschechoslowakei 1939–90,* Martin-Gropius-Bau, Berlin **1991** *Festival of light,* Stalin monument, Praha · *Dimensions of the Void,* Regional Gallery, Roudnice · *Dal grottesco al magico,* Instituto nazionale per la grafica calcografia, Roma · *Prague in Eindhoven,* De Krabbedans, Eindhoven · *Beitrag zum Glück,* Galerie der Künstler, München · *Nahroubeno,* Sypka Gallery, Osova Bityska

Performances Aktionen | Performances Actions

1988 Circular group copying of drawing process, with The Theatre in Motion, Brno · Faux pas performance, with Dunaj Group, Brno **1989** Latent performance (My struggle against performance), The Peace Caravane Theatre Festival, Praha

Musik | Music

1990 LP : *E,* live, Globus International

Bibliographie | Bibliography

Texte und Bücher vom Künstler
Texts and books by the artist
Zaroseny kraj, in: Kat. Karel Rossi, Galerie mladych, Brno, 1984 · *Diagram,* Atrium Gallery, Praha, 1986 · *Diagram,* Otevrena divadelni prehlika, Palace of Culture, Praha, 1986 · *Normalni malba,* in: sbornik Nr. 3, samizdat, Praha, 1986 · *Diagram,* Na bidylku Gallery, Brno, 1987 · *Roman Wenzel,* in: Kat. Na bidylku Gallery, Brno, 1988 *Sommer Atelier,* in: Atelier, Herbst, 1990 · *Narcis and Echo,* in: Kat. A.N. 90, Köln, 1990 · in: Points East Conference papers, New Beginnings, Glasgow, 1991

Periodika/Periodicals
S. **Agalides,** *Esthetic Refinements,* in: Artweek, 1990 · Egon **Bondy,** *Tri ›zakladatelé',* in: Tvorba, Nr. 20, 1991 · P. **Cap,** *Absolutni Trenazér,* in: Rock a pop, Nr. 10, 1990 · Gretchen **Faust,** *New York in review,* in: Arts Magazine, April, 1991 · Radek **Horacek,** *Na Sypce Nahroubeno,* in: Tvorba, Nr. 24,

1991 · Magda **Jurikova,** *Sochy objekty instalace,* in: Technicky magazin, Nr. 12, 1990 · Pavel **Ondracka,** *Laureati ve Spalovce,* in: Atelier, Nr. 11, 1991 · Pavla Pecinkova, *Sopko a Kokolia,* in: Atelier, Nr. 7, 1991 · Ivona **Raimanova,** *Vladimir Kokolia,* in: Opus Musicum, Nr. 4, 1987 · M. Schipper, *The Czechs are in the Mall,* in: Visions, Winter, 1990 · Philip **Vann,** *Three Czech Contemporary Artists,* British Council, 1990 · Josef **Vlcek,** *Vyvlekani hlavy z kruhu,* in: Gramorevue, Nr. 10, 1990 · Linda **Wright,** *Art of Liberation,* in: Newsweek, 13. August, 1990

Video
1986 Zlevnené zbozi Gallery, Brno · **1990** *Diagram,* A.N. 90 · *Hapesttetika,* Galerie mladych, Praha · *Totalitarian zone,* Linharte Foundation, Praha **1991** *Bago,* Czechoslovakian TV, Herbst · **1992** *Where is painting,* lecture, Clermont Art College

JOSEPH KOSUTH

*Toledo/Ohio (USA), 1945
Lebt/Lives in New York, Gent

Einzelausstellungen | One-man exhibitions

1967 *15 People present their favorite book,* Lannis Museum of Normal Art, New York **1968** *Nothing,* Gallery 669, Los Angeles · Bradford Junior College, Massachusetts **1969** The Pasadena Art Museum, Pasadena · Douglas Gallery, Vancouver · Nova Scotia College of Art, Halifax · Institutio Torquato di Tella, Buenos Aires · St. Martin's School of Art, London · Museum of Contemporary Art, Chicago · A 37 90 89, Antwerpen · Pinacotheca, St. Kilda, Victoria · Art & Project, Amsterdam · Galleria Sperone, Torino · Coventry College, Coventry · Leo Castelli Gallery, New York · The Art Gallery of Ontario, Toronto **1970** Jysk Kunstgalerie, Kobenhavn · Århus Kunstmuseum, Århus · Kunstbiblioteket i Lyngby, Lyngby · Galleria Sperone, Torino · Galerie Daniel Templon, Paris **1971** Protetch-Rivkin, Washington, DC · Galerie Paul Maenz, Köln · *Art as idea as idea,* Centro de Arte y Comunicacion, Buenos Aires (Kat.: J. Glusberg, J. K.) · City, New Jersey · Galerie Bruno Bischofberger, Zürich, Leo Castelli Gallery, New York · Galleria Toselli, Milano · Carmen Lamanna Gallery, Toronto · Lia Rumma/Studio d'Arte, Napoli **1972** The New Gallery, Cleveland · Leo Castelli Gallery, New York · Sperone Fischer Gallery, Roma **1973** Galerie Günther Sachs, Hamburg · Galerie Paul Maenz, Bruxelles · Kunstmuseum, Luzern **1974** *The tenth investigation 1974. Proposition 3,* Carmen Lamanna Gallery, Toronto · *The tenth investigation 1974. Proposition 7,* Galleria Sperone Fischer Gallery, Roma · *The tenth investigation 1974. Proposition 5,* Claire Copley Gallery, Los Angeles · Galerie La Bertesca, Düsseldorf · Musée d'Art Moderne de la Ville, Paris **1975** *The tenth investigation 1974. Proposition 4,* Leo Castelli Gallery, New York (Kat.: J. K.) · Galleria Peccolo, Livorno · *Practice,* Galerie MTL, Bruxelles · *Praxis I,* Lia Rumma/Studio d'Arte, Napoli · *Face/ Surface,* Galerie Liliane & Michel Durand-Dessert, Paris **1976** The Renaissance Society, Chicago · *Practice. Praktijk. Pratique.* Internationaal Cultureel Centrum, Antwerpen · Kunsthalle, Bremen **1978** *Tekst/Kon-*

tekst, Stedelijk Van Abbemuseum, Eindhoven · Text/Context, Museum of Modern Art, Oxford · Text/Context (Toronto) part one, Carmen Lamanna Gallery, Toronto 1979 Text/Context, New 57 Gallery, Edingburgh · Texte/Contexte, Galerie Eric Fabre, Paris · Text/Context, Galerie Paul Maenz, Köln · Text/Context, Galerie Rüdiger Schöttle, München · Text/Context, Leo Castelli Gallery, New York (Kat.: J. K.) · Text/Context, Saman Gallery, Genova · Dix descriptions partielles, Musée de Chartres, Chartres 1980 Ten partial descriptions, P.S. 1, Long Island City, New York 1981 Cathexis, Saman Gallery, Genova · Cathexis, Françoise Lambert Gallery, Milano · Bedeutung von Bedeutung, Staatsgalerie, Stuttgart (Kat.: J. K.) · Carmen Lamanna Gallery, Toronto · Cathexis, Vereniging voor het Museum van Hedendaagse Kunst/Gewad, Gent 1982 Cathexis, Leo Castelli Gallery, New York (Kat.: J. K.) · Galleria Mario Diacono, Roma · Galerie Michelle Lachowsky, Antwerpen · Galerie France Morin, Montréal · Proto investigations and first investigations..., Galerie Ghislain Mollet-Vieville, Paris · Galerie Eric Fabre, Paris 1985 Fort Dal, Leo Castelli Gallery, New York · Oeuvres récentes 1981–1985, Centre d'Art Contemporain, Genève · 2 Installations, Musée d'Art Contemporain Staint-Pierre, Lyon · Galleria Marcello Silva, Roma · New Works, Galerie Ascan Crone, Hamburg (Kat.: J. K.) 1986 Leo Castelli Gallery, New York · Work 1965–1987, Galerie Ascan Crone, Hamburg 1987 Galeria Comicos, Lisboa · Jay Gorney Modern Art, New York · New Work, Margo Leavin Gallery, Los Angeles · Recent Works, Galerie Thaddaeus Ropac, Salzburg · New Works, Galleria Giorgio Persano, Torino · Galerie Crousel-Hussenot, Paris · Kamakura Gallery, Tokyo · Galerie Georg Bertsch, Barcelona 1988 New Works, Leo Castelli Gallery, New York · ›Modus Operandi‹ Cancellato, Rovesciato, Museo di Capodimonte, Napoli · Kabinett für aktuelle Kunst, Bremerhaven 1989 Exchange of meaning, translation in the work of Joseph Kosuth, Museum van Hedendaagse Kunst, Internationaal Cultureel Centrum, Antwerpen 1990 Galeria Juana de Aizpuru, Madrid 1991 Three Installations: 1970, 1979 and 1988, RubinSpangle Gallery, New York (Kat.: J. Avgikos) · Galerie Peter Pakesch, Wien 1992 Platzverführung, Stuttgart · Protoinvestigations 1965 & The First Investigations 1967, Galerie Renée Ziegler, Zürich (Kat.)

Gruppenausstellungen | Group exhibitions

1987 Works on Paper, Galerie Ascan Crone, Hamburg · Leo Castelli and Castelli Graphics at Gabrielle Breyers..., Gabrielle Bryers Gallery, New York · Leo Castelli at Gagosian, Larry Gagosian Gallery, Los Angeles · Monsters: the phenomena of dispassion, Barbara Toll Fine Arts, New York · Light Works: 1965–1986, Rhona Hoffman Gallery, Chicago · Whitney Biennial, Whitney Museum of American Art, New York · Kosuth, Morris, Oldenburg, Serra, Stella, Therrien, Leo Castelli Gallery, New York · Sculpture of the Sixties, Margo Leavin Gallery, Los Angeles · Vito Acconci/Joseph Kosuth/Anette Lemieux, International with Monument, New York · Dessins, Galerie Cathérine Issert, Paris · Leo Castelli and his Artists, Centro Cultural Arte Contemporaneo, Mexico City · Pictoral Grammar, Barbara Krakow Gallery, Boston · Aspects of

Conceptualism in American Work: part II – modern and contemporary Conceptualism, Avenue B Gallery, New York · Conceptual Languages, Galleria Schema, Firenze · L'état Des Choses 2, Kunstmuseum, Luzern · Hommage to Leo Castelli: dedicated to the memory of Toiny Castelli, Galerie Daniel Templon, Paris · Galeria Comicos, Lisboa · The Beauty of Circumstance, Josh Baer Gallery, New York · For Collectors II: Works $ 600 & under selected by William Radawec, Cleveland Center for Contemporary Art, Cleveland · Walk out to Winter, Bess Cutler Gallery, New York · Galerie Johnen & Schöttle, Köln · Stichting De Appel, Amsterdam · 1+1, 5+2 + 2,5..., Galerie de Paris, Paris · Galerie Pakesch, Wien · Implosion, Moderna Museet, Stockholm · Nightfire, Stichting De Appel, Amsterdam 1988 Generations..., Frac, Rhône -Alpes · Gordon Matta-Clark and Friends, Galerie Lelong, New York · Pier Paolo Calzolari, Jenny Holzer, Joseph Kosuth, Mario Merz, Bruce Nauman, Keith Sonnier, Barbara Gladstone Gallery, New York · Leo Castelli: a tribute exhibition, Butler Institute of American Art, Youngstown · Blow-up, Kunstmuseum, Luzern · Locations, Tiroler Landesgalerie, Taxispalais, Innsbruck · In memory of Toiny Castelli, James Mayor Gallery, London · Corpo a Corpo, Palazzo delle Mostre e dei Congressi, Alba · Presi X Incantamento, Padiglione di Arte Contemporanea, Milano · Home Show, Santa Barbara Contemporay Arts Forum, Santa Barbara · Art Conceptuel I, Musée d'Art Contemporain, Bordeaux · SMS: a Collection of original Multiples, Reinhold-Brown Gallery, New York · Minos Beach Art Symposium, Minos Beach Hotel, Minos · The Flag Project, Gran Pavese Foundation, Rotterdam (et al.) · International Landscape, Forum Stadtpark, Graz · Altered images, The Penson Gallery, New York · Langer & Co. Fine Arts Gallery, New York · Conceptart, Stalke Gallery, Kobenhavn · Jay Gorney Modern Art, New York · Studio Guenzani, Milano · Sujet a discretion, American Fine Arts. Co., New York · In de lege ruimte, Galerij de Lege Ruimte, Brugge · Generations, Maison des Artistes, Lyon · Coleccion Leo Castelli, Fundacion Juan March, Madrid 1989 The Desire of the Museum, Whitney Museum of American Art, New York · Der Sigmund Freud Gesellschaft, Sigmund Freud Museum, Wien · Das Spiel des Unsagbaren, Ludwig Wittgenstein und die Kunst des 20. Jahrhunderts, Wiener Secession, Wien (et al.) · Words, Tony Shafrazi Gallery, New York · Natur naturata (an argument for still-life), Josh Bear Gallery, New York · James Rosenquist, Joseph Kosuth, Meyer Vaisman, Leo Castelli Gallery, New York · Marcel Duchamp, Joseph Kosuth, Eran Schaerf, Galerie Xavier Hufkens, Bruxelles ·

Fondation Daniel Templon, Musée Temporaire, Fréjus 1990 Sammlung Marzona, Kunsthalle, Bielefeld · The Brooklyn Museum Collection: the Play of the Unmentionable, Brooklyn Museum, New York · Life-Size, The Israel Museum, Jerusalem 1991 Buchstäblich, Van der Heydt-Museum, Wuppertal/Kunsthalle Barmen/ Wuppertal Elberfeld · L'artiste, l'oeuvre, l'autre, Ecole des Beaux-Arts, Rennes · Denk-Bilder, Kunsthalle der Hypo-Kulturstiftung, München 1992 Yvon Lambert collectionne, Musée d'Art Moderne de la Communauté de Lille, Villeneuve D'Ascq

Bibliographie | Bibliography

Vollständige Bibliographie
Complete bibliographical references in:
J. K.: Art after Philosophy and After. Collected Writings, 1966–1990, Cambridge, Massachusetts/London, 1991

Texte und Bücher vom Künstler
Texts and books by the artist
Any five foot sheet of glass to lean against the wall, New York, 1965 · Ad Reinhardt: The Art of an Informal Formalist: Negativity, Purity, and the Clearness of Ambiguity, Manuscript from the School of Visual Arts, New York, 1966 (mit/with Christine Koslov) · Non-anthropomorphic Art, New York, Lannis Museum, 1967 · Time art as idea as idea, in: The London Times, The Daily Telegraph, The Finacial Times, The Daily Express, The Observer, London, 27. Dezember, 1968 · Present where about unknown, New York, 1968 · Existence Art (AAIAI), in: Museum News, New York, 1. Januar, 1969 · Art after philosophy I, in: Studio International, Nr. 915, Oktober, 1969 (Artpress, 1. Dezember 1972/Januar 1973) · Art after philosophy, part II, 'Conceptual art' and recent art, in: Studio International, Nr. 916, November, 1969 · Art after philosophy III, in: Studio International, Nr. 917, Dezember 1969 · Four interviews with Barry, Heubler, Kosuth, Weiner, in: Arts Magazine, Nr. 4, Februar, 1969 · Status and priority: Terry Atkinson, Michael Baldwin, David Bainbridge and Hurell, in: Studio International, Nr. 918, Januar, 1970 · Function, Funzione, Funcion, Fonction, Funktion, Torino, Sperone Editore, 1970 · Correspondence: Kosuth Replies to Claura, in: Studio International, Nr. 919, Februar, 1970 · An Answer to Criticisms, in: Studio International, Nr. 923, Juni, 1970 · 48-Page Exhibition, in: Studio International, Nr. 924, Juli/August, 1970 · Introductory note by the American editor, in: Art-Language, Februar, 1970 (Note introductive, in: VH 101, Nr. 3, Herbst, 1970) · Kosuth on his Works, in: Flash Art, Nr. 22, Februar/März, 1971 · (Notes) On a anthropologize art, in: Kat.: Projekt 74, Köln, 1974 · The artist as anthropologist, in: The Fox, Nr. 1, 1975 · 1975, in: The Fox, Nr. 2, 1975 · Statement [21 September 1973], in: Der Löwe, Nr. 5, Juli, 1975 · Teksten/Textes, Antwerpen, Internationaal Cultureel Centrum, 1976 · Work, in: The Fox, Nr. 3, 1976 · Within the context: modernism and critical practice, Gent, Coupure, 1977 · An Ant-Catalogue, New York : The Catalogue Committee of Artists Meeting for Cultural Change, 1977 · International Local [videotaped discussion], (mit/with Sarah Charlesworth, Anthony McCall), New York Loeb Student Center, 1977 (Reprinted in: Discussion, New

York, Annina Nosei Weber ed., Milano, Out of London Press, 1980) · *1979*, in Kat.: Symposium über Fotografie, Graz, Akademische Druck-u. Verlaganstalt, 1979 (Reprinted in: Artistes, Nr. 16, Sommer 1983) · *Long Night at the Movies*, in: Art in America, Nr. 2, März, 1979 · *Portraits: Necrophilia, mon amour*, Artforum, Nr. 9, Mai, 1982 · *Cathexis 48, 1982*, in: Bomb, Nr. 5, 1983 · *Well I asked for it*, in: Museumjournaal, Nr. 3/4, 1986 · *L'arte dopo la filosofia; il significato dell' arte concettuale*, Genève, Editione Costa & Nolan, 1987 · *The Success of Failure*, in: New York, Independant Curators, Inc., 1987 · *No Exit [Project for Artforum]*, in: Artforum, März, 1988 · *Ten Questions for Franz Erhard Walther*, in: Franz Erhard Walther 1963–1983, New York, John Weber Gallery, 1988 · *Joseph Kosuth's Five recent details*, in: Journal of Contemporary Art, Winter, 1988 · *History For*, in: Flash Art, Nr. 143, November/Dezember, 1988 · *No exit*, in: Artforum, Nr. 7, März, 1988 · *T.D.O.T.F.T.-P.O.T.S.T.T.O.O.T.S.*, in: New Observations, Dezember, 1988 · (mit/with Seth Siegelaub) *Replies to Benjamin Buchloh on Conceptual Art*, in: October, Nr. 57, Sommer, 1991

Bücher | Books
Joseph Kosuth: Interviews, Stuttgart, Edition Patricia Schwarz, 1989 · J. K., *Kein Ausweg/ No Exit*, Stuttgart, Edition Cantz, 1991

Periodika | Periodicals
Artist **Page**, in: Forum International, Nr. 8, Mai/August, 1991 · Thomas **Beller**, Margret Sundell, *Interview with Joseph Kosuth*, in: Spash, Februar, 1988 · Maurice **Berger** (et al.), *L'art conceptual: L'avant et l'après*, in: Art Press, Nr. 139, September 1989 Kenneth **Baker**, *Artists in residences*, in: House & Garden, Nr. 1, Januar, 1989 · Nicolas **Bourriaud**, *Joseph Kosuth*, in: New Art International, Nr. 3 Oktober/November, 1988 · Nicolas **Bourriaud**, *Joseph Kosuth, entre les mots*, in: Artstudio, Nr. 15, Winter 1989 · Benjamin **Buchloh**, *Reply to Joseph Kosuth and Seth Siegelaub*, in: October, Nr. 57, Sommer, 1991 · Dan **Cameron**, *Joseph Kosuth da Jay Gorney Modern Art*, in: Tema Celeste, Nr. 14, Dezember 1987/Februar 1988 · Frederick **Castle**, *Occurences/New York*, in: Art Monthly, Nr. 108, Juli, 1987 · Holland **Cotter**, *Museum talk: Art & Language*, in: Art in America, Nr. 6, Juni, 1988 · Steven **Evans**, *Joseph Kosuth at Leo Castelli*, in: Artscribe, Nr. 75, Mai, 1989 · Jean-Michel **Foray**, *Art Copnceptuel: une possibilité de rien*, in: Artstudio · Colin **Gardner**, *Language of the subconcious*, in: Artweek, November, 1987 · Catherine **Grout**, *Joseph Kosuth*, in: Artefactum, Juni/Juli/August, 1991 · Susan **Hapgood**, *Language and its (dis)contents*, in: Contemoporanea, Nr. 7, Oktober, 1989 · Ronald **Jones**, *Clegg & Guttmann and Joseph Kosuth at Jay Gorney*, in: Artscribe, Nr. 61, Januar/Februar, 1987 · Michael von **Lingner**, *Kunst als Kunstdefinition*, in: Wolkenkratzer Art Journal, März/April, 1989 · Alexandro **Melo**, *Joseph Kosuth, a arte faz a o mundo*, in: Expresso, September, 1987 · Alexandro **Melo**, *Comicos Gallery, Lisbon; exhibition*, in: Flash Art, Nr. 139, März/April, 1988 · Ghislain **Mollet-Vieville**, *Exposition: Art Conceptual I*, in: Galeries Magazine, Nr. 27, Oktober/November, 1988 · Daniela **Morera**, *Joseph Kosuth*, in: Italian Vogue, Nr. 450, September, 1987 · Robert **Morgan**, *The making of wit: Joseph*

Kosuth and the Freudian palimpset, in: Arts Magazine, Nr. 5, Januar, 1988 · Robert **Morgan**, *Jay Gorney Modern Art*, New York; Exhibit, in: Flash Art, Nr. 138, Januar/Februar, 1988 · Robert **Morgan**, *The situation of conceptual art*, in: Arts Magazine, Nr. 6, Februar, 1989 · Hector **Obalk**, *Cinq pièces de Joseph Kosuth (pour les comprendre puis les juger)*, in: Art Press, Nr. 127, Juli/August, 1988 · Sania **Papa**, *Collections: Dakis Joannou*, in: Galeries Magazine, Oktober/November, 1988 · John **Perrault**, *Sleepers awake*, in: Village Voice, 13. Dezember, 1988 · David **Robbins**, *Joseph Kosuth: absolute responsibility*, in: Arts Magazine, Nr. 8, April, 1987 · Arthur **Rose**, *Four interviews*, in: Arts Magazine, Februar, 1989 · Arthur **Rose**, *The return of Arthur Rose*, in: Arts Magazine, Februar, 1989 · Mark **Ruyters**, Wim van **Mulders**, *Joseph Kosuth: Taal is Kunst-[matig]*, in: Kunst & Cultuur, Mai, 1989 · Daniela **Salvioni**, *Spotlights: Joseph Kosuth*, in: Flash Art, Nr. 143, November/Dezember · Barry **Schwabsky**, *Diversion, oblivion, and the the persuit of new objects: reflections of another biennial*, in: Arts Magazine, Nr. 10, Juni, 1987 · **s.n.**, *Album: Joseph Kosuth*, in: Arts Magazine, Nr. 3, November 1987 · Mary Anne **Staniszewski**, *Conceptual art*, in: Flash Art, Nr. 143, November/Dezember, 1988 · Robert **Walsh**, *Visual Statements*, in: Vanity Fair, Nr. 9, September 1988

MARIUSZ KRUK

*Poznan (PL), 1952
Lebt/Lives in Poznan

Einzelausstellungen | One-man exhibitions

1984 Akumulatory 2 (2 installations), Poznan · Krysztofory Gallery (pictures/objects), Krakau 1986 Obraz Gallery (pictures/objects), Poznan 1988 DESA Gallery (sculptures/pastels), Poznan 1990 AT Gallery (sculptures) 1991 Center for Contemporary Art (objects), Ujadowski Castle, Warszawa (Kat.: J. Jedlinski) 1992 Galerie Schröder, Mönchengladbach · Kunstverein, Arnsberg

Ausstellungen | Exhibitions
mit/with Kolo Klipsa

1984 Wielka 19 Gallery, Poznan 1985 Foksal Gallery, Warszawa · Wielka 19 Gallery, Poznan · BWA Gallery, Bydgoszcz · Polish Theater, Poznan 1986 Wielka 19 Gallery, Poznan · Krysztofory Gallery, Krakau · *Figures and Things*, BWA Gallery, Putawy · Contemporary Theater, Wroclaw · BWA Gallery, Olsztyn 1987 K 18, *Künstler Gruppen zeigen Gruppenkunstwerke*, Kassel

Gruppenausstellungen | Group exhibitions

1987 *What's going on*, Department of the Museum of Technology, Former Norblin Factory, Warszawa 1988 *Bruno Schulz*, SARP Pavilion, Warszawa · *And Now to Sculpture*, SARP Pavilion, Warszawa · Centrum voor Aktuele Kunst, Den Haag · *Polish Realities*, Third Eye Centre, Glasgow/Museum Sztuki, Lodz 1989 *El Dan Forum*, Ein Kerem · *Metaphisical Visions Middle Europe*, Artists Space Gallery, New York · *Festival International d'Art de Groupe, Abattoirs 89*, Marseille · *Potatoes*, BWA Gallery, Poznan 1990 Zacenta Gallery, Warszawa 1991 *Magicians and Mystics*, Center for Contemporary Art, Ujadowski Castle, Warszawa · *Sketch for a Contemporary Art Gallery*, National Museum, Warszawa · *Collection of the XXth Century Art of the Museum Sztuki*, Zacheta Gallery, Warszawa/Museum Sztuki, Lodz · *Kunst Europa*, Bonner Kunstverein (et al.) · *Festival International d'Art de Groupe*, Marseille · *Fuente. Nieuwe Kerk*, Amsterdam 1992 Le Magasin, Grenoble · Espace Lyonnais d'Art Contemporain, Lyon

GUILLERMO KUITCA

*Buenos Aires (BR), 1961
Lebt/Lives in Buenos Aires

Einzelausstellungen | One-man exhibitions

1974 Galeria Lirolay, Buenos Aires 1978 Galeria Christel K, Buenos Aires 1980 Fundacion San Telmo, Buenos Aires 1982 CAYC, Centro de Artes y Comunicacion, Buenos Aires 1984 Julia Lublin Galeria Del Retiro, Buenos Aires 1985 Elizabeth Franck Gallery, Knokke (Het Zoute) 1986 Thomas Cohn Arte Contemporanea, Rio de Janeiro · Galeria del Retiro, Buenos Aires 1987 Galeria Julia Lublin, ARCO, Feria Internacional de Arte Contemporaneo, Madrid · Galeria Pablo Figueredo, San Pablo 1988 Galeria Julia Lublin, ARCO, Madrid 1989 Galeria Atma, San José de Costa Rica · Galeria Thomas Cohn, Rio de Janeiro 1990 Annina Nosei Gallery, New York · Kunsthalle, Basel · Galerie Barbara Farber, Amsterdam (Kat.: W. Beeren, E. Lucie Smith) · Witte de With, Rotterdam (Kat.: R. Carvajal) · Städtisches Museum, Mulheim · Thomas Solomon's Garage, Los Angeles · Gian Enzo Sperone, Roma (Kat.: C. Merewether) 1991 Annina Nosei Gallery, New York (Kat.: A. B. Oliva) · *Projects 30*, Museum of Modern Art, New York (Kat.: L. Zelevansky) *New Paintings*, Galerie Barbara Farber, Amsterdam 1992 Newport Harbor Art Museum, Newport Beach · Corcoran Art Gallery, Washington, DC · Contemporary Art Museum, Houston

Gruppenausstellungen | Group exhibitions

1987 *Arte Argentino 1810–1987,* Instituto ialo-latinoamericano, Roma · *La nueva imagen, dos generaciones,* Galeria Forum, Lima · *Art of the fantastic, Latin America 1920–1987,* Indianapolis Museum of Art, Indianapolis (et. al.) · *Argentina, pintura joven,* Galeria Arte Actual, Santiago 1989 Salon Internacional Bienal L. & S., San José de Costa Rica · *U-ABC,* Stedelijk Museum, Amsterdam · *Bienal de São Paulo · New Image Painting, Argentine in the Eighties,* American Society, Art Gallery, New York · Annina Nosei Gallery, New York · Basel Art Fair, Galerie Barbara Farber, Amsterdam 1990 *U-ABC,* Fundacio Gulbenkian, Lisboa · *Tribute to Van Gogh,* Poster design, Holland · Chicago Art Fair, Annina Nosei Gallery, New York · Fiac (Annina Nosei Gallery), Paris 1991 *Metropolis,* Martin-Gropius-Bau, Berlin · Annina Nosei Gallery, New York · *Mito y Magia en America. Los '80. Marco,* Museo de Arte Contemporaneo de Monterrey, Monterrey 1992 *The Abscent Body,* Institute of Contemporary Art, Boston

Bibliographie | Bibliography

Bücher | Books
Donald **Baechler,** *Guillermo in Rio,* New York, Ajax Press, 1988 · Fabian **Legenblik,** *Kuitca,* Buenos Aires, Julia Lublin Ediciones, 1989

Periodika | Periodicals
Josefina **Averza,** *Guillermo Kuitca at MOMA,* in: Flash Art, November, 1991 · Josefina **Averza,** *Conversation with Guillermo Kuitca,* in: Lancanian Ink., Nr. 1, 1991 · Eric **Bolle,** *Op de rand van de extase en de catastrofe,* in: Metropolis M., Nr. 4, September/Oktober, 1990 · Eric **de Bruyn,** in: Artscribe, März/April 1991 · Lelia **Driben,** *El simbolo Kuitca,* in: El Nuevo Periodista, Nr. 199, 15. Juli, 1988 · Robert **Feintuch,** *Guillermo Kuitca at Annina Nosei,* in: Art in America, Nr. 9, 1990 · A. **Gasteiger,** *Kuitca,* in: Juliet, Nr. 38, Oktober/November, 1988 · Paoloa **Morsiani,** *Guillermo Kuitca,* in: Juliet Art Magazine, Nr. 48, 1990 · Donald **Greenless,** *(Interview),* in: Art News, Oktober, 1991 ·

Edward **Shaw,** *The end of sollitude: young artists on the rise,* in: Art News, Oktober 1990 · Martijn van **Nieuwenhuyzen,** *Guillermo Kuitca. Julio Galan,* in: Flash Art, Nr. 154, 1990

SUZANNE LAFONT

*Nimes (F), 1949
Lebt/Lives in Paris

Einzelausstellungen | One-man exhibitions

1986 Fondation de la Photographie, Lyon 1989 Centre de la Vieille Charité, Marseille (Kat.: J-F Chevrier) 1991 Centre genevois de Gravure Contemporaine, Genève 1992 Jeu de Paume, Paris (Kat.) · Museum of Modern Art, New York · Marian Goodman Gallery, New York

Gruppenausstellungen | Group exhibitions

1987 *Contemporary French Landscape Photography,* Museum of Art, Cleveland · *Le corps figuré 1,* Musée de Roanne, Roanne · *Le corps figuré 2,* Fondation nationale de la Photographie, Lyon 1988 *Another Objectivity,* Institute for Contemporary Arts, London 1989 *Photo Kunst: Arbeiten aus 150 Jahren,* Staatsgalerie, Stuttgart (et al.) · *Un'Altra Oggettività/Another Objectivity,* Pace-MacGill Gallery, New York (et al.) 1990 *Passage de l'image,* Centre Georges Pompidou, Paris (et al.) 1991 *Kunst Europa, (Frankreich),* Kunstverein, Ulm · *A Dialogue about Recent American and European Photography,* The Museum of Contemporary Art, Los Angeles 1992 The Israel Museum, Jerusalem

Bibliographie | Bibliography

Texte und Bücher von der Künstlerin
Texts and books by the artist
nature et classicisme: la leçon du XIXe siècle, in: Photographies, Nr. 7, Mai, 1985 · *La Mission phototgraphique de la DATAR, travaux en cours, 1984–1985,* Paris, Ed. Hazan, 1985 · *Robert Adams, l'intuition du paysage,* in: Galeries Magazine, Nr. 32, August/September, 1989 · *Je n'entrerai pas dans la pomme,* Symposium die Photographie, in: der zeitgenössischen Kunst, Ed. Cantz, Stuttgart, 1990

Periodika/Periodicals
Florette **Camard,** *Passage de l'image,* in: Galeries Magazine, Nr. 39, Oktober/November, 1990 · Jean-François **Chevrier,** *L'Atelier dans la nature,* in: Art Press, Nr. 21, Januar 1988 · Jean-François **Chevrier,** *Suzanne Lafont, l'expérience de la nature,* in: Galeries

Magazine, Nr. 30, April/März, 1989 · Jean-François **Chevrier,** *Faces,* in: Galeries Magazine, Nr. 36, April/Mai, 1990 · Jean-François **Chevrier,** *Suzanne Lafont,* in: Galeries Magazine, Nr. 48, April/Mai, 1992 · Jacinto **Lageira,** *Image, Machine, Oeuvre,* in: Les Lettres françaises, Oktober, 1990 · Antony **Iannacci,** *Prato, Another Objectivity,* in: Artscribe, Januar, 1990

JONATHAN LASKER

*Jersey City (USA)
Lebt/Lives in New York

Einzelausstellungen | One-man exhibitions

1981 Landmark Gallery, New York · Gunnar Kaldewey, Düsseldorf 1984 Annette Gmeiner, Kirchzarten · Tibor de Nagy, New York 1986 Galerie Michael Werner, Köln · Tibor de Nagy, New York · Massimo Audiello, New York 1987 Galerie Michael Werner, Köln (Kat.: J. Masheck) · *16 Drawings,* Anders Tornberg, Lund 1988 Massimo Audiello, New York · Gian Enzo Sperone, Roma 1989 Massimo Audiello, New York · *Cultural Promiscuity,* Gian Enzo Sperone, Roma (Kat.: Collins & Milazzo) 1990 Galerie Michael Werner, Köln (Kat.: J. Schwendenwien) · Anders Tornberg, Lund 1991 Galleria Gian Enzo Sperone, Roma · *4 Studies,* Schmidt-Markow, St. Louis · Annette Gmeiner, Stuttgart · *J.L.: Studies,* Galleri Lars Bohman, Stockholm · Sperone Westwater, New York

Gruppenausstellungen | Group exhibitions

1987 *The Shape of Abstraction,* Rathbone Gallery, Russell Sage College, Albany · *Interstices,* Laurie Rubin Gallery, New York · *Fortieth Biennial Exhibition of Painting,* The Corcoran Gallery of Art, Washington · Postmasters Gallery, New York · *Post-Abstract Abstraction,* Aldrich Museum of Contemporary Art, Ridgefield · *Cal-Arts; Skeptical Belief(s),* The Renaissance Society, Chicago · Massimo Audiello, New York · *Meine Maler,* Annette Gmeiner, Stuttgart · Michael Werner, Köln · *New York, New Art,* Mayor Rowan Gallery, London 1988 Lang & O'Hara, New York · *Art At The End Of The Social,* Roos Museum, Malmö · *Hybrid Neutral,* University of North Texas, Denton (et al.) · *The Kaldwey Press,* Metropolitan Museum of Art, Thoman J. Watson Library, New York · *Schwarzwaldbild,* Kunstverein Hochrhein e.V., Villa Berberich, Bad Säckingen · *Benefit Exhibition,* White Columns, New York 1989 *Diagrams & Surrogates,* Shea & Beker, New York · *Horn of Plenty/Hoorn van overvloed,* Stedelijk Museum, Amsterdam · *The Pellizzi Collection,* Emily Lowe Gallery, Hofstra University Hempstead · *The Silent Baroque,* Galerie Thaddaeus Ropac, Salzburg · *Specchi Ustori,* Galleri Regionale di Palazo Bellomo, Siracusa · *Drawings,* Daniel Newburg, New York 1990 *Spellbound,* Marc Richards Gallery, Los Angeles · *Token Gestures,* Scott Hanson Gallery, New York · Anders Tornberg, Lund · *Mythic Moderns,* Real Art Ways, Hartford · *Benefit Exhibition,* Nicole Klagsbrun, New York · *Worlds '90 International Art Show,* Joensuu Art Museum, Joensuu · *Benefit Exhibition,* Daniel Weinberg, Los Angeles · *The Last Decade: American Artists of the*

80's, Tony Shafrazi, New York · *Painting Alone*, Pace Gallery, New York · *Clifford Still: A Dialogue*, Philippe Briet, New York · *Paper: The History of an Art*, New York Public Library, Goottesman Exhibition Hall, New York · *Fortieth Anniversary Exhibition*, Tibor de Nagy, New York **1991** *Strategies For The Next Painting*, Wolff Gallery, New York/Feigen, Inc., Chicago · *Between Intuition and Reason: Saint Clair Cemin and Jonathan Lasker*, Grossman Gallery, School of Museum of Fine Arts, Boston · *The Thing*, Perry Rubenstein, New York · *Hybrid Abstract*, Uaden Gallery, Bennington College, Bennington · *Anni Novanta*, Galleria Communale d'Arte Moderna Bologna, Bologna · *Summer Group Exhibition*, Sperone Westwater, New York

Bibliographie | Bibliography

Periodika | Periodicals
Paolo **Balmas**, *New York, A Kaleidoscope From Outside*, in: Segno, Annual Edition, 1990 · Marja **Bosma**, *Horn of Plenty*, in: Contemporanea, Mai, 1989 · David **Carrier**, *Washington: Corcoran Gallery*, in: Burlington Magazine, Juli, 1987 · David **Carrier**, *Abstract Working Spaces*, in: Art International, Nr. 10, Frühjahr, 1990 · Matthew **Collings**, *Posthumous Meaning: Tricia Collins & Richard Milazzo Interviewed*, in: Artscribe, September/Oktober, 1987 · **Collins & Milazzo**, *Hybrid Neutrale*, in: J.A.A. Journal, Nr. 7, 1987 · **Collins & Milazzo**, *From Kitsch And Back Again*, in: Tema Celeste, Januar/Februar, 1991 · Helmut **Draxler**, *The Silent Baroque*, in: Flash Art, Oktober, 1989 · Nikolai B. **Forstbauer**, *Jonathan Lasker: Why Things are Born Yesterday*, in: Zyma Art Today, Nr. 3, Juni/Juli, 1991 · Shoichiro **Higuchi**, *Artist in New York: Jonathan Lasker*, in: Anthrops, November, 1989 · Shoichiro **Higuchi**, *Jonathan Lasker, This Side And The Opposite Side Of Lasker's Screen*, in: Idea, März, 1990 · Lise **Holst**, *Diagrams and Surrogates*, in: Art News, Mai, 1989 · Alan **Jones**, *Carte Blanche; Books in Artists' Lives, Part II*, in: Arts Magazine, Februar, 1991 · Shirley **Kaneda**, *Interview with Jonathan Lasker*, in: Bomb, Winter, 1989/90 · Shirley **Kaneda**, *Painting and Its Others*, in: Arts Magazine, Sommer, 1991 · Shirley **Kaneda**, *Painting Alone*, in: Arts Magazine, Dezember, 1990 · Jutta **Koether**, *Jonathan Lasker At Michael Werner, Cologne*, in: Artscribe, September, 1987 · Angela **Lombardi**, *Interview With Jonathan Lasker*, in: Tema Celeste, April/Juni, 1989 · John **Loughery**, *Affirming Abstraction: The Corcoran Biennial*, in: Arts Magazine, September, 1987 · Steven **Madoff**, *Washington, D.C.: An Inevitable Gatering*, in: Art News, September, 1987 · Alessandra **Mammi**, *Jonathan Lasker: Galleria Gian Enzo Sperone*, in: Artforum, Februar, 1989 · Joseph **Masheck**, *Painting In Double Negative, Jonathan Lasker's Third-Stream Abstraction*, in: Arts Magazine, Januar, 1990 · Pat **McCoy**, *»Interstices« Laurie Rubin*, in: Artscribe, Sommer, 1987 · Martijn Van **Niewenhuyzen**, *Horn of Plenty*, in: Flash Art, März/April, 1989 · Saul **Ostrow**, *Painting Alone*, in: Tema Celeste, Januar/Februar, 1991 · Demetri **Paparoni**, *Conversation With Jonathan Lasker*, in: Tema Celeste, Oktober/Dezember, 1989 · Demetri **Paparoni**, *Le Pulsioni Dell'Arte*, in: Riza Scienze, April, 1991 · Carter **Ratcliff**, *Notes In Line*, in: Art in America, Juni, 1990 · David **Reisman**, *Token Gestures : Scott Hanson, Curated by Collins & Milazzo*, in: Artscribe, September/Oktober, 1990 · Barry **Schwabsky**, *Forwarding Address: Abstract Painting In Some Recent Manifestations*, in: Arts Magazine, November, 1990 · Jude **Schwendenwien**, *The Silent Baroque*, in: Contemporanea, Oktober, 1989 · Jude **Schwendenwien**, *A Thousand Words, Jonathan Lasker's Sublime Discourse*, in: Artscribe, Januar/Februar, 1990 · Noemi **Smolik**, *Who ever Sets Up Urinals Shouldn't Wonder When They're Pissed Into*, in: Wolkenkratzer Art Journal, Nr. 1, Januar/Februar, 1987 · John **Zinser**, *Jonathan Lasker at Massimo Audiello*, in: Art in America, November, 1988

JAC LEIRNER

*São Paulo (BR), 1961
Lebt/Lives in São Paulo

Einzelausstellungen | One-man exhibitions

1982 Galeria Tenda, São Paulo (mit Acao) (Kat.: J. Plaza) **1987** *The One Hundreds*, Petite Galerie, Rio de Janeiro · *Lung*, Galeria Millan, São Paulo **1989** *Names*, Galeria Millan, São Paulo (Kat.: G. Brett) **1991** *Currents*, Institute of Contemporary Art, Boston · The Museum of Modern Art, Oxford (Kat.: D. Elliot) · *Viewpoints*, Walker Art Center, Minneapolis (Kat.: B. Ferguson) **1922** Galerie Hoffmann, Friedberg

Gruppenausstellungen | Group exhibitions

1988 *National Fine Arts Exhibition*, National Art Foundation, Rio de Janeiro · Petite Galerie, Rio de Janeiro · *Paper in Space*, Aktuell Galerie, Rio de Janeiro · *Tridemnsional Forms*, Museum of Modern Art, São Paulo **1989** Basel Art Fair, Galerie Andata/Ritorno (Genève) · *Biennale de São Paulo, Art in Newspaper*, São Paulo **1990** *Transcontinental*, Ikon Gallery, Birmingham · Art Frankfurt, Galerie Hoffmann (Friedberg) · Galerie Bruno Musatti, São Paulo · Contemporary Art Brazil/Japan, Tokyo Central Museum (et al.) · *Aperto*, Biennale di Venezia, Venezia · *S*, Gust Vasiliades Gallery, New York · *Past Future Tense*, Winnipeg Art Gallery, Winnipeg (et al.) **1991** *Viva Brasil Viva*, Kulturhuset, Stockholm · *Brazilian Art: The New Generation*, Fundación Museo de Belas Artes, Caracas · *TransMission*, Rooseum, Center for Contemporary Art, Malmö **1992** *By Arrangement*, Galerie Ghislaine Hussenot, Paris · *Dominant White*, Galerie São Paulo, São Paulo · Galerie Camary, Vilaça

Bibliographie | Bibliography

Periodika | Periodicals
Tadeu **Chiarelli**, *Jac Leirner*, in: Galeria Revista de Arte, Nr. 16, 1989 · Michael **Corris**, *Não exótico: Jac Leirner*, in: Artforum International, Dezember 1991 · Anne **Dagbert**, in: Art Press, Dezember, 1989 · Paulo **Herkenhoff**, *Arte è Money*, in: Galeria Revista de Arte, Nr. 24, 1991 · Giovanni **Joppolo**, in: Opus International, Nr. 120, 1990 · Jeffrey **Kestner**, *Jac Leirner*, in: Tema Celeste, Februar 1992 · Tim **Martin**, *Jac Leirner*, in: Art Monthly, October 1991 · Riddle **Mason**, *Jac Leirner*, in: Arts Magazines, März 1992 · Michel **Nuridsany**, in: Galeries Magazine, August/September, 1990 · Desa **Phillipi**, in: Artforum, Sommer, 1990 · Adrian **Searle**, in: Artscribe, Sommer, 1990 · Robert **Silbermann**, *Jac Leirner at the Walker Art Center*, in: Art in America, Februar 1992 · Timo **Valjakka**, *Jac Leirner: rahaa ja tupakkaa*, in: Taide, Bd. 30, Nr. 3, 1990

ZOE LEONARD

*New York (USA), 1961
Lebt/Lives in New York

Einzelausstellungen | One-man exhibitions

1979 Fourth Street Photo Gallery, New York **1983** Hogarth Gallery, Sydney **1985** Greathouse, New York **1990** Galerie Gisela Capitain, Köln (Kat.: J. Koether) **1991** Luhring, Augustin Hetzler, Los Angeles · University Art Museum, University of California, Berkeley (Kat.: L. Rinder) · Trans Avant-Garde Gallery, San Francisco (Kat.: J. Hanley) · Richard Foncke Gallery, Gent · *Photographien*, Galerie Gisela Capitain, Köln

Gruppenausstellungen | Group exhibitions

1987 *Consonance*, ISD, New York **1988** *Selections from the Artists' File*, Artists Space, New York **1989** *Strange Attractors: Signs of Chaos*, New Museum of Contemporary Art, New York · *First Amendment Show*, Sally Hawkins Gallery, New York · *War Resisters' League Benefit*, 101 Spring St., New York · *The Female Eye*, Circus Maximus, New York · *The Center Show*, Lesbian and Gay Community Center, New York · *Aids Tileline*, Group Material, Berkeley **1990** *Groupshow*, Luhring Augustine & Hodes Gallery, New York · *The Köln Show*, Köln · *Wendy Jacobs & Zoe Leonard*, Andrea Rosen Gallery, New York · *Survey of Gay & Lesbian Artists*, Penine Hart Gallery, New York · *Ponton Temse*, Museum van Hedendaagse Kunst Gent, Temse · *Works on Paper*, Paula Allen Gallery, New York ·

Act Up Auction For Action, Paula Cooper Gallery, New York **1991** *From Desire. A Queer Diary*, St. Lawrence University, Richard F. Brush Art Gallery · *Gulliver's Reisen*, Galerie Sophia Ungers, Köln · *New Museum Benefit Auction*, New Museum, New York · *Zoe Leonard*, University Art Museum at U.C. Berkeley, Matrix Gallery · *John Baldessari, Burt Barr, Robert Gober/ Sherrie Levine, Ronald Jones, On Kawara, Zoe Leonard*, Paula Cooper Gallery, New York

Bibliographie | Bibliography

Periodika | Periodicals
Isabelle **Graw**, *Ein Interview mit Zoe Leonard,* in: Texte zur Kunst, Herbst, 1991 · Susan **Kandel**, *Zoe Leonard,* in: Arts Magazine, Mai, 1991 · Jutta **Koether**, *Zoe Leonard,* in: Flash Art, Sommer, 1990 · Luk **Lambrecht**, *Zoe Leonard,* in: Forum International, Nr. 9, September/Oktober, 1991 · Arlene **Raven**, *Fo(u)r Freedoms,* in: Village Voice, 10. Oktober, 1989 · Laura **Trippi**, *The Strange Attraction of Chaos,* in: New Art International, 1990

Film · Video
1987 *Films by Photographers,* White Columns, New York (Cuarator) **1988** *Before the Dawn* (Still Photographer), directed and produced by Amy Goldstein **1989** *Keep Your Laws Off My Body,* mit/with Catherine Saalfield, 12 Min. Video: Erotophobia, Simon Watson, New York City, AIDS Timeline, Group Material · Target City Hal, DIVVA T.V. (Member of Collective) **1990** *Keep Your Laws Off My Body,* Frameline, San Francisco Gay and Lesbian Film and Video Festival, Juni; American Film Institute Video Festival; American Film Institute Video Festival, November **1991** *Keep Your Laws Off My Body,* British Film Institute, Lesbian and Gay Film Festival; The New Festival, Biograph Theatre, New York; ICA, Boston, August · *East River Park,* 4 Min., s/w; 5th New York Lesbian and Gay Experimental Film Festival, Anthology Film Archives, New York, September · *Motion Pinchers: 8 Films at 4 Walls,* Su Friedrich, Michael Gitlin, Brooklyn

EUGÈNE LEROY

*Tourcoing (F), 1910
Lebt/Lives in Wasquehal

Einzelausstellungen | One-man exhibitions

1937 Galerie Monsallut, Lille **1943** Galerie Else Clausen, Paris (Kat.: G. Diehl) **1946/47** Salon d'Automne, Paris **1948** Galerie Marcel Evrard, Lille **1954** Galerie Art Vivant **1955**

Galerie A. Droulez, Reims **1956** Salon de Mai, Galerie Creuze, Paris **1957** Musée de Dunkerque, Dunkerque **1958** Musée des Beaux-Arts, Tourcoing (Kat.: G. Waldemar) **1959** Galerie Synthèse, Paris · Galerie Création, Roubaix **1960** Galerie Betty Thommen, Basel **1961** Galerie Claude Bernard, Paris **1962** *Les Peintres de l'Ecole de Paris*, Mave **1963** Galerie Claude Bernard, Paris (Kat.: J. Bornibus) **1964** Galerie Kaleidoscoop, Gent · Carnegie Institute, Pittsburgh **1965** Harvard University, Cambridge USA · Galerie Nord, Lille **1966** Galerie Pilotes, Lausanne **1970** Galerie Veranneman, Brussel (Kat.: E. Leroy) · Wiener Sezession, Wien **1971** Galerie Nord, Lille (Kat.: S. Fontan) **1972** Galerie Septentrion, Marcq-en-Baroeul **1977** Ecole des Beaux-Arts, Lille (Kat.: F. Mathey) **1978** Galerie Jean Leroy, Paris (Kat.: C. Bouyeure) **1979** *Rétrospective de l'œuvre gravéé, IVe Biënnale de Gravelines* (Kat.: D. Daubriat) · Galerie Jean Leroy, Paris · Fiac 1979, Paris **1980** Galerie K, Washington **1982**, Museum van Hedendaagse Kunst, Gent (Kat.: R. Jooris, J. Hoet) **1983** *Acht Bilder*, Galerie Michael Werner, Köln (Kat.: M. Deswarte) · *Bilder 1955–82*, Galerie Ascan Crone, Hamburg (Kat.: J. Clair) · Galerie Winter, Wien (Kat.: H. Draxler) · Galerie Springer, Berlin (Kat.: J. Hoet) **1984** Galerie Jean Bernier, Athinai · Edward Thorp Gallery, New York **1985** *Fünf Bilder*, Galerie Michael Werner, Köln (Kat.: R. Jablonka) · Galerie Winter, Wien · Edward Thorp Gallery, New York · Galerie Richard Foncke, Gent **1986** Galerie Gillespie-Laage-Salomon, Paris **1987** *Zeichnungen*, Galerie Michael Werner, Graphische Räume, Köln · Musée d'Art Moderne, Villeneuve d'Ascq (Kat.: G. Baselitz, R.H. Fuchs, R. Jablonka, J. Lasker, B. Marcadé) **1988** Stedelijk Van Abbemuseum, Eindhoven/Musée d'Art Moderne de la Ville, Paris (Kat.: H. Driessen, R.H. Fuchs, E. Leroy, B. Marcadé, S. Pagé) · Galerie Richard Foncke, Gent · *Recent Paintings*, Edward Thorpe Gallery, New York · *Dessins 1965–90*, Musée Sainte-Croix, Poitiers **1989** *Zehn Bilder*, Michael Werner, Köln (Kat.: F. Hergott) · Galerie Isy Brachot, Bruxelles · *Recent Paintings*, Galerie Richard Foncke, Gent **1990** *Neue Bilder*, Galerie Springer, Berlin (Kat.: H. Obalk) · Galerie Laage-Salomon, Paris · *Recent Paintings*, Edward Thorp Gallery, New York · *Dessins 1965–1990*, Musée Sainte-Croix, Poitiers (Kat.: B. Cha-

vanne) **1991** *Schilderijen 1945–1960*, Magnus Fine Arts, Gent (Kat.: B. Lamrche Vadel) · Galerie de France, Paris (Kat.) · *Eugène Leroy – nus, portraits, paysages, 1960–1981*, Galerie Protée, Paris · Musée des Beaux-Arts, Dunkerque **1992** Galerie Michael Werner, Köln (Kat.: H. Weidemann)

Gruppenausstellungen | Group exhibitions

1987 *Accrochage*, Galerie Michael Werner, Köln **1988** *Signaturen*, Museum van Hedendaagse Kunst, Gent · *Art Français du XXème siècle*, Musée National d'Art Contemporain, Seoul · *Uit de verzameling van stichting Veranneman*, De Brakke Grond, Amsterdam · *Van Abbe-Museum*, Musée d'Art Contemporain, Nimes **1989** *Bilderstreit*, Museum Ludwig, Köln · *Europese raaklijnen*, Museum Dhondt-Dhaenens, Deurle · *Open Mind*, Museum van Hedendaagse Kunst, Gent · *Portrait*, Galerie Ascan Crone, Hamburg **1990** *Le Diaphane*, Musée des Beaux-Arts, Tourcoing **1991** *Dodeigne. Leroy*, Provinciaal Museum voor Moderne Kunst, Oostende · *Bienal de São Paulo* · *L'amour de l'art*, Biennale d'Art Contemporain de Lyon, Lyon · *D'une Décennie... l'autre*, Galerie de France, Paris

Bibliographie | Bibliography

Bücher | Books
Fabrice **Hergott**, *Le retour d'Ulysse / De terugkeer van Odysseus/Ulysses returns*, Eindhoven, Stedelijk Van Abbemuseum, 1988 · Jean **Clair**, *Eugène Leroy, peinture, lentille du monde*, Bruxelles · Irmhild **Lebeer**, Hossmann, 1979

Periodika | Periodicals
Alain **Busine**, *Les murailles de peinture d'Eugène Leroy*, in: Art Press, Nr. 121, Januar, 1988 · Florette **Camard**, *Eugène Leroy*, in: Galeries Magazine, Nr. 45, Oktober/November, 1991 · Holland **Cotter**, *Eugène Leroy at the Stedelijk Van Abbemuseum*, in: Art in America, November, 1988 · Gerard **Durozoi**, *Expositions: Eugène Leroy, Musée d'Art Moderne Villeneuve d'Ascq*, in: Art Press, Nr. 117, September, 1987 · Bernard **Marcadé**, *Sans titre-Situations françaises*, in: Art Studio, Nr. 5, Sommer, 1987 · Bernard **Marcadé**, *Portrait. Eugène Leroy*, in: Beaux Arts, Nr. 49, September, 1987 · Bernard **Marcadé**, *La Peinture d'Eugène Leroy. Lumière derrière, lumière devant*, in: Galeries Magazine, Juni/Juli, 1988 · s.n., *Eugène Leroy*, in: Sans Titre, Bulletin d'Art Contemporain, publié par l'A.C.R.A.C., Lille, Juli/August/September, 1988 · Daniel **Soutif**, *Review: Eugène Leroy – ARC, Musée d'Art Moderne de la Ville de Paris*, in : Artforum, 1988

Film
Bernard, Claeys, *Eugène Leroy*, 16 mm., ORTF, Lille, 1968

VIA LEWANDOWSKY

*Dresden (D), 1963
Lebt/Lives in Berlin, New York

Einzelausstellungen | One-man exhibitions

1988 *Im Eischweiß der letzten Tausend Tage (In the Egg Sweat of the Last Thousand Days)*, VEB Denkmalpflege, Dresden · *Tag des Grasessers (Day of the Grass Eater)*, (19. 6.), Zionskirche, Dresden · *Sublime Liebe (Sublime Love)*, (mit/with Else Gabriel) Samariterkirche, Berlin (DDR) · *Ahnen im Aus (Ancestors Out)*, Klubhaus ›Arthur Hoffmann‹, Leipzig 1989 *Sie können nichts schreien hören – Acht Porträts zur Euthanasie (They can't hear Anything screaming – Eight Portraits on Euthanasia)*, Neue Gesellschaft für bildende Kunst, Berlin (Kat.: D. Grünbein, C. Tannert) 1990 *Zwölf Bahren zur Verbrüderung (Twelfe Stretchers for Fraternization)*, Galerie Vier, Berlin (DDR) (Kat.: D. Grünbein, R. Rheinsberg, T. Wulffen) 1991 *Biologie der Ermüdung (Biology of Fatigue)*, Stadtgalerie Saarbrücken (Kat. V. L.) · *Perplexing Intangibilities Like Taste*, Goethe-Institut, Toronto · *Erfüllung (Fulfillment)*, (Art Cologne) Galerie Sonne, Berlin 1992 *Motor (Something about Resuming of the Terminal Vilocity)*, Galerie Sonne, Berlin

Gruppenausstellungen | Group exhibitions

1989 *Menetekel*, Galerie Nord, Dresden · *Neue Kunst aus Dresden*, BASF-Feierabendhaus, Ludwigshafen · *Zwischenspiele (Intermezzos)*, Elefanten Press Galerie, Berlin (West) · *Junge Ostberliner Künstler II*, Ausstellungszentrum unterm Fernsehturm, Berlin (DDR) 1990 *L'autre allemagne hor les murs*, La Grande Halle de La Villette, Paris · *Die Kerbe im Boot (The Notch in the Boat)*, Galerie Sonne, Berlin · *Jetzt Berlin (Now Berlin)*, Kunsthalle, Malmö (et al.) · *Change of Gait*, Ann Arbor, Detroit (et al.) · *Zur Lage des Hauptes (On the Position of the Head)*, Berlin 1991 *Frühes Erkennen (Early Recognition)*, Beitrag zu: *Calculi*, Neuer Berliner Kunstverein, Berlin · *Fäulnisprobe (Rotting Trial)* Beitrag zu: *L'Ordine Delle Cose*, Palazzo delle Esposizioni, Roma · *Reste des Problems (The Residuals of the Problem)* Beitrag zu: *Interferenzen*, Riga (et al.) · *Bemerke den Unterschied*, Kunsthalle, Nürnberg · *Direkte Verherrlichung (Direct Gloryfication)* Beitrag in: *Models of Reality: Approaches to Realism in Modern German Art*, Harris Museum, Preston · *Zukunft – Biologie der Ermüdung IV (Future – Biology of Fatigue IV)* Beitrag in: *Acht mal zwei aus Sieben*, Neue Galerie, Graz (et al.) 1992 *Counclusion by Destruction*, Beitrag in: *Encounters with Diversity*, P.S. 1, New York · *Counterselection*, Beitrag in: *Interface*, Corcoran Gallery of Art, Washington, DC

Performances

1985 *Langsam nässen*, Hochschule für Bildende Künste, Dresden, mit Karina Alisch, Micha Brendel, Else Gabriel, Rainer Görss 1986 *Spitze des Fleischbergs*, Hochschule für Bildende Künste, Dresden, mit Micha Brendel, Peter Dittmer, Else Gabriel, Rainer Görss, Hanne Wandtke 1987 Gründung der Gruppe/Foundation of the Group »Auto-Perforations-Artisten« durch/between Micha Brendel, Else Gabriel, V. L., in Zusammenarbeit mit/with Peter Dittmer, Rainer Görss u.a. · *Herz Horn Haut Schrein*, Hochschule für Bildende Künste, Dresden, mit Micha Brendel, Else Gabriel · *Vom Ebben und Fluten*, Leonhardi Museum, Dresden mit/with Autoperforatonsartisten 1988 *RumpfStampfen*, Akademie der Künste, Berlin (DDR), mit Micha Brendel, Else Gabriel, Rainer Görss · *Im Eischweiss der letzten tausend Tage*, VEB Denkmalpflege Dresden, mit Else Gabriel · *Ghettohochzeit*, Samariterkirche, Berlin (DDR), mit Durs Grünbein · *Panem et circenses*, Hochschule für Bildende Künste, mit Micha Brendel, Rainer Görss 1989 *Verlesung der Befehle*, Galerie Nord, Dresden, mit Durs Grünbein · *Trichinen auf Kreuzfahrt*, Galerie Weißer Elefant, Berlin (DDR) · *Deutsche Gründlichkeit*, Galerie Weißer Elefant, Berlin (DDR), mit Durs Grünbein · *Humunkulusmonolog*, Hochschule für Bildende Künste Dresden, zu »Midgard« von Rainer Görss, mit Micha Brendel, Hanne Wandtke · *Von Ost nach Nord*, Hochschule für Bildende Künste, Dresden, zu »Midgard« von Rainer Görss, mit Durs Grünbein, Suheer Saleh · *So tröstet uns Beständigkeit*, Ausstellungszentrum am Fernsehturm, Berlin (DDR), mit Micha Brendel, Else Gabriel, Rainer Görss · *An alles denken*, Art Betweens, Potsdam, mit Durs Grünbein · *So tröstet uns Beständigkeit*, Elefanten Press Galerie, Berlin, mit Micha Bendel, Else Gabriel, Rainer Görss 1990 *Hitlers Ohr rosig im Bunker der Reichskanzlei*, La Grande Halle de La Villette, Paris, mit Durs Grünbein · *Wir sind wie alle*, La Grande Halle de La Villette, Paris, mit Micha Brendel, Else Gabriel, Rainer Görss · *Leibbrand*, Ballhaus Düsseldorf, mit Else Gabriel · *Hauptsache gesund (I–III)*, Casino Stuttgart, Kleine Schalterhalle, Kulturzentrum Mitte, Stuttgart, mit Else Gabriel, Micha Brendel · *V.I.V.*, Teil 1: SO 36, Berlin, Teil 2: *Der Kongress*, Bahnhof Westend, Berlin, Teil 3: *Tacheles*, Berlin, mit Else Gabriel, Hans J. Schulze 1991 *Das Ende (5)*, Moltkerei, Köln, mit Else Gabriel, Micha Brendel · *Das Problem der Verjüngung*, Moltkerei, Köln, mit Durs Grünbein · *An den Wangen werdet ihr mich erkennen*, Neue Galerie, Graz, mit Freie Praxis – Pina Lewandowsky

Bibliographie | Bibliography

Texte vom Künstler/Texts by the artist
Beuys Beine machen, in: U.S.W. XI, 1986–87, hg. v. Micha Brendel, Selbstverlag, Dresden 1987

Periodika | Periodicals
Katrin Bettina **Müller**, *Eigentum der Wunden*, in: TAZ, 14.12.1989 · Thomas **Wulffen**, *Via Lewandowsky*, in: Kunstforum, Bd. 106, 1990

Super-8-Film
1985 *3 Min 50 sec*, 8 Min., Farbe/s/w, Cabaret Voltaire · *Femilia*, 12 Min., Farbe/s/w, Musik variabel · *Dresden – Blühende Stadt am Strom*, 28 Min., Farbe/s/w, Musik-Mix 1986 *Advent im Bezirk*, 22 Min., Farbe/s/w, Sampler, Voices and Noices · *Sublime Liebe*, mit Else Gabriel, 16 Min., s/w, Ethno-Pop-Mix 1987 *Report*, 8 Min., s/w, Test Department · *Herz Horn Haut Schrein*, mit Micha Brendel, Else Gabriel, 30 Min., Farbe · *Eloi*, 16 Min., s/w, Geräuschcollage, Radio Moskau · *European Art Festival*, Osnabrück 1988 *Eisenwinter*, 6 Min., Farbe, Officine Schwartz · *Herz Horn Haut Schrein*, – Werbefassung, 8 Min., Farbe, Zimmergeräusche · *Doublage Fantastique*, mit Jana Milev, 17 Min., Farbe, Musik-Mix · *European Art Festival*, Osnabrück 1990 *No Budget*, Filmfestival, Hamburg

BERND LOHAUS

*Düsseldorf (D), 1940
Lebt/Lives in Antwerpen

Einzelausstellungen | One-man exhibitions

1965 *El Nacimiento del Huevo*, La Asociacion Cultural Iberoamericana, Madrid (Kat.: M. Viola) 1967 New Smith Gallery, Bruxelles 1969 Galerie René Block, Berlin 1970 Galerie Mickery, Lonersloot 1971 Galerie MTL, Bruxelles 1972 Galerie Les Contemporains, Genval 1973 Galerie 14, Paris 1975 Verelst-Poirier, Antwerpen 1976 Galerie MTL, Bruxelles 1977 Konrad Fischers Raum, Düsseldorf · Vereniging voor het Museum van Hedendaagse Kunst, Gent · Galerie Albert Baronian, Bruxelles 1978 Haus Nieting, Geldern 1979 Stedelijk Van Abbemuseum (Kat.: R. H. Fuchs) 1980 Kunstmuseum, Düsseldorf (Kat.: J. Bremer, A. Moerenhout, S. von Wiese) · Provinciaal Begijnhof, Hasselt · Kunstraum, München 1981 Galerie Albert Baronian, Bruxelles · Internationaal Cultureel Centrum, Antwerpen (Kat.: W. Van Mulders) 1982 Zeeuws Kunsrenaarscentrum, Middelburg (Kat.: B. L.) · Vereniging voor het Museum van Hedendaagse Kunst, Gent · Galerie Maier-Hahn, Düsseldorf · Galerie L'A, Liège 1984 Haus Nieting, Geldern 1985 Galerie Micheline Szwajcer, Antwerpen · Palais des Beaux-Arts, Bruxelles (Kat.: T. Duve, B.L.) 1986 Galerie de Lege Ruimte, Brugge · Galerie Maier-Hahn, Düsseldorf 1987 *Holz, Stein, Papier*, Museum van He-

dendaagse Kunst, Gent (Kat.: B. De Baere) ·
Galerie Micheline Szwajcer, Antwerpen
(Kat.: R. Denizot) 1988 Musée d'Art Moderne, Villeneuve d'Ascq (Chapelle des Carmélites, Toulouse) (Kat.: M. Buissart, A. Busine,
H. Depotte, B. L., G. Perelin) · Galerie L'A,
Liège 1990 Centrum voor Ruimtelijke Kunst,
Hof ter Beuken, Lokeren (Kat.: M. Gildemyn) 1991 Städtische Galerie, Nordhorn ·
Galerie Fricke, Düsseldorf 1992 Arti Magazine/House of Cyprus, Athinai · Le Consortium
– l'Usine, Dijon

Gruppenausstellungen | Group exhibitions

1987 *Brennpunkt Düsseldorf*, Kunstmuseum, Düsseldorf (et al.) · *Inside-Outside*,
Museum van Hedendaagse Kunst, Antwerpen · *Paper Art*, Dominicanenkerk, Maastricht · *L'Art La Ferme*, Saint-Michel-en-Thiérache · *Quai du Wault*, Lille (et al.) ·
Beelden buiten, Cultureel Centrum, Tielt ·
Lieu, Ancienne Linière, Liège · *Artistes en
Belgique*, Espace Lyonnais d'Art Contemporain, Lyon 1988 *De verzameling*, Museum van Hedendaagse Kunst, Antwerpen
Paper Art, Provinciaal Begijnhof Hasselt
1990 *Sammlung Marzona*, Kunsthalle, Bielefeld · *Made of Stone*, Galerie Isy Brachot,
Bruxelles · Antwerpen-Haarlem, De Vleeshal, Haarlem · *Ponton Temse*, Museum van
Hedendaagse Kunst Gent, Temse · *Artisti
della Fiandra*, Palazzo Sagredo, Venezia ·
De verzameling als nog, Provinciaal Begijnhof, Hasselt 1991 *Acht Entwürfe für die
Landspitze*, Städtische Galerie, Nordhorn ·
Mit Worten ein Bild bereiten, Ausstellungshalle am Hawerkamp, Münster (et al.) ·
*Von der Wiederholung der Träume zur
Realität*, Galerie Insam, Wien · *Betekende
Ruimte*, Dhondt-Daenens, Deurle · *Facts
and Rumours*, Witte de With, Rotterdam

Bibliographie | Bibliography

Vorträge | Lectures
1976 Kunstverein, Frankfurt/M. 1977 Vereniging voor het Museum van Hedendaagse
Kunst, Gent 1979 Van Abbemuseum, Eindhoven 1980 Kunstmuseum, Düsseldorf
1983/84/85 Galerie Zeno-X, Antwerpen 1984
Haus Nieting, Geldern 1988 Galerie Inexistent, Antwerpen

Periodika | Periodicals
Christoph **Blase**, *Bernd Lohaus. Holz –
Worte – Stimmt*, in : Nike, Nr. 39, Juli/
August/September, 1991 · Edith **Doove**, *Mit
Worten ein Bild bereiten*, in: Artefactum,
Nr. 42, Februar/März, 1992 · Ilse **Kuijken**,
Bernd Lohaus, in: *Arti Art Today*, Bd. 8,
Januar/Februar, 1992

INGEBORG LÜSCHER

*Freiburg/Sachsen (D), 1936
Lebt/Lives in Tegna

Einzelausstellungen | One-man exhibitions

1969 Galerie Gunar, Düsseldorf 1971 Galerie
Ingo Kümmel, Köln 1973 Galerie Arte Arena,
Zürich 1974 Galerie Germain, Paris · Galerie
Ernst, Hannover 1975 Galerie Germain, Paris 1976 Musée d'Art Moderne de la Ville,
Paris (Kat.: I.L.) 1977 Galerie Nächst St.

Stephan, Wien (Kat.: F. Zaugg) · Galerie
Krinzinger, Innsbruck (Kat.: F. Zaugg) 1977
Forum Stadtpark, Graz 1978 Galerie Apropos, Luzern 1979 Galerie Apropos, Luzern ·
C. Space, New York 1980 Galerie Dany Keller, München · Centre d'Art Contemporain,
Genève · Steirischer Herbst, Kulturhaus,
Graz · Galerie Herta Klang, Köln · Galerie
Nächst St. Stephan, Wien · Galerie Krinzinger, Innsbruck 1982 Galerie Dany Keller,
München (Kat.: A. Monteil) · Kunstmuseum
Solothurn (Kat.: I. L., A. Kamber, A. Monteil,
K. Voswinkel) · Galerie Nächst St. Stephan,
Wien · Galerie Krinzinger, Innsbruck 1984
Centre d'Art Contemporain, Genève 1985
Galerie Marilena Bonomo, Bari · Galerie
Heike Curtze, Düsseldorf (Kat.: F. Zaugg) ·
Galerie Juana de Aizpuru, Madrid (Kat.: F.
Zaugg) · Galerie Nächst St. Stephan, Wien ·
Galerie Krinzinger, Innsbruck · Galerie Dany
Keller, München 1986 Galerie Dany Keller,
München · *La Alquimia del Ser*, Museum
Diputacion Provincial de Malaga (Kat.: F.
Zaugg) · Galerie Elisabeth Kaufmann, Zürich
1987 Centro Culturale B. Berno, Ascona
1988 Galerie Heike Curtze, Düsseldorf (Kat.:
D. Davvetas) · Galerie Elisabeth Kaufmann,
Zürich (Kat.: D. Davvetas) · Galerie Farideh
Cadot, Paris (Kat.: D. Davvetas) · Galerie
Arteria, Locarno · Galerie Krinzinger, Innsbruck 1989 Galerie Krinzinger, Wien 1990
Galerie Catherine Maurer, Bern · Galerie
Elisabeth Kaufmann, Basel · Galerie Tilly
Haderek, Stuttgart 1991 Galerie Apropos,
Luzern · Gemeentemuseum, Den Haag (Kat.:
M. Brüderlin, R. H. Fuchs, A. Gruen, H. J.
Müller) 1992 *Kabinett*, Galerie Dororthea
van der Koelen, Mainz · Kunstverein, Düsseldorf (Kat.: J. Svestka) · Museum, Wiesbaden
(Kat.: V. Rattemeyer) · Galerie Tilly Haderek
– Klaus Fischer, Berlin

Gruppenausstellungen | Group exhibitions

1987 *Die Gleichzeitigkeit des Anderen*,
Kunstmuseum, Bern · *Drapeaux d'artistes*,
Musée d'Art et d'Histoire, Genève · *Das
Tessin und seine Fotografen*, Museo Cantonale d'Arte, Lugano · Kunsthaus, Zürich
1988 *Sculptures de chambre*, Centre d'Art
Contemporain, Genève · *Aspects of Abstraction*, Holly Solomon Gallery, New York ·
Biennale of Sydney · *Zeitlos*, Hamburger
Bahnhof, Berlin 1989 *4. Triennale*, Musée
Cantonal des Beaux-Arts, Fellbach/Lausanne · *Des Corps en Décors*, Textilmuseum, St.
Gallen · *Das Land der tieferen
Einsichten*, Galerie Barbara Gross, München · *Unikat und Edition*, Helmhaus, Zürich (et al.) · *Einleuchten*, Deichtorhallen,
Hamburg 1990 *Kunstgepäck eines Diplomaten*, Bündner Kunstmuseum, Chur 1991
Bildlicht, Museum moderner Kunst, Wiener
Festwochen, Wien · *Visionäre Schweiz*,
Kunsthaus, Zürich 1992 *Weltausstellung
Sevilla*, Schweizer Pavillon, Sevilla · Galerie

Introduction I, Tilly Haderek – Klaus
Fischer, Berlin · *Hommage an Angelika
Kaufmann*, Bregenz

Bibliographie | Bibliography

Texte und Bücher von der Künstlerin
Texts and books by the artist
Der größte Vogel kann nicht fliegen. Dokumentation über A.S., Köln, DuMont,
1972 · *Erlebtes und Erdäumeltes einander zugeordnet*, Venezia, Fantonigrafica,
1975 · *Avant-Après, Sheer Prophecy –
True Dreams*, Genève, Centre d'Art Contemporain, 1980 · *Die Angst des Ikarus
oder Hülsenfrüchte sind Schmetterlingsblütler*, Aarau-Frankfurt-Salzburg, Sauerländer Verlag, 1982 · *Der unerhörte Tourist
Lawrence Pfautz*, Aarau-Frankfurt-Salzburg, Sauerländer Verlag, 1985

Periodika | Periodicals
Borris **Brollo**, *Ingeborg Lüscher*, in: Juliet,
Nr. 53, 6. Juni, 1991 · Markus **Brüderlin**,
Ingeborg Lüscher, in: Artforum, Januar,
1991 · Fernando de **Carli**, *Ingeborg Lüscher*,
in: Treterre, Nr. 13, 1989 · **Dabbeni**, *Sculturi
di Ingeborg Lüscher*, in: Temporale – Rivista d'Arte e di Cultura (Lugano), Nr. 17, 1988
· Yvonne Van **Eckelen**, *Ingeborg Lüscher*, in:
Stilte en Storm, 1991 · Yvonne **Friedrichs**,
Ingeborg Lüscher Lichtmasse, Skulpturen 1987/88, in: Das Kunstwerk (Stuttgart),
1988 · Roman **Kurzmeyer**, *Ingeborg Lüscher
– von einem Element und Elementarem,
von Schwefel, Leben, Kunst und dem
Dreischritt zur Skulptur*, in: Nike, Nr. 21,
Dezember 1987/Februar 1988 · Cornelia
Müller, *Ausstellungen*, in: Das Kunst-Bulletin, Nr. 12, Dezember, 1990

ATTILA RICHARD LUKACS

*Edmonton (CDN), 1962
Lebt/Lives in Berlin

Einzelausstellungen | One-man exhibitions

1983 *Prime Cuts*, Unit Pitt Gallery, Vancouver 1986 *New Paintings*, Diane Farris Gallery, Vancouver 1988 Diane Farris Gallery,
Vancouver · Künstlerhaus Bethanien, Berlin
(Kat.: M. Haerdter, S. Watson) · Galerie
Dietmar Werle, Köln · Plug-In Gallery, Winnepeg (Kat.: W. Baerwaldt) 1989 49 Parallel
Gallery/Diane Farris Gallery, New York
(Kat.: T. W. Sokolowski) · The Power Plant,
Toronto (Kat.: L. Dompierre) 1990 Moderne
Kunst Dietmar Werle, Köln · Teck Gallery,
Simon Fraser University, Vancouver · Illingworth Kerr Gallery, Alberta College of Art,
Calgary (Kat.: R. Mayor) · Diane Farris Gallery, Vancouver (Kat.: A. Kroker, T.W. Sokolowski) · London Regional Art and Historical
Museums, London (Ontario)

Gruppenausstellungen | Group exhibitions

1987 *Art Cologne 87*, Diane Farris Gallery,
Köln · *Morality Tales: History Painting in
the 80's*, Grey Art Gallery, New York University, New York · *West Coast Painting: New
Directions*, Canada House, London · *Vancouvers Painters*, Paul Kuhn Fine Arts,
Calgary, Alberta · *Toyama Now '87: New
Art Around the Pacific*, Museum of Modern

Art, Toyoma · *London Life Young Contemporaries,* London Regional Art Gallery, London 1988 *Vollbild,* Neue Gesellschaft für bildende Kunst, Berlin 1990 *Artropolis '90,* The Roundhouse, Vancouver 1991 *Seoul International Art festival,* The National Museum of Modern Contemporary Art, Seoul · *Sixty Years Sity Artists,* Vancouver Art Gallery, Vancouver · *Interferenzen-Kunst aus West Berlin 1960–90,* Riga (et al.) · *Celebrations and Ceremonies,* Security Pacific Gallery, Seattle (Washington) · *The Big Picture,* Diane Farris Gallery, Vancouver · *Myth and Magic in America: The Eighties,* Museo de Contemporeno, Monterrey (Mexico) · *Vollbild,* Tableaux du Sida, Kulturzentrum, Bern (et al.) · *Urban Animals,* The Surrey Art Gallery, Surrey (Br. Columbia) · *Outrageous Desire,* Rutgers, The State of New Jersey University, New Brunswick (New Jersey) · *Das goldene Zeitalter,* Württembergischer Kunstverein, Stuttgart

Bibliographie | Bibliography

Periodika | Periodicals
Anon, *Skinheads on Earth,* in: Tip Magzine, September, 1988 · Lawrence **Chua,** *Attila Richard Lukacs,* in: Flash Art, Oktober, 1989 · Peter **Day,** *Morality Tals: History Painting in the 1980's,* in: Candian Art, Herbst, 1987 · Peter **Grubbe,** *Ein Haus für Künstler und Bürger,* in: Schöner Wohnen, November, 1987 · Eleanor **Heartney,** *Report from Seoul: Korea Opens the Door,* in: Art in America, April, 1991 · Ken **Johnson,** *Attila Richard Lukacs at 49th Parallel,* in: Art in America, Septemberr, 1989 · Kay **Larson,** *Shrinking History,* in: New York Magazine, Oktober, 1987 · Earl **Miller,** *Attila Richard Lukacs,* in: C Magazine, Nr. 23, Herbst, 1989 · Ann **Wilson Lloyd,** *Canada Comes of Age,* in: Contemporanea, November 1989 · **Opferdach,** *Golden Outlaws,* in: Berlin Kultur, 14. Mai, 1988 · Noemi **Smolik,** *Attila Richard Lukacs,* in: Artforum, Nr. 27, Februar, 1989 · Nancy **Tousley,** *Fast Forward,* in: Canadian Art, Herbst, 1990 · Scott **Watson,** *Attila Richard Lukacs,* in: Canadian Art, Herbst, 1988 · Scott **Watson,** *The Generic City and Its Discontents: Vancouver Accounts For Itself,* in: Arts Magazine, Februar, 1991 · Luther G. **Whitington,** *ART/LA 90,* in: Art & Auction, Februar, 1991 · Thomas **Wulffen,** *Beispielhafte Konfrontation,* in: ZITTY, Juli, 1988

Gruppenausstellungen | Group exhibitions

1987 *Biennial Exhibition,* Whitney Museum of American Art, New York · *Surfaces: Two Decades of Painting in Chicago,* Terra Museum of American Art, Chicago · *Home Front,* Randolph Street Gallery, Chicago 1988 *Awards in the Visual Arts 7,* traveling exhibition (see wards) · Group Show, Chicago International Art Exposition, Dart Gallery, Chicago · *Art and Democracy,* Group Material, DIA Foundation, New York 1989 *Encore – Celebrating Fifty Years,* The Contemporary Arts Center, Cincinnati

Bibliographie | Bibliography

Periodika | Periodicals
Dennis **Adrian,** *Two decades of painting in Chicago,* in: New Art Examiner, Dezember, 1987 · Michael **Bulka,** in: New Art Examiner, März, 1991 · Kathryn **Hixson,** *Jim Lutes,* in: Arts Magazine, Dezember, 1988 · Kathryn **Hixson,** in: Arts Magazine, April, 1991 · Carla **McCormick,** *Jim Lutes: Fat Chances,* in: Artforum, Dezember, 1988 · Eileen **Neff,** *Jim Lutes: Temple Gallery,* in: Artforum, Dezember, 1990 · Susan **Snodgrass,** in: Dialogue, Mai/Juni, 1991 · Sue **Taylor,** *Jim Lutes,* in: Art in America, April, 1990

Bruxelles (Brochure: K. J. Geirlandt) · *Grafiek,* Galerie Denise Emmanuel, Bruxelles 1970 *Grafiek en recente schilderijen,* Book Center Gallery, Antwerpen · *Environment bloemen,* Galerie Denise Emmanuel, Bruxelles · *Portes,* Galerie Arditti, Paris · *Deuren en vensters,* Galerie Foncke, Brugge · *Illustraties van Marcel Maeyer voor »Jacqueline en ik« door Marnix Gijsen,* Huis Osterrieth en Stadhuis, Antwerpen 1971 *Vensters, deuren en huizen,* Kunstforum, Schelderode · *Werken 1963–71,* Galerie Campo, Antwerpen 1973 *Marcel Maeyer,* Richard Foncke Gallery, Gent · *Wirklichkeit ohne Bedeutung?,* Das Belgische Haus, Köln (Kat.: K. J. Geirlandt) 1975 *Marcel Maeyer,* Palais des Beaux Arts, Bruxelles · Galerie Jurka, Amsterdam · Galerie Ado, Bonheiden · Universiteit, Faculteit Letteren en wijsbegeerte, Leuven 1976 Galerij Jurka, Amsterdam · Galerij de Biggelarij, Nuenen · *Fiac,* Galerie Jurka, Paris 1976 Stichting Veranneman, Kruishoutem · *Art 8'77,* Galerie Jurka , Basel · *Marcel Maeyer,* Muzeum Sztuki, Lodz · Galerie Alexandra Monett, Bruxelles 1978 Galerie Marie-Louise Jeanneret, Genève · Galerie Modulo, Oporto (Kat.: R. Stanislewski, L. Tegenbosch) · Centro de Arte Contemporâna, Porto · Fundaçao Calouste Gulbenkian, Lisboa · *Arte Fiera,* R + S Galleries, Bologna · Galerie Jurka, Amsterdam · *Internationaler Kunstmarkt,* Galerie Jurka, Amsterdam 1979 Galerie L. Tegenbosch, Heusden · *Fiac,* Galerie Marie-Louise Jeanneret, Paris 1980 Galerie Delta, Bruxelles · Galerie Jurka, Amsterdam 1981 Galerie Modulo, Lisboa · Galerie Modulo, Oporto 1982 Herman Teirlinck Galerij, Beersel · Stichting Veranneman, Kruishoutem 1983 *Contestatair paradijs,* Galerie Wauters, Oosteeklo · *Modulaties van groene structuren,* Palais des Beaux-Arts, Bruxelles (Kat.: K. J. Geirlandt) · *Paradise lost II,* De Brakke Grond, Amsterdam · Galerie Jurka, Amsterdam 1984 *Paradise lost II,* Pulchri Studio, Den Haag · *Het boeket; Bloemen van Ingrid,* Museum van Hedendaagse Kunst, Gent (Brochure: J. Coucke, J. Hoet) · Galerie Paul Deweverwakken · Galerie Pudelko, Bonn 1985 Galerie Hugo Minnen, Dessel 1986 *Retrospetieve Marcel Maeyer,* Koninklijk Museum voor Schone Kunsten, Antwerpen (Kat.: C. Van Damme)

JAMES LUTES

*Lewis (USA), 1955
Lebt/Lives in Chicago

Einzelausstellungen | One-man exhibitions

1977 *Pedestrian Art,* Pullman, Washington 1986 Dart Gallery, Chicago 1987 Dart Gallery, Chicago 1988 Dart Gallery, Chicago 1989 Michael Kohn Gallery, Los Angeles · *FOCI (Forms of Contemporary Illinois),* Illinois State Museum, Springfield (The State of Illinois Gallery, Chicago) 1990 Temple Gallery Tyler School of Art, Philadelphia · University of Missouri, St. Louis 1991 Dart Gallery, Chicago · Ledis Flam Gallery, New York 1992 S. Bitter-Larkin Gallery (mit/with Mike Hill), New York

MARCEL MAEYER

*Sint-Niklaas (B), 1920
Lebt/Lives in Sint-Martens-Latem

Einzelausstellungen | One-man exhibitions

1964 *„I gladiatori", disegni di Marcel Maeyer,* Galleria Ciranna, Milano · *Vies des XII Césars,* Galerie Arditti, Paris 1965 *De goden en de mensen,* Galerie Cogeime, Bruxelles 1966 Galerie Bleue, Stockholm 1968 *Paradise lost,* Galerie Veranneman, Bruxelles 1969 *Environment,* Galerie Foncke, Sint-Martens-Latem · *Tekeningen 1963–1969,* Galerie Foncke, Gent · *Retrospectieve Marcel Maeyer,* Centrum voor kunstambachten, Sint-Pietersabdij, Gent (Kat.: K. J. Geirlandt) · *Maeyer 1963–66,* Galerie Fitzroy,

Gruppenausstellungen | Group exhibitions

1992 *Selectie Belgische Kunstenaars von Documenta IX,* Museum Dhondt-Dhaenens, Deurle

Periodika | Periodicals
Sylvie **Cotton,** *Documenta IX – Marcel Maeyer,* in: Sint-Lukas Galerij (Bruxelles), Nr. 4, 1992

BRICE MARDEN

*Bronxville (USA), 1938
Lebt/Lives in New York

Einzelausstellungen | One-man exhibitions

1964 Wilcox Gallery, Swarthmore College, Swarthmore 1966 Bykert Gallery, New York 1968 Bykert Gallery, New York · *Drawings,* Bykert Gallery, New York 1969 *Drawings by Brice Marden,* Bykert Gallery, New York · Galerie Yvon Lambert, Paris · *New Paintings,* Bykert Gallery, New York 1970 Galleria Françoise Lambert, Milano · Bykert Gallery, New York 1971 Galerie Konrad Fischer, Düsseldorf · Galleria Gian Enzo Sperone, Roma 1972 Bykert Gallery, New York · Galerie Konrad Fischer, Düsseldorf · *New Paintings,* Locksley-Shea Gallery, Minneapolis 1973 Galerie Konrad Fischer, Düsseldorf · Jack Glenn Gallery, Coronoa del Mar · *New Paintings, Grove Group,* Bykert Gallery, New York · Galerie Konrad Fischer, Düsseldorf · Galerie Yvon Lambert, Paris · *Brice Marden Disegni,* Galleria Françoise Lambert, Milano 1974 Bykert Gallery, New York · Cirrus Gallery, Los Angeles · Jared Sable Gallery, Toronto · Locksley-Shea Gallery, Minneapolis · *Drawings 1964–1974,* Contemporary Arts Museum, Houston (Loretto Hilton Gallery, Webster College, St. Louis; Bykert Gallery, New York; For Worth Art Museum, For Worth; Minneapolis Institute of Arts, Minneapolis) 1975 Galerie Konrad Fischer, Düsseldorf · D'Alessandro/Ferranti, Roma · Solomon R. Guggenheim Museum, New York 1976 Sperone Westwater Fischer Gallery, New York 1977 Max Protech Gallery, Washington DC · Bell Gallery, Brown University, Providence · Galerie Jean & Karen Bernier, Athinai · Galleria Gian Enzo Sperone, Roma 1978 Pace Gallery, New York (Kat.: B. M.) 1979 *Drawings 1964–1978,* Kunstraum, München (Institut für Moderne Kunst, Nürnberg) (Kat.: H. Kern, K. Kertens, B. M.) 1980 Pace Gallery, New York · Galerie Konrad Fischer, Düsseldorf · InK, Zürich 1981 Stedelijk Museum, Amsterdam (Kat.: S. Bann, E. de Wilde, B. M., R. Smith) · Whitechapel Art Gallery, London (Kat.: S. Bann, N. Serota, R. Smith) 1982 Pace Gallery, New York 1984 Pace Gallery, New York · Daniel Weinberg Gallery, Los Angeles 1987 Mary Boone Gallery, New York / Michael Werner, Köln (Kat.: P. Scheldahl) · Galerie Montenay, Paris (Kat.: K. Kertess, J.C. Lebensztejn) 1988 Mary Boone Gallery, New York · Anthony d'Offay Gallery, London · *Prints,* Van Straaten Gallery, London 1989 Galerie Michael Werner, Köln (Kat.: W. Dickhoff) 1990 *B.M. Projekte für das Basler Münster,* Kunsthalle im Kulturhaus Palazzo, Baselland (Kat.: P. Ursprung) 1991 *The Grove Group,* Gagosian Gallery, New York · Con-

nections, The Museum of Fine Arts, Boston · *Recent Drawings and Etchings,* Matthew Marks, New York · *Brice Marden – Cold Mountain,* The Dia Center for the Arts, New York (Walker Art Center, Minneapolis; The Menil Collection, Houston; Museo Nacional Centro de Arte, Madrid)

Gruppenausstellungen | Group exhibitions

1987 *Works on Paper,* Anthony d'Offay Gallery, London 1988 *Contemporary American Art,* Sara Hildenin Taidemuseo, Tampere (Finland) 1989 *Bilderstreit,* Museum Ludwig, Köln · *Biennial Exhibition,* Whitney Museum of American Art, New York · *Yves Klein, Brice Marden, Sigmar Polke,* Hirsch & Adler Modern, New York · *Jasper Johns, Brice Marden, Bruce Nauman: Prints from the Seventies,* Luhring Augustine, New York 1990 *Sammlung Marzona,* Kunsthalle, Bielefeld · *The Future of the Object!* Galerie Ronny Van de Velde, Antwerpen · *Amerikanische Zeichnungen in den achtziger Jahren,* Albertina, Wien (et al.) · *Polyptiques du Louvre,* Paris · *Le Diaphane,* Musée des Beaux-Arts, Tourcoing · *Master Drawings 1520–1990,* New York/Kate Ganz Ltd., London, 63 Thompson Street, New York 1991 *Amerikanische Druckgraphik,* Galerie Cora Hölzl, Düsseldorf · *An Overview of Drawing,* David Nolan Gallery, New York · *Strategies for a New Painting,* Wolff Gallery, New York · *Artists' Sketchbooks,* Matthew Marks, New York · *Dead Heroes,* Lorence Monk, New York · *Kulturen – Verwandschaften In Geist Und Form,* Galerie Nächst St. Stephan-Rosemarie Schwarzwälder, Wien 1992 RubinSpangle Gallery, New York · *Yvon Lambert collectionne,* Musée d'Art Moderne de la Communauté de Lille, Villeneuve D'Ascq

Bibliographie | Bibliography

Texte und Bücher vom Künstler
Texts and books by the artist
New in New York: Line Work, in: Arts Magazine, Nr. 7, Mai 1967 · *Three Deliberate Greys for Jasper Johns,* in: Art Now (New York), Nr. 1, März, 1971 · *Points of view,* in: Arts Magazine, Nr. 3, Dezember/Januar, 1971 · *Notes: A Mediterranean Painting,* in: Kat. The Structure of Color, Whitney Museum of American Art, New York · *(Statement),* in: Kat. *Invitational,* University Art Gallery, University of Massachusetts, Amherst, 1971 · *(Statement),* in: Kat. Options and Alternatives: Some Directions in recent Art, Yale University Art Gallery, New Haven, 1973 · *(Statement),* in: Kat. Eight Contem-

porary Artists, The Museum of Modern Art, New York, 1974 · *Suicide Notes,* Lausanne, Editions des Massons, Facsimile of notebook, 1974 · *(Statement)* in: Word of Mouth, prepared by 12 artists recorded on Ponape, Vision 4, Crown Point Press and Museum of Conceptual Art, San Francisco, s.d.

Bücher | Books
Could Mountain Studies, München, Schirmer/Mosel, 1991 · Wilfried **Dickhoff,** *Brice Marden,* Köln, Michael Werner, 1989

Periodika | Periodicals
David **Anfam,** *Matthew Marks Gallery, New York: Recent Drawings and Etchings,* in: Burlington Magazine, August, 1991 · Stephan **Bann,** *Brice Marden: Vom Materiellen Zum Immateriellen,* in: Kunstforum, März, 1987 · Shaun **Caley,** *Brice Marden,* in: Flash Art, Juni, 1987 · Helmut **Draxler,** *Vienna: Abstrakte Malerei,* in: Artforum, Mai, 1987 · William **Furlong,** *Brice Marden in conversation with William Furlong,* in: Art Monthly, Nr. 117, 1988 · Charles **Hagen,** *Brice Marden,* in: Artforum, Juni, 1987 · Ellen **Handy,** *Matthew Marks, New York: Recent Drawings and Etchings,* in: Arts, Oktober, 1991 · Faye **Hirsch,** *Larry Gagosian Gallery, New York: The Grove Group,* in: Arts, April, 1991 · Robert **Hughes,** *Lines That Go For A Walk,* in: Time, 4. November, 1991 · Klaus **Kertess,** *Painting Hot Staying Cool,* in: Elle, November, 1991 · Donald **Kuspit,** *Brice Marden. Dia Center for the Arts,* in: Artforum, Nr. 5, Januar, 1992 · Robert **Mahoney,** *Brice Marden: This is what things are about,* in: Flash Art, Nr. 155, November/Dezember, 1990 · Peter **Mahr,** *European and American Abstract Painting: Nächst St. Stephan,* in: Artscribe, März, 1987 · Saul **Ostrow,** *Brice Marden,* in: Bomb, Dezember, 1987 · Maurice **Poirier,** *Brice Marden,* in: Art News, Juni, 1987 · Meyer Raphael **Rubinstein,** *Matthew Marks Gallery, New York: Recent Drawings and Etchings,* in: Artnews, September, 1991 · Robert **Schiess,** *Glasscheiben für das Basler Münster: ein Sterben auf Amtswegen,* in: Kunst-Bulletin, Nr. 12, Dezember, 1987 · Peter **Schjeldahl,** *Brice Marden: 'Cold Mountain' at Dia,* in: Village Voice, November, 1991 · Berry **Schwabsky,** *Brice Marden,* in: Artscribe, September, 1987 · Dorothy **Spears,** *Brice Marden,* in: Arts Magazine, Januar, 1992 · Bob **Spitz,** *Different Strokes,* in: Mirabella, November, 1991 · Pat **Steir,** *What Artists Like About the Art They Like when They Don't Know Why,* in: Artnews, Oktober, 1991 · Robert **Storr,** *Brice Marden: Laisser à l'Abstraction son Mystère,* in: Art Press, März, 1987 · Paul **Taylor,** *Marden's Metamorphosis,* in: Connoiseur, Oktober, 1991 · Phyllis **Tuchman,** *Brice Marden: In the Groves of Color,* in: The Journal of Art, Nr. 2, Februar, 1991 · John **Yau,** *Brice Marden,* in: Flash Art, Nr. 142, Oktober, 1988 · Lilly **Wei,** *Talking Abstract,* in: Art in America, Juli, 1987 · Stephen **Westfall,** *Marden's Web,* in: Art in America, Nr. 3, März, 1992

CILDO MEIRELES

*Rio de Janeiro (BR), 1948
Lebt/Lives in Rio de Janeiro

Einzelausstellungen | One-man exhibitions

1967 *Drawings,* Museu de Arte Moderna, Salvador (Bahia) (Kat.: M. Cravo jr.) 1975 *Eureka/Blindhotland,* Museu de Arte Moderna do Rio de Janeiro (Kat.: C. M.) · *Blindhotland/Gueto; Espaços virtuais Cantos,* Galeria Luiz Buarque de Hollanda e Paulo Bittencourt, Rio de Janeiro 1977 *Casos de Sacos,* Pinacoteca do Estado de São Paulo, São Paulo 1978 *Desenhos de Cildo Meire les / Drawings,* Pinacoteca do Estado de São Paulo, São Paulo (Kat.: A. Amaral) 1979 *O sermão da montanha Fiat Lux / The Sermon on the Mountain: Fiat Lux,* Centro Cultural Cândido Mendes, Rio de Janeiro (Folder : P. Venâncio Filho) 1981 *The definite Articles & Virtual Spaces: Corners,* Galeria Luisa Strina, São Paulo 1983 *Obscura Luz / Obscura light,* Galeria Luisa Strina, São Paulo/Galeria Sramenha, Rio de Janeiro (Kat.: J. Moura) 1984 *Desvio para o Vermelho / Red Shift,* Museu de Arte Moderna, Rio de Janeiro (Folder: R. Brito) · *Two Collections – Drawings (from Mr. L. Buarqua de Hollanda & A. Maluf collections),* Sala Oswaldo Goeldi, Brasilia 1986 *Desvio para o Vermelho / Red Shift,* Museum of Contemporary Art, São Paulo (Kat.) 1989 *C. M. ›Through‹/Tunga ›Lezarts‹,* Stichting Het Kanaal, Kortrijk (Kat.: G. Brett, P. Venâncio Filfo, C. de Zegher) 1990 *Mission/Missions (How to build Cathedrals) & Cinza (Gray),* Institute of Contemporary Arts, Lower Gallery, London (Folder) · *Projects: Cildo Meireles (Olvido),* The Museum of Modern Art, New York (Folder: L. Zelevansky)

Gruppenausstellungen | Group Exhibitions

1987 *A visao do artista,* Foyer superior da Sala Villa Lobos do Teatro Nacional, Brasilia (et. al.) · *Modernidade, art brésilien du 20ème siècle,* Musée d'Art Moderne de la ville, Paris 1988 *Brazil Projects,* P.S. 1, The Institute for Art and Urban Resources, Long Island City, New York · *The Latin American Spirit,* Bronx Museum of the Arts, New York · *The Debt,* Exit Art, New York 1989 *The Readymade Boomerang,* Biennale of Sydney Art Gallery of New South Wales, Sydney · *Les Magiciens de la Terre,* Centre Georges Pompidou, Paris 1990 *Transcontinental,* Ikon Gallery/Birmingham – Cornerhouse/Manchester · *Rhetorical Image,* The New Museum of Contemporary Art, New York 1991 *Denonciation,* Ecole d'Architecture de Rouen (Normandie) 1992 *Pour la suite du monde,* Musée d'Art Contemporain de Montréal, Montréal

Bibliographie | Bibliography

Bücher | Books
Ronaldo Brito, Marciera de Sousa, Eudoro Augusto, Cildo Mereiles, Rio de Janeiro, Funarte, 1981

Periodika | Periodicals
Guy **Brett**, *South American Strategies,* in: And, Nr. 21, 1990 · Dwight V. **Gast**, *Import/Export: Courting the Carnivalesque,* in: Art in America, Nr. 1, Januar, 1989 · Edward **Leffingwell**, *Report from Brazil,* in: Art in America, Nr. 1, Januar, 1989 · Edward **Leffingwell**, *Report from Brazil: Tropical Bazaar,* in: Art in America, Nr. 6, Juni, 1990 · John **Perrault**, *A Rain Forest of signs,* in: Village Voice, 3. April, 1990 · Adrian **Searle**, *(Review),* in: Artscribe, Sommer, 1990 · **s.n.**, *Cinq questions à des artistes non-occidentaux interviews,* in: Art Press, Nr. 136, Mai, 1989 · Michael **Tarantino**, *Reviews: Cildo Meireles, Tunga; Kanaal* in: Artforum, Nr. 5, Januar, 1990 · Lawrence **Weschler**, *Studio: Cildo Meireles: Cries from the Wilderness,* in: Artnews, Nr. 6, Sommer, 1990

ULRICH MEISTER

*Schaffhausen (CH), 1947
Lebt/Lives in Düsseldorf

Ausstellungen | Exhibitions

1976/87 *Mit, Neben, Gegen,* Kunstverein Frankfurt/M. und andere Austellungsbeteiligungen, Lesungen 1988 Galerie Werth, Frankfurt/M. (Lesung) 1989 Gaby Kraushaar, Düsseldorf (Lesung) 1990 Achim Kubinski, Stuttgart (Bilder) 1991 Achim

Kubinski, Stuttgart (Objekte) · Gaby Kraushaar, Düsseldorf (Objekte) · Achim Kubinski, Köln (Objekte) 1992 Kunstverein, Freiburg/Br.

Bibliographie | Bibliography

Texte und Bücher vom Künstler
Texts and books by the artist
Interfunktionen 8, 9, Köln (Hrsg. F.W. Heubach) · *Ich tue so, als ob ich's nicht kann – hinterher kann ich's dann doch nicht,* Stuttgart, Edition Patricia Schwarz – Galerie Kubinski, 1987 · *Objekte 1990/91,* in: Flugasche, 12. Jg., Nr. 37, Frühjahr 1991

Periodika | Periodicals
Nikolai B. **Forstbauer**, *Ulrich Meister. Bildtexte – Textbilder,* in: Zyma, Nr. 5, November/Dezember, 1990

THOM MERRICK

*Sacramento (USA), 1963
Lebt/Lives in New York

Einzelausstellungen | One-man exhibitions

1988 American Fine Arts Co., New York 1989 American Fine Arts Co., New York 1990 Galerie Rolf Ricke, Köln · Zeno X Gallery, Antwerpen · 1991 Pat Hearn Gallery, New York · Galerie Ryszard Varisella, Frankfurt/M. · *Le creux de l'enfer,* Centre d'Art Contemporain, Thiers · Zeno X Gallery, Antwerpen · Ministerio de Asuntos sociales, Madrid

Gruppenausstellungen | Group exhibitions

1987 American Fine Arts Co., New York · Galerie Pierre Huber, Genève 1989 Tom Cugliani Gallery, New York · Pat Hearn Gallery, New York · Massimo Audiello Gallery, New York · *Aus meiner Sicht,* Kunstverein, Köln · Pat Hearn Gallery, New York 1990 *Köln Show – Nachschub,* Köln · *Ponton Temse,* Museum van Hedendaagse Kunst Gent, Temse · *Art Cologne,* Zeno X Gallery, Köln 1991 *Time Festival,* Museum van Hedendaagse Kunst, Gent

Bibliographie | Bibliography

Periodika | Periodicals
Jennifer P. **Borum**, in: Artforum, Mai, 1991 · Josh **Dector**, in: Arts Magazine, Mai, 1991 · Ellen **Handy**, in: Arts, September, 1989 · Kay **Heymer**, in : Flash Art, Mai/Juni, 1990 · Ralf **Kulschwskil**, in: Nike, Mai/Juni, 1990 · Luk **Lambrecht**, *Thom Merrick*, in: Metropolis M, Nr. 6, Dezember, 1991 · José **Lebrero Stals**, in: Lapiz, Nr. 67, 1990 · Isabelle **Lemaître**, *Thom Merrick, Zeno X Gallery*, in: Tema Celeste, Nr. 34, Januar/März, 1992 · Kim **Levin**, Slouching Towards the Millennium, in: Village Voice, 13. März, 1991 · Kim **Levin**, in: Village Voice, 6. März, 1991 · Robert **Mahoney**, in: Flash Art, Sommer, 1991 · **Morsiani**, New York, in : Juliet Art Magazine, Nr. 52, April/Mai, 1991 · Dirk **Pultau**, *Unstable World – Thom Merrick at Zeno X Gallery*, in: Artscribe, November/Dezember, 1991 · Marc **Ruyters**, in: Kunst & Cultuur, April, 1990 · John **Zinsser**, in: Art in America, Dezember, 1989

GERHARD MERZ

* Mammendorf/Fürstenfeldbruck (D), 1947
Lebt/Lives in Köln

Einzelausstellungen | One-man exhibitions

1975 Kunstraum München (Kat.: H. Kern) **1976** Galerie R. Schöttle, München · Galerie Heiner Friedrich, München · Galerie Konrad Fischer, Düsseldorf **1978** Galerie Konrad Fischer, Düsseldorf · Kunstforum, Städtische Galerie im Lenbachhaus, München · Kunstkabinett, Bremerhaven **1979** Galerie Konrad Fischer, Düsseldorf · *5 Bilder*, Galerie Schellmann & Klüser, München (Kat.: L. Rinn) **1980** Halle für internationale Kunst, Zürich · Sperone Westwater, Fischer Gallery, New York **1981** Galerie Konrad Fischer, Düsseldorf · Galerie Schellmann & Klüser, München **1982** Galerie Schellmann & Klüser, Düsseldorf · Galerie Schellmann & Klüser, München (Kat.: W. Thomas) · Kunstraum, München (Kat.) **1983** Galerie Konrad Fischer, Zürich · Galerie Susanna Kulli, St. Gallen · Scottish Arts Council, Fruit Market Gallery, Edinburgh · *Mondo Cane*, Präs. FIAC 83,

Galerie Tanit, Paris/München (Kat.: B. Brock) **1984** Kunstverein, Kassel (Arnold-Bode-Preis) · Galerie Marika Malacorda, Genève · Galerie Elisabeth Kaufmann, Zürich **1985** Galerie Konrad Fischer, Düsseldorf · *Aus den Alpen*, Barbara Gladstone Gallery, New York **1986** *Elfenbeinschwarz*, Galerie Nächst St. Stephan, Wien · *Italia MCMLXXXVI*, Galerie Susanna Kulli, St. Gallen · *Dove Sta Memoria*, Kunstverein, München (Kat.: Z. Felix) · *Brennero*, Galerie Tanit, München · *Mare*, Galerie Elisabeth Kaufmann, Zürich **1987** Kunsthalle, Baden-Baden (Kat.: Z. Felix, J. Poetter, L. Rinn)· Barbara Gladstone Gallery, New York (Kat.: R. Floot) · *MCMLXXXVII*, Le Consortium, Dijon (et al.) (Kat.: X. Douroux, C. Poullain, R. Recht, L. Rinn) **1988** *Mnemosyne or the Art of Memory: Gerhard Merz*, Art Gallery of Ontario, Toronto (Kat.: J.D. Campbell) **1989** Galeria Marga Paz, Madrid · Kunsthalle, Zürich · Galleria Mario Diacono, Boston (Kat.: M. Diacono) · Museum-Galerie, Bozen (Kat.: M. Klammer) **1990** Galeria Comicos/Luis Serpa, Lisboa · *Archipittura*, Galerie Nächst St. Stephan, Wien · Galerie Folker Skulima, Berlin · *De Ordine Geometrico*, Stichting De Appel, Amsterdam (Kat.: S. Germer) · *Den Menschen der Zukunft*, Kunstverein, Hannover (Kat.: F. Neumeyer) **1991** Galleria Giorgio Persano, Torino · *Construire*, Edition Schellmann, München · *Archipittura*, Galerie Tanit, München · Galleria Artiaco, Pozzuoli/Napoli · *Für Ludwig Mies van der Rohe*, Galerie Konrad Fischer, Düsseldorf · *Barcelona*, Galerij Joost Declercq, Gent **1992** Barbara Gladstone Gallery, New York · *Less is More – For Ludwig Mies Van Der Rohe*, County Museum, Los Angeles · Deichtorhallen, Hamburg · Kunsthalle Hamburg · Galerie Laage – Salomon, Paris

Gruppenausstellungen | Group exhibitions

1987 *L'époque, la mode, la morale, la passion*, Centre Georges Pompidou, Paris · *documenta 8*, Kassel · Christine Burgin Gallery, New York · *Manierisme Subjektiv*, Galerie Krinzinger, Wien/Innsbruck · *Stations*, Centre International d'Art Contemporain, Montréal · *Implosions – ett postmodernt Perspektiv*, Moderna Museet, Stockholm **1988** *Cultural Geometry*, Deka Foundation, Athinai · *Mythos Italien*, Haus der Kunst und Staatsgalerie Moderner Kunst, München · *Biennal*, Sydney · *Art et Language*, Université, Rennes (et al.) · *München Focus 88*, Kunsthalle der Hypo-Kulturstiftung, München · ROSC, Dublin · *De Facto*, Charlottenburg, Kobenhavn · *BiNationale*, Städtische Kunsthalle, Kunstsammlung Nordrhein-Westfalen, Kunstverein für die Rheinlande und Westfalen, Düsseldorf (et al.) · *La Couleur Seule*, Musée St. Pierre, Lyon · *Saturne en Europe*, Ancienne Douane, Musées de la Ville de Strasbourg, Strasbourg **1989** *Xth anniversary show*, Galerie Deweer, Otegem · *Prospect 89*, Frankfurter Kunstverein, Frankfurt/M. · *Einleuchten*, Deichtorhallen, Hamburg · *Blickpunkte 89*, Musée d'Art Contemporain, Montréal · *For 20 Years: Editions Schellmann*, The Museum of Modern Art – Tatyana Grosman Gallery, New York · *Wirklichkeit im Bild aufheben*, Steirischer Herbst, Graz **1990** *Neoclassico a Trieste – Verso il Neoclassico*, Museo Civico Revoltella, Trieste **1991** *Münchner Räume*, Stadtmuseum, München · *Metropolis*, Martin-Gropius-Bau,

Berlin · *To Return to Base*, Deweer Art Gallery, Otegem · *Das Goldene Zeitalter*, Württembergischer Kunstverein Stuttgart, Stuttgart · *Les Couleurs de l'Argent*, Musée de la Poste, Paris

Bibliographie | Bibliography

Bücher | Books
Laszlo **Glozer**, Vittorio Magnago **Lampugnani**, *Gerhard Merz Tivoli*, Köln, Verlag der Buchhandlung Walther König, 1986

Periodika | Periodicals
Jörg-Uwe **Albig**, *Der schmale leere Weg zur Grösse*, in: Art, Nr. 6, Juni 1988 · Jan **Avgikos**, *The BiNational – ICA Boston*, in: Artscribe, Nr 76, Sommer, 1989 · Christoph **Blase**, in: Artscribe, Nr. 61, Januar/Februar, 1987 · Christoph **Blase**, in: Artis, Nr. 1, Januar, 1988 · Achille **Bonito Oliva**, *Neo Europe(West)*, in: Flash Art International (It.), Nr. 139, März/April, 1988 · Jean-Pierre **Bordaz**, *Imi Knoebel, Isa Genzken, Gerhard Merz: Affinitäten zur Architektur/Affinities with Architecture*, in: Parkett, Nr. 31, 1992 · Dominic van den **Boogerd**, *De Münchener variant* in: Metropolis M, Nr. 3, Juli/August, 1989 · Saskia **Bos**, *Topics on Atopy*, in: De Appel, Nr. 2, Amsterdam, Dezember 1989/Januar 1990 · Markus **Brüderlin**, *Painting as Architecture*, in: Flash Art International (It.), Nr. 145, März/April, 1989 · Horst **Christoph**, *Seinen Augen trauen*, in: Profil, Nr. 3, 15. Januar, 1990 · Xavier **Douroux**, Frank Gautherot, Jean Hubert Martin, *Gerhard Merz: l'esprit du futurisme*, in: Art Press, Nr. 119, November, 1987 · Doris von **Drateln**, in: Kunstforum, Bd. 101, Juni, 1989 · Thomas **Dreher**, *Gerhard Merz: Werke der achtziger Jahre*, in: Artefactum, Nr. 25, September/Oktober, 1988 · Thomas **Dreher**, *A quite different coldness*, in: Artscribe, Nr. 72, November/Dezember, 1988 · Thomas **Dreher**, *Kunst und Geschichte – Bundesrepublikanische Kunst und deutsches Nationalbewußtsein*, in: Artefactum, Nr. 32, Februar/März, 1990 · D. **Fabris**, in: Juliet Art Magazine, Dezember 1986/Januar 1987 · Wolfgang Max **Faust**, in: Wolkenkratzer, Nr. 1, Januar/Februar, 1988 · Catherine **Franclin**, in: Art Press, Nr. 130, November, 1988 · Helmut **Friedel**, *A la busca de la belleza y contra la irracionalidad*, in: Quadrens, Nr. 43, April, 1989 · Gabriella **Gabrielli**, in: Juliet, Nr. 42, Juni, 1989 · Umberto **Galimberti**, *L'Architettura e le Figure del Tempo*, in: Tema Celeste, Nr. 10, 1987 · Let **Geerling**, *Van monument tot denkoord – het monument als thema in de hedendaagse kunst*, n: Archis, Nr. 2, Februar, 1990 · Linda **Genereux**, *Gerhard Merz falls under Rome's spell*, in: Metropolis (Toronto), 9. Juni, 1988 · Linda **Genereux**, *Gerhard Merz: an interview by Linda Genereux*, in: Parachute, Nr. 53, Dezember 1988/Februar 1989 · Antonio **Guzman**, *Gerhard Merz – Un Manifeste de la Mélancolie/Gerhard Merz: L'Art , Le Langage, Le Monochrome. Entretien*, in: Mars, Nr. 24, Sommer/Herbst, 1989 · Ronald **Jones**, *I love my time: Gerhard Merz*, in: Tema Celeste, Nr. 3, Oktober/Dezember, 1988 · Eva **Karcher**, *Mythos Italien-Wintermärchen Deutschland*, in: Noemea, Nr. 17, April/Mai, 1988 · Mark **Kremer**, Moritz Küng, *Traditio sine qua non*, in: Artefactum, Nr. 34, Juni/Juli/August, 1990 · Donald **Kuspit**, *Totalitarian Space*, in: Arts Magazine, Nr. 10, Sommer, 1989 · Daniela **Lanzer**, in: Nike, Nr. 24, Juli/Augustus/September, 1988 · Do-

reet **Levitte Harten,** *We androids,* in: Artforum, Nr. 5, Januar, 1989 · Robert **Mahoney,** in: Arts Magazine, Nr. 1, September, 1989 · Giorgio **Maragliano,** *Gerhard Merz,* in: Flash Art, Nr. 152, Mai/Juni, 1990 · Norbert **Messler,** in: Noemea, Nr. 27, Heft 6, 1989 · Norbert **Messler,** *The Artist as Builder – on Architecturalism in German Art,* in: Artscribe, Nr. 79, Januar/Februar, 1990 · Jean-Noel **Oudin,** *Saturne en Europe,* in: Artforum, Nr. 27, Februar/März, 1989 · Hermann **Pfütze,** *Von Adorno zu Beuys,* in: Kunstforum, Bd. 100, April/Mai, 1989 · S. **Rogenhofer,** F. Rötzer, *Kunst liegt als Grammatik vor uns,* in: Noema, Nr. 16, Januar/Februar/März, 1988 · Christoph **Schenker,** *Aneignung – Variationen über ein Thema,* in: Noema, Nr. 21, November/Dezember, 1988 · Christoph **Schenker,** in: Flash Art, Nr. 150, Januar/Februar, 1990 · Richard **Schindler,** *Gerhard Merz – Construire,* in: Nike, Nr. 31, Dezember, 1989 · Johannes von **Schlebrügge,** Interview, in: Fama & Fortune Bulletin (Wien), Heft 3, September, 1990 · Stephan **Schmidt-Wulffen,** in: Flash Art, Nr. 138, Januar/Februar, 1988 · Uwe M. **Schneede,** *Lenbach und seine Freunde,* in: Merian (Hamburg), Nr. 1/43, Januar, 1990 · Heinz **Schütz,** in: Kunstforum, Bd. 87, November/Dezember, 1988 · Daniel **Soutif,** in: Artforum, Nr. 5, Januar, 1989 · Urs **Stahel,** *Kunst ist ein geistiger Kampfplatz,* in: Noema, Nr. 27, Heft 6, 1989

MARIO MERZ

*Milano (I), 1925
Lebt/Lives in Torino

Einzelausstellungen | One-man exhibitions

1954 Galleria La Bussola, Torino **1962** *Dipinti di Merz,* Galleria Notizie : Associazione Arti Figurative (Kat.: C. Lonzi) **1968** Galleria Gian Enzo Sperone, Torino (Kat.: G. Celant) **1969** Galleria L'Attico, Roma · Galleria Gian Enzo Sperone, Torino · Galerie Sonnabend, Paris (Kat.: M. Sonnabend) **1970** *Igloo Fibonacci,* Galerie Konrad Fischer, Düsseldorf · Sonnabend Gallery / Auxiliary Space, New York · *Sciopero generale azione politica relativa proclamata relativamente all'arte,* Galleria Françoise Lambert, Milano **1971** Galleria Gian Enzo Sperone, Torino · Sonnabend Gallery / John Weber Gallery, New York **1972** Walker Art Center, Minneapolis (Brochure : interview M.M.) · *A real sum is a sum of people,* Jack Wendler Gallery, London **1973** *Tables from drawings of Mario Merz,* John Weber Gallery, New York/Jack Wendler Gallery, London (Kat.: M.M.) **1974** Haus am Lützowplatz, DAAD, Berlin (Kat.: M. Haerdter, M.M., K. Ruhrberg, W. Schmied) · Galleria Area, Firenze · Sascina Ova, Tortona · Galleria Toselli, Milano **1975** Kunsthalle, Basel (Kat.: C. Huber, M. Merz) · Institute of Contemporary Arts, London · Galerie Hetzler, Stuttgart/Lauffen a. N. **1976** Galleria Gian Enzo Sperone, Roma · Galleria Mario Pieroni, Pescara · *Tavola a spirale per festino di giornali datati il giorno del festino,* Galleria Antonio Tucci Russo, Torino · *La natura è l'arte del numero,* Galerie Konrad Fischer, Düsseldorf · Museo Diego Aragona Pignatelli Cortes, Napoli **1977** Galleria Salvatore Ala, Milano · *Vento preistorico delle Montagne*

Gelate, Annemarie Verna Galerie, Zürich · *La Bottiglia di Leyda,* via delle Battaglie 55a, Brescia **1978** *Evidenza di 987,* Galleria Antonio Tucci Russo, Torino · *Evidenza di 10946,* Jean & Karen Bernier Gallery, Athinai **1979** Museum Folkwang, Essen (Van Abbemuseum, Eindhoven) (Kat.: G. Celant, M.M., Z. Felix) · Sperone Westwater Fischer Gallery, New York · Institute of Modern Art, Brisbane · Galerie Liliane et Michel Durand-Dessert, Paris · *Irritabile irritatio,* Galerie Annemarie Verna, Zürich · Galleria Toselli, Milano · *6765,* Studio d'Arte Contemporanea, Guiliana De Crescenzo, Roma · OOLP, Libreria Internazionale, Torino **1980** *Près de la table,* Galerie Albert Baronian, Bruxelles · Whitechapel Art Gallery, London (Kat.: G. Celant, M.M., Z. Felix) · Galleria *I rinoceronti,* Christian Stein, Torino · Galerie Max Hetzler, Stuttgart · Sperone Westwater Fischer Gallery, New York · Galleria Gian Enzo Sperone, Torino · Galleria Salvatore Ala, Milano **1981** *1–80 Series,* Joslyn Art Museum, Omaha (Brochure : H. Sturges) · Galerie Konrad Fischer, Düsseldorf · Studio W Kwietniu, Warszawa (Brochure : M.M.) · Musée d'Art Moderne de la Ville, Paris (Kunsthalle, Basel)(Kat.: J.-C. Ammann, M.M., S. Pagé) · Galerie Konrad Fischer, Zürich · *Architettura fondata dal tempo, architettura sfondata dal tempo,* Galleria Antonio Tucci Russo, Torino · *Vento preistorico dalle Montagne Gelate,* Galleria Christian Stein, Torino · Galleria Lucio Amelio, Napoli **1982** Museum Folkwang, Essen (Staatsgalerie, Stuttgart) (Kat.: Z. Felix) · Sperone Westwater Fischer Gallery, New York · *Facets VII,* Oackland Art Museum, Chapel Hill · Galerie Brinkman, Amsterdam · Galleria Mario Diacono, Roma (Brochure : M. Diacono) · *Disegni/Arbeiten auf Papier,* Kestner-Gesellschaft, Hannover (Westfälischer Kunstverein, Münster) (Kat.: M. Grüterich, C. Haenlein) · *An Installation,* Flow Ace Gallery, Venice, California · *Neue Arbeiten,* Galerie Vera Munro, Hamburg · Galleria Marilena Bonomo, Bari **1983** *Esercizi di lettura,* Galleria Comunale d'Arte Moderna, Bologna · *Recent Drawings and Collages,* Flow Ace Gallery, Venice · *Installation,* Neuberger Museum, Purchase, New York · Moderna Museet, Stockholm (Kat.: O. Granath, C. Haenlein, M.M.) · Anthony d'Offay Gallery, London · Galleria Mario Pieroni, Roma · The Israel Museum, Jerusalem (Kat.: Y. Fischer, S. Landau) · *Über Mario Merz,* Galerie Nächst St. Stephan, Wien (Kat.: G.

Böhm, G. Celant, Z. Felix, R. Fleck, M. Grüterich, F. Mrkvicka, D. Ronte, R. Schwarzwälder, P. Weibel, K. Wut) · *Mario Merz: ritratto di geco ritratti di rapace gallinaceo e di sfinge che avrebbero dovuto essere fatti 50000 anni prima del 1983,* Galerie Buchmann, Basel (Kat.: M.M.) · Palazzo Congressi ed Esposizioni, San Marino (Kat.: J. C. Ammann, M. Bandini, R. Barilli, A. B. Oliva, G. Celant, B. Corà, S. Pagé) **1984** Institute of Contempory Art, Boston (Brochure : M.M., E. Sussman) · Albright-Knox Art Gallery/Hallwalls, Buffalo (Kat.: S. Krane, M.M.) · *Pittore in Africa,* Sperone Westwater Gallery, New York (Kat. Photos: Mussat Sartor) · *Al Torrente,* Galerie Konrad Fischer, Düsseldorf · Kunstverein, St. Gallen · Galerie Pietro Sparta-Pascale Petit, Chagny (Kat.: B. Corà, B. Merz, M.M.) · Galleria Christian Stein, Torino · Musée Toulouse-Lautrec, Albi · *Atelier sur l'herbe,* Ecole des Beaux-Arts, Nantes **1985** Kunsthaus, Zürich (Kat.: M. Grüterich, M.M., U. Perucchi-Petri, D. Zacharopoulos) · *Neue Arbeiten,* Galerie Vera Munro, Hamburg · Westfälischer Kunstverein, Münster · Galerie Schurr, Stuttgart · Galleria Christian Stein, Milano · Sperone Westwater Gallery/Leo Castelli Gallery, New York · *Prix de la Banque Hypothécaire du Canton Genève,* Musée d'Art et d'Histoire, Genève **1986** Galleria Antonio Tucci Russo, Torino **1987** *Une ouvre, une mesure de terre qui donne un portrait bien terrestre,* Galleria Pietro Sparta-Pascale Petit, Chagny (Kat.: B. Corà, B. Merz, M.M.) · Galerie Konrad Fischer, Düsseldorf · Museo di Capodimonte, Napoli (Kat.: G. Lonardi Buontempo, B. Corà, N. Spinosa) · *Oeuvres récentes,* Musée d'Art Contemporain, Bordeaux · *Arbeiten auf Papier,* Galerie Meyer-Ellinger, Frankfurt/M. · *Triple Igloo,* Musée d'Art Contemporain, Montréal (Kat.: P. Gagnon) · *Festival D'Automne à Paris, La Planète Merz,* Chapelle Saint-Louis de la Salpêtrière, Paris **1988** Anthony d'Offay Gallery, London · *Opere su carta,* Galleria in Arco, Torino (Kat.: M.M.) · Institute of Contemporary Art, Nagoya (Kat.: G. Celant, D. Davvetas, M.M., F. Nanjo) · Richard Demarco Gallery, Edinburgh · Louisiana Museum of Modern Art, Humlebaek · Galleria Christian Stein, Milano **1989** Salomon R. Guggenheim Museum, New York (Kat.: G. Celant, T. Krens) · Museum of Contemporary Art, Los Angeles · *Dessins,* Le Nouveau Musée, Villeurbanne · *Pitti Immagine Uomo,* Fortezza da Basso, Firenze (Brochure : M.M.) · *Déclaration des droits de l'Homme et du Citoyen,* Galerie Amelio Brachot, Paris **1990** *La spazio è curvo o dirrito,* Museo d'Arte Contemporanea, Prato (Kat.: A. Banzel, M.M.) · *Terra Elevata o la storia del disegno,* Castello di Rivoli, Rivoli (Kat.: R.H. Fuchs, J. Gachnang) **1991** Galerie Jean Bernier, Athinai **1992** *Master Works,* Sperone Westwater Gallery, New York

Gruppenausstellungen | Group exhibitions

1987 *Octobre des Arts: Sol LeWitt, Mario Merz,* Musée Siant-Pierre d'Art Contemporain, Lyon · *Colleccion Sonnabend,* Centro de Arte Reina Sofia, Madrid (et al.) · *Skulptur Projekte Münster,* Westfälisches Landesmuseum, Münster · *Italie hors d'Italie,* Musée des Beaux-Arts, Nîmes · *Terrae Motus 2,* Grand Palais, Paris · *Disegnata,* Loggetta Lombardesca, Ravenna · *L'époque, la mode, la morale, la passion,* Centre Geor-

ges Pompidou, Paris · *Effetto Arcimboldo,* Palazzo Grassi, Venezia **1988** *Positionen heutiger Kunst,* Nationalgalerie, Berlin · *Europa oggi,* Museo d'Arte Contemporanea Luigi Pecci, Prato · *Beelden in de Stad/ Rotterdam Sculpture in the City,* Rotterdam · *Ritrattare,* Galleria Eva Menzio, Torino · *Pier Paolo Calzolari, Jenny Holzer, Joseph Kosuth, Mario Merz, Bruce Nauman, Keith Sonnier,* Barbara Gladstone Gallery, New York · *Mythos Italien,* Bayerische Staatsgemäldesammlungen, München (et al.) · *Contemporary Print Acquisitions 1986–88,* Museum of Modern Art, New York · *Zeitlos,* Hamburger Bahnhof, Berlin · *Disegno Italiano: Italienische Zeichnungen 1908–1988,* Städelschen Kunstinstitut, Frankfurt/M. · *Nature Morte,* Galerie Liliane et Michel Durand-Dessert, Paris **1989** *Bilderstreit,* Museum Ludwig, Köln · *Einleuchten,* Deichtorhallen, Hamburg · *John Chamberlain, Luciano Fabro, Dan Flavin, Donald Judd, Jannis Kounellis, Mario Merz,* Margo Leavin Gallery, Los Angeles · *Italien Art in the 20th Century,* Royal Academy of Arts, London · *Verso l'Arte Povera,* Padiglione d'Arte Contemporanea, Milano · *Jannis Kounellis/Mario Merz,* Barbara Gladstone Gallery, New York · *Les Magiciens de la Terre,* Musée National d'Art Moderne, Centre Georges Pompidou, Paris · *Carte segrete,* Galleria Christian Stein, Torino **1990** *Sammlung Marzona,* Kunsthalle, Bielefeld · *Collection: Christian Boltanski, Daniel Buren, Gilbert & George, Jannis Kounellis, Sol LeWitt, Richard Long, Mario Merz,* Centre d'Art Contemporain, Bordeaux · *La Collezione 1988–90,* Museo d'Arte Contemporanea Luigi Pecci, Prato **1990** *Ponton Temse,* Museum van Hedendaagse Kunst Gent, Temse **1991** *Buchstäblich,* Van der Heydt-Museum, Wuppertal/Kunsthalle Barmen/ Wuppertal Elberfeld · Galerie Turske & Turske, Zürich

Bibliographie | Bibliography

Vollständige Bio-/Bibliographie
Complete bio-/bibliography
Kat. Mario Merz, Solomon R. Guggenheim Museum, New York, 1989

Texte und Bücher vom Künstler
Texts and books by the artist
(Ohne Titel/Without title), in: Studio International, Juli/August, 1970 · *Merz: l'opera e il fiume,* in: Domus, Nr. 563, Oktober, 1976 · *Una domenica lunghissima dura approssimativamente dal 1966 e ora siamo al 1976,* in: La Città di Riga, 1. Herbst, 1976 · *La mancanza di iconografia è la nostra conquista o la nostra dannazione ?,* in: La Città di Riga, 2, Frühjahr, 1977 · *Fiere Arte Fiere,* in: Domus, Nr. 573, August, 1977 · *The Scheme,* in: Domus, Nr. 579, Februar, 1978 · *La serie di Fibonacci...,* 1970–72, in: Data, Nr. 32, Sommer, 1978 · *Scritto il 9 di luglio per Domus,* in: Domus, Nr. 586, September, 1978 · *Meine Ungeduld ist ein Schritt ins Auge..., Es waren einmal..., Der große Kochtopf des Hauses schmeckt nach Freiheit,* in: Kunstforum, 1980 · *Pensando si può eseguire...,* in: Domus, Nr. 610, Oktober 1980 · *Il castello di foglie,* in: Domus, Nr. 634, 1982 · *Alla Mole Antonelliana, Torino,* in: Domus, Nr. 652, Juli/ August, 1984 · *Voglio fare subito un libro. Sofort will ich ein Buch machen,* Aarau-Frankfurt, Salzburg, Verlag Sauerländer,

1985; Firenze, Hopeful Monster, 1986 · *28 Internationales Kunstgespräche der Galerie Nächst St. Stephan, Wien, 28 und 29 Oktober 1983,* Wien, pubblicato in proprio, 1985 · *Project for Artforum: Written Leaf,* in: Artforum, Nr. 5, Januar, 1986 · *Tavola,* Edinburgh, A Scottish Trust Publication in associazione con la Richard Demarco Gallery, 1988 · *Did I say or didn't I ?,* in: Parkett, Nr. 15, Februar, 1988 · *La casa e gli animali,* Genève, Costa & Noland, 1989 · *Una poesia,* in: Spazio Umano, Nr. 2, April/Juni, 1985 · *Igloo = House,* in: Parkett, Nr. 5, 1985 · *(Zwei Texte von Mario Merz/Two texts by Mario Merz),* in: Louisiana Revy, Nr. 3, Mai, 1988 · *I want to write a book right now,* Firenze, Hopeful Monster, 1989

Periodika | Periodicals
Maïten **Bouiset,** *Mario Merz: l'année en france d'un nomade du temps présent,* in: Art Press, Nr. 119, November, 1987 · Carolyn **Christov-Bakargiev,** *Arte povera 1967-1987,* in: Flash Art, Nr. 137, November/Dezember, 1987 · Demosthenes **Davvetas,** *The »JEN« of Kung Fu-Tse and the Merizan City,* in: Parkett, Nr. 15, Februar, 1988 · Demosthenes **Davvetas,** *Planeten Merz,* in: Louisiana Revy, Nr. 3, Mai, 1988 · Corinna **Ferrari,** *Lo spazio Merz: tre eventi,* in: Domus, Nr. 685, Juli/August, 1987 · Tony **Godfrey,** *A tale of four cities,* in: Art in America, November, 1988 · Marlis **Grüterich,** *Paths for here and now in impenetrable places: Mario Merz's travel pictures 1987,* in: Parkett, Nr. 15, Februar, 1988 · Remo **Guidieri,** *Errors and wrecks lie about me. Mario Merz,* in: Tema Celeste, Oktober/Dezember, 1988 · Gregorio **Magnani,** Barry **Schwabsky,** recensione in: Flash Art, Nr. 138, Januar/Februar · Albert **Merz,** *Merz om Merz,* in: Louisiana, Nr. 3, Mai, 1988 · Philippe **Piquet,** *Bordeaux: Mario Merz,* in: L'Oeuil, Nr. 384/85, Juli/August, 1987 · Jeanne **Silverthorne,** *Mario Merz's future of an illusion,* in: Parkett, Nr. 15, Februar, 1988 · Denys **Zacharopoulos,** *The present of a work,* in: Parkett, Nr. 15, 1988

MARISA MERZ

Lebt/Lives in Torino

Einzelausstellungen | One-man exhibitions

1967 Galleria Gian Enzo Sperone, Torino · Piper Club, Torino **1968** Galleria L'Attico, Roma · Aeroporto di Giampino, Roma **1974** Galleria Franco Toselli, Milano **1975** Galleria L'Attico, Roma **1977** Salvatore Ala, Milano **1978** Galleria Franco Toselli, Milano · Galleria Lucio Amelio, Napoli **1979** Galerie Jean & Karen Bernier, Athinai **1980** Galleria Antonio Tucci Russo, Torino **1983** Galerie Konrad Fischer, Düsseldorf **1984** Galerie Jean & Karen Bernier, Athinai

Gruppenausstellungen | Group exhibitions

1988 *Zeitlos,* Hamburger Bahnhof in Berlin, Berlin **1989** *Bilderstreit.* Museum Ludwig, Köln · *Einleuchten,* Deichtorhallen, Hamburg **1990** *Ponton Temse,* Museum van Hedendaagse Kunst Gent, Temse

MEUSER

*Essen (D), 1947
Lebt/Lives in Düsseldorf

Einzelausstellungen | One-man exhibitions

1978 Galerie Arno Kohnen, Düsseldorf **1979** Kippenbergers Büro, Berlin **1980** Axel Hütte, Düsseldorf **1981** Galerie Schmela, Düsseldorf **1982** Galerie Max Hetzler, Stuttgart **1983** Kunstraum, München (Kat.) **1984** Galerie Max Hetzler, Köln · Ausstellungsraum Fettstraße 7a, Hamburg · Galerie Schmela, Düsseldorf **1985** *Die Dunkelheit, Klarheit, Deutlichkeit, Angemessenheit und die volle Zusammenschau (Intuition),* Kabinett für aktuelle Kunst, Bremerhaven · Galerie Bärbel Grässlin, Frankfurt/M. · Galerie Hubert Winter, Wien **1986** Galerie Max Hetzler, Köln · Galerie Ascan Crone, Hamburg **1987** Galerie Borgmann-Capitain, Köln · Galerie Schmela, Düsseldorf · Galerie Grässlin-Ehrhardt, Frankfurt/M. **1988** Galerie Max Hetzler, Köln · Galerie Ascan Crone, Hamburg · Koury Wingate Gallery, New York **1989** Galerie Nächst St. Stephan-Rosemarie Schwarzwälder, Wien · Galerie Grässlin-Ehrhardt, Franfurt/M. **1990** Galerie Gisela Capitain, Köln · Galerie Grässlin-Ehrhardt, Frankfurt/M. · Galerie Nordenhake, Stockholm · Galerie Max Hetzler (mit On Kawara) (Kat.: M.), Köln · Galeria Juana de Aizpura, Madrid **1991** Kunsthalle, Zürich (Kat. M. Wechsler) · Villa Arson, Nice (Kat.) · Galerie Schmela, Düsseldorf

Gruppenausstellungen | Group exhibitions

1987 *Dreiundzwanzigste Ausstellung,* Galerie Grässlin-Ehrhardt, Frankfurt/M. · Galerie Max Hetzler, Köln · Galerie Ascan Crone, Hamburg · *Room Enough,* Sammlung Schürmann, Suermondt – Ludwig Museum · *Broken Neon,* Steirischer Herbst 87, Forum Stadtpark, Graz **1988** *Broken Neon,* Galerie Sylvana Lorenz, Paris · *Skulpturen und Zeichnungen,* Galerie Nächst St. Stephan – Rosemarie Schwarzwälder, Wien · *BRD – Abstract Tendencies in New German Art,* Karl Bornstein Gallery, Santa Monica · *L'inventaire,* St. Etienne **1989** *Prospekt '89,* Frankfurter Kunstverein, Frankfurt/M. · *I Triennal de Dibuix Joan Miró,* Fundació Joan Miró, Barcelona **1990** Koury Wingate Gallery, New York · *About Round – Round About,* Anders Tornberg Gallery, Lund · *Le désenchantement du monde,* Villa Arson, Nice · *Small Works,* Koury Wingate, New

York 1991 Galerie Bruges la Morte, Brugge · *Gullivers Reisen,* Galerie Sophia Ungers, Köln · *La Sculpture Contemporaine,* Fondation Daniel Templon, Musée Temporaire, Fréjus · *Gedachtengangen/Gedankengänge,* Museum Fridericianum, Kassel (Provinciaal Museum, Hasselt) · Ludwig Forum für Internationale Kunst, Aachen · *Ars viva 91/92,* Westfälischer Kunstverein, Münster

Bibliographie | Bibliography

Periodika | Periodicals
Françoise **Bataillon,** *Broken Neon,* in: Art Press, Mai, 1988 · Christoph **Blase,** *Über kleine und große Monumentalitäten,* in: Artis, Nr. 2, Februar, 1988 · Martin **Bochynek,** *Meuser,* in: Galeries Magazine, April/Mai, 1990 · Martin **Bochynek,** *Meuser – Die Assoziationen liegen versteckt,* in: Artis, Oktober, 1990 · Sigrid **Feeser,** *Meuser,* in: Kunstforum, Bd. 110, November, 1991 · Kirby **Gookin,** *A Phoenix Built from the Ashes,* in: Arts Magazine, März, 1990 · Martin **Hentschel,** *Assoziation und Form – Gespräch mit Meuser,* in: Neue Kunst in Europa, Nr. 14, Juli/August/September, 1987 · Norbert **Messler,** *Meuser, Galerie Max Hetzler,* in: Artforum, Nr. 6, Februar, 1991 · John **Miller,** *Meuser/Koury Wingate,* in: Artforum, Januar, 1989 · Saul **Ostrow,** *Meuser,* in: Arts Magazine, Februar, 1989 · Sabine B. **Vogel,** *Free Association: Meuser,* in: Artscribe, November, 1989 · Vera **Vogelsberger,** *Meuser – Nächst St. Stephan, Wien,* in: Noemea Art Magazine, Nr. 23, April/Mai, 1989

JÜRGEN MEYER

*1945
Lebt/Lives in Düsseldorf

Einzelausstellungen | One-man exhibitions

1978 Galerie Arno Kohnen, Düsseldorf 1982 Galerie Rolf Ricke, Köln 1983 Galerie Hans Strelow, Düsseldorf 1985 Galerie Montenay-Delsol, Paris (Kat.: R.Tio Bellido) 1987 Galerie Rolf Ricke, Köln 1990 Galerie Nelson, Lyon 1992 Galerie Konrad Fischer, Düsseldorf

Bibliographie | Bibliography

Reinhard **Ermen,** *Jürgen Meyer,* in: Galeries Magazine, Nr. 47, Februar/März 1992

LILIANA MORO

*Milano (I), 1961
Lebt/Lives in Milano

Einzelausstellungen | One-man exhibitions

1990 Spazio di via Lazzaro Palazzi, Milano 1991 Galerie Hortense Stael, Vetrina del Peep Show, Paris 1992 Spazio di via Lazzaro Palazzi, Milano

Gruppenausstellungen | Group exhibitions

1987 Chiesa dei Morti della Selva, Drugolo (Brescia) 1988 Politica per del o riguardante il cittadino, Novi Ligure (Alessandria) 1989 Spazio di via Lazzaro Palazzi, Milano · *Fabbrica,* Galleria Minini, Brescia · *Conto Terzi,* Soncino (Cremona) · *Comodosa, Scattosa, Risparmiosa,* Primo Piano Gallery, Milano · *Venticinque per Trentacinque Miglia,* Spazio di Lazzaro Palazzi, Milano 1990 *Fisica,* Palestra Ex Gil, Montevarchi (Arezzo) · *Avanblob,* Galleria Massimo De Carlo, Milano 1991 *Una Scena Emergente,* Museo d'Arte Contemporanea Luigi Pecci, Prato (Museum des 20. Jahrhunderts, Wien) · *Artisti Italiani Contempornei,* Centro Culturale Sergio Valmaggi, Sesto San Giovanni, Milano · Galleria Margiacchi, Arezzo · Centro per l'Arte Contemporanea, Umbertide, Perugia · *Arte Contemporanea,* Scuola Elementare, Castellafiume, L'Aquila 1992 *Trigon,* Neue Galerie, Graz · *Imagini proletarte,* Viafarini, Milano · *Trigon,* Aargauer Kunsthaus, Aarau · Shedhalle, Zürich · *Molteplici Culture,* Palazzo delle Esposizioni, Roma

Bibliographie | Bibliography

Periodika | Periodicals
Patrik **Amine,** in: Art Presse, Oktober1991 · Carolyn **Christov-Bakargiev,** *Chi Li ha visti? Contrappunti nell'arte italiana,* in: Flash Art (It.), Oktober/November , 1990 · Giulio **Ciavoliello,** *Liliana Moro,* in: Juliet Art Magazine, Sommer, 1991 · Giulio **Ciavoliello,** *Fisica,* in: Juliet Art Magazine, Dezember 1990/Januar 1991 · Saretto **Cincinelli,** *Avanblob come Paradigma,* in: Next (Roma), Januar, 1991 · Mauro **Panzera,** *Fabbrica,* in: Tema Celeste, Juli/September, 1989 · Francesca **Pasini,** *Giuseppina Male, Liliana Moro,* in: Flash Art (It.), Sommer, 1989 · Francesca **Pasini,** *Fabbrica,* in: Flash Art (It.), Sommer, 1989 · Angela **Vettese,** *Via Lazzaro Palazzi,* in: Flash Art (It.), Oktober/November, 1990 · Angela **Vettese,** *Avanblob,* in: Flash Art, März, 1991

REINHARD MUCHA

*Düsseldorf (D) , 1950
Lebt/Lives in Düsseldorf

Einzelausstellungen | One-man exhibitions

1977 *...sondern stattdessen einen Dreck wie mich,* Verwaltungs- und Wirtschaftsakademie, Düsseldorf 1980 *Kopfdiktate,* Galerie Annelie Brusten, Wuppertal 1981 *Erwachtet,* Karl-Anton-Straße 16, Düsseldorf (mit/with Jürgen Drescher) 1982 *Wartesaal,* Galerie Max Hetzler, Stuttgart (Kat.: G. Inboden) · Galerie Schellmann & Klüser, München (mit/with Jürgen Drescher) 1983 *Feuer und Leben,* Kabinett für aktuelle Kunst, Bremerhaven · Galerie Max Hetzler, Köln 1985 *Clair-Obscur,* Galerie Philip Nelson, Lyon · *Hagen-Vorhalle,* Galerie Bärbel Grässlin, Frankfurt/M. · *First go Gerresheim-Glashütte,* Galerie Max Hetzler, Köln · *Das Figur-Grund Problem in der Architektur des Barock (für dich allein bleibt nur das Grab),* Württembergischer Kunstverein, Stuttgart (Kat.: M. Imdahl, M. M. Kraft, U. Loock, T. Osterwold, D. Zacharopoulos) 1986 *Wasserstandsmeldung,* Galerie Konrad Fischer, Düsseldorf · *Berichterstattung der zweiten Hälfte,* Galerie Max Hetzler, Köln · *Gladbeck,* Centre Georges Pompidou, Paris (Kat.: C. David, L. Gerdes, G. Inboden, U. Loock, P. Virilio) 1987 *Nordausgang,* Kunsthalle, Basel (Kat.: J. Ammann, U. Loock) · *Kasse beim Fahrer,* Kunsthalle, Bern (cfr. Kat Kunsthalle Basel) 1989 *Mutterseelenallein,* Galerie Lia Rumma, Napoli 1990 *Kopfdiktate,* Museum Haus Esters, Krefeld (Kat.) · *Das Deutschlandgerät,* Biennale di Venezia, Venezia

Gruppenausstellungen | Group exhibitions

1987 *Raumbilder,* Centro de Arte Reina Sofia, Madrid · *Implosion,* Moderna Museet, Stockholm · 1988 *Zeitlos,* Hamburger Bahnhof, Berlin 1989 *Bilderstreit,* Museum Ludwig, Köln · *Open Mind,* Museum van Hedendaagse Kunst, Gent 1990 *Culture and Commentary,* Hirshhorn Museum, Washington, DC · *Life-Size,* The Israel Museum, Jerusalem 1991 *Metropolis,* Martin-Gropius-Bau, Berlin · Carnegie International 1991, The Carnegie Museum of Art, Pittsburgh 1992 *Photography in Contemporary Art: 1960 to the Present,* Walker Art Center, Minneapolis · *Allegories of Modernism. Contemporary Drawing,* The Museum of Modern Art, New York

Bibliographie | Bibliography

Texte vom Künstler | Texts by the artist
The Mansberg Collection: A project for Artforum by Reinhard Mucha, in: Artforum, Oktober, 1987

Periodika | Periodicals

Eva **Baumgarten**, *Reinhard Mucha,* in: New Art International, Juni/Juli, 1990 · Martin **Bochynek**, *Reinhard Mucha – Malerei und Plastik,* in: Artis, Februar, 1990 · Carolyn **Christov-Bakargiev**, *Haunted By Ghost – Like Structures Of Industrialism,* in: Flash Art, Oktober, 1989 · Carolyn **Christov-Bakargiev**, *Reinhard Mucha,* in: Flash Art, Oktober/November, 1989 · Achille **Bonito Oliva**, *Neo-Europe (West),* in: Flash Art, März/April, 1988 · Lynn **Cooke**, *Reinhard Mucha,* in: Artscribe, März/April, 1987 · Doris von **Drateln**, *Pavillon BRD: Reinhard Mucha und Bernd und Hilla Becher,* in: Kunstforum, Bd. 109, August/Oktober, 1990 · Lars **Ericsson**, *Implosion: Moderna Museet,* in: Art News, Februar, 1988 · Werner **Esser**, *Reinhard Mucha – »Abzw. Erftkanal«,* 1985, in: Kunst + Unterricht, Nr. 123, Juni 1988 · Patrick **Frey**, *Reinhard Mucha – Verbindungen/Connections,* in: Parkett, Nr. 12, 1987 · Kirby **Gookin**, *A Phoenix Built from the Ashes,* in: Arts Magazine, März, 1990 · Isabelle **Graw**, *Ein Ausflug in marktbeherrschte Zonen,* in: Artis, Bd. 11, November, 1988 · Marlis **Grüterich**, *Einleuchten – Will, Vorstel & Simul in HH,* in: Kunst-Bulletin, Nr. 1, Januar, 1990 · Martin **Hentschel**, *Das Geschäft des Schaustellers,* in: Nike, Nr. 17, August, 1987 · Manfred **Hermes**, *Repetition, Disguises, Documents,* in: Flash Art, Oktober, 1989 · John **Miller**, *Günther Förg, Reinhard Mucha, Bernd & Hilla Becher at Luhring, Augustine & Hodes,* in: Artscribe, März/April, 1987 · Philip **Monk**, *Reinhard Mucha. The Silence of Presentation,* in: Parachute, Nr. 51, Juni/Juli/August, 1988 · Alfred **Nemeczek**, *Biennale '90 – Amerika verkauft sich am besten,* in: Art, Nr. 7, Juli, 1990 · Christoph **Schenker**, Reinhard Mucha, in: Flash Art International, Nr. 135, Sommer 1987 · Karlheinz **Schmid**, *Erinnerung an das Bauhaus,* in: Artis, März, 1987 · **s.n.,** in: Flash Art (Russische Ausgabe), Nr. 1, 1989 · Pier Luigi **Tazzi**, *Dear Harry…,* in: Artforum, September, 1988 · Pier Luigi **Tazzi**, *Reinhard Mucha -Lia Rumma,* in: Artforum, Dezember, 1989 · Thomas **Trescher**, *Kasse beim Fahrer,* in: Wolkenkratzer Art Journal, Nr. 3, Mai/Juni, 1987 · Thomas **West**, *Republic of Ready-Mades,* in: Art International, Oktober, 1987 · Thomas **Wulffen**, *Kulturstadt Berlin,* in: Kunstforum, Bd. 93, Februar,/ März, 1988 · Thomas **Wulffen**, *A German Problem,* in: Flash Art, Nr. 154, Oktober, 1990 · Harry **Zellweger**, *Reinhard Mucha: Kunsthallen Bern und Basel,* in: Noema, Mai, 1987

MATT MULLICAN

*Santa Monica (USA), 1951
Lebt/Lives in New York

Einzelausstellungen | One-man exhibitions

1973 Project Inc., Boston **1976** Artists Space, New York **1978** Nova Scotia College of Art and Design, Halifax, Nova Scotia · The Kitchen, New York **1979** Foundation for Art and Resources, Los Angeles · The Kitchen, New York **1980** Mary Boone Gallery, New York **1981** Galerie Tanja Grunert, Stuttgart · Saman Galleria, Genova **1982** Mary Boone Gallery, New York · Galerie Chantal Crousel, Paris · Galleria Deambrogi, Milano · Institute Franco-American, Rennes **1983** Texas Gallery, Houston · Institute of Contemporary Art, Boston **1984** Schellman and Klüser, München · The Queens Museum, Flushing Meadows, Corona Park, New York · Centre d'Art Contemporain, Genève · Mary Boone Gallery, New York **1985** Galerie Tanja Grunert, Köln · Richard Kuhlenschmidt Gallery, Los Angeles · Mc Intosh/Drysdale Gallery, Washington **1986** The Clocktower, New York · Michael Klein, Inc., Amsterdam · The Everson Museum of Art, New York **1987** Kuhlenschmidt/Simon Gallery, Los Angeles · *Concentrations 15,* Dallas Museum of Art, Dallas · Fuller Goldeen Gallery, San Francisco · *Banners Monuments and the City,* Moore College of Art, Philadelphia (Kat.: H. Cotter) · Michael Klein, Inc., New York **1988** Lawrence Oliver Gallery, Philadelphia · *Untitled, 1987–88,* Winnipeg Art Gallery, Winnipeg (Manufrance, St. Etienne; Le Fonds Régional d'Art Contemporain, Rhone-Alps; The Brooklyn Museum, Brooklyn; San Diego State University, San Diego) · Bath International Festival, Bath · *Photograph and Posters,* Riverside Studios, London · Carl Solway Gallery, Cincinnati · Mai 36 Galerie, Luzern (Kat.: P. L. Tazzi) · Michael Klein, Inc., New York (Kat.: N. Princenthal) **1989** Mario Diacono Gallery, Boston · Galerie Albert Baronian, Bruxelles · Galerie Bruges La Morte, Brugge · Oregon Art Institute, Portland (Western Washington University, Bellingham) · *Project,* Museum of Modern Art, New York · Galerie Ghislaine Hussenot, Paris · Kuhlenschmidt Gallery, Los Angeles · Fuller-Gros Gallery, San Francisco · *Works,* Hirshhorn Museum, Washington DC **1990** Ecole Régionale Supérieur d'Expression Plastique, Tourcoing · List Art Center, MIT, Boston · Le Magasin, Grenoble · Portikus, Frankfurt/M. · Galeria Atlântica, Oporto (Kat.: C. Vidal) · *The MIT Project,* MIT List Visual Arts Center, Cambridge (Kat.: K. Kline, J. Meinhardt, M. Tarantino) **1991** Stichting De Appel, Amsterdam (Kat.: L. Geerling) · Rijksmuseum Kröller-Müller, Otterlo · *The City Project,* Bruges la Morte, Brugge **1992** Architektur Forum, Zürich · Fondation pour l'arichitecture, Bruxelles · *Circa 1980,* Barbara Gladstone Gallery · *Instructions & Diagrams,* Victoria Miro Gallery, London · *Works on Paper,* Brooke Alexander, New York · *Overlay,* Louver Gallery, New York

Gruppenausstellungen | Group exhibitions

1987 *On Paper,* Curt Marcus Gallery, New York · *Monsters: The Phenomena of Dispassion,* Barbara Toll Fine Arts, New York · *Avant Garde in the 80's,* County Museum of Art, Los Angeles · *Wrinkled,* Burnett Miller Gallery, Los Angeles · *Schema,* Baskerville and Watson Gallery, New York · *CalArts: Skeptical Belief(s),* The Renaissance Society, Chicago (et al.) · *Real Pictures,* Wolff Gallery, New York · *Topology,* Asher/Faure Gallery, Los Angeles · *Systems,* Krygier/Landau Contemporary Art, Los Angeles · *Wall Works,* Kuhlenschmidt/Simon, Los Angeles · *Works on Paper,* Galerie Bernd Klüser, München · *Signes des Temps,* Galerie Ghislaine Hussenot, Paris · *New Acquisitions,* Carl Solway Gallery, Cincinatti · *Works on Paper,* Texas Gallery, Houston · *A Different Corner, Definition and Redefinition, Painting in America,* First Bienal Internacional de Pintura, Museo Del Arte Moderna, Cuerva · *Skulptur Projekte Münster,* Westfälisches Landesmuseum, Münster · *L'époque, la mode, la morale, la passion,* Centre Georges Pompidou, Paris **1988** *Eté 1988. Images et mages,* Centre Culturel de l'Albigeois, Albi · *Cultural Geometry,* Deka Foundation, Athinai · Galerie De Lege Ruimte, Brugge · *Works on Paper,* Curt Marcus Gallery, New York · *Sculptures de Chambres,* Centre d'Art Contemporain, Genève · Lawrence Oliver Gallery, Philadelphia · *Life Like,* Lorence Monk Gallery, New York · *Group Show,* Villa Arson, Nice · *Desire Paths,* Schulman Sculpture Garden, White Plains, New York · *Betekenis,* Printinghouse Mart, Spruijt bv., Amsterdam · *Matt Mullican, Annette Lemieux, Ericson/Ziegler,* Fuller Gross Gallery, San Francisco · *The New Urban Landscape,* North Gatehouse, World Financial Center, New York · *The Inside and The Outside,* Rhona Hoffman Gallery, Chicago **1989** *Altered States,* The Harcus Gallery, Boston · *New York Artists,* Linda Farris Gallery, Seattle · *Words and Images – Seven Corporate Commissions,* The Cleveland Center for Contemporary Art, Cleveland · *Conspicuous Display,* Stedman Art Gallery, Rutgers, The State University of New Jersey, Camden · *Messages,* Didactic Gallery, Plano · *A Forest of Signs,* Museum of Contemporary Art, Los Angeles · *Biennial Exhibition,* Whitney Museum of American Art, New York · *Art of the Eighties,* Montclair Art Museum, Montclair · *Hommage a la Déclaration Universelle Des Droits de L'Homme,* Centre D'Art Contemporain, Genève · *Mullican + Mullican,* Johnson Gallery, University of New Mexico, Albuquerque · *Public Domain,* Kent Gallery, New York · *Selected Works from the Frederick R. Weisman Foundation,* Frederick S. Wight Art Gallery, UCLA (et al.) · *32 Portraits; Photography in Art,* Centrum voor Aktuele Kunst, Den Haag · *Remembering The Future,* The Queens, New York · *The Silent Baroque,* Galerie Thaddaeus Ropac, Salzburg · *Image World. Art and Media Culture,* Whitney Museum of American Art, New York · *Scultura da Camera,* Castello Svevo, Bari · *Drawings,* Daniel Newburg Gallery, New York · *Troy Brauntuch, Matt Mullican, James Welling,* Kent Gallery, New York · *Drawing,* Joe Fawbush Gallery, New York · *Benefit For The Wooster Group,* Brooke Alexander Editions, New York **1990** *A new necessity,* First Tyne International, Queensway North, New Castle · *About Round, Round About,* An-

ders Tornberg Gallery, Lund · *Works on Paper,* The Harcus Gallery, Boston · *Ponton Temse,* Museum van Hedendaagse Kunst Gent, Temse **1992** *Circa 1980,* Barbara Gladstone Gallery, New York

Bibliographie | Bibliography

Texte vom Künstler | Texts by the artist
Notes and Excerpts from a Talk. Around a Picture, in: Vol. 2, Nr. 4, **1991** Mai 36 Galerie, Luzern (mit/with Lawrence Weiner)

Periodika | Periodicals
Max **Alexander,** *Art in the Inderground,* in: Art in America, Dezember, 1989 · Michael **Archer,** *Wall Works Cornerhouse,* in: Artscribe International, März/April, 1988 · Sandy **Ballatore,** *Mullican + Mullican: Living the Modern/Postmodern Continuum,* in: Artspace, Juli/August, 1989 · Jean-Pierre **Bordaz,** *Images et Mages,* in: Galeries Magazine, August/September, 1988 · Dan **Cameron,** *documenta 8 Kassel,* in: Flash Art, Oktober, 1987 · Dan **Cameron,** *Now New York New,* in: Wolkenkratzer Art Journal, Januar/Februar, 1988 · Joshua **Decter,** *New York in Review,* in: Arts Magazine, Januar, 1989 · Joshua **Decter,** *Symbols from a Logocentric Society,* in: Flash Art, Nr.158, Mai/Juni 1991 · Nena **Dimitrijević,** *Wall Works, Cornerhouse, Manchester,* in: Flash Art, März/April, 1988 · Doris von **Drateln,** *Matt Mullican,* in: Kunstforum, Januar/Februar 1991 · Arielle **Emmett,** *Supercomputer Art,* in: Computer Graphics World, April, 1990 · Colin **Gardner,** *reviews,* in: Artforum, April, 1987 · Lawrence **Gipe,** *Matt Mullican's Operatic Installation,* in: Artweek, 14. Februar, 1987 · Paul **Groot,** *Matt Mullican,* in: Parkett, Nr. 17, 1988 · Susan **Kandell,** *Matt Mullican,* in: Arts Magazine, Februar, 1990 · John **Kemp,** *Matt Mullican; Bath,* in: Arts Review, Juni, 1988 · Franz **Kluge,** *Bilder von völlig neuer Art,* in: Horizon, Nr. 8, Februar, 1990 · Donald **Kuspit** (et al.), *The Critics Way,* in: Artforum, September, 1987 · Janet **Kutner,** *Dallas: Matt Mullican,* in: Art News, April, 1987 · Kim **Levin,** *Matt Mullican,* in: Village Voice, Oktober, 1989 · Susan **Morgan,** *Views From L.A.,* in: Artscribe, März/April, 1987 · Robert **Nickas,** *Reviews,* in: Flash Art, Februar/März, 1987 · Luis Francisco **Perez,** *El Arte y su Doble,* in: Tema Celeste, April/Juni, 1987 · Kathy **O'Dell,** *Through the image Maze,* in: Art in America, Januar, 1988 · Chantal **Pontbriand,** *Skulptur in Münster,* in: Parachute, September/Oktober/November, 1987 · Stephan **Schmidt-Wulffen,** *Enzyklopädie der Skulptur,* in: Kunstforum, Oktober/November, 1987 · Stephan **Schmidt-Wulffen,** *Ablehnung alter Zwänge Wiederkehr des Schönen,* in: Art das Kunstmagazin, Februar, 1988 · Dena **Schottenkirk,** *Matt Mullican,* in: Artforum, Januar, 1990 · Allan **Schwarzman,** *Corporate Trophies,* in: Art in America, Februar, 1989 · Gail **Stavitsky,** *Concerning the Spiritual in Art,* in: Arts Magazine, Sommer, 1987 · Brian **Wallis,** *Kapitalistische Stigmata,* in: Kunstforum, Oktober/November, 1987

JUAN MUÑOZ

*Madrid (E), 1954
Lebt/Lives in Madrid

Einzelausstellungen | One-man exhibitions

1984 Galeria Fernando Vijande, Madrid **1985** Galeria Comicos, Lisboa **1986** Galerie Joost Declercq, Gent · Galeria Marga Paz, Madrid **1987** Galerie Roger Pailhas, Marseille · Lisson Gallery, London · Galeria Comicos, Lisboa · Musée d'Art Contemporain, Bordeaux (Kat.: J. L. Froment, J.-M. Poinsot **1988** Galerie Jean Bernier, Athinai · Galerie Konrad Fischer, Düsseldorf · Galerie Ghislaine Hussenot, Paris **1989** Galerie Marga Paz, Madrid · Galerie Joost Declercq, Gent · Lisson Gallery, London **1990** Galerie Jean Bernier, Athinai · Arnolfini Gallery, Bristol · The Renaissance Society, Chicago · Centre d'Art Contemporain, Genève **1991** *Arbeiten 1988 bis 1990,* Museum Haus Lange, Krefeld (Kat.: J. Heynen, J. M.) · Galerie Konrad Fischer, Düsseldorf · Marian Goodman Gallery, New York · Stedelijk Van Abbemuseum, Eindhoven · Galerie Ghislaine Hussenot, Paris

Gruppenausstellungen | Group exhibitions

1987 *Dynamiques et Interrogations,* Musée d'Art Moderne de la Ville, Paris **1988** *Steirischer Herbst '88,* Kunstverein, Graz · Arti et Amicitae, Amsterdam **1989** *Theatergarten Bestiarium,* P.S. 1 Museum, New York (et al.) · *Magiciens de la Terre,* Centre Georges Pompidou, Paris · *Spain Art Today,* Museum of Modern Art, Takanawa, Kanizawa **1990** *Biennale of Sydney* · *Objectives,* Newport Harbour Art Museum, Newport Beach · *X Salon de Los 16,* Museo Español de Arte Contemporaneo, Madrid · *Le spectaculaire,* Centre d'Histoire de l'Art Contemporain, Rennes · *Meeting Place,* York University, Toronto · *Possible Worlds,* Institute of Contemporary Art /Serpentine Gallery, London · *Weitersehen,* Museum Haus Lange und Haus Esters, Krefeld **1991** *Metropolis,* Martin-Gropius-Bau, Berlin · Rooseum, Center for Contemporary Art, Malmö · Galerie Ghislaine Hussenot, Paris

Bibliographie | Bibliography

Texte vom Künstler | Texts by the artist
Correspondencias, in: Kat. 5 Arquitectos, 5 Escultores, Palacio de Las Alhajas, Madrid, 1983 · *Los Primeros – Los Ultimos,* in: Kat. La Imagen del Animal, Palacio de las Alhajas, Madrid, 1983 · *The best sculpture is a toy horse,* in: Domus, Nr. 659, März, 1984 · *Desde...a...,* in: Figura, Nr. 5, 1986 · *De lo Luminosa Opacidad de los Signos,* in: Figura, Nr. 6, 1986 · *El Hijo Mayor de Laocoonte,* in: Kat. Chemo Cobo, Kunstmuseum Bern, Bern, 1986 · *Un Hombre Subido a una Farola,* in: Kat. Escultura Inglesa entre el Objeto y la Imagen, Palacio de Velasquez, Madrid, 1986 · *Richard Long: De la Prècision en las Distancias,* in: Kat. R.L., Palacio de Cristal, Madrid, 1986 · *La Imagen Prohibida o el Juegeo de la Rayuela,* in: Conde, 1987 · *Nada es tan Opaco como un Espejo,* in: Sur Express, Nr. 1, April/Mai, 1987 · *Un Objeto Matalico,* in: Arti et Amicitae, (Amsterdam), Mai, 1988 · *Tres Imagines o Cuatro,* in: Kat. Spain Art Today, Museum of Modern Art, Takanawa, Kanizawa, 1989 · *Segment,* Renaissance Society,

Chicago/Centre d'Art Contemporain, Genève, 1990 · *Auf einemen Platz,* in: Kat. Weitersehen, Museum Haus Lange und Haus Esters, Krefeld, 1990 · *Segment,* in: Kunst & Museumjournaal, Nr. 3, 1991

Periodika | Periodicals
Dominic van **den Boogerd,** *Bevroren barok,* in: Metropolis M, Nr. 6, Dezember, 1991 · Kim **Bradley,** *Juan Muñoz at Galeria Marga Paz,* in: Art in America, Februar, 1990 · José-Luis **Brea,** *Juan Muñoz. The System of Objects,* in: Flash Art, Januar/Februar, 1988 · David **Deitcher,** *Art on The Installation Plan,* in: Artforum, Nr. 5, Januar, 1992 · Luk **Lambrecht,** *Juan Muñoz,* in: Flash Art, November/Dezember, 1989 · Alexandro **Melo,** *Some Things that Cannot Be Said Any Other Way,* in: Artforum, Mai, 1989 · Kevin **Power,** *Juan Muñoz,* in: Artscribe, Sommer, 1987 · James **Roberts,** *Juan Muñoz,* in: Artefactum, Nr. 32, 1990

CHRISTA NÄHER

*Lindau (D), 1947
Lebt/Lives in Köln

Einzelausstellungen | One-man exhibitions

1982 Galerie Arno Kohnen, Düsseldorf **1983** Bonner Kunstverein, Bonn (Kat.: A.Pohlen) · Galerie Arno Kohnen, Düsseldorf **1984** *Aus Deutschland...* (mit Astrid Klein und Isolde Wawrin), Kunstmuseum Luzern (Kat.) · Galerie Susan Wyss, Zürich · Galerie Susan Wyss, Zürich **1985** Galerie Silvia Menzel, Berlin · Galerie Bärbel Grässlin, Frankfurt/M. · Galerie Arno Kohnen, Düsseldorf **1986** Galerie Arno Kohnen, Düsseldorf **1987** Kunstverein Bielefeld (Kat.) · Museum Schloß Morsbroich, Leverkusen · Galerie Grässlin-Ehrhardt, Frankfurt/M. (Kat.: S. Morgan) · Galerie Janine Mautsch, Köln · Galerie Juana de Aizpuru, Madrid **1988** Alte Pfarr, Wolfegg · Galerie Grässlin-Ehrhardt, Frankfurt/M. · Westfälischer Kunstverein, Münster (Kat.) **1989** Kunstverein Konstanz · Galerie Janine Mautsch, Köln · Galerie Silvia Menzel, Berlin (Kat.) **1990** Galerie Tanit, München · Galerie Grässlin-Ehrhardt, Frankfurt/M. · Galerie Gisela Capitain, Köln · Kunsthalle Bremen (Kat.) **1991** Galerie der Stadt, Stuttgart

(Kat.: W. Winkler) · Galerie Schurr, Stuttgart
1992 Galerie Tanit, Köln · Galerie Janine
Mautsch, Köln

Gruppenausstellungen | Group exhibitions

1987 *Junge rheinische Kunst,* Museum für
zeitgenössische Kunst, Sevilla · *Zehn: Zehn,*
Kunsthalle Köln/Staatliche Kunsthalle Ber-
lin 1988 *Der Hang zur Architektur in der
Malerei der Gegenwart,* Deutsches Archi-
tekturmuseum, Frankfurt/M. · *Refigured
Painting: The German Image 1960–1988,*
Solmonon R.Guggenheim Museum, New
York (et al.) · *2000 Jahre – Die Gegenwart
der Vergangenheit,* Bonner Kunstverein,
Bonn 1989 *Art from Cologne,* Tate Gallery,
Liverpool · *Open Mind,* Museum van Heden-
daagse Kunst, Gent · *Zeitzeichen – Statio-
nen Bildender Kunst in Nordrhein-West-
falen,* Bonn (et al.) 1991 *Arcangelo, Biber-
stein, Näher,* Galleria Mazzochi, Parma · *13
Künstler an 7 Orten,* Kempten · Galerie
Sytsema, Baarn

Bibliographie | Bibliography

Periodika | Periodicals
Konstanze von **Crüwell,** *Mythos und Reali-
tät,* in: Kunst und Antiquitäten, Nr.2, 1989 ·
D. **Galloway,** *Christa Näher,* in: Art News,
Nr. 89, 1990 · Isabelle **Graw,** *Christa Näher,*
in: Flash Art, Nr. 143, 1988 · Jutta **Koether,**
Christa Näher, in: Flash Art, Nr. 138, 1988 ·
Elfie **Kreis,** *Christa Näher – Bilder und
Gouachen,* in: Nike, Nr. 32, März/April, 1990
· Johannes **Meinhardt,** *Christa Näher in der
Galerie der Stadt Stuttgart,* in: Kunst-Bul-
letin, Nr. 9, September 1991 · Johannes
Meinhardt, *Christa Näher – Galerie der
Stadt Stuttgart,* in: Artforum, Nr.3, Novem-
ber 1991 · Norbert **Messler,** *Christa Näher,*
in: Artforum, Nr. 5, 1990/91 · Stuart **Morgan,**
Christa Näher, in: Noema, Nr. 18, 1987 ·
Dietrich **Sauerbier,** *Christa Näher. Der
Raum, die Leere und die Schöpfung,* in:
Artis, Jg. 42, 1990

HIDETOSHI NAGASAWA

*Manchuria (RC), 1940
Lebt/Lives in Milano

Einzelausstellungen | One-man exhibitions

1969 Galleria Sincron, Brescia 1970 Galleria
Françoise Lambert, Milano 1971 Galleria
Toselli, Milano · Galleria La Bertesca, Milano
· Galleria L'Attico, Roma 1972 Galleria Arte
Borgogna, Milano (Kat.: L. M. Venturi) ·
Galleria Nuove Museo, Bologna 1974 Galle-
ria Arte Borgogna, Milano (Kat.: L. M. Ventu-
ri) · Galleria Acme, Brescia 1975 Galleria
Christian Stein, Torino · Galleria L'Attico,
Roma 1976 Galleria Christian Stein, Torino
1977 Galerie 't Venster, Rotterdamse Kunst-
stichting, Rotterdam 1978 Galleria Piero Ca-
vellini, Brescia · Galleria L'Attico, Roma ·
Galleria Arco D'Alibert, Roma 1979 Galleria
Cesare Manzo, Pescara 1980 Galleria Wirz,
Milano 1981 Galleria Sperone, Torino · To-
kyo Gallery, Tokyo 1982 Galleria Piu Due
Cannaviello, Milano · Galleria Piero Cavelli-
ni, Brescia 1985 Galleria Piero Cavellini,
Milano (Kat.: J. de Sanna) 1987 Galleria
Studio G 7, Bologna (Kat.: W. Gaudagnini, P.
Jori, E. Pontiggia) 1988 Galleria Belvedere,
Milano (Kat.: J. de Sanna) · Padiglione D'Arte
Contemporanea, Milano (Kat.: M. Garberi, T.
Minemura, E. Pontiggia) 1990 Galleria Bel-
vedere, Milano · Galleria Arco D'Alibert,
Roma · Studio La Citta, Verona · Studio
Barnabo, Venezia 1991 Galleria Falconiere,
Ancona · Studio Framart, Napoli · Nabis
Gallery, Tokyo · Gallery Ueda SC, Tokyo
(Kat.: T. Minemura)

Gruppenausstellungen | Group exhibitions

1987 *4 Scultori – Leoncillo, Pascali, Naga-
sawa, Nunzio,* Associazione Culturale l'At-
tico, Roma · *Drei Japanische Künstler,*
Stadtgalerie, Saarbrücken · *Entre Centre et
Absence. Sculture in Italia,* Galleria Marta-
no, Torino (et al.) · *Ateliers Internationaux
des pays de la Loire 1987,* Frac, Pays de la
Loire, Clisson · *Voluti inganni,* Studio G 7,
Bologna 1988 *Biennale di Venezia,* · *Villa
Domenica con undici artisti,* Trevisio ·
*Periplo della scultura italiana contem-
poranea,* Matera · *Viaggio in Italia,* Pina-
coteca, Ravenna · *Immagini del silenzio,*
Abbazia di Novalesa, Piemonte · *Borderline,*
Monteciccardo, Pesaro · *Yorkhire Sculpture
Park* 1989 *Omaggio a Brancusi,* Associa-
zione Culturale L'Attico, Roma · *Material
Mente,* Galleria d'Arte Moderna, Bologna ·
Borderland, Museo d'Arte Moderna, Reggio
Emilia · *Serata per Tre Assdolo,* Instituto
Diapponese di Cultura, Roma · *Opere ope-
razioni,* Studio d'Eramo, Milano · *20ste
Biennale Middelheim-Japan,* Antwerpen ·
Fiumara d'Arte, Santo Stefano di Cama-
stra, Messina · *Campo del sole,* Tuoro ·
*L'oggetto restituito-Ievolella, Monari, Na-
gasawa,* Abbazia di S. Maria in Castagnola,
Chiaravalle · *Pensieri Spaziali,* Torre Mar-
tiniana, Cagli · *Biennale di Alatri · Dieci
capital di realta,* Castello di Volpaia ·
A.S.P.I.S., Cagliari · Europalia '89 Japan, Mu-
seum van Hedendaagse Kunst, Gent 1990
Ermes, i viaggi dell'arte, Galleria d'Arte
Contemporanea, Padova · *Prigioni d'in-
venzione,* Spoleto · *Incontri di lavoro,*
Triennale di Milano · *Arte Lago '90,* Osmate ·
*Temperamenti-Contemporary Art from
Italy,* Tramway, Glasgow · Galleria Giogio

Mazzochi, Parma · *Intersezioni: arte Italia-
na negli anni '70–'80,* Budapest · *Etica
all'arte!,* Gubbio · *Specie di spazi,* Pècioli ·
*Movements of Japanese contemporary
art,* Toyama modern art museum, Toyama
1991 *Rhizome,* Gemeentemuseum, Den
Haag

Bibliographie | Bibliography

Periodika | Periodicals
Jole de **Sanna,** *Nagasawa,* in: Arti, Nr. 6, 1991
· **S.R.,** *Hidetoshi Nagasawa,* in: L'Uomo
Vogue, Bd. 7, November, 1990

Film
1970 *Toccata* (video) 1971 Film n. I

BRUCE NAUMAN

*Fort Wayne/Indiana (USA), 1941
Lebt/Lives in Pecos, Galisteo/New Mexico

Einzelausstellungen | One-man exhibitions

1966 Nicolas Wilder Gallery, Los Angeles
1968 Leo Castelli Gallery, New York (Kat.: D.
Whitney) · Galerie Konrad Fischer, Düssel-
dorf 1969 Sacramento State College Art
Gallery, Sacramento · *Holograms, Video-
tapes and Other Works,* Leo Castelli Galle-
ry, New York · Nicholas Wilder Gallery, Los
Angles · Galerie Ileana Sonnabend, Paris
1970 Nicolas Wilder Gallery, Los Angeles ·
Galerie Konrad Fischer, Düsseldorf · Galle-
ria Sperone, Torino · San Jose State College,
San Jose · Reese-Paley Gallery, San Francis-
co 1971 Galerie Ileana Sonnabend, Paris ·
Galerie Bischofberger, Zürich · Leo Castelli
Gallery, New York · Galerie Konrad Fischer,
Düsseldorf · Helman Gallery, St. Louis · Ace
Gallery, Vancouver · Galleria Françoise
Lambert, Milano 1972 *Bruce Nauman: 16
mm Films 1967–1970,* Projection Gallery,
Ursula Wevers, Köln · *Bruce Nauman:
Works from 1965–1972,* Los Angeles Coun-
ty Museum of Art (Whitney Museum of
American Art, New York; Kunsthalle Bern;
Städtische Kunsthalle Düsseldorf; Stedelijk
Van Abbemuseum, Eindhoven; Palazzo Rea-
le, Milano; Contemporary Arts Museum,
Houston; San Francisco Museum of Modern
Art, San Francisco) (Kat.: J. Livingstone, M.
Tucker) 1973 *Bruce Nauman – Floating
Room,* University of California, Irvine ·
Floating Room, Leo Castelli Gallery, New
York · Cirrus Gallery, Los Angeles · *Flayed
Earth/Flayed Self (Skin/Sink),* Nicholas
Wilder Gallery, Los Angeles 1974 Ace Galle-
ry, Vancouver · Galerie Art in Progress,
München · Galerie Konrad Fischer, Düssel-
dorf · *Wall with Two Fans,* Wide White
Space, Antwerpen · *Yellow Triangular
Room,* Santa Ana College Art Gallery, Cali-

fornia 1975 *Cones/Cojones,* Leo Castelli Gallery, New York · *The Mask to Cover the Need for Human Companionship,* Albright Knox Art Gallery, Buffalo (Kat.: L. Cathcart) · *Sundry Obras Nuevas,* Gemini G.E.L., Los Angeles · *Forced Perspective,* Galerie Konrad Fischer, Düsseldorf 1976 *Enforced Perspective, Allegory and Symbolism,* Ace Gallery, Vancouver · *White Breathing,* UNLV Art Gallery, University of Nevada, Las Vegas · Leo Castelli Gallery, New York · *The Consummate Mask of Rock,* Sonnabend Gallery, New York · Sperone Westwater Fischer Gallery, New York · *Enforced Perspective (Drawings),* Ace Gallery, Los Angeles · *Enforced Perspective,* Ace Gallery, Venice 1977 *The Consummate Mask of Rock,* Nicholas Wilder Gallery, Los Angeles · Bruno Soletti, Milano 1978 Minneapolis College of Art and Design, Minneapolis · Leo Castelli Gallery, New York · Ink, Zürich · *Recent Sculpture,* Ace Gallery, Vancouver · Galerie Konrad Fischer, Düsseldorf · *1/12 Scale Study in Fibreglass and Plaster for Cast Iron of a Trench and Four Tunnels in Concrete at Full Scale,* California State University, San Diego 1979 Galerie Schmela, Düsseldorf · Marianne Deson Gallery, Chicago · *Bruce Nauman: Prints,* Hester van Royen Gallery, London · *Bruce Nauman: An Installation,* Portland Center for the Visual Arts, Portland 1980 Leo Castelli Gallery, New York · *Smoke Rings,* Hill's Gallery of Contemporary Art, Santa Fe · Galerie Konrad Fischer, Düsseldorf · Carol Taylor Art, Dallas 1981 Nigel Greenwood Inc., London · *Bruce Nauman 1972–81,* Rijksmuseum Kröller-Müller, Otterlo (Staatliche Kunsthalle, Bern) (Kat.: S. Holsten, E. Joosten, K. Schmidt) · Young Hoffmann Gallery, Chicago · *Dokumentation 8,* Ink, Zürich (Kat.: S. Christel) · The Albuquerque Museum, Albuquerque (Kat.: J. Lusk) 1982 Sperone Westwater Gallery, New York · Leo Castelli Gallery, New York · *Bruce Nauman: Neons,* Baltimore Museum of Art, Baltimore (Kat.: B. Richardson) 1983 Carol Taylor Art, Dallas · Galerie Konrad Fischer, Düsseldorf · *Dream Passages,* Museum Haus Esters, Krefelder Kunstmuseum, Krefeld (Kat.: J. Heynen) 1984 Daniel Weinberg Gallery, Los Angeles · Leo Castelli Gallery, New York · Sperone Westwater Gallery, New York 1985 Leo Castelli Gallery, New York · *Bruce Nauman. New Work, Neons and Drawings, New Neons,* Galerie Konrad Fischer, Düsseldorf · Leo Castelli, New York · Donald Young Gallery, Chicago · Galerie Elisabeth Kaufmann, Zürich 1986 Galerie Jean Bernier, Athinai · *Oeuvres sur papier,* Galerie Yvon Lambert, Paris · *Bruce Nauman Drawings 1965–86,* Museum für Gegenwartkunst, Basel (Kunsthalle, Tübingen; Städtisches Kunstmuseum, Bonn; Boymans-van Beuningen, Rotterdam; Kunstraum München, München; Badischer Kunstverein, Karlsruhe; Kunsthalle, Hamburg; New Museum of Contemporary Art, New York; Contemporary Arts Museum, Houston; Museum of Contemporary Art, Los Angeles; University Art Museum, Berkeley) (Kat.: C. Van Bruggen, D. Koepplin, F. Meyer) · Kunsthalle, Basel (Musée d'Art Moderne de la Ville, Paris; Whitechapel Art Gallery, London) (Kat.: J. Simon, J.-C. Ammann) 1987 Donald Young Gallery, Chicago/Daniel Weinberg Gallery, Santa Monica · Barbara Gladstone Gallery, New York · Contemporary Arts Museum, Houston 1988 *Sex and Death 1985,* Elisabeth Kaufmann, Zürich ·

Drawings 1965–1986, University Art Museum, University of California, Berkeley · *Drawings 1965–1986, Video,* The Museum of Contemporary Art, Los Angeles · Galerie Micheline Szwajcer, Antwerpen · Galerie Konrad Fischer, Düsseldorf · *Vices and Virtues,* University of California, San Diego · Sperone Westwater Gallery, New York · *Southern California Summer 1988,* Cirrus Gallery, Los Angeles · Sperone Westwater Gallery, New York 1989 *Prints 1970–89,* Castelli Graphics, Lorence Monk Gallery, New York (Earl MacGrath Gallery, Los Angeles; Donald Young Gallery, Chicago) (Kat.: C. Cordes, J. Yau) · *Prints,* Sperone Westwater Gallery, New York · Texas Gallery, Houston · Saatchi Collection, London · *Repetition,* Hirsch & Adler Modern, New York · *Encontros,* Fundacao Calouste, Gulbenkian, Lisboa · *Hardware,* Museum Boymansvan Beuningen, Rotterdam · *Works on Paper,* Leo Castelli Gallery, New York · *Seven Virtues Seven Vices,* Stuart Collection, University of California San Diego, La Jolla · *B.N. Heads and Bodies,* Galerie Konrad Fischer, Düsseldorf 1990 Museum für Gegenwartkunst, Basel (Städtische Galerie im Städelschen Kunstinstitut, Frankfurt/M.; Musée Cantonal des Beaux-Arts, Lausanne) (Kat.: F. Meyer, J. Zutter) · *Bruce Nauman, Prints 1970–89,* Lorence-Monk Gallery, New York · *Animal Pyramid,* Permanent Installation, des Moines Art Center, Des Moines (Iowa) · Langer Fain Galerie, Paris · *Bruce Nauman: A Survey,* Anthony D'Offay Gallery, London · Sperone Westwater Gallery, New York · Leo Castelli Gallery, New York · Galerie B. Coppens and R. van de Velde, Bruxelles/Antwerpen · Daniel Weinberg Gallery, Santa Monica · 65 Thompson Street, New York · Galerie Jürgen-Becker, Hamburg 1991 Daniel Weinberg Gallery, Santa Monica · *Clear Vision,* Museum Boymans-van Beuningen, Rotterdam · Galerie Metropol, Wien · *Bruce Nauman, Prints and Multiples,* Museum van Hedendaagse Kunst, Gent · *Graphik 1970–89,* Hochschule für angewandte Kunst, Wien · *Bruce Nauman,* Fundacio Espai Poblenou, Barcelona

Gruppenausstellungen | Group exhibitions

1987 *Skulptur Projekte Münster,* Westfälisches Landesmuseum, Münster · *L'époque, la mode, la morale, la passion,* Centre Georges Pompidou, Paris · Michael Kohn Gallery, Los Angeles · *Light,* Centro Cultural Arte Contemporaneo, Mexico · *A Tribute to Leo Castelli,* Centro Cultural Arte Contemporaneo, Mexico · *Merce Cunningham and His Collaborators,* Lehman Center, Lehman College, New York · *Light Works 1965–1986,* Rhona Hoffman Gallery, Chicago · Galerie Daniel Templon · *Works on Paper,* Anthony d'Offay Gallery, London · Hallen für Neue Kunst, Schaffhausen · *About Sculpture,* Anthony d'Offay Gallery, London · *Pictorial Grammar,* Barbara Krakow Gallery, Boston · *Imi Knoebel, Barry Le Va, Bruce Nauman,* Barbara Gladstone Gallery, New York · *Aspects of Conceptualism in American Work: Part II – Modern and Contemporary Conceptualism,* Avenue B Gallery, New York · *Schizophrenia,* Josh Baer Gallery, New York · *Works on Paper,* Galerie Bernd Klüser, München · *Bruce Nauman, Richard Nonas, David Smyth,* Harm Bouckaert Gallery, New York · *Nauman, Serra, Sonnier,* Städtisches Mu-

seum Abteiberg, Mönchengladbach · *Multiples,* Galerie Daniel Buchholz, Köln · *Hommage to Leo Castelli,* Galerie Daniel Templon, Paris · *Sculpture,* Galerie Lelong · *1987 Biennial Exhibition,* Whitney Museum of American Art, New York · *Artschwager, Nauman, Stella,* Leo Castelli Gallery, New York · *Sculpture of the Sixties,* Margo Leavin Gallery, Los Angeles · *Avant Garde in the Eighties,* Los Angeles County Museum of Art, Los Angeles · *Photography and Art. Interactions since 1976,* Los Angeles County Museum of Art, Los Angeles (et al.) · *1987 Phoenix Biennial. Regionalism, Nationalism, Internationalism,* Phoenix Art Museum, Phoenix · *Computer and Art,* Everson Museum of Art, Syracuse · *Fifty Years of Collecting: An Anniversary Selection; Sculpture of a Modern Era,* Solomon R. Guggenheim Museum, New York · *The Great Drawing Show 1587–1987,* Michael Kohn Gallery, Los Angeles · *Corps Etrangers,* Galerie Yvon Lambert, Paris · *An Exhibition to Benefit the Armitage Ballet,* Mary Boone Gallery, New York · Burnett Miller Gallery, Los Angeles · *L.A. Prints: Prints from Southern California,* Brody's Gallery, Washington, DC · *Big Drawings,* Center for Contemporary Arts, Santa Fe · *Leo Castelli and his Artists: 30 Years of Promoting Contemporary Art,* Centro Cultural Arte Contemporaneo, Mexico City · *Collection Agnes Frits Becht,* Centre Régionale d'Art Contemporain, Midi-Pyrénées · *Sculpture from the 60's and the 70's,* Sperone Westwater Gallery, New York · *The Spiritual in Art: Abstract Paintings 1890–1985,* Los Angeles County Museum of Art, Los Angeles (et al.) · *Leo Castelli: A Tribute Exhibition,* The Butler Institute of American Art, Youngstown · *Individuals; A Selected History of Contemporary Art, 1945–1986,* The Museum of Contemporary Art, The Temporary Contemporary, Los Angeles · *Committed to Print,* The Museum of Modern Art, New York · Lead, Hirschl & Adler Modern Gallery, New York · *Three Decades of Exploration – Hommage to Leo Castelli,* Museum of Art, Fort Lauderdale · *Leo Castelli at Gagosian,* Larry Gagosian, Los Angeles 1988 *Three Decades,* Oliver Hoffman Collection, Museum of Contemporary Art, Chicago · *Identity: Repre-*

sentations of the Self, Whitney Museum of American Art, New York · Sculptors on Paper: New Work, Bassett, Steenbok, & Brittingham Galleries, Madison (et al.) · Nobody's Fools, Stichting De Appel, Amsterdam · Avant-garde in the Eighties, Los Angeles County Museum of Art, Los Angeles · L.A. Hot & Cool; Pioneers & Futura, Bank of Boston Art Gallery, Boston · Illuminations: The Art of Light, The Cleveland Museum of Art, Cleveland · Marcel Duchamp und die Avantgarde seit 1950, Museum Ludwig, Köln · Works on Paper, Texas Gallery, Houston · Permanent Installation, The Stuart Collection, University of California, San Diego · Planes of Memory – Three Video Installations, Long Beach Museum of Art, Long Beach · Artists Series Project, The New York City Ballet, New York · Sperone Westwater Gallery, New York · Galerie Elisabeth Kaufmann, Zürich · Donald Young Gallery, Chicago · 1988 – The World of Art Today, Milwaukee Art Museum, Milwaukee · Altered States, Kent Fine Art, New York · Der Schlaf der Vernunft, Kassel · Zeitlos, Hamburger Bahnhof, Berlin · Parkett Künstler – Collaborations, Galerie Susan Wyss, Zürich · Welcome Back: Painting Sculpture and Works on Paper by Contemporary Artists from Indiana, Indianapolis Center for Contempory Art, Herron Gallery, Indianapolis · Works. Concepts. Processes. Situations. Information, Galerie Hans Mayer, Düsseldorf · Exhibition for the Benefit of the Foundation for Contemporary Performance Arts, Leo Castelli Gallery, New York · Museum der Avantgarde. Die Sammlung Sonnabend New York, Berlin · The Sonnabend Collection, Centro De Arte Reina Sofia, Madrid · Life Like, Lorence Monk Gallery, New York · Castelli Graphics 1969–1988, Castelli Graphics, New York · Images du Futur, Vieux-Port de Montréal, Montréal · Objects, Lorence Monk Gallery, New York · Hommage a Toiny Castelli: Prints, Galerie des Ponchettes, Nice · Language in Art Since 1960, Whitney Museum of American Art, Federal Reserve Plaza, New York · Carl Andre, Jannis Kounellis, Bruce Nauman, Barbara Gladstone Gallery, New York · SMS, Reinhold-Brown Gallery, New York · Contemporary Sculptors, Maquettes and Drawings, University Hempstead, New York · Jasper Johns, Bruce nauman, David Salle, Leo Castelli Gallery, New York · Pier Paolo Calzolari, Jenny Holzer, Joseph Kosuth, Mario Merz, Bruce Nauman, Keith Sonnier, Barbara Gladstone Gallery, New York 1989 Words, Tony Shafrazi Gallery, New York · A Decade of American Drawing, Daniel Weinberg Gallery, Los Angeles · Modern Master Works From the Permanent Collection of the Museum of Fine Arts, Santa Fe · Hallen für Kunst, Schaffhausen · Robert Gober and Bruce Nauman, Galerij Micheline Schwajcer, Antwerpen · Time Span, Fundació Caixa de Pensions, Barcelona · First Impressions, Walker Art Center, Minneapolis · B.N., Robert Mangold, Saatchi Collection, London · Seeing is Believing, Christine Burgin Gallery, New York · Collection Panza: B.N., Richard Long, Musée d'Art Moderne, Saint-Etienne · 1st Triennal d Dibuix, Fundació Joan Miró, Barcelona · Wiener Diwan. Sigmund Freud heute, Museum des 20. Jahrhunderts, Wien · Video-Skulptur retrospektiv und aktuell 1963–1989, Kölnischer Kunstverein, Du-Mont Kunsthalle (et al.) · Bilderstreit, Mu-

seum Ludwig, Köln · Fondation Daniel Templon, Musée Temporaire, Fréjus · Just to look at, Museum Hedendaagse Kunst Gent, Stadsgalerij, Heerlen · Einleuchten, Deichtorhallen, Hamburg · B. N., Cindy Sherman, John Boskovich, Laurie Rubin Gallery, New York · Innovators Entering Into the Sculpture, Ace Gallery, Los Angeles · Multiples, Marc Richards Gallery, Los Angeles · Open Mind, Museum van Hedendaagse Kunst, Gent · Selected Photographs from the Donnelly Collection, Barbara Gladstone Gallery, New York · Major Sculpture, Fred Hoffman Gallery, Santa Monica · Image World. Art and Media Culture, Whitney Museum of American Art, New York 1990 Figuring the Body, Museum of Fine Arts, Boston · Video, Art Institute of Chicago, Chicago · Pharmakon '90, Makuhari Nesse Contemporary Art Exhibition, Nippon Convention Center, Tokyo · Neon Stucke, Sprengle Museum, Hannover · The 60's Revisited. New Concepts/New Materials, Leo Castelli Graphics, New York · The Future of the Object! A Selection of American Art; Minimalism and After, Galerie Ronny Van de Velde, Antwerpen · Territory of Desire, Louver Gallery, New York · Fragments, Parts, Wholes, The Body and Culture, White Columns, New York · Work in Progress, Fundació Caixa de Pensions, Madrid · Zeichnungen. Joseph Beuys, Francesco Clemente, Martin Disler, Donald Judd, B.N., Claes Oldenburg, A.R. Penck, Frank Stella. Aus dem Kupferstichkabinett Basel, Kunsthalle, Nürnberg · Regard sur la collection Asher B. Edelman, Musée cantonal des Beaux-Arts, Lausanne · The New Sculpture 1965–75. Between Geometry and Gesture, Whitney Museum of American Art, New York · 7 Objects/69/90, University Gallery, University of Massachusetts at Amherst · Beyond the Frame, Rubin-Spangle Gallery, New York · Seven American Artists, Vivian Horan Fine Art, New York · A Tribute to Nicholas Wilder, Stuart Regen Gallery, Los Angeles · Chris Burden, Mario Merz, Bruce Nauman, Fred Hoffman Gallery, Santa Monica · Works on Paper 1965–1975, Galerie Georges-Philipe Vallois, Paris · Massimo Audiello Gallery, New York · Selected Works from the Avant-Garde, Kent Gallery, New York · Affinities and Intuitions, The Gerald S. Elliot Collection of Contemporary Art, The Art Institute of Chicago, Chicago · The Readymade Boomerang, Biennale of Sydney, Sydney · American Masters of the 60's; Early and Late Works, Tony Shafrazi Gallery, New York · Drawings, Lorence Monk Gallery, New York · Sculpture, Daniel Weinberg Gallery, Santa Monica · Sculptor's Drawings, L.A. Louver Gallery, Venice · Art What Thou Eat, Edith C. Blum Art Institute, Milton and Sally Avery Center for the Arts, The Bard Center, Annandale-on-the-Hudson, New York · Committed to Print, Newport Harbor Art Museum, Newport Beach · Fiac, Grand Palais, Paris · Leo Castelli Post Pop Artists, Nadia Bassanese Studio d'Arte, Trieste · The Transparent Thread: Asian Philosophy in Recent American Art, Hofstra Museum, Hofstra University, Hempstead, New York (et al.) · High and Low: Modern Art and Popular Culture, Museum of Modern Art, New York (et al.) · Multiples, Hirsch & Adler Modern, New York · Minimalism, Nicola Jacobs Gallery, London · Faces, Marc Richards Gallery, Santa Monica · John Baldessari, Donald Judd,

Bruce Nauman, Brooke Alexander Editions, New York · Sammlung Marzona, Kunsthalle, Bielefeld · The Decade Show, Museum of Contemporary Hispanic Art/The New Museum of Contemporary Art/The Studio Museum, Harlem · Jannis Kounellis, Bruce Nauman, Ulrich Rückriem, Richard Serra, Antoni Tàpies, Donald Young Gallery, Chicago · Energieën, Stedelijk Museum, Amsterdam · Life-Size, The Israel Museum, Jerusalem 1991 Suck Cuts, Museum für Moderne Kunst, Frankfurt/M · Twentieth Century Collage, Margo Leavin Gallery, Los Angeles · Contemporary Sculpture: Matserworks, Blum Helman Gallery, New York · Günther Förg, Bruce Nauman, Museum van Hedendaagse Kunst, Gent · Biennial, Whitney Museum of American Art, New York · De woorden en de beelden/The words and images, Centraal Museum, Utrecht · Metropolis, Martin-Gropius-Bau, Berlin · Telekinesis, Mincher-Wilcox Gallery, San Francisco · 4th Semaine Internationale de Vidéo, Saint- Gervais, Genève · Selections From the Elaine and Werner Dannheisser Collection: Painting and Sculpture From the '80s and '90s, The Parrish Museum, Southampton · Immaterial Objects, Whitney Museum of American Art, New York · Devil on the Stairs/Looking Back on the Eighties, Institute of Contemporary Art, University of Pennsylvania, Philadelphia · Carnegie International, Carnegie Museum of Art, Pittsburgh · Beyond the Frame: American Art 1960–1990, Setagaya Art Museum, Tokyo (et al.) · The Interrupted Life, The New Museum, New York · Sélection, Musée d'Art Contemporain, Pully-Lausanne · Emanuel Hoffmann-Stiftung 1980–1990, Museum für Gegenwartskunst, Basel · Buchstäblich, Van der Heydt-Museum, Wuppertal/Kunsthalle Barmen/ Wuppertal Elberfeld · Clear Vision, Museum Boymans-van Beuningen, Rotterdam · Galerie Metropol, Wien/Galerie Konrad Fischer, Düsseldorf · Fundació Espai Poblenou, Barcelona · Dislocations, Museum of Modern Art, New York · Denk-Bilder, Kunsthalle der Hypo-Kulturstiftung, München · Ludwig Forum für Internationale Kunst, Achen · Use Me (mit Damien Hirst), Institute of Contemporary Arts, London 1992 Yvon Lambert collectionne, Musée d'Art Moderne de la Communauté de Lille, Villeneuve D'Ascq · Edward Muybridge and Contemporary American Photography: Motion and Document – Sequence and Time, Addison Gallery of American Art, Andover, Massachusett, International Center of Photography, Midtown, New York · Long Beach Art Museum, Long Beach · Allegories Americana 1930–1970, Lingotto, Torino · Psycho, KunstHall, New York

Bibliographie | Bibliography

Texte und Bücher vom Künstler
Texts and books by the artist
Pictures of Sculptures in a Room, 1965–68 · Clear Sky, 1967–68 · Burning Small Fires, 1968 · LAAir, 1970, in: Artists and Photographs, New York: Multipkles, Inc. , 1971 · Notes and Projects, in: Artforum, Nr. 4, 1970 · Body Works, (photo essay) in: Interfunktionen, 6. September 1971 · Left or Standing, Standing or Left Standing, 1971 (Begleittext zu/Text written to accompany Installation with Yellow Lights, Leo Castelli Gallery, New York) · Construction of the Ellipse Piece, in: Bruce Kurtz, ed.

Documenta 5: A Critical Preview, Arts Magazine, Nr. 8, Sommer, 1972 · *(Notes and statements)*, in: Grégoire Müller and Gianfranco Gorgoni. *The New Avant-Garde: Issues for the Art of the Seventies,* New York, Praeger Publishers, 1972 · *Floating Room,* 1973 (Begleittext zu/Text written to accompany the installation *Floating Room: Lit from the inside,* Leo Castelli Gallery, New York, März, 1973) · *(Image Projection and Displacement), (No promises),* 1973 (Begleittext zur Installation/Text written to accompany the installation *Image Projection and Displacement,* Ace Canada, Vancouver, Dezember, 1973) · *Flayed Earth/ Flayed Self (Skin/Sink),* 1974 (Begleittext zur Installation/Text written to accompany the installation *Flayed Earth/Flayed Self (Skin/Sink),* Nicholas Wilder Gallery, Los Angeles, Dezember 1973/Januar 1974) · *Körperdruck/Body Pressure,* 1974 (Begleittext zur Wandinstallation ohne Titel/ Text written to accompany an untitled wall installation, Galerie Konrad Fischer, Düsseldorf, Februar/März, 1974) · *Cones/Cojones,* 1974/75 (Begleittext zur Installion/Text written to accompany the installation *Cones/Cojones,* Leo Castelli Gallery, New York, Januar, 1975) · *False Silences,* in: Vision, Nr. 1, September, 1975 · *The Consummate Mask of Rock,* 1975 (Begleittext zur Installation/Text written to accompany the installation *The Mask to Cover the Ned for Human Companionship* später unter dem Titel/later retitled *The Consummate Mesk of Rock,* Albright-Knox Art Gallery, Buffalo, September/November, 1975) · *Forced Perspective,* 1975 (Begleittext zur Installation/Text written to accompany the installation *Forced Perspective,* Galerie Konrad Fischer, Düsseldorf, Dezember 1975/Januar 1976) · *Diamond Mind,* 1975 (Begleittext zur Installation/Text written to accompany the installation *Diamond Mind,* Konrad Fischer, Düsseldorf, Dezember 1975/Januar 1976)

Bücher | Books
Coosje van Bruggen, *Bruce Nauman,* New York, Rizzoli International Publications, 1988 (with bibliographical references until 1988) · *Bruce Nauman Sculptures et Installations,* Bruxelles, Ludion, 1991

Periodika | Periodicals
Brooks **Adams,** *The Nauman Phenomenon,* in: Art and Auction, Dezember, 1990 · Kenneth **Baker,** *Carnegie International,* in: Artforum, Nr. 7, März, 1989 · Mary Rose **Beaumont,** *Bruce Nauman, Robert Mangold: Saatchi Collection,* in: Arts Review, Nr. 12, 30. Juli, 1990 · Stephan **Berg,** *Bruce Nauman,* in: Kunstforum, Bd. 112, März/ April, 1991 · Francesco **Bonami,** *Dislocation, the Place of Installation,* in: Flash Art, Nr. 162, Januar/Februar, 1992 · Kim **Bradley,** *Bruce Nauman: the private and the public,* in: Artspace, Nr. 3, Sommer, 1987 · Silvia **Camerini,** *Los Angeles. Bruce Nauman al MOCA,* in: Vogue (It.), Nr. 455, Februar, 1988 · Dan **Cameron,** *Opening Salvos. Part One,* in: Arts Magazine, Nr. 4, Dezember, 1987 · Timothy **Cohrs,** *Bruce Nauman: Drawings,* in: Art News, Nr. 9, November, 1987 · Lynne **Cook,** *Minimalism reviewed,* in: The Burlington Magazine, Nr. 1038, September, 1989 · Regina **Cornwell,** *A Question of Public Interest,* in: Contemporanea, Nr. 2, Februar, 1990 · Holland **Cotter,** *Dislocating the Modern,* in: Art in America,

Nr. 1, Januar, 1992 · Alain **Cueff,** *Le crime expérimental de Bruce Nauman,* in: Beaux-Arts, Nr. 91, Juni, 1991 · Joshua **Decter,** *Bruce Nauman: Sperone Westwater,* in: Flash Art, Nr. 143, November/Dezember, 1988 · David **Deitcher,** *Art on The Installation Plan,* in: Artforum International, Nr. 5, Januar, 1992 · Nikolai B. **Forstbauer,** *Das Schreien der Stille,* in: Zyma, Nr. 3, Juni/ Juli, 1991 · Christopher **French,** *Bruce Nauman: Humor versus Terror,* in: The Journal of Art, Nr. 5, Mai, 1989 · Colin **Gardner,** *The Esthetics of Torture,* in: Artweek, Nr. 12, 4. April, 1987 · Colin **Gardner,** *The Body as Signifier,* in: Artweek, Nr. 11, 19. März, 1988 · Liam **Gillick,** *Bruce Nauman, Robert Mangold. Saatchi Collection,* in: Artscribe International, Nr. 78, November/Dezember, 1989 · Deborah **Gimelson,** *Works on Paper,* in: Art and Auction, Nr. 10, Mai, 1987 · Nancy **Goldring,** *Identity Representations of the Self,* in: Arts Magazine, Nr. 7, März, 1989 · Jonathan **Goodman,** *From Hand to Mouth to Paper to Art: The Problems of Bruce Nauman's Drawings,* in: Arts Magazine, Nr. 6, Februar, 1988 · Adam **Gopnik,** *The Art World: Bits and Pieces,* in: The New Yorker, Nr. 13, 14. Mai, 1990 · Antje von **Graevenitz,** *Geloof en twijfel in het werk van Christo en Bruce Nauman. Rituele aspecten in het existentialistisch perspectief,* in: Archis, Maandblad voor Architectuur, Stedebouw, Beeldende Kunst, Nr. 6, Juni, 1990 · Antje von **Graevenitz,** *Horror en schoonheid. Recent werk van Bruce Nauman,* in: Archis, Maandblad voor Architectuur, Stedebouw, Beeldende Kunst, Nr. 7, Juli, 1990 · Antje von **Graevenitz,** *Belief and Doubt in the Work of Christo and Bruce Nauman,* in: Art & Design, Nr. 3/4, 1990 · Eleanor **Heartney,** *Bruce Nauman: Sperone Westwater, Castelli, Thompson Street,* in: Art News, Nr. 7, September, 1990 · Martin **Hentschel,** *Bruce Nauman. Konrad Fischer,* in: Artforum International, Nr. 1, September, 1988 · Martin **Hentschel,** *Bruce Nauman, Konrad Fischer,* in: Artforum International, Nr. 7, März, 1990 · Claudia **Jolles,** *Bruce Naumans Skulpturen und Installationen im Museum für Gegenwartskunst Basel,* in: Das Kunst-Bulletin, November, 1990 · David **Joselit,** *Lessons in Public Sculpture,* in: Art in America, Nr. 12, Dezember, 1989 · Richard **Kalina,** *Bruce Nauman: Leo Castelli Gallery; Sperone Westwater Gallery,* in: Arts Magazine, Nr. 10, Sommer, 1990 · Dodoe **Kazanjian,** *New Image,* in: Vogue, Nr. 180, Mai, 1990 · Carin **Kuoni,** *Bruce Nauman – zum Tatbestand des Gegebenen,* in: Das Kunst-Bulletin, November, 1990 · Donald **Kuspit,** *Bruce Nauman. Leo Castelli Gallery, Lorence Monk,* in: Artforum, Nr. 5, Januar, 1990 · Kay **Larson,** *New York, Dislocations,* in: Galeries Magazine, Nr. 46, Dezember 1991/Januar 1992 · Christopher **Lyon,** *Bruce Nauman. Sperone Westwater,* in: Artnews, Nr. 10, Dezember, 1988 · Robert **Mahoney,** *New York in Review,* in: Arts Magazine, Nr. 4, Dezember, 1988 · Robert C. **Morgan,** *Jasper Jones, David Salle, Bruce Nauman. Leo Castelli,* in: Flash Art, Nr. 144, Januar/Februar, 1989 · Robert C. **Morgan,** *Eccentric Abstraction and Postminimalism: From Biomorphic Sensualism to Hard-Edge Concreteness,* in: Flash Art, Nr. 144, Januar/Februar, 1989 · Ulli **Moser,** *Bruce Nauman,* Künstlerforum, Bd. 117, 1992 · Lois E. **Nesbitt,** *Lie Down, Roll Over. Bruce Nauman's Body-Conscious Art Reawakens New York,* in: Artscribe, Nr. 82, Som-

mer, 1990 · Linda **Novak,** *Bruce Nauman: Drawings 1965–1986,* in: High Performance, Nr. 41/42, Frühjahr/Sommer, 1988 · John **O'Brien,** *The Epitome of Minimal Sculpture,* in: Artweek, Bd. 20, Nr. 39, 9. November, 1989 · Leah **Ollman,** *Bruce Nauman: Vices and Virtues,* in: High Performance, Nr. 13, Herbst, 1989 · William **Peterson,** *Albuquerque. The Kitsch of Death,* in: Artnews, Nr. 8, Oktober, 1988 · Patricia C. **Phillips,** *Bruce Nauman. Sperone Westwater Gallery,* in: Artforum, Nr. 4, Dezember, 1988 · Peter **Plagens,** *Under Western Eyes,* in: Art in America, Nr. 1, Januar, 1989 · Jerry **Saltz,** *Assault and Battery, Surveillance and Captivity,* in: Arts Magazine, Nr. 8, April, 1989 · Christoph **Schenker,** *Tears of a clown,* in: Flash Art, Nr. 158, Mai/Juni, 1991 · Joseph **Simas,** *Letter from Belgium and France,* in: Arts Magazine, Nr. 3, November, 1989 · Joan **Simon,** *Breaking the Silence,* in: Art in America, Nr. 9, 1988 · Pat **Steir,** *The Word Unspoken,* in: Artforum, Nr. 4, Dezember, 1989 · Erika **Suderberg,** *Defining an Art Form,* in: Artweek, Nr. 5, 20. Februar, 1988 · Susan **Tallman,** *Clear Vision. The Prints of Bruce Nauman,* in: Arts Magazine, Nr. 3, November, 1989 · Amy **Taubin,** *Clowning Around,* in: Village Voice, Nr. 52, 26. Dezember, 1989 · Majorie **Welish,** *Who's Afraid of Verbs, Nouns, and Adjectives?,* in: Arts Magazine, Nr. 8, April, 1990 · C. H. **van Winkel,** *Manupulations and Rotations. Bruce Nauman in Dutch Collections,* in: Kunst & Museumjournaal, Nr. 4, 1991 · Max **Wechsler,** *Bruce Nauman. Museum für Gegenwartkunst,* in: Artforum, Nr. 4, Dezember, 1990 · Girard **Xavier,** *Le temple et l'architecte,* in: Art Press, Nr. 140, Oktober, 1989 · Frank **Zoretisch,** *Tunnel Vision. Bruce Nauman's walk-through concrete art causes critical campus controversy,* in: Albuquerque Journal Magazine, 8. März, 1988 · Jörg **Zutter,** *Alienation of the Self, Command of the Other in the Work of Bruce Nauman,* in: Parkett, Nr. 27, März, 1991

MAX NEUHAUS

*Beaumont/Texas (USA), 1939
Lebt/Lives in New York/Paris

Kurzzeitige Klangarbeiten
Einzelausstellungen und andere Arbeiten
Short-Term Sound Works
One-man shows and other works

1966 *Public Supply I* (telephone/ broadcast work), WBAI, New York **1966/76** *Listen,* 15 sound walks, various locations in the United States and Canada **1966/67** *American Can* (sound event series), New York · *By-Product,* sound event series, New York **1967/ 1968** *Drive-In-Music,* Lincoln Parkway, Buffalo, New York **1968** *Fan Music,* rooftops of 137–141 Bowery, New York · *Southwest Stairwall,* Ryerson University, Toronto · *Maxfeed,* sound event and edition of sound objects, New York · *Telephone Access,* sound responsive telephone number, New York · **1968** *Public Supply II* (telephone/ broadcast work) , CJRT, Toronto **1970** *Public Supply III* (telephone/ broadcast work), WBAI, New York **1971** *Water Whistle I,* New York University, New York · *Water Whistle II* Newark State College, Newark **1972** *Water Whistle III,* Walker Arts Center,

Minneapolis · *Water Whistle IV*, California Institute for the Arts, Newhall · *Water Whistle V*, University of California, La Jolla · *Water Whistle VI*, State University of New York, Buffalo · *Water Whistle VII*, Jewish Community Center, Buffalo · *Water Whistle VIII*, University of South Florida, Tampa · *Water Whistle IX*, Central Michigan University, Mount Pleasant · *Water Whistle X*, Michigan State University, East Lansing **1973** *Water Whistle XI*, York University, Toronto · *Water Whistle XII*, Everson Museum, Syracuse · *Water Whistle XIII*, University of Southern California, Los Angeles · *Public Supply IV* (telephone/ broadcast work), WFMT, Chicago · *Water Whistle XIV*, Rochester Institute of Technology, Rochester **1973/77** *Walkthrough*, Jay Street subway station, New York **1974** *Listen*, Op Ed editorial, New York Times, December 6, 1974 · *Water Whistle XV*, Leo Castelli Gallery, New York · *Water Whistle XVI*, John Weber Gallery, New York · *Water Whistle XVII*, Sonnabend Gallery, New York **1975** *Drive-In-Music*, Lewiston State Arts Park, New York **1976** *Round*, Old US Customs House, New York · *Underwater Music I*, Radio Bremen · *Underwater Music II*, Institute for Art and Urban Resources, New York **1977** *Radio Net* (telephone/ broadcast work), National Public Radio Network, USA · *Underwater Music III*, Radio RIAS, Berlin **1978** *(untitled sound work)*, The Museum of Modern Art, New York · *(untitled sound work)*, Stichting De Appel, Amsterdam · *Underwater Music IV*, Stichting De Appel, Amsterdam · *Listen*, postcard decal, Hear Inc., New York **1979** *Five Russians*, The Clocktower, New York **1980/83** *(untitled sound work)*, Botanical Garden, Como Park, St. Paul **1983** *(untitled sound work)*, ARC 2, Musée d'Art Moderne de la Ville, Paris (Kat.: M. N.) · *(untitled sound work)*, Kunsthalle, Basel (Kat.: C. Ratcliff, J.-C. Ammann) · *(untitled sound work)*, Bell Gallery, Brown University, Providence (Kat.: M. N.) **1988** *River Gwove*, Roaring Fork River, Aspen · *Sound Line*, Magasin, Centre National d'Art Contemporain de Grenoble, Grenoble (Kat.: F. Kaiser) · *Infinite Lines From Elusive Sources # 1*, Galerie Ghislaine Hussenot, Paris **1989** *A Bell For St. Cäcilien*, Kölnischer Kunstverein, Köln (Kat.: W. Herzogenrath, U. Loock, M. N.) **1990** *Infinite Lines From Elusive Sources # 2*, Galleria Giorgio Persano, Milano (Kat.: U. Loock, D. Zacharopoulos) · *Two Sides of The »Same« Room*, Dallas Museum of Art, Dallas

Permanent Sound works

Since 1977 *Times Square*, pedestrian island between 46th and 45th Streets, New York (anonymous) **Since 1979** *(untitled sound work)*, Museum of Contemporary Art, Chicago **Since 1983** *(untitled sound work)*, Villa Celle, Pistoia **Since 1986** *(untitled sound work)*, Domaine de Kerguehennec, Locmine (Kat.: D. Zacharopoulos) · *Works For One Person – Number 1*, Eric Franck, Genève **Since 1989** *Time Piece*, Kunsthalle, Bern (Kat.: W. Herzogenrath, U. Loock, M. N.) · *A Large Small Room*, Karsten Greve, Köln **Since 1990** *Three »Similar« Rooms*, Giorgio Persano, Torino

Gruppenausstellungen | Group shows

1973 *Rooms* (untitled sound work), Institute for Art and Urban Resources, New York **1977** *Documenta 6* (untitled sound work), Kassel **1983** *Whitney Biennial* (Time Piece 'Archetype'), Whitney Museum of American Art, New York **1985** *Promenades* (untitled sound work), Centre d'Art Contemporain, Genève **1989** *Einleuchten (Two „Identical" Rooms)*, Deichtorhallen, Hamburg

Bibliographie | Bibliography

Texte und Bücher vom Künstler
Texts and books by the artist
Audium für eine Welt als Hör-Raum, in: Vom Verschwinden der Ferne, Telekommunikation und Kunst, Köln, DuMont Verlag, Köln, 1990

Periodika | Periodicals
Alain **Cueff**, *Max Neuhaus, The Space of Sound*, in: Artscribe, September/Oktober, 1988 · Arthur **Danto**, *Max Neuhaus: Sound Works*, in: The Nation (New York), 4. März, 1991 · Carter **Ratcliff**, *Max Neuhaus: Aural Spaces*, in: Art in America, Oktober, 1987 · Pierre **Restany**, *Max Neuhaus: Concetto e Metodo du Una Arhittura Sonora*, in: Domus, Nr. 684, Juni, 1987 · Calvin **Tomkins**, *Hear*, in: The New Yorker, 24. Oktober, 1988

PEKKA NEVALAINEN

*Tyrvää (SF), 1951
Lebt/Lives in Kisko

Einzelausstellungen | One-man exhibitions

1976 Gallery Cheap Thrills, Helsinki **1981-1982** Old Studenthouse, Helsinki **1984** Kluuvi Gallery, Helsinki **1985** Finnish Painter's Society, Helsinki · Book Cafe, New

Studenthouse, Helsinki **1986** Oulu Art Museum, Oulu **1989** Kluuvi Gallery, Helsinki **1991** Pieni Agora Gallery, Helsinki · Gallery of the Kotka Artists' Association, Kotka **1992** Galerie Artek, Helsinki

Gruppenausstellungen | Group exhibitions

1987 *Streif*, Nordic sculpture, Kunsthallen Brandts Klaedefabrik, Odense (et al.) **1989** *Borealis*, Louisiana · The 125th Anniversary Exhibition of the Finnish Artists' Association, Art Museum of the Ateneum and Kluuvi Gallery, Helsinki **1990** *Distances*, Biennale Balticum, Rauma · *New Nordic Art*, the Central House of Artists, Moskva · *Nach den Regeln der Kunst*, Zeitgenössische Finnische Skulptur/contemporary Finnish sculpture, Karmeliterkloster, Frankfurt/M. **1991** *Free Zone*, Helsinki Art Exhibition Hall and Mücsarnok, Budapest · *Nach den Regeln der Kunst*, Kunststation Kleinsassen, Fulda/Joensuu Art Museum (Finl.)

NIC NICOSIA

*Dallas (USA), 1951
Lebt/Lives in Dallas

Einzelausstellungen | One-man exhibitions

1981 *Photographs*, Brown Lupton Gallery, Texas Christian University, Fort Worth **1982** Artist Space, New York · *Domestic Dramas*, Delahunty Gallery, Dallas **1984** The Akron Museum, Akron · *Near (modern) Disasters*, Delahunty Gallery, New York · *Domestic Dramas/Near Modern Disasters*, Jane Corkin Gallery, Toronto **1985** *Nic Nicosia's Realities*, Milwaukee Art Museum, Milwaukee · *Domestic Dramas/Near (modern) Disasters*, Center of Photography, Houston · *The Cast*, Marcuse Pfeifer Gallery, New York · *New Photographs* – Dart Gallery, Chicago **1986** *Concentrations 13* – Museum of Art, Dallas · *Recent Photographs, Wellesley Jewitt Museum*, Wellesley Colege, Boston · *The Cast*, Texas Gallery, Houston · Maurice Keitlman Gallery, Bruxelles · Film in the Cities, St. Paul · *Photographs*, Eve Mannes Gallery, Atlanta, Georgia **1987** *Life as we know it*, Albert Totah Gallery, New York/ Barry Whistler Gallery, Dallas/Janie Beggs Fine Art, Ltd., Aspen · *Photographs*, Arthur Roger Gallery, New Orleans · *Life as we know it*, University Art Galleries, Wright State, Dayton · Honolulu Academy of Arts, Honolulu · *Real Pictures & Life as We Know it*, Art Museum of Southeast Texas, Beaumont **1988** *Real Pictures*, Texas Gallery, Houston · *Real Pictures*, Bruno Facchetti Gallery, New York (Kat.) **1989** *Real Pictures*, Dart Gallery, Chicago/Barry Whistler Gallery, Dallas **1990** *New Photographs: Real Pictures*, Linda Cathcart Gallery, Santa Monica · *New Work*, Facchetti Gallery, **1991** *A Progression of Photographs*, University of North Texas Art Gallery, Denton · *Love + Lust*, Dart Gallery, Chicago/Pace/MacGil Gallery, New York/Linda Cathcart Gallery, Santa Monica/Barry Whistler Gallery, Dallas/Texas Gallery, Houston

Gruppenausstellungen | Group exhibitions

1987 *Arrangement for the Camera*, Baltimore Museum of Art, Baltimore · *Derek*

Boshier, Nic Nicosia, Susan Whyne, Albert Totah Gallery, New York · Crime and Punishment, Schreiber/Cutler Contemporary Art, New York · Torino Fotografia 87, Biennale International, Torino · Selections from the Exxon Series, Guggenheim Museum, New York · Contemporary Photographic Portraiture, ELAC, Lyon · Third Coast Revie: A Look At Art In Texas, Aspen Art Museum, Aspen 1988 Photographic Truth, Bruce Museum, Greenwitch · Texas, Groninger Museum, Groningen · Photography on the Edge, Haggerty Museum, Marquette University, Milwaukee · Fabricatios, Sert Gallery, Harvard University, Cambridge · Evocative Presence, Museum of Fine Arts, Houston · Vision/Television, JIPAM, Montpellier · Life Stories, Henry Art Gallery, University of Washington, Seattle 1989 Stage Documents, Tina Barney and Nic Nicosia SF Camerawork, San Francisco · Nature and Culture: Conflict and Reconciliation in Recent Photography, The Friends of Photography, San Francisco · Konstruierte Fotografie, Kunstverein Museum, München 1990 Reinventing Reality, Sarah Campbell Blaffer Gallery University of Houston · Family Stories, Newhouse Center for Contemporary Art Snug Harbor Cultural Center, Staten Island, New York · Black and White: Works on Paper, Linda Cathcart Gallery, Santa Monica · Art that Happens to be Photography, Texas Gallery, Houston 1991 Pleasures and Terrore of Domestic Comfort, Museum of Modern Art, New York · Past/Present: Photographs from the Collection of the Museum of Fine Arts, Houston

Bibliographie | Bibliography

Texte vom Künstler | Texts by the artist
On Fire (Project for Artforum)), in: Artforum, Nr. 3, November, 1989

Periodika | Periodicals
Vince Aletti, Nic Nicosia, in: Village Voice, Nr. 11, März, 1987 · Vince Aletti, Nic Nicosia, in: The Village Voice, Nr. 46, 15. November, 1988 · Vince Aletti, Choices – Photo: Nic Nicosia, in: The Village Voice, Nr. 18, Mai, 1990 · Terry Barrett, Joel-Peter Witkin, Nic Nicosia, in: New Art Examiner, Januar, 1988 · Dana Farver, Life as Nicosia Knows it, in: Ultra Magazine, Februar, 1988 · Susan Freudenheim, Suburban Hamlets, in: Artforum, Nr. 9, Mai, 1987 · Jamey Gambrell, Texas: State of the Art, in: Art in America, März, 1987 · Susan Hapgood, Nic Nicosia, in: Art in America, Nr. 10, Oktober, 1990 · Eleanor Heartney, Nic Nicosia, in: Artnews, Nr. 5, Mai, 1987 · Max Kozloff, Hopless Figures in an Artificial Storm, in: Artforum, Nr. 3, November, 1989 · Rob Perree, De Ontmaskering Van Dynasty, in: Kunstbeeld, April, 1988 · Christian Pouligo, Ping-Photo et Pong-Tele, in: Photo Magazine, Mai, 1988 · Joe Scanlan, Nic Nicosia, in: Artscribe, Nr. 82, Sommer, 1990 · Carol Squiers, Domestic Blitz: The Modern Cleans House, in: Artforum, Nr. 2, 1991 · Susan Weiley, The Darling of the Decade, in: Artnews, Nr 4, April, 1989

MOSHE NINIO

*Tel-Aviv (IL), 1953
Lebt/Lives in Tel-Aviv

Einzelausstellungen | One-man exhibitions

1983 Naomi Givon Gallery, Tel-Aviv 1986 Camera Obscura Gallery, Tel-Aviv 1987 Camera Obscura Gallery, Tel-Aviv 1989 Institute of Art Gallery, Oranim · Bertha Urdang Gallery, New York 1990 The Israel Museum, Jerusalem (Kat.: M.N., M. Ron, Y. Zalmona)

Gruppenausstellungen | Group exhibitions

1987 Environment/Presence, Kalisher 5 Gallery, Tel-Aviv 1988 Art L. A., Givon Gallery, Los Angeles · Wet Paint, Tel-Aviv Museum of Art · Artist Studios – The Aika (Ariel Brown) Gallery, Jerusalem · Artist, Communication, Artist, Beit Hayotzer Gallery, Haifa · Fresh Paint, The Younger Generation in Israeli Art, Tel-Aviv Museum of Art · New Aquisitions, The Israel Museum, Jerusalem 1990 Life-Size, The Israel Museum, Jerusalem · Space/Presentation/Power, Bograshov Gallery, Tel-Aviv · Towards the 90's, Mishkan Le'Omanut, Ein Harod · Photograph Department Gallery, Bezalel Academy of Art and Design, Jerusalem 1991 Lignes de mire, Fondation Cartier, Jouy-en-Josas · Persistence of Memory, Israeli Biennale of Photography, Mishkan Le'Omanut, Ein Harod · Place & Mainstream, Contemporary Sculpture from Israel, Hara Museum Arc, Gunma Prefecture 1992 Routes of Wandering: Nomadism, Journeys and Transitions in Contemporary Israeli Art, Israel Museum, Jerusalem

Bibliographie | Bibliography

Periodika | Periodicals
Galia Bar-Or, But we're not really in the picture, in: Studio, Nr. 10, April, 1990 · Michael Segan Cohen, A Cautious Approach to the Sources, in: Studio, Nr. 14, September, 1990 · David Gurevitch, Post-Modernism and the State of Things: The Floating Catastrophe, Sign Language, the Goal, in : Studio, Nr. 14, September, 1990

JUSSI NIVA

*Pello (SF), 1966
Lebt/Lives in Helsinki

Einzelausstellungen | One-man exhibitions

1990 Kluuvi Gallery, Helsinki 1991 Galerie Artek, Helsinki

Gruppenausstellungen | Group exhibitions

1987 The Annual Exhibition of the Artists, Association of Finland, Helsinki 1988 The Young Artists Exhibition, Helsinki Art Hall, Helsinki Fiskars Factory, Porvoo 1989 Televisio – 9 young Finnish Artists, Otso Gallery, Espoo · The 60th Anniversary Exhibition of Finnish Painters Union, Helsinki/Poro 1990 Finnish Visions, Kunstnernes Hus, Oslo 1991 Seeing, The Pori Art Museum, Pori · Stillstand Switches, Shedhalle, Zürich · Ars Baltica Prolog, Stadtgalerie Sophienhof, Kiel · Aurora 4, The Nordic Arts Center, Helsinki · Aurora 4, Kulturhuset, Stockholm · Ars Baltica Prolog, Riga 1992 Ars Baltica Prolog, Berlin · Perpektiv, The Museum of Contemporary Art, Helsinki

CADY NOLAND

*Washington, DC (USA), 1956
Lebt/Lives in New York

Einzelausstellungen | One-man exhibitions

1988 The white Room, White Columns, New York · Wester Singel, Rotterdam 1989 Massimo De Carlo Arte Contemporanea, Milano · Anthony Reynolds Gallery, London · American Fine Arts, Co., New York 1990 Luhring Augustine, Hetzler Gallery, Santa Monica · Neue Gesellschaft für Bildende Kunst, Berlin 1991 Museum Fridericanum, Kassel (Kat.)

Gruppenausstellungen | Group exhibitions

1987 Nature Morte, New York 1988 Sunrise

Highway, John Gibson Gallery, New York · *Artists and curators,* John Gibson Gallery, New York · *Still Trauma,* Milford Gallery, New York · *Works Concepts Processes Situations Information,* Galerie Hans Mayer, Düsseldorf · *The White Room,* White Columns Benefit, New York · KunstRai, Amsterdam · *White Columns Update – 1988,* White Columns, New York **1989** *A climate of site,* Galerie Barbara Farber, Amsterdam · *Matter/Anti Matter: Defects in the Model,* Terrain Gallery, San Francisco · Galerie Hufkens, Bruxelles · Daniel Newburg Gallery, New York · *Strange attractors: signs of chaos,* The New Museum of Contemporary Art, New York · *Einleuchten, Will, Vorstel & Simul in HH,* Deichtorhallen, Hamburg · *Aus Meiner icht,* Kölner Kunstverein, Köln · *Amerikarma,* Hallwalls, Buffalo · Roy Boyd Tallery, Santa Monica · The Mattress Factory, Pittsburgh · *The Elements: Sex, Politics, Money & Religion,* Real Art Ways, Hartford · *Une autre affaire,* Le Consortium, Dijon · *Filling in the Gap,* Richard L. Feigen & Co., Chicago · New Langton Arts, San Francisco · Massimo Audiello Gallery, New York · *Jet Lag,* Turon Travel, New York · *A Climate of Site,* Galerie Barbara Farber, Amsterdam · Galerie Hussenot, Paris **1990** Galerie Max Hetzler, Köln · *Jardins de Bagatelle,* Galerie Tanit München · *No, not that one it's a chair,* Galerie 1900, Paris · *Just Pathetic,* Rosamund Felsen Galleria, Los Angeles **1991** *The Museum of Natural History,* Galerie Barbara Farber, Amsterdam · *Metropolis,* Martin-Gropius-Bau, Berlin · *AnniNovanta,* Galleria Comunale d'Arte Moderna, Bologna · Galerie Max Hetzler, Köln · *Objects for the Ideal Home,* Serpentine Gallery, London · *American Artists of the Eighties,* Palazzo delle Albere, Museo Provinciale d'Arte Contemporanea, Trento · *Larry Clark, Robert Gober, Mike Kelley, Jeff Koons, Cady Noland, Richard Prince, Cindy Sherman, Christopher Wool,* Luhring Augustine Hetzler Gallery, Santa Monica · *Social Sculpture,* Vrej Baghoomian Gallery, New York · *The Good, the Bad & the Ugly: Knowledge and Violence in American Art,* Ezra and Cecile Zilkha Gallery, Center for the Arts, Wesleyan University, Connecticut · *Strange Abstraction,* Touko Museum of Contemporary Art, Tokyo · Galerie Max Hetzler, Köln · Ludwig Forum für Internationale Kunst, Aachen · *Home for June,* Home for Contemporary Theatre and Art, New York · *BAM Art Sale,* Benefit for Brooklyn Academy of Music, Pace Gallery, New York · *Sculptors‹ Drawings,* Paula Cooper Gallery, New York · *Biennial,* Whitney Museum of American Art, New York · *The Museum of natural History,* Barabara Farber Gallery, Amsterdam · *ECART,* Genève, Galerie van Gelder, Amsterdam · *FluxAttitudes,* Hallwalls, Buffalo · *Transcendent Pop,* trans-Avantgarde Gallery, San Francisco · *Cady Noland and Felix Gonzalez-Torres,* Museum Fridericianum, Kassel **1992** *Just Pathetic,* American Fine Arts, Co, New York

Bibliographie | Bibliography

Texte der Künstlerin | Texts by the artist
Towards a Meta-Language of Evil, in: Balcon, Nr. 4, 1989

Periodika | Periodicals
Jean-Christophe **Ammann,** *Wie offen ist das Aperto an der Biennale von Venedig,* in:

Kunst-Bulletin, Juli/August, 1990 · Jan **Avgikos,** *Degraded World,* in: Artscribe, Nr. 78, 1989 · Nicolas **Bourriaud,** *Figuration in Age of Violence,* in: Flash Art, Januar/Februar, 1992 · Dan **Cameron,** *Changing Priorities in American Art,* in: Art International, Nr. 10, 1990 · Phillippe Evans **Clark,** *Artistes Et Curators – Galerie John Gibson,* in: Art Press, Dezember, 1988 · **Collins & Milazzo,** *From Kant to Kitsch and Back Again,* in: Tema Celeste, Januar/Februar, 1991 · Michele **Cone,** *Cady Noland,* in: Journal of Contemporary Art, Nr. 2, 1990 · Stephen **Even,** Nancy Spector, *Double Fear,* in: Parkett, Nr. 22, 1989 · Gretchen **Faust,** in: Nike, Nr. 23, 1988 · Gretchen **Faust,** *New York in Review,* in: Arts Magazine, September, 1989 · Richard **Hawkins,** *Just Pathetic,* in: Art Issues, Nr. 14, November, 1990 · Michael **Hübl,** *Grosstadtfieber,* in: Kunstforum, Mai/Junui, 1991 · Anthony **Iannacci,** *Cady Noland,* in: Artforum, Februar, 1990 · Ken **Johnson,** *General Saga,* in: Art in America, Juni, 1991 · Nancy **Jones,** *Anxieux Objets Made in USA,* in: Artstudio, Nr. 19, Winter, 1990 · Susan **Kandel,** *Review,* in: Arts Magazine, Oktober, 1990 · Kay **Larson,** *Whitney Biennial,* in: Galeries Magazine, Juni/Juli, 1991 · Lisa **Liebmann,** *Cady Noland at American Fine Arts,* in: Art in America, November, 1989 · Susanne **Lingemann,** *Ein Spiel mit Amerikas Mythen,* in: Art, Nr. 7, Juli, 1991 · Robert **Mahoney,** *Artists and Curators,* in: Tema Celeste, Nr. 19, Januar/März, Nr. 19, März, 1989 · R. Terry **Myers,** *From The Junk Aesthetic To The Junk Mentality,* in: Arts Magazine, Februar, 1990 · Robert C. **Morgan,** *Word, Document, Installtion,* in: Arts Magazine, Mai, 1991 · Robert **Nickas,** *Entropy and the New Objects,* in: El Paseante, Oktober, 1988 · Klaus **Ottmann,** *Cady Noland. La mort en action,* in: Art Press, Nr. 148, 1990 · Renate **Puvogel,** *Status of Sculpture,* in: Kunstforum, Mai/Juni, 1991 · Raphael Meyer **Rubinstein,** in: Flash Art, Nr. 151 März/April, 1990 · Daniela Salvioni, *Cady Noland. The Homespun Violence of the Hearth,* in: Flash Art, Oktober, 1989 · Jeanne **Siegel,** *The American Trip. Cady Noland's Investigations,* in: Arts Magazine, Dezember, 1989 · Jeanne **Siegel,** *The 1991 Whitney Biennial,* in: Tema Celeste, Mai/Juni, 1991 · Jody **Zellen,** *Rethinking Cowboy Culture,* in: Artweek, 16. August, 1990

MANUEL OCAMPO

*Quezon City (RP), 1965
Lebt/Lives in Los Angeles

Einzelausstellungen | One-man exhibitions

1988 La Luz de Jesus Gallery, Los Angeles **1989** The Onyx Gallery, Hollywood **1990** Christopher John Gallery, Santa Monica · Guggenheim Gallery, Santa Monica **1991** Fred Hoffman Gallery, Santa Monica

Gruppenausstellungen | Group exhibitions

1987 *I Just Stopped Off For A Beer,* Kulay Diwa Gallery, Manila · *The I love / Jesus Show,* La Luz de Jesus Gallery, Los Angeles · *Salon des Indépendants,* Richard Bennett Gallery, Los Angeles **1988** *Smaller Than a Breadbox,* SITE, Culver City · *The Scream Show,* ATA Gallery, San Francisco **1989**

Francine Ellman Gallery, Los Angeles · Da Gallery, Pomona · *Day of the Dead Show,* La Luz de Jesus Gallery, Los Angeles **1990** *Art Cafe,* Municipal Art Gallery, Hollywood · *Enigmatic Messages,* John Thomas Gallery, Santa Monica · Action Gallery, Los Angeles · *Asian American Art,* Korean Cultural Service, Los Angeles · *Opression 4 Voices,* John Thomas Gallery, Santa Monica

Bibliographie | Bibliography

Periodika | Periodicals
Michael **Laurence,** in: Art in America, Januar, 1991 · Pierre **Picot,** *Manuel Ocampo,* in: Visions, Frühling, 1991 · Marc **Selwyn,** *Manuel Ocampo,* in: Flash Art, Mai/Juni, 1991 · Benjamin **Weissman,** *Manuel Ocampo,* in: Artforum, Mai, 1991

JEAN-MICHEL OTHONIEL

*Saint-Etienne (F), 1964
Lebt/Lives in Paris

Einzelausstellungen | One-man exhibitions

1989 Galerie Antoine Candau, Paris (Kat.) **1990** Institut Français, Napoli · Das Lapidarium, Berlin · Galerie Ghislaine Hussenot, Paris **1991** Centre Gennevois de Gravure Contemporaine, Genève **1992** Galerie des Arènes, Musée d'Art Contemporain de la Ville, Nîmes · Galerie Nicole Klagsburn, New York

Gruppenausstellungen | Group exhibitions

1987 *Salon de la jeune sculpture,* Paris · *Germinations IV,* Vieille Charité, Marseille

1988 *Germinations IV,* Bonn (et al.) · *Ateliers 88*, Musée d'Art Moderne de la Ville, Paris · *Caserne Vauban*, Villa-St-Clair, Sète 1989 CIMAL International, Valencia · *Nos Années 80*, Fondation Cartier, Jouy-en-Josas · *Arène/Rituels*, Musée Bonnat, Bayonne 1990 *Total Novo*, Palermo · *Je viens de chez le charcutier*, de B. Marcadé, Galerie Ghislaine Hussenot, Paris 1991 *Moules, Moules*, Espace Paul Boyer, Sète · *Veramente Falso*, Rottonda di Via Besana, Milano · *Echt Falsch*, Villa Stuck, München · *Anni Novanta*, Galleria d'Arte Moderna, Bologna · *Too French*, Musée de Hong-Kong, Musée de Tokyo · *Les couleurs de l'argent*, Musée de la Poste, Paris 1992 *Regards multiples*, Galeries Contemporaines, Centre Georges Pompidou, Paris

Bibliographie | Bibliography

Texte und Bücher vom Künstler
Texts and books by the artist
El suspiro del Moro, JMO éditeur · *Le prêtre mysogine*, JMO éditeur · *Le Hôla de Valence*, JMO éditeur · *Les Amers*, (mit/with) Anne Pesce, édition Villa-St-Clair

Periodika | Periodicals
Hervé **Chandès**, *Nos années 80 – Fondation Cartier*, in: Beaux-Arts (hors série), 1989 · Michel **Nuridsany**, *Jean-Michel Othoniel – poésie ininterrompue*, in: Art Press, Januar, 1991 · **s.n.**, *Evidence de rencontres*, in: Ad Hoc, Herbst, 1990

Video
1987 *Les travaux du soir de l'amateur photographe*, Vidéo, 8 mm, Anna Erhel, Prod. ENSAD 1989 *Le prêtre Mysogine*, Vidéo, 5 mm, Luigi Gorry/Gigi Cazes, Prod. Savoir au présent, DAP. DDF. DRAC Ile ded France · *Nos anées 80*, In tranche de l'Art, Nr. 18, Vidéo, 3 mm, Brigitte Cornrad, Prod. Canal + (25. Juni, 1989) 1991 *Too French*, Vidéo, 2 mm, Fondation Cartier, Prod. Cartier Hong-Kong

TONY OURSLER

*1957
Lebt/Lives in Jamaica Plain

Einzelausstellungen | One-man exhibitions

1981 University Art Museum, University of California, Bekeley · *Video Viewpoints*, Museum of Modern Art, New York · The School of the Art Institute of Chicago, Chicago 1982 The Walker Art Center, Minneapolis · Boston Film/Video Foundation, *Boston* · *A Scene*, P.S. 1, New York · *A Scene*, M.C.A.D., Minneapolis · *Complete Works*, The Kitchen, New York · Soho TV M/T Channel 10, New York 1983 La Mamelle, San Francisco · *My Sets*, Media Study, Buffalo · *Son of Oil*, A Space, Toronto · Lace-Panic House, Los Angeles · *X-Catholic*, Beyond Baroque, Los Angeles 1984 Anthology Film Archives, New York · *L-7, L-5*, The Kitchen, New York · Mo David Gallery, New York 1985 Kijkhuis, Den Haag · Kunst Delft, Delft · Elac, Lyon · Schule für Gestaltung, Basel · The American Center, Paris 1986 *Spheres of Influence*, Centre Georges Pompidou, Paris (Kat.: J. Minkowsky, C. Van Assche) · Novia Scotia College of Art and Design, Nova Scotia · Noston Film/

Video Foundation, Boston 1987 The Kitchen, New York 1988 *Tony Oursler Works*, Le Lieu, Québec City · *Constellation: Intermission*, Diane Brown Gallery, New York · Western Front, Vancouver: *Tony Oursler and Constance Dejong*, LACPS/EZTV, Los Angeles 1989 *Relative* (video/performance), The Kitchen, New York (Rockland Center for the Arts, West Nyack; Seattle Arts Museum, Washington; Mikery Theatre, Amsterdam; ECG-TV Studios, Frankfurt) · *Drawings, Objects, Videotapes*, Delta Gallery, Düsseldorf Museum Folkwang Essen (Kat.: F. Malsch, T.O.) · Collective for Living Cinema, New York · Museum für Gegenwartskunst, Basel · Bobo Gallery, San Francisco 1990 Hallwalls, Buffalo, New York · Diane Brown Gallery, New York · The Kitchen, New York · *On Our Own*, The Segue Gallery, New York 1991 Diane Brown Gallery, New York · *Dummies, Hex Signs, Watercolors*, The Living Room, San Francisco · The Pacific Film Archives, San Francisco · The Cinematheque, San Francisco 1992 *F/X Plotter, 2 Way*, Kijkhuis, Den Haag · *Station Project* (mit/with James Casebere), Kortrijk (railway station)

Gruppenausstellungen | Group exhibitions

1987 *L'époque, la mode, la morale, la passion*, Centre Georges Pompidou, Paris · *Aspects of Media: Video*, Department of Video/Art Advisory Service of the Museum of Modern Art for Johnson & Johnson · *Japan 1987 Television and Video Festival*, Spiral Tokyo · documenta 8, Kassel · *Schema*, Baskerville + Watson Gallery, New York 1988 *The BiNational*, Institute of Contemporary Art, Museum of Fine Arts, Boston (et al.) · *Film Video Arts, 17 Years*, Museum of Modern Art, New York · *World Wide Video Festival*, Den Haag · *Twilight, Festival Belluard 88 Bollwerk*, Fribourg · *2nd Videonale*, Bonn · *New York Dagen*, Kunststichting, Rotterdam · *Videografia*, Barcelona · *Varitish*, Korea · *New York Musikk*, Oslo · *Festival International du Nouveau Cinéma et de la Vidéo*, Montréal · *Replacement*, LACE, Los Angeles · *Interfermental 7*, Hallwalls, Buffalo · *Serious Fun Festival*, installation for Alice Tully Hall, Lincoln Center 1989 *Biennial Exhibition* , Whitney Museum of American Art, New York · *Video Sculpture 1963–1989*, Kölnischer Kunst-

verein, Köln (et al.) · *XII Salso Film & TV Festival*, Salsomaggiore · *Masterpieces*, Stadtgarten, Köln · *Nepotism*, Hallwalls, Buffalo · *Video and Language*, Museum of Modern Art, New York · *Sanity is Madness*, The Artists Foundation Gallery, Boston · *World Wide Video Festival*, Den Haag 1990 *The Technological Muse*, Katonah Mueum of Art, Katonah, New York · *Tendance Multiples, Vidéo des Années 80*, Centre Georges Pompidou, Paris · *Video/Objects/Installations/Photography*, Howard Yerzerski Gallery, Boston · *Video Transforms Television – Communicating Unease*, New Langton Arts, San Francisco 1991 *New York Time Festival*, Museum van Hedendaagse Kunst, Gent · *Triune*, Bluecoat Gallery, Video Positive Festival, Liverpool

Bibliographie | Bibliography

Texte vom Künstler
Texts by the artist
Phototropic, in: Forehead, Bd. 2, reprinted in: Illuminating Video: An Essential Guide to Video Art, Aperture Foundation, 1987 · *Vampire*, in: Communications Video, Nr. 48, November, 1988 · *Phototropic*, in: Illuminating Video: an Essential Guide to Video Art, Doug Hall, Sally Jo Fifer, New York: Aperture, 1990 · *Triune: a Work in Progress*, in: Visions, Nr. 3, Sommer, 1991

Periodika | Periodicals
John **Berlinsky**, *The Light Fantastic*, in: Metro, Oktober, 1988 · C. **Carr**, *Constance Dejong and Tony Oursler: Relatives*, The Kitchen, in: Artforum, Mai, 1989 · Jean-Paul **Fargier**, *Installation à Beaubourg*, in: Le Journal Cahiers du Cinéma, Nr. 380, Februar, 1987 · Charles **Hagen**, *Video Art: the Chameleon*, in: Artnews, Sommer, 1989 · Jürgen **Hohmeyer**, *Die Fernbedienung der Kunstgeschichte*, in: Der Spiegel, Nr. 52, 1988 · Tony **Labat**, *Tony Oursler*, in: Shift, Nr. 2, 1991 · Dorothée **Lalanne**, *Tony Oursler: Dernier Soir*, in: Cinéma, 10. Februar, 1987 · Regina **Lange**, *Media-Power, Videoarbeiten von Tony Oursler*, in: Apex-Heft, Nr. 70, 1989 · Jaakko **Lintinen**, *Uudella mediataiteella taitaa olla hallussaan 90-luvun avaimet (To break into the new media arts is to possess the key to the 1990s)*, in: Taide (Finnland), Nr. 2, 1990 · John **Miller**, *Tony Oursler, Diane Brown Gallery*, in: Artforum, Oktober, 1990 · Elspeth **Sage**, *The Joy of collaboration: an interview with Constance Dejong and Tony Oursler*, in: Vancouver Guide, Nr. 4, 1988 · Amy **Taubin**, *Choices*, in: Village Voice, 20. Juni, 1990 · Margaret **Tiberio**, *Method to this Media: an interview with Tony Oursler*, in: Visions: a publication for the Media Arts by the Boston Film/Video Foundation, Nr. 1, 1989

Video
1976 *Joe, Joe's Transexual Brother and Joe's Woman*, 25 Min., s/w 1977/78 *The Life of Phillis*, 55 Min., s/w 1978/1979 *Life*, 10 Min., s/w · *Good Things + Bad Things*, 10 Min., s/w 1979 *Diamond Head*, 10 Min., s/w · *Selected Shorts*, 20 Min. · *The Rosery Finger of Dawn*, 10 Min., Farbe 1980 The Weak Bullet, 15 Min., Farbe · *The Loner*, 32 Min., Farbe 1981 *Grand Mal*, 23 Min., Farbe 1982 *Son of Oil*, 18 Min., Farbe 1983 *Spinout, 17 Min.* · *Theme Song from Si Fi*, 5 Min. · *Rome Hilton*, 2 Min. · *My Class*, 12 Min., Farbe 1984 *EVOL*, 30 Min. 1985 *Sphères d'influ-*

ence, 45 Min., Farbe 1986 *Diamond the 8 Lights: Sphères d'Influence*, 55 Min. 1987 *Sucker*, 5 Min. 1988 *ONOUROWN*, 55 Min. 1990 *Tunic (for Karen)*, 6 Min. 1991 *Kepone*, 10 Min.

PANAMARENKO

*Antwerpen (B) , 1940
Lebt/Lives in Antwerpen

Einzelausstellungen | One-man exhibitions

1963 Comité voor Artistieke Werking, Antwerpen 1966 *Panamarenko. Tree With Beautiful White Snow,* Wide White Space Gallery, Antwerpen · *De première van de hersenexpansie in kleuren!,* Wide White Space Gallery, Antwerpen 1967 *Panamarenko en Uncle Sam!,* Galerij Orez, Den Haag · *Panamarenko. Opgepast! Bochten! Blijf op het voetpad!,* Wide White Space Gallery, Antwerpen 1968 Staatliche Kunstakademie, Düsseldorf 1969 *Panamarenko Closed System Power Devices for Space. Portable Air Transport,* Gas Turbines, John Gibson Commissions, Inc., New York · *Blockade '69, Raum IV, Panamarenko,* Galerie René Block, Berlin · *Das Flugzeug,* Städtisches Museum, Mönchengladbach (Kat.: J. Cladders) · Galerie Konrad Fischer, Düsseldorf · Galerie Rudolf Zwirner, Köln · *Portable Air Transport,* Wide White Space Gallery, Antwerpen 1970 Stedelijk Van Abbemuseum, Eindhoven (Kat.: J. Leering) 1971 Wide White Space Gallery, Antwerpen 1972 *Der Mechanismus des Meganeudons,* Galerie Onnash, Köln (Kat.: P.) · *Automobile und Flugmaschinen,* Kunstmuseum, Luzern (Staatliche Kunsthalle, Düsseldorf; Württembergischer Kunstverein, Stuttgart) (Kat.: J.-C. Ammann, J. Harten, W. Heubach, I. Lebeer, P.) 1973 Musée d'Art Moderne de la Ville, Paris (Kat.: J.-C. Ammann, P.) · Wide White Space Gallery, Antwerpen 1974 Galerie Véga, Liège · Stedelijk Van Abbemuseum, Eindhoven (at the hangars of Bergeijk) 1975 Zeeuws Museum, Middelburg (at the hangars of Bergeijk) (Kat.: P. Van Daalen) · *Atom and Manpower,* Kölnischer Kunstverein, Köln · *Tekeningen – teksten, meikever,* Galerie Seriaal, Amsterdam 1976 *Introductie van een elektrisch vliegtuig,* Museum van Hedendaagse Kunst, Gent (Kat.: J. Hoet, M. Vanroose) · *Dessins et manuscrits, General Spinaxis,* Galerie Bama & Galerie Vega, Paris · *Objekte, Zeichnungen, Grafik,* Galerie Gabriele von Loeper, Hamburg 1977 *Flugobjekte und Zeichnungen,* Kunsthalle, Basel (Kat.: D. Helms, F. P. Ingold) · *Général Spinaxis, dessins et maquettes,* Musée d'Art et d'Industrie, Saint-Etienne · *Umbilly I,* Stedelijk Van Abbemuseum, Eindhoven (Kat.: P. Hefting, F. P. Ingold) 1978 Nationalgalerie, Berlin (Rijksmuseum Kröller-Müller, Otterlo; Palais des Beaux-Arts, Bruxelles) (Kat.: P. Van Daalen, L. Grisebach, P. Hefting, C. Hirsch, J. Leering, R. Oxenaar, P.) 1981 *The Aeromodeller,* Centre Georges Pompidou, Paris · Elisabeth Franck Gallery, Knokke · *Struycken en Panamarenko,* Technische Hogeschool, Eindhoven (Kat.: J. Leering, W. H.G. Lewin, P., T. Prüst, P. Struycken) 1982 *De keus van de kunstenaar,* Gemeentemuseum, Den Haag (Kat.: G. J. De Rook) · *Retrospektive,*

Haus der Kunst, München (Kat.: L. Grisebach, J.Hoet, H. Waterschoot) 1983 Galerie Durand-Dessert, Paris · *Reis naar de sterren. Nieuwe Grafiek 1983,* Avantgarde Gallery, Antwerpen · *Mathematica en elektriciteit als uitdaging,* CIAP, Hasselt · Deweer Art Gallery, Zwevegem-Otegem 1984 Musée d'Art Modern du Nord, Villeneuve d'Ascq (Kat.: J.Coucke, J. Hoet) · Fundació Joan Miró, Barcelona · *Rucksackflugzeug,* Furkart, Hotel Furkablick, Furkapasshöhe 1985 Frans Halsmuseum, Haarlem · De Vleeshal, Middelburg · *Arbeiten 1966–1985,* Kunstverein und Stadt, Friedrichshafen (Kat.: J.-C. Aeschlimann, L. Tittel) 1986 *Icarus: The vision of angels,* Ronald Feldman Fine Arts, New York · Kunstverein, Ulm (Kat.: W. Van Mulders) · *reis naar de sterren/Voyage aux Etoiles,* Galerie Christine & Isy Brachot, Bruxelles (Kat.: B.d Lamarche-Vadel) 1987 Cité des Sciences et de l'industrie, Parc de la Villette, Paris · Galleria Sperone, Roma · Galleria Primo Piano, Roma · Galerie Roger Pailhas, Marseille · Galerie Konrad Fischer, Düsseldorf · *U-Controll III & Rugzak,* Galerie Ronny Van de Velde & Co, Antwerpen (Kat.: L. Grisebach) 1988 *Multiples 1966–1988,* Provinciaal Museum voor Moderne Kunst, Oostende 1989 *Motors pastilles,* Galerie Ronny Van de Velde & Co, Antwerpen (Kat.: P. Morrens, J. Sacks, H. Theys) · Galerie Christine & Isy Brachot, Paris (Kat.: W. Van Mulders) · Furkart, Hotel Furkablick, Furkapasshöhe · *Een overzicht 1965–1985,* Museum van Hedendaagse Kunst, Antwerpen (Kat.: A. De Decker, J. Foncé, L. Dewachter) · *L'epérimentation,* Centre du Création Contemporaine, Tours (Kat.: B. Lamarche-Vadel) 1990 *De multiples van Panamarenko,* Galerie Jos Jamar, Knokke-Duinbergen · *Reis naar de sterren,* Roger Pailhas, Marseille · Jack Tilton Gallery, New York · *Das Flugzeug 1967. Un été belge Nantes-Clisson,* Musée des Beaux-Arts, Chapelle de l'Oratoire, Nantes · D'Huysser Gallery, Knokke-Zoute (Kat.: H. Brutin) · *Prints, Multiples, Drawings,* Galerie B. Coppens & Ronny Van de Velde, Bruxelles · *Garage des Alpes,* Musée d'Art Contemporain, Lyon 1991 *Accrochage,* Galerie Isy Brachot, Bruxelles · *Multiples 1966–91,* Galerie Jule Kewenig, Frechen-Bachem · In situ, Maastricht · 4 x furkart, Furkapasshöhe · *De Kip,* Vereniging voor culturele informatie en actueel prentenkabinet, Hasselt 1992 Bunkamura The Museum, Tokyo · The National Museum of Art, Osaka · Fukuyama Museum of Art, Toyama · The Museum of Modern Art, Kamakura Mulier Mulier Gallery, Knokke

Gruppenausstellungen | Group exhibitions

1987 *Brennpunkt,* Kunstmuseum, Düsseldorf (et. al.) · *L'Innimaginario a cura de Achille Bonito Olivia,* Roma 1988 *Bilder*

für den Himmel, Goethe-Institut Osaka, Kunstmuseum der Präfektur Miyagi, Sendai (et. al.) · *Belgicisme,* Casa Frolo, Venezia · *Collectie & Collecties,* Floraliapaleis, Museum van Hedendaagse Kunst, Gent 1989 *Acquisitions récentes,* Musée des Beaux-Arts, Nantes · *Xth Anniversary Show,* Galerie Deweer, Otegem 1990 *The Readymade Boomerang,* Biennale of Sydney, Art Gallery of New South Wales, Sydney · *Sammlung Marzona,* Kunsthalle, Bielefeld · *L'Art en Belgique au XX siècle,* Musée d'Art Moderne de la Ville, Paris · *Artisti (della Fiandra),* Palazzo Sagredo, Venezia · *Hommage aan Karel J. Geirlandt,* Museum van Hedendaagse Kunst, Gent · *Nam June Paik – Joseph Beuys – Panamarenko,* Galerie Ronny Van de Velde, Antwerpen · *Ouverture,* Galerie Pailhas, Paris · *Perspectives – Prospectives,* Galerie Christine & Isy Brachot, Bruxelles · *Kunstenaars (uit Vlaanderen),* Museum van Hedendaagse Kunst, Gent · *Mikpunt Muzentempel. De museumcontestatie omstreeks 1968,* Internationaal Cultureel Centrum, Antwerpen 1991 *Metafor och Materia,* Moderna Museet, Stockholm · In Situ, Maastricht · *Paradoxe des Alltages,* Städtische Galerie im Lenbachhaus, München · *1951–1991. Een tijdsbeeld,* Palais des Baux Arts, Bruxelles · *Irony by Vision,* Watari-Um Gallery, The Watari Museum of Contemporary Art, Tokyo · *Schwerelos,* Orangerie Schloß Charlottenburg, Berlin 1992 *Selectie Belgische Kunstenaar voor DOCUMENTA IX,* Museum Dhondt-Dhaenens, Deurle

Bibliographie | Bibliography

Texte vom Künstler | Texts by the artist
Artists on their Art, in : Art International, Nr. 5, 1968 · *Notes to the work,* press release for the exhibition: Panamarenko, John Gibson Commissions, Inc., New York, 1969 · *Der Mechanicus des Meganeudons,* in : Kat. Panamarenko. Der Mechanismus des Meganeudons, Köln 1972 · *Der Mechanismus der Schwerkraft, geschlossene Systeme der Geschwindigkeitsveränderung – Insektenflug, aus dem Rumpf des Insekts gesehen – Der Helikopter als potentieller Sieger – »U-Control III«, ein verbessertes, von Menschenkraft betriebenes Flugzeug – »Polistes«, Gummiauto mit Düsenantrieb – »Scotch Gambit«, Entwurf eines großen, schnellen Flugbootes,* Bielefeld, Ed. Marzona, 1975 · *Polistes: Gummiauto mit Düsenantrieb,* in: Kat. documenta 6, Bd. 3, Kassel, 1977 · *Het relativistische interstellaire magnetische ruimteschip,* in: Kat. Panamarenko, Berlin, Otterlo, Bruxelles, 1978 · *»A Flying Cigar« called »Flying Tiger«,* in: Kat. Pier + Ocean, London, Otterlo, 1980 · *Het mentaliteitsvenster,* in: Kunstbeeld in Vlaanderen, vandaag, Tielt, Lannoo, 1982 · *Voor Stroop die dikwijls impotent is bij de vrouwtjes...eet meer look (20.09.89),* in: Nous, 5. Februar, 1991

Bücher | Books
Panamarenko, Bielefeld, Marzona, 1975

Periodika | Periodicals
Bart De Baere, Jan Hoet, *Panamarenko,* in: Flash Art, Nr. 146, Mai/Juni, 1989 · Michel Baudson, *Panamarenko,* in: Art Studio, Nr. 18, Oktober, 1990 · Guy Gilsoul, *Parcours Panamarenko. Vingt-cinq ans dans l'invention, la scince, le bricolage et le génie. Un plan de vol peu ordinaire,* in: Le Vif-

L'Express, 23. Juni, 1989 · Nikola B. **Forstbauer**, *Panamarenko*, in: Zyma, Jg. 9, Nr. 5, Dezember 1991/Januar 1992 · Rika **Heymans**, *Alweer een zomer vol beelden. Panamarenko*, in: Streven, September, 1989 · Ilse **Kuijken**, *Panamarenko, une vision d'ingénieur*, in: Galeries Magazine, Juni/Juli, 1989 · Jef **Lambrecht**, *Discours populaire pou un art d'avant-garde*, in: Style, März, 1992 · Wim Van **Mulders**, *On the earth and in the air. Panamarenko*, in: Artforum, Nr. 8, April, 1987 · Wim Van **Mulders**, *Nostalgie de la physique*, in: Art & Culture, Mai, 1989 · Marc **Reynebeau**, *Er staat bijna wat er staat*, in: Knack, 13. Januar, 1988 · Riki **Simons**, *Panamarenko. Wetenschapper of kunstenaar?*, in: Avenue, April, 1988 · Roger Pierre **Turinne**, *Art et Espace*, in: Le Vif-l'Express – Pourquoi Pas?, 19. Oktober, 1990

Video
De jaren '60: (R)evolutie in de Plastische Kunsten (50 Min.) · *Het Heilig Vuur* (15 Min.) · *Sonsbeek buiten de Perken* (45 Min.) · *Openbaar Kunstbezit* (5 Min.) · *Ijsbreker* (50 Min.) · *Eiland* (18 Min.)

GIULIO PAOLINI

*Genova (I), 1940
Lebt/Lives in Torino

Einzelausstellungen | One-man exhibitions

1964 Galleria La Salita, Roma **1965** Galleria Notizie, Torino (Kat.: C. Lonzi) **1966** Galleria dell'Ariete, Milano (Kat.: C. Lonzi) **1967** Sala delle Colonne, Teatro Stabile, Torino · *Una poesia*, Libreria Stampatori, Torino · Galleria del Leone, Venezia (Kat.: G. Celant) · Galleria Christian Stein, Torino **1968** Libreria dell'Oca, Roma · Galleria Notizie, Torino (Kat.: G. P.) **1969** *2121969*, Galleria De Nieubourg, Milano (Kat.: G. P.) · *Una copia della luce*, Studio La Tartaruga, Roma · Galleria del Leone, Venezia **1970** *Vedo*, Qui arte contemporanea, Roma (Galleria Notizie, Torino) (Kat.: G. P., M. Volpi Orlandini) **1971** *Un quadro*, Galleria dell'Ariete, Milano (Galleria La Salita, Roma; Galleria Notizie, Torino) (Kat.: G. P.) · *Apollo e Dafne*, Libreria Stampatori, Torino (Studio C, Brescia) · Galerie Paul Maenz, Köln · *Apoteosi di Omero*, Festival internazionale di teatro sperimentale, Beograd; VII Biennale de Paris; Incontri internazionale d'arte Roma; Galleria Bonomo, Bari; Modern Art Agency, Napoli (Kat.: G.P.) **1972** Galleria Notizie, Torino · Sonnabend Gallery, New York **1973** *Idem*, Galleria Notizie, Torino · *Idem (II)*, Galleria Toselli/ Françoise Lambert, Milano · *La Doublure*, Galleria L'Attico/Sperone-Fischer, Roma (Kat.: G. P.) · Royal College of Art, London · Galerie Annemarie Verna, Zürich · Studio Marconi, Milano (Kat.: G. P., A. B. Oliva) **1974** *Idem (III)*, Modern Art Agency, Napoli · Museum of Modern Art, New York (Kat.: C. Rosevear) · *Idem (IV)*, Galleria Forma, Genova (Kat.: G. P.) · Galerie Paul Maenz, Köln · Galleria Bonomo, Bari · Galleria Il Sole, Bolzano **1975** *Museo*, Galleria Notizie, Torino (Kat.: G. P.) · Galerie Annemarie Verna, Zürich · Galerie Art in Progress, München · *Idem(V)*, Galerie Paul Maenz, Köln · Galleria D'Alessandro/Ferranti, Roma · Studio G 7, Bologna · Galleria

Ferrari, Verona **1976** Saman Gallery, Genova · Multipli, Torino · Studio Marconi, Milano (Kat.: T. Trini) · Istituto di Storia dell'Arte, Università di Parma (Kat.: M. Fagiolo, G. P., A. C. Quintavalle, AA. VV.) · Galleria Arena, Firenze · Incontri internazionali d'arte, Roma · *Idem (VI)*, Galerie Paul Maenz, Köln · Branco, Brescia **1977** Sperone Westwater Fischer, New York · Galerie Annemarie Verna, Zürich · Städtisches Museum Mönchengladbach (Kat.: J. Cladders) · Lisson Gallery, London · Kunstverein, Mannheim (Kat.: AA. VV.) · *Annali 1961–1976*, Galleria Ugo Ferranti, Roma · Galerie Paul Maenz, Köln **1978** Museo Diego Aragona Pignatelli Cortes, Napoli (Kat.: G. P.) · *Le tre Grazie*, Galerie Yvon Lambert, Paris · Galleria Christian Stein, Torino · Marilena Bonomo, Spoleto · Galerie Albert Baronian, Bruxelles · *Idem (VII)*, Mario Diacono, Bologna (Kat.: M. Diacono) · *Del bello intelligibile*, Arc 2, Musée d'Art Moderne de la Ville, Paris (Kat.: S. Pagé, G. P.) · Galerie Paul Maenz, Köln **1979** Galleria dell'Oca, Roma · *Liber veritatis*, Lisson Gallery, London · Galerie Jean & Karen Bernier, Athinai · *Atto unico in tre quadri*, Studio Marconi, Milano (Kat.: C. Bertelli, G. P., G. Vattimo) **1980** *Pendant*, Galerie Annemarie Verna, Zürich · Stedelijk Museum, Amsterdam/Museum of Modern Art, Oxford (Kat.: D. Elliot, H. Szeeman) · *Ritratto dell'artista come modello*, Galleria Ugo Ferranti, Roma **1981** Galleria Christian Stein, Torino · *Hortus Clausus*, Kunstmuseum, Luzern (Kat.: M. Kunz) · Galerie Paul Maenz, Köln · *Casa di Lucrezio*, Banco, Brescia · *Lo sguardo della Medusa*, Galleria Nazionale d'Arte Moderna, Roma (Kat.: I. Panicelli, G. P.) **1982** *La caduta d'Icaro*, Padiglione d'Arte Contemporanea di Milano (Kat.: G. P.) · Kunsthalle, Bielefeld (Von der Heydt Museum, Wuppertal; Neuer Berliner Kunstverein) (Kat.: W.M. Faust, E. Franz) · *Mnemosine/ Nonsense*, Galerie Marilena Bonomo, Bari/Françoise Lambert, Milano · *Raum für Kunst*, Hamburg (Kat.: M. Kramer) · *Une introduction à l'oeuvre de Giulio Paolini/1960–70*, Le Nouveau Musée, Lyon-Villeurbanne · *Scene di conversazione*, The Japan Foundation, Laforet Museum, Tokyo (Kat.: G. De Marchis, N. Nakamura) · *Hierapolis*, Galerie Yvon Lambert, Paris **1983** Galleria Christian Stein, Torino · *Place des Martyrs*, Galerie Paul Maenz, Köln · *Era vero (Averroè)*, Galleria L. De Domizio, Pescara **1984** *Trionfo della rappresentazione*, Los Angeles Institute of Contemporary Art (Kat.: P. L.

Tazzi) · Le Nouveau Musée, Lyon-Villeurbanne · Cythère, Studio Marconi, Milano (Kat.: G. P., F. Poli) · *Dessins et collages*, Direction régionale des affaires culturelles de Bourgogne, Dijon · *Casa di Lucrezio*, 27 · Festival dei Due Mondi, Spoleto (Kat.: B. Mantura, AA. VV.) · Galerie Annemarie Verna, Zürich · Studio G 7, Bologna **1985** *Giochi d'acqua*, Galleria Mario Pieroni, Roma (Kat.: G. P.) · *Melancolia ermetica*, Galerie Maeght Lelong (Kat.: J.L. Mauvant, D. Soutif) · *Les fausses confidences*, Guggenheim Museum, New York (Kat.: G. P.) · *Tutto qui*, Pinacoteca comunale, Ravenna (Kat.: M. Bandini, B. Corà, S. Vertone, AA. VV.) · 420 WB arti visive, Ravenna (Kat.: G. Guberti) · Art Gallery, Vancouver · Musée d'Art Contemporain, Montréal · *Dal »Trionfo della rappresentazione« (Cerimoniale: l'artista è assente)*, Marian Goodman Gallery, New York · *Tra sé e me*, Galleria Locus Solus, Genova · *La pittura abbandonata*, Galleria Marilena Bonomo, Bari (Kat.: G. P.) **1986** Palais des Beaux-Arts, Charleroi (Kat.: L. Busine) · *Tableau vivant*, Galerie Albert Baronian, Bruxelles · *Dal Trionfo della rappresentazione (Cerimoniale: in prospettiva)*, Galerie Paul Maenz, Köln · *Abat-jour (giochi proibiti)*, De Vleeshal, Middelburg (Kat.: D. Zacharopoulos) · Staatsgalerie Stuttgart (Kat.: G. Inboden, AA. VV.) · *Intervallo*, University Art Museum, Berkeley **1987** Galleria Mario Pieroni, Roma · Galleria Christian Stein, Milano · Musée des Beaux-Arts, Nantes (Kat.: H.C. Cousseau, AA. VV.) · Marian Goodman Gallery, New York (Kat.: C. Owens) · ICA, Nagoya (Kat.: F. Nanjo, J. L. Maubant) · *Carambole*, De Vleeshal, Middelburg (Kat.: A. van Gemert, G. P., D. Zacharopoulos) **1988** *Giorno e notte*, Kölnischer Kunstverein (Kat.: W.M. Faust) · *Sotto le stelle*, Galerie Annemarie Verna, Zürich · *Signore e Signori...*, Museo di Capodimonte, Napoli (Kat.: B. Corà, G. P.) · *Opere su carta*, Galleria In Arco, Torino · Galleria Nazionale d'Arte Moderna, Roma (Kat.: A. Monterini, G. P., G. Vattimo, S. Vertone, AA. VV.) **1989** Ydess Hendeles Art Foundation, Toronto · Galerie Yvon Lambert, Paris · *Impressions graphiques*, Salone del Libro, Torino · *L'ospite*, Galleria Massimo Minini, Brescia · *Künstler-Theater*, Galerie Paul Maenz, Köln **1990** *Giulio Paolini: Hortus Clausus, a work from 1981*, Stein Gladstone Gallery, New York · *Come non detto*, Galleria Marilena Bonomo, Bari · *Rialto*, Studio d'arte Barnabo, Venezia · *Hotel de l'Univers*, Villa delle Rose, Galleria d'Arte Moderna, Bologna (Kat.: P. G. Castagnoli, F. D'Amico, G. P.) **1991** *Anteprima*, Castello di Rivoli, Rivoli (Kat.: G. Verzotti) · *Metafore* (mit/with J. Kounellis), Galleria dell'Oca, Roma (Kat.: C. Briganti) · *Il »tetaro« dell'opera*, Galleria di Franca Mancini, Pesaro (Kat.: F. Poli) · Stein Gladstone Gallery, New York **1992** *La commedia dell'arte*, Galleria Lucio Amelio s.r.l., Napoli

Gruppenausstellungen | Group exhibitions

1987 *Paolini, Pistoletto, Zorio*, Galleria, Persano, Torino · *Neoclassicismo: Goethe in Italia*, Centro Ausoni, Roma · *Fabro, Paolini, Penone*, Galerie Roger Pailhas, Marseille · *Corps étrangers*, Galerie Yvon Lambert, Paris · *Avant-Garde in the Eighties*, Los Angeles County Museum of Art, Los Angeles · *Drapeaux*, Musée d'Art d'Histoire, Genève · *Vis à vis*, Musée St. Denis, Reims · *Berlinart 1961–1987*, Mu-

seum of Modern Art, New York · Galerie Françoise Lambert, Milano · *Opere Italiane*, Galerie Triebold, Basel · *Lo specchio e il suo doppio*, Mole Antonellia, Torino · *Incrocio: un racconto*, Palazzo di città, Erice · *Bienal de São Paulo* · *Italie hors d'Italie*, Musée des Beaux-Arts, Nîmes · *Implosion/ a postmodern perspective*, Moderna Museet, Stockholm · *Meltem, Château d'Oiron* · *Ls années 70*, Abbaye Saint-André, Meymac · *Disegno italiano del dopoguerra*, Galleria Civica, Modena/Frankfurt Kunstverein **1988** *Mythos Italien*, Haus der Kunst, München · *Sydney Biennale*, Sydney · *Vent'anni fa: il 1968*, Studio La Città, Verona · *Presi per incantamento*, Padiglione d'Arte Contemporanea di Milano · *Visions/Revisions*, Marlborough Gallery, New York · Musée des Beaux-Arts, Grenoble · Gemeentemuseum, Den Haag · *Europa oggi*, Museo d'Arte Contemporanea, Prato · Galerie Di Meo, Paris · *Il cielo e clintorni*, Castello di Volpaia · *Dannuziana*, Università di Pescara · *Mnemosyne*, Schloss Herrnsheim, Worms · Galerie René Blouin, Montréal · *Balkon mit Fächer*, Daad, Akademie der Künste, Berlin **1989** *Italian Art in the Twentieth Century*, Royal Academy of Arts, London · *Verso l'arte povera*, Padiglione d'Arte Contemporanea, Milano/Elac, Lyon · *Intorno al Sessanta*, Chiostri di S. Domenico, Imola · *Bilderstreit*, Museum Ludwig, Köln · *Open Mind*, Museum van Hedendaagse Kunst, Gent · *Sculptura*, Studio La Città, Verona · *Pas à côté, pas n'importe où*, Villa Arson, Nice · *A Sculpture Show*, Marian Goodman Gallery, New York · *Anteprima*, Villa delle Rose, Galleria d'Arte Moderna, Bologna · *Arc*, Castello di Volpaia · *2000 Jahre/Die Gegenwart der Vergangenheit*, Bonner Kunstverein, Bonn · Galleria dell'Oca, Roma · *Carte scoperte*, Galleria Stein, Torino **1990** *Chiasmus*, Anna Bornholt Associates, London · *Millienovecente sessanta*, Galleria N. Vespignani, Roma · *Terksel II*, Museet for Samtidskunst, Oslo · *Quotations*, Galerie Annemarie Verna, Zürich · *Halley, Opie, Paolini*, Galerie Albrecht, München · *Allegorie*, Galerie Steirsemler, Kiel · *Sul tema ritratto*, Galleria dell'Oca, Roma · *Mémoires d'artistes*, Musée du Château de Montbéliard · *Lo zingaro bla*, Galleria Mario Pieroni, Roma · *Portrait d'une collection*, Palais des Beaux-Arts, Charleroi · *Roma anni '60*, Palazzo delle Esposizioni, Roma · *Entretien*, Centre a. Borchette, Bruxelles · *Moderno e contemporanea*, Fondazione P. Guggenheim, Venezia · *Totalnovo*, Biblioteca Centrale, Palermo · *Contemporary Illustrated Books*, Franklin Furnace Archive, New York · *Temperamenti*, Tramway, Glasgow · *Arte povera*, Musée Cantini, Marseille · *Relazioni pericolose*, Galleria F. Fossati, Torino · *Recent Italian Art*, A.T. Gallery, Tokyo · *Memoria del futuro*, Centro de Arte Reina Sofia, Madrid **1991** *Intersezioni*, Galleria Mücsarnok, Budapest · *Beauty is difficult*, Museo d'arte moderna, Bolzano · *Un'idea di leggerezza*, Galleria Niccoli, Parma · *30 oeuvres à la Défense*, Paris · *Denk-Bilder*, Kunsthalle, München · Da Magritte a Magritte, Galleria d'Arte Moderna, Verona · *Imprevisto*, Castello di Volparia · *Bildlicht*, Wiener Festwochen · *Antiquitat/Modernitat en l'art del segle XX*, Fundació Joan Miró, Barcelona · *Carnegie International*, Pittsburgh **1991** *Das goldene Zeitalter*, Württembergischer Kunstverein, Stuttgart · *Denk-Bilder*, Kunsthalle der Hypo-Kulturstiftung, München

Bibliographie | Bibliography

Texte und Bücher vom Künstler
Texts and books by the artist

Il quadro di sempre, in: B't, Nr. 5, Milano, 1967 · *Happening*, in: Qui arte contemporanea, Nr. 5, 1969 · *Note per le scene e i costumi del »Bruto II«*, in: Qui arte contemporanea, Nr. 6, 1969 · *»Intenzioni« su Don Chisciotte*, in: Rivista Rai, Juli, 1970 · *Un quadro*, in: Data, Nr. 2, 1972 · *»Apoteosi di Omero*, in: Data, Nr. 2, 1972 · *Note di lavoro*, in: Nac, Nr. 3, 1973 · *Statement*, Zürich, Ed. Annemarie Verna, 1979 · *Lezione di pittura*, in: Imprinting, Roma, Ed. Bianci e Nero, 1979 · *Paolini, Premio Bolaffi 1980*, in: Catalogo nazionale d'arte moderna, Nr. 15, 1980 · *Incontro con l'artista*, a cura di Bruno Corà, Accademia di Belle Arti, Perugia, 28. April, 1981 · *Les fausses confidences*, Torino, Ed. Einaudi, 1983 · *La melanconia di un partenza*, dall'inchiesta »L'Italia? Io la vedo in questo quadro«, in: Tuttolibri, 24. September, 1983 · *Sette note*, in: Idea del tempio della pittura, Roma, Ed. A.E.I.U.O., 1983 · *Trionfo della rappresentazione*, in: Gran Bazaar, April, 1983 (in: Furor, Nr. 12, Oktober, 1984) · *Scene di conversazione*, in: Tema Celeste, Nr. 1, 1983 · *Platea*, in: Figure, Nr. 6, 1984 · *La cosa stessa*, in: Gran Bazaar, Oktober/November, 1984 · *Conversazione (Tout ce qu'il y a de beau en Italie)*, in: Kat. Castello di Volpaia, 1986 · *Il cielo e dintorni*, in: Kat. Castello di Volpaia, 1988 · *Il fronte del Moderno*, in: L'Espresso, 2. Oktober, 1989 · *Eight decorative execices*, in: Ottagono, Nr. 94, März, 1990 · *Au-delà de la ligne de l'avant-garde*, in: Les Lettres Française, Nr. 5, Januar, 1991 · *When a painting is Not a Horse*, in: Tema Celeste, Nr. 34, Januar/März, 1992 · *Identikit*, in: Artforum International, Nr. 7, März, 1992

Bücher | Books

M. Robin, *Signes et sens de l'antiquité dans l'œune œuvre de G. Paolini*, promotor J.M. Poinsot, Université de Rennes, 1991 (sciption)

Periodika | Periodicals

M. Apa, *La spazio dell'idea e dell'arte*, in: Arte e Cronaca, Nr. 13, März, 1989 · C. Apuleo, *Paolini: lucide emozioni*, in: Next, März, 1989 · Giulio Carlo Argan, *Intervista*, in: Flash Art, Januar/Februar, 1987 · Mirella Bandini, F. Piqué, *Torino an ni Settanta*, in: Flash Art, Juni/Juli, 1991 · A. Battistelli, *L'arte nei bilanci*, in: Vogue, November, 1987 · M. Bourel, *(interview)*, in: Art Press, Dezember, 1991 · P. Brigone, *Paolini à l'Hotel de Croisilles*, in: Beaux-Arts, Paris, 1988 · M. Castello, *Percezione e mito/Giulio Paolini*, in: Tema Celeste, Nr. 22–23, 1989 · Carolyn Christov-Bakargiev, *Arte povera 1967–1987*, in: Flash Art, November/Dezember, 1987 · Carolyn Christov-Bakargiev, *Giulio Paolini*, in: Flash Art, April, 1987 · Annie Chevrefils-Desbiolles, *Giulio Paolini*, in: Art Press, Juni, 1989 · E. Coen, *Sulle soglie di interni labirinti*, in: Wimbledon, Nr. 14, 1991 · Titiziani F. Conti, *Giulio Paolini*, in: Titolo, Nr. 4, 1991 · Titiziani F. Conti, *Giulio Paolini*, in: in: Nike, Jg. 9, Nr. 39, Juni/Juli/September · Bruno Corà, *Metafore eccellenti*, in: Wimbledon, Juli, 1991 · V. Costa, *Les pleonasmes de Paolini*, in: Beaux-Arts, Dezember, 1987 · G. Dortles, *Artisti, Artisti nel loro studio: Giulio Paolini*, in: Vogue, Juli, 1987 · N. Emery, *Conver-*

sazione con Gianni Vattimo, in: Temporale, Nr. 26, 1991 · Eleanor Heartney, *Giulio Paolini at Stein Gladstone*, in: Art in America, Juli, 1990 · Alfred MacAdam, *Contemporary illustrated Books*, in: Art News, Sommer, 1990 · Friedeman Malsch, *Giulio Paolini*, in: Kunstforum, Bd. 94, 1988 · D. Nardone, *Giulio Paolini*, in: Juliet, April, 1990 · L.E. Nesbitt, *Giulio Paolini*, in: Artscribe, Sommer, 1990 · Demetrio Paparoni, *Object and thing: a conversation between Giulio Paolini and Demetrio Paparoni*, in: Tema Celeste, Nr. 24, Januar/März, 1990 · V. Pasca, *Progetto per frammenti*, in: Casa Vogue, Mai, 1988 · R. Pinto, *Giulio Paolini*, in: Flash Art, Nr. 159, 1991 · F. Piqué, *Giulio Paolini*, in: Flash Art News, Nr. 151, 1989 · Marco De Poli, *Markus Lüpertz/Giulio Paolini*, in: Tema Celeste, April, 1987 · R. Simons, *De wereld van*, in: Avenue, Juli, 1990 · A. Testa, *Alla Volpaia si ride di piu*, in: Il Giornale dell'Arte, Oktober, 1988 · P. Ugolini, *Roma/Kounellis e Paolini*, in: Flash Art, Sommer 1991 · Gianni Vattimo, *Un'estate da leggere*, in: L'Espresso, Mai, 1988 · Giorgio Verzotti, *La verità dell'arte*, in: Milanbook, Nr. 5, 1987 · G.P. Vincenzo, *Giulio Paolini*, in: Flash Art, Nr. 141, 1987 · Craig Fisher, *Giulio Paolini, Steiglandstone Gallery*, in: Tema Celeste, Nr. 34, Januar/März, 1992

A. R. PENCK

*Dresden (D), 1939
Lebt/Lives in Dublin/London/Düsseldorf, Köln

Einzelausstellungen | One-man exhibitions

1968 *Deutsche Avantgarde 3. A. R. Penck, Bilder*, Galerie Hake, Köln **1969** Galerie Michael Werner, Köln **1970** *Erstes Training mit Standart*, Galerie Michael Werner (Kunstmarkt), Köln · *Serie Standart*, Galerie Michael Werner, Köln **1971** Galerie Heiner Friedrich, München · Galerie Michael Werner, Köln · *Zeichen als Verständigung. A. R. Penck (Ralf Winkler) Dresden. Bücher und Bilder*, Museum Haus Lange, Krefeld (Kat.: P. Wember, A. R. Penck) **1972** *Standart Modelle*, Galerie Michael Werner, Köln · *Training mit Standart*, Galerie Stampa, Basel · *Training mit Standart*, Wide White Space Gallery, Antwerpen · *Training mit Standart*, Galerie im Goethe-Institut, Amsterdam · *Training mit Standart*, Galerie Grafikmeyer, Karlsruhe · *Zeichnungen und Graphik*, Galerie Beck, Erlangen **1973** *Zeichnungen*, Galerie Loehr, Frankfurt/M. · *L'Uomo e l'Arte*, Milano (Kat.: A. R. Penck) · *Installations, Paintings, Films, Books, Soundtapes and Photographic*, Anna Leonowens Gallery/Nova Scotia College of Art & Design, Halifax · *A. R. Penck – DDR*, Daner Galeriet, Kobenhavn · Städtische Galerie im Lenbachhaus, München **1974** Wide White Space Gallery, Antwerpen (Kat.: A. R. Penck) · *Ralf Winkler, Dresden. Frühe Arbeiten*, EP Galerie Jürgen Schweinebraden, Berlin (DDR) · Galerie Stampa, Basel · *Zeichnungen*, Galerie Nächst St. Stephan, Wien · *Neue Bilder*, Galerie Michael Werner, Köln · *Zeichnungen, Bilder, Bücher*, Galerie Cornelis, Baden-Baden · *T-M Serie*, Galerie Heiner Friedrich, München · Städtische Galerie Al-

tes Theater, Ravensburg · Wide White Space Gallery, Antwerpen · *Bilder, Zeichnungen,* Galerie Cornelis, Baden-Baden **1975** *Mike Hammers Vermächtnis,* Galerie Neuendorf, Hamburg (Kat.: G. Gercken, A. R. P.) · *Penck mal TM,* Kunsthalle, Bern (Kat.: J. Gachnang, D. Koepplin, A. R. P.) · *Neue Bilder,* Galerie Michael Werner, Köln · *Tekeningen, gouaches, schilderijen,* Galerie Seriaal, Amsterdam · Stedelijk Van Abbemuseum, Eindhoven **1976** Club junger Künstler, Budapest · *N-Komplex. Neue Bilder 1976,* Galerie Michael Werner, Köln · *A. R. Penck. Bilder. A. Höckelmann. Skulpturen,* Galerie Heiner Friedrich, München · Galerie Heike Curtze, Wien **1977** *Immendorff mal Penck. Penck mal Immendorff,* Galerie Michael Werner, Köln · *Recent werk,* Galerie Seriaal, Amsterdam · Galerie Fred Jahn, München · *Bilder,* Galerie Michael Werner, Köln · Galerie Rolf Preisig, Basel · *Neue Bilder,* Galerie Michael Werner, Köln **1978** *Vierzehnteilige Arbeit 1977,* Galerie Fred Jahn, München/Galerie Michael Werner, Köln · Galerie Springer, Berlin · *Der Begriff Modell, Erinnerungen an 1973,* Galerie Michael Werner, Köln (Kat.: A. R. P.) · *A.R. Penck/Y. Schilderijen gouaches,* Galerie Helen van der Meij, Amsterdam · *A. R. Penck/Y. Zeichnungen bis 1975,* Kunstmuseum, Basel (Bündner Kunstmuseum, Chur; Kunstverein, Mannheim; Museum Ludwig, Köln; Nationalgalerie, Berlin) (Kat.: J. Gachnang, D. Koepplin, A. R. P.) **1979** *Y. Rot-Grün. Grün-Rot,* Galerie Michael Werner, Köln (Kat.: A. R. P.) · *Ralf Winkler, Dresden, Übermalungen,* EP Galerie Jürgen Schweinebraden, Berlin · *A. R. Penck, tekeningen en boeken, tentoonstellingsperiode,* Groninger Museum, Groningen (Kat.: A. R. P.) · *Neue Bilder,* Galerie Michael Werner, Köln (Kat.: A.R. P.) · *Concept conceptruimte,* Museum Boymans-van Beuningen, Rotterdam (Kat.: W. A. L. Beeren, J. Gachnang, M. Visser, P. Groot, A. R. P.) **1980** *Bilder 1967–1977,* Galerie Fred Jahn, München · *Zeichnungen und Aquarelle,* Städtisches Museum, Schloß Morsbroich, Leverkusen (Kat.: R. Wedewer) · *Y. Verwandlung eines DDR-Bürgers in einen BRD-Bürger,* Galerie Michael Werner, Köln **1981** Kunstmuseum, Basel · *Schilderijen en gouaches,* Galerie Helen van der Meij, Amsterdam · *Overgang,* Gewad, Vereniging aktuele kunst, Gent (Kat.: A.R. P.) · α λ. *(a.r. penck) 38 neue Bilder,* Galerie Neuendorf, Hamburg (Kat.: G. Gercken, A. R. P.) · *Gemälde Handzeichnungen,* Josef-Haubrich-Kunsthalle, Köln (Kat.: S. Gohr, A. R. P.) · *Bilder aus den 60er Jahren,* Galerie Fred Jahn, München · α λ. *(a. r. penck),* Kunsthalle, Bern (Kat.: J. Gachnang, A. R. Penck) · *A. R. Penck. 1968–1980,* Galerie Annemarie Verna, Zürich · *Painting,* Ileana Sonnabend Gallery, New York · *Nieuw werk,*

Galerie Helen van der Meij, Amsterdam **1982** *Wellpappen,* Galerie Michael Werner, Köln · Ileana Sonnabend Gallery, New York · Galleria Lucio Amelio, Napoli · Studio d'Arte Cannaviello, Milano · *Y. a. r. penck,* Galerie Gillespie-Laage-Salomon, Paris (Kat.: A. R. P.) · Waddington Galleries, London (Kat.: R. Calvocoressi, A. R. P.) · *45 Zeichnungen Bewusstseinsschichten,* Kunstmuseum, Basel (Kat.: D. Koepplin) · Kunstmuseum, Bonn · *Skulpturen,* Galerie Michael Werner, Köln **1983** Galleria Toselli, Milano · *Terrae Motus,* Galleria Lucio Amelio, Napoli · Galerie Liesbeth Lips, Delft · *Baselitz und Penck. Druckgrafik der letzten 5 Jahre,* Museum Haus Esters, Krefeld · Galerie Yarlow/Salzmann, Toronto · *Skulpturen,* Galerie Michael Werner, Köln (Kat.: A. R. P.) · *»Welt des Adlers (Problem)« und Zeichnungen 1982/83,* Galerie Springer, Berlin (Kat.: A. R. P.) · Galerie Sabine Knust, München · Galerie Gillespie-Laage-Salomon, Paris · *Zeichnungen auf Wellpappe 1981,* Galerie Fred Jahn, München · *Neue Radierungen 1983,* Maximilian Verlag/Sabine Knust, München · *Zwei 14-teilige Arbeiten von 1977,* Galerie Rudolf Zwirner, Köln · *Männer I-IV,* Galerie Michael Werner, Köln · Bienale de São Paolo, **1984** Galerie Jurka, Amsterdam · Mary Boone/Michael Werner Gallery, New York (Kat.: A. R. P.) · Galerie Watari, Tokyo · Studio d'Arte Cannaviello, Milano · *Bilder und Zeichnungen,* Galerie Maeght Lelong, Zürich (Kat.: Th. Kneubühler) · Waddington Galleries, London · *Gravures de la collection du Cabinet des estampes Genève,* Galerie Alma, Lyon (Kat.: B. Ceysson) · Ulrike Kantor Gallery, Los Angeles · *Browns's Hotel and other works,* Tate Gallery, London (Kat.: R. Calvocoressi) · *Opere recenti,* Studio d'Arte Cannaviello, Milano · Galerie 13, Langen · *Recent Paintings,* Akira Ikeda Gallery, Tokyo (Kat.: R. Calvocoressi) · Galerie Sabine Knust, München · *Männer,* Galerie Michael Werner, Köln (Kat.: A. R. P.) · Temple Bar Studios, Dublin **1985** Musée d'Art et d'Industrie, St. Etienne (Kat.: J. Beauffet, B. Ceysson, A. R. P.) · Brody's Gallery, Washington · Arnolfini Gallery, Bristol · Galerie Michael Werner, Köln (Kat.: A. R. Penck, E. Spiekermann) · *Mike Hammer Konsequenzen,* Städtisches Museum Abteiberg, Mönchengladbach (Kat.: J. Cladders, A.R. Penck) · *Tskrie. A. R. Penck. Strike,* Galerie Michael Werner, Köln (Kat.: A. R. Penck) · *Gouaches, Zeichnungen,* Galerie Herbert Meyer-Ellinger, Frankfurt/M. (Kat.: G. Gercken) **1985/86** Neue Galerie-Sammlung Ludwig, Aachen · *Graphik Ost/West,* Kunstverein, Braunschweig (Kat.: W. Bojescul, A. R. P.) **1986** Galerie Suspect, Amsterdam · *Gemälde und Zeichnungen,* Galerie De Ganzerik, Eindhoven · Deweer Art Gallery, Otegem (Kat.: J. Coucke) · *Zeichnungen und Grafik,* Galerie Springer, Berlin · Galleria Christian Stein, Milano · *Graphik Ost/West,* Galerie Maeght Lelong, Paris · *Zeichnungen und Graphik,* Galerie Springer, Berlin · *100 frühe Zeichnungen 1956–1964,* Galerie & Edition Stähli, Zürich · *Peintures des années 80,* Galerie Gillespie-Laage-Salomon, Paris · *Sculptures,* Galerie Maeght Lelong, Zürich (Kat.: K. von Waberer) · *Graphik,* Kunstverein, Freiburg i.2Br. · *Radierungen,* Maximilian-Verlag/Sabine Knust, München · *Recente sculpturen,* Galerie Collection d'Art, Amsterdam · *Werke auf Papier,* Galerie Tegenbosch, Amsterdam · Galerie Christian Stein, Milano · *Zeichnungen und*

druckgraphische Werke im Basler Kupferstichkabinett, Cabinet des Estampes, Genf (1987: Städtisches Museum Abteiberg, Mönchengladbach; Ulmer Museum, Ulm; Musée de Strasbourg, Strasbourg; Stedelijk Van Abbemuseum, Eindhoven) (Kat.: D. Koepplin) · *Drawings 1956–1964,* Barbara Toll Fine Arts, New York · *Angriff auf V. Plastische Ideen 1980–1986,* Galerie Michael Werner, Köln (Kat.: A. R. P.) · *Sculptures in Bronze,* Waddington Galleries, London (Kat.: A. R. P.) · *94 Drawings 1956–1964,* Galerie und Edition Stähli, Zürich · *Johann Brus: Sculptures and Works on Paper. A. R. Penck: Paintings and Works on Paper,* Galerie De Ganzerik, Eindhoven · *Bilder in Bronze: Kirkeby – Lüpertz – Penck,* Kunsthalle, Bielefeld · *Arbeiten auf Papier,* Galerie Döbele, Ravensburg · *Penck-West in Berlin,* Daadgalerie, Berlin (Kat.: W. Schmied) **1987** *The northern darkness A. R. Penck,* Orchard Gallery, Londonderry (Douglas Hyde Gallery, Dublin; Edinburgh College of Art, Edinburgh; Fruitmarket Gallery, Edinburgh) (Kat.: A. Schlieker, A. R. Penck) · *Übergang: Tuschpinselzeichnungen 1981,* Graphische Räume, Galerie Michael Werner, Köln · *Lithographien 1978–1980,* Galerie Steinmetz, Bonn · *Grafik,* Galerie Chobot, Wien (Kat.: O. Rychlik) · Galerie & Edition Stähli, Zürich · *Was einem Emigranten durch den Kopf geht,* Galerie Jule Kewenig, Frechen-Bachem (Kat.: O. Rychlik) · Kettle's Yard Gallery, Cambridge · *Skulpturen und Zeichnungen 1985–1987, Skulpturen 1985 bis 1987, Bilder und Zeichnungen,* Galerie Thaddaeus Ropac, Salzburg · *Graphik,* Galerie Springer, Berlin · *Malerei – Skulptur,* Galerie Schurr, Stuttgart · Aschenbach Galerie, Amsterdam **1988** *Sculptures,* Galerie Lelong, Paris (Kat.: R. Guidieri) · *Graphik,* Galerie Chobot, Wien (Kat.: O. Rychlik) · Galerie Springer, Berlin · Nationalgalerie Berlin, Berlin (Kunsthaus, Zürich) (Kat.: S. Anderson, J. Gachnang, L. Grisebach, T. Kirchner, A. R. P., J. Schweinebraden) · *Skulpturen und Zeichnungen 1971 bis 1987,* Kestner-Gesellschaft, Hannover (Kat.: R. Guidieri, C. Haenlein) · Maximilian-Verlag/Sabine Knust, München · *Zeichnungen aus dem Basler Kupferstichkabinett,* Kunstverein, Hamburg · *Holzschnitte,* Gerhard Marcks-Haus, Bremen (Kat.: M. Rudloff) · *Vor dem Übergang. Frühe Arbeiten aus deutsch/deutschen Privatsammlungen,* Galerie Frank Hänel, Frankfurt/M. · *Schilderijen en tekeningen,* Aschenbach Galerie, Amsterdam · *Der Begriff Modell (2),* Michael Werner, Köln (Kat.: A. R. P.) · *Graphische Arbeiten von 1983–1988,* Galerie Karin Bolz, Köln · *Modelle und Arbeiten auf Papier,* Galerie Lelong, Zürich (Kat.: R. Schmitz) · *Tekeningen: A. R. Penck,* Gemeentemuseum, Den Haag (Kat.: M. Josephus Jitta, R. H. Fuchs, A. R. P.) · *Peintures 1978–85,* Marianne & Pierre Nahon, Galerie Beaubourg, Paris **1989** *Bronzen und Holzschnitte,* Galerie Harald Behm, Hamburg · Galerie Mary Boone, New York · *Werke aus 20 Jahren,* Galerie Beyeler, Basel · *Skulpturen 1983–1987, Arbeiten auf Papier 1987,* Galerie Van de Loo, München · *Holzschnitte 1966–1987,* Museum für Kunst und Kulturgeschichte der Hansestadt Lübeck, St. Annen-Museum, Lübeck · Galerie Fred Hoffmann, Santa Monica (Kat.: F. Hoffman, P. Kort) · *Wolokolamsker Chaussée,* Galerie Jule Kewenig, Frechen/Bachem · *Future of the soldiers,* Galerie Michael

Werner, Köln (Kat.: A. R. P.) · *A. R. Penck – Keramik*, Droysen Keramikgalerie, Kattrin Kühn/Galerie Springer, Berlin (Kat.: S. Anderson, A. R. P., R. Springer) · *Kaltnadelradierungen 1988*, Maximilian-Verlag/Sabine Knust, München (Kat.: A. R. P.) · Galerie Juana Mordo, Madrid · Porin Taidemuseuo, Pori · *A survey of prints*, Galeries Stuart Gerstman, Richmond · *Skulpturen*, Stockholm Konsthall, Stockholm (Kat.: D. Kuspit) · *Maleri, skulptur, tegning*, Galerie Susanne Ottesen, Kobenhavn · *Magasin 3*, Konsthall Stockholm, Stockholm (Kat.: D. Kuspit) · *Skulpturen und Bilder*, Galerie Sties, Kronberg · *Übermalungen 1974/75*, Galerie Frank Hänel, Frankfurt/M. (Kat.: A. R. P.) **1990** *Tekeningen*, Museum van Hedendaagse Kunst, Gent · Galerie Fahnemann, Berlin · Galerie Michael Haas, Berlin · *Das Jahr 1989*, Galerie Michael Werner, Köln (Kat.: J. Gachnang, A. R. P.) · Galerie Philippe Guimiot, Bruxelles · Obaine Galerije Piran, Ljubljana · Michael Werner/Monika Sprüth Galerie, Köln (mit/with Rosemarie Trockel) · *Skulpturen und Zeichnungen*, Kunsthalle, Bielefeld · *Prints*, Eleni Koroneou Gallery, Athinai · *Radierungen. Holzschnitte 1989/1990*, Maximilian Verlag Sabine Knust, München (Kat.: A. R. Penck) · *Sculptures*, Michael Werner, New York (Kat.: A. R. Penck) · *Bronzes – Estampes*, Galerie Beaumont, Luxembourg · *Gouachen 1975*, Galerie Chobot, Wien · *Penck incontra Roma*, Cleto Polcina Artemoderna, Roma (Kat.: A. Bonito Oliva) · *Opere*, Sei del Carmine, Milano · *Skulptur und Graphik*, Museum Waldhof, Bielefeld · *Opere recenti*, Galleria in Arco, Torino (Kat.: D. Paparoni) · *Eugene Bilder Gallery*, Dallas · Galerie Hänel, Frankfurt/M. · *Drawings + Prints*, Margarete Roeder Gallery, New York · Altstadt Galerie, Wiesbaden **1991** *Wallenstein*, Galerie Vier, Berlin (Kat.: Sara Kirsch) · Galerie Steinmetz, Bonn · *Frühe Zeichnungen*, Museum für Gegenwartskunst, Basel · Pierre Rippstein, Basel · Kerin Gallery, Dublin · *Zeichnungen aus der Sammlung Visser*, Museum Boymans-van Beuningen, Rotterdam · *Keramik*, Droysen-Keramikgalerie/Galerie Springer, Berlin · *Arbeiten aus dem Jahr 1975*, Michael Kunsthandel & Galerie Darmstadt (Kat.: S. Anderson) · Galerie Laage Salomon, Paris · Galerie Lelong, Zürich · Irish Museum of Modern Art, Dublin · Salander O'Reilly Galleries, Berlin; Beverly Hills, New York · *Gouaches*, Raiman Art Gallery, Knokke

Gruppenausstellungen | Group exhibitions

1987 *Works on Paper*, Waddington Galleries, London · *Baselitz-Lüpertz-Penck – Estampes récentes*, Galerie Gillespie-Laage-Salomon, Paris · *Wechselströme*, Kunstverein, Bonn · *Der unverbrauchte Blick*, Martin-Gropius-Bau, Berlin · *750 Jahre Berlin*, Galerie Deweer, Otegem · *Mathematik in der Kunst der letzten dreißig Jahre*, Wilhelm-Hack-Museum, Ludwigshafen · ARCO Palacio de Cristal, Madrid · *Sammlung Thomas – Kunst aus den achtziger Jahren*, Museum A 11 Art Forum, München · *L'état des choses I*, Kunstmuseum, Lausanne · *Frauenbilder*, Graphische Räume, Galerie Michael Werner, Köln · *Microscopia*, Galerie Deweer, Otegem · *Vom Impressionismus zur Gegenwart*, Galerie Schwarzer, Düsseldorf · *Zeichnungen*, Galerie Swidbert, Düsseldorf · *Malerei. Painting. Peinture – Malerei. Skulptur –*

Skulpturen von Malern, Kunstverein, Mannheim · *Wasserfarben*, Galerie Harald Behm, Hamburg · *Berlin Art*, Galerie Dorsky, New York · *Black and White*, Nicola Jacobs Gallery, London · *Skulptur Projekte Münster*, Westfälisches Landesmuseum, Münster · *Männerbilder*, Graphische Räume, Galerie Michael Werner, Köln · *Comic Iconoclasm*, Institute of Contemporary Arts, London · *Die Säule im Spiegel der Bildenden Kunst des XX. Jahrhunderts*, Galerie Silvia Menzel, Berlin · Galerie Neuendorf, Hamburg · *La nouvelle peinture Allemande*, Musée Cantini, Marseille · *Accrochage*, Galerie Triebold, Basel · Simon/Neumann Gallery, New York · *Exotische Welten, Europäische Phantasien*, Institut für Auslandsbeziehungen, Württembergischer Kunstverein, Stuttgart · *Für Joseph Beuys*, Galerie Heinz Holtmann, Köln · *International art show for the end of world hunger*, Minnesota Museum of Art, Saint Paul · *Beelden van schilders – Werken op papier*, Galerie Wanda Reiff, Maastricht · *Standort 1987 – Eine persönliche Auswahl*, Galerie Pels-Leusden, Berlin · *Blickpunkte*, Galerie Neher, Essen · *Inaugural exhibition*, Galerie David Nolan, New York · *Works on Paper*, Galerie Bernd Klüser, München · *Baselitz, Lüpertz, Penck – Works on Paper – Watercolors, Gouaches, Drawings*, Galerie Worthington, Chicago · *Standing Sculpture*, Castello di Rivoli, Rivoli (Torino) · *Selection from the Frederick R. Weisman Collection*, Los Angeles (et al.) **1988** *Kunst der 60er und 70er Jahre. Graphik, Objekte, Dokumente aus Privatbesitz*, Bergisch Gladbach, Rathaus Bensberg · *Die Kunst der Aquarelle (1920–1987)*, Galerie Neher, Essen · *Passion und Discipline*, Galerie Dorsky, New York · *Schwarzweiss*, Galerie Mühlerbusch, Düsseldorf · *New Expressionist Visions*, College at New Paltz, College Art Gallery, New York · *Augen-Blicke*. Kölnisches Stadtmuseum, Köln (et al.) · *Furniture as art*, Museum Boymans-van Beuningen, Rotterdam · *The international art show for the end of world hunger*, Kölnischer Kunstverein, Köln · *Collection Sonnabend*, Musée d'Art Contemporain, Bordeaux · *Pyramiden*, Internationales Congress Centrum, Berlin · *Au royaume du Signe, Appliqués sur toile du Kubas, Zaire*, Fondation Dapper, Paris · *Selected works from our Gallery*, Galerie Laurens A. Daarne, Amsterdam · *50th anniversary exhibition*, Rijksmuseum Kröller-Müller, Otterlo · *Deutsche Kunst in den 50er und 60er Jahren*, Galerie Neher, Essen · *A la surface de la peinture. Les années 80*, Centre d'Art Contemporain, Abbaye Saint-André, Meymac · *Verzameling aan zee. Nieuwe keuze en presentatie/Collection next-the-sea. New choice and presentation*, Haags Gemeentemuseum, Den Haag · *Baselitz, Penck, Immendorff. Holz- und Linolschnitte, Radierungen*, National Museum of Contemporary Art, Seoul · *Made in Cologne*, DuMont-Halle, Köln · *Collection du Van Abbemuseum d'Eindhoven*, Musée d'Art Contemporain, Carré d'Art, Nîmes · *Farbe Blau*, Galerie Silvia Menzel, Berlin · *Zeichenkunst der Gegenwart, Sammlung Prinz Franz von Bayern*, Staatliche Graphische Sammlung, München · *Arbeit in Geschichte – Geschichte in Arbeit*, Kunstverein, Hamburg · *Tysk Samtidskunst*, Sonja Henies og Niels Onstads Stiftelser, Hövikodden · *Farbe bekennen, Zeitgenössische Kunst aus Bas-*

ler Privatbesitz, Museum für Gegenwartskunst, Basel · *Mit Messer und Eisen... Holz- und Linolschnitte aus Eigenbesitz*, Städtisches Museum, Schloß Morsbroich, Graphisches Kabinett, Leverkusen · *Aquarelle, Gouachen, Zeichnungen*, Galerie Beyeler, Basel · *A choice: recent acquisition*, Kana Contemporary Art, Berlin *Aquarelle*, Galerie Fred Jahn, München · *Blickpunkte deutscher Kunst im 20. Jahrhundert*, Galerie Neher, Essen · *Zwischenbilanz*, Galerie Remberti, Bremen **1989** Galerie Laage-Salomon, Paris · *Abstraktion und Figuration*, Galerie Neher, Essen · *Nutidskunst. Fra Jytte og Jarl Borgenssamling*, Silkeborg Kunstforening, Kunstmuseum, Kobenhavn · *Malerei Peinture Pintura, Kirkeby, Lam, Lüpertz, Nitsch, Penck, Rainer, Tapies*, Galerie Lelong, Zürich · *Günther Brus, Georg Jiri Dokoupil, Otto Mühl, A. R. Penck*, Atelier del Sur, San Sebastian, Gomera · *Tesioras de las colecciones particulares madrillinas: Pintura y Escultura Contemporaneas*, Real Accademia de Bellas Artes de San Fernando, Madrid · *Skulpturen und Zeichnungen*, Ausstellungsraum Harry Zellweger, Basel · *Deutsche Graphik der 80er Jahre in Ost und West*, Walker Hill Art Center, Seoul · *Museumskizze*, Kunsthalle, Nürnberg · *Figuratively speaking: Drawings by seven Artists*, State University of New York at Purchase, Purchase · *Bilderstreit*. Museum Ludwig, Köln · *Neue Figuration/Deutsche Malerei 1960–1988*, Kunstmuseum, Düsseldorf (et al.) · *Farbe Rot*, Galerie Sylvia Menzel, Berlin · *Triennal de Dibuix Joan Miró*, Fundació Miró, Barcelona · *Triennale Fellbach Kleinplastik*, Fellbach (et al.) · *Zeitgenössische Deutsche Malerei*, Nationalmuseum für zeitgenössische Kunst, Seoul · *Skulptur*, GNAC, Rouen · *Portrait*, Galerie Ascan Crone, Hamburg · *Xth anniversary show*, Galerie Deweer, Otegem · Current European trends, Galerie Evelyn Aimis, Toronto · *Skulls*, Galerie Susanne Ottesen, Kobenhavn · *Farbe Rot*, Galerie Kammer (Studio), Hamburg · *Europese raaklijnen*, Museum Dhondt-Dhaenens, Deurle · *Works on Paper*, Dorsky Gallery, New York **1990** *A. R. Penck, Georg Baselitz*, Galerie Deweer, Otegem · *Am Anfang war das Bild*, Galerie van de Loo, München · *Zeichnungen von Beuys, Clemente, Disler, Judd, Nauman, Oldenburg, Penck und Stella aus dem Kupferstichkabinett Basel*, Kunsthalle, Nürnberg · *Le désenchantement du monde*, Villa Arson, Nice · *Expression & Engagement. German Painting from the Collection*, Tate Gallery, London · *Tra Mito e Stereotipo*, Galleria in Arco, Torino · *Figural Signs*, University of Massachusetts · *Werner Büttner, Jörg Immendorf, A. R. Penck – Ausgewählte Graphik*, Galerie Schurr, Stuttgart · *Experimenta 6*, Wolokolamsker Chaussee I-V, Frankfurt/M. · *Quattordici x Quattordici*, Cleto Polcina, Roma · *GWM – Baselitz, Immendorff, Lüpertz, Kirkeby, A. R. Penck*, Galleri Ottesen, Kobenhavn · *Sommerausstellung. Gemeinschaftarbeiten. Bilder – Grafik*, Galerie Gunar Barthel, Berlin · *Neuerwerbungen der Graphischen Sammlung*, Museum Schloß Morsbroich, Leverkusen · *Aus der Sammlung.* Kunsthalle, Nürnberg · *Bilder vom Neuen Deutschland*, Städtische Kunsthalle, Düsseldorf · *Pharmakon '90*, Makuhari Messe, Tokyo · *Deutsche Graphik des 20. Jahrhunderts*, Walker Hill Art Center, Seoul ·

Skulptur des XX. Jahrhunderts, Galerie Academia, Salzburg · Graphik live, Graphik-Sammlung der Eidgenössischen TH, Zürich · Ulrich Bleiker/A. R. Penck, Galerie Flora, Kirchberg · Rockens Billeder. Images of Rock, Kunsthallen Klaedefabrik, Odense · Ausgebürgert. Künstler aus der DDR und aus dem sowjetischen Sektor Berlins 1949–1989, Statliche Kunstsammlungen, Dresden · Keramische Gefässe & Objekte: Helge Leiberg. A. R. Penck, Droysen-Keramikgalerie Kattrin Kühn, Berlin · A. R. Penck – Rolf König – Volker Mehner, Eugene Bilder Gallery, Dallas · Baselitz, Chilida, Kirkeby, Lüpertz, Penck, Tapies: Graphics large formats, Lelong Gallery, Zürich · Mischiare lecarte – immagine seculare, GianFerrari Artecontemporanea, Milano **1991** Atelier del Sur, El Cabrito La Gomera, Islas Canarias Espana · Die Hand des Künstlers, Museum Ludwig, Köln · Erwerbungen der Graphischen Sammlung Staatsgalerie Stuttgart 1983–1990, Staatsgalerie, Stuttgart · Ausgebürgert. Künstler aus der DDR uns aus dem sowjetischen Sektor Berlins 1949–1989, Kleine Deichtorhalle, Hamburg · Campano – Lüpertz – Penck – Plensa – Primitive Art, Gallerie Philippe Guimiot, Bruxelles · Figur. Ansichten von Figur in der Moderne, Städtische Galerie, Heilbronn · Rockens Bilder – Images of Rock, Göteborgs Konstmuseum, Göteborg · Georg Baslitz – Markus Lüpertz – A. R. Penck. Oeuvres sur papier 1977–1990, Galerie Laage-Salomon, Paris · Deus ex charta, Studio d'Arte Cannaviello, Milano · Autoritratto del Blu in Prussia, Kunsthalle, Luzern · Moderne Deutsche Malerei, Deko Art Center, Seoul · Menschen und Tiere nach der Öffnung, Galerie Frank Hänel, Art Frankfurt · Werke aus dem Bestand der Galerie, Galerie Cornelius Hertz, Bremen · XX Century Art, Galerie Beyeler, Basel · La Sculpture Contemporaine après 1970, Fondation Daniel Templon, Musée Temporaire, Fréjus · Paris-Bar, Artcurial, Centre d'Art Plastique Contemporain, Paris · Six German Painters, Holm Gallery, London · Series Drawings Show, Michael Werner Inc., New York · Orangerie '91, Internationale Kunsthandel im Martin-Gropius-Bau, Berlin · Bienale de São Paulo

Bibliographie | Bibliography

Texte und Bücher vom Künstler
Texts and books by the artist
Standart making, München, Verlag Jahn und Klüster, 1970 · Was ist Standart, Köln/New York, Verlag Gebr. König, 1970 · ICH-Standart-Literatur, Paris, Editions Agentzia, 1971 · Der Adler, in: Interfunktionen, Nr. 11, 1974 · Ich über mich selbst, in: Kunstforum, Bd. 12, Mainz, 1974/75 · Macht und Geist Analytische Studie zu Kunst im politischen Kampf, Bruxelles, [1975] · Ich bin ein Buch, kaufe mich jetzt, Oberhausen, 1976 (Paris, Galerie Gillespie-Laage-Salomon, 1981) mit/with J. Immendorff, Immendorff besucht Y. Deutschland mal Deutschland – Ein Deutsch – Deutsch Vertrag, München, Rogner & Bernhard Gmbh & Co, 1979 · Kneipen und Kneipentexte, Dresden, 1980 · Ende im Osten, 98 Zeichnungen, Berlin, 1981 · Standart, en begreppsintroduktion, Moderna Museet, Nr. 1, 1983 · mit/with J. Immendorff, Brandenburger Tor Weltfrage, New York, 1982 · Zwanzig Skizzen aus dem Jahre 1968, Zweiundzwanzig Post-Karten, s.l., 1982

(Einl./Introd. Jürgen Schweinebraden) · Welt des Adlers, 466 Zeichnungen, Berlin, Rainer Verlag, 1984 · Paris. Graphik, München, 1984 · Krater und Wolke, H 1–5, Köln, 1982–1985 · 99 Zeichnungen 1956–1966, Zürich, 1985 (Einl./Introd. Jürgen Schweinebraden) · Standart 1971–73, Nachdruck, Berlin, Rainer Verlag, 1985 · Standart-Modelle 1973/74, Köln, Verlag Walther König, 1985 · Mein Denken, Frankfurt/M., Edition Suhrkamp, 1986 · Der verborgene Kampf, in: Parkett, Nr. 10, 1986 · Köln, in: Tema Celeste, Nr. 9, November, 1986 · Don van Vliet, Bern/Berlin, Verlag Gachnang & Springer, 1987 · Un flirt, in: Tema Celeste, Nr. 12/13, Juli/November, 1987 · mit/with Sarah Kirsch, (Ohne Titel), Berlin, Edition Malerbücher, 1987 · Für Antonius Höckelmann, in: Malerei, Painting, Peinture, Nr. 4, 1987 · Der Jimmy Hendrix der Plastiker, in: Zeitmagazin, Nr. 48, 25. November, 1988 · The Technological Wasteland Don van Vliet, in: Tema Celeste, Nr. 20, April/Juni, 1989 · Allgemeine Untersuchung der Problematik der Situation unter besonderer Berücksichtigung individueller und ewiger Aspekte, in: Maler über Malerei/Einblicke-Ausblicke, Köln, DuMont Buchverlag, 1989 · mit/with S. Anderson, Jewish Jetset, Berlin, Hg. Sascha Anderson, 1989 · Der wahre Martin oder das Gespür auf die Fährte gebracht, die an den Fußsohlen ritzelt !, in: Kat. Martin Kippenberger, Villa Arson, Nice, 1990 · Reise durch Ireland/Reise durch Irrland, Berlin, Hg. Sascha Anderson, 1990 · S. Anderson: Zachor/A. R. Penck: Wasserzeichen/John Gerard, Papier, Hg. Sascha Anderson in Zusammenarbeit mit dem Maximilian Verlag, Sabine Knust, München und der Galerie Rudolf Springer, Berlin, 1990 · Tiské, Heidelberg, Edition Staeck, 1990 · Analysis, Heidelberg, Edition Staeck, Mai, 1990 · Ich, der Tourist, fast 7 Jahre, 7 Jahre West, Berlin–Bern, Verlag Gachnang & Springer, 1990 · mit/with Thomas Brasch, Telegramm, Berlin, Hg. Sascha Anderson, 1990 · der Vergleich als Methode der Bild-Forschung, in: Bilderstreit-Almanach, München, Johannes Gachnang/Siegfried Gohr, 1990 · Krater und Wolke Nr. 6, Köln, Michael Werner, 1990

(Rundfunk/Broadcasting)
Kunst ist nie ein Gegen, Interview Sara Rogenkofer und Florian Rötzer mit/with A. R. Penck in: Frankfurter Rundschau, 25.07.1987

Bücher | Books
Bernard Marcadé, A. R. Penck, Paris, Editions de la Différence, 1988

Periodika | Periodicals
Pascale Bertrand, A. R. Penck-Skulptures, in: Beaux-Arts Magazine, Nr. 53, Januar, 1988 · Nicolas Bourriaud, Utopia. 'L'atelier du midi' – Une Kunsthalle aux Iles Canaries, in: New Art, Nr. 1, Februar/März, 1988 · Demosthènes Davvetas, A. R. Penck, in: New Art, Nr. 1, Februar/März, 1988 · Eddy Devolder, A. R. Penck, Bruxelles, in: Artefactum, Nr. 34, Juni/Juli/August, 1990 · Wolfgang Max Faust, Review: A. R. Penck, Neue Nationalgalerie Berlin, in: Artforum, Oktober, 1988 · Siegfried Gohr, Ich-Selbstbewusstsein – Eine monumentale Skulptur von A. R. Penck, in: Kölner Museumbulletin, Sonderheft II, 1987 · Christian Huther, Kein Interesse an deutscher Geschichte. Ein Wandbild für die Frankfurter Paulskir-

che, in: Kunstforum, Nr. 97, November/Dezember, 1988 · Eva Karcher, A. R. Penck: 'Ein bißchen Glanz muß sein', in: Pan, Nr. 5, 29. April, 1988 · Jutta Koether, Under the influence, in: Flash Art, Nr. 133, April, 1987 · José Lebrero Stals, A. R. Penck, Contra la fantasia y por la realidad, in: Balcon, Nr. 4, Februar, 1989 · Bernard Marcadé, A. R. Penck – Quo vadis Germania ?, in: Cimaise, Nr. 198, Januar/Februar, 1989 · Roland Mischke, A. R. Penck, in: FAZ-Magazine, Nr. 358, 9. Januar, 1988 · P.W., Im Totemwald, in: Weltkunst, Nr. 14, 15. Juni, 1988 · Peter Sager, Penck, in: Zeitmagazin, Nr. 15, 1988 · Brigitte Schenk, A. R. Penck. We live in an age of belief not science, we are machines in transition, in: Flash Art, Nr. 150, Januar/Februar, 1990 · Rudolf Schmitz, Die Geheimwaffe eines Exilanten, in: Kunst-Bulletin, Nr. 5, Mai, 1991 · Stephan Schmidt-Wulffen, Enzyklopädie der Skulptur, in: Kunstforum, Nr. 91, Oktober/November, 1987 1 · Christiane Vielhaber, A. R. Penck at Jule Kewenig and Ropac, in: Art in America, Dezember, 1987 · Scott Watson, Bilder, Zeichen, Räume, in: Wolkenkratzer, Nr. 4, Juli/August, 1988 · Max Wechsler, Skulptur Projekte in Münster 1987, in: Kunst-Bulletin, Nr. 9, September, 1987 · Hanne Westkott, A. R. Penck, in: Kunstforum, Nr. 89, Mai/Juni, 1987 · Thomas Wulffen, A. R. Penck, in: Kunstforum, Nr. 96, August/Oktober, 1988

MICHELANGELO PISTOLETTO

*Biella (I), 1933
Lebt/Lives in Milano

Einzelausstellungen | One-man exhibitions

1960 Galleria Galatea, Torino (Kat.: L. Carluccio) **1963** Galleria Galatea, Torino (Kat.: L. Carluccio) **1964** Galerie Ileana Sonnabend, Paris (Kat.: A. Jouffroy, M. Sonnabend, T. Trini) · Galleria del leone, Venezia · I plexiglas, Galleria Gian Enzo Sprone, Torino (Kat.: M. P.) **1965** Sala Espressioni-Ideal Standard, Milano (Kat.: Sottsass jr.) **1966** Oggetti in meno, Atelier des Künstlers, Torino · M.P.: A Reflected World, Walker Art Center, Minneapolis (Kat.: M. Friedman) · Galleria del Leon, Venezia · Galleria Gian

Enzo Sperone, Milano · *Oggetti inn meno,* Galleria La Bertesca, Genua (Kat.: L. Carluccio, J. Ashberry, M. Fagiolo, M. Friedman, A. Jouffroy, S. Simon, M. Sonnabend, T. Trini, M. P.) **1967** Galerie Zwirner · *Festival of the Underground Cinema,* Carnegie International, Pittsburgh · Hudson Gallery, Detroit · Galleria del Naviglio, Milano (Kat.: T. Trini) · Palais des Beaux-Arts, Bruxelles (Kat.: J. Dypréau, H. Martin, M. P.) · Komblee Gallery, New York · Galerie Ileana Sonnabend, Paris · Galleria Gian Enzo Sperone, Torino **1968** *Festival des neuen Films,* Knokke · Galleria Christian Stein, Torino · Galleria L'Attico, Roma (Kat.: G. C. Argan, M. P.) **1969** Badischer Kunstverein, Karlsruhe · Komblee Gallery, New York · Museum Boymans-van Beuningen, Rotterdam (Kat.: R. Hammacher-van den Brande, H. Martin, M. P.) · Albright-Knox Art Gallery, Buffalo, New York (Kat.: R.M. Murdock) **1970** Modern Agency, Napoli · *Padre Figlio Spirito Santo e Le Tre Grazi,* Galleria Gian Enzo Sperone, Torino · *Tutte le donne,* Galleria dell'Ariete, Milano (Kat.: T. Trini) · Palazzo Ricci, Montepulciano **1971** Galerie M.E. Thelen, Köln · Studio Santandrea, Milano **1972** Galleria Toninelli, Roma **1973** Galleria dell'Ariete, Milano (Kat.: M. P.) · *Ettore Olivero Pistoletto – Michelangelo Pistoletto – Vater und Sohn,* Galleria Gian Enzo Sperone, Torino (Kat.: E. O. Pistoletto) · Kestner-Gesellschaft, Hannover (Kat.: M. Bandini, A. Boatto, J. Dypréau, M. Friedman, H. Martin, R.M. Murdoch, W. Schmied, M. P.) **1974** Galerie Gunther Sachs, Hamburg · Mathildenhöhe (Kat.: B. Krimmel) · Sidney Janis Gallery, New York (Kat.: T. Trini) **1975** *La prigione, il suicidio, il pericolo della morte, l'agguato, il decadimento, gli escrementi, il cimitero, la cattura,* Galleria Gian Enzo Sperone, Roma · Art Agency Gallery, Tokyo · Galleria Il Centro, Napoli · Galleria Aprile Ronda, Biella · *Le stanze,* Galleria Christian Stein, Torino (Kat.: M. P.) · Galleria Multipli, Torino (Kat.: M. P.) · Modern Agency, Napoli · Castelli Graphic Gallery, New York **1976** Galleria Salvatore Ala, Milano (Einladung/Innitation: M. P.) · Samangallery, Genua (Texte Saman Bulletin, Nr. 6: M. P.) · *Retrospektive,* Palazzo Grassi, Venezia (Kat.: G. Celant, M. P.) · *Centro mostre del messe di ottobre,* Galleria Giorgio Persano, Torino · *Chi sei tu?,* Galleria Il Collezionista, Roma · Galleria Christian Stein, Torino · Incontri Internazionale d'Arte, Roma **1977** Galleria Giorgio Persano, Torino · Museo Principe Diego Aragona Pignatelli Cortes, Napoli · *16 anni dentro allo specchio,* Galerie Marie-Louise Jeanneret, Genève (Kat.: V. Anker) · *L'alto in basso, il basso in alto, il dentro fuori,* Samangallery, Genua (Text Saman Bulletin, Nr. 11: M. P.) **1978** Nordiyllands Kunstmuseum, Aalborg (Kat.: M. Bandini, G. Celant, J.O.H., T. Trini, M. P.) · *L'arte assume la religione – Divisione e moltiplicazione dello specchio,* Galleria Giorgio Persano, Trino (Kat.: G. Risso, M. P.) · *Le gallerie,* Studio von Pistoletto, Torino · *Reflexionen,* Nationalgalerie, Berlin · *Pistoletto in Berlin,* an dreizehn öffentlichen Orten, Berlin (Kat.: H. Ohff, W. Schmied, M. P.) · *Un' isola nel tempo,* Galerie Schweinebraden, Berlin · *Mostra antilogica,* Galleria Mario Diacono, Bologna (Kat.: M. Diacono, M. P.) **1979** *Mirror-Works,* Institute of Arts, Rice University, Houston (Kat.: M. Jackson, W. Paul, H. Rosenstein, M. P.) · *Creative Collaboration – Feldman, Gennero, Pistoletto, Rava,* High Museum of Art und verschiede-

ne Orte in der Stadt, Atlanta (Kat.: M. Jackson, W. Paul, H. Rosenstein, M. P.) · *Furniture Environment,* Georgia Museum of Art, Athens (Kat.: M.Jackson, W. Paul, H. Rosenstein, M. P.) · Internationaal Cultureel Centrum, Antwerpen · *Le tavole della legge,* Galleria Giorgio Persano, Torino · *Gli oggetti in meno,* L.A.I.C.A., Los Angeles **1980** *La freccia penetrabile,* Mayfield Mall, Palo Alto (Kat.: M. P.) · Hansen Fuller Goldeen Gallery, San Francisco · Museum of Modern Art, San Francisco · *One Arrow,* The Clocktower, New York · *Le tavole della legge,* Palazzo Comunale, Pistoia – Incontri Internazionale Arte/Teatro: Italia – California · *L'arte assume la reglione,* Studio La Torre, Pistoia · *Il giudizio universale a dimensione reale,* Galleria Giorgio Persano, Torino · *Il tavolo del giudizio,* Galleria Lucrezia de Domizio, Pescara (Kat.: M. P.) · *Welcome to New York,* Galleria Giuliana De Crescenzo, Roma · *Il Testa Coda,* Galleria Giorgio Persano, Torino (Kat.: I. Puliaffito) **1981** *Spiegelbilder,* Westfälisches Landesmuseum, Münster (Museum Doberman, Altenbergen) · *Nativity,* Salvatore Ala Gallery, New York **1982** *La mana, la spalla, la testa,* Galleria Mario Pieroni, Roma (Kat.: B. Corà) · Galleria Aprile Ronda, Biella · *La porta obliqua, il tempio a dondolo,* Galleria Toselli, Milano (Kat.: M. P.) · Galerie Tanit, München (Kat.: R. Comi) · Holin Gallery, Miami **1983** *Vita eretta, trans scendenza, sopra vivenza, gene razione,* Galleria Giorgio Persano (Kat.: M. P.) · Galleria La Polena, Genua (Kat.: E. Battisti) · *M. P. – Skulpturen,* Westfälischer Kunstverein (Kat.: B. Corà, T. Deecke) · *Retrospektive,* Palacio de Cristal-Parque del Retiro, Madrid (Kat.: A. Boatto, A. Bonito Oliva, S. Becket, L. Carluccio, G. Celant, R. Comi, B. Corà, M. Friedman, C. Ferrari, A. Garcia, A. Jouffroy, W. Schmied, T. Trini, M. Welish, M. P.) · Italienisches Kulturinstitut, Madrid **1984** *Sculptures,* Centre d'Art Contemporain, Genève (Kat.: F. Salvadori) · Centro d'Art Contemporain, Syrakus (Kat.: M. Castello, M. P.) · Forte di Belvedere, Firenze (Kat.: G. Celant, G.C. Argan, U. Allemandi, A. Boatto, A. Bonito Oliva, G. Bousier, M. Calvesi, L. Carluccio, M. Castello, Bruno Corà, R. Di Giammarco, M. Diacono, C. Ferrari, G. Ficara, M. Friedman, A. Garcia, A. Jouffroy, U. Mulas, F. Prestipino, H. Rosenstein, F.C. Serraller, W. Schmied, E. Sottsass, T. Trini, M. P.) **1985** *Les quatre saisons,* Galerie de France, Paris · *Arte dello squallore – Michelangelo Pistoletto – Quarta generazione,* Galleria Giorgio Persano, Torino (Kat.: R. H. Fuchs, M. P.) · *Les Génies du Temps,* Hotel de la Region, Toulouse **1986** Kunstnernes Hus, Oslo (Kat.: D. Paparoni) · *The Great Dipper,* Art Gallery of Ontario und Istituto Italiano di cultura, Toronto (Kat.: R. Naasgard, F. Valente, R.F. Welsh · Galleria Pieroni, Roma · *Pistoletto (Prima Parte),* Stedelijk Van Abbe Museum, Eindhoven (Kat.: R. H. Fuchs) · *Le temps du miroir,* Le Magasin, Grenoble (Kat.: B. Corà, J. Guillot, F. Kaiser) · Locus Solus, Genua · *M. P. jalons anciens, oeuvres récentes,* Musée Cantini, Marseille (Kat.: F. Bazzoli, M. P.) **1987** *Basso-rilievi,* Galleria Massimo Minini, Brescia · *Vedersi,* Galleria Numero 5, Capri, Napoli · *Dentro,* Galerie Montevideo, Antwerpen (Kat.: W. van Mulders, M. P.) **1988** Grazer Kunstverein, Künstlerhaus, Graz (Kat.: B. Corà, P. Pakesch, M. P.) · *Long playing,* Galleria Lia Rumma, Napoli · *M. P. Division and Multiplicationn of the Mirror,* P.S. 1,

New York (Kat.: G. Celant, A. Heiss, M. P.) · *Distanze,* Staatliche Kunsthalle Baden-Baden, Baden-Baden (Kat.: M. P., J. Poetter) **1989** *Michelangelo Pistoletto, ogeti in meno 1965 – 1966,* Kunsthalle Bern (Wiener Secession; Camden Arts Centre, London) (Kat.: U. Loock, M. P., D. Zacharopoulos) · Galeria Opera, Perugia · Jay Gorney Gallery, New York · Galleria Persano, Milano · Museo di Capodimonte · Galerie Tanit, München · Galerie Xavier Hufkens, Bruxelles **1990** Galleria Nazionale d'Arte Moderna, Roma (Kat.: F. Fiorani, A. Imponente, A. Monferini) · Galeria Comicos, Lisboa · Centre d'Art Santa Monica, Barcelona · Galerie Peter Pakesch, Wien · Galerie Tanit, Köln · Galerie Durand-Dessert **1991** Maureen Paley Interim Art, London · Espace Lulay, Liège · Atrium, Biella · Galleria Persano, Torino · Galeria Juana de Aizpuru, Madrid · Museet for Samtidskunst/Museum of Contemporary Art, Oslo

Gruppenausstellungen | Group exhibitions

1987 *Giulio Paolinio, M. P., Gilberto Zorio,* Galleria Giorgio Persano, Torino · *Disegnta,* Logetta Lombardesca, Ravenna Pinacoteca comunale · *Terrae Motus, Naples tremblement de terre,* Grand Palais, Paris · *Beuys, Walther, Horndash, Mullican, Morris, Pistoletto, Rauschenberg, Spitzer,* Burnett Miller Gallery, Los Angeles · *Turin 1965 – 1987 de l'Arte povera dans les collections publiques françaises,* Musée Savoisien, Chambéry · Musée de l'Hospice Comtesse, Lille (et al.) · *James Brown, Joel Otterson, M. P.,* Nature Morte Gallery, New York · *Arte povera,* Centre de Création Contemporaine, Tours · *Lo specchio e il suo doppio,* Mole Antonelliana, Torino · *Monumenta, 19. Biennale der Skulptur,* Middelheim, Antwerpen · *L'Attico 1957 – 1987,* Chiesa di San Nicolo, Spoleto · *Italie hors d'Itali,* Musée des Beaux-Arts, Nîmes · *Dalla Pop Americana alla nuova figurazione,* Padiglione d'arte contemporanea, Milano · *1. International Istanbul Contemporary Art Exhibitions,* Istanbul Foundation for Culture and Arts, Istanbul · *Collection Sonnabend,* Centro de Arte Reina Sofia, Madrid (et al.) · *Standing Sculpture,* Castello di Rivoli, Rivoli (Torino) · *Reason and Emotion in Contemporary Art,* Edinburgh International – The Royal Scottish Academy, Edinburgh **1988** *Presentaion & Propositions,* Villa du Parc, Rhône-Alpes · *Italian Aspects of Avant-garde in Italy,* National Museum of Contemporary, Seoul · *Mythos Italien,* Haus der Kunst, München · *Ventanni Fa '68,* Studio La Città, Verona · *Corpo a corpo contro la storia dell'arte,* Palazzo delle mostre e dei congressi · *Hopeful Monstre,* Fiera del Libro, Torino · *Presi per incantamento,* Padiglione d'arte contemporanea, Milano · *L'inventaire,* Locaux de Manufrance, St. Etienne · *De verzameling,* Museum van Hedendaagse Kunst, Antwerpen **1989** *Europese raaklijnen,* Museum Dhondt-Dhaenens, Deurle · *Open Mind,* Museum van Hedendaagse Kunst, Gent · *Italian art of the twentieth century,* Royal Academy of Arts, London · *Verso l'Arte Povera Momenti e aspetti degli anni sessanta in Italia,* Padiglione d'Arte Contemporanea, Milano · *Materialmente, Scultori degli anni Ottanta,* Galleria Comunale d'Arte Moderna, Bologna · *Natura naturata,* Josh Baer Gallery, New York · *Sculptura,* Studio La Città, Verona · *La collezio-*

ne Sonnabend. Dalla Pop Art in poi, Galleria Nazionale d'Arte Moderna, Roma · International Contemporary Art, Art Gallery of Ontario, Toronto · Arte contemporanea per un museo, Padiglione d'arte contemporanea, Milano · Hic sunt leones, ex Zoo, Torino · Anteprima, Villa delle Rose, Bologna · Wittgenstein, Wiener Secession, Wien · Effts des miroirs, Credac, Ivry-sur-Seine, Paris · Italian aspects of Avant-Garde Art in Italy 1960–1986, Jahrhunderthalle Hoechst, Frankfurt · Neue Galerie, Staatliche Kunstsammlungen, Kassel · Artisti italiana oggi, Istituto di Arte italiano, Lima · La collezione Sonnabend. Dalla Pop Art in poi, Museo d'arte moderna e contemporanea, Palazzo delle Albere, Trento · Momenti della scultura italiana 1946–1989, National Museum of Contemporary Art, Seoul · Specchi ustori, Museo di Palazzo Bellomo, Siracusa 1990 Totalnovo, Biblioteca Della Regione – Siciliana, Palermo · Venus, Moulins Albigeois, Alby · II Mostra Collettiva, Ex Zoo Parco Michelotti, Torino · Ultralux, Galleria Claudio Bottello, Torino · Memoria del Futuro, Centro de Arte Reina Sofia, Madrid · Arte Povera Nella Collezione del Centre Pompidou, Musée Cantini, Marsiglia · Dieci in Qualita, Galleria Spaggiari, Milano · I Giovedi: Ero Leandro, Galleria Rizardi, Milano · Le Diaphane, Musée des Beaux-Arts, Tourcoing · Ende der Asthetik-Beginn der Kunst, Symposium, Theaterhaus, Stuttgart · Venus, Musée d'Art et d'Histoire, Saint Denis · Roma Anni '60 al di la'della pittura, Palazzo delle Espozizioni, Roma · Modernitat en L'Art del Segle XX, Fondació Joan Miró, Barcelona 1991 Venus, Musée de L'Eveche, Evreux · Ultralux, Museo d'Arte Moderna, Bolzano · Arte Povera, Studio Oggeto, Milano · Arte e Arte, Castello di Rivoli, Rivoli (Torino) · Extralage, Galleria Eva Menzio, Torino · Arte Povera Nella Collezioni del Centre Pompidou, Deichtorhalle, Hamburg · Jardins de Bagatelle, Galerie Tanit, München · Antinomia, Facolta di Architettura, Castello dell Valentino, Torino · Arte Povera 1971 und 20 Jahre Danach, Kunstverein, München · Opere d'Arte per il Restauro del Tempio, Sala Bolaffi, Torinio · Noir, Galleria Galliata, Alassio · Eventi, Videoarte, Istituto Italiana, Madrid · Letteratura Artistica, Castello di Rivoli, Rivoli (Torino) · Autoritratto, Galleria Fossati, Torino · Da Magritte a Magritte, Palazzo Forti, Verona · Europäische Dialoge, Museum, Bochum · Borealis V, Porin Taidemuseum, Pori · Ottantanovanta, Monastero dei Benedettini Monreale, I Biennale D'Artefilosofia e Spettacolo, Palermo · Popart, Royal Accademy of Arts, London · Denonciation, L'Usine Fromage, Rouen · Parallel Linee della scultura contemporanea, Galleria Gian Ferrari arte Contemporanea, Milano 1992 Pistoletto, Kawara, Knoebel, Deichtorhallen, Hamburg

Aktionen | Actions

1967 La fine di Pistoletto, Piper, Torino · Taglio dei capelli, Università-Istituto di storia dell'arte, Genua 1968 Scultura da passegio, auf den Straßen der Stadt/on the streets, Torino · Le trombedel giudizio, Atelier des Künstler, Torino · Con questo manifesto invito le persone che lo desiderano a collaborare con me alla XXXIV Biennale di Venezia, Manifest Biennale Venedig, Torino · Applauso al mare, Vernazza · Teatro degli spettatori, Teatro Go-

betti, Torino 1969 Labrinto, Museum Boymans-van Beuningen, Rotterdam 1970 L'uomo nro ..., Galleria dell'Ariete, Milano · Operazione subacquea, Modern Art Agency, Napoli 1976 Silenzio rosa, »Attivo«, Sektion für Performances, XXXVII Biennale, Venezia 1977 Invito alla mostra, Galleria Giorgio Persano, Torino · Dietrofront, Incontri internazionale d'arte, Roma 1978 Un isola nel tempo, Galerie Schweinebraden, Berlin 1979 Creative Collaboration, an verschiedenen Orten der Stadt/different locations in town, Atlanta · Walking Art, auf den Straßen der Stadt/on the street, Athinai 1980 La Venere e il grande carro, 80 Laughton Street · La famiglia, Galleria Lucrezia De Domizio, Pescara · Il tavolo del giudiuzio mit G. Ferraris, M. Pioppi, Armona, Cristina, Pietra, M.P. 1981 L'occhio è lo specchio, Accademia di belle arti, Perugia

Aktionen der Gruppe »Zoo« | Actions of the Group »Zoo«
1968 Cocapicco e Vestitorito, Torino · L'uomo ammaestrato, Vernazza, Levanto, Amalfi, Roma · Zuppa, Galleria l'Attico, Roma · Teatro baldacchino, Torino · Play, Deposito d'arte presente, Torino 1969 Il principe pazzo, Galleria Il Centro, Napoli · Il tè di Alice, Galleria Il Centro, Napoli (et al.) · Bella gente, Salone Istituto San Paolo, Torino · Concerto da gabbia, Paradiso, Amsterdam · I ratti baratti, De Lantaren, Rotterdam · La danza del gabbiano, im Turm, Vernazza (et al.) · Lo Zoo scopre l'uomo nero, Galleria Gian Enzo Sperone, Torino · L'uomo nero, Artestudio, Macerata 1970 Chi dei tu?, 4 Bitef, Belgrado (et al.) · L'uomo ammaestro, auf der Straße/on the street, 4 Bitef · Bello e basta, Teatro Uomo, Milano

Theaterproduktionen
Theatre Productions

1967 La fine di Pistoletto, Piper, Torino · Chiuso per amore del proprietario, Torino · Taglio di capelli, Università, Istituo di Storia dell'Arte, Genova 1968 Teatro degli spettatori, Teatro Gobeti, Torino · Applausi al mare, Vernazza · Le trombe del giudizio, I studio di Pistoletto, Torino 1970 L'uomo nero, Galleria dell'Ariete, Milano 1977 Neither, Teatro dell'Opera, Roma 1978 I trombonauti, Trittico '78, Avigliana-Trana · Neither, Nationalgalerie, Metamusik-Festival, Berlin · Creative collaboration, Atlanta 1979 Opera Ah, Piazza, Corniglia 1980 Venere e il Grande Carro, 80 Laughton, San Francisco · La Famiglia, Galleria De Domizio, Pescara 1981 Anno Uno, Teatro Quirino, Roma · L'occhio è lo sppecchio, Accademia di Belle Arti, Perugia 1991 Dall'anno uno ad oggi, Castello di Rivoli, Rivoli (Torino) · Concerto per Megafoni, Festival del Teatro, Parco Le Serre, Grugliasco-Torino

Bibliographie | Bibliography
Vollständige Bio-/Bibliographie | Complete bio-/bibliography in: Kat. Michelangelo Pistoletto, Galleria nazionale d'Arte Moderna, Roma 1990

Texte und Bücher vom Künstler
Texts and books by the artist
L'uomo nero, 1969 · I pozzi di Foligno, in: Lo Spazio dell'Immagine, Foligno, 1976 · Una lettera, in: Pianeta fresco, Milano II e III equinozio invernale, 1968 · Riposta a »E il momento della negazione?«, in: Sipario,

Nrn. 268/269, Milano, August/September, 1968 · Lo Zoo, in: Teatro, Nr. 1, Milano, 1969 · In occasione del mio 37° compleanno..., in: Flash Art, Nr. 19, September/Oktober, 1970 · in: Saman, Nr. 6, Genua, Mai/Juni, 1976 · Gli Spettatori, in: Saman, Nr. 7, Genua, 1977 · Il progresso ha ammassato una tale quantità di avanguardia nella prospettiva del futuro che io vedo per essa piu spazio nel passato, in: Data, Oktober, 1977 · L'alto in basso, il basso in alto, il dentro fuori, in: Saman, Nr. 11, Genua, November/Dezember, 1977 · Una nota – Neither, in: Bollettino Teatro dell'Opera, Roma 1976–1977 · Divisione e moltiplicazione dello specchio, in: bollettino Saman, Nr. 13, Genua, März/April, 1978 · The Sign, The Creative Collaboration, in: Contemporary Art Southeast, Atlanta, Band, II, Nr. 11, 1979 · Anno Uno, Text für ein Theaterstück vom Oktober/November 1980 · Annunciazione, in: La ruota del Lotto, Jessi, Pinacoteca Comunale, Dezember, 1981 · Der Spiegel, in: Kat. Spiegelbilder, Kunstverein, Hannover, 1982 · Zur documenta, in: documenta 7, Kassel, Band II, Juni, 1982 · Lo specchio come progetto, in: Rassegna, Milano, Nr. 13, Jg. 5, März, 1983 · Incontro tra mondi, in: Domus, April, 1983 · Una città senza autonomia, in: Gazetta del Popolo, 23.April, 1983 · Vivere nel disegno, in: Kat. Il grande disegno, Alinari, Firenze, 1983 · Lo specchio, prima dopo, in: Kat. Il disegno del mondo, Mole Antonelliana, Torino, 1983 · Anima, in: Tema Celeste, Nr. 1, November, 1983 · Michelangelo Pistoletto, in: Collection, 2 Bde., 4 Farbtafel, Text von Germano Celant, Firenze, 1983 · Aforisma, in: Tema Celeste, Nr. 2, März, 1984 · La mia donna di pietra scandalizza Firenze, in: La Stampa, Beilage Tuttolibri, Torino, 20. Oktober, 1984 · Poetica dura, in: Tema Celeste, Nr. 6, 1985 · Matriale anonimo, in: Spazio Umano-Human Space, Nr. 2, Milano, April/Juni, 1986 · Im Strudel des Krieges, in: Kat. Beuys zu Ehren, Städtische Galerie im Lenbachhaus, München, 1986 · in: Spazio Umano-Human Space, Nr. 1, Milano, März, 1988 · in: Kat. Presi perincantamento, Padiglione d'arte contemporanea, Milano, 1988 · Il Titolo »Distanza« Comprende..., Torino, Castello di Rivoli, 1991 · pagina Aperta, Ciclostilato distribuito al festival del Teatro, Parco le Serre, Grugliasco, Torino

Periodika | Periodicals
R. Assunto, Futurismo e sessantottismo neoavanguardia, in: Lo Spazio, Nr. 2, Napoli, Oktober, 1987 · Carolyn Christov-Bakargiev, Michelngelo Pistoletto's Anno Bianco: after 1989, nothing is the same as before, in: Flash Art, Nr. 151, März/April, 1990 · O. Chupin, Michelangelo Pistoletto. Le temps du miroir, in: Halle, Nr. 13, Genève, Januar/März, 1987 · E.R. Comi, M. Pistoletto, Unita specificita, differenza, in: Spazio Umano, Nr. 2, April, 1987 · V. Conti, Michelangelo Pistoletto, in: Flash Art, Nr. 137, Februar 1987 · Michael Craig-Martin, Michelangelo Pistoletto, in: Terksel – Threshold, Nr. 6, 23. November, 1991 · C. Grout, Michelangelo Pistoletto, in: Flash Art, Nr. 132, Februar/März, 1987 · F. Kaiser, Le miroir de Pistoletto ou Narcisse inventeur de la peinture, in: A.E.I.U.O., Nr. 20/22, April/Dezember, 1987 · Ulrich Loock, Germano Celant, Michelangelo Pistoletto: oggetti in meno, 1968–1966, in: Berner Kunstmitteilungen, Nr. 272, November/Dezember, 1989 · A. Mammi, Michelangelo Pistoletto, in: Artforum, Mai, 1988 · D. Papa-

roni, *L'origine della ferita*, in: Tema Celeste, Nr. 16, Juni, 1988 · A. **Pelene**, *Michelangelo Pistoletto, le temps du miroir*, in: Art Press, Nr. 112, März, 1987 · U. **Sala**, *Immagni Italia*, in: Segno, Nr. 72, Februar, 1988 · Barry **Schwabsky**, *Pistoletto through the looking glass: a conversation on the art of subtraction*, in: Arts Magazine, Vol. 63, Nr. 4, Dezember, 1988 · A. **Tecce**, *Dopo Pistoletto, la Sherman e oggeti famosi*, in: Il Giornale dell'arte, Torino, April, 1988 · A. **Trimarco**, *Immagini allo specchio*, in: II Mattino, 5. März, 1988 P. Vangelisti, *Da »Perfect Stranger«*, in: Spazio Umano, Nr. 2, April, 1987

Film · Video

1968 Filme in Zusammenarbeit mit Filmemachern und M. Pistoletto anlässlich der Ausstellung in der Galleria L'Attico, Roma · **1968** *La Vestizione*, A. De Bernardi, 8 mm, Farbfilm, 25 Min. · *Il Giornale*, R. Dogliani, 8 mm, Farbfilm, 10 Min. · *Pistoletto & Sothby*, Epremiam, 8 mm, Farbfilm, 25 Min. · *Communicato Speciale*, R. Ferraro, 16 mm, Farbfilm, 8 Min. · *Michelangelo andrà all'inferno*, M. Ferrero, 16 mm, s/w, 10 Min. · *Frankenstein Prossimamente*, P. Menzio, 16 mm, s/w, 25 Min. · *Maria Fotografia*, P. Martelli, 16 mm, s/w, 18 Min. · *Marisa Merz*, 16 mm, s/w, 3 Min. · *Buongiorno Michelangelo*, U. Nespolo, 16 mm, s/w, 25 Min · *Vernissage*, F. Nichot, 8 mm, Farbfilm, 15 Min. · *Float*, G. Oriani, 8 mm, Farbfilm, 20 Min. · *Arte povera/Azioni povere* Emidio-Greco-Film · *Vernissage-Film*, Aldo Conti · *telegiornale*, in Zusammenarbeit mit/in collaboration with H. Martin, s/w, Tonfilm **1970** *Circumnavigazione*, in Zusammenarbeit mit/in collaboration with T. Trini, s/w, Stummfilm **1976** *Chi sei tu?*, M. Pistoletto, s/w, Tonfilm, 30' · *Le Stanze*, Gualtiero Bonisegni, Venzia, s/w, Video · *Arte ambiente*, Gualtiero Boninsegni, Biennale von Venedig, s/w, Video **1978** A. Zanoli, M. Pistoletto, Tonfilm in Farbe, RAI · *Division e moltiplicazione dello specchio. L'arte assume la religione*, Gualtiero Boninsegni, Beffe Risso, s/w, Video mit Ton **1979** *Opera Ah*, Bagnasco, Tonfilm in Farbe, RAI · *Opera Ah*, Gilberto Grasso, s/w, Video mit Ton · *I Trombonauti*, Gilberto Grasso, s/w, Video mit Ton **1983** A. Mulas, M. Pistoletto, Tonfilm in Farbe, RAI **1985** *Le génie du temps*, CNAC, Toulouse, Farbvideo mit Ton **1986** *Le temps du miroir*, Schwerfel, Farbvideo mit Ton · *Mostra alla Galleria Locus Solus*, Bagnasco, Tonfilm in Farbe, RAI **1988** *I have a mirror, you have a mirror*, filmische Werkübersicht, G. Barberi, M.M. Di Castri, M.P., Farbvideo mit Ton, 30 Min. **1989** *Michelangelo Pistoletto Anno Bianco*, Barberi-Dicastri, Farbvideo mit Ton **1990** *M. Pistoletto l'Uomo Nero*, Barberi-Dicastri, Farbvideo mit Ton **1991**, *M. Pistoletto dall'Anno Uni ad oggi*, Barberi-Dicastri, Farbvideo mit Ton

HERMAN PITZ

*Oldenburg (D), 1956
Lebt/Lives in Düsseldorf

Einzelausstellungen | One-man exhibitions

1979 *Lützowstrasse Situatione 2*, Berlin · K19, Oberhausen **1981** Museum für (Sub-)Kultur, Berlin **1982** Kabinett für aktuelle Kunst, Bremerhaven · Galerie Wittenbrink, Regensburg · *Potzblitzpitzputzt*, Atelier Kummer, Berlin-Admiralstraße **1983** Moltkerei, Köln · Galerie Giannozzo, Berlin **1984** Galerie Wittenbrink, Regensburg **1985** Galerie Fahnemann, Berlin (Kat.: H. P.) · *Marginalia delle Forme d'Arte*, Torino · Galerie Wittenbrink, München · Galerie Fahnemann Art Cologne, Köln (Kat.: H. P., W. Siano) **1986** Kunstforum Lenbachhaus, München · Galerie Albert Baronian, Bruxelles · Wohnung M. Schwarz, Braunschweig **1987** Stichting De Appel, Amsterdam · Christine Burgin Gallery, New York **1988** De Vleeshal, Middelburg (Kat.) · Produzentengalerie, Hamburg (Kat.: H. P.) · Galerie Fricke, Düsseldorf · Galerie Fahnemann (Art Cologne), Köln · Galerie Wittenbrink, München **1990** Galerie Fahnemann, Berlin · Produzentengalerie, Hamburg (Frac Poitiers Charentes, Hôtel Saint-Simon, Angoulème) (Kat.: P. Javault) · Galerie Albert Baronian, Bruxelles **1991** *Panorama Hermann Pitz MCMXCI*, Witte de With, Rotterdam (Westfälischer Kunstverein, Münster; Kunstverein Braunschweig) (Kat.: H. P.) **1992** *Panorama Hermann Pitz MCMXCI (I)*, Castello di Rivara, Rivara (Kat.: H. P.)

Gruppenausstellungen | Group exhibitions

1987 *Berlin Art,* Museum of Modern Art, New York · *documenta 8*, Kassel · *Drawings and Photographs*, Galerie Baskerville & Watson, New York · *Skulptur Projekte Münster*, Westfälisches Landesmuseum, Münster · *Zehn: Zehn*, Joseph-Haubrich-Kunsthalle Köln/Neuer Berliner Kunstverein, Berlin · *Stations*, Centre International d'Art Contemporain, Montréal **1988** *Aperto*, Biennale di Venezia, Venezia · *Galerie Baronian in Internationaal Cultureel Centrum*, Antwerpen · *Palestra*, Castello di Rivara, Rivara (Torino) · *Junge Deutsche Kunst*, Warszawa **1989** *Junge Deutsche Kunst*, Belgrado/Zagreb · *Theatregarden-Bestiarium*, P.S. 1 – Museum for Contemporary Art, New York · *Teatrojardin Be-*

stiarium, Casino de la Exposición, Sevilla · *Bestiarium Jardin Théatre*, Entrepôt-Galerie du Confort Moderne, Poitiers · *Fac Simile*, Stichting De Zaak, Groningen · *Per gli anni noventa*, PAC Milano/Istanbul · *Photographie als Kunst als Photographie*, Berlinische Galerie, Berlin · *Ressource Kunst*, Akademie der Künste, Berlin/Städtische Galerie, Saarbrücken · *Künstlerischer Wettbewerb zur Gestaltung eines Mahnmals für die Opfer des Nationalsozialismus*, Mahn- und Gedenkstätte Düsseldorf · **1990** *Dorothea von Stetten-Kunstpreis 1990*, Kunstmuseum, Bonn · *Aus der Hauptstadt, dezentral + optimiert*, Bonner Kunstverein, Bonn · *Berlin im März*, Kunstverein, Braunschweig · *The Readymade Boomerang*, Biennale of Sydney, Art Gallery of New South Wales, Sydney · *Mirrored Images*, The Lobby Gallery, New York · Zomermanifestatie De Kunstlijn, Dalen · *Het Cicuit*, Moltkerei Köln **1991** *Eine Rose ist eine Rose ist eine Rose*, Städtische Galerie, Göppingen · *Berlin!*, Municipal Gallery of Modern Art, Dublin · *Zeitrutsch – Forschungsprojekt Magnetschnellbahn*, Bonner Kunstverein, Bonn · *Gestaltete Räume*, Westfälischer Kunstverein, Münster/Museum Bochum · *Ars Viva 91/92*, Westfälischer Kunstverein, Münster (et al.) · *Opus 13, Düsseldorf '91*, Museum für Moderne Kunst, Bozen · *Opus 13 Düsseldorf '9*, Museo d'Arte Moderna, Bolzano **1992** *De Campagne*, Stroom hcbk, Den Haag · *Sammlung Block*, Statens Museum, København

Bibliographie | Bibliography

Texte und Bücher vom Künstler
Texts and books by the artist
Sieben Menschen mit individuellen Traditionen..., in: Kat. Räume, Kummer, R, J. Kotik, H. Pitz, Berlin, 1978 · R. Kummer, H. Pitz, *Lützowstrasse Situation*, in: Control Magazine (London), Nr. 12, 1979 · *Worum es geht – Der Stand der Ermittlungen*, in: Kat. Auch ein Weg von tausend Meilen beginnt mit einem Schritt, Kunstverein Hamburg, 1980 · *Büro Berlin*, in: Kat. Art Allemagne Aujourd'hui, Musée d'Art Moderne de la Ville de Paris, 1980 · *Der passop-'sche Schriftsatz*, Berlin, Ed. Pitz Passop, 1981 · *Im Orte Campaccio...*, Poster , Bremerhaven, Ed. Kabinett für aktuelle Kunst, 1982 · *bicicletta*, Dokumentation, Berlin, Ed. H. Pitz, 1983 · *Der Schritt nach vorn: Arbeit mit dem TGV als Pilotprojekkt*, in: Kat. Egal, Hauptsache gut!, Ed. Deutsch-Französisches Jugendwerk Bad Honnef... · H. P. , F. Kleinefenn, R. Kummer, *TGV-Projekt*, in: De Appel Bulletin, Nr. 1, Amsterdam, 1983 · H. P., F. Kleinefenn, R. Kummer, *TGV – un projet pilote*, in: Artistes (Paris), Nr. 14, 1983 · H. P., J. C. Ruggirello, *Projet Villa Angèle 800 000 F*, Berlin-Marseille · H. P., F. Kleinefenn, R. Kummer, *Oh la la l'autocriticisme*, in: Doc(k)s (Paris), Nr. 54, 1983 · *Der großrahmige Kummer...*, in: Kat. 7 Positionen, Haus am Waldsee, Berlin, 1984 · *Zu Stephan Huber*, in: Kat. Stephan Huber, Bonner Kunstverein, Bonn, 1984 · *Zum ersten Mal in Holland...*, in: De Fabriek Bulletin, Eindhoven, 1985 · *›Nein, nein‹ sagte Fritz...*, in: Kat. Arbeitsstipendium 1985, Kunstamt Wedding, Berlin, 1986 · H. P., R. Kummer, F. Rahmann, *Büro Berlin – Ein Produktionsbegriff*, Berlin, Dokumentation Ed. Künstlerhaus Bethanien, Berlin, 1986 · *Schäfer rief an und teilte mit...*, in: Kat. Kleinplastik, M. Schnecken-

burger/ 3. Triennale Fellbach · *Magistrale Böller,* in: Dokumentation Das Engadinprojekt, Ed. S. Huber/Künstlerhaus Bethanien, Berlin, 1987 · *Hermann Pitz 4–3 t/m 27–4 1988,* Poster, Middelburg, De Vleeshal, bureau cultuur, Midelburg, 1988 · *Über mein Arbeit – Bemerkungen in sieben Überschriften,* in: De Rijksakademie Bulletin (Amsterdam), Nr. 6, 1988 · *Pitzfiles,* in: Artscribe, Nr. 76, 1989 · *Strictly speaking, it is an investigation...,* in: Kat. The Readymade Boomerang, The 8th Biennale of Sydney, 1990 · *8. Mai 1842,* in: Kat. Zeitrausch – Forschungsprojekte Magnetschnellbahn, Bonner Kunstverein, Bonn, 1991 · *Vorschlag Faradayischer Käfig,* in: Kat. Gestaltete Räume, Westfälischer Kunstverein Münster, 1991 · *The Manual of Sculpture,* Den Haag, Stroom hcbk, 1992 · *Panorama Hermann Pitz MCMXCI (I),* Castello di Rivara (Torino), 1992 (italienisch-englische Ausgabe)

Periodika | Periodicals
M. A. **Brayer,** *Hermann Pitz Expositions Angoulême, Bruxelles, Rotterdam,* in: Artfecatum, Nr. 39, 1991 · M. **Bruinsma,** *Die Praxis als Fiktion,* in: Metropolis M, Nr. 1, 1987 · Dan **Cameron,** *The Critics Way,* in: Artforum, August, 1987 · Wolfgang Max **Faust,** *Büro Berlin – Ein Produktionsbegriff,* in: Wolkenkratzer, Art Journal, Nr. 2, 1987 · M. **Focchessati,** *Hermann Pitz. Gal. Paludetto,* in: Tema Celeste, Nr. 26, 1990 · Angelika **Kindermann,** *Verkehrte Welt: Das Kleine wird groß,* in: Art, Nr. 10, Oktober, 1991 · J. **Raap,** *Hermann Pitz. Galerie Frikke,* in: Kunstforum, Bd. 98, 1988 · D. **Ruby,** *Hermann Pitz Galerie Christine Burgin,* in: Arts, Dezember, 1987 · D. **Ruyters,** *Hermann Pitz Panorama MCMXCI,* in: Metropolis M, Nr. 4, 1991 · Stephan **Schmidt-Wulffen,** *documenta 8: Kunst auf dem Prüfstand,* in: Kunstforum, Bd. 90, 1987 · M. **Tarantino,** *Hermann Pitz. Galerie Baronian,* in: Artforum, Dezember, 1990 · Thomas **Wulffen,** *Realkunst,* in: Kunstforum, Bd. 91, 1987

STEPHEN PRINA

*Galesburg (USA), 1954
Lebt/Lives in Los Angeles

Einzelausstellungen | One-man exhibitions

1976 *A Planar Delination,* Northern Illinois University, Gallery 214, Visual Arts Building **1978** *Duet for Metronome and Frequency Analyze, 1978,* Carl Sandburg College · *Related Projects,* Galesburg Civic Art Center, Galesburg **1979** *The Development of a Planar Standard,* California Institute of the Arts, Mezzanine Gallery **1980** Luhring, Augustine & Hodes Gallery, New York · University Art Museum, University of California at Santa Barbara **1989** Galerie Crousel-Robelin, Paris · *Monochrome Painting,* The Renaissance Society, Chicago (Los Angeles Municipal Art Gallery; P.S. 1, New York) (Kat.: S. P.) · Luhring Augustine Hetzler, Los Angeles · Karsten Schubert Ltd., London **1990** Galerie Gisela Capitain, Köln · Luhring Augustine Gallery, New York · Robbin Lockett Gallery, Chicago **1991** Galerie Peter Pakesch, Wien · Galerie Max Hetzler, Köln · Fricke, Düsseldorf **1992** Luhring Augustine Hetzler Gallery, Los Angeles · Museum Boymans-van Beuningen, Rotterdam (Kat.: W. Crouwel, E. de Groot, W.Lippert, S.P., M. Prinzhorn, L.Tillman)

Gruppenausstellungen | Group exhibitions

1987 *Projections in Public: A Strirefront Window Projection,* Bloomsbury City Flower Mart, Los Angeles · *2nd Annual Night of Erotica,* Beyond Baroque Literary Arts Center, Venice · *Tenth Anniversary Benefit Auction 1987,* The New Museum of Contemporary Art, New York · *Cal Arts: Skeptical Belief(s),* The Renaissance Society, Chicago (Newport Harbor Art Museum, Newport Beach) · *Nothing Sacred,* Margo Leavin Gallery, Los Angeles · *Tim Ebner, John L. Graham, Stephen Prina, Christopher Williams,* Kuhlenschmidt/Simon Gallery, Los Angeles · *LA: Hot and Cool: The Eighties,* MIT, List Visual Arts Center, Cambridge **1988** *Material Ethics,* Milford Gallery, New York · *Extended Paly,* Emily Harvey Gallery, New York · *MOCArtAuction '88,* Jan Turner Gallery, Tamara Bane Gallery and The Temporary Contemporary, Los Angeles · *James Casebere, Stephen Prina, Christopher Wool,* Robbin Lockett Gallery, Chicago · *Striking Distance,* Museum of Contemporary Art/The Temporary Contemporary, Los Angeles · *An Evening of 19th & 20th Century Piano Music,* Ahmanson Auditorium, Museum of Contemporary Art · *The BiNational: American Art of the late 80's,* Institute of Contemporary Art, Museum of Fine Art, Boston (et al.) · Galerie Crousel-Robelin, Paris · Luhring Augustine & Hodes Gallery, New York **1989** *300 Years of Still-Life Painting,* Michael Kohn Gallery, Los Angeles · *Mediated Knot,* Robbin Lockett Gallery, Chicago · *A Brave New World,* Karsten Schubert, London · *Prospect 89,* Schirn Kunsthalle, Kunstverein, Frankfurt/M. · *Group Showw,* Luhring Augustine Gallery, New York · *Thomas Bernhard Memorial Reading,* Beyond Baroque Literary Arts Center, Venice · *A Forest of Signs: Art in the Crisis of Representation,* MOCA, Los Angeles · *Group Show,* Schmidt/Markow Gallery 1709, St. Louis · *Oppningsutstallning,* Galleri Nordanstad-Skarstedt, Stockholm · *Media Influences,* The Forum, St. Louis · *Recent Acquisitions at MOMA,* Museum of Modern Art, New York · *Constructing a History: A Focus on MOCA's Permanent Collection,* Museum of Contemporary Art, Los Angeles · *Une Autre Affaire,* Salle de Flore, Dijon **1990** *Prints and Multiples,* Luhring Augustine Hetzler, Santa Monica · Galerie Ursula Schurr, Stuttgart · *The Readymade Boomerang,* Biennale of Sydney, Art Gallery of New South Wales, Sydney · *Aperto,* Biennale di Venezia, Venezia · *Drawings,* Luhring Augustine Hetzler, Santa Monica · *Prints and Related Works,* Tomoko Liguori Gallery, New York · *The Children's Aids Project: A Benefit Exhibition,* Daniel Weinberg Gallery, Santa Monica · *In the Beginning,* Cleveland Center for Contemporary Art, Cleveland · *Feux Pales,* Musée d'Art Contemporain, Bordeaux **1991** *Vanitas,* Galerie Crousel-Robelin, Paris (et al.) · *Gullivers Reisen,* Galerie Sophia Ungers, Köln · *Gordon Lebredt/Stephen Prina: Comedies of Objecthood,* The Power Plant, Toronto · *Rodney Graham, Stephen Prina, Christopher Williams,* S.L. Simpson Gallery, Toronto · Carnegie International, Carnegie Museum of Art, Pittsburgh **1992** *Knowledge: Aspects of Conceptual Art,* University Art Museum, Santa Barbara · Museum of Modern Art, New York

Bibliographie | Bibliography

Texte und Bücher vom Künstler
Texts and books by the artist
Los Angeles Times, January 3–7, 1984, in: Whitewalls, Nr. 10/11, Frühjahr/Sommer 1984 · Stephen Prina, Christopher Williams, *A Conversation with Sheila McLaughlin and Lynne Tillman,* in: Journal, Los Angeles Institute of Contemporary Art, Nr. 4, Frühling, 1985 · *The Twenty-Six Inch Experience,* in: TV Guides, New York, Barbara Kruger, Ed. The Kukolian Press, 1985 · Stephen Prina, Christopher Williams, *New Observations,* in: Marginalia, Nr. 1, November, 1986 · Stephen Prina, Christopher Williams, *New Observations,* in: Journal, Los Angeles Institute of Contemporary Art, Nr. 46, Winter, 1987 · Stephen Prina, Christopher Williams, *The Constructions and Maintenance of Our Enemies,* New York, Eds. New Observations, 1987 · *Twelve Artists on the Year's Books,* in: Artforum, Dezember, 1989

Periodika | Periodicals
Maja **Damjanov,** *Stephn Prina,* in: Tema Celeste, Juli/Oktober, 1990 · Robert **Dean,** *Stephen Prina: Museum of Contemporary Art,* in: Artforum, September, 1988 · Joshua **Decter,** *Stephen Prina,* in: Flash Art, Oktober, 1988 · Joshua **Decter,** *History as Image,* in: Flash Art, November/Dezember, 1991 · Helmut **Draxler,** *Articulatory Practice (The Message as Medium),* in: Parkett, Nr. 29, 1991 · Hunter **Drohojowska,** *Stop Making Sense,* in: Artnews, Oktober, 1989 · Fred **Fehlau,** *Tim Ebner, John L. Grahm, Stephen Prina, Christopher Williams,* in: Flash Art, November/Dezember, 1987 · Christopher **French,** *La-La Land Goes Legitimate,* in: Journal of Art, April, 1989 · Colin **Gardner,** *Stephen Prina and Christopher Williams,* in: Artforum, Dezember, 1987 · Susan **Hapgood,** *Stephen Prina at Luhring Augustine,* in: Art in America, Oktober, 1989 · Daniel **Herwitz,** *A Forest of Signs,* in: Modern Painters, Juni, 1989 · Susan **Kandel,** *L.A. in Review,* in: Arts, November, 1989 · Christopher **Knight,** *Obscurs Objets du Désir: Une Forêt de Signes,* in: Art Press, 1989 · Gary **Kornblau,** *Stephen Prina,* in: Art Issues, Nr. 2, Februar, 1988 ·

Catharin **Lumby,** *Sydney Biennial, Art Gallery of new South Wales, Sydney,* in: Flash Art, Sommer, 1990 · Friedemann **Malsch,** *Stephen Prina,* in: Kunstforum, Oktober, 1990 · Bernardo **Mercuri,** Peter **Weiermair,** *Prospect 89,* in: Tema Celeste, Juli/September, 1989 · David **Pagel,** *Stephen Prina: Municipal Art Gallery and Luhring Augustine Hetzler,* in: Artscribe, Januar/Februar, 1989 · David **Pagel,** *The Politics of Negativity,* in: Art Issues, Sommer 1991 · Laurie **Palmer,** *Stephen Prina: The Renaissance Society,* in: Artforum, September, 1989 · Robert **Raczka,** *MOCA Sights Local Art in 'Striking Distance',* in: New Art Examiner, Juni, 1988 · David **Rimanelli,** *Stephen Prina at Luhring Augustine,* in: Artforum, Sommer, 1990 · Jerry **Saltz,** *Carnegie International,* in: Galeries Magazine, Dezember 1991/Januar 1992 · Marc **Selwyn,** *New Art L.A.,* in: Flash Art, Sommer, 1988 · Richard **Smith,** *MOCA Navigates 'A Forest of Signs,* in: New Art Examiner, Sommer, 1989 · Nancy **Stapen,** *Review of Bi-National, MFA & ICA, Boston,* in: Art News, Dezember, 1988 · Barbara **Steffen,** *Los Angeles: Something New in the West,* in: Artscribe, November/Dezember, 1989 · Joseph **Woodward,** *Playing with Information,* in: Artweek, 26. November, 1988

RICHARD PRINCE

*Panama Canal Zone, 1949
Lebt/Lives in New York

Einzelausstellungen | One-man exhibitions

1980 Artist Space, New York (Kat.: R.P.) · CEPA Gallery, Buffalo, New York (Kat.: R.P.) **1981** Metro Pictures, New York · Richard Kuhlenschmidt Gallery, Los Angeles **1982** Metro Pictures, New York **1983** Le Nouveau Musée, Lyon (Kat.: K. Linker) · Institute of Contemporary Art, London · Richard Kuhlenschmidt Gallery, Los Angeles · Baskerville + Watson, New York **1984** Riverside Studios, London · Feature Gallery, Chicago · Baskerville + Watson, New York **1985** International with Monument, New York · Richard Kuhlenschmidt Gallery, Los Angeles

1986 International with Monument, New York · Feature Gallery, Chicago **1987** Galerie Isabella Kacprzak, Stuttgart · Daniel Weinberg Gallery, Los Angeles **1988** *Tell Me Everything,* Spectator Lightboard, One Times Square, New York · Barbara Gladstone Gallery, New York · Le Casa d'Arte, Milano · Le Magasin, Grenoble (Kat.) · Galerie Ghislaine Hussenot, Paris · Galerie Rafael Jablonka, Köln (Kat.: P. de Jonge) **1989** Daniel Weinberg Gallery, Los Angeles · Barn Gallery, Ogunquit, Maine · IVAM Centre del Carme, Valencia (Kat.) · Barbara Gladstone Gallery, New York · *Paintings,* Jay Gorney Modern Art/Barbara Gladstone Gallery, New York **1990** *Richard Prince, Jokes Gangs Hoods,* Jablonka Galerie/Galerie Gisela Capitain, Köln (Kat.: R.P.) · Galerij Micheline Szwajcer, Antwerpen · Arthur Roger Gallery, New Orleans **1991** Barbara Gladstone Gallery, New York · Galleri Nordanstad – Skarstedt, Stockholm · Galerie Ghislaine Hussenot, Paris · Stuart Regen Gallery, Los Angeles

Gruppenausstellungen | Group exhibitions

1987 *The Viewer as Voyeur,* Whitney Museum of American Art at Philip Morris, New York · *Preverted by Language,* Hillwood Art Gallery, C.W. Post Campus/Long Island University · *Der Reine Alltag,* Galerie Christoph Dürr, München · *Prints,* Harm Boukkaert Gallery, New York · *True Pictures,* John Good Gallery, New York · *1987 Biennial Exhibition,* Whitney Museum of American Art, New York · *Photography and Art: Interactions Since 1946,* Los Angeles County Museum of Art, Los Angeles · *Romance,* Knight Gallery/Spirit Square Arts Center, Charlotte · *Fotografien,* Galerie Nächst St. Stephan, Wien · Le Casa d'Arte, Milano · *Recent Tendencies in Black and White,* Sidney Janis Gallery, New York **1988** *Photographic Truth,* The Bruce Museum Museum, Greenwich · *Sexual Difference: Both Sides of the Camera,* Wallach Art Gallery, Columbia University, New York · *Photography on the Edge,* The Haggerty Museum of Art, Marquette University, Milwaukee, Wisconsin · *A Drawing Show,* Cable Gallery, New York · *Nostalgia as Resistance,* Clocktower, New York · *Hover Culture,* Metro Pictures · *Allan McCollum – Richard Prince,* Kunsthalle, Zürich · *Life-like,* Lorence Monk Gallery, New York · *Reprises de Vus,* Halle Sud, Genève · *The Object of the Exhibition,* Centre National des Arts Plastiques, Paris · Galerie Point, Hamburg · *Modes of Address: Language in Art Since 1960,* Whitney Museum of American Art, Downtown at Federal Reserve Plaza, New York · *Gangs of Surrogate Entertainers: Prince – McCollum – Robbins,* PPS. Galerie F.C. Gundlach, Hamburg · *The BiNationale: American Art of the late 80s,* Institute of Contemporary Art, Museum of Fine Art, Boston (et al.) · *New Works by Ashley Bickerton, Robert Gober, Peter Halley, Jeff Koons, Richard Prince, Meyer Vaisman, Christopher Wool,* Daniel Weinberg Gallery, Los Angeles · Galleri Contur, Stockholm · *Das Licht von der anderen Seite,* PPS. Galerie F. C. Gundlach, Hamburg **1989** *Wittgenstein,* Palais des Beaux-Arts, Bruxelles · *Image World – Art and Media Culture,* Whitney Museum of American Art, New York · *Bilderstreit,* Museum Ludwig, Köln · *Prospect 89,* Frankfurter Kunstverein, Frankfurt/M. · *Arrangement 1,* Mai 36

Galerie, Luzern · *Horn of Plenty,* Stedelijk Museum, Amsterdam · *Conspicuous Display,* Stedman Art Gallery, Camden · *Scripta Manent Verba Volant,* Monika Sprüth Galerie, Köln · *Photography Now,* Victoria & Albert Museum, London · *Through a Glass, Darkly,* University Galleries, Illinois State University, Normal · *Inside World,* Kent Gallery, New York · *Nocturnal Visions in Contemporary Painting,* Whitney Museum of American Art, Equitable Center, New York · *The Photography of Invention: American Pictures of the 1980s,* National Museum of American Art, Washington, DC · *Surburban Home Life: Tracking the American Dream,* Whitney Museum of American Art, Downtown at Federal Reserve Plaza, New York · *A Forest of Signs: Art in the Crisis of Representation,* Museum of Contemporary Art, Los Angeles · *Moskau – Wien – New York,* Festial of Vienna, Wien · *Prospect Photographie,* Frankfurter Kunstverein, Frankfurt/M. · *Une autre Affaire,* Festival Nouvelles Scenes '89, Dijon · *Dream Reality,* The School of Visual Arts Gallery, New York · *In Other Words: Wort und Schrift in Bildern der Konzeptuellen Kunst,* Museum am Ostwall, Dortmund · *D&S Ausstellung,* Kunstverein, Hamburg · *Contemporary Art from New York – The Collection of the Chase Manhattan Bank,* Yokohama Museum of Art, Yokohama · *New Acquisitions, New Work, New Directions,* International Museum of Photography at George Eastman House, Rochester, New York · *Re-presenting the 80's,* Simon Watson Gallery, New York **1990** *Life-Size,* The Israel Museum, Jerusalem · *Word as Image: American Art 1960–1990,* Milwaukee Museum of Art, Milwaukee (et al.) · *Images in Transition: Photographic Representation in the Eighties,* National Museum of Modern Art, Kyoto · *The Last Decade: American Artists of the 1980's,* Tony Shafrazi Gallery, New York · *The Charade of Mastery,* Whitney Museum of American Art Downtown at Federal Reserve Plaza · *Art et Publicité 1890–1990,* Centre Georges Pompidou, Paris · *Paintball,* 303 Gallery, New York/Stuart Regen Gallery, Los Angeles · *The Decade Show: Frameworks of Identity in the 80',* The New Museum, New York · *The Age of Information,* Andrea Ruggieri Gallery, Washington · *Disconnections,* Galleri Nordanstad-Skarstedt, Stockholm · *The Indomitable Spirit: Photographers and Friends United Against, Aids,* International Center of Photography Midtown, New York **1991** *Metropolis,* Martin-Gropius-Bau, Berlin · *Night Lines,* Centraal Museum, Utrecht · *The Words and the Images,* Centraal Museum, Utrecht · *Power: Its Myths, Icons, and Structures in American Art, 1961–1991,* Indianapolis Museum of Art, Indianapolis · *Words & Images,* Museum of Contemporary Art, Wright State University, Dayton · *Oeuvres Originales,* Fonds Régional d'Art Contemporain des Pays de la Loire, Clisson · *20th Century Collage,* Margo Leavin Gallery, Los Angeles · *Rope,* Fernando Alcolea Gallery, Barcelona · *To Wit,* Rosa Esman Gallery, New York · *Portraits on Paper,* Robert Miller, Gallery, New York · Pat Hearn Gallery, New York · Stuart Regen Gallery, Los Angeles · Luhring Augustine Hetzler, Santa Monica **1992** *Circa 1980,* Barbara Gladstone Gallery, New York · *Guy Mees, Harald Klingelhöller, Richard Prince, Robert Therrien,* Galerie Micheline Szwajcer, Antwerpen

Bibliographie | Bibliography

Texte und Bücher vom Künstler
Texts and books by the artist
Eleven Conversations, in: Tracks Magazine, Herbst, 1976 · *From None,* in: The Paris Review, Herbst, 1978 · *Author's Note,* in: Whie Walls, Nr. 2, Winter/Frühjahr, 1979 · *Primary Transfer,* in: Real Life Magazine, März, 1980 · *Moving by Wading More Than Swimming,* in: White Walls, Nr. 4, Juli, 1980 · *Why I Go to The Movies Aone,* New York, Tanam Press, 1980 · *Pissing on Ice,* in: Real Life Magazine, Oktober, 1981 · *The Thomas Crown Affair,* in: Wedge, Nr. 2, Herbst, 1983 · *The Velver Well,* in: Effects, Nr. 1, Sommer, 1983 · *Overdetermination,* in: Effects, Nr. 2, Herbst/Winter · *The Erotic Politicians,* in: Just Another Asshole, Nr. 6, 1983 · *Da Perche Vado al Cinema da Solo,* in: Postmoderno e Letteratura, Bompiani, 1984 · *The Bela Lugosi Law,* in: Wild History, New York, Tanam Press, 1984 · *Anyone Who is Anyone,* in: Parkett, Nr. 6, 1985 · *Citizen Sundown,* in: TV Guides, 1985 · *The Perfect Joke,* in: Kat.: Wien Fluss, Wien, Wiener Festwochen, 1986 · *The Velvet Beach,* in: Kat.: The 6th Biennale of Sydney, Sydney, 1986 · *Jokes,* in: Top Stories (New York), Nr. 23/24, 1986 · *The Perfect Tense,* in: Blasted Allegories, New York, Brian Wallis, ed., Museum of Contemporary Art, 1987 · *Bringing It All Back Home,* in: Art in America, Bd. 76, September, 1988 · *Two Husbands and a Wife,* in: Real Life Magazine, Nr. 20, 1990

Periodika | Periodicals
Guy **Aletti,** *Art,* in: Village Voice, 13. März, 1988 · Dan **Cameron,** *Art and Its Double: A New York Perspective,* in: Flash Art, Nr. 134, Mai, 1987 · Dan **Cameron,** *The Season That Almost Wasn't,* in: Arts Magzine, Nr. 62, September, 1987 · Daniel **Canogar,** *Richard Prince,* in: Lapiz, Bd. 6, 1988 · Giulio **Ciavoliello,** *Richard Prince,* in: Flash Art, Nr. 146, Oktober/November, 1988 · Joshua **Decter,** *New York in Review,* in: Arts Magazine, Bd. 64, Oktober, 1988 · Maria Luisa **Frisa,** *Americana: Richard Prince,* in: Dolce Vita Magazine, Nr. 15/16, Dezember 1988/Januar 1989 · Gabriella **Gabrielli,** *Richard Prince,* in: Juliet Art Magazine, Nr. 38, Oktober/November, 1988 · Isabelle **Graw,** *Wiederaufbereitung,* in: Wolkenkratzer Art Journal, Nr. 2, März/April, 1988 · Marvin **Heiferman,** *Richard Prince: when jokes become second nature,* in: Bomb, Nr. 24, Sommer, 1988 · Kay **Heymer,** *Richard Prince: Jablonka Galerie,* in: Tema Celeste, Nr. 19, Januar/März, 1989 · Gregorio **Magnani,** *Richard Prince and Hans-Peter Feldmann,* in: Flash Art, Nr. 144, Januar/Februar, 1989 · John **Miller,** *Whitney Biennial,* in: Artscribe International, Nr. 64, Sommer, 1987 · John **Miller,** *Richard Prince: Barbara Gladstone Gallery,* in: Artscribe International, Nr. 71, September/Oktober, 1988 · Robert C. **Morgan,** *Paris,* in: Arts Magazine, Nr. 65, Januar, 1989 · Stuart **Morgan,** *Tell MeEverythingg: Richard Prince Interviewed by Stuart Morgan,* in: Artscribe International, Nr. 73, Januar/Februar, 1989 · Patricia C. **Phillips,** *Richard Prince-Times Square,* in: Artforum, Bd. 26, April, 1988 · Peter **Plagens,** *International Shows: Under Western Eyes,* in: Art in America, Bd. 77, Januar, 1989 · Jeffrey **Rian,** *Richard Prince,* Bijutsu Techo, Bd. 41, Januar, 1989 · Jerry **Saltz,** *Notes on a drawing,* in: Arts Magazine, Nr. 5, Januar, 1990 · Daniela **Salvioni,** *Richard Prince: Jokes Epitomize the Social Unconscious,* in: Flash Art, Nr. 141, Sommer, 1988 · Daniela **Salvioni,** *Richard Prince,* in: Flash Art, Nr. 142, Oktober, 1988 · Christoph **Schenker,** *Allan McCollum/Richard Prince: Kunsthalle Zürich,* in: Noemea, Nr. 20, September/Oktober, 1988 · Jude **Schwendenwien,** *Richard Prince,* in: New Art Examiner, September, 1988 · Jude **Schwendenwien,** *Thomas Ruff, Richard Prince, Robert Mapplethorpe, Jeff Wall,* in: Artscribe, Nr. 72, · Wim van **Sinderew,** *Richard Prince,* in: Metropolis M, Nr. 1, Februar/März, 1989 · Paul **Taylor,** *Richard Prince: Interview,* in: Flash Art, Nr. 142, Oktober, 1988

MARTIN PURYEAR

*Washington DC (USA), 1941
Lebt/Lives in New York State

Einzelausstellungen | One-man exhibitions

1968 Gröna Palletten Gallery, Stockholm **1972** Henri 2 Gallery, Washongton, DC · Carl van Vechten Gallery, Fisk University, Nashville (Brochure: F. F. Bond) **1973** Henri 2 Gallery, Washington, DC **1977** The Corcoran Gallery of Art, Washington, DC **1978** Protetch-McIntosh Gallery, Washington, DC **1979** Protetch-McIntosh Gallery, Washington, DC **1980** *Options 2,* Museum of Contemporary Art, Chicago (Brochure : J. R. Kirshner) · Young Hoffman Gallery, Chicago · *1–80 Series : M. P.,* Joslyn Art Museum, Omaha (Kat.: Holliday T. Day) **1981** Delahunty Gallery, Dallas **1982** McIntosh/Drysdale Gallery, Washington, DC · Young Hoffman Gallery, Chicago **1983** Donald Young Gallery, Chicago **1984** University Gallery, University of Massachusetts, Amherst/The Berkshire Museum, Pittsfield/Museum of the National Center of Afro-American Artists, Boston; La Jolla Museum of Contemporary Art, New York (Kat.: M. Davies, H. Posner) **1985** Margo Leavin Gallery, Los Angeles · *Matrix/Berkeley 86,* University Art Museum, Berkeley (Brochure : C. Lewallen) · Donald Young Gallery, Chicago **1987** *M. P.: Public and Personal,* Chicago Public Library Cultural Center, Chicago (Kat.: Deven K. Golden) · *Sculpture and Works on Paper,* Carnegie Mellon, Pittsburgh (Brochure: E. King) · Donald Young Gallery, Chicago · *Stereotypes and Decoys,* David McKee, Gallery, New York **1988** *New Wall Sculpture,* McIntosh/Drysdale Gallery, Washington, DC · The Brooklyn Museum, Brooklyn **1989** Margo Leavin Gallery, Los Angeles **1990** *Connections : M. P.,* Museum of Fine Arts, Boston

Gruppenausstellungen | Group exhibitions

1987 *Structure to Resemblance: Work by Eight American Sculptors,* Albright -Knox Art Gallery, Buffalo · *Emerging Artists 1978–1986: Selections from the Exxon Series,* Solomon R. Guggenheim Museum, New York **1988** *Private Works for Public Spaces,* R.C. Erpf Gallery, New York · *Vital Signs: Organic Abstraction from the Permanent Collection,* Whitney Museum of American Art, New York · *1988: The World of Art Today,* The Milwaukee Art Museum, Milwaukee · *Sculpture Inside Outside,* Walker Art Center, Minneapolis · Museum of Fine Arts, Houston · *Skulptur: Material + Abstraktion: 2x5 Positionen,* Aargauer Kunsthaus, Aarau (et al.) · *New Sculpture/Six Artists,* The Saint Louis Art Museum, Saint Louis · *Edelson, Puryear, Scanga, Stackhouse,* The Corcoran Gallery of Art, Washington, DC · *Enclosing the Void: Eight Contemporary Sculptors,* Whitney Museum of American Art at Equitable Center, New York **1989** *Introspectives: Contemporary Art by Americans and Brazilians of African Descent,* The California Afro-American Museum, Los Angeles · *Traditions and Transformations: Contemporary Afro-American Sculpture,* The Bronx Museum of th Arts, Bronx · *Biennial Exhibition,* Whitney Museum of American Art, New York · *New Sculpture: Tony Cragg, Richard Deacon, Martin Puryear, Susana Solano,* Donald Young Gallery, Chicago **1990** *Objects of Potential: Five American Sculptors from the Anderson Collection,* College of Notre Dame, Wiegand Gallery, Belmont · *The Decade Show: frameworks of Identity in the 1980s,* The New Museum for Contemporary Art, New York (et al.) **1989** Biennal de São Paulo

Bibliographie | Bibliography

Periodika | Periodicals
Terry Y. **Allen,** *The Unconventional Eye,* in: Amherst Magazine, Sommer, 1990 · Holland **Cotter,** *A Bland Biennial,* in: Art in America, Nr. 9, September, 1989 · Frances **De Vuono,** *The Decade Show,* in: Artnews, Nr. 9, November, 1990 · V. **Dwight Gast,** *Martin Puryear: Sculpture as an Act of faith,* in: The Journal of Art, Nr. 1, September/Oktober, 1989 · David **Joselit,** *Lessons in Public,* in: Art in America, Nr. 12, Dezember, 1989 · Jason Edward **Kaufman,** *XXth São Paulo Bienal,* in: Art Papers, Nr. 1, Januar/Februar, 1990 · Paul **Krainak,** *Contraprimitivism and Martin Puryear,* in: Art Papers, Nr. 2, März/April, 1989 · Victoria **Lautman,** *Martin Puryear: Chicago Public Library Cultural Center,* in: Sculpture, Nr. 4, Juli/August, 1987 · Ann Lee **Morgan,** *Martin Puryear: Sculpture as Element Expression,* in: New Art Examiner, Nr. 9, Mai, 1987 · Robert C. **Morgan,** *American Sculpture and the Search for a Referent,* in: Arts, Nr. 3, November, 1987 · Nancy **Princenthal,** *Intuitions's Disciplinarian,* in: Art in America, Nr. 7, Januar, 1990 · David **Raymond,** *Museum of Fine Arts/Boston, Connections: Martin Puryear,* in: Art New England, Nr. 6, Juni, 1990 · Walter **Robinson,** Cathy **Lebowitz,** *Artworld: Puryear Chosen for São Paulo,* in: Art in America, Nr. 1, Januar, 1990 · Barry **Schwabsky,** *The Obscure Objects of Martin Puryear,* in: Arts, Nr. 3, November, 1987 · Sue **Taylor,** *Report from Minneapolis: Garden City,* in: Art in America, Nr. 12, Dezem-

ber, 1988 · Colin **Westerbeck**, *Chicago: Martin Puryear, Chicago Public Library Cultural Center*, in: Artforum, Nr. 25, Mai, 1987

ROYDEN RABINOWITCH

*Toronto (CDN), 1943
Lebt/Lives in Gent

Einzelausstellungen | One-man exhibitions

1966 20/20 Gallery, London (Canada) 1967–1978 Carmen Lamana Gallery, Toronto 1973 Forest City Gallery, London (Canada) 1978 John Weber Gallery, New York 1980 The Clocktower, New York 1981 John Weber Gallery, New York · David Bellman Gallery, Toronto 1982 David Bellman Gallery, Toronto · Galerie Gilles Gheerbrant, Montréal 1983 John Weber Gallery, New York · David Bellman Gallery, Toronto · Richard Demarco Gallery, Edinburgh · Graigcrook Castle, Edinburgh 1984 *Sculptures and Drawings in the Collection*, Museum van Hedendaagse Kunst, Gent (Kat.: J. Hoet) 1985 John Weber Gallery, New York · Galerie Gilles Gheerbrant, Montréal · *Skulpturen. Eine Auswahl 1963–1985*, Städtisches Museum Abteiberg, Mönchengladbach (Kat.: D. Bellman, J. Cladders, K. Fleming, K. Ruhrberg, D. Stemmler, R. R.) · Oliver Dowling Gallery, Dublin 1986 Orchard Gallery, Londonderry 1987 Oliver Dowling Gallery, Dublin · *Furkart*, Furkapasshöhe · Krzysztofory Gallery, Krakow (Kat.: J. Jedlinski) 1988 Galerie Media, Neuchatel · Foksal Gallery, Warszawa (Kat.: W. Borowski, J. Jedlinski) 1989 Peter Pakesch Gallery, Wien · Galerie Gilles Gheerbrant, Montréal 1990 Atelier del Sur, Canary Islands (Kat.: J. Hoet, R. R.) · Kunstmuseum, Bern (Kat.: R. H. Fuchs, J. Hoet, J. Jedlinski, R. Kurzmeyer, M. Landert, H.C. von Tavel) 1991 Wiener Secession, Wien (Kat.: A. Krischanitz) 1992 Gemeentemuseum, Den Haag (Kat.: R. H. Fuchs)

Gruppenausstellungen | Group exhibitions

1987 *Ringing in the New*, Fabian Carlsson Gallery, London · *Joseph Beuys & Royden Rabinowitch*, Muzeum Sztuki, Lodz (Muzeum Akademii Sztuk Pieknych, Warszawa) · *Idea of North*, 49th Parallel Gallery, New York 1988 *Zeitlos*, Hamburger Bahnhof in Berlin, Berlin · *Aspecten van Kunst*, Kortrijk 1989 *Just To look at*, Museum van Hedendaagse Kunst Gent; Stadsgalerij, Heerlen · *Einleuchten*, Deichtorhallen, Hamburg · *Open Mind*, Museum van Hedendaagse Kunst, Gent · *Poesis*, Kunstmuseum, Bern 1991 *60 Anniversary Exhibition of*

the Museum Sztuki, Lodz, Warszawa 1992 *Platzverführung*, Stuttgart · *International Drawing Triennala*, Wroclaw

Bibliographie | Bibliography

Periodika | Periodicals
David **Carrier**, *Of One Substance*, in: Arts Magazine, November 1991

ROBER RACINE

*Montréal (CDN), 1956
Lebt/Lives in Montréal

Einzelausstellungen | One-man exhibitions

1978 *Tetras I*, Galerie Laurent Tremblay; Véhicule Art, Montréal; Musée d'Art Contemporain, Montréal 1979 *Décomprendre le sourire d'une perle*, Musée d'Art Contemporain, Montréal 1981 *Le terrain du dictionnaire A/Z*, P.S. 1, Queens, New York 1982 *Dictionnaire A*, Musée des Beaux-Arts, Montréal; Galerie Sans Nom, Monction, Nouveau-Brunswick (Kat.: R. R) 1983 *Dictionnaire A*, The Fine Arts Galleries, The University of Wisconsin-Milwaukee · *Dictionnaire A*, 49' Parallèle, Centre d'Art Contemporain Canadien, New York · *Le terrain du dictionnaire A/Z*, Language Plus, Alma, Québec 1987 Galerie René Blouin, Montréal · *Dictionnaire A/Z*, Musée d'Art de Saint-Laurent, Montréal 1988 *Les Pages-Miroirs 1980–88, La musique des Pages-Miroirs*, Galerie René Blouin, Montréal · *La musique des Pages-Miroirs*, La Chambre Blanche, Québec 1989 Galerie Georges Verney-Carron, Lyon 1990 *Les Pages-Miroirs*, Chapelle historique du Bon Pasteur, Montréal

Gruppenausstellungen | Group exhibitions

1987 *Paysage*, Galerie Dazibao, Montréal (et al.) · *Histoire en quatre temps*, Musée d'Art Contemporain, Montréal · *From Sea to Shining Sea*, The Power Plant, Toronto · *Traces*, collection du Ministère des Affaires extérieures (Canada), Washington DC 1988 *L'art à Montréal: la ruse historique*, Power Plant, Toronto · *Trio pour Samuel Beckett*, Galerie l'Imagier, Aylmer, Québec 1989 *Trio pour Samuel Beckett*, Oboro, Montréal · *Les cités ›Proust‹ (1982)*, Art Gallery, McMaster University, Hamilton, Ontario 1990 *Aperto*, Biennale di Venezia, Venezia · *The Readymade Boomerang*, Biennale of Sydney, Art Gallery of New South Wales, Sydney 1991 *Un archipel de désirs. Les artistes du Québec et la scène internationale*, Musée du Québec, Québec

Performances · Aktionen · Konzerte
Performances · Actions · Concerts

1973–77 Ier, 2e et 3e livre pour piano, Écoles et Collèges dans Laval et Montréal, Québec 1978–79 *Performance ininterrompue de Vexations d'Erik Satie*, Véhicule Art, Montréal, Québec (14 Std. 8 Min.); Maison Moisan, Arthabaska, Québec (17 Std. 35 Min.); Music Gallery, Toronto, Ontario (19 Std.); The Western Front, Vancouver, C.-B. (17 Std.) 1978–80 *Echelle R.V. Williams*, Studio Z, Montréal, Québec; ›Art Montréal‹, télévision par cable, Montréal, Québec; Entrepôts lainés, Bordeaux 1979–80 *Marteaux*

muets, Symposium international de sculpture environnementale, Chicoutimi, Québec; 222 Warehouse, Harbourfront, Toronto; Entrepôts lainés, Bordeaux; Ateliers Continus, Montréal, Québec 1980 *Flaubert 1880–1980: lecture du roman Salammbô*, Musée des Beaux-Arts du Canada, Ottawa · *Dictionnaires: introduction*, Entrepôts lainés, Bordeaux; Galerie Motivation V, Montréal; Ecole des Arts Décoratifs, Paris 1982 *Ecrire dans le Scriptorium de ›Dictionnaire A'*, Musée des Beaux-Arts, Montréal 1982–83 *Entendre la Castiglione*, Musée des Beaux-Arts du Canada, Ottawa; Kanada Akademie der Künste, Berlin 1988 *Trois mouvements de Quatuors à Cordes de 1974. Musique d'une Page-Miroir chantée par Roger Bellemare*. Konzert. Galerie René Blouin, Montréal 1990 *La Musique des Pages-Miroirs*, (Version Quatuor à cordes), Chapelle historique du Bon Pasteur, Montréal 1991 *La musique du refus Global* (Version clarinette), Musée d'Art Contemporain, Montréal, dans le cadre de l'évènement *Autour du Refus Global en musique*

Bibliographie/Bibliography

Texte und Bücher vom Künstler
Texts and books by the artist
Festival de performances au Musée des Beaux-Arts de Montréal, in: Parachute, Nr. 13, Winter, 1978 · *Télé-performance. Toronto*, in: Parachute, Nr. 13, Winter, 1978 · *18 heures de Vexations: Erik Satie*, in: Virus Montréal, Nr. 3, November, 1978 · *Standish Lawder ou la répétition comme unicité variable*, in: Le Journal du jeune cinéma québécois, Nr. 2, Juli/August, 1978 · *Michael Snow ou la spirale du temps*, in: Le Journal du jeune cinéma québécois, Nr. 3, September, 1978 · *Moise et Aaron autrement que dodécaphonique*, in: Le journal du jeune cinéma québécois, Nr. 3, September, 1978 · *L'étoile du Nord ou le triptyque de la conscience*, in: Virus International, Juni, 1978 · *Montréal: performances d'octobre*, in: Parachute, Nr. 17, Winter, 1979 · *L'action/performance versus Montréal*, in: La Grande réplique – revue québécoise d'esthétique théâtrale, Nr. 7, Winter, 1979 · *Vexations*, in: Parachute, Nr. 15, Winter, 1979 · *Le dernier punctum de Roland Barthes*, in: Virus Montréal, Nr. 4, Juni, 1980 · *Le mysticisme onirique: Kopernicus, l'opéra de Claude Vivier*, in: Virus Montréal, Nr. 3, Mai, 1980 · *La leçon d'Irène Whittome*, in: Propos d'art, Nr. 1, Winter, 1980–1981 · *Le corps est un dictionnaire*, in: Intervention, Nr. 8/11, März, 1981 · *Le jet d'eau qui jase: un geste-miroir liquéfié*, in: Propos d'art, Nr. 2, Frühjahr, 1981 *Thirteen choreographers for two dancers*, in: Arts Canada, Nr. 5, April, 1981 · *Entendre la Castiglione*, Note festival OKANADA, Musée des Beaux-Arts du Canada, Kunstakade-

mie, Berlin, 1982 · *Entendre la Castiglione,* in: 10–5155-20 Art Contemporain, Nr. 3, Frühjahr, 1982 · *Marie chien noir de Marie Chouinard: l'étoilement de l'amour,* in: Arts Canada, Nr. 1, November, 1982 · *Ecouter la fabrication d'un savoir,* in: Almost six feet long de David Moore, Montréal, Véhicule Press, 1982 · *Ecouter la fabrication d'un savoir,* in: Trafics, Nr. 1, Winter, 1982 · *Le Terrain du dictionnaire A/Z,* in: Repère, art actuel au Québec Musée d'art contemporain de Montréal, 1982 · *L'Ordinatrice et le temps des lieux mobiles,* Salle Pollack, Université McGill, Juni, 1983 · *Les 28 Pages-Miroirs,* in: Kat. Künstler Aus Kanada, Räume und Installationen, Stuttgart, 1983 · *Irene Whittome: 1030 rue St. Alexandre/Galerie Yajima,* in: Vanguard, Nr. 1, Februar, 1983 · *J'aurais dit Glenn Gould,* in: Viva Virus, Nr. 8, Oktober, 1983 · *V.I.E.. (Voix. Image. Ecriture),* Parallélogramme, Nr. 2, Dezember, 1983 · *Bouguereau (Adolphe William),* Musée des Beaux-Arts de Montréal, Herbst, 1984 · *Dictionnaire et parc,* in: l'art Pense, Société d'esthétique du Québec, 1984 · *La biopictura,* in: Etudes Françaises (Canada), Nr. 3, 1985 · *Ecrire une installation ou installer l'écriture?,* in: Parachute, Nr. 39, 1985 · *Démonter ou démoter le dictionnaire?,* in: Kat. Québec-Montréal Art Contemporain, Elac, Lyon, 1985 · *La dernière installation (et) Rangé ou Ranndjeur, monsieur Ranger?,* Installation/Fiction, in: La Nouvelle Barre du Jour, Herbst, 1986 · *Créer à rebours vers le récit,* in: Parachute, Nr. 48, 1987 · *Table-Tableau-Toile: la demeure et l'exil,* in: Vanguard, Nr. 5, Herbst, 1987 · *Michel Denée – Graver sous le paysage,* in: Vie des Arts, Nr. 128, Herbst, 1987 · *Le Terrain du dictionnaire A/Z et Les Pages-Miroirs, 1979–1988,* Ed. Parachute/Galerie René Blouin, 1988 · *Le Dictionnaire,* Montréal, Ed. Parachute/Galerie René Blouin, 1988 · *Elle m'a certainement vu les regarder...,* in: Vanguard, Nr. 3, Sommer, 1988 · *Raymond Gervais – Re Henri Rousseau, le tourne-disque t la recréation du monde,* in: Vie des Arts, Frühjahr, Bd. 32, 1988 · *Des couples sans fin,* in: Kat. von Guy Pellerin, Southern Alberta Art Gallery, 1989 · *Le Regard de Nipper. Raymond Gervais et l'art du tourne-disque,* in: Parachute, Bd. 61, Januar/Februar/März, 1991

Periodika | Periodicals
Serge **Bérard**, *Rober Racine ou le travail de déconstruction du dictionnaire,* in: Parachute, Nr. 62, April/Mai/Juni, 1991 · Jessica **Bradley**, *Fast Forward – Rober Racine,* in: Canadian Art, Nr. 4, Winter, 1988 · Gilles **Daigneault**, *Les marathons de Rober Racine,* in: Décormag, Dezember, 1989 · Gilles **Daigneault**, *Les dernières pages de Rober Racine et de Denis Juneau,* in: ETC... Montréal, Nr. 7, Frühjahr, 1989 · Michel **Denée**, *Poussières de Paysages,* in: Vie des Arts, Dezember, 1987 · Serge **Fisette**, *Rober Racine. Portrait de l'artiste en allé,* in: Espace, Bd. 6, Nr. 1, Herbst, 1989 · Arni Runar **Haraldsson**, *Paysage,* in: C Magazine, Sommer, 1988 · Lesley **Johnstone**, *Paysages – Dazibao,* in: Vanguard, September/Oktober, 1987 · Johanne **Lamoureux**, *French Kiss from a No Man's Land,* in: Arts Magazine, Nr. 6, Februar, 1991 · René **Rozon**, *Art Cologne, Angst et Luxe,* in: Vie des Arts, März, 1987 · **s.n.**, *From Truis Back to Popism,* in: Kunstforum, Nr. 109, August/Oktober, 1990

Video
1984 *J'aurais dit Glenn Gould,* 30 Min./ Farbe, Produktion Western Front Video

Radiosendungen | Broadcasting
1984 *Les bâtiseurs de dictionnaires,* 9 émissions de 30 Min., Doc., Produktion Radio Canada MF **1986** *Des voix pour Glenn Gould,* 60 Min. Doc., Produktion Radio Canada MF · *Vladimir Jankélévitch et ses livres de musique,* 60 Min., Doc., Produktion Radio Canada MF · *Vers la musique,* 13 émissions de 30 Min., Produktion Radio Canada **1989** *Présence de l'art,,* Produktion Radio Canada MF **1990** *La muséologie est-elle un luxe?,* 80 Min., Produktion Radio Canada MF, 4. März 1990

PHILIP RANTZER

*(RO), 1956
Lebt/Lives in Tel-Aviv

Einzelausstellungen | One-man exhibitions

1980 Shinar Gallery, Tel-Aviv **1983** The Aquarium Gallery, Tel-Aviv **1984** *Family Paintings,* Maimad Katan Gallery, Tel-Aviv · Ahad-Ha'am 90 Gallery, Tel-Aviv **1987** *Paintings 1985–87,* Rega Gallery, Tel-Aviv · *Installation: Down with Progress,* Artifact Gallery, Tel-Aviv · *Window Displays and Flower Arrangements,* Sara Levi Gallery, Tel-Aviv **1988** *Installation: From the Diary of A Freedom Fighter,* Janco-Dada Museum, Ein-Hod (Kat.: D. Manor, R. Zommer) **1989** *New Works,* Artifact Gallery, Tel-Aviv **1990** *Hands,* Artifact Gallery, Tel-Aviv **1991** *The Gun, the Knife, the Candle and the Notebook,* Tel-Aviv Artists' Studios (Kat.) **1992** Israel Museum, Jerusalem (video Kat.)

Gruppenausstellungen | Group exhibitions

1987 *Theatrical Aspects,* Kalisher 5 Gallery, Tel-Aviv · *Couple,* Rega Gallery, Tel-Aviv · *36 Artists Exhibit,* Julie M. Gallery, Tel-Aviv **1988** *Fresh Paint (Sculpture),* Israel Museum, Jerusalem · *40 From Israel,* Brooklyn Museum, New York **1989** *Aperto,* The Museum of Israeli Art, Ramat Gan **1990** The Sculpture Biennale of Ein-Hod **1991** *Place & Mainstream,* The Museum of Israeli Art, Ramat Gan

CHARLES RAY

*Chicago (USA), 1953
Lebt/Lives in Tujuga

Einzelausstellungen | One-man exhibitions

1983 64 Market Street, Los Angeles · New Langton Arts, San Francisco **1985** Mercer Union, Toronto · New Langton Arts, San Francisco **1987** Feature, New York · Burnett Miller Gallery, Los Angeles **1988** Feature, New York · Burnett Miller Gallery, Los Angeles **1989** Feature, New York · Burnett Miller Gallery, Los Angeles · The Mattress Factory, Pittsburgh **1990** Newport Harbor Art Museum, Newport Beach (Kat.: L. Barnes) · Burnett Miller Gallery, Los Angeles · Feature, New York · Galerie Claire Burrus, Paris · Interim Art, London **1991** Galerie Metropol, Wien · Galerie Claire Burrus, Paris · Galerie Joost Declercq, Gent · Donald Young Gallery, Seattle · Feature, New York

Gruppenausstellungen | Group exhibitions

1987 *Industrial Icons,* University Art Gallery, San Diego State University, San Diego · *Nature, Feature, Chicago* · Burnett Miller Gallery, Los Angeles **1988** *Selections from the Permanent Collection,* Newport Harbor Art Museum, Newport Beach · *Still Trauma,* Milford Gallery, New York · *Near Miss,* Feature, Chicago · 303 Gallery, New York · *Still Trauma,* Milford Gallery, New York · *Near Miss,* Feature, Chicago · 303 Gallery, New York **1989** *Biennial,* Whitney Museum of American Art, New York · *Loaded,* Kuhlenschmidt Gallery, Los Angeles · *Blood Remembering,* Snug Harbor Cultural Center, Staten Island · Donald Young Gallery, Chicago · *Heart in Mouth,* Fahey/Klein Gallery, Los Angeles **1990** *Recent Drawings,* Whitney Museum of American Art, New York · Matrix Gallery, University Art Museum, Berkeley **1991** *The Savage Garden,* Fondació Caixa des Pensions, Madrid · *Katarina Fritsch, Robert Gober, Reinhard Mucha, Charles Ray, Rachel Whiteread,* Luhring Augustine, New York · *Cadences,* The New Museum of Contemporary Art, New York · Galerie Max Hetzler, Köln · *Cadences : Icon and Abstraction in Context,* The New Museum of Contemporary Art, New York

Bibliographie | Bibliography

Texte und Bücher vom Künstler
Texts and books by the artist
New Work, in : New Orleans Review 7, Nr. 2, Sommer, 1980, in: Spazio Umano, Januar, 1988 · in: Spazio Umano, April, 1989 · *Forehead 1* (1989) : 86–90. A publication of the Beyond Baroque Foundation, Venice

Periodika | Periodicals
Adam **Brooks**, *Shock of the Mundane*, in: Vogue, März, 1990 · Peter **Clothier**, *Charles Ray: Edgy, Provocative Presences*, in: Artnews, Nr. 10, Dezember, 1987 · Peter **Clothier**, *Charles Ray in the Black*, in: Artspace, September/Oktober, 1990 · Susan **Geer**, *Marked by Art; Charles Ray at Newport Harbor Art Museum*, in: Artweek, Nr. 28, 6. September, 1990 · Mike **Kelley**, *Foul Perfection: Thoughts on Caricature*, in: Artforum, Nr. 5, Januar, 1989 · D. **Knaff**, *The Wrong Turn Was the Right Move*, in: Riverside Co. Press Enterprise, 26. August, 1990 · Gary **Kornblau**, *Cover*, in: Art Issues, Nr. 9, Februar, 1990 · Terry R. **Meyers**, *Charles Ray*, in: Flash Art, Oktober, 1989 · David **Pagel**, *Vexed Sex*, in: Art Issues, Nr. 9, Februar, 1990 · Laurie **Palmer**, *Charles ray : Feature*, in: Artforum, Nr. 8, April, 1988 · Jane **Rankin-Reid**, *Still Trauma*, in: Flash Art, Mai/Juni, 1989 · Jeffrey **Rian**, *Past Sense, Present Sense*, in: Artscribe, Nr. 73, Januar/Februar, 1989 · Wade **Saunders**, *Los Angeles*, in: Bomb, Nr. 22, Winter, 1988 · Peter **Schjeldahl**, *Think Box*, in: Village Voice, März, 1991 · Mark **Selwyn**, *New Art L.A.*, in: Flash Art, Nr. 141, Sommer, 1988 · Richard **Smith**, *Tradition and Transition in Southern California Art*, in: New Art Examiner, März, 1989 · Richard **Stephens**, *Aspects of our Corporeal Selves*, in: Artweek, Nr. 26, August, 1989 · Paul **Vangelisti**, *Relating Appearances and Realities*, in: Artweek, Bd. 19, 26. März, 1988

MARTIAL RAYSSE

*Golfe-Juan, 1936
Lebt/Lives in Issigeac

Einzelausstellungen | One-man exhibitions

1957 Galerie Longchamp, Nice **1959** Galerie d'Egmont, Bruxelles **1961** Galerie Schwarz, Milano **1962** Galerie Schmela, Düsseldorf · *Raysse Beach*, Alexander Iolas Gallery, New York (Kat.: J. Ashbery) **1963** *Mirrors and Portraits*, Dwan Gallery, Los Angeles · De Young Museum, San Francisco · Galleria del Leone, Venezia **1964** Dawan Gallery, Los Angeles · *…Made in Japan…Tableau horrible…Tableau de mauvais goût*, Alexander Iolas Gallery, New York (Kat.: J. Ashbery,

P. Restany) **1965** *…Made in Japan… Tableau horrible… Tableau de mauvais goût*, Galerie Alexandre Iolas, Paris (Kat.: O. Hahn) · *Rétrospective Martial Raysse, maitre et esclave de l'imagination*, Stedelijk Museum, Amsterdam (Kat.: O. Hahn, M.R.) **1966** Alexandre Iolas Gallery, New York (Kat.: M.R.) **1967** *M.R. 1963–1966*, Galleria Alexandre Iolas, Milano · *Rétrospective M.R.*, Palais des Beaux-Arts, Bruxelles (Kat.: P. Restany) · *5 tableaux, 1 sculpture*, Galerie Alexandre Iolas, Paris · *M.R. 1960–1966*, Dwan Gallery, Los Angeles (Kat.: O. Hahn, M.R.) · Galerie der Spiegel, Köln · *Martial Raysse 1960–1967*, Svensk-Franska Galleriet, Stockholm **1968** Museum of Contemporary Art, Chicago · *Films*, Galerie Claude Givaudan, Paris · *3 jours, 3 Martial Raysse*, Galerie Alexandre Iolas, Paris (Kat.: P. Centauri) **1969** Galerie der Spiegel, Köln · Galerie Iolas, Genève · *Une forme en liberté*, Galerie Alexandre Iolas, Paris · *Rétrospective Martial Raysse, oeuvres et objets*, Galerie National, Praha (Kat.: M.R., P. Restany) **1970** *Une forme en liberté*, Alexandre Iolas Gallery, New York · *Oued Laou*, Modern Art Museum, München · Galleria Alexandre Iolas, Milano **1972** *6 images calmes, sérigraphies et objets*, Galerie Alexandre Iolas, Paris (Kat.) **1974** *Coco Mato*, 25 Rue du Dragon, Paris **1975** *Sic transit gloria mundi, 13 aquarelles 1974–1975*, Galerie Benador, Genève · *Neue Bilder und Zeichnungen*, Galerie der Spiegel, Köln **1976** *Loco Bello*, Galerie Karl Flinker, Paris (Kat.) **1977** Galerie Eva de Buren, Stockholm · Centre d'Art, Flaine (Haute-Savoie) (Kat.: G. Lascault) **1978** *Spelunca*, Galerie Karl Flinker, Paris **1980** *12 dessins, Un jardin au bord de la lune*, Galerie Claude Givaudan, Genève · *Aquarelles et dessins*, Fondation Veranneman, Kruishoutem **1981** *Martial Raysse 1970–1980*, Centre Georges Pompidou, Paris (Kat.: P. Hulten, M.R.) · Stedelijk Museum, Amsterdam (Kat.) **1982** Musée Picasso, Antibes · Galerie der Spiegel, Köln

Gruppenausstellungen | Group exhibitions

Bühnenbild · Kostüme | Décors · Costumes
1965 *L'éloge de la folle*, ballet de Roland Petit, Théâtre des Champs Elysées, Paris **1967** *Lost Paradise*, ballet de Roland Petit, Covent Garden, London **1969** *Votre Faust*, opéra de H. Pousseur, M. Butor, la Piccola Scala, Milano

Bibliographie | Bibliography

Film
1967 *Jesuscola*, 35 mm, Farbe · *Portrait Electro Machin Chose*, 16 mm, Farbe **1968** *Homero Presto*, 35 mm, Farbe **1969** *Camembert Martial Extra-Doux*, 16 mm, Farbe **1970** *Le Grand Départ*, 35 mm, Farbe **1971** *Pig Music*, s/w in Farbe **1976** *Lotel des Folles Fatmas*, 25 Min. **1978** *Intra Muros*, 12 Min. **1978/80** *La petite danse*, 15 Min.

readymades belong to everyone

Entstanden in New York (1987)
created in New York (1987)

Einzelausstellungen | One-man exhibitions

1982 *Frage der Präsentationen*, Museum für Kultur, Berlin **1986** *Fictionnalisme: Une pièce à conviction*, Galerie Claire Burrus, Paris **1987** *Sujet à discrétion*, American Fine Arts Gallery, New York · *Création de l'agence readymades belong to everyone*, Cable Gallery, New York (von/by Philippe Thomas) **1988** Ouverture de la filiale française *les ready made appartiennent à tout le monde*, Galerie Claire Burrus, Fiac, Paris · *Agencement 88*, Maison de la Culture et de la Communication de Saint-Etienne, Saint-Etienne · *Epreuves d'artistes*, Galerie Claire Burrus, Paris **1989** *Ready mades gehören allen*, Galerie Esther Schipper, Köln · *Insights*, Curt Marcus Gallery, New York **1990** *Feux pâles*, Musée d'Art Contemporain de Bordeaux, Entrepôt, Bordeaux **1991** *Un Cabinet d'amateur*, Galerie Claire Burrus, Paris **1992** *Un Cabinet d'amateur*, Künstlerhaus, Stuttgart

Gruppenausstellungen | Group exhibitions

1987 Galerie Claire Burrus, FIAC, Paris · **1988** *Camouflage*, Curt Marcus Gallery, New York · *Vivent les Frac*, Nouveau Musée, Villeurbanne **1989** *Shadow of a Dream*, Cambridge Darkroom, Cambridge · Bienal de São Paulo **1990** *Insights*, Centre National des Arts Plastiques, Paris (et al.) · *Aperto*, Biennale di Venezia · *Art & Publicité*, Centre Georges Pompidou, Paris **1991** *Kunst Europa (Frankreich)*, Württembergischer Kunstverein, Stuttgart (et al.) · *Lieux commun, figures singulières*, Musée d'Art Moderne de la Ville, Paris

Performances · Aktionen | Actions

1987 *Philippe Thomas décline son identité*, Centre Georges Pompidou, Paris, **1988** *Philippe Thomas décline son identité*, Musée de Peinture, Grenoble, 1988

Bibliographie | Bibliography

Publikationen des Künstlers
Publications by the artist
Un manuscrit trouvé, Galerie Ghislain Mollet-Viéville, Paris, 1981 · *Frage der Präsentation*, Museum für Kultur, Berlin, 1982 · Michel Tournereau, *Philippe Thomas : Sujet à discrétion?*, Public, Nr. 3, Paris, 1985 · *Fictionnalisme: Une Pièce à conviction*, Galerie Claire Burrus, Paris, 1986 · *Sur un lieu commun* (un entretien avec Georges Verney-Carron), Maison de la Culture et de la Communication de Saint-Etienne · Daniel Bosser, *Philippe Thomas décline son identitté*, Paris, Ed. Yellow Now/Galerie Claire Burrus, 1987 · Estelle Schwarz, *Advertising, Advertising: some cases in point*, in: Artscribe, Nr. 71, 1988 · Georges Verney-Carron, *Publicité, Publicité: de quelques cas de figures*, in: Art Press, Nr. 129, 1988 · Lidewij Edelkoort, *Reclame, Reclame: een paar voorbeelden*, in: Artefactum, Nr. 26, 1988 · Laura Carpentier, *Insights*, New York, Ed. Curt Marcus Gallery, 1989 · Laura Carpenter, *Insights*, Paris,

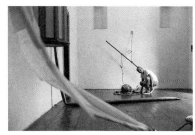

Ed. Galerie Claire Burrus, 1990 · Musée d'Art Contemporain de Bordeaux, *Feux pâles*, Bordeaux, Ed. Musée d'Art Contemporain, 1990 · Georges Verney-Carron, *Reklame, Reklame: nogle sporgsmal til figurernes ekskluson*, in: Andsindustri, Nr. 4, 1991 · Les ready made appartiennent à tout le monde, *Dossier*, Cahiers du Musée National d'Art Moderne, Centre Georges Pompidou, Paris, 1991 · Georges Verney-Carron, *Publicidad: en torno a ciertas figuras*, Kalias, rivista d'arte, Bd. 3, Nr. 6, 1991 · Georges Verney-Carron, *Werbung, Werbung: einige Beispiele zur Sache*, in: Die Kunst und Ihr Ort Meta 1, Künstlerhaus Stuttgart, 1992

Periodika | Periodicals
Annie **Chèvrefils-Desbiolles**, *Si Philippe Thomas était conté*, in: Art Press, November, 1987 · Annie **Chèvrefils-Desbiolles**, *Qui perd gagne*, in: Vice/Versa, November, 1989 · Claudia **Hart**, *Vanishing Act: Philippe Thomas*, in: Artforum, April, 1988 · Catherine **Kempeneers**, *Philippe Thomas, CNAP, Paris*, in: Forum, September/Oktober, 1990 · Kim **Levine**, *Readymades belong to everyone*, in: Village Voice, 5. Januar, 1988 · Kim **Levine**, *Jay Chiat/Edouard Mérino: Insights*, in: Village Voice, 19. Dezember, 1989 · Catherine **Millet**, *Philippe Thomas, artiste*, in: Art Press, Juli/August, 1989 · Jean-Marc **Poinsot**, *La signature contre l'art*, in: Ligeia (Nr. 7/8), 4. Trimester, 1990 · Daniel **Soutif**, *Philippe Thomas au MNAM*, in: Art in America, Oktober, 1987 · Stéphane **Wargnier**, *Images de Pub*, in: Jardin des Modes, November, 1990

Video
1989 L'ouverture de l'agence *readymades belong to everyone*, New York, 1987, Bande annonce 1991 Projets de publicité pour l'agence *readymades belong to everyone*, Exposition *Art & Publicité*, Centre Georges Pompidou, Paris · *Chiat/Day/Mojo:* Publicité pour l'agence readymades belong to veryone

JOSÉ RESENDE

*São Paulo (BR), 1945
Lebt/Lives in São Paulo

Einzelausstellungen | One-man exhibitions

1968 Petite Galerie, Rio de Janeiro · Artart Gallery, São Paulo 1970 Museum of Modern Art, Rio de Janeiro · Museum of Contemporary Art of the University of São Paulo, São Paulo 1972 Brazilian Cultural Mission, Asuncion 1974 Museum of Art of São Paulo, São Paulo 1975 Museum of Modern Art, Rio de Janeiro · Museum of Contemporary Art, Campinas 1979 Praca de Sé, São Paulo 1980

National Art Foundation, Rio de Janeiro 1981 Raquel Arnaud Art Gallery, São Paulo 1982 C. Mendes Gallery, Rio de Janeiro 1985/83 Raquel Arnaud Art Gallery, São Paulo 1988 National Art Foundation, Rio de Janeiro · Subdistrito Gallery, São Paulo 1990 Museum of Contemporary Art of the University of São Paulo 1991 Joseloff Gallery, University of Hartford, Hartford

Gruppenausstellungen | Group exhibitions

1987 *Brazilian Art of the Twentieth Century*, Musée d'Art Moderne de la Ville, Paris 1988 *Biennale di Venezia*, · *Olympic Park Sculpture Exhibition*, Seoul 1989 *São Paulo Bienal*, 1991 *Viva Brasil Viva*, Lijevalch Museum, Stockholm

Bibliographie | Bibliography

Bücher vom Künstler | Books by the artist
A Parte do Fogo, Rio de Janeiro, 1980

GERHARD RICHTER

*Dresden (D), 1932
Lebt/Lives in Köln

Einzelausstellungen | One-man exhibitions

1963 *Demonstration für den Kapitalistischen Realismus*, Möbelhaus Berges, Düsseldorf 1964 Galerie Heiner Friedrich, München · Galerie Alfred Schmela, Düsseldorf · Galerie René Block, Berlin (Kat.: M. la Motte) 1966 Galleria La Tartaruga, Roma · *Polke/Richter*, Galerie h, Hannover (Kat.: G. R., S. Polke) · Galerie Bruno Bischofberger, Zürich · *Die beste Ausstellung Deutschlands*, Galerie Patio, Frankfurt/M. · Galleria Del Leone, Venezia · Galerie Heiner Friedrich, München · *Volker Bradke*, Galerie Alfred Schmela, Düsseldorf · Galerie René Block, Berlin 1967 Galerie Heiner Friedrich, München · Wide White Space, Antwerpen 1968 Galerie Rolf Ricke, Kassel · Galerie Rudolf Zwirner, Köln 1969 Galleria del Naviglio, Milano · Galerie René Block, Berlin · Gegenverkehr, Aachen (Kat.: K. Honnef) 1970 Palais des Beaux-Arts, Bruxelles · Galerie Konrad Fischer, Düsseldorf · Galerie Heiner Friedrich, München · *Für Salvadore Dali*, Galerie Ernst, Hannover · Museum Folkwang, Essen (Kat.: D. Honisch) 1971 Galerie Heiner Friedrich, Köln · Kabinett für aktuelle Kunst, Bremerhaven · *Arbeiten 1962–71*, Kunstverein für die Rheinlande und Westfalen, Düsseldorf (Kat.: D. Helms, K.-H. Hering) · Galleria Lucio Amelio, Napoli 1972 *48 Porträts*, Galerie Rudolf Zwirner, Köln · *48 Porträts, Vermalungen, Farbtafeln*, Kunstmuseum, Luzern · *48 Porträts*, Galerie Nächst St. Stephan, Wien · *48 Por-*

träts, Suermondt Museum, Aachen · *Vermalungen*, Galerie Konrad Fischer, Düsseldorf · Galerie Heiner Friedrich, Köln · Galerie Heiner Friedrich, München · *Atlas*, Kabinett für aktuelle Kunst, Bremerhaven · *Atlas*, Museum Hedendaagse Kunst, Utrecht · *4 Städtebilder*, Galleria Lucio Amelio, Napoli 1973 *Vermalung no. 338*, Seriaal, Amsterdam · Städtische Galerie im Lenbachhaus, München (Kat.: J.-C. Ammann) · Reinhard Onnasch Galerie, New York · Kunstverein, Bremerhaven (Kat.: H. Heissenbüttel) 1974 Galerie Rudolf Zwirner, Köln · Galerie René Block, Berlin · Galerie Heiner Friedrich, München · Städtisches Museum, Mönchengladbach (Kat.: J. Cladders) 1975 Galerie Preisig, Basel · Galerie Konrad Fischer, Düsseldorf · *Verkündigung nach Tizian*, Galleria La Bertesca, Milano · *Graue Bilder*, Kunstverein, Braunschweig (Kat.: H. Holtmann) 1975/76 Kunsthalle, Bremen (Kat.: M. Schneckenburger, M. Grüterich) 1976 *Peinture 1962–1975*, Palais des Beaux-Arts, Bruxelles (Kat.: M. Schneckenburger) · *Atlas der Fotos, Collagen und Skizzen*, Museum Haus Lange, Krefeld (Kat.: G. Storck) · Galleria Lucio Amelio, Napoli · Galerie Durand-Dessert, Paris · Galleria La Bertesca, Genova · Renzo Spagnoli Galleria, Firenze (Kat.: G. Cartenova, G.R.) 1977 Centre Georges Pompidou, Paris (Kat.: B. H.D. Buchloh) · 1978 Sperone Westwater Fischer Gallery, New York · A. Leonowens Gallery, Halifax · Nova Scotia College of Art and Design, Halifax · *Abstract Painting*, Stedelijk Van Abbemuseum, Eindhoven (Kat.: B.H.D. Buchloh, R. H. Fuchs) 1979 *Abstract Paintings*, Whitechapel Art Gallery, London (Kat.: B.H.D. Buchloh, R. H. Fuchs) · Galerie Isernhagen, Isernhagen · Galerie Bernd Lutze, Friederichshafen 1980 Sperone Westwater Fischer Gallery, New York · Galleria Pieroni, Roma · *Zwei gelbe Striche*, Museum Folkwang, Essen (Kat.: Z. Felix) · *Zwei gelbe Striche*, Stedelijk Van Abbemuseum, Eindhoven 1981 Kunsthalle, Düsseldorf (Kat.: J. Harten) · Padiglione d'Arte Contemporanea, Milano (Kat.: B. Corà) 1982 *Abstrakte Bilder 1976–1981*, Kunsthalle, Bielefeld (Kat.: R. H. Fuchs, H. Heere) · Kunstverein, Mannheim · Galerie Fred Jahn, München · Galerie Konrad Fischer, Zürich · Galerie Max Hetzler, Stuttgart 1983 Sperone Westwater Fischer Gallery, New York · Marianne Deson Gallery, Chicago · Galleria Lucio Amelio, Napoli · *Isa Genzken. Gerhard Richter*, Galleria Pieroni, Roma (Kat.: R. H. Fuchs) · Galerie Konrad Fischer, Düsseldorf 1984 Musée d'Art et d'Industrie, St. Etienne (Kat.: B. Blistène) · Galerie Thomas Borgmann, Köln · Galerie Durand-Dessert, Paris · Galerie Wilkens – Jacobs, Köln · *Aquarelle*, Kunstverein, Kassel (Kat.: D. Elger) 1985 *Aquarelle*, Staatsgalerie, Stuttgart (Kat.: U. Loock) · Marian Goodman Gallery/Sperone

Westwater Gallery, New York (Kat.: B.H.D. Buchloh) · Galerie Jean Bernier, Athinai · Galerie Bernd Lutze, Friedrichshafen · Galerie Fred Jahn München **1986** Städtische Kunsthalle, Düsseldorf (Nationalgalerie, Berlin; Kunsthalle, Bern; Museum moderner Kunst/Museum des 20. Jahrhunderts, Wien) (Kat.: J. Harten) · *Paintings 1964–1974,* Barbara Gladstone Gallery/Rudolf Zwirner Gallery, New York (Kat.: R. H. Fuchs) **1987** *Werken op papier,* Museum Overholland, Amsterdam (Kat.: G. R.) · *Paintings,* Marian Goodman Gallery/Sperone Westwater Gallery, New York (Kat.: A. Rorimer, D. Zacharopoulos) · Wadsworth Atheneum, Hartford · Galerie Rudolf Zwirner, Köln · *Isa Genzken, Gerhard Richter,* Galleria Pieroni, Roma (Kat.: P. Groot) **1988** Galerie Fred Jahn, München · Galerie Durand-Dessert, Paris (Kat.: D. Zacharopoulos) · *The London paintings,* Anthony d'Offay Gallery, London (Kat.: J. Lloyd) · Art Gallery of Ontario, Toronto · Galerie Bernd Lutze, Friedrichshafen · *Paintings,* Museum of Contemporary Art, Chicago (Kat.: B.H.D. Buchloh, I. M. Danoff, R. Nasgaard, W. J. Withrow) · Hirshhorn Museum & Sculpture Garden, Washington, DC **1989** Museum of Modern Art, San Francisco · *18. Oktober 1977,* Museum Haus Esters, Krefeld (Portikus, Frankfurt/M.; Institute of Contemporary Arts, London; Saint Louis; New York; Los Angeles; Boston) (Kat.: B.H.D. Buchloh, S. Germer, K. König, G. Storck) · Galerie Jean Bernier, Athinai · *Atlas,* Städtische Galerie im Lenbachhaus, München (Museum Ludwig, Köln) (Kat.: A. Zweite) · *Gerhard Richter 1988/89,* Museum Boymans-van Beuningen, Rotterdam (Kat.: B.H.D. Buchloh, K. Schampers, A. Tilroe) · Galerie Fred Jahn, München · Nelson-Atkins Museum of Art, Kansas City (Kat.: D.E.Scott) · Galleria Pieroni, Roma · David Noln Gallery, New York · Nelson-Atkins Museum of Art, Kansas City (Kat.: D.E.Scott) **1990** *Bilder,* Marian Goodman Gallery/Sperone Westwater Gallery, New York · *18. Oktober 1977,* Saint Louis Art Museum, Saint Louis (The Grey Art Gallery, New York; Montréal Museum of Fine Arts, Montréal; Lennan Foundation, Los Angeles; Institut of Contemporary Art, Boston) **1991** *Mirrors,* Anthony d'Offay Gallery, London (Kat.: R. Cork) · Liliane & Michel Durand-Dessert, Paris · Galerie Fred Jahn, München/Stuttgart · Galerie Achenbach, Frankfurt/M. · The Douglas Hyde Gallery, Dublin · The Tate Gallery, London (Kat.: N.Ascherson, S. Germer; S. Rainbird) · *Arbeiten auf Papier,* Galerie Bernd Lutze, Friedrichshafen · Whitworth Art Gallery, Manchester

Gruppenausstellungen | Group exhibitions

1987 *Wechselströme,* Kunstverein, Bonn · *Zauber der Medusa – Europäische Manierismen,* Wiener Festwochen, Künstlerhaus, Wien · *L'époque, la mode, la morale, la passion,* Centre Georges Pompidou, Paris · *Brennpunkt Düsseldorf,* Kunstmuseum, Düsseldorf (et. al.) · *documenta 8,* Kassel · *Watercolours by Joseph Beuys, Blinky Palermo, Sigmar Polke, Gerhard Richter,* Goethe-Institut, London · *Malerei – Wandmalerei,* Steirischer Herbst, Kunstverein, Graz · *Regenboog,* Stedelijk Van Abbemuseum, Eindhoven **1988** *Rot- Gelb – Blau,* Kunstmuseum St. Gallen/Museum Fridericianum, Kassel · *Biennale of Sydney,* Art Gallery of New South Wales, Sydney · *La couleur seule,* Musée St.-Pierre

d'Art Contemporain, Lyon · *Carnegie International,* Museum of Art, Carnegie Institute, Pittsburgh · *Europa oggi/Europe now,* Museo d'Arte Contemporanea Luigi Pecci, Prato · *Bilder für den Himmel,* Goethe-Institut, Osaka, (et. al.) **1989** *Refigured Painting: the German Image 1960–88,* Solomon R. Guggenheim Museum, New York (et al.) · *Bilderstreit,* Museum Ludwig, Köln · *Art from Cologne,* Tate Gallery, Liverpool · *Blickpunkte,* Musée d'Art Contemporain, Montréal · *256 Farben & Basics on Form,* Stiftung für Konstruktive und Konkrete Kunst, Zürich · *Zeitzeichen,* Ministerium für Bundesangelegenheiten des Landes NRW, Bonn (et al.) · *Drawing as itself,* National Museum of Art, Osaka · *Another focus – photographs by painters ans sculptors,* Karsten Schubert Gallery, London · *Aus meiner Sicht,* Kunstverein, Köln · *Akademierundgang 1950–1988,* Verbindungsbüro Nordrhein-Westfalen, Bruxelles · *Fondation Daniel Templon,* Musée Temporaire, Fréjus **1990** *Sammlung Marzona,* Kunsthalle, Bielefeld · *Portrait d'une collection d'art contemporain – collection Uhoda,* Palais des Beaux-Arts, Charleroi · *Gegenwart Ewigkeit,* Martin-Gropius-Bau, Berlin · *Abstraktion und Konkretion,* Galerie Neher, Essen · *65–75 Aspects and practices of European art,* Castello di Rivoli, Rivoli (Torino) · *Obra sobre papel de la Coleccio Deutsche Bank,* Banco Bilbao Vizcaya, Madrid/Bilbao · *Aktuelle Kunst Europas, Sammlung Centre Pompidou,* Deichtorhallen, Hamburg · *Régions de Dissemblance,* Musée Département de Rochechouart, Château de Rochechouart · *A new necessity,* First Tyne International, Queensway North, New Castle · *Rauma Biennale Balticum 1990,* Rauman Taidemuseo, Rauma · *Life-Size – A sense of the real in recent art,* The Israel Museum, Jerusalem · *Passages de l'image,* Centre Georges Pompidou · *Work in progress,* Fundació Caix de Pensions, Madrid · *Ausgebürgert, Kunst aus der DDR 1949–1989,* Albertinum zu Dresden, Kleine Deichtorhalle, Hamburg · Galerie Durand-Dessert, Paris · *The Times, The Chronicle & The Observer,* Kent Fine Art, New York · *Feux pâles,* Musée d'Art Contemporain, Bordeaux **1991** *Metropolis,* Martin-Gropius-Bau, Berlin · *Pop-Art,* Royal Academy of Arts, London (et al.) · *Strategies for the next Painting,* Wolff Gallery, New York · *Erwerbungen der Graphischen Sammlung,* Staatsgalerie, Stuttgart · *Das Bild nach dem letzten Bild,* Galerie Metropol, Wien · *A Choice among recent Purchases from the 80's 90's,* Musée d'Art Moderne de la Ville, Paris · *Trente oeuvres du FNAC à La Défense,* Fonds National d'Art Contemporain, Paris · *Models of Reality: Approaches to Realism in Modern German Art,* Harris Museum and Art Gallery, Harris (et al.)

Bibliographie | Bibliography

Texte vom Künstler | Texts by the artist

Bericht über eine Demonstration, Flugblatt zu: Demonstration für den Kapitalistischen Realismus, Düsseldorf, 1963 · *1024 Farben in 4 Permutationen,* in: Kat.(ohne Titel/without title), Palais des Beaux-Arts, Bruxelles 1974 · *(About eight years ago…),* in: Kat. Fundamentele Malerei, Amsterdam, Stedelijk Museum, 1975 · *(Statement),* in: Kat. Acht Künstler – Acht Räume, Städtisches Museum, Mönchengladbach 1976 ·

(Statement), in: Kat. Pier + Ocean, Hayward Gallery, London 1980 · *(Statement),* in: Kat. documenta 7, Bd. 1, Kassel, 1982 · *(Statement),* in: Flash Art, Nr. 149, November/Dezember 1989

Bücher | Books

Hubertus **Butin,** *Zu Richters Oktober-Bildern,* Köln, Verlag der Buchhandlung Walther König, 1991 · Ulrich **Loock,** Denys **Zacharopoulos,** *Gerhard Richter,* München, Verlag Silke Schreiber, 1985 · Terry A. **Neff,** I. Michael **Danoff,** Roald **Nasgaard,** *Gerhard Richter,* London, Thames and Hudson, 1988

Periodika | Periodicals

Hugh **Adams,** (review), in: New Art Examiner, Nr.15, Mai 1988 · Jean-Christophe **Ammann,** *18. Oktober 1977,* in: Du, Februar, 1989 · Jean-Christophe **Ammann,** *Das Werk als Menetekel,* in: Zyma, November/Dezember, 1989 · Michael **Archer,** (review), in: Art Monthly, Nr. 115, April 1988 · Kenneth **Baker,** *Abstract Gesture,* in: Artforum, Nr.28, September 1989 · Mary Rose **Beaumont,** *Gerhard Richter,* in: Art Review, Nr. 8, April 1988 · Mary Rose **Beaumont,** *Gerhard Richter,* in: Art Review, 17. Mai, 1991 · Christian **Bernard,** *Gerhard Richter: Emma,* in: Art Press, Nr. 120, Dezember, 1987 · Roger **Bevan,** *New York/Gerhard Richter,* in: The Burlington Magazine, Februar, 1990 · Bernard **Blistène,** *Méchanique et manuel dans l'art de Gerhard Richter,* in: Galeries Magazine, Nr. 24, April/Mai, 1988 · Martin **Bochynek,** *RAF und Wohnzimmerrevolution,* in: Marabo, März, 1989 · Martin **Bochynek,** *18. Oktober 1977,* in: Wolkenkratzer Art Journal, Nr. 3, Mai/Juni, 1989 · Martin **Bochynek,** *Fotos, Collagen, Skizzen,* in: Marabo, Nr. 3, März, 1990 · Benjamin H.D. **Buchloh,** *A note on Gerhard Richter's October 18, 1977,* in: October, Nr. 48, Frühjahr, 1989 · Shaun **Caley,** (review), in: Flash Art, Nr. 133, April 1987 · David **Cameron,** Seven Types to Criticality,in: Arts Magazine, Bd.61, Mai 1987 · Peter **Chametzky,** *Sieben Worte sind genug,* in: Zyma, Nr. 4, September/Oktober, 1990 · Anna Maria **Corbi,** *Sol Lewitt – Gerhard Richter,* in: Proposte, Nr. 2, Februar, 1990 · Peggy **Cyphers,** (review), in: Arts Magazine, Bd.63, September 1988 · Maja **Damjanovic,** *Gerhard Richter,* in: Tema Celeste, Nr. 26, Juli/Oktober, 1990 · Peter **Day,** *On the Richter scale,* in: Canadian Art, Bd. 5, März, 1988 · Joshua **Decter,** *Gerhard Richter,* in: Contemporanea, Sommer, 1990 · Thomas **Dreher,** *Gerhard Richter,* in: Das Kunstwerk, Dezember, 1989 · William **Feaver,** (review), in: Art News, Bd. 89, Januar 1990 · Robert **Fleck,** *Gerhard Richter – Durant-Dessert,* in: Flash Art, Nr. 162, Januar/Februar 1992 · Viktoria von **Fleming,** *Enigma within an Enigma,* in: Contemporanea, Nr. 8, November, 1989 · Jean-Michel **Foray,** *Du musée au site – et retour,* in: Cahiers du Musée National d'Art Moderne, Nr. 27, Frühjahr, 1989 · Enrique **Garcia-Herraiz,** (review), in: Goya, Bd. 198, Mai/Juni 1987 · Tony **Godfrey,** (review), in: The Burlington Magazine, Bd. 131, Dezember 1989 · Walter **Grasskamp,** *Gerhard Richter 18. Oktober 1977,* in: Jahresring, 1989 · Isabelle **Graw,** *Stoffsammlung,* in: Artis, Mai, 1989 · Isabelle **Graw,** *View,* in: Artscribe International, September/Oktober, 1989 · Catherine **Grout,** *Le paysage en question,* in: Artefactum, Nr. 34, Juni/August, 1990 · James **Hall,** *Richter's Baader-Meinhof paintings,* in: Art International, Nr. 9, Winter, 1989 · Char-

lotte **Harder,** *Bilder der Trauer,* in: Skyline, Mai, 1989 · Glen **Helfand,** *A Single-minded Pluralist,* in: Artweek, Bd.20, April 1989 · Martin **Hentschel,** *Gerhard Richter,* in: Artforum, Nr. 27, Mai, 1989 · Gerhard **Hesler,** *Graues Phantom Mitleid,* in: Zyma, November/Dezember, 1989 · Hans Günther **Heyme,** *Trauerarbeit der Kunst muß sich klarer geben,* in: Art. Das Kunstmagazin, Nr.4, April, 1989 · Jürgen **Hohmeyer,** *Das Ende der RAF, gnädig weggemalt,* in: Der Spiegel, 13. Februar, 1989 · Michael **Hübl,** *The »Melancholist of Virtuosity«,* in: Artnews, Bd.88, Februar, 1989 · Christian **Huther,** *Gerhard Richter 18. Oktober 1977,* in: Apex, Juli, 1989 · Angeli **Janshen,** *18. Oktober 1977,* in: Weltkunst, 1. April, 1989 · Donald **Kuspit,** *All our yesterdays,* in: Artforum , April, 1990 · Elisabeth **Lebovici,** *Gerhard Richter: peinture terminée, peinture interminable,* in: Art Press, Nr. 124, April 1988 · Elisabeth **Lebovici,** *Un peu trop,* in: Artstudio, Nr. 16, 1990 · André **Lamarre,** *Gerhard Richter,* in: Parachute 61, Januar/März, 1991 · Jhim **Lamoree,** *Richters Hebbedingetjes,* in: HP, Oktober, 1989 · James **Lewis,** *Gerhard Richter: the Problem of Belief,* in: Art Issues, Nr. 12, Sommer, 1990 · Ulrich **Loock,** *Gerhard Richter,* in: Parachute, Nr. 53, Dezember 1988/Januar 1989 · Gregorio **Magnani,** *(Gerhard Richter),* in: Flash Art, Bd. 146, Mai/Juni, 1989 · Johannes **Meinhardt,** *Gerhard Richter: 18. Oktober 1977,* in: Zyma, Nr. 5, November/Dezember, 1989 · Lee **Montgomery,** *W-German's work opens L.A.s Lanan Foundation,* in: News Piklot, Juli, 1990 · Roald **Nasgaard,** *Art as the highest form of hope,* in: AGO News, Nr. 4, April, 1988 · John T. **Paoletti,** *Gerhard Richter: ambiguity as an agent awareness,* in: Print Collector's Newsletter, Bd. 19, pt. 1, März/April, 1988 · Robert L. **Pincus,** *Richter's October: a perplexing view of Baader-Meinhof gang,* in: The San Diego Union, Juli, 1990 · Pia **Phora,** in: Artefactum, Juni/Juli/August, 1989 · Ferdinand **Quante,** *Der Anti-Star,* in: Prinz, Februar, 1990 · Sean **Rainbird,** *Gerhard Richter at Anthony d'Offay,* in: The Burlington Magazine, Mai, 1988 · Andrew **Renton,** *Gerhard Richter,* in: Flash Art, Mai/Juni, 1991 · Wolfgang **Rüger,** *Against all methods,* in: Auftritt, Mai, 1989 · Ralph **Rugoff,** *Eulogy in gray,* LA Weekly, August, 1990 · **s.n.,** *The easiest way to mark...',* in: Art Monthly, April, 1988 · **s.n.,** *Hearts of gold,* in: Performing Arts (Los Angeles), Juni, 1990 · Esther **Schipper,** *Gerhard Richter le 18 Octobre 1977,* in: Après, April, 1989 · Peter **Schjeldahl,** *Death and the painter,* in: Art in America, April, 1990 · Christoph **Schreier,** *Die Leere und der Tod im Bild,* in: Mitteilungen des Instituts für moderne Kunst, Oktober, 1989 · Sabine **Schütz,** *Gerhard Richter,* in: Journal of Contemporary Art, Winter, 1990 · Barry **Schwabsky,** *Gerhard Richter,* in: Arts Magazine, Mai, 1990 · Sophie **Schwarz,** *Gerhard Richter,* in: Contemporanea, Mai, 1989 · Thorsten **Scheer,** *Die Ausdauer der Postmoderne,* in: Artefactum, Nr. 42, Februar/März, 1992 · Bettina **Semmer,** *18. Oktober 1977,* in: Artscribe , Juli/August, 1989 · Ken **Sofer,** *Gerhard Richter,* in: New York Reviews, Sommer, 1987 · Jan **Thorn-Prikker,** *Gerhard Richter, 18. Oktober 1977,* in: Parkett, Nr. 19, 1989 · Jan **Thorn-Prikker,** *Stammheim im Bild,* in: Kulturforum, Mai, 1989 · Jan **Thorn-Prikker,** *Malerei, Erlösung, Gewalt,* in: Kunst und Kirche, September, 1989 · Heiner **Stachelhaus,** *Der Ter-*

roristen-Tod – malerisch verschlüsselt, in: NRZ, Nr. 36, 11. Februar, 1989 · Christiane **Vielhaber,** *Manchmal hat man eben keine Lust abstrakt zu malen,* in: Kunst Köln, Nr. 1. Januar, 1989 · Torsten H. **Walraff,** *Gerhard Richter,* in: Noema, Sommer, 1989 · Denys **Zacharopoulos,** *Gerhard Richter,* in: Faces, Nr. 18, Herbst, 1990

ULF ROLLOF

*Karlskrona (S), 1961
Lebt/Lives in Stockholm

Einzelausstellungen | One-man exhibitions

1982 *Rooms,* Galerie Ahlner, Stockholm · *Rooms,* Galleri Camera Obscura, Stockholm **1984** *Passage,* Galerie Ahlner, Stockholm **1986** *Faros,* Lake Pazcuaro, Pazcuaro, Mexico **1987** *Despues del 19 sep 1985,* Excovento, Mexico City **1988** *Bellows 4,* Concert for Bellows, Fylkingen, Stockholm · *Hule mio,* Bergen Art Society, Bergen · *Dormimundo,* Galerie Nordenhake, Stockholm · *Dormimundo,* Malmö Konsthall, Malmö (Kat.: B. Springfeldt) **1989** *Axolotl,* Galleri Eklund, Umea (Kat.: J. P. Nilsson) **1990** *Lifeboat,* Nordic Arts Center, Helsinki (Kat.: J. P. Nilsson) · *Land,* Galerie Nordenhake, Stockholm **1991** *Diagnose,* Galleri Riis, Oslo · *Seven Sick Sailors were Succored by Seven Splendid Sisters on the Sinking Steamer Shanghai,* Galerie Anhava, Helsinki

Gruppenausstellungen | Group exhibitions

1987 *Verktyg,* Sveagalleriet, Stockholm **1989** Konstnationalen, Globen, Stockholm · *Wanasutställningen,* Wanas · *Frizon,* Kulturhuset, Stockholm **1990** *Spegling,* Moderna Museet, Stockholm · *12th International Biennale of Drawings,* Museum of Modern Art, Rijeka **1991** *Gullivers Reisen,* Galerie Sophia Ungers, Köln · *Metafor och Materia – Panamarenko-Rollof-Shannon,* Moderna Museet, Stockholm · *The last Border,* Galleri Enkehuset, Stockholm · *Biennal de São Paulo* · Shedhalle, Zürich

Bibliographie | Bibliography

Text vom Künstler
Text by the artist
Drawings (1987), in: Kat. 12th International Biennale of Drawings, Museum of Modern Art, Rijeka, 1991

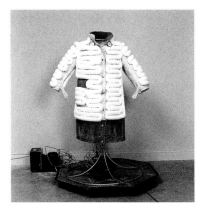

ERIKA ROTHENBERG

*New York (USA), 1950
Lebt/Lives in Los Angeles

Einzelausstellungen | One-man exhibitions

1986 P.P.O.W., New York **1987** W.P.A., Washington, DC · San Francisco Airport, San Francisco · P.P.O.W., New York **1988** Rosamund Felsen Gallery, Los Angeles **1989** *New California Artist XV,* Newport Harbor Art Museum, Newport Beach · Rosamund Felsen Gallery, Los Angeles · *Have You Attacked America Today?,* New Museum, New York **1990** P.P.O.W., New York **1991** *Bathroom doors, Greetings cards, Trophies... and a Test,* Rosamund Felsen Gallery, Los Angeles · Zolla/Lieberman Gallery, Chicago **1992** *Greeting Cards, Trophies, Self-Muattion and ›Phone Sex‹,* P.P.O.W., New York

Gruppenausstellungen | Group exhibitions

1987 *Press/Art,* University Art Museum, Long Beach · *Connections,* Museum of Contemporary Hispanic Art, New York · *Madness in America,* Elizabeth Galasso, New York **1988** *Committed to Print,* Museum of Modern Art, New York · *Products and Promotion,* Franklin Furnace, New York · *Art and Law,* (Travelling exhibition) · *Home Show,* Santa Barbara Contemporary Arts Forum, Santa Barbara · *Agit/Pop,* Otis Art Institute, Los Angeles · *New Works on Paper,* Rosamund Felsen Gallery, Los Angeles · *Democracy,* Dia Foundation, New York · *Fresh from New York,* Artspace, Auckland · *Signs of the Times,* Bread and Rose Cultural Center **1989** *Art Against Aids,* Bilboard Project, San Francisco · *Media Talk,* Security Pacific Gallery, Costa Mesa **1990** *Past & Present – Selected Works by Gallery Atists,* Rosamund Felsen Gallery, Los Angeles · *Selections from P.P.W.O.W.,* Weatherspoon Art Gallery, University of North Carolina, Greensboro · *Word as Image: 1960 – 1990,* Milwaukee Art Museum, Milwaukee (et al.) · *Taking Liberties,* The Woman's Building, Los Angeles · *Aids Timeline,* A Group Material Project, Museum of Contemporary Art, San Francisco · *Food, from Pleasure to Politics,* Goddard Riverside Community Center, New York **1991** *1991 Whitney Biennial,* Aids Timeline, A Group Material Project, Whitney Museum of American Art, New York · *No Laughing Matter,* University Gallery, University of North Texas, Denton (et al.) · *Art of Advocacy,* Aldrich Musum, Ridgefield · *To Wit,* Rosa Esman Gallery, New York · *Quick Coagulation Forms The August Corpse,* Rosamund Felsen Gallery, Los Angeles · *Addictions,* Contemporary Arts

Forum, Santa Barbara · *Artists of Conscience: 16 Years of Social and Political Commentary,* The Alternative Museum, New York 1992 *Empowering The Viewer: Art, Politics and The Community,* Temple Gallery, Temple University, Philadelphia

Bibliographie | Bibliography

Texte und Bücher von der Künstlerin
Texts and books by the artist
Morally Superior Products: A New! Idea for Advertising, S/Z Press, New York, 1983 · *Have You Attacked America Today?,* in: Framework, Bd. 3, 1990 · *Abandon the Good Life for a Life of Goodness,* in: Artforum Artists Project, Februar, 1989

Periodika | Periodicals
Susan **Kandel,** (Review), in: Art Issues, September/Oktober, 1991 · Kim **Levin,** *(Review),* in: Village Voice, 6. Oktober, 1987 · Judith **Spiegel,** *Wry, Sly and to the Point,* in: Artweek, 9. April, 1988 · Benjamin **Weissman,** *(Review),* in: Artforum, Februar, 1990 · James **Yood,** *Erika Rothenberg. Zolla/Lieberman Gallery,* in: Artforum International, Nr. 5, Januar, 1992 · Jody **Zellen,** *Erika Rothenberg,* in : Arts Magazine, November, 1991

SUSAN ROTHENBERG

*Buffalo (USA), 1945
Lebt/Lives in New York

Einzelausstellungen | One-man exhibitions

1975 *Three Large Paintings,* 112 Green Street Gallery, New York 1976 Willard Gallery, New York 1977 Willard Gallery, New York 1978 *Susan Rothenberg, Matrix/Berkeley 3,* University Art Museum, Berkeley · Greenberg Gallery, St. Louis · Walker Art Center, Minneapolis 1979 Willard Gallery, New York 1980 Mayor Gallery, London (Galerie Rudolph Zwirner, Köln) 1981 *Five Heads,* Willard Gallery, New York · Akron Art Museum, Ohio 1982 Stedelijk Museum, Amsterdam 1983 Willard Gallery, New York 1983/85 Los Angeles County Museum of Art, Los Angeles (San Francisco Museum of Art; Carnegie Institute , Pittsburgh; Institute of Contemporary Art, Boston; Aspen Center for the Visual Arts, Colorado; Detroit Institute of Arts; Tate Gallery, London; Virginia Museum of Fine Arts, Richmond 1984 Barbara Krakow Gallery, Boston · Davison Art Center Gallery, Wesleyan University, Middletown, Connecticut · *Currents,* Instiute of Contemporary Art, Boston 1985 *Centric 13: Susan Rothenberg – Works on Paper,* University Art Museum, California State Center, Long Beach (Des Moines Art Center, Iowa) · Willard Gallery, New York · *Prints,* Des Moines Art Center, Iowa · *Prints,* A.P. Giannini Gallery, San Francisco · The Phillips Collection, Washington, DC (Portland Visual Arts Center, Oregon) · *New Prints,* Gemini G.E.L., Los Angeles 1987 *The Horse Paintings,* Larry Gagosian Gallery, New York · Sperone Westwater, London · *Heads, Hands, Horses: Susan Rothenberg Prints,* University of Iowa Museum, Iowa City 1988 *Drawing Now: Susan Rothenberg,* Baltimore Museum of Art, Maryland · *Drawings,* Galerie Gian Enzo Sperone, Roma 1990 Sperone Westwater, New York · Rooseum Center for Contemporary Art, Malmö

Gruppenausstellungen | Group exhibitions

1986–88 *Individuals,* Museum of Contemporary, Los Angeles 1986–90 *Focus on the Image, Selections from the Rivendell Collection,* Phoenix Art Museum, Arizona (et al.) 1987 *Prints,* Willard Gallery, New York · *The Presence of Nature – Some American Paintings,* Barbara Krakow Gallery, Boston 1987–88 *The Monumental Image,* University Art Gallery, Sonoma State University, California (et al.) · *Lead,* Hirschl & Adler Modern, New York 1987–1991 *The International Art Show for the End of World Hunger,* Minnesota Museum of Art, Saint Paul 1988 *Artist Series Project,* New York City Ballet, New York · *The M. Anwar Kamal Collection of Art: Printmaking: Late Nineteenth and Twentieth Century,* Cummer Gallery of Art, Jacksonville, Florida · *1988 – The World of Art Today,* The Milwaukee Art Museum, Wisconsin · *Gordon Matta-Clark and Friends,* Galerie Lelong, New York · *Jennifer Bartlet, Elizabeth Murray, Eric Fischl, Susan Rothenberg,* Saatchi Collection · *Works on Paper,* John Berggruen Gallery, San Francisco 1990 *Art in Europe & America: The 1960s & 1970s,* Wexner Center for the Visual Arts, Ohio State University, Columbus · *Exhibition of Work by Newly Elected Members and Recipients of Awards,* American Academy and Institute of Arts and Letters, New York · *Artist for Amnesty,* Blum Helman Gallery and Germans van Eck Gallery, New York · *Line & Action,* Tavelli Gallery, Aspen, Colorado 1991 *Dead Heros, Disfigured Love,* Lorence-Monk Gallery, New York · *Drawings Conclusions,* Molica Guidarte Gallery, New York · *Summer Group Exhibition,* Sperone Westwater, New York · *Sieben Amerikanische Maler,* Staatsgalerie Moderner Kunst Bayerische Statsgemäldesammlungen, München · *Mito y Magia en America: Los Ochenta,* Museo de arte contemporaneo, Monterrey, Mexico

Bibliographie | Bibliography

Texte von der Künstlerin
Texts by the artist
Diffusions – A Project for Artforum, in: Artforum, Nr. 8, April, 1988

Periodika | Periodicals
Kenneth **Baker,** *Carnegie International,* in: Artforum, März, 1989 · Achille **Bonito Oliva,** *Spostamenti Allegorici dell'Arte,* in: Tema Celeste, Nr. 10, Januar/März, 1987 · Dan **Cameron,** *Opening Salvos, Part One,* in: Arts Magazine, Nr. 4, Dezember, 1987 · Cecilia **Casorati,** *Rome and Naples,* in: Contemporanea, Nr. 2, Juli/August, 1988 · Laura **Cottingham,** *Susan Rothenberg – Sperone Westwater,* in: Flash Art International, Nr. 138, Januar/Februar, 1988 · Brian **D'Amato,** *Susan Rothenberg: Sperone Westwater,* in: Flash Art, Oktober, 1990 · Ginger **Danto,** *What Becomes an Artist Most,* in: Art News, Nr. 9, 1987 · April **Gornick,** Freya **Hansell,** *Susan Rothenberg, Three Painters,* in: Bomb, Nr. 23, Frühjahr, 1988 · Ellen **Handy,** *Mysteries of Motion: Recent Paintings by Susan Rothenberg,* in: Arts Magazine, Mai, 1990 · Alan J. **Hanson,** *Susan Rothenberg: Sperone Westwater Gallery,* in: Contemporanea, September, 1990 · Eleanor **Heartney,** *How Wide is the Gender Gap,* in: Artnews, Nr. 6, Sommer, 1987 · Eleanor **Heartney,** *Susan Rothenberg: Sperone Westwater,* in: Artnews, Oktober, 1990 · Robert **Hughes,** *Spectral Light, Anxious Dancers,* in: Time Magazine, Nr. 19, 9. November, 1987 · Dodie **Kazanjian,** *New Image,* in: Vogue, Mai, 1990 · Donald **Kuspit,** *Gordon Matta-Clark – Josh Baer Gallery, Galerie Lelong,* in: Artforum, Sommer, 1988 · Ann **Lumbye** Sorensen, *Susan Rothenberg: The Rooseum,* in: Contemporanea, Nr. 23, Dezember, 1990 · Lenore **Malen,** *Susan Rothenberg,* in: Art News, Januar, 1988 · Peter **Plagens,** *Under Western Eyes,* in: Art in America, Januar, 1989 · Barry **Schwabsky,** in: Arts Magazine, Nr. 8, April, 1987 · Phyllis **Tuchman,** *Rothenberg's Dancers: Serial Image of Figures In Motion: The Subject of New Murals,* in: View: The Photojournal of Art, Juni/Juli, 1989 · Theodore F. **Wolff,** *The power and influence in today's art world,* in: The Christian Science Monitor, 20. April, 1987 · John **Yau,** in: Artforum, Nr. 8, April, 1987

Film
Four Artists, Michael Blackwood, Produktion: Michael Blackwood Productions, Premiere: Solomon R. Guggenheim Museum, New York, 18. Mai 1988

ULRICH RÜCKRIEM

*Düsseldorf (D), 1938
Lebt/Lives in Köln

Einzelausstellungen | One-man exhibitions

1964 Domgalerie, Köln · *Skulpturen in Stein und Holz,* Leopold-Hoesch-Museum, Düren (Kat.: H. Appel) 1967 Galerie Ad Libitum, Antwerpen 1968 Galerie Tobiès & Silex, Köln 1969 Galerie Ernst, Hannover · Galerie Konrad Fischer, Düsseldorf · Galerie Ricke Köln 1970 *Steine und Eisen,* Museum Haus Lange, Krefeld (Kat.: P. Wember) 1971

Kabinett für aktuelle Kunst, Bremerhaven · Galerie Ernst, Hannover · Galerie Konrad Fischer, Düsseldorf · Mayfair Gallery, London · Galerie Paul Maenz, Köln · Videogalerie Gerry Schum, Düsseldorf 1972 Paula Cooper Gallery, New York · 14x14, Staatliche Kunsthalle, Baden-Baden 1973 Kunsthalle, Tübingen · Städtisches Museum, Mönchengladbach 1974 Kunstverein, Frankfurt/M. · Kunstraum, München (Kat.: H. Kern) · Galerie Preisig, Basel · Galerie Paul Maenz, Köln · Galerie Konrad Fischer, Düsseldorf 1975 Lisson Gallery, London · Galerie Preisig, Basel · Galerie Durand-Dessert, Paris · Art & Project, Amsterdam 1976 Museum of Modern Art, Oxford (Beilage: *The Oxford Multiple*) 1977 *Skulpturen 1968–1976*, Stedelijk Van Abbemuseum, Eindhoven (Kat.: R.H. Fuchs) · Galerie Konrad Fischer, Düsseldorf · *Sämtliche Auflagenobjekte und Druckgraphiken*, Galerie Erhard Klein, Bonn (Kat.: J. Cladders) 1978 Galerie Hetzler & Keller, Stuttgart · *Skulpturen 1968–1978*, Museum Folkwang, Essen/Städtisches Kunstmuseum, Bonn (Kat.: R. H. Fuchs, erweiterte Ausgabe von Kat. Eindhoven) 1979 Kunsthalle, Bielefeld (Kat.: M. Pauseback) · Kabinett für aktuelle Kunst, Bremerhaven · Mannheimer Kunstverein, Mannheim · Westfälischer Kunstverein, Münster (Kat.: T. Deecke) · Stichting, Eindhoven · Sperone Westwater Fischer Gallery, New York · Graeme Murray Gallery, Edinburgh · Galerie Durand-Dessert, Paris 1980 Galerie Konrad Fischer, Düsseldorf · Kunstraum, München · Galerie Max Hetzler, Stuttgart · Galerie Erhard Klein, Bonn 1981 *New Works*, Fort Worth Art Museum, Fort Worth (Kat.: M. Goldwater) · Galerie Konrad Fischer, Zürich 1982 Galerie Nordenhake, Malmö 1983 *Sculpture*, Centre Georges Pompidou, Paris (Kat.: B. Blistène, L. Glozer, F. Heubach, U.R.) · Raum für Kunst, Hamburg 1984 Galerie Konrad Fischer, Düsseldorf · *Skulpturen*, Städtische Galerie im Städel, Frankfurt/M. (Kat.: L. Glozer, H. Kersting) · *Skulpturen für Hamburg*, Produzentengalerie, Hamburg (Kat.: W. Hofmann) · Kamakura Gallery, Tokyo (Kat.: Y. Nakahara) 1985 Galerie Wilkens und Jacobs, Köln · Westfälisches Landesmuseum, Münster (Kat.: B.H.D. Buchloh, U. Franke, F. Meschede) · *Zeichnungen 1978–1985*, Galerie Erhard Klein, Bonn (Kat.: F. Meschede) · Staatliche Kunstsammlung, Neue Galerie, Kassel 1986 Galerie Konrad Fischer, Düsseldorf · Kröller-Müller Museum, Otterlo · *3 Skulpturen*, Galerie Löhrl, Mönchengladbach (Kat.: F. Meschede) · *Multiples und Druckgraphik 1969–1985. Sammlung Jacobs*, Kunstverein, Freiburg i. Br. (Kat.: F. Meschede) 1987 Donald Young Gallery, Chicago (Kat.: B. H. D. Buchloh, D. Soutif · Kunstsammlung Nordrhein-Westfalen, Düsseldorf · Kölnischer Kunstverein, Köln · Städtisches Museum Abteiberg, Mönchengladbach · Halle von Ulrich Rückriem, Köln ·

Galerie Erhard Klein, Bonn 1988 Galerie Jean Bernier, Athinai · Galerie Emmerich Baumann, Zürich · Blau-Gelbe Galerie im Niederösterreichischen Landesmuseum, Wien (Kat.) · Hoffman & Borman Gallery, Santa Monica · *Van steen tot steen*, Diepenheim (Kat.: E. Marcus) · Halle der Städelschule, Frankfurt/Daimlerstrasse · Galerie Wilkens & Jacobs, Köln · Donald Young Gallery, Chicago · Galerie Tschudi/Glarus · 1989 Galerie Nordenhake, Stockholm · Brooke Alexander Gallery, New York · Palacio de Cristal, Reina Sofia, Madrid (Kat.: R.H. Fuchs) · Galerie Erhard Fischer, Düsseldorf · Galerie Erhard Klein, Bonn · Edition Schellmann, München · Galerie Tschudi, Glarus · The Barn, Clonegal (Ireland) · Galerie Durand-Dessert, Paris 1990 Galerie Grässlin-Ehrhardt, Frankfurt/M. · The Henry Moore Sculpture Trust, Dean Clough, Halifax · Halle Frankfurt, Daimlerstrasse · Grimaldis Gallery, Baltimore · Galleria Alfonso Artiaco, Pozuoli/Napoli · Galerie Sven Heier, Köln · Galerie Jean Bernier, Athinai · Galerie Tschudi, Glarus 1991 Centre d'Art Contemporain, Genève · Kunstmuseum, Winterthur (Kat.: D. Schwarz) · Galerie Durand-Dessert, Paris · *Werkzeichnungen*, Serpentine Gallery, London (Kat.: D. Batchelor) 1992 Galerie Durand-Dessert, Paris · Galerie Jule Kewenig, Frechen (Kat.: H. Kerstning)

Gruppenausstellungen | Group exhibitions

1987 *documenta 8*, Kassel · *Skulptur Projekte Münster*, Westfälisches Landesmuseum, Münster · *Standing Sculpture*, Castello di Rivoli, Rivoli (Torino) 1988 *Zeitlos*, Hamburger Bahnhof, Berlin 1989 Galerie Grässlin-Ehrhardt, Frankfurt/M. · *Bienal de São Paulo* 1990 *Zeitzeichen, Stationen Bildender Kunst in Nordrhein-Westfalen*, Wilhelm-Lehmbruck-Museum (et al.) · Donald Young Gallery, Chicago · Galerie Lelong, New York 1991 *Brennpunkt 2 1970 1991*, Kunstmuseum, Düsseldorf 1992 Liliane & Michel Durand-Dessert, Paris

Bibliographie | Bibliography

Texte und Bücher vom Künstler
Texts and books by the artist
[über seine Arbeitsprinzipen], in: Skulpturen, 1973 · [über seine Skulptur für die Biennale], in: Kat. Venezia, 1978 · *Sein Kunstwerk auf der Strasse inszeniert! Demonstranten als Komparsen missbraucht*, in: Kat. Für Jochen Hiltmann: ein Solidaritätsausstellung, Stedelijk Van Abbemuseum, Eindhoven, 1979 · *Ich lege keine Musterkarte vor. Über Wettbewerbe und Kunst am Bau*, in: Der Spiegel, 50, 8. Dezember, 1980 · [über Stephan Balkenhol und figürliche Skulptur], in: Kat. Stephan Balkenhol, Ausstellungshallen Mathildenhöhe, Darmstadt, 1985 · *Bildstock*, Dezember, 1985. Faltblatt *Des sculptures pour le domaine de Kerguéhennec*, Domaine de Kerguéhennec-en-Bignan.

Bücher | Books
Ulrich Rückriem Skulpturen 1968–1973, Köln, Verlag M. DuMont Schauberg, 1973 · *Texte über Ulrich Rückriem*, Kunstsammlung Nordrhein-Westfalen Düsseldorf/Kölnischer Kunstverein/Städtisches Museum Abteiberg Mönchengladbach, 1987 · *Ulrich Rückriem Skulpturen fotografiert von Thomas Struth*, Kunstsammlung NRW, Düsseldorf/ Kölnischer Kunstverein, Köln/Städ-

tisches Museum Abteiberg, Mönchengladbach · Jürgen **Hohmeyer**, *Ulrich Rückriem*, München, Verlag Silke Schreiber, 1988

Periodika | Periodicals
Pier Luigi **Tazzi**, *Romancing the stone*, in: Artforum, September, 1990 · Peter **Winter**, *Der Stein ist die Figur: Ulrich Rückriem*, in: Weltkunst, Nr. 8, 15. April, 1988

THOMAS RUFF

*Zell am Harmersbach (D), 1958
Lebt/Lives in Düsseldorf

Einzelausstellungen | One-man exhibitions

1981 Galerie Rüdiger Schöttle, München 1984 Galerie Rüdiger Schöttle, München · Galerie Konrad Fischer, Düsseldorf 1986 Galerie Philip Nelson, Villeurbanne 1987 Galerie Johnen & Schöttle, Köln · Galerie Sonne, Berlin · Galerie Rüdiger Schöttle, München · Galerie Crousel-Robelin, Paris 1988 *Portaits*, Museum Schloß Hardenberg, Velbert (et al.) (Kat.: K.König, C.Will) · Portikus, Frankfurt/M. · Mai 36 Galerie, Luzern · Ydessa Hendeles Art Foundation, Toronto 1989 Galerie Bebert, Rotterdam · Cornerhouse, Manchester · Galerie Philip Nelson, Lyon · 303 Gallery, New York · XPO Galerie, Hamburg · Galerie Johnen & Schöttle, München · Stichting De Appel, Amsterdam · Galerie Rüdiger Schöttle, München · Galerie Pierre Huber, Genève · *Porträts, Häuser, Sterne*, Stedelijk Museum, Amsterdam (Le Magasin, Grenoble; Kunsthalle, Zürich) (Kat.: E. Barents, W. Beeren) 1990 Galerie Sonne, Berlin · *Häuser*, Mai 36 Galerie, Luzern · Galerie Crousel-Robelin-Bama, Paris · Stuart Regen Gallery, Los Angeles · 303 Gallery, New York 1991 Kunstverein Bonn/ Kunstverein Arnsberg; Kunstverein Braunschweig, Kunst + Projekte, Galerie der Stadt Sindelfingen · Galerie Johnen & Schöttle, Köln · Galerie Lia Rumma, Napoli · Galerie Johnen & Schöttle, Köln · Galerie Rüdiger Schöttle, Paris · Galerie Turske & Turske, Zürich

Gruppenausstellungen | Group exhibitions

1987 *Foto/Realismen*, Villa Dessauer, Bamberg (et al.) 1988 *BiNationale*, Städtische Kunsthalle, Kunstsammlung Nordrhein-Westfalen, Kunstverein für die Rheinlande und Westfalen, Düsseldorf (et al.) 1989 *Acquisitations 1989*, Centre National des Arts Plastiques, Paris · *Just look at*, Museum van Hedendaagse Kunst, Stadsgalerij, Heerlen 1990 *Weitersehen*, Museum Haus Lange und Haus Esters, Krefeld 1991 *Surgence. La création photographique contempo-*

raine en Allemagne, Comédie de Reims, Reims · *Metropolis*, Martin-Gropius-Bau, Berlin · *AnniNovanta*, Galleria Comunale d'Arte Moderna, Bologna · *Aus der Distanz*, Kunstsammlung Nordrhein-Westfalen, Düsseldorf · *Histoire d'Oeil*, Espace Lyonnais d'Art Contemporain/Nouveau Musée de Villeurbanne · Museum of Contemporary Photography, Chicago · *La revanche de l'image*, Galerie Pierre Huber, Genève · *Entre terre et ciel*, Hôpital Ephèmère, Paris · *Typologies: Nine Contemporary Photographers*, Newport Harbor Art Museum, Newport Beach/Akron Art Museum · *7 Women*, Andrea Rosen Gallery, New York · *Solaris*, Galerie Mai, Luzern · 303 Gallery, New York · *Interieurs*, Galeries Croussel-Robelin, Paris · *Sguardo di medusa*, Castello di Rivoli, Rivoli (Torino) · Stuart Regen Gallery, Los Angeles · Museum für Gegenwartkunst, Basel · *Neuerwerbungen*, Städtische Galerie im Lenbachhaus, München

Bibliographie | Bibliography

Periodika | Periodicals
Lucie **Beyer**, *Thomas Ruff, Johnen & Schöttle, Cologne*, in: Flash Art, Mai, 1987 · Nicolas **Bourriaud**, *The trailer effect*, in: Flash Art, November/Dezember, 1989 · Nicolas **Bourriaud**, *Lignes de Mire, Fondation Cartier*, in: Art Press, Nr. 148, 1990 · Jean-François **Chevrier**, *Faces*, in: Galeries Magazine, April/März, 1990 · R. **Dank**, *Zur Durchsetzung am Markt*, in: Kunstforum, Dezember/Januar, 1987/1988 · J. **Dornberg**, *Thomas Ruff*, in: Artnews, April, 1989 · Régis **Durand**, *Maniérismes contemporains*, in: Art Press, Februar, 1988 · Trevor **Fairbrother**, Norman Bryson, *Thomas Ruff: spectacle and surveillance/Spektakel und Uberwachung*, in: Parkett, Nr.28, 1991 · Raija **Fellner**, *Thomas Ruff. Portraits*, in: Artefactum, November/Dezember/Januar, 1988/89 · Robert **Fleck**, *Thomas Ruff/Galerie Crousel-Robelin-Bama*, in: Flash Art, März/April, 1991 · Marc **Freidus**, *Lack of Faith /Fehlender Glaube*, in: Parkett, Nr. 28, 1991 · Isabelle **Graw**, *Bernhard Becher's Students. Johnen & Schöttle, Cologne*, in: Flash Art, November/Dezember, 1988 Isabelle **Graw**, *Aufnahmeleitung. Ein Interview*, in: Artis, Oktober, 1989 · Isabelle **Graw**, *Bildbesprechung*, in: Artis, Februar, 1990 · Catherine **Grout**, *Arena*, in: Inernational Art, Juni, 1989 · Manfred **Hermes**, *Doppelgänger*, in: Artscribe, März/April, 1988 · Manfred **Hermes**, *Repetition, Disguises, Documents. How Photography has pervaded two Decades of Contemporary German Art*, in: Flash Art, Oktober, 1989 · F.A. **Hettig**, *Thomas Ruff*, in: Das Kunstwerk, März, 1990 · Julian **Heynen**, *Thomas Ruff*, in: Das Kunstwerk, Januar, 1989 · Jörg **Johnen**, *Fremde Gesichter, Ferne Sterne/Street and interior*, in: Parkett, Nr.28, 1991 · Eva **Karcher**, *Thomas Ruff. Galerie Rüdiger Schöttle, München*, in: Das Kunstwerk, Dezember, 1987 · Jutta **Koether**, *A report from the Field*, in: Flash Art, Sommer, 1988 · Gregorio **Magnani**, *Second Generation. PostPhotography*, in: Flash Art, März/April, 1988 · Gregorio **Magnani**, *Thomas Ruff. Schloß Hardenberg, Velbert*, in: Flash Art, Sommer, 1988 · Gregorio **Magnani**, *Ordening procedures*, in: Arts Magazine, März, 1990 · Helga **Meister**, *Mit Licht, kühlem Blick und Methode*, in: Art, Oktober, 1989 · Annelie **Pohlen**, *Deep Surface*, in: Artforum, April, 1991 · D. **Rimanelli**, *Thomas Ruff, 303 Galle-

ry*, in: Artforum, Januar, 1991 · Meyer Raphael **Rubinstein**, *Apollo in Düsseldorf. The Photographs of Thomas Ruff*, in: Arts Magazine, Oktober, 1988 · Jérôme **Sans**, *Thomas Ruff, Crousel-Robelin, Paris*, in: Flash Art, März/April, 1988 · Karlheinz **Schmid**, *Kühl, karg und immer in Serie*, in: Art, November, 1987 · Karlheinz **Schmid**, *Thomas Ruff: Ein Foto muß es zweimal geben. Ein Gespräch mit Thomas Ruff*, in: Kunstforum, September/Oktober, 1989 · E. **Troncy**, *Thomas Ruff, Galerie Crousel-Robelin-Bama*, in: Art Press, Januar, 1988 · M. **Winzen**, *Thomas Ruff at Portikus*, in: Art in America, Dezember, 1988 · Thomas **Wulffen**, *Thomas Ruff, Galerie Nikolaus Sonne, Berlin*, in: Artscribe, Mai, 1990 · J. **Zellen**, *Thomas Ruff*, in: Arts Magazine, Januar, 1991 · Ingrid **Burgbacher-Krupka**, Gianluigi Caravaggio, *Thomas Ruff. Der schöne Schein einer fragmentarischer Welt*, in: Zyma, Jg. 9, Nr. 5, Dezember 1991/Januar 1992

STEPHAN RUNGE

*Barkhausen (D), 1947
Lebt/Lives in Köln

Einzelausstellungen | One-man exhibitions

1975 Galerie Klein, Bonn · Studio Oppenheim, Köln **1977** Studio Oppenheim, Köln **1978** Galerie Müller, Köln **1980** Galerie Forme, Frankfurt/M · Galerie Müller, Köln · *Oxymoren*, Kunstverein Krefeld **1981** Galerie Müller, Köln · Galerie Tanja Grunert, Stuttgart · Kunstverein, Krefeld **1982** Galerie Tanja Grunert, Stuttgart · Galerie Müller, Köln **1983** Galerie Toni Gerber, Bern **1984** Galerie Müller, Köln · Galerie Tanja Grunert, Stuttgart **1985** Städtisches Kunstmuseum, Bonn/ Museum van Hedendaagse Kunst, Gent (Kat.: A. M. Fischer, J. Hoet) **1986** Galerie Dietmar Werle, Köln **1987** Galerie Dietmar Werle, Köln **1988** Galerie Dietmar Werle, Köln · Nordjyllands Kunstmuseum Aalborg, Aalborg (Kat.: E. Bülow) **1989** Galerie Dietmar Werle, Köln · Mata, Museo Arte Moderna, São Paolo · Eisenraum Kunst Museum, Düsseldorf **1990** Galerie Claudine Papillon, Paris · Galerie Klein, Bonn · Galerie Dietmar Werle, Köln **1991** Staatliche Kunsthalle, Baden-Baden (Kat.: A. Beckmann, Jochen Poetter) · Galerie Claudine Papillon, Paris

Gruppenausstellungen | Group exhibitions

1987 *Exotismus*, Württembergischer Kunstverein, Stuttgart · *Brennpunkt*, Kunstmuseum, Düsseldorf (et al.) · Nordjyllands Kunstmuseum Aalborg · Lijewalchs Konsthall, Stockholm · Malmö Konsthall ·

Medien Mafia, Düsseldorf Hafen **1988** *Meine Zeit mein Raubtier*, Kunstmuseum, Ehrenhof, Düsseldorf · *Internationale Biennale der Papierkunst*, Düren · *Zeichnungen*, Kunstverein Kobenhavn & Horsens **1989** Kyoto Museum, Kyoto Azabu Museum, Tokyo **1990** *Vincent zuliebe – van Gogh zu Ehren*, Kasseler Kunstverein, Kassel · *Kombination*, Galerie Müller, Köln

Periodika | Periodicals
Johannes **Meinhardt**, *Stephan Runge*, in: Kunstforum, Bd. 115, September/Oktober, 1991

EDWARD RUSCHA

*Omaha/Nebraska (USA), 1937
Lebt/Lives in Los Angeles

Einzelausstellungen | One-man exhibitions

1963 Ferus Gallery, Los Angeles **1964** Ferus Gallery, Los Angeles **1967** *Gunpowder Drawings*, Alexander Iolas Gallery, New York **1968** Irving Blum Gallery, Los Angeles · Galerie Rudolf Zwirner, Köln **1969** *New Graphics*, Multiples, Inc., Los Angeles · La Jola Museum of Art, La Jolla **1970** Alexander Iolas Gallery, New York (Kat.) · *Books by Edward Ruscha*, Galerie Heiner Friedrich, München (Kat.) · *Prints 1966–1970/Books 1962–1970*, Hans Fuller Gallery, San Francisco · Galerie Alexandre Iolas, Paris **1971** *Books*, Nigel Greenwood, London · Contract Graphics Gallery, Houston **1972** Corcoran & Corcoran Gallery, Coral Gables · *Colored People*, Leo Castelli, New York · D-M Gallery, London · *Drawings*, Leo Castelli, New York · *Books and Prints*, Mary Porter Sesnon Gallery, University of California, Santa Cruz · Janie C. Lee Gallery, Dallas · Minneapolis Institute of Arts, Minneapolis (Kat.) **1973** Ace Gallery, Los Angeles · *Books by Edward Ruscha*, University of California, San Diego · *Drawings*, Leo Castelli Gallery, New York · *Graphics from the Collection of Donald Marron*, Leo Castelli, New York · Projection/ Ursula Weevers, Köln · The Greenberg Gallery, Saint-Louis, Saint Louis · *Edward Ruscha/Ed-werd Rew-shay/Young Artist*, John Bergruen Gallery, San Francisco · Nigel Greenwood Inc., London · *Stains/Edward Ruscha*, Françoise Lambert, Milano · *Works by Edward Ruscha from the Collection of Paul J. Schupf ›58*, The Picker Gallery, Colgate University, Hamilton, New York (Kat.) **1974** *Books by Edward Ruscha*, Françoise Lambert, Lambert · *Contemporary Graphics Center*, Santa Barbara Museum of Art, Santa Barbara · *Prints and Books*, Root Art Center, Hamilton College, Clinton (Kat.) · Golden West Colege, Huntington Beach, California · H. Peter Findlay/ Works of Art, New York · Leo Castelli, New York · *Recent Paintings*, The Texas Gallery, Houston **1975** *Drawings/Selected Prints*, The Glaser Gallery, La Jolla · *Prints and Publications 1962–74*, The Arts Council of Great-Britain (et al.) (Kat.) · *Miracle and Premium film screening*, Fox Venice Theatre, Venice · Galerie Ricke, Köln · Jared Sable Gallery Ltd., Toronto · *Miracle*, Leo Castelli (Rizzoli Screening Room), New York · Northlight Gallery, Arizona State University, Tempe (books) · *Tropical Fish Series*, Gemini G.E.L., Los Angeles · University of

North Dakota Art Galleries, Grand Forks · *Various drawings,* Ace Gallery, Vancouver · *Various Miracles,* Ace Gallery, Los Angeles **1976** Dootson/Calderhead Gallery, Seattle, Washington · *Exhibition and Presentations,* Institute of Contemporary Art, Los Angeles · Institute of Contemporary Arts, London · *Paintings, Drawings and Other Work by Edward Ruscha,* Albright-Knox Art Gallery, Buffalo (Kat.) · Sable Castelli Gallery Ltd., Toronto · Stedelijk Museum, Amsterdam (Kat.) · *Various Cheeses Series,* Gemini G.E.L., Los Angeles · Wadsworth Atheneum, Matrix Gallery, Hartford, Connecticut (Kat.) **1977** Ace Gallery, Venice/Los Angeles · *Recent Drawings,* Elmwood Arts Foundation/The Fort Worth Museum, Fort Worth, Texas · Castelli Graphics, New York · University of Lethbridge, Alberta, Canada **1978** *A Selection of Paintings and Pastels 1974–1977,* MTL Gallery, Bruxelles · Castelli Uptown, New York · *Books,* Rüdiger Schöttle, München · *Prints and Drawings,* Ace Gallery, Vancouver · Galerie Ricke, Köln · *Graphic Works by Edward Ruscha,* Auckland City Art Gallery, Auckland, New Zealand, (Kat.) · Peppers Art Gallery, University of Redlands, Redlands, California **1979** *New Works,* The Texas Gallery, Houston · *Neue Ausstellungen im Ink.,* Hallen für internationale neue Kunst, Zürich (Kat.) · *New Works,* Marianne Deson Gallery, Chicago · *New Works,* Richard Hines Gallery, Seattle, Washington **1980** *Paintings,* Ace Gallery, Venice · *Paintings and Drawings,* Portland Center for the Visual Art, Los Angeles (Kat.) · Castelli, Goodman, Solomon, Easthampton, New York · *Drawings,* Leo Castelli, New York **1982** *A Selection of Drawings from 1967 to 1972,* John Berggruen Gallery, San Francisco · *New Drawings,* castelli Uptown, New York · *Edward Ruscha: 1960–1970,* Castelli, Feigen, Corcoran, New York · *New Paintings and Drawings,* Flow Ace Gallery, Los Angeles *The works of Edward Ruscha,* San Francisco Museum of Modern Art, San Francisco (Whitney Museum of American Art, New York; Vancouver Art Gallery, British Columbia; The San Antonio Museum of Art, San Antonio; Los Angeles County Museum of Art, Los Angeles) (Kat.) **1983** Contemporary Arts Museum, Houston · Bernard Jacobson Gallery, Los Angeles · *Selection of Graphic Works 1970–1982,* Cirrus Editions, Ltd., Los Angeles · Galleria del Cavallino, Venezia · *Drawings and Prints,* Route 66, Philadel-

phia, Pensylvania **1984** Leo Castelli, New York · Morgan Gallery, Kansas City **1985** Fisher Gallery, University of Southern California, Los Angeles · Galerie Gilbert Brownstone, Paris · James Corcoran Gallery, Los Angeles · *Octobre des Arts,* Musée St. Pierre, Lyon (Kat.: B. Brunon, T. Raspail, P. Schjeldahl) · Tanja Grunert, Köln **1986** Fuller Goldeen Gallery, San Francisco · Galerie Susan Wyss, Zürich · Janie Beggs Fine Arts, Ltd., Aspen, Colorado · Leo Castelli, New York · Texas Gallery, Houston · *4x6,* Westfälischer Kunstverein, Münster (Kat.) **1987** *Drawings 1962–1972,* Acme Art, San Francisco · *Drawings Through the Years,* Cirrus Gallery, Los Angeles · Leo Castelli, New York · Robert Miller Gallery, New York (Kat.) **1988** *Early Paintings,* Tony Shafrazi Gallery, New York (Kat.) · *Recent Paintings,* Museum of Contemporary Art, Chicago · *Recent Works on Paper 1988,* Karsten Schubert Gallery, London (Kat.) · Gallery Takagi Nagoya, Japan · Galerie Susan Wyss, Zürich · Henry Vincent Gallery, San Diego · Institute of Contemporary Art, Nagoya (Kat.) · Leo Castelli, New York · *Words Without Thoughts Never to Heaven Go,* Lannan Museum, Lake Worth, Florida (Kat.: B. Clearwater, C. Knight) **1989** Leo Castelli, New York · James Corcoran Gallery, Santa Monica · Rhona Hoffman Gallery, Chicago · Touko Museum of Contemporary Art, Tokyo (Kat.) · *Drawings and Prints,* Thomas Babeor Gallery, La Jolla · *Paintings,* Centre Georges Pompidou, Paris (Museum Boymans-van Beuningen; Fundació Caixa de Pensions, Barcelona) (Kat.: B. Blistène, D. Cameron, E. de Groot, Pontus-Hulten) **1990** Serpentine Gallery, London · The Museum of Contemporary Art, Los Angeles **1991** Galerie Carola Mösch, Berlin

Gruppenausstellungen | Group exhibitions,

1987 *Biennial Exhibition,* Whitney Museum of Contemporary Art, New York · *Comic Iconoclasm,* Institute of Contemporary Arts, London · *Leo Castelli y Sus Artistas,* Centro Cultural Arte Contemporaneo, Mexico City · *Los Angeles Today: Contemporary Visions,* Amerika Haus, Berlin (et al.) · *Made in the U.S.A.: Film Artists in the '50s and 60s/Artists Use · Film: Films by Oldenburg, Rauschenberg and Ruscha,* Pacific Film Archive, University of California, Berkeley · *The New Romantic Landscape,* Whitney Museum of American Art, Fairfield County, Stamford · *Pop Art: U.S.A./U.K.,* Odakyu Grand Gallery Tokyo; Daimaru Museum of Fine Art, Osaka (et al.) **1988** *Absolut Sekt,* Galerie Heland Wetterling, Castelli Graphics, New York · *L'ABCD de l'art moderne: 21 peintures + 1 sculpture,* Stedelijk Museum à l'institut néerlandais, Paris · *Lost and Found in California/Four Decades of Assemblage Art,* Pence Gallery, Santa Monica **1989** *Drawings, Günther Förg, Georg Herold, Ed Ruscha, Christopher Wool,* Karsten Schubert Gallery, London · *L. A. Pop in the Sixties,* Newport Harbor Art Museum, Newport Beach · *Prospect 89,* Frankfurter Kunstverein, Frankfurt/M. · *Selected Works From the Frederick R. Weisman Collection,* Wight Art Gallery, University of California, Los Angeles · *Sigmund Freud heute,* Thadaeus Ropac, Salzburg · *Words,* Tony Shafrazi Gallery, New York **1990** *Now see here !,* Wellington City Art Gallery, Wellington · **1990** *The Readymade Boomerang,*

Biennale of Sydney, Art Gallery of New South Wales, Millers Point **1991** *De woorden en de beelden/The words and images,* Centraal Museum, Utrecht **1991** *Metropolis,* Martin-Gropius-Bau, Berlin · *Buchstäblich,* Van der Heydt-Museum, Wuppertal/Kunsthalle Barmen/Wuppertal Elberfeld

Bibliographie | Bibliography

Texte und Bücher vom Künstler | Texts and books by the artist
Twenty-six Gasoline Stations, 1963 · Various Small Dires and Milk, 1964 · Some Los Angeles Apartments, 1965 · Every Building on the Sunset Strip, 1966 · Thirtyfour Parking Lots in Los Angeles, 1967 · Royal Road Test (in collaboration with Mason Williams, Patrick Blackwell), 1967 · Business Cards (in collaboration with Billy Al Bengston), 1968 · Nine Swimming Pools and a Broken Glass, 1968 · Stains, Hollywood, Heavy Indusry Publications, 1969 · Crackers, Story by Mason Willias, Hollywood, Heavy Industry Publications, 1969 · Babycakes, New York, Multiples Inc., 1970 · Real Estate Opportunities, 1970 · A Few Palm Trees, Hollywood, Heavy Industry Publications, 1971 · Records, Hollywood, Heavy Industry Publications, 1971 · Dutch Details, Deventer, Octopus Foundation for Sonsbeek, 1971 · Colored People, 1972 · Edward Ruscha, Book accompanying the exhibition of prints, drawings, books, Minneapolis, The Minneapolis Institute of Arts, 1972 · Hard Light, in collaboration with Lawrence Weiner, Hollywood, Heavy Industry Publications, 1978 · *Guacamole Airlines,* New York, Harry N. Abrams, 1980

Periodika | Periodical
Bill **Berkson,** in: Artforom, Nr. 5, Januar, 1987 · Fred **Fehlau,** *(Interview),* in: Flash Art, Nr. 138, Januar/Februar, 1988 · Eleanor **Heartney,** *Ed Ruscha at Robert Miller and Castelli,* in: Art in America, Bd. 76, Februar, 1988 · A. **Jan,** in: Flash Art, Nr. 132, Februar/März, 1987 · Donald **Kuspit,** *Edward Ruscha,* in: Artforum, Bd. 26, Februar, 1988 · E. **Turner,** *To read or not to read,* in: Art News, Bd. 87, Sommer, 1988 · in: Parkett, Nr. 18, 1988

Film
1970 *Premium,* 24 Min., Farbe/Ton, 16 mm · **1975** *Miracle,* 28 Min., Farbe/Ton, 16 mm

REINER RUTHENBECK

*Velbert (D), 1937
Lebt/Lives in Düsseldorf

Einzelausstellungen | One-man exhibitions

1967 Charlottenborg, Kobenhavn · Galerie Heiner Friedrich, München · Verlaghaus DuMont Schauberg, Köln **1968** Galerie Konrad Fischer, Düsseldorf · White Wide Space Gallery, Antwerpen **1969** Galerie Konrad Fischer, Düsseldorf · *Blockade 69,* Galerie René Block, Berlin · Galerie Heiner Friedrich, München **1970** Galerie Konrad Fischer, Düsseldorf · *Gegenverkehr,* Aachen (Kat.: K. Honnef) · Galerie Ernst, Hannover **1971** Galerie Heiner Friedrich, München · Kabinett für aktuelle Kunst, Bremerhaven (Westfälischer Kunstverein, Münster) **1972**

Galerie Konrad Fischer · Städtisches Museum, Mönchengladbach · Stedelijk Museum, Amsterdam 1973 Kunstverein, Krefeld · Kunsthalle, Kiel · Gallery Situation, London 1974 *Objekte,* Städtische Kunsthalle, Düsseldorf (Kat.: J. Harten) · Galerie René Block, Berlin · Galerie R. Preisig · Kabinett für aktuelle Kunst, Bremerhaven · Galerie Müller, Stuttgart 1975 Galerie Klein, Bonn · Gallery Block, New York 1976 Kabinett für aktuelle Kunst, Bremerhaven · Galerie Durand-Dessert, Paris 1977 Galerie Keller, Stuttgart · Galleria Peccolo, Livorno · Centre Culturel, Paris 1978 Samangallery, Genova · Galerie Klein, Bonn · Museum Haus Lange, Krefeld 1979 Galerie Maier-Hahn, Düsseldorf 1980 Galerie E. und O. Friedrich, Bern 1981 Galerie Klein, Bonn 1982 Forum Kunst, Rottweil · Galerie Konrad Fischer, Düsseldorf 1983 Kunstverein, Braunschweig 1984 Raum für Kunst, Hamburg · Haus Waende, Düsseldorf 1985 Kunstforum, München · Galerie Walter Storms, München 1986 Galerie E. und O. Friedrich, Bern · Galerie Elisabeth Kaufmann, Zürich · Musée d'Art Moderne de la Ville, Paris (Kat.: S. Pagé) · Galerie d + c Mueller-Roth, Stuttgart · *Acumulatory II,* POLMROK (Zwielicht), Poznan 1987 *Slalom,* Salon am Burgplatz, Düsseldorf 1988 Galerie Anselm Dreher, Berlin · Galerie Elisabeth Kaufmann, Zürich · Galerie für Kunst und Architektur, Hamburg · Galerie Klein, Bonn · Galerie Tanja Grunert, Köln · *Silbergraue Bodenraute mit Fugen,* Raum 1, Düsseldorf 1989 Galerie Nächst St. Stephan, Wien · Galerie Ingrid Dacić, Tübingen 1990 Jablonka Galerie, Köln · Galerie Shimada, Yamaguchi · National-Altes Museum, Berlin-Ost 1991 *Fotografien 1956–1976,* Kunstverein, Düsseldorf (Kat.: J. Svestka) · Galerie Nächst St. Stephan, Wien · Jablonka Galerie, Köln · Westfälisches Landesmuseum (Lichthof), Münster (Kat.: H. Liesbrock, E. Schmidt) 1992 *Zwischen Wolf und Hund,* (Lichtinstallation) Hamburger Kunsthalle · Galerie Klein, Bonn

Gruppenausstellungen | Group exhibitions

1987 Wilhelm-Hack-Museum, Ludwigshafen · P.S. 1, New York · Kunstmuseum, Düsseldorf · Kunsthalle zu Kiel, Kiel · *Skulptur Projekte Münster,* Westfälisches Landesmuseum, Münster · Künstlerwerkstätten Lothringerstraße, München 1988 Musée de Grenoble, Grenoble · *Brennpunkt Düsseldorf,* Kunstmuseum, Düsseldorf (et al.) · *Punt de Confluencia,* Fundació Caixa de Pensions, Barcelona · *Papierarbeiten,* Galerie für Kunst und Architektur, Hamburg ·

Ecke/Le coin, Kantonales Kunstmuseum, Sitten · *Public Concepts,* Forum Kunstmesse, Hamburg · *Furniture as Art,* Museum Boymans-van Beuningen, Rotterdam · *50 Jahre Rijksmuseum Kröller-Müller,* Rijksmuseum Kröller-Müller, Otterlo · *Collection next-the-sea,* Gemeentemuseum, Den Haag · Galerie Klein, Im Syndikat, Bonn · *Zeichnungen von Bildhauern,* Galerie d + c Mueller-Roth, Stuttgart · *Skulpturen und Zeichnungen,* Galerie Nächst St. Stephan, Wien · *The Drawing of Sculptors,* Rijksmuseum Kröller-Müller, Otterlo · Galerie Elisabeth Kaufmann, Basel · Galerie Daniel Buchholz, Köln · *Rot,* Galerie Cora Hölzl, Düsseldorf 1989 *Abstraktion und Figuration,* Galerie Neher, Essen · *Objekt Glas,* Jahrhunderthalle, Hoechst · *Niemandsland,* Kunsthalle, Recklinghausen · *Prospect 89,* Kunstverein, Frankfurt/M. · *Gedankenstrich,* Galerie d + c Mueller-Roth, Stuttgart · *Kunstraum Buchberg,* Schloß Buchberg · *Sonderschau,* Art 20, Basel · *40 Jahre BRD und der Deutsche Künstlerbund,* Kunsthalle zu Kiel, Kiel · *Ein weiterer Flügel,* Museum Haus Lange, Krefeld · *Dahn, Hom, Penone, Ruthenbeck* Galerie Elisabeth Kaufmann, Basel · *Blickpunkte,* Musée d'Art Contemporain, Montréal · *Zeitzeichen,* Stationen Bildender Kunst in NRW, Bonn (et al.) · *Beuys, Gerz, Ruthenbeck,* Galerie von Witzleben, Karlsruhe · *Nordlicht, die letzten 22 Jahre,* Kunstverein, Hamburg · *Uit het leven in de Kunst,* Museum van Hedendaagse Kunst, Antwerpen 1990 *Bis jetzt,* Georgengarten, Hannover-Herrenhausen · *Sammlung Marzona,* Kunsthalle, Bielefeld · *The Readymade Boomerang,* Biennale of Sydney, Art Gallery of New South Wales, Sydney · *Kunstminen,* Kunstmuseum, Düsseldorf · Video Arte Internacional, Buenos Aires 1991 *Von der geistigen Kraft in der Kunst,* Städtische Galerie, Würzburg · *Grandes Lignes,* Gare de l'Est, Paris · 1992 *Unter Null,* Museum für Industriekultur, Nürnberg · *Sammlung Lafrenz,* Neues Museum Weserburg, Bremen · Slyszenie Sztulci (Sound-Art), Kunstzentrum, Warzawa

Bibliographie | Bibliography

Periodika | Periodicals
Doris von **Dratein,** *Monografie Reiner Ruthenbeck,* in: Kunstforum, Bd. 101, 1989 · Martin **Hentschel,** *Reiner Ruthenbeck,* in: Artforum, Dezember, 1988 · Renate **Puvogel,** *Reiner Ruthenbeck,* in: Artis, Juli/August, 1990 · Stephan **Schmidt-Wulffen,** *Enzyklopädie der Skulptur,* in: Kunstforum, Bd. 91, 1987

REMO SALVADORI

*Cerreto Guidi Firenze (I)
Lebt/Lives in Milano

Einzelausstellungen | One-man exhibitions

1971 Galleria LP 220, Torino 1973 Galleria Toselli 1975 Galerie December, Münster 1976 Galleria Tucci Marinucci · Galleria Lucrezia de Domizio, Pescara 1978 Galleria Ferruccio Fata, Bologna · Galleria Paola Betti, Milano · Galleria Lucio Amelio, Napoli 1979 Galleria Lucrezia de Domizio, Pescara 1980 Galleria Salvatore Ala, New York ·

Galleria Salvatore Ala, Milano 1981 Galleria Mario Pieroni, Roma (Kat.: R.S.) 1982 Galleria Salvatore Ala, Milano · Galleria Salvatore Ala, New York 1985 Galleria Mario Pieroni, Roma · Galleria Locus Solus, Genova 1986 Galleria Mario Pieroni, Roma 1987 Art Gallery of Ontario, Toronto · Instituto Italiano di Cultura, Toronto · Art Departement University of Toronto, Toronto · Galleria Locus Solus 1988 Galleria Christian Stein, Torino 1989 Galleria Locus Solus, Genova (Kat.: R.S.) 1991 Galleria Christian Stein · Centre National d'Art Contemporain de Grenoble (Kat.: G. Celant)

Gruppenausstellungen | Group exhibitions

1987 *Il Cangiante,* PAC, Milano 1988 *All that Matters,* Art Gallery of Windsor, Windsor (et al.) · *Das gläserne Ü-Boot,* Tabaksfabrik, Krems · *East meets West,* Convention Center, Los Angeles 1989 *International Contemporary Art,* Art Gallery of Ontario, Toronto · *Periodi di Marmo,* Palazo di Città, Parco delle Terme, Acireale · Galleria Christian Stein, Milano · Galleria Christian Stein, Torino · *Specchi Ustori,* Tema Celeste, Siracusa · *Eternel Metaphors, New Art from Italy,* New York 1990 *Galleria,* Galleria Locus Solus, Genova · Galleria Christian Stein, Torino 1991 *L'idea di Europa,* PAC, Milano · *20th Century Collage,* Margo Leavin Gallery, Los Angeles · *Metri 242 sul livello del mare,* Palazzo Surbone, Montescudaio, Firenze

Bibliographie | Bibliography

Texte und Bücher vom Künstler
Texts and books by the artist
Autografi degli artisti presenti, Firenze, 1970 · *Il libro come luogo di ricerca,* Venezia, Ed. Toselli, 1972 · *Janus,* 26 filigrane, Ed. autore, copie limitate, 1972 · *La capriola nella stanza,* Ed. in fotocopia, 1975 · *Il tiro strabico dell'attenzione,* Torino, Ed. Tucci Marinucci, 1975 · *La cita di Riga,* Macerata, Ed. La Nuova Foglio, 1976 · *Il clavicembalo,* Ed. Lucrezia de Domizio, 1979 · *Incontri con Corrado Levi,* Milano, Facultà di Architettura, 1982 · *L'attenzione divisa,* Toronto, Ed. Pieroni, 1987 · *Nel momento,* Milano, Accademia di Belle Arti Brera, 20. April, 1989 · *Remo Salvadori,* Accademia di Belle Arti, Brera, Milano, 31. Januar, 1991

Gedichte | Poems
1979 *Esperienze frammentarie · L'osservatore si sposta osservandosi* **1981** *Il colore* **1984** *Disegno* **1986** *La stanza é sempre questa* **1988** *Giardino quadrato*

Bücher | Books
Germano **Celant**, *Remo Salvadori*, Milano, Fabbri, 1991

Periodika | Periodicals
M. **Bandini**, *Quegli anni ›70 a Torino*, in: Flash Art (It.), Nr. 162, Juni/Juli, 1991 · M. **Casadio**, *Remo Salvadori*, in: Interview (New York), Mai, 1991 · R. **Casarin**, *L'idea di Europa*, in: Tema Celeste, Nr. 31, Mai/Juni, 1991 · Carolyn **Christov-Bakargiev**, *Periodi di marmo: verso l'inespressionismo*, in: Flash Art (It.), Nr. 154, Februar/März, 1990 · E. Comi, *Una poesia di Remo Salavadori*, in: Spazio Umano, Nr. 2, 1987 · G. **Di Pietrantonio**, *Idea d'europa*, in: Flash Art (It.), Nr. 161, April, 1991 · C. **Ferrari**, *Nel momento*, in: News, Nr. 1/2/3, April, 1989 · Luk Lambrecht, *Kunst. Italie (Remo Salvadori)*, in: Weekend Knack, Mai, 1991 · Lisa **Licitra Ponti**, *Remo Salvadori*, in: Juliet Art Magazine, Nr. 34, Dezember 1987/Januar 1988 · P. **Magi**, *Domenico Bianchi, Günther Förg, Remo Salvadori, Thomas Schütte*, in: Tema Celeste, Nr. 24, Januar/März, 1990 · F. **Pasini**, *Remo Salvadori*, in: Flash Art, Nr. 153, 1989 · F. **Pasini**, *Les effets optiques de Bagnoli et Salvadori*, in: Beaux-Arts, Nr. 91, Juni, 1991 · F. **Pasini**, *Alchemical Shift*, in: Artscribe, September, 1991 · F. **Piquè**, *Remo Salvadori*, in: Flash Art, Nr. 148, Februar/März, 1989 · F. **Piquè**, *Torino, Anni ›70*, in: Flash Art (It.), Nr. 162, Juni/Juli, 1991 · M. **Senaldi**, *Remo Salvadori: una riflessione sul rapporto tra illusione e sostanza*, in: Flash Art (It.), Nr. 163, Sommer, 1991 · L. **Spadaro**, *XX Rassegna d'Arte di Acireale*, in: Segno, Nr. 87, Oktober, 1989 · Pier Luigi **Tazzi**, *Lo spazio è un germoglio*, in: Il secolo XIX (Genova), 11. Januar, 1989 · Giorgio **Verzotti**, *Remo Salvadori. Le Magasin*, in: Artforum, Nr. 2, Oktober, 1991

JOE SCANLAN

*Stoutsville/Ohio (USA), 1961
Lebt/Lives in Chicago

Einzelausstellungen | One-man exhibitions

1991 *Fairly Recent Work*, Robbin Lockett Gallery, Chicago

Gruppenausstellungen | Group exhibitions

1987 *Urgent Messages*, The Chicago Public Library and Cultural Center **1988** *Detail in the Cottage*, Randolph Street Gallery, Chicago · *Sex, Death and Jello*, Randolph Street Gallery, Chicago **1989** *Plus*, Robbin Lockett Gallery, Chicago · *The Size of Chicago*, Ricky Renier Gallery, Chicago **1990** *Stuttering*, Stux Gallery, New York (Kat.: M. Merleau-Ponty, V. Muniz, D. Rimanelli, B. Wilson) · *Mark Depman, Robert Feintuch, Joe Scanlan*, Nicole Klagsbrun Gallery, New York · *Get well soon*, Robbin Lockett Gallery, Chicago · *Beneath the Skin*, Hyde Park Art Center, Chicago **1991** *Körper und Körper*, Grazer Kunstverein, Graz · *Casual Ceremony*, White Columns, New York ·

Comfort, Christopher Grimes Gallery, Los Angeles · *Grounded*, Betty Rymer Gallery, The School of The Art Institute, Chicago · *Improvements? On The Ordinary*, Randolph Street Gallery, Chicago

Bibliographie | Bibliography

Texte vom Künstler | Texts by the artist
in: Hawaiian Journal, Nr. 1–2, Oktober/November, 1986 · in: Hawaiian Journal, Nr. 3, Februar, 1987 · *Robert Gober*, in: Dialogue, November/Dezember, 1988 · in: Primer, a free, collaborative publication, Nr. 1, Oktober, 1988 · *Kay Rosen*, in: Dialogue, Juli/August, 1988 · *Tim Rollins + K.O.S.*, in: Dialogue, März/April, 1988 · *Primary Structures*, in: Dialogue, Januar/Februar, 1988 · *Risa Sekigucht*, in: Artscribe, November/Dezember, 1989 · in: Primer, „How To", Nr. 3, November, 1989 · *Dorothy*, in: New Art Examiner, November, 1989 · *Problems with Reading Rereading*, in: Artscribe, September/Oktober, 1989 · *Barbara Bloom*, in: Artscribe, März/April, 1989 · *An Autobiography*, in: Primer, Nr. 2, März, 1989 · *Gerhard Richter*, in: Dialogue, Januar/Februar, 1989 · *Peter Huttinger*, in: Artscribe, November/Dezember, 1990 · *Franz Graf*, in: Artscribe, September/Oktober, 1990 · *Robert Colescott*, in: Artscribe, Sommer, 1990 · *Haha: Murmur*, in: Artscribe, Mai, 1990 · in: Primer, „Fame and Ecology", Nr. 4, April, 1990 · *Mitchell Kane*, in: Artscribe, Mai/April, 1990 · *Peter Saul*, in: Artscribe, Januar/Februar, 1990 · *Peter Huttinger*, in: Artscribe, November/Dezember, 1990 · *Franz Graf*, in: Artscribe, September/Oktober, 1990 · *Tomoharu Murikami*, in: Artscribe, September, 1991 · *Berlin*, in: Art Issues, Sommer, 1991 · *20th Century Dots: Sigmar Polke*, in: Artscribe, März/April, 1991 · *Prominent Neckties: Ed Paschke*, in: Artscribe, Januar/Februar, 1991

Periodika | Periodicals
M. **Bulka**, *Art in the Waste-stream*, in: New Art Examiner, Bd. 18, Nr. 4, Dezember, 1990 · Kathryn **Hixson**, *Chicago in Review*, in: Arts, Bd. 65, Nr. 8, April, 1991 · Rhonda **Liebermann**, *Stuttering*, in: Flash Art, Bd. 24, Nr. 157, März/April, 1991 · Laurie **Palmer**, *Review*, in: Artforum, Bd. 29, Nr. 10, Sommer, 1991 · Lonette **Stonitsch**, *Curiouser and Curiouser*, in: Exeter, Bd. I, Nr. 3, Sommer, 1991 · Jason **Pickleman**, *Dissent Flares in Chicago*, in: New Art Examiner, Bd. 16, Nr. 7, März, 1989

ERAN SCHAERF

*Tel-Aviv (IL), 1962
Lebt/Lives in Bruxelles

Einzelausstellungen | One-man exhibitons

1988 *(It's)I prefer chocolate*, Anselm Dreher Galerie, Berlin **1990** *Einladungskarte, Bestellkarte, Bachstelze*, Sprechstunde im Künstlerhaus Bethanien Berlin, Vortag im Künstlerhaus Stuttgart, Plakatierung im Kunstverein Hamburg & Künstlerhaus Stuttgart; Kartenversand

Gruppenausstellungen | Group exhibitions

1987 *From the newsagency*, Künstlerhaus, Bethanien, Berlin (Kat.) · Art Forum 87, ART Basel **1989** *Paper*, Stalker Galerie, Breda · Hans Gilles Galerie, Amsterdam · *Natura Naturata*, Josh Baer Gallery, New York · Xavier Hufkens Gallery, Bruxelles · *VU*, Kutscherhaus, Berlin · Impulse e.v. Hamburg (mit/with Ulrike Grossarth) · *D & S Ausstellung Kunstverein Hamburg* **1990** *Ceterum censero*, Künstlerhaus Bethanien, Berlin · *1, 2, 3*, Galerie Wewerka & Weiss, Berlin **1991** *Take over*, Fabian Carlsson Gallery, London · *Open Box*, Karl Ernst Osthaus Museum, Hagen · *Zehn Tage im Leben*, Kumpelnest, Berlin · *The Artists‹ Beautiful Language*, Galerie Anselm Dreher, Berlin · *Interferenzen, Kunstaus West-Berlin 1960–90*, Riga · *Wealth of Nations*, Centre for Contemporary Art Ujazdowskie, Warszawa **1992** *Invitational*, Stux Gallery, New York · *Interface*, Corcoran Gallery of Art, Washington, DC

Bibliographie | Bibliography

Veröffentlichungen | Publications
IT'S (I prefer chocolate), Leporello (mit Rainer Borgemeister), Galerie Anselm Dre-

her, Berlin, 1988 · *WRITTEN IN LANGUAGE*, 16 Karten, Impulse e.v. Hamburg, 1989 · *Einladungskarte, Bestellkarte, Bachstelze*, 29 Karten, Künstlerhaus Bethanien, Berlin, 1990 · *L'homme de la lettre du soleil de la femme*, 12 Karten, Centre for Contemporary Art Ujadowskie, Warszawa, 1991

Periodika | Periodicals
Fritz **Balthaus**, *Adib Fricke, Eran Schaerf, Bernhard Striebel – The Artist's Beautiful Language*, in: Artefactum, Nr. 42, Februar/März, 1992 · Eva **Meyer**, *Stilleben*, in: Texte zur Kunst, Nr. 4, 1991 · Holger **Weh**, *From the letter box*, in: Nike, Nr. 42, März, 1992 · Thomas **Wulffen**, *Ulrike Grossarth/Eran Schaerf*, in : Kunstforum, Bd. 94, April/Mai, 1988 · Thomas **Wulffen**, *Berlin art now*, in: Flash Art, Bd. 151, März/April, 1990 · Thomas **Wulffen**, *Eran Schaerf, Künstlerhaus Bethanien*, in : Flash Art, März, Bd. 158, Mai/Juni 1991 · Thomas **Wulffen**, *For a small art*, in: Metropolis M, Nr.2, April 1992

Video
1986 *Same place*, Berlin · *Like*, Berlin

ADRIAN SCHIESS

*Zürich (CH), 1959
Lebt/Lives in Meisterschwanden

Einzelausstellungen | One-man exhibitions

1981 Galerie Bob Gysin, Dübendorf 1984 Galerie Bob Gysin, Dübendorf · Kunsthalle Waaghaus, Winterthur 1987 Galerie Brigitta Rosenberg, Zürich · Galerie Bob Gysin, Dübendorf (Kat.: C. Schenker) 1988 Galerie Susanna Kulli, St. Gallen 1989 Galerie Rolf Ricke, Köln 1990 Aargauer Kunsthaus, Aarau (Kat.: A.S., B. Wismer) · Galerie Susanna Kulli, St. Gallen (Kat.) 1991 Laure Genillard Gallery, London (mit/with Urs Frei) · Galerie Nächst St. Stephan, Wien · Villa Arson, Nice 1992 Galerie Francesca Pia, Bern · Galerie Rolf Ricke, Köln

Gruppenausstellungen | Group exhibitions

1987 *Sehen Sie junge Kunst*, Landesmuseum und Pavillon Werd, Zürich · *Sparsam, aber teuer*, Forum Stadtpark, Graz · Galerija Studentskog Centra, Zagreb · *Wind im Getriebe*, Galerie Insam, Wien 1988 *Jürg Moser, Vavlav Pozarek, Christoph Rütimann, Adrian Schiess*, Temple des Chartrons, Bordeaux · *La couleur seule*, Musée Saint Pierre d'Art Contemporain, Lyon 1989 *Igitur*, Kunsthalle, Winterthur · *Prospect 89*, Frankfurter Kunstverein, Schirn Kunsthalle, Frankfurt/M. · *François Perrodin, Adrian Schiess, Michel Verjux*, Sous-Sol, Ecole Supérieure d'Art Visuel, Genève · *Sei Artisti Svizzeri in Cintrapposizione*, Palazzo dei Priori, Palazzo del Vescovato, Perugia · *Aus meiner Sicht*, Kölnischer Kunstverein, Köln · *256 Farben & Basics on Form*, Stiftung für konstruktive und konkrete Kunst, Zürich 1990 *Adrian Schiess, Bernhard Voïta*, Centre Culturel Suisse, Paris · *Helmut Federle, Olivier Mosset, Gerwald Rockenschaub, Adrian Schiess*, Galerie Susanna Kulli, St. Gallen · *Biennale di Venezia* · *Le carré libéré*, Château de Mouans-Sartoux, Espace de l'Art Concret, Mouans-Sartoux 1991 Musée d'Art Moderne,

Ancienne Douanne (collection Brolly), Strasbourg · *Extra-Muros, Zeitgenössische Schweizer Kunst*, Musée Cantonal des Beaux-Arts, Lausanne (et al.) · *Kunst, Europa* (Schweiz), Westfälischer Kunstverein, Münster (et al.) · *Adrian Schiess, Urs Frei*, Laure Genillard Gallery, London · *A Swiss Dialectic*, The Renaissance Society, Chicago · *The Painted Desert*, Galerie Renos Xippas, Paris · *Gaylen Gerber, Herbert Hamak, Adrian Schiess, Günter Umberg*, Laure Genillard Gallery, London 1992 *Abstrakte Malerei zwischen Analyse und Synthese*, Galerie Nächst St. Stephan, Wien

Bibliographie | Bibliography

Periodika | Periodicals
William **Jeffet**, *Adrian Schiess/Urs Frei*, in: Artefactum, Nr. 40, Oktober, 1991 · Christian **Kravagna**, *Adrian Schiess*, in: Kunstforum, Bd. 115, September/Oktober, 1991 · Peter **Nesweda**, *Being There*, in: Arts Magazine, November, 1991 · Robert **Nickas**, *That Sinking Feeling*, in: Flash Art, Nr. 152, Oktober, 1990 · s.n., *Neue Platten von Adrian Schiess*, in: Kunst-Bulletin, Nr. 11, November, 1989 · Stella **Rollig**, *Adrian Schiess Galerie St. Stephan, Rosemarie Schwarzwälder Wien*, in: Artis, Jg. 43, November, 1991 · Christoph **Schenker**, *Adrian Schiess*, in: Kunstforum, Bd. 93, Februar/März, 1988 · Christoph **Schenker**, *Adrian Schiess*, in: Flash Art International, Nr. 140, Mai/Juni, 1988 · Christoph **Schenker**, *Ereignisräume, Zu den Werken von Adrian Schiess, Werk*, in: Bauen + Wohnen, Nr. 6, 1988 · Christoph **Schenker**, *Adrian Schiess*, in: Flash Art, Nr. 152, Oktober, 1990 · Max **Wechsler**, *Adrian Schiess*, in: Flash Art, September, 1990

THOMAS SCHÜTTE

*Oldenburg (D), 1954
Lebt/Lives in Düsseldorf

Einzelausstellungen | One-man exhibitions

1979 „La Vitrine", Paris · Galerie Arno Kohnen, Düsseldorf 1980 Galerie Rüdiger Schöttle, München 1981 Galerie Konrad Fischer, Düsseldorf 1982 Galerie Rüdiger

Schöttle, München 1983 Galerie Konrad Fischer, Zürich 1984 Galerie Philip Nelson, Lyon (Kat.: J.-H. Martin, D. Zacharopoulos) · Galerie Johnen & Schöttle, Köln (Kat.: L. Gerdes) · Galerie Jean Bernier, Athinai 1985 Galerie Konrad Fischer, Düsseldorf · Galerie Philip Nelson, Lyon · *Pläne I – XXX, 1981, Skizzen zu Skulpturen*, Produzentengalerie, Hamburg (Kat.: L. Glozer, U. Loock) · Galerij Micheline Szwajcer, Antwerpen 1986 Museum Haus Lange, Krefeld (Kat.: J. Heynen, T. Sch.) · Galerie Rüdiger Schöttle, München · Galerie Philip Nelson, Lyon · Galerie Crousel-Hussenot, Paris · Galleria Tucci Russo, Torino (Kat.: B. Hesse) 1987 *Obst und Gemüse*, Lichthof, Landesmuseum, Münster (Kat.: K. Bußmann, U.Wilmes) · Museum Overholland, Amsterdam (Kat.: U. Loock, T. Sch.) · Galerie Konrad Fischer, Düsseldorf · Galerie Jean Bernier, Athinai · Galerij Micheline Szwajcer, Antwerpen 1988 Staatliche Kunsthalle, Baden-Baden (Kat.: B. Dürr, M. Hentschel, B. Hesse, J. Poetter) · Galerie Philip Nelson, Lyon · Galleria Tucci Russo, Torino · Galleria Christian Stein, Milano 1989 Musée de Clamecy, Clamecy · Portikus, Frankfurt/M. · Stichting De Appel, Amsterdam (Kat.: S. Bos, K. König) · Galerie Konrad Fischer, Düsseldorf · Marian Goodman Gallery, New York · Galerie Pietro Sparta, Chagny · Galerie Ute Parduhn, Düsseldorf (Kat.: T.Sch.) 1990 Kunsthalle, Bern (Musée d'Art Moderne de la Ville, Paris; Stedelijk Van Abbemuseum, Eindhoven) (Kat.: L. Gerdes, M. Hentschel, U. Loock) · Marian Goodman Gallery, New York · *Jokes*, Galerie Rüdiger Schöttle, München · Galerie Konrad Fischer, Düsseldorf 1991 Galerie Philip Nelson, Lyon · Kunstverein, Kassel 1992 Raum für Kunst, Hamburg

Gruppenausstellungen | Group exhibitions

1987 *Tekenen '87*, Kunststichting, Rotterdam · *Metropolis*, Spedale degli Innocenti, Firenze · *Raumbilder*, Reina Sofia, Madrid · *Juxtapositions*, P.S. 1, New York · *Im Auftrag*, Museum Folkwang, Essen · *Bildhauerzeichnungen*, Kunstverein, Graz · *documenta 8*, Kassel · *Das andere Medium*, Museum am Ostwall, Dortmund · *Musée St. Pierre*, Kunstverein, Frankfurt/M. · *Hacen lo que quieren*, Museo de Arte Contemporáneo, Sevilla · *Skulptur Projekte Münster*, Westfälisches Landesmuseum, Münster · *Förg, Kiecol, Mucha, Schütte*, Galleria Lia Rumma, Napoli · *L'époque, la mode, la morale, la passion*, Centre Georges Pompidou, Paris 1988 *Schlaf der Vernunft*, Fridericianum, Kassel · *Europe Now*, Museo d'Arte Contemporanea Luigi Pecci, Prato · *L'inventaire*, Manufrance, St. Etienne · *4 x 8*, Kunstraum, Neuss · *Vision sur l'Art Contemporain*, U.C.L., Leuven 1989 *Akademierundgang 1950–1968*, Verbindungsbüro Nordrhein-Westfalen, Bruxelles · *Wieder + Wider*, Portikus, Frankfurt/M. · *Complex*

Object, Galerie Marga Paz, Madrid · *Bühnenstücke,* Kunstverein, München · *Periodi di Marmo,* Palazzo di Città, Acireale · *Skulpturen für Krefeld,* Museum Haus Esters, Krefeld · *Zeitzeichen, Stationen Bildender Kunst in NRW,* Bonn (et al.) · *Blickpunkte,* Musée d'Art Contemporain, Montréal · *With No Words,* Galleria Christian Stein, Milano 1990 *Weitersehen,* Museum Haus Lange und Haus Esters, Krefeld 1991 *Espacio Mental,* IVAM, Centre del Carme, Valencia · *Harem,* Galerie Philip Nelson, Lyon · *Opus 13, Düsseldorf '91,* Museum für Moderne Kunst, Bozen

Bibliographie | Bibliography

Bücher | Books
Notes, New York, Marian Goodman Gallery, 1989 *Aufzeichnungen aus der 2. Reihe,* Düsseldorf o.J. (1992)

Periodika | Periodicals
Oscarine **Bosquet,** *Le théâtre de l'oeil,* in: Galeries Magazine, April, 1990 · Pier Luigi **Tazzi,** *Thomas Schütte,* in: Artforum, Februar, 1987 · Pier Luigi **Tazzi,** *Outside in the Stroms of Springtime,* in: Artforum, Nr. 9, Mai 1991

Video
1990 *Tomatensalat,* Videofilm einer Ausstellung von T. S. im Van Abbemuseum 1990, Kamera/Schnitt/Regie: Martin Kreyssig, Musik: Red Ant Feet, 40 Min, VHS

HELMUT SCHWEIZER

*Stuttgart (D), 1946
Lebt/Lives in Düsseldorf

Einzelausstellungen | One-man exhibitions

1969 Puyk im Kunstverein, Hannover 1970 Puyk im Kunstverein, Karlsruhe (Kat.: G. Bussmann) · Puyk in der Neuen Galerie, Aachen 1973 Galerie Grafikmeyer, Karlsruhe 1974 Badischer Kunstverein, Karlsruhe (Kat.: J.W. Koch) · Kunsthalle, Kiel (Kat.: E. Freitag) 1975 Cannaviello Studio d'Arte, Roma 1978 Staatliche Kunsthalle, Baden-Baden (Kat.: J. Ch. Jensen, H.A. Peters) · Kunsthalle, Kiel (Kat.: cfr. Baden-Baden) · Galerie Magers, Bonn · Kölnischer Kunstverein (Kat.: W. Herzogenrath) 1984 Galerie Kohnen, Düsseldorf 1985 Galerie Magers, Bonn 1986 Galerie Kohnen, Düsseldorf · Galerie Walser, München 1987 Galerie Kohnen, Düsseldorf 1988 Galerie Kohnen, Düsseldorf 1989 Kunstverein für die Rheinlande und Westfalen, Düsseldorf (Kat.: J. Svestka) · Galerie Ermer, Berlin 1990 Kunstverein, Heidelberg (Kat.: H. Gercke) · Galerie Walser, München · Galerie Spieker, Viersen 1992 Galerie im Schloß, Neuhausen

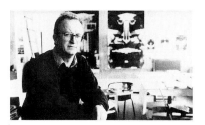

Gruppenausstellungen | Group exhibitions

1987 *Vom Landschaftsbild zur Spurensicherung,* Museum Ludwig, Köln 1988 *Vorbilder. Kunst in Karlsruhe 1950–1988,* Badischer Kunstverein, Karlsruhe 1989 *Photo-Kunst,* Staatsgalerie, Stuttgart · *Ressource Kunst,* Akademie der Künste, Berlin (et al.) 1990 *Präferenzen,* Kunstverein, Bonn 1991 *Kunstfonds,* Kunstverein, Bonn · *Fotografie als Kunst im öffentlichen Raum,* Lenbachhaus, München

Bibliographie | Bibliography

Texte und Bücher vom Künstler
Texts and books by the artist
Tulpen, Kunstverein, Heidelberg, 1976 · *New York – Paris. Deutsch-Französisches Jugendwerk,* Bad Honnef, 1977

Periodika | Periodicals
M. **Hentschel,** *Helmut Schweizer,* in: Artforum, November, 1989 · H.N. **Jocks,** *Helmut Schweizer,* in: Kunstforum, Bd. 102, 1989 · H.N. **Jocks,** *Im stillen Atelier des malenden Fotografen Helmut Schweizer. Vom Himmel fällt das Feuer,* in: Kunst Köln, Nr. 3, 1989 · Martin **Tschechne,** *Das Land ahnt die Katastrophe,* in: Art, Juni, 1991

Video
1971–1972 *Handlungen,* Farbe, 30 Min. · *Pantheon für Bernini,* 1981–1984, Farbe, 30 Min. · Fliegen für Fellini, 1976–1984, Farbe, 30 Min. 1987 *1986,* Farbe, 30 Min.

MARINA SEREBRIAKOVA

*Moskva (CIS), 1965
Lebt/Lives in Moskva

Einzelausstellungen | One-man exhibitions

1991 *The Way Things stand,* Galleri Skola, Moskva 1992 Maria Serebriakova, Zeno X Gallery, Antwerp

Gruppenausstellungen | Group exhibitions

1987 *Representation,* Exhibition Hall of Union, Belajevo, Moskva · *Retrospectional Exhibition of Moscow Artists 1957–1987,* Exhibition Hall of Union, Belajevo, Moskva 1988 *Labirint,* The Central Palace of Youth, Moskva · *XVIII Allunion Exhibition of Young Artists,* The Central Exhibition Hall, Moskva 1989 *Dorogoje Iskusstvo,* The Central Palace of Youth, Moskva · *Installation,* Gallery Garage, Belgrado · *Moscow-New-Jerusalem,* New-Jerusalem · Group Exhibition of Moscow Artists, Gallery Monumentalis, Oporto · *Inexpensive Art/Exhibition of Little Creations (Nedorogoje Iskusstvo),* First Gallery, Moskva · *Moscow – Vienna – New York,* Wiener Messepalast, Wiener Festwochen 1990 *Maria Serebriakova & Anatolij Shuravlev, Malerei und Objekte,* Inter Art, Berlin · *Mosca Moscow Mockba '90,* Sala Umberto Boccioni, Milano/Provinciaal Museum voor Moderne Kunst, Oostende · *In the direction of Object,* Exhibition Hall on Kashirskajz, Moskva/Stedelijk Museum, Amsterdam · *Catalog,* The Central Palace of Youth, Moskva · *Between Spring and Summer: Soviet Conceptual Art of the Epoch of the late Communist,* Tacum Mu-

seum, Seattle/ISA, Boston · *The Work of Art in the Age of Perestroika,* Phillis Kind Gallery, New York · *Art Summer,* Split · *Artedomani, 1990 punto divista,* Ex-Ospedale San Matteo degli Infermi, Spoleto · *Da Mosca,* Unione Culturale, Torino · *Schizokity,* BC, Moskva · *Wystavka-Zasada,* Moskva · *The missing picture,* MIT, Boston 1991 *Perspective of Conceptual,* University Hawaii (Honolulu)/P.S. 1, New York · *Serebriakova, Rezun – Zwezdotsotova, Turnova,* Picaron Editions, Amsterdam/Antwerpen · *Private Work,* Soljanka, Moskva · *Optika Vzglyada, Ida Applebroog, M. Serebriakova,* Avtozovodskaj, Moskva · *Unknown Europe,* Krakov

Bibliographie | Bibliography

Periodika | Periodicals
in: Iskusstvo, Nr. 2, 1989 · in: Contemporanea, Nr. 6, 1989 · in: Art in America, Nr. 3, 1990 · in: Quorum (Zagreb), Nr. 2, 1989 · in: Human Space, Nr. 1, 1990 · in: Human Space, Nr. 4, 1990 · Jan **Braet,** *Het innerlijk Meubilair · Maria Serebrjakova door de leegte,* in: Knack, Februar 1992

MARIELLA SIMONI

*Dezenano del Garda (I), 1948
Lebt/Lives in Gent/Paris

Einzelausstellungen | One-man Exhibition

1975 Galerie Deambrogi, Milano 1976 Galerie Cavellini, Brescia · Galerie Deambrogi, Milano 1978 *Via Crivelli,* Galerie Deambrogi, Milano · Palazzo dei Diamanti, Ferrara · Galerie Del Falconiere, Ancona 1980 Galerie Karen & Jean Bernier, Athinai (Kat.) · The Parellel Window, New York · *Perspectives,* Basel (Kat.: M.S.) 1981 Galerie Franz Paludetto, Torino · Galerie Fabjbasaglia, Bologna 1982 Galerie Deambrogi, Milano · Galerie Karen & Jean Bernier, Athinai 1983 *Peintures,* Galerie Catherine Issert, Saint Paul de Vence 1984 Galerie Peter Pakesch, Wien 1985 Galerie Franz Paludetto, Torino (Kat.) 1987 Galerie Peter Pakesch, Wien 1989 Galerie Peter Pakesch, Wien · Ecole Régionale Supérieure d'Expression Plastique, Tourcoing (Kat.: J. Hoet, D. Zacharopoulos) 1990 Galerie Peter Pakesch, Wien 1991 Galerie Ric Urmel, Gent · Jennifer Flay, Paris

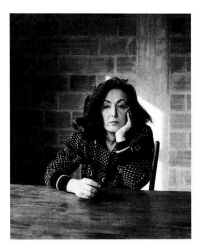

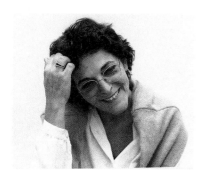

Gruppenausstellungen | Group exhibitions

1989 *Destini incrociati,* Castello di Rivara · *H. Brandl, G. Förg, I. Huber, M. Oehlen, M. Simoni,* Galerie Peter Pakesch, Wien **1990** *Le Diaphane,* Ecole des Beaux-Arts, Tourcoing

Bibliographie | Bibliography

Texte von der Künstlerin
Texts by the artist
In: Kat. Melancolia, 1975 · Text: Installation *Tres Letteres d'amore,* Via Creveli, 1979 · Text: Film, *Lasciareilsensoamarelasciare,* 1979 · In: Kat. Nostalgia, Peter Paresch, Wien · In: Kat. Che male c'e ad essere immortali, 1985 · *I'm moving or I'm stopping?,* in: Fama & Fortune Bulletin (Wien), Heft 3, September, 1990 · *La pittura non ha potere ma l'autorità,* in: Kat. Herbert Brandl, 1991

Periodika | Periodicals
Doris von **Drateln,** *Mariella Simoni,* in: Kunstforum, Bd. 115, September/Oktober, 1991 · Ann **Wilson Lloyd,** *Mariella Simoni at Jennifer Flay,* in: Art in America, Nr. 1, Januar, 1992

SUSANA SOLANO

*Barcelona (E), 1946
Lebt/Lives in Barcelona

Einzelausstellungen | One-man exhibitions

1980 Fundació Joan Miró, Barcelona **1983** Galeria Ciento, Barcelona **1986** Galeria Fernando Vijande, Madrid · Galeria Charpa, Valencia **1987** *Senza Uccelli,* Galeria Montenegro, Madrid (Kat.: M. Logrono, R. Queralt) · *Escultures,* Galeria Maeght, Barcelona (Kat.: F. Calvo Serraller) · Musée d'Art Contemporain, Bordeaux (Kat.: J.-M. Poinsot) · Galerie des Arènes – Chapelle des Jésuites, Nîmes · Galleria Giorgio Persano, Torino **1988** *Plaça del joc de la pilota,* Bonnefantenmuseum, Maastricht (Kat.: A. Himmelreich) · Anthony Reynolds Gallery, London (Kat.: T. Blanch) **1989** *Encreuar,* Galeria La Maquina Espanola i Galeria Oliva Arauna, Madrid · Bonnefantenmuseum, Maastricht (Kat.: G. Aurora) · Städtisches Museum Abteiberg, Mönchengladbach (Kat.: T. Blanch, D. Stemmler) · Donald Young Gallery, Chicago (Kat.: F. Huici) · *Encreunar,* La Maquina Espagnola/Galeria Oliva Arauna, Madrid · *Directions,* Hirshhorn Museum, Washington, DC **1990** Mala Galerija, Moderna Galerija, Ljubljana · *Dibujos,* Galeria Revenga, Madrid · *Grabados y Monotipos,* Madrid ·

Acotacion, Fattoria di Celle/Spazi d'Arte, Santomato di Pistoia · *Art Cologne,* Galeria Luis Adelantado, Köln · *Acotacion-2,* Galleria Giorgio Persano, Milano **1991** Galerie Daniel Lelong, Paris (Kat.: R. Guidieri) · Museum of Modern Art, San Francisco · Centre d'Art Contemporain du Domaine de Kerguéhennec (Kat.: J.-M. Poinsot) **1992** Galeria Joan Prats, Barcelona

Gruppenausstellungen | Group exhibitions

1987 *Arco 87,* Galeria Montenegro, Madrid · *A propos de dessin,* Galerie Adrien Maeght, Paris · *Skulptur Projekte Münster,* Westfälisches Landesmuseum, Münster · *Extra.* Palau Robert, Generalitat de Catalunya, Barcelona · *Art triangle Barcelona 1987,* Casa de la Caritat, Barcelona · *Inicis d'una collecio,* Fundació Caixa de Pensions, Barcelona · *documenta 8,* Kassel · *F. Leiro-S. Solano,* Museo de Bellas Artes de Alava, Vitoria · *São Paulo Bienal,* · *Cinq Siècles d'Art Espagnol – Dynamiques et Interrogations,* Musée d'Art Moderne de la Ville, Paris **1989** *Acquisitations 1989,* Centre National des Arts Plastiques, Paris · *Conceptos, Ojetos y Energia,* Ministerio de Industria y Energia, Ifema, Madrid · *Epoca Nueva. Painting and Sculpture from Spain,* The Chicago Public Library Cultural Center, Chicago (et al.) · *Esculturas Monumentales,* Galerie Maeght-Montrouge, Paris · *De Varia Commensuracion,* Jorge Oteiza/Susana Solano, *Bienale di Venezia,* Venezia · *Europa Oggi,* Centro per l'Arte Contemporanea Luigi Pecci, Prato · Fonds Régional d'Art Contemporain, Musée Bonnat, Bayonne · *Le défi Catalan. de Miró et Picasso à la nouvelle génération,* Château de Biron, Dordogne · *Deu,* Galeria Joan Prats, Barcelona · *A. Aycock, M. Jetelova, S. Solano. Dialogue with space,* Jack Shainman Gallery, New York · Accademia Bonnefantenmuseum, Maastricht · *Les années 80 vues par 5 galeries,* Galerie la Défense Art 4, Paris · *Espana. Artisti spagnoli contemporanei,* Rotonda di Via Besagna-Studio Marconi, Milano · *Carnegie International,* Carnegie Museum of Art, Pittsburgh · *Spansk Kunst 1980 erne de nyeste tendenser,* Gl. Holtegaard, Vejle Kunstmuseum, Vejle · *Aspekte der Biennale Venedig,* Forum Thomas, München **1989** *Sol Lewitt-Susana Solano,* Marta Cervera Gallery, New York · *Arco 89,* Donald Young Gallery, Madrid · *T. Cragg, R. Deacon, M. Puryear, S. Solano,* Donald Young Gallery, Venezia · *Ad Usum Dimorae,* Artemide, Fondazio Querini Stampalia, Venezia · *Ars Longa Vita Brevis,* Universitat Autonoma de Barcelona, Bellaterra · *Isa Genzken, Susana Solano, Amikam Toren, John Wikins,* Anthony Reynolds Gallery, London · *L'escultura catalana d'avantguarda,* Generalitat de Barcelona, Barcelona · *Paysages,* Jaycees, Waregem · *Die Spanische Kunst in der Sammlung der Fundació Caixa de Pensions,* Städtische Kunsthalle, Mannheim (et al.) **1990** *Arco 90,* Donald Young Gallery, Madrid · *Acquisitions 1989,* Fonds National d'Art Contemporani, Centre National des Arts Plastiques, Paris · *Africa Queen, A Gonzola, S. Solano, C. Velilla,* Arxipèlag Bijagos, Guinea Bissau · *Art Espagnol des Années,* Centre Régional d'Art Contemporain, Midi-Pyrénées · *Spanische Eisenskulptur,* Städtische Kunsthalle, Mannheim · *Terskel Threshold,* Museet for Samtidskunst, The National Museum of Contemporary Art, Oslo · *10 Con-*

temporains espagnols, Travail et Culture, Le Péage-de-Rousillon · *L'avantguarda de l'escultura catalana,* Sa Llotja, Palma de Mallorca · *X Salon de los 16,* Museo Espanol de Arte Contemporaneo, Madrid · *Barcelona Avant-garde,* Museode Yokohama, Yokohama · *Sculpture Contemporaine Espagnole,* Palais du Tau, Reims **1991** *Miquel Barcelo, Jaume Plensa, Susana Solano, Antoni Tapies,* Fons D'Art, Girona **1992** *Bern et Hilla Becher, Jannis Kounellis, Susana Solano,* Musée d'Art Contemporain, Bordeaux

Bibliographie | Bibliography

Periodika | Periodicals
Maria Teresa **Blanch,** *Progetti di Scultura per Münster,* in: Flash Art, Nr. 139, Mai/Juni, 1987 · Maria Teresa **Blanch,** *Susana Solano, oleadas de espacios,* in: Sur Express, Juni, 1987 · Maria Teresa **Blanch,** *L'escultura imaginada,* in Barcelona Metropolis Mediterrània, 1988 · Juan Manuel **Bonet,** *Cuatro artistas espanoles en Burdeoa,* in: Diario 16, 1. Oktober 1987 · Juan Manuel **Bonet,** *La fuerza de un designio,* in: Diario 16, 20. Mai, 1988 · Luisa **Borras,** *Susana Solano, Bienvenida,* in: La Vanguardia, 28. April, 1987 · Enrico **Comi,** *Cinque poesie per Susana Solano,* in: Lo Spazio, Nr. 4, 1987 Umano · Doris von **Draten,** *Biennale de Venise 1988,* in: Galeries Magazine, Nr. 26, 1988 · Miguel **Fernandez-Cid,** *La definicion de un sistema,* in: La Buhardilla, Nr. 2, Februar, 1987 · Miguel **Fernandez-Cid,** *Susana Solano, premio Nacional de Artes Plasticas,* in: Diario 16, 20. Mai, 1988 · Jamey **Gambell,** *Five from Spain,* in: Art in America, Nr. 9, September, 1987 · Angel Gonzalez **Garcia,** *Estas Bienales de ahora. Representacion espanola,* in: Cambio 16, 18. Juli, 1988 · Anton **Gugg,** *Susana Solano,* in: Noema, Nr. 8719, 1988 · Marc Le **Bot,** *Susana Solano/Marc Le Bot,* in: Artics, Nr. 7, März/April, 1987 · Vincente **Llorea,** *Senza Uccelli,* in: Cyan, Nr. 4, Juni, 1987 · Josep **Masjuan,** I. **Codina,** *Susana Solano: una artista que ha reeixit,* in: Vall De Verç, Nr. 102, September, 1988 · Gloria **Moure,** *An encounter with a secret,* in: Artforum, Nr. 26, September, 1987 · Italo **Musa,** *Susana Solano,* in: Tema Celeste, Nr. 17/18, 1988 · Rosa **Olivares,** *Conversacion con Susana Solano. La rigida estructura de la libertad,* in Lapiz, Nr. 51, 1988 · Pilar **Parcerisas,** *Dues propostes reveladoras de l'escultura actual, S. Flores y S. Solano,* in: Avui, 12. April, 1987 · J-M. **Parreno,** *Susana Solano,* in: ABC de las Artes, Februar, 1987 · Luis **Permanyer,** *Nacimiento,* in: La Vanguardia, 18. April, 1987 · Kevin **Power,** *Susana Solano – Montenegro,* in: Flash Art, Nr. 135, Sommer, 1987 · Ana **Rabino,** *Susana Solano,* in: L'Uomo Vogue, Nr. 182, 1988 · Uta M. **Reindl,** *Strenge Zeichen des Aufbegehrens,* in: Art, Nr. 7, Juli, 1991 · Teresa **Roberto,** *Susana Solano exposicion Anthony Reynolds,* in: Flash Art, Nr. 142, 1988 · Barbara **Rose,** *Susana Solano. The poetry of silence,* in: View, Dezember, 1988 · s.n., *Susana Solano,* in: Cimal, Nr. 32–33, Februar, 1987 · s.n., *Susana Solano,* in: Kunstforum, Bd. 94, April/Mai, 1988 · s.n., *La escultura domina la participacion espanola en la 43 edicion de la Bienal de Venecia,* in: Diario 16, 1988 · s.n., *Escultura y arquitectura: hacia unas nuevas relaciones,* in Punto y Plano, Nr. 4, 1987 · s.n., *Susana Solano, ante el desafio de la Bienal de Venecia,* in: La

Vanguardia, 19. Juni, 1988 · Olga **Spiegel**, *La escultura es un amante celoso y absorbente, pero tambien compleciente, opinia Susana Solano,* in: La Vanguardia, 8. April, 1987 · Olga **Spiegel**, *Oteiza y Solano representan a Espana en la Bienal de Venecia,* in: La Vanguardia, 26. März, 1988 · Elisabetta **Tolosano**, *Le stazioni balneari di Susana Solano,* in: Torino Sette, Dezember, 1987 · Luis **Valle**, *Susana Solano: la escultura es uin tema de existencia que uno expresa con un lenguaje,* in: Diario 16, 10. Februar, 1987

OUSMANE SOW

*Dakar (SN), 1935
Lebt/Lives in Dakar

Einzelausstellungen | One-man exhibitions

1989 *Nouba,* Musée de la Vieille Charité, Marseille (Kat.) 1990 *Nouba,* Musée d'Art Moderne, Troyes (Kat.) · *Nouba et Masai,* Musée Municipal, Angoulème · *Nouba,* Collégiales St. Pierre Le Puellier, Orléans · *Masai,* Citadelle de Calvi, Haute Corse · *Nouba,* Hotel de Ville, Pessac/Bordeaux 1991 *Nouba et Masai,* Centre d'Art Contemporain, Montbéliard · *Nouba et Masai,* Musée Municipal, Saint-Amand-Les-Eaux · *Nouba et Masai,* Loft Forum, Tokyo/Unitopia, Sasayama/M.B.S. Osaka (Kat.)

Gruppenausstellungen | Group exhibitions

1990 *Masai,* Grande Arche de la Fraternité, Paris 1991 *Zoulou,* Galerie Nationale, Dakar · *Zoulou,* Musée Fabre, Montpellier

Bibliographie | Bibliography

Bücher | Books
Marie **Lavandier**, *L'oeuvre d'Ousmane SOW,* Université Paris I, s.d.

Periodika | Periodicals
(Monographie), In: Revue Noire (Ed. Bleu Outrmer), Nr. 1, Frühjahr, 1991 · in: Ulysses International, Nr. 5, 1991

Filme | Video
NHK, 11 Min., 18. Juli, 1991

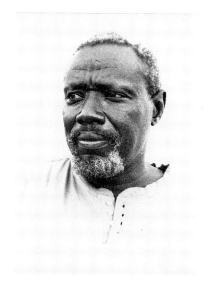

ETTORE SPALLETTI

*Capelle sul Tavo (I), 1940
Lebt/Lives in Capelle sul Tavo

Einzelausstellungen | One-man exhibitions

1975 Galleria La Tartaruga, Roma 1976 Galleria Mario Pieroni, Roma 1977 Galleria Paola Betti, Milano 1978 Galleria Ferrucio Fata, Bologna 1979 Galleria Mario Pieroni, Roma 1981 Galleria Mario Pieroni, Roma 1982 Galleria Lucrezia di Domizio, Pescara · Museum Folkwang, Essen (Kat.: B. Corà, Z. Felix) · Museum van Hedendaagse Kunst, Gent (Kat.: Z. Felix, J. Hoet, P. A. Rihoux) 1984 Galleria Pieroni, Roma · Galerij Micheline Szwajcer, Antwerpen (Kat.: P. A. Rihoux) · Galerie Philip Nelson, Villeurbanne 1985 Galleria Pieroni, Roma · Musée Saint Pierre Art Contemporain, Lyon 1986 Baskerville – Watson Gallery, New York 1987 Galleria Locus Solus, Genova · Burnett Miller Gallery, Los Angeles 1988 La Criée, Rennes · *Autunno,* Galleria Pieroni, Roma 1989 Stichting De Appel, Amsterdam · *Gruppo della Fonte,* Kunstverein, München · Galerie Max Hetzler, Köln · Associazione Opera, Perugia (Kat.: M. A. Binda, B. Corà) · *Fonte dei Passeri,* Portikus, Frankfurt/M. 1990 Galleria Locus Solus, Genova · *Iris,* Galerie Joost Declercq, Gent 1991 Galleria Locus Solus, Genova · Musée d'Art Moderne de la Ville, Paris · Galerie Anne de Villepoix, Paris

Gruppenausstellungen | Group exhibitions

1987 *Skulptur Projekte Münster,* Westfälisches Landesmuseum, Münster · Ateliers Internationaux des Pays de la Loire, Fontévraud 1988 *La couleur seule,* Musée St. Pierre, Lyon · *Dannunziana,* Pescara 1989 *Günther Förg, Christina Iglesias, Ettore Spalletti, Jan Vercruysse, Franz West, Christopher Wool,* Galerie Joost Declercq, Gent/Max Hetzler, Köln/Luhring Augustine, New York/Peter Pakesch, Wien/Marga Paz, Madrid/Mario Pieroni, Roma · *Eternel Metaphors – New Art from Italy,* I.C.I., New York · *Periodi di Marmo,* Rassegna internazionale d'arte, Acireale · *Galleria,* Galleria Locus Solus, Genova · *Open Mind,* Museum van

Hedendaagse Kunst, Gent · Galleria Pieroni, Roma 1990 *Noli me tangere,* Musée Cantonaux des Beaux-Arts, Sion · *Lo Zingaro Blu,* Galleria Pieroni, Roma · *Ponton Temse,* Museum van Hedendaagse Kunst Gent, Temse · *Art Mets Scienc.,* Musée Fodor, Amsterdam · *Le Jardin de Bagatelle,* Galerie Tanit, München 1991 *L'Espai i la idea,* Fundació Caixa de Pensions, Barcelona

Bibliographie | Bibliography

Texte von Künstler | Texts by the artist
Project for Artforum summer 1987 by Ettore Spaletti, in: Artforum, Sommer, 1987

Bücher | Books
André **Ducret,** *Invitation a la Promenade,* Genève, 1985 · Francesca **Pasini,** *Tra me e te,* 1990 · Danile **Pieroni,** *L'Adagio,* September, 1987

Periodika | Periodicals
Jean-Christophe **Amman,** *Arte Architettura e Spazio Pubblico,* in: Domus, Nr. 708, 1989 · Anna **Cascella,** *Ettore Spaletti,* in: Vogue Italia, Mai, 1988 · Germano **Celant,** *Ettore Spaletti,* in: Halle du Sud, Nr. 17, 1988 · Carolyn **Christov-Bakargiev,** *Qualcosa in Nessun Luogo,* in: Flash Art, Nr. 145, 1988 · Carolyn **Christov-Bakargiev,** *Periodi Di Marmo: Verso L'Inespressionismo,* in: Flash Art, Nr. 154, Februar/März, 1990 · Viana **Conti,** *Ettore Spalletti,* in: Flash Art, Nr. 156, Juni/Juli, 1990 · Mo **Goumelon,** Le Carreres, *Ettore Spaletti,* in: Artefactum, Dezember 1988/Januar 1989 · Bernardo **Mercuri,** *Ettore Spaletti,* in: Tema Celeste, Nr. 19, 1989 · Giancinti Di **Pietrantonio,** *Ettore Spaletti,* in: Flash Art, Nr. 150, 1989 · Giancinti Di **Pietrantonio,** *Ettore Spaletti,* in: Flash Art, Nr. 153, 1990 · Riki **Simons,** *Italiaanse kunstenaars. De werelden van,* in: Avenue, Juli, 1990 · Genevieve **Monnier,** *Breve Storia del Bleu,* in: Art Studio, Nr. 16, 1990 · Pier Luigi **Tazzi,** *Fogli d'Autunno,* in: Flash Art, Nr. 144, 1988 · Barbara **Tosi,** *Acireale,* in: Contemporanea, Nr. 213, 1989

HAIM STEINBACH

*Rechovot (IL), 1944
Lebt/Lives in Brooklyn

Einzelausstellungen | One-man exhibitions

1969 Panoras Gallery, New York 1974 Johnson Gallery, Middlebury College, Middlebury 1975 Carlo Lamagna Gallery, New York 1979 Artists Space (Display #7, installation), New York 1980 Fashion Moda (Changing Displays, installation), Bronx, New York 1982 Concord Gallery, New York 1985 Cable Gallery, New York 1986 Washington Projects for the Arts, Washington, DC 1987 Galleria Lia Rumma, Napoli · Rhona Hoffman Gallery, Chicago · Sonnabend Gallery, New York 1988 Musée d'Art Contemporain, Bordeaux (Kat.: G. Celant, J. Froment, E. Lebovici, J. Miller, H.S.) 1989 Margo Leavin Gallery, Los Angeles · Galerie Roger Pailhas, Marseille · Galerie Yvon Lambert, Paris 1990 Sonnabend Gallery, New York 1991 Galerie Yvon Lambert, Paris · *fresh once upon a time,* Jay Gorney Modern Art, New York · Rhona Hoffman Gallery, Chicago 1992 Witte de With, Rotterdam

Gruppenausstellungen | Group exhibitions

1987 *Primary Structures*, Rhona Hoffman Gallery, Chicago · *N.Y., Art Now*, The Saatchi Collection, London · *documenta 8* (The castle, Group Material), Kassel · *Art Against Aids*, Paula Cooper Gallery, New York · *Extreme Order*, Lia Rumma, Napoli · *Les Courtiers du Désir*, Centre Georges Pompidou, Paris · *Avant-Garde in the Eighties*, County Museum of Art, Los Angeles · *New York Now*, The Israel Museum, Jerusalem · *Currents 12: Simulations, New American Conceptualism*, Art Museum, Milwaukee · *New York New*, Galerie Paul Meanz, Köln **1988** *The Sonnabend Collection*, Centro de Arte Reina Sofia, Madrid (et al.) · *Schlaf der Vernunft*, Museum Fridericianum, Kassel · *Collection Pour une Région*, Musée d'Art Contemporain, Bordeaux · *Hover Culture*, Metro Pictures, New York · *Art at the End of the Social*, Rooseum, Malmö · *Innovations in Sculpture 1985–1988*, Aldrich Museum, Ridgefield · *Three Decades The Oliver-Hoffman Collection*, Museum of Contemporary Art, Chicago · *The BiNational*, Institute of Contemporary Art, Museum of Fine Art, Boston (et al.) · *New Urban Landscape*, The World Financial Center, New York · *The Pop Project: Part IV*, The Clocktower, New York · *Metamorphosis of the Object*, The Israel Museum, Jerusalem · *New York in View*, Kunstverein, München · *60s/80s Sculpture Parallels*, Sidney Janis Gallery, New York · *Democracy: Cultural Participation, Group Material*, Dia Art Foundation, New York · *Works. Concepts. Processes. Situations. Information*, Galerie Hans Mayer, Düsseldorf · *Cultural Geometry*, Deka Foundation, Athinai **1989** *Wittgenstein: The Play of The Unsayable*, Wiener Secession, Wien (et al.) · *Une Autre Affaire*, Le Consortium, Dijon · *Abstraction in Question*, The John and Mable Ringling Museum of Art, Sarasota (et al.) · *Complex Object*, Galeria Marga Paz, Madrid · *Horn of Plenty/Hoorn van overvloed*, Stedelijk Museum, Amsterdam · *A Forest of Signs*, Museum of Contemporary Art, Los Angeles · *What is Contemporary Art?*, Rooseum, Malmö · *The Silent Baroque*, Gallerie Thaddaeus Ropac, Salzburg · *Periodi di Marmo*, XX Rassegna Internazionale d'Arte, Acireale · *Hamburg Projekt 1989*, Kunstverein Hamburg, Künstlerhaus Bethanien, Hamburg · *Fonds National d'Art Contemporain, Acquisitions 1988*, Centre National des Arts Plastiques, Paris **1990** *Art et Publicité*, Centre Georges Pom-

pidou, Paris · *Reproduced Authentic*, Galerie Via Eight, Tokyo · *Lotte, or the transformation of the Object*, Grazer Kunstverein/Stadtmuseum, Graz · *Word as Image*, Art Museum, Milwaukee (et al.) · *1e Spectaculaire*, Centre d'Histoire de l'Art Contemporaire, Rennes · *Worlds*, Art Museum, Joensuu · *Objectives: The New Sculpture*, The Newport Harbor Art Museum, Newport Beach · *Un Art de la Distinction*, Abbaye Saint-André, Centre d'Art Contemporain, Meymac · *Jardins de Bagatelle*, Galerie Tanit, München · *The Decade Show*, Museum of Contemporary Hispanic Art/The New Museum of Contemporary Art/The Studio Museum, New York · *The Future of the Object!* Galerie Ronny Van de Velde, Antwerpen · *Life-Size*, The Israel Museum, Jerusalem **1991** *Metropolis*, Martin-Gropius-Bau, Berlin · *AnniNovanta*, Galleria Comunale d'Arte Moderna, Bologna · *Objects for the Ideal Home*, Serpentine Gallery, London · *Das goldene Zeitalter*, Württembergischer Kunstverein Stuttgart, Stuttgart · *Denk-Bilder*, Kunsthalle der Hypo-Kulturstiftung, München · *L'Espai I La Idea*, Fundació Caixa de Pensions, Barcelona · *Desplazamientos, Aspectos de la identidad y culturas*, Centro Atlantico de Arte Moderno, Las Palmas de Gran Canaria (et al.) · *John Knight and Haim Steinbach*, Palais des Beaux-Arts, Bruxelles (et al.) · *Joseph Kosuth, Michelangelo Pistoletto, H.S.*, Jay Gorney Modern Art, New York · *Once again the world is flat*, Galleria Juana de Aizpuru, Madrid · *Joseph Beuys, Anne and Patrick Poirier, H. S.*, Galerie Thaddaeus Ropac, Salzburg · *H.S. and Julia Wachtel*, Galerie Faust, Genève · *Beyond the frame: American Art 1960–1990*, Setagaya Art Museum, Tokyo (et al.) · *Power: Its Myths and Mores in American Art 1961–1991*, Museum of Art, Indianapolis (et al.) · *The Adventure of the Object, Quindicesima Biennale Internazionale del Bronzetto Piccola Scultura*, Padova **1992** *Yvon Lambert Collectionne*, Musée d'Art Moderne de la Communauté de Lille, Villeneuve D'Ascq · *Osmosis*, Guggenheim Museum, New York · *American Art of the 80's*, Museo d'Arte Moderna e Contemporanea, Trento · *The Eighties in the Collection of the ›La Caixa‹ Foundation*, Estacion de Plaza de Armas, Sevilla · *Psycho*, KunstHall, New York · *Biennale*, Art Gallery of New South Wales, Sydney · *Translation*, Center for Contemporary Art at Ujadowski Castle, Warszawa

Bibliographie | Bibliography

Texte vom Künstler | Texts by the artist
Observations (project), in: Art and Culture, Herbst, Nr. 4, 1981 · *Untitled* (project), in: File Magazine, Nr. 28, 1987 · *joy of tapping our feet* (project), in: Parkett, Nr. 14, 1988 · *Fresh Once Upon a Time* (project), in: De Rijksakademie (Amsterdam), September, 1989 · *Get Out of the Dark* (project), in: Flash Art (Russian Ed.), Nr. 1, 1989 · *Once (project)*, in: Artforum, März, 1990 · *beep, honk, toot* (project), in: Tema Celeste, Nr. 34, Januar/März, 1992

Periodika | Periodicals
Didier **Arnaudet**, *Haim Steinbach*, in: New Art, Februar/März, 1989 · Beni **Avni**, *Haim is No Longer Ours: Tel Aviv-New York, New York-New York*, in: Monitin (Israel), Nr. 112, Januar, 1988 · Achille **Bonito Olivia**, *Neo-America*, in: Flash Art, Januar/Februar,

1988 · Florette **Camard**, *Jean-Pierre Raynaud & Haim Steinbach*, in: Galeries Magazine, Nr. 42, April/Mai, 1991 · Dan **Cameron**, *Art and its Double: A New York Perpective*, in: Flash Art, Mai, 1987 · Dan **Cameron**, Wolfgang Max Faust, *Now New York New*, in: Wolkenkratzer Art Journal, Nr. 1, Januar/Februar, 1988 · Dan **Cameron**, *Haim Steinbach*, in: Art Today (videotape), Arts Video News Service, New York, Nr. 5, Mai, 1990 · Germano **Celant**, *Haim Steinbach's Wild, Wild, West*, in: Artforum, Dezember, 1987 · Carolyn **Christov-Bakargiev**, *Spotlight: Haim Steinbach: Staging the Illusion of Fake*, in: Flash Art, März/April, 1988 · Matthew **Collins**, *Posthumous Meaning*, in: Artscribe, September/Oktober, 1987 · Tricia **Collins**, Richard Milazzo, *McDonalds's is in Moscow and the Shadow of Batman's Cape*, in: Tema Celeste, Nr. 25, April/Juni, 1990 · Brigitte **Conrand**, *Inexpressioniste ou Déconstructionniste*, in: Actuel, Nr. 118, April, 1989 · Lynne **Cooke**, *Object Lessons*, in: Artscribe, September/Oktober, 1987 · Holland **Cotter**, *Haim Steinbach: Shelf Life*, in: Art in America, Mai, 1988 · Joshua **Dechter**, *Haim Steinbach*, in: Arts, Januar, 1992 · Thomas **Dreher**, *Haim Steinbach: The Exotic of the Familiar*, in: Artefactum, Nr. 37, Februar/März, 1991 · Jeremy **Gilbert-Rolfe**, *The Price of Goodness*, in: Artscribe, November/Dezember, 1989 · Eleanor **Heartney**, *Simultationism*, in: ArtNews, Januar, 1987 · Francois **Jeannot**, *Haim Steinbach*, in: New Art International, Mai, 1989 · Ken **Johnson**, *Haim Steinbach*, in: Art in America, Oktober, 1990 · Ronald **Jones**, *Haim Steinbach*, in: Artscribe, September/Oktober, 1987 · Ronald **Jones**, *Hover Culture*, in: Artscribe, Sommer, 1988 · David **Joselit**, *Investigating the Ordinary*, in: Art in America, Mai, 1988 · Donald **Kuspit**, *The Modern Fetish*, in: Artforum, Oktober, 1988 · Donald **Kuspit**, *Breakfast of Duchampians*, in: Contemporanea, Mai, 1989 · Hervé **Legros**, *Haim Steinbach*, in: Beaux-Arts Magazine, Nr. 90, Mai, 1991 · Christian **Leigh**, *Haim Steinbach*, in: Artforum, Oktober, 1988 · Christian **Leigh**, Octavio Zaya, *The Silent Baroque*, in: Balcon, Nr. 5/6, 1989 · Kim **Levin**, *Haim Steinbach: Signes de Progrès/Objets contradictoires*, in: Artstudio, Winter, 1990 · Lisa **Liebman**, *M.B.A. Abstractionism*, in: Flash Art, März, 1987 · Michael **Linger**, *Haim Steinbach: Stratgien Asthetischen Handelns II: Imaginair Gebrauch*, in: Kunst + Unterricht, Juni, 1991 · Kate **Linker**, *Sherrie Levine/Haim Steinbach*, in: Artforum, März, 1987 · Dalia **Manor**, *Haim Steinbach: Still Life*, in: Kav (Israel), Januar, 1989 · Robin **Mariner**, *Signs of the Times: Sculpture as Non-Specific Objects: The work of Koons and Steinbach*, in: Art Monthly, Juli/August, 1990 · John **Miller**, *In the Beginning There Was Formica*, in: Artscribe, März/April, 1987 · John **Miller**, *Haim Steinbach*, in: Artscribe, September/Oktober, 1987 · John **Miller**, *The Consumption of Everyday Life*, in: Artscribe, Januar/Februar, 1988 · Cathérine **Moreau**, *Haim Steinbach*, in: Beaux-Arts Magazine, 1989 · Robert **Morgan**, *Haim Steinbach*, in: Flash Art, Oktober, 1988 · Robert **Morgan**, *The Spectrum of Object-Representation*, in: Arts, Oktober, 1988 · Robert **Nickas**, *Shopping with Haim Steinbach*, in: Flash Art, Nr. 133, April, 1987 · William **Olander**, *Made in U.S.A.*, in: Beaux-Arts Magazine, Mai, 1987 · John **Perreault**, *Through a Glass Darkly*, in: Artforum, März, 1989 · Peter **Plagens**, *Under Western*

Eyes, in: Art in America, Januar, 1989 · Daniella **Salvioni**, *Haïm Steinbach,* in: Flash Art, Oktober, 1987 · Marjolein **Schaap**, *De archeologische waarde van linoleum,* in: Metropolis M, Nr. 1, Februar/März, 1989 · Jeanne **Siegel**, *Suits, Suitcases and Other Look-Alikes,* in: Arts, April, 1989 · **s.n.**, *(Interview),* in: Pataphysics G/H (Melbourne), 1990 · **s.n.**, *Haïm Steinbach: Works,* in: Spazio Umano, Nr. 2, 1989 · John **Russell Taylor**, *The New New Yorkers and the Avant Avant-Garde,* in: Art & Design, Nr. 3/4, 1988 · Pier Luigi **Tazzi**, *Haïm Steinbach,* in: Galeries Magazine, Dezember 1988/Januar 1989 · Paul **Taylor**, *Haïm Steinbach: An Easygoing Aesthetic that appeals to the Flaneur in many of us,* in: Flash Art, Nr. 146, Mai/Juni, 1987

PAT STEIR

*Newark (New York, USA) 1940
Lebt/Lives in New York/Amsterdam

Einzelausstellungen | One-man exhibitions

1964 Terry Dintenfass Gallery, New York **1969** Bienville Gallery, New York **1971** Graham Gallery, New York **1972** Douglass College, Rutgers University, New Brunswick · Paley & Lowe, Inc., New York **1973** Ball State University Art Gallery, Muncie · The Corcoran Gallery of Art, Washington, DC · Max Protetch Gallery, Washington, DC **1975** Fourcade, Droll, Inc., New York · John Doyle Gallery, Paris · State University of New York, Oneonta **1976** The Art Gallery, University of Maryland, College Park · Galerie Farideh Cadot, Paris · Morgan Thomas Gallery, Santa Monica · Otis Art Institute, Los Angeles · White Gallery, Portland State University, Portland · Xavier Fourcade, Inc., New York **1977** Carl Solway Gallery, Cincinnati **1978** Art School for Children, Birmingham · Droll/Kolbert Gallery, New York · Galeria Marilena Bonomo, Bari · Galerie Farideh Cadot, Paris **1979** Galerie Farideh Cadot, Paris **1980** Droll/Kolbert Gallery, New York · Galerie d'Art Contemporain, Genève · Galerie Farideh Cadot, Paris · Max Protetch Gallery, New York **1981** Galerie Marilena Bonomo, Bari · Galerie Farideh Cadot, Paris · *Etchings & Lithos & Drawings,* Galleriet, Lund · Marianne Deson Gallery, New York ·

Bell Art Gallery, List Art Center, Brown University, Providence · *Etchings and Paintings,* Crown Point Press Gallery, Oakland **1982** Eason Gallery, Santa Fe · Galerie Annemarie Verna, Zürich · Galerie Farideh Cadot, Paris · Nina Frudenheim Gallery, Buffalo **1983** *At Sea, 1982,* Crown Point Press, New York · Fuller Goldeen Gallery, San Francisco · Galeria Marilena Bonomo, Bari · Gloria Luria Gallery, Bay Harbour Islands · The Harcus Gallery, Boston · McIntosh/Drysdale Gallery, Houston · *Arbitrary Order: Paintings by Pat Steir,* Contemporary Arts Museum, Houston (Lowe Art Museum, Coral Gables; The Contemporary Arts Center, Cincinnati) (Kat.: M. Mayo) · *Form Illusion Myth: The Prints and Drawings of Pat Steir,* Spencer Museum of Art, University of Kansas, Lawrence (University Art Museum, California State University, Long Beach; Contemporary Arts Museum, Houston; The Wellesley College Museum, Wellesley; Brooks Memorial Art Gallery, Memphis) (Kat.: E. Broun) **1984** *New Paintings and Works on Paper,* Van Straaten Gallery, Chicago · *New Paintings,* Galleriet, Lund · Signet Gallery, St. Louis · *New Work,* Nina Freudenheim Gallery, Buffalo · *New Paintings,* Galerie Barbara Farber, Amsterdam · Real Art Ways, Hartford **1984/87** *The Breughel Series,* The Brooklyn Museum, Brooklyn (Minneapolis College of Art and Design, Minneapolis; Joslyn Art Museum, Omaha; Matrix University Art Museum, Berkeley; The Ohio State University Gallery of Fine Art, Columbus; The Honolulu Academy of Fine Art, Honolulu; Dallas Museum of Fine Arts, Dallas; Centre d'Art Contemporain Palais Wilson, Genève; Los Angeles County Museum, Los Angeles; Des Moines Art Center, Des Moines; Gemeentemuseum, Den Haag) (Kat.: T. McEvilley, J. Yenson) **1985** *New Drawings,* Cincinnati Art Museum, Cincinnati · *Major Prints and Drawings,* Dolan/Maxwell Gallery, Philadelphia · *Peintures 1981–1985,* Galerie Eric Franck, Genève · Fuller Goldeen Gallery, San Francisco · *Prints/Printmaking,* Philadelphia College of Art, Philadelphia **1986** Fuller Goldeen Gallery, San Francisco · John C. Stoller & Co., Minneapolis · Castelli Uptown, New York · The Harcus Gallery · *New Monoprints and Etchings,* Crown Point Press, New York · *New Paintings,* Kuhlenschmidt/Simon Gallery, Los Angeles · *Concentrations 14: P.S.,* Dallas Museum of Art, Dallas (Kat.: S. Graze) **1987** *Self-Portrait: An Installation,* New Museum of Contemporary Art, New York (Kat.: M. Tucker) · *The Moon and the Wave,* M. Knoedler & Co. Inc., New York · *P.S.,* Galerie Eric Franck, Genève · *Schilderijen 1981–84,* Rijksmuseum Vincent Van Gogh, Amsterdam · Galerie Adelina von Fürstenberg, Genève · *P.S. Autoritrato,* Galleria Alessandro Bonomo, Roma · *Drawing Now,* Museum of Art, Baltimore · *Paintings and Drawings,* Kunstmuseum, Bern (Kat.: D. Zacharopoulos) **1988** *Waterfall Series,* Knoedler & Co., Inc., New York · Victoria Miro Gallery, London · *Prints 1976–1988,* Musée d'Art et d'Histoire, Genève (Tate Gallery, London) (Kat.: J. Willi) · *Waterfall Monoprints,* Crown Point Press, San Francisco/Crown Point Pres, New York **1989** *New Works,* Harcus Gallery, Boston · *Waterfall Paintings,* Massimo Audiello Gallery, New York · Galeria Marilena Bonomo, Bari · *Waterfall Paintings,* Fuller Gross Gallery, San Francisco · *New Monoprints,* Crown Point Press,

New York · *New Waterfall Paintings,* Galerie Eric Franck, Genève · Galleria *P.S.: Neue Wasserfallbilder,* TransArt Exhibitions, Köln **1990** *Paintings,* Art Museum, University of Southern Florida, Tampa (Kat.: L. Leibman) · Galerie Montenay, Paris · *Ways of Seeing, Paintings Drawings Prints of the 1980s,* New Jersey Center for the Visual Arts, Summit (Kat.: N. Cohen) · Musée d'Art Contemporain, Lyon (Kat.: D. Zacharopoulos) · *Drawings,* Dennis Ochi Gallery, Sun Valley and Boise · *Conversation with Artists, V,* National Gallery of Art, Washington DC · *Waterfall Paintings,* Robert Miller Gallery, New York (Kat.: H. Cotter) · USF Art Museum, University of South Florida, Tampa · *Waterfalls,* Victoria Miro Gallery, London **1991** *Self–Portrait Installation,* MakKenzie Art Gallery, Regina · Linda Cathart Gallery, Santa Monica · Galerie Franck & Schulte, Berlin · *Waterfall Paintings,* Galerie Franck & Schulte, Berlin **1992** *One Woman Travelling Show,* The Brooklyn Museum, Brooklyn

Gruppenausstellungen | Group exhibitions

1986/88 *Images on Stone: Two Centuries Artists' Lithographs,* Sarah Campbell Blaffere Gallery, University of Houston (et al.) **1986/90** *Focus on the Image: Selection from the Rivendell Collection,* The Art Museum Association of America (et al.) **1987** *Working Woman,* The Harcus Gallery, Boston · *Avant Garde in the Eigthies,* Los Angeles County Museum, Los Angeles · *Art Against Aids,* M. Knoedler & Co., New York · *Drawings from the Eighties,* Carnegie Mellon University Art Gallery, Pittsburgh · *The Importance of Drawing,* Fuller Goldeen Gallery, San Francisco · *Still Life: Beyond Tradition,* Visual Arts Museum, New York · *Prints in Paris,* Crown Point Press, New York · *The Success of Failure,* Independant Curators Inc., New York (et al.) · *FACES,* Crown Point Press, San Francisco · *Art and the Law,* The West Company, St. Paul · *Drawings,* Sylvia Cordish Fine Art, Baltimore · *Romanticism and Classicism,* The QCC Art Gallery, Queensborough Community College, Bayside · *Not so Plain Geometry,* Crown Point Press, New York · *Stephen Antonakos, Michael Springer, Robert Stackhouse, Pat Steir,* Bienale de São Paulo, São Paulo · *D'Ornamentation,* Daniel Newburg Gallery, New York · *Recent Publications,* Crown Point Press, San Francisco · *A Decade of Pattern: Prints, Pieces and Prototypes from the Fabric Workshop,* The Graduate School of Fine Arts, University of Pennsylvania at the Institute of Contemporary Art, Philadelphia · *For 25 Years: Crown Point Press,* Museum of Modern Art, New York · *Art-to-Wear Fashion Show, Boutique and Luncheon,* Cleveland Center for Contemporary Art, Cleveland · *Stations,* Centre International d'Art Contemporain, Montréal · *Malerei-Wandmalerei,* Grazer Kunstverein, Stadtmuseum Graz **1988** *Idea Image: Etching and Woodblocks,* Crown Point Press, New York/San Francisco · *The Feminine Touch,* Thomas Fine Arts, Pasadena · *Alan Charlton, Matt Mullican, Pat Steir,* Michael Klein, Inc., New York · *Prints by Contemporary Women Artists,* Mary Ryan Gallery, New York **1989** *Contemporary Masters,* S. Bitter-Larkin Gallery, New York · *American Artists: curated by Donald Kuspit,* Kuznetsky Most Exhibition Hall, Moskva · *Les Cents Jours,* Centre

International d'Art Contemporain, Montréal · *The Silent Baroque,* Galerie Thaddeaus Ropac, Salzburg · *Pat Steir/Waves & Waterfalls and Joel Perlman/Recent Bronzes,* Gloria Luria Gallery, Bay Harbor · *Methods of Abstraction,* Gallery Urban, New York · *Art of Renewal,* Orchard Gallery, Derry · *Encore II: Celebrating 1980–89,* Contemporary Arts Center, Cincinnati · *Specific Metaphysics,* Sandra Gering Gallery, New York · *First Impressions,* Walker Art Center, Minneapolis (et al.) **1990** *The Grid: Organization and Idea,* Ben Shahn Gallery, William Patterson College, Wayne · *3-Person Installation Show,* Le Magasin, Grenoble · *Group Show: Installations,* Ecole des Beaux Arts, Tourcoing · *Terra Incognita,* Museum of Art, Rhode Island School of Design, Providence · *Spellbound,* Marc Richards Gallery, Los Angeles · *Inconsolable,* Louver Gallery, New York · *Some Seventies Works,* Robert Miller Gallery, New York · *Contemporary Prints and Multiples,* Norah Haime Gallery, New York · *Twenty Years of Landfall Press,* Landfall Press, Chicago · *Vertigo,* Galerie Thaddeaus Ropac, Paris · *Le Diaphane,* Musée des Beaux-Arts, Tourcoing **1991** *Art Pro Choice II Print Portfolio,* K. Kimpton Gallery, San Francisco · *Masterworks of Contemporary Sculpture, Paintings and Drawings: 1930s – 1990s,* Bellas Artes, Santa Fe · *Vertigo,* Thaddeaus Ropac, Salzburg (smaller version of show of 1990) · *Rope,* Galleria Fernando Alcolea, Barcelona · *Biennial Exhibition,* Whitney Museum of American Art, New York · *A Dialogue of Images – Recent German and American Paintings,* Galerie Pfefferle, München · *Art Pro-Choice II,* Linda Cathcart Gallery, Santa Monica · *Landscape Seven Views,* Nina Freudenheim Gallery, Buffalo **1992** *Psycho,* KunstHall, New York

Bibliographie | Bibliography

Texte von der Künstlerin | Texts by the artist
Where The Birds Fly, What The Lines Whisper, in: Artforum, Bd. 25 Mai, 1987 · *The Word Unspoken,* in: Artforum, Bd. 28, Nr. 4, Dezember, 1989 · *Pictures of Light,* in: Tema Celeste, Nr.34, Januar/März 1992

Bücher | Books
Carter **Ratcliff,** *Pat Steir Paintings,* New York, Harry N. Abrams, 1986

Periodika | Periodicals
Liliana **Albertazzi,** *Canada,* in: Contemporanea, Nr. 2, Februar, 1990 · Ans Van **Berkum,** *Pat Steirs variant op de Vanitas-gedachte. Onsterfelijkheid in plaats van verwelken,* in: Ruimte, Januar, 1987 · Robert **Campbell,** in: Architectural Digest, Februar, 1988 · Holland **Cotter,** *Pat Steir: New Museum,* in: Flash Art, 1987 · Holland **Cotter,** *Pat Steir,* in: Flash Art, Nr. 159, Sommer, 1991 · Ginger **Danto,** *What Becomes an Artist Most ?,* in: Artnews, November, 1987 · Susan **Drew,** *Artist's On Break,* in: Elle, August, 1988 · Paul **Gardner,** *I Dream of a Dazzling Waterfall,* in: Contemporanea, Oktober, 1990 · Susan **Gill,** *New York Reviews, Pat Steir: Knoedler, New Museum of Contemporary Art,* in: Artnews, Nr. 6, 1987 · Matias **Grilj,** *Steirische Herbst,* in: Wolkenkratzer, Art Journal Dezember, 1987 · Elizabeth **Hess,** *Upstairs, Downstairs,* in: Village Voice, 30. April, 1991 · Gene **Grinnell,** *Printed Art Today Part 4: Crown Point Press,* in: Mizue, Nr. 959, 1991 · Lise **Holst,** *Pat Steir*

Robert Miller, in: Art in America, Nr. 12, Dezember, 1990 · David **Hornung,** *Pat Steir: Massimo Audiello,* in: Artnews, Nr. 6, Sommer, 1989 · Anne **Hoy,** *Portrait Photographs From Artnews 1905 – 1986,* in: Artnews, Nr. 2, Februar, 1987 · John **Howell,** *A Bloom of One's Own,* in: Elle, Februar, 1988 · Barbara **Kafka,** *Pleasing the Palette,* in: Artnews, Nr. 8, Oktober, 1989 · Christian **Leigh,** *The 1991 Whitney Biennial,* in: Flash Art, Nr. 159, Sommer, 1991 · Catherine **Liu,** *Pat Steir Robert Miller Gallery,* in: Artforum, Nr. 4, Dezember, 1990 · Barbara **MacAdam,** *Pat Steir Robert Miller,* in: Artnews, Nr. 10, Dezember, 1990 · Robert **Mahoney,** *Pat Steir,* in: Tema Celeste, Nr. 29, Januar/Februar, 1991 · Pat **McCoy,** *Pat Steir: Knoedler,* in: Artscribe, Januar/Februar, 1988 · Thomas **McEvilley,** *Reviews, Pat Steir: New Museum of Contemporary Art,* in: Artforum, Nr. 10, Sommer, 1987 · Herbert **Muschamp,** *Oil and Water,* in: Vogue, Juli, 1990 · Nancy **Princenthal,** *The Self in Parts,* in: Art in America, Nr. 11, November, 1987 · Peter **Schjeldahl,** *Cutting Hedge,* in: Village Voice, 30. April, 1991 · Marvin **Shinbrot,** *Things Fall Apart,* in: The Sciences, Mai/Juni, 1987 · Riki **Simons,** *Pat Steir: Interview,* in: Avenue Magazine, Dezember, 1987 · Joshua **Teplow,** *Self Portrait: An Installation,* in: C Magazine, Herbst, 1987 · Jeff **Weinstein,** *Installation Art 305A,* in: Village Voice, März, 1987

WOLFGANG STRACK

arbeitet in Hamburg
lebt in Landau in der Pfalz

Lebenslauf – Kunstlauf

1956 Am 79. Geburtstag von Alfred Kubin, am 62. Geburtstag von Ben Nicholson, am 36. Geburtstag von Kenneth Noland und am 24. Geburtstag von James Lee Byars, sowie leider erst fünf Tage vor Leonardo da Vincis 405. Geburtstag und vier Tage nach Raffaels 473. Geburtstag und 436. Todestag wurde Wolfgang Strack als Sohn seines Vaters und seiner Mutter in Landau/Pfalz geboren. Drei Tage später stirbt Emil Nolde in Seebüll.
1957 Erster eigener Geburtstag.
1958 Erster Ausspruch: »Moler moled Maale«, anschließend erste »Kopffüßler«-Bilder.

1959 Erste Auseinandersetzung mit Leonardo da Vinci bei der Zusammensetzung eines Mona Lisa-Puzzles und erstes Zerreißen einer (Papier-)Schlange.
1960 Erste Reaktionen von Unverständnis auf seine ersten gestotterten Erkenntnisse, die Strack nach der Betrachtung von Picassos »Guernica« widerfuhren.
1961 Erste Verarbeitung von Spielzeug in Kunstzeug und Comics in Kunstmix.
1962 Erste suizidale Versuche.
1963 Erste Klasse in der Pestalozzi-Schule Landau.
1964 Erster Verkauf eines Gemäldes (Palmen mit Kokosnüsse) für 50 Pfennig an Tante Gertrud; anschließend erste Preiserhöhung.
1965 Erste Leiden des jungen W.
1966 Erster Versuch einen Skandal zu provozieren. Ohne Erfolg. 10. Geburtstag.
1967 Erstes Jahr am Max Slevogt-Gymnasium Landau und gleich eine Ohrfeige wegen »Schmierereien« am Schulinventar während des Kunstunterrichts von Frau Orschiedt.
1968 Erste künstlerisch-therapeutische Auseinandersetzung mit der eigenen Phonophobie.
1969 Erste Begegnung mit einem Schlumpf.
1970 Erste Konfrontation mit Arbeiten von Joseph Beuys während eines Besuches des Hessischen Landesmuseums in Darmstadt (mit Tante Gertrud). Anschließend am Oberwaldhaus Eierschalen aufgesammelt.
1971 Erste Erfindung des One-day-ismus, anschließend erster Rheumatismus.
1972 Erste Erkenntnis, daß Stottern auch Kunst sein kann (nach einer Filmvorführung im Kunstunterricht von Herrn Burg, wo eine Rezitation von Hugo Ball gezeigt wurde).
1973 Erste Naturerfahrung in Südfrankreich, wo Strack während der Osterferien als Hirte einem neugeborenen schwarzen Lamm seine Sandzeichnungen erklärte und dabei von dem zufällig des Weges kommenden Picasso entdeckt wurde (am 17. Geburtstag).
1974 Erstes Manifest für die programmatische Forderung nach dem BkfbK (Beifallklatschen für bildende Künstler).
1975 Erste Retrospektive von Arbeiten auf Pausenbrotpapier aus der Zeit vom 6. Dezember bis 1. April 1975.
1976 Erst Abitur, dann 20. Geburtstag und schließlich kaufmännische Lehre (bis 1978).
1977 Erste Verweigerung aller Ausstellungsbesuche, erster Streik als bildender Künstler, erste Armut.
1978 Erster Besuch der Galerien Klewan und Storms in München. Danach kunstgeschichtliches Studium als ordentlich immatrikulierter Student an der Ludwig Maximilian-Universität in München (seit 1980 an der Universität Hamburg).
1979 Erste Verkaufsausstellung an der Leopoldstraße in München. Ohne Erfolg. Anschließend erstes U.N.-Stipendium.
1980 Erste Ablehnung zur Großen Kunstausstellung im Haus der Kunst München. Erste Begegnung mit Joseph Beuys und Waldemar Kramer.
1981 Erste Studienreise nach Gleiszellen-Gleishorbach (mit Mathias Buck und Thomas Dittelbach). Besuch bei Luise Roth und Roland Pramor.
1982 Erstes offizielles Semester an der Hochschule für bildende Künste Hamburg im Fachbereich Freie Kunst.

1983 Erster Diebstahl seiner Werke während der HfbK-Jahresausstellung.
1984 Erster Hedwig Merkel-Gedächtnispreis.
1985 Erste Tätigkeit als Detektiv, Stuntman, Sandmann, Printmediendistributor, Pinselwäscher und Sektionsgehilfe.
1986 Erster Konflikt mit der Staatsgewalt (wg. OWi gm. § 56 OWiG i.V.m. § 27 StVG) und 30. Geburtstag.
1987 Erste nicht stattgefundene Ausstellung im Kunstraum e.V. München.
1988 Erste Lücke in der Biographie.
1989 Erste erfolgreiche, historische Lucio Fontana-Rezeption an der Berliner Mauer.
1990 Erste Geige in seinem ersten Stück »Der Kunstmacher«.
1991 Erste Begegnung mit dem Kunstsammler Dr. med. dent. Heinz Hunstein auf dessen Behandlungsstuhl in Kassel. Gleichzeitig erste Stornierung des ersten U.N.-Stipendiums in Hamburg und letzte Korrektur der ersten Dissertation über das Thema: »Meta-Kunst, eine kunst-wissenschaftliche Dissertation für Erwachsene« bei Prof. Dr. Martin Warnke.

Curriculum vitae – curriculum artis

1956 On the 79th birthday of Alfred Kubin, the 62nd birthday of Ben Nicholson, the 36th birthday of Kenneth Noland, the 24th birthday of James Lee Byars – also, unfortunately, five days before the 504th birthday of Leonardo and four days after the 473rd anniversary of Raphael's birth and the 436th of his death – Wolfgang Strack born at Landau, Palatinate, the son of his father and of his mother. Three days later, Emil Nolde dies at Seebüll.
1957 First birthday, his own.
1958 First statement: »Painta painta painta,« then first »Headfoot« paintings.
1959 First confrontation with Leonardo da Vinci, occasioned by assembling a Mona Lisa jigsaw puzzle; first snake (a paper one) torn apart.
1960 First reactions of incomprehension to his first, stammered insight, directly after the viewing of Picasso's Guernica.
1961 First conversion of playthings into artthings and of comics into artmix.
1962 First suicidal attempts.
1963 First class at Pestalozzi School, Landau.
1964 First sale of a painting (Palms with Coconuts), for 50 pfennigs, to Aunt Gertrud; then first price increase.
1965 First Sorrows of Young W.
1966 First attempt to provoke a scandal. Unsuccessful. Tenth birthday.
1967 First year at high school, Max-Slevogt-Gymnasium, Landau, and immediate box on the ear for »daubing« school property in Frau Orschied's art class.
1968 First attempt at artistic self-therapy for phonophobia.
1969 First encounter with a Smurf.
1970 First confrontation with works of Joseph Beuys, on a visit to Hessisches Landesmuseum, Darmstadt (with Aunt Gertrud). Later collects eggshells at Oberwaldhaus.
1971 First invention of One-Day-Ism, followed by first rheumatism.
1972 First realization that stammering can be art (after a film, shown in Herr Burg's art class, that included a recitation by Hugo Ball).

1973 First experience of Nature in the South of France. Working as a shepherd during the Easter vacation, Strack was explaining his sand drawings to a newborn black lamb when he was accidentally discovered by Picasso, who happened to be passing (on his 17th birthday).
1974 First manifesto of programmatic demand for the BHAA (Big Hand to Applaud Artists) code.
1975 First retrospective of works on sandwich wrappers dating from the period 6 December 1974 – 1 April 1975.
1976 First, High school graduation, then 20th birthday; business traineeship (until 1978).
1977 First refusal to visit all exhibitions, first strike as an artist, first poverty.
1978 First visit to Klewan gallery and Storms gallery, Munich. Then registers as student of art history at Ludwig-Maximilian University, Munich (later, from 1980 onward, at University of Hamburg).
1979 First selling exhibition on Leopoldstrasse, Munich. A failure. Then first U.N. Bursary.
1980 First rejection at Grosse Kunstausstellung in the Haus der Kunst, Munich. First meeting with Joseph Beuys and with Waldemar Kramer.
1981 First study trip to Gleiszellen-Gleishorbach (with Mathias Buck and Thomas Dittelbach). Visit at Luise Roth and Roland Pramor.
1982 First official semester at art school, Hochschule für bildende Künste, Hamburg, as student in department of fine art.
1983 First theft of his works at Hochschule annual exhibition.
1984 First Hedwig Merkel Memorial Prize.
1985 First employment as detective, stuntman, sandman, print media distributor, brush washer, and autopsy assistant.
1986 First conflict with authority (wg. OWi gm. § 56 OWiG i.V.m. § 27 StVG) and 30th birthday.
1987 First exhibition that has not taken place (at Kunstraum, Munich).
1988 First gap in biography.
1989 First successful, historic appreciation of Lucio Fontana, at the Berlin Wall.
1990 First fiddle in his first piece, The Art Maker.
1991 First encounter with art collector and dental surgeon, Dr. Heinz Hunstein, in his dental chair in Kassel. Simultaneously, first cancellation of first U.N. Bursary in Hamburg and final corrections to first dissertation, entitled: "Meta-Art, an Art-Scientific Thesis for Adults," supervised by Professor Martin Warnke.

(Translated from the German by David Britt)

THOMAS STRUTH

*Geldern (D), 1954
Lebt/Lives in Düsseldorf

Einzelausstellungen | One-man exhibitions

1978 *P.S. 1*, The Clocktower Gallery, New York **1980** Galerie Rüdiger Schöttle, München **1985** Galerie Rüdiger Schöttle, München **1986** Shimada Gallery, Yamaguchi **1987** Galerie Max Hetzler, Köln · *Unbewußte Orte/Unconscious Places*, Kunsthalle, Bern

(Westfälisches Landesmuseum, Münster; Fruitmarket Gallery, Edinburgh; Prefectural Museum of Art, Yamaguchi) (Kat.: I. Hartmann, U. Loock, F. Meschede) · Galerie Meert Rihoux, Bruxelles · Galerie Rüdiger Schöttle, München **1989** Halle Sud, Genève (Kat.: J.-F. Chevrier, R. Cornu) · Galerie Max Hetzler, Köln **1990** *Portraits*, Marian Goodman Gallery, New York (Kat.: B. H.D. Buchloh) · Galerie Paul Andriesse, Amsterdam · Giovanna Minelli, Paris · Urbi et Orbi Galerie, Paris · The Renaissance Society, Chicago (Kat.: B.H.D. Buchloh, S. Ghez) **1991** Shimada Gallery, Yamaguchi, · Institute of Contemporary Art, Boston · Galerie Meert Rihoux, Bruxelles **1992** Galerie Max Hetzler, Köln · *Portraits*, Museum Haus Lange, Krefeld

Gruppenausstellungen | Group exhibitions

1987 *Skulptur Projekte Münster*, Westfälisches Landesmuseum, Münster · *Das Ruhrgebiet heute*, Museum Folkwang, Essen · *Ars viva*, Villa Dessauer, Bamberg (et al.) **1988** *Another Objectivity*, Institute of Contemporary Arts, London · Galerie Rüdiger Schöttle, München · *Fotoarbeiten*, Wolfgang Wittrock Kunsthandel, Düsseldorf · *La raó revisada*, Fundació Caixa de Pensions, Barcelona · *Die Becher-Klasse*, Galerie Johnen & Schöttle, Köln **1989** *Prospect Photographie*, Kunstverein, Frankfurt/M. · *Photo-Kunst, Arbeiten aus 150 Jahren*, Neue Staatsgalerie, Stuttgart · *Künstlerische Fotografie der 70er und 80er Jahre*, Neue Staatsgalerie, Stuttgart · *Another Objectivity*, Centre National des Arts Plastiques, Paris · Luhring Augustine Gallery, New York · Marian Goodman Gallery, New York · *Deconstructing Architecture – Reconstructing History*, Massimo Audiello Gallery, New York **1990** *Weitersehen*, Museum Haus Lange und Haus Esters, Krefeld · *Paesaggio*, Galleria Lia Rumma, Napoli · *Aperto*, Biennale di Venezia, Venezia · *Le Diaphane*, Musée des Beaux-Arts, Tourcoing · *German Photography*, Aldrich Museum of Contemporary Art, Ridgefield · *Images in Transition*, National Museum of Modern Art, Kyoto/National Museum of Modern Art, Tokyo · *De afstand*, Witte de With, Rotterdam · *Spiel der Spur*, Shedhalle Zürich · *Affinities and Intuition*, Art Institute of Chicago, Chicago **1991** *Aus der Distanz*, Kunstsammlung Nordrhein-Westfalen, Düsseldorf · *Surgence. La creation photographique contemporaine en Allemagne*, Comédie de Reims, Reims (et al.) · *Carnegie International*, Carnegie Museum of Art, Pittsburgh · *A Dialogue about recent American and European Photography*, Museum of Contemporary Art, Los Angeles · *Sguardo di Medusa*, Castello di Rivoli, Rivoli (Torino) · *This Land*, Marian Goodman Gallery, New York · *La Revanche de l'Image*, Galerie Pierre Huber, Genève · *Kunstfonds 10 Jahre*, Kunstverein, Bonn · *Lyne Cohen, Thomas Struth, Christopher Williams*, Galerie Samia Sãouma, Paris · *Typologies*, Newport Harbor Art Museum, Newport Beach · *Currents*, Institute of Contemporary Art, Boston · Giovanna Minelli, Paris *Fotografija*, Moderna Galerija, Ljubljana

Bibliographie | Bibliography

Periodika | Periodicals
Françoise **Bataillon**, *Thomas Struth*, in: Beaux Arts Magazine, Nr. 86, Januar, 1991 ·

Christoph **Blase**, *Fotos vom Leben – ganz ohne Menschen. über die ›Unbewußten Orte‹ des Thomas Struth*, in: Artis, Februar, 1988 · Christoph **Blase**, *Vom Betrachten der Kunst*, in: Kunst-Bulletin, Februar, 1991 · Gabrielle **Boller**, *Lieux Inconscients*, in: Art Press, Nr. 122, Februar, 1988 · David **Bussel**, *Thomas Struth*, in: Flash Art, 1991 · Giuseppe **Cannilla**, *Thomas Struth*, in: Juliet, Nr. 52, April/Mai, 1991 · Jean-François **Chevrier**, *Bernd & Hilla Becher, Thomas Struth*, in: Galeries Magazine, Dezember/Januar, 1988/ 1989 · Christoph **Doswald**, *Thomas Struth ›Unbewußte Orte'*, in: Kunstforum, April/ Mai, 1988 · Wolfgang Max **Faust**, *Kunst mit Fotografie heute*, in: Wolkenkratzer Art Journal, Januar/Februar, 1989 · Justin **Hoffmann**, *Thomas Struth, Galerie Rüdiger Schöttle*, in: Artforum, April, 1989 · Patrick **Frey**, *Genau konturierte Geschichte geräumte Leere*, in: Wolkenkratzer Art Journal, Januar/Februar, 1988 · Isabelle **Graw**, *Berhard Becher's Students. Johnen und Schöttle, Cologne*, in: Flash Art, November/ Dezember, 1988 · Isabelle **Graw**, *Ortskunde*, in: Artis, Dezember, 1989 · Isabelle **Graw**, *Bildbesprechung*, in: Artis, Februar, 1990 · Catherine **Grout**, *Thomas Struth, Genève, Halle Sud*, in: Artefactum, September/Oktober, 1989 · Susan **Hapgood**, *Thomas Struth at Marian Goodman*, in: Art in America, Januar, 1991 · Manfred **Hermes**, *Thomas Struth, Galerie Max Hetzler*, in: Artscribe, Sommer, 1989 · Manfred **Hermes**, *Repetition, Disguises, Documents. How Photography has pervaded two Decades of Contemporary German Art*, in: Flash Art, Oktober, 1989 · Kathryn **Hixson**, *Thomas Struth – Hoping to transcend the photograph representational function*, in: Flash Art, Juli, 1990 · Justin **Hoffmann**, *Thomas Struth, Galerie Rüdiger Schöttle*, in: Artforum;, April, 1989 · Donald **Kuspit**, *Thomas Struth – Marian Goodman*, in: Artforum, Dezember, 1990 · José **Lebrero Stals**, *La Escuela de Düsseldorf*, in: Lapiz, Nr. 68, Mai, 1990 · Ulrich **Loock**, *Thomas Struth*, in: Creative Camera, Mai, 1988 · Ulrich **Loock**, *Thomas Struth: ›Unbewußte Orte‹*, in: Parkett, Nr. 23, 1990 · Harm **Lux**, *Thomas Struth*, in: C Laiwan, Sommer, 1988 · Helga **Meister**, *Mit Licht, kühlem Blick und Methode*, in: Art, Oktober, 1989 · François Yves **Morin**, *Le Regard Indifférent*, in: Halle Sud Magazine, Nr. 21, 1989 · Hans Rudolf **Reust**, *Backdrop*, in: Artscribe, Mai/April, 1989 · Jerry **Saltz**, *What is the reason for your visit to this museum?*, in: Arts Magazine, Januar, 1991 · Karlheinz **Schmid**, *Kühl, karg und immer in Serie*, in: Art, November, 1987 · Barry **Schwabsky**, *Thomas Struth*, in: Arts Magazine, Dezember, 1990 · Maureen P. **Sherlock**, *Thomas Struth*, in: Tema Celeste, Nr. 27–28, November/Dezember, 1990 · Maureen P. **Sherlock**, *Thomas Struth*, in: Tema Celeste, 30, März/April, 1991 · Anne **Wauters**, *Chacun son Réel*, in: Art & Culture, Januar, 1991 · Herta **Wolf**, *Zu Skulpturen geronnene Architekturen*, in: Camera Austria, Nr. 2, 1990 · Regina **Wyrwoll**, *Revedierte Vernunft?*, in: Kunstforum, Januar/Februar, 1989

JÁNOS SUGÁR

*Budapest (H), 1958
Lebt/Lives in Budapest

Einzelausstellungen | One-man exhibitions

1984 Bercsényi Club, Budapest **1985** Adolf Fényes Gallery, Budapest · Bercsényi Club, Budapest **1986** Studio Gallery, Budapest **1987** Liget Gallery, Budapest · LKH Gallery, Budapest **1988** REM Gallery, Wien · FMK Gallery, Budapest · Institut Français, Budapest **1989** Salone Villa Romana, Firenze · Gallery Knoll, Wien · Künstlerhaus, Dortmund **1990** Gallery Knoll, Budapest · Lajos utca Exhibition House, Budapest **1991** Ujlak Exhibition Space, Budapest

Gruppenausstellungen | Group exhibitions

1988 5th Biennal of European Graphic Art, Heidelberg · Asian-European Art Biennal, Ankara · 1st Intern. Triennal of Patterns, Budapest **1989** *Symmetry and Assymmetry*, Hungarian National Gallery, Budapest · *Different View*, Ernst Museum, Budapest **1990** *Triumf, the Uninhabitable*, Charlottenborg Kobenhavn/Mücsarnok, Budapest **1991** *European Workshop*, Recklinghausen · *Europe Unknown*, Palac Sztuki, Cracow · *Kunst, Europa*, Gesellschaft für aktuelle Kunst, Bremen · *Oscillation*, 6th Bastion, Komarno, Czeh and Slovak Federal Republic · *Sub Voce*, video installation, Mücsarnok, Budapest · Biennal de São Paolo · *8×2 aus 7*, Neue Galerie am Landesmuseum Joanneum, Graz · *Budapest!*, RHA, Gallery, Dublin

Ausstellungen mit Indigo Group
Exhibitions with Indigo Group

1980 *Biography*, FMH, Budapest · *Arboretum*, KEK, Budapest · *Watercolour*, Bercsényi, Budapest **1981** *Paper*, PIK Csepel, Budapest · *Hard and Soft*, Obuda Gallery, Budapest · *My Greatest Summer Experience*, Postas Müv. Ház, Budapest **1982** *Table Actions* (Happening), Postas Müv. Ház, Budapest **1983** *Actual Performance* (Happening), Postás Müv. Ház, Budapest · Telephone Concert between Vienna, Berlin, Budapest · *Experimental Film in Hungary*, Budapest Gallery, Budapest · *Drawing Course*, Museum of Fine Arts, Budapest · *Pax* (Happening), L. Rajk College, Budapest **1984** *The Personal and the Sacred*, Bercsényi Club, Budapest · *Money-Washing* (Happening), BMK, Budapest · *Yellow Pictures*, FMK, Budapest **1986** Opening performance of the exhibition of Miklós Erdély, Obuda Gallery, Budapest · *Table Actions* (Happening), Mücsarnok, Budapest

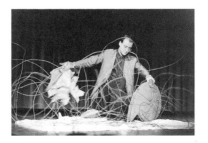

Performances

1984 *Fast Culture*, Kossuth Club, Budapest **1985** *Fast Culture*, Kossuth Club, Budapest **1986** *Fast Culture*, Kossuth Club, Budapest **1987** *Fast Culture*, Kossuth Club, Budapest · *The Circle and the Dawn*, New York Café, Kassel **1988** *Fast Culture*, Kossuth Club, Budapest **1990** *Vidéo -performances téléphoniques*, Budapest-Albi **1992** *Strecke durch Zeit*, Künstlerhaus Bethanien, Berlin

Theaterproduktionen | Theatre Productions

1988 *The Immortal Culprits*, Szkene Theater, Budapest **1991** *The Immortal Culprits*, Várszinház, Budapest

Bibliographie | Bibliography

Texte vom Künstler | Texts by the artist
Actual Performance, in : Al Galantai Periodical (Budapest), 1982 · *The Exit*, in : Jóvilág (Budapest) University Magazin, 1985 · *The Velocity of Succes*, in : Filmkultura (Budapest), 1987 · *The Holy Picture*, in : Uj képkorszak határán (Budapest), 1988 · *The Circle and the Dawn*, in : Újhold (Budapest), Nr. 2, 1989 · *Minus Pathos*, in : A 84-es kijárat (Budapest), Nr. 1, 1990 · *The Camera in Trouble*, in : A 84-es kijárat (Budapest), Nr. 3, 1990 · *Golden Age*, in : Belvedere (Budapest), Nr. 6/7, 1990 · *The Fate of Intention in the Medium of Two-dimensional Moving Puictures*, in : FILM (Budapest), 1990 · *Reinforcement of Center*, in : New Observations (New York), 1992

Periodika | Periodicals
E. **Beck**, *Hungary After the Soft Revolution*, in : Art News, Nr. 3, 1991 · G. **Bora**, *Konceptus és Kontextus*, in : Belvedere (Budapest), Nr. 6/7 · P. **György**, *A baloldali kritika*, in : Hiany (Budapest), Nr. 7, 1990 · M. **Tarantino**, *Sub Voce*, in : Artforum, Dezember, 1991

Film
1982 *The Camera is in Trouble*, Super 8, 40 Min., 16 mm, Ton, BBS Produktion · **1983** *This Type of Intention is on the Border of Credibility*, Super 8, 7 Min., 16 mm, Ton, BBS Produktion · **1985** *Persian Walk*, Farbe, 16 mm, 50 Min., BBS Produktion · **1987** *Tweedle*, BW, 16 mm, 5 Min., BBS

Video
1984 *The Little Mermaid*, VHS, 10 Min. · **1985** *Faust by Remote Control*, VHS, 10 Min. · **1986** *A Pirate of His Fate*, VHS, 5 Min. · **1987** *Fotex Faust*, U-matic, 9 Min., BBS prod. · **1988** *The Immortal Culprits*, U-matic, 30 Min., BBS Prod. · **1990** *faust Forward*, U-matic, 3 Min., BBS Prod · **1991** *Misunderstandings*, TV series, 5x28 Min., Friz Prod.

YUJI TAKEOKA

*Kyoto (J), 1946
Lebt/Lives in Düsseldorf

Einzelausstellungen | One-man exhibitions

1980 Heidelberger Kunstverein, Heidelberg (Kat.: H.Gercke, Y.T.,) **1981** Kunstforum der Städtischen Galerie im Lenbachhaus, Mün-

chen (Kat.: H. Friedel Y.T.) **1986** Galerie Konrad Fischer, Düsseldorf **1987** Bonner Kunstverein, Bonn (Kat.: A. Pohlen, Y. T.) · Galerie Liesbeth Lips, Amsterdam · Slalom Salon am Burgplatz, Düsseldorf (Kat.: M. Kreutzer) · Japanisches Kulturinstitut (mit Ernst Caramelle) (Kat.: S. von Wiese) **1988** Gallery Shimada, Yamaguchi · Galerie Konrad Fischer, Düsseldoef **1989** *Standing Sculpture,* Gallery S 65, Aalst (Kat.: F. Poli) **1990** Galerie Konrad Fischer, Düsseldorf **1991** Galerie Philippe Casini, Paris · *Specific Rooms,* Transmission Gallery, Glasgow · Kunstraum, Kassel

Gruppenausstellungen | Group exhibitions

1988 *Meine Zeit mein Raubtier,* Kunstpalast, Düsseldorf **1989** *Bremer Kunstpreis 89,* Kunsthalle, Bremen · *Europalia 89 Japan,* Museum van Hedendaagse Kunst, Gent · *Rückblick nach vorn,* Kunstverein, Heidelberg · *Owen Giffith, Ton Mars, Yuji Takeoka,* Kunstzentrum De Gele Rijer, Ahnheim **1990** *Shibukawa Triennal Exhibition of Contemporary Sculpture,* Shibukawa **1991** *Contemporary Art from Japan,* Edinburgh College of Art, Edinburgh · *Das goldene Zeitalter,* Württembergischer Kunstverein, Stuttgart

Bibliographie | Bibliography

Periodika | Periodicals
Anne **Dagbert,** *Yuji Takeoka – Galerie Philippe Casini,* in: Art Press, Nr. 163, November 1991 · Martin **Hentschel,** *(Review),* in: Artforum, 1988 · Jürgen **Raap,** *Meine Zeit – mein Raubtier,* in: Kunstforum, Bd. 96, August / September / Oktober, 1988 · in: Kunstmagazin Atelier (Japan), Nr. 757, März 1990 · in: Kunstmagazin Atelier (Japan), Nr. 758, April 1990

ROBERT THERRIEN

*Chicago (USA), 1947
Lebt/Lives in Los Angeles

Einzelausstellungen | One-man exhibitions

1975 Ruth S. Schaffner Gallery, Los Angeles **1977** Ruth S. Schaffner Gallery, Los Angeles **1978** Holly Solomon Gallery, New York **1979** Institute of Contemporary Art, Los Angeles **1980** Otis Art Institute of the Parsons School of Design, Los Angeles **1982** Ace Gallery, Los Angeles **1984** Museum of Contemporary Art, Los Angeles (Kat.: J. Brown) **1985** Ace Gallery, Los Angeles **1986** Leo Castelli, New York **1987** Galerie Konrad Fischer, Düsseldorf · Hoshour Gallery, Albuquerque **1988** Leo Castelli, New York **1990** Galerie Konrad Fischer, Düsseldorf · Leo Castelli, New York · John C. Stoller & Co., Minneapolis (The Greenberg Gallery, St. Louis; Barbara Krakow Gallery, Boston) **1991** Leo Castelli, 65 Thompson Street, New York · Centro de Arte Reina Sofia, Madrid (Kat.: M.Rowell) **1992** Angeles Gallery, Santa Monica

Gruppenausstellungen | Group exhibitions

1987 *Abstract Expressions Recent Sculpture,* Lannan Museum, Lake Worth · *Poetic Substance,* Barbara Krakow Gallery, Boston · *small scale sculpture LARGE SCALE SCULPTURE,* The Atlanta College Art, Atlanta · *Leo Castelli y sus Artistas,* Centro Cultural Arte Contemporaneo, Polanco · *On Paper,* The Greenberg Gallery, St. Louis · *Structure to Resemblance: Work by Eight American Sculptors,* Albright-Knox Art Gallery, Buffalo · *A Collecting Partnership: Highlights of California Art Since 1945,* Newport Harbor Art Museum, Newport Beach · *New Work by Kosuth, Morris, Oldenburg, Serra, Stella, Therrien,* Leo Castelli, New York **1988** *Sculpture Inside Outside,* Walker Art Center, Minneapolis (et al.) · *Selection From The Berkus Collection,* Long Beach Museum of Art, Long Beach · *Painting in Relief/Sculpture on the Wall II,* John C. Stoller & Co., Minneapolis · *Vital Signs,* Whitney Museum of American Art, New York · *The University Collects: Recent Gifts From Ruth S. Schaffner,* University Art Museum, Santa Barbara · *Lynde Benglis, John Chamberlain, Joel Fisher, Mel Kendrickx, Robert Therrien,* Magasin 3, Stockholm · *Skulptur, Material & Abstraction: 2 x 5 Positionen,* Aargauer Kunsthaus, Aarau (et al.) **1989** *Dreams and other Works on Paper,* Leo Castelli Gallery, New York · *Sculptors' Drawings,* John C. Stoller, Minneapolis · *Art in Place,* Whitney Museum of American Art, New York · *A Decade of American Drawing 1980 – 1989,* Daniel Weinberg Gallery, Los Angeles · *I Triennal de Dibuix Joan Miró,* Fundació Joan Miró, Barcelona · *Art in The Public Eye: Selected Developments,* Daniel Weinberg Gallery, Los Angeles · *Seven Sculptures by Seven Sculptors,* John C. Stoller & Co., Minneapolis · *Robert Moskowitz, Ed Ruscha, Robert Therrien,* Craig Cornelius Gallery, New York · *Sculpture 1960's-1980's,* The Greenberg Gallery, St. Louis · *Monochrome,* Barbara Krakow Gallery, Boston **1990** *Diverse Representations 1990,* Morris Museum, Morristown · *In Memory of James, 1984 – 1988, The Children's AIDS Project. A Benfit Exhibition,* Daniel Weinberg Gallery, Santa Monica · *Objects of Potential. Five American Sculptors from the Anderson Collection,* Wiegand Gallery, College of Notre Dame, Belmont **1991** *Lafrenz Collection,* Neues Museum, Bremen (et al.) · *Minimalism and Post-Minimalism,* The Parrish Art Museum, Southampton, New York (et al.) · *Summer Group Show,* Leo Castelli, New York · *Dots,* Angel Gallery, Santa Monica **1992** *Guy Mees, Harald Klingelhöller, Richard Prince, Robert Therrien,* Galerij Micheline Szwajcer, Antwerpen · *Surface to Surface,* Barbara Krakow Gallery, Boston · RubinSpangle Gallery, New York

Bibliographie | Bibliography

Periodika | Periodicals
Robert C. **Morgan,** *American Sculpture and the Search for a Referent,* in: Arts Magazine, Nr. 3, November, 1987 · Stuart **Morgan,** *Past Present Future, Count Giuseppe Panza di Biumo, interviewed by Stuart Morgan,* in: Artscribe, Nr. 76, Sommer, 1989 · William **Peterson,** *Robert Therrien with Responses by Robert Creeley,* in: Artspace, Nr. 2, Mai/Juni, 1989 · Margit **Rowell,** *Ordinaire-extraordinaire: l'œuvre de Robert Therrien,* in: Art Press, Nr. 164, Dezember 1991 · Katleen **Shields,** *Albuquerque Letter,* in: Artspace Magazine, Sommer, 1987 · William F. **Stern,** *Sculpture Inside Outside,* in: Citeations, Frühjahr/Sommer, 1989

FREDERIC MATYS THURSZ

*Casablanca (MA), 1930
Lebt/Lives in Ossining/New York

Einzelausstellungen | One-man exhibitions

1957 Centre Culturel des Etats-Unis, Paris **1958** University of Kentucky Gallery of Art, Lexington **1959** Jefferson Place Gallery, Washington, DC **1960** University of Kentucky Gallery of Art, Lexington **1962** Art Center Association Gallery, Louiville, Kentucky · Jefferson Place Gallery, Washington, DC **1963** Merida Gallery, Louisville · University of Kentucky Gallery of Art, Lexington **1965** University of Kentucky Gallery of Art, Lexington (Kat.: F.M.T) **1967** Aspen Museum, Aspen **1968** Morlan Gallery of Contemporary Art, Lexington · Merida Gallery, Louisville **1969** Aspen Museum, Aspen **1970** Fredkens Museum, Caesarea **1972** Paley & Lowe Gallery, New York **1973** Ruth S. Schaffner Gallery, Santa Barbara **1975** Ruth S. Schaffner Gallery, Santa Barbara **1976** Edward Thorp Gallery, New York **1984** Raum für Malerei, Köln · New York Studio School **1985** Galerie Nordenhake, Malmö **1987** Galerie Krings-Ernst, Köln **1989** Musée d'Art Moderne, St. Etienne (Kat.) **1990** Galerie Krings-Ernst, Köln **1991** Galerie Lelong, New York (Kat.: K. Wahl) · Galerie Lelong, Paris (Kat.)

Gruppenausstellungen | Group exhibitions

1987 *Resümee I*, Kunsträume Krings-Ernst, Köln · *Absolutes Defined: Line, Light & Surface*, Oscarsson-Siegeltuch Gallery, New York 1988 *La Couleur Seule*, Musée Saint-Pierre d'Art Contemporain, Lyon

Bibliographie | Bibliography

Texte vom Künstler | Texts by the artist
Has Anyone Seen Leger's Palette Recently?, in: Issue 4: A Journal for Artists, Frühjahr, 1986 · *A Painting, Painting, the Painting*, in: Art in America, Dezember, 1981 · in: Graphics '62, University of Kentukky, 1962 · *On Abstract Painting*, in: The Kentucky Engineer, Lexington, s.d.

Periodika | Periodicals
Brooke **Adams**, *Frederic Matys Thursz at Lelong*, in: Arts Magazine, Mai, 1991 · Claude **Bouyeure**, *Frederic Matys Thursz: L'Identité de la lumière/The Identity of Light*, in: Cimaise, Oktober, 1991 · Dorothée **Horps**, *Du monochrome au polychrome*, in: France-Amérique, 19–25. Januar, 1991 · Dina **Sorensen**, *Frederic Matys Thursz*, in: Arts Magazine, April, 1991 · Kenneth **Wahl**, *Painting Beyond Paint: Frederic M. Thursz*, in: Nike, Mai/Juni, 1990

NIELE TORONI

*Locarno-Muralto (I), 1937
Lebt/Lives in Paris

Einzelausstellungen | One-man exhibitions

1969 Rue Castagnary 16, Paris 1970 Galerie Yvon Lambert, Paris · Rue Armand Campenhout/Armand Campenhoutstraat 48, Bruxelles 1971 Galerie Michael Werner, Köln 1972 Galerie Michael Werner, Köln · Galerie Yvon Lambert · Jack Wendler Gallery, London 1973 Françoise Lambert, Milano · Wide White Space Gallery, Antwerpen 1974 John Gibson Gallery Inc., New York · Minetti Rebora Galleriaforma, Genova · d'Alessandro, Roma · Wide White Space Gallery, Antwerpen 1975 Palais des Beaux-Arts, Bruxelles · Galerie MTL, Bruxelles · Françoise Lambert, Milano · Galerie Yvon Lambert, Paris 1976 Galerie Paul Maenz, Köln · Robert Self Ltd, London · Galerie Kiki Maier-Hahn, Düsseldorf-Oberkassel · Banco 32, Brescia 1977 D'Alessandro – Ferranti, Roma · Stedelijk Van Abbemuseum, Eindhoven (Kat.: R. Denizot, R. H. Fuchs) · Galerie Yvon Lambert, Paris · Kunstverein, Bochum (Kat.: N. T.) · Galerie MTL, Bruxelles 1978 Françoise Lambert, Milano · *52 pages – 52 pagine- 52 Seiten*, Kunsthalle, Bern (Kat.: R. Denizot, J. Gachnang, P.H. Liardon) · Samangallery, Genova 1979 Galerie Yvon Lambert, Paris · Ugo Ferranti, Roma · Galerie Paul Maenz, Köln 1980 Centre d'Art Contemporain, Genève · Herman & Nicole Daled, Bruxelles 1981 *Galleria Allegria 1*, Banco/Massimo Minini, Brescia · *Galleria Allegria 2*, Samangallery, Genova · *Galleria Allegria 3*, Françoise Lambert, Milano 1982 Vereniging voor het Museum van Hedendaagse Kunst, Gent · Galerie Micheline Szwajcer, Antwerpen · *Le coin du miroir*, Dijon 1983 Galerie Yvon Lambert, Paris · Jean Broly, Paris 1985 Musée d'Art Moderne de la Ville, Paris (Kat.: R. Denizot) · *Hommage au petit bacchus*, Pietro Sparta – Pascale Petit, Chagny · Galerie Yvon Lambert, Paris 1986 Galerie L'Hermitte, Coutances (Kat.: J. Aupetitallot, W. Ladopulos, P.H. Liardon) · Mary Boone/Michael Werner, New York · Galerij Micheline Szwajcer, Antwerpen 1987 Galerie Nächst St. Stephan, Wien (Kat.: M. Benhamou) · *Empreintes de pinceau no. 50 répétées à intervalles réguliers de 30 cm*, Villa Arson, Nice/Musée de Peinture et de Sculpture, Grenoble (Kat.: C. Besson, A. Coulange, R. Denizot, R.H. Fuchs, J. Gachnang, Jean-Hubert Martin, N.T., M. Verjux) · *Omaggio*, Gemeentemuseum, Den Haag · Museo cantonale, Lugano · Art Space Saga, Kyoto 1988 Meguro Museum of Art, Tokyo · Musée d'Art et d'Histoire, Lugano · Art Space Saga, Kyoto 1988 (Kat.: K. König, N.T.) · Yvon Lambert, Paris · Kunsthalle, Winterthur (Kat.: D. Schwarz, N. T.) 1989 Ecole Régional Supérieure d'Expression Plastique, Tourcoing (Kat.: R.Denizot) · Marian Goodman Gallery, New York · *Faux tableaux, vraie peinture*, Ecole Régionale des Beaux-Arts, Mâcon (Kat.) · Galleria Alfonso Artiaco, Pozzuoli 1990 *Vom wisse gäge rote zue*, Kunsthalle Luzern, Luzern (Kat.: H. Szeemann, N. T.) · *Affinités sélectives I* (mit/with Giovanni Anselmo), Palais des Beaux-Arts, Bruxelles · Galerie Buchmann, Basel · *Linos et Coups de pinceau*, Galerie Pietro Sparta, Chagny · Le Consortium, Dijon · Galerie Micheline Szwajcer, Antwerpen · The Renaissance Society, Chicago (Kat.) · 1991 Württembergischer Kunstverein, Stuttgart (Kat.: N.T., T. Osterwold) · *Empreintes de pinceau no 50 répétées à intervalles réguliers (30 cm)*, Centre Georges Pompidou, Paris (Kat.: A. Coulange, N.T.) · *Andata e Ritorno*, Marian Goodman Gallery, New York · Galerie Yvon Lambert, Paris · Galerie Martina Detterer, Frankfurt/M. · *Les bleus de Marseille: première escale*, Musée Cantini, Marseille · Museo Comunale d'Arte Moderna, Ascona (Kat.: H. Szeeman, N.T.)

Gruppenausstellungen | Group exhibitions

1987 *L'époque, la mode, la morale, la passion*, Centre Georges Pompidou, Paris · *Jardin de peinture*, Meguro Museum of Art, Tokyo · *Drapeau d'Artistes*, Musée d'Art et d'Histoire, Genève · *Malerei – Wandmalerei*, Stadtmuseum, Graz 1988 *Rot Gelb Bau*, Kunstmuseum, St. Gallen (et al.) · *Zeitlos*, Hamburger Bahnhof in Berlin, Berlin · *Just look at*, Museum van Hedendaagse Kunst Gent/Stadsgalerij, Heerlen · *La couleur seule*, Musée Saint-Pierre Art Contemporain, Lyon · *Opera e spazio*, Studio d'Arte Contemporanea, Dabbeni – Lugano 1989 *Bilderstreit*, Museum Ludwig, Köln · *Histoire de Musée*, Musée d'Art Moderne de la Ville, Paris · *Einleuchten*, Deichtorhallen, Hamburg 1990 *Furkart*, Furkapass · *Le Diaphane*, Musée des Beaux-Arts, Tourcoing 1991 *Individualités*, Art Gallery of Ontario, Toronto · *Voir et s'asseoir*, Espace de l'Art Concret, Mouans-Sartoux · *Biennale d'art contemporain*, Musée Saint-Pierre d'Art Contemporain, Lyon · *Bienal de São Paulo* · *Suisse Visionnaire*, Kunsthaus, Zürich · *Denk-Bilder*, Kunsthalle der Hypo-Kulturstiftung, München 1992 *Platzverführung*, Stuttgart · *Yvonne Lambert Collectionne*, Musée d'Art Contemporain, Bordeaux

Bibliographie | Bibliography

Texte und Bücher vom Künstler
Texts and books by the artist
5 empreintes de pinceau no. 50, Poissy, 1973 (10 Ex.) · *11 documents photographiques réunis par Niele Toroni*, Bruxelles, Daled & Gevaert, 1975 · *100 empreintes de pinceau no. 50*, Paris, Eigenverlag, 1979 (10 Ex.) · *Galleria/Allegria*, Paris, Eigenverlag, Juli, 1981 · *En roue libre. Collection Gramma Nr. 7* Hg. Alain Coulange, Saint-Julien-du-Sault, Editions F.-P. Lobies, 1984 · *Hommage au petit Bacchus. Comme un roman photo*, Chagny, Editions Pascale Petit & Pietro Sparta, 1986 · *1,2,3,4,5. Prétexte à un livre d'artiste*, Gent, Imschoot Uitgevers (zur Ausstellung/for the exhibition *Affinités Sélectives*, Palais des Beaux-Arts, Bruxelles), 1990

Bücher | Books
Benjamin H. D. **Buchloh**, *Niele Toroni – L'index de la peinture*, Bruxelles, Edition Daled, 1985 · René **Denizot**, *Une empreinte n'est jamais seule*, Paris, Ed. Yvon Lambert, 1975

Periodika | Periodicals
Alain **Coulange**, *Niele Toroni. Un »travail/peinture, inchangé depuis plus de vingt ans, inchangeable. Une oeuvre aux effets inattendus*, in: Le Magazine, 15. September/15. November, 1991 · René **Denizot**, *Signe, singe, songe: ou des empreintes de pinceau no. 50 ne ressemblent à rien*, in: Artstudio, Nr. 5, Sommer, 1987 · René **Denizot**, *Poétique de la peinture*, in: Galeries Magazine, Nr. 41, Februar/März, 1991 · Mo **Gourmelon**, *Niele Toroni: en toute différence*, in: Artefactum, Nr. 23, April/Mai, 1988 · Catherine **Lawless**, *Entretien avec Niele Toroni*, in: Les Cahiers du Musée National d'Art Moderne, Nr. 25, Herbst, 1988 · Bernard **Marcadé**, *Le cabinet de peinture de Niele Toroni*, in: Beaux-Arts Magazine, April, 1990 · Jeanne **Siegel**, *Real Painting*, in: Arts Magazine, Oktober, 1989

THANASSIS TOTSISKAS

*Nicaea of Thessaly (GR), 1951
Lebt/Lives in Nicaea of Thessaly

Einzelausstellungen | One-man exhibitions

1982 *Transformation 3,* Desmos Gallery, Athinai 1985 Larissa 1989 Gallery Epikentros, Patras 1991 Ileana Tounta Contemporary Art Center, Athinai

Gruppenausstellungen | Group exhibitions

1987 *Bienal de São Paolo* 1988 *Hyperproducer,* Athinai · Minos Bits, Creta 1989 *Topos Tomes,* Deste Foundation, Athinai 1990 Foundation Cartier, Jouy-en-Josas · *Artificial nature,* Deste Foundation, Athinai

Bibliographie | Bibliography

Periodika | Peridicals
Catherine Cafopoulos, *Thanassis Totsikas,* in: Arti Art today, Bd.8, Januar/Februar 1992

ADDO LODOVICO TRINCI

*Pistoia (I), 1956
Lebt/Lives in Pistoia

Einzelausstellungen | One-man exhibitions

1991 *Il soprano regna sullo spazio perché è il padrone del tempo,* Museo Riz à Porta, Firenze

Gruppenausstellungen | Group exhibitions

1991 *Biglietto da visita,* House of Virginia and Fabio Gori, Prato · *Intercity,* Fondazione Bevilacqua La Masa, Venezia · *411 S.L.M.,* Montescudaro

MITJA TUŠEK

*Maribor (YU), 1961
Lebt/Lives in Bruxelles

Einzelausstellungen | One-man exhibitions

1986 *Objets photographiques,* Galerija Ars, Maribor 1988 Centre d'Art Contemporain, Genève 1989 L'Ecole de Nîmes, Nîmes 1990 *Etendues, Disparitions,* Galerie Froment & Putman, Paris (Kat.: A. Cueff) · Shedhalle, Zürich 1991 Galerie Nelson, Lyon · Galerie Bruges la Morte, Brugge 1992 Galerie Paul Andriesse, Amsterdam

Gruppenausstellungen | Group exhibitions

1987 *Quand voir c'est faire,* Salle Crosnier, Genève 1988 *Marie José Burki, Eric Lanz, Bernard Voïta, Mitja Tušek,* Centre d'Art Contemporain, Genève 1989 Confort Moderne, Poitiers · *Figures,* Frac Rhône-Alpes, Lyon · Frac Poitou-Charentes, Angoulême 1990 *De Pictura,* Galerie Bruges la Morte, Brugge

Bibliographie | Bibliography

Periodika | Periodicals
Lysiane **Léchot,** *Deux et deux font quatre,* in: Faces,, Nr. 10, 1988 · Julika **Funk,** *Mitja Tušek: Verspiegelte Bildflächen,* in : Du, Nr. 6, Juni, 1991

LUC TUYMANS

*1958
Lebt/Lives in Antwerpen (B)

Einzelausstellungen | One-man exhibitions

1988 *Josephine n'est pas ma femme,* Ruimte Morguen, Antwerpen 1989 *Zimmer Frei,* Ruimte Morguen, Antwerpen · *A Place in the Sun,* Ruimte Morguen, Antwerpen 1990 Vereniging voor het Museum van Hedendaagse Kunst, Gent · Provinciaal Museum

voor Moderne Kunst, Oostende (Kat.: W. van den Bussche, R. Van Ruyssevelt, M. Schepers) · *Tekeningen,* Schouwburg Galerij, Rotterdam · *Suspended,* Zeno X Gallery, Antwerpen 1991 Zeno X Gallery, Antwerpen · *Le creux de l'enfer,* Centre d'Art Contemporain, Thiers 1992 Kunsthalle, Bern (Kat.: U. Loock)

Gruppenausstellungen | Group exhibitions

1988 *Doodgewoon: beelden van de dood,* De Warande, Turnhout 1989 *Wahrheit und Dichtung,* März-Ausstellungen, Köln 1990 *Art Cologne,* (Zeno X Gallery, Antwerpen), Köln Centre d'Art Contemporain, Iury-sur-Seine, Paris 1991 *Works on Paper,* Zeno X Gallery, Antwerpen · *Vis à Vis,* Galerie Sacré, Liège 1992 *Kunst in Vlaanderen Nu,* Museum van Hedendaagse Kunst, Antwerpen · *Selectie Belgische Kunstenaars von documenta IX,* Museum Dhondt-Dhaenens, Deurle

Bibliographie | Bibliography

Periodika | Periodicals
Luk **Lambrecht,** *Obsessies,* in : Knack-Weekend, 14. März, 1990 · Johan **Pas,** *Luc Tuymans, Disenchantment/Ontgoocheling,* in: Artefactum, Nr. 42, Februar/März, 1992 · Marc **Ruyters,** *Luc Tuymans,* in: Kunst en Cultuur, November, 1989 · Marc **Ruyters,** *Geluidloze herinneringen,* in: Knack, 28. Februar, 1990 · Marc **Ruyters,** *Luc Tuymans,* in: Kunst & Cultuur, Dezember, 1990 · Marc **Ruyters,** *Verstild,* in: Knack, 23. Oktober, 1991 · R. Van **Ruyssevelt,** *Luc Tuymans,* in: Kunst Nu, Nr. 2, 1990

MICHA ULLMAN

*Tel Aviv (IL), 1939
Lebt/Lives in Ramat Hasharon

Einzelausstellungen | One-man exhibitions

1969 Galerie Dugit, Tel Aviv 1971 Galerie Mabat, Tel Aviv 1972 Galerie Sara Gilat, Jerusalem 1973 *Bienal de São Paulo* 1975 Galerie Mabat, Tel Aviv 1976 Galerie Tzavta, Tel Aviv 1977 Galerie Julie M., Tel Aviv · Galerie Art in Progress, Düsseldorf 1979

Galerie Sara Levi, Tel Aviv · Künstlerhaus, Tel Aviv **1980** Museum Tel Aviv · *Biennale di Venezia* **1981** Bertha Urdang Gallery, New York **1982** Galerie Noemi Givon, Tel Aviv · Galerie Art in Progress, Düsseldorf **1985** Galerie Sara Levi, Tel Aviv **1986** Bertha Urdang Gallery, New York **1987** Galerie Cora Hölzl, Düsseldorf **1988** Israel Museum, Jerusalem (Kat.: Y. Zamona, A. Ofek) **1989** *Bienal de São Paulo* **1990** Neuer Aachener Kunstverein, Aachen · Nationalgalerie, Berlin (Kat.: A. Barzel, J. Sartorius) · Galerie Cora Hölzl, Düsseldorf **1992** Galerie Cora Hölzl, Düsseldorf

Gruppenausstellungen | Group exhibitions

1987 *documenta 8*, Kassel **1989** *In The Shadow of Conflict*, Jewish Museum, New York **1990** *Europäische Skulptur der Zweiten Moderne*, Wilhelm-Lehmbruck-Museum, Duisburg · *Construction in Process*, Back in Lodz 1990, Lodz · *Chagall to Kitaj*, Barbican Art Gallery, London **1991** *Dez Artistas de Israel*, Museu de Arte de São Paulo, Assis Chateaubriand · *Museum und Kirche*, Wilhelm-Lehmbruck-Museum, Duisburg · *Steine und Orte*, Städtisches Museum Schloß Morsbroich, Leverkusen · *Israelische Kunst um 1990*, Städtische Kunsthalle, Düsseldorf (et al.) · *Place & Mainstream*, Ramat Gan Museum (et al.) · *The Presence of the Absent*, University Art Gallery, Tel Aviv **1992** *Rootes of Wandering*, Israel Museum, Jerusalem

Bibliographie | Bibliography

Periodika | Periodicals
Marius **Babias**, *Micha Ullman/Ernst Caramelle*, in: Kunstforum, Bd. 109, 1990 · Ralph **Dank**, *Was uns umtreibt*, in: KunstKöln, Nr. 3, 1987 · Haim **Manor**, *Micha Ullman – Digging, Gespräch mit Dalia Manor. The Containers from Micha Ullman*, in: Studio Magazine, Nr. 1, Juli, 1989 · Angelika **Stepken**, *Eine Skulptur für den Berliner Stadtraum*, in: Kunstblatt Berlin, Nr. 66, 1990 · Angelika **Stepken**, *Construction in Process back in Lodz*, in: Kunstforum, Nr. 111, 1991 · Heinz **Thiel**, *Micha Ullman – Waage – Ein Landschaftprojekt*, in: Kunstforum, Bd. 110, 1990

Video
1975 *Place*, 25 Min., Sand, Besen, Schaufel und der Künstler, Photo:Uri Barsemer · *Steps*, 7 Min., Bausteine und der Künstler, Photo: Uri Barsemer

JUAN USLÉ

*Santander (E), 1954
Lebt/Lives in New York

Einzelausstellungen | One-man exhibitions

1981 Museo de Bellas Artes, Santander · Galeria Ruiz Castillo, Madrid **1982** Galeria Palau, Valencia **1983** Galeria Montenegro, Madrid **1984** Galeria Ciento, Barcelona · Fundación Botin, Santander · Galeria Nicanor Pinorole, Gijón **1985** *Currents*, Institute of Contemporary Art, Boston · Galeria Montenegro, Madrid · Windsor Kulturgintza, Bilbao · Galerie 121, Antwerpen **1986** Galeria La Máquina Espanola, Sevilla · Palacete Embarcadero, Santander **1987** Galeria Montenegro, Madrid · Galerie Farideh Cadot, Paris **1988** Farideh Cadot Gallery, New York · Galeria Fernando Silió, Santander **1989** Galeria Montenegro, Madrid · Galerie Farideh Cadot, Paris · Farideh Cadot Gallery, New York **1990** Galerie Barbara Farber, Amsterdam **1991** Galerie Farideh Cadot, Paris (Kat.: A. Tager) · Galeria Soledad Lorenzo, Madrid · Palacete Embarcadero y Nave Sotoliva, Santander (Kat.: R.Crone, D. Moss)

Gruppenausstellungen | Group exhibitions

1988 *L'Observatoire*, Salle Méridienne, L'Observatoire, Paris/Farideh Cadot Gallery, New York **1989** *Epoca Nueva: Painting and Sculpture from Spain*, Meadows Museum, Southern Methodist University of Dallas (et al.) · *Imagenes de la Abstraction*, Galeria Fernando Alcolea, Barcelona · *Crucero*, Galeria Magda Bellotti, Algeciras **1990** *Imagenes Liricas*, Albright-Knox Art Gallery, Buffalo (et al.) · *Inconsolable: An Exhibition about Painting*, Louver Gallery, New York · *Painting Alone*, The Pace Gallery, New York · *Abstract Painter*, L.A. Louver, Venice **1991** *Imagenes Liricas, - New Spanish Vision*, Sarah Campbell Gallery, University of Houston, Houston (et al.) · The Queens Museum of Art, New York · *Suspended light*, The Suisse Institute, New York · John Good Gallery, New York

Bibliographie | Bibliography

Texte vom Künstler | Texts by the artist
Escritos en tinta blanca, in: Balcon, Nr. 5/6, 1990

Periodika | Periodicals
Jose Manuel **Costa**, *Documenta de Kassel. salto de generacion*, in: ABC Cultural, Nr. 11, 1991 · Julian **Gallego**, *Las Marinas abstractas de Juan Uslé*, in: ABC (Madrid), 14. März 1991 · Constanza **Gonzalez**, *Romances: Juan Uslé*, in: Revista Capital, Nr. 2, 1991 · Catherine **Grout**, *La nueva generacion espanola*, in: Flash Art (Sp), Nr. 1, Februar, 1988 · Shirley **Kaneda**, *Painting alone*, in: Arts Magazine, Dezember, 1990 · Rosa **Olivares**, *Juan Uslé*, in: Lapiz, Nr. 58, April, 1988 · Rosa **Olivares**, *Juan Usle*, in: Lapiz, Nr. 77, 1991 · Kevin **Power**, *Juan Uslé*, in: Flash Art, Nr. 147, 1989 · Kevin **Power**, *Los gozos y las sombras de los ochenta*, in: El Paseante, Nr. 18/19, 1991 · Javier **Rubio**, *Juan Uslé*, in: ABC (De los Artes), 5. Februar 1987 · Andrea **Silverman**, *Juan Uslé*, in: Art News, Oktober, 1988 · Barbara **Rose**, *Beyond the Pyrenees: Spaniards Abroads*, in: The Journal of Art, Februar, 1991

BILL VIOLA

*New York (USA), 1951
Lebt/Lives in Long Beach

Einzelausstellungen | One-man exhibitions

1973 *New Video Work*, Everson Museum of Art, Syracuse, New York **1974** *Bill Viola: Video and Sound Installations*, The Kitchen Center, New York **1975** *Rain – Three interlocking Systems*, Everson Museum of Art, Syracuse, New York **1977** *Bill Viola*, The Kitchen Center, New York **1979** *Projects: Bill Viola*, Museum of Modern Art, New York **1980** Long Beach Museum of Art, Long Beach **1981** Vancouver Art Gallery, Vancouver **1982** Whitney Museum of American Art, New York **1983** Musée d'Art Moderne de la Ville, Paris (Kat.: D. Boyle, A.-M. Duguet, J. Hanhardt) **1985** *Summer 1985*, Museum of Contemporary Art, Los Angeles (Kat.: B. V.) · Moderna Museet, Stockholm **1987** *Installations and Videotapes*, Museum of Modern Art, New York (Kat.: J. Hoberman, Donald Kuspit, Barbara London, Bill Viola) **1988** *Survey of a Decade*, Contemporary Arts Museum, Houston (Kat.: D. Boyle, K. Huffman, C. Knight, M. Nash, J. Seeman Robinson, G. Youngblood, M. Zeitlin) · *Video Installation and Videotapes*, Riverside Studios, Hammersmith **1989** *The City of Man*, Brockton Art Museum/Fuller Memorial, Brockton · *Bill Viola: Installations and Videotapes*, The Winnipeg Art Gallery, Winnipeg · *Sanctuary*, Capp Street Project, San Francisco · Fukui Prefectural Museum of Art, Fukui City **1990** *The Sleep of Reason*, Fonadation Cartier, Jouy-en-Josas (Kat.: J. de Loisy) · *He Weeps for You*, La Box, Ecole National des Beau-Arts, Bourges **1991** *Reasons for Knocking at an Empty House*, North Dakota Museum of Art, Grand Forks, North Dakota · *Video Projects*, Museum für Moderne Kunst, Frankfurt/M. **1992** Donald Young Gallery, Washington

Gruppenausstellungen | Group exhibitions

1987 *L'époque, la mode, la morale, la passion*, Centre Georges Pompidou, Paris · *The Arts for Television*, Stedelijk Museum, Amsterdam/Museum of Contemporary Art,

Los Angeles 1988 *Selections from the Permanent Collection*, Newport Harbor Art Museum, Newport Beach · *Carnegie International*, Carnegie Museum of Art, Pittsburgh · *American Landscape Video, The Electronic Grove*, Carnegie Museum of Art, Pittsburgh 1989 *Einleuchten*, Deichtorhallen, Hamburg · *Video-Skulptur: retrospektiv und aktuell 1963–1989*, Kölnischer Kunstverein, Köln (et al.) · *Image World, Art and Media Culture*, Whitney Museum of American Art, New York 1990 *LIFE-SIZE – A Sense of the Real in Recent Art*, The Israel Museum, Jerusalem · *Passages de l'image*, Centre Georges Pompidou, Paris · *Niennal de la Imagen en Movimento*, Centro de Arte Reina Sofia, Madrid 1991 *Metropolis*, Martin-Gropius-Bau, Berlin · *Opening Exhibition*, Museum für Moderne Kunst, Frankfurt/M. · *Selections from the Permanent Collection 1975–1991*, Museum of Contemporary Art, Los Angeles

Bibliographie | Bibliography

Texte und Bücher vom Künstler
Texts and books by the artist
The European Scene and Other Observations, in: Video Art, New York, eds. Ira Schneider/Beryl Korot, 1976 · *Sight Unseen – Enlightened Squirrels and fatal Experiment*, in: Video 80, Nr. 4, Frühjahr/Sommer, 1982 · *Will There Be Condominiums In Date Space?* in: Video 80, Nr. 5, Herbst, 1982 (in: Communications, eds. Raymond Bellour and Anne Marie Duguet, Nr. 48, 1988) · *I Do Not Know What It Is I Am Like*, notes for laser disc, VHS, Los Angeles: Voyager Press; Boston; The Contemporary Art Television Fund, 1986 · *The Sound of One Line Scanning*, in: Sound by Artists, Toronto, eds. Dan Lander and Micah Lexier, Art Metropole/Walther Phillips Gallery, Banff, 1990 · *Video Black-The Mortality of the Image*, in: Illuminating Video: An Essential Guide to Video Art, eds. Doug Hall and Sally Jo Fifer, Aperture/Bay Area Video Coalition, 1990

Bücher | Books
John **Hanhardt**, *Cartografando il visible: l'arte di Bill Viola*, in: Ritratti: Greenaway, Martinis, Pirri, Viola, Parco Duca di Cesaro, ed. Valenitina Valentini, Taormina Arte, 1987

Periodika | Periodicals
Deirdre **Boyle**, *Bill Viola: Womb With a View*, in: Artnews, Bd. 87, Nr. 1, Januar, 1988 · Charles **Guiliano**, *Bill Viola: Heaven and Hell in Real Time*, in: Art New England, Bd. 10, Nr. 8, September, 1989 · Michael **Nash**, *Bill Viola's Re-visions of Mortality*, in: High Performance, Nr. 37, 1987 · Michael **Nash**, *Eye and I: Bill Viola's Double Vision*, in: Parkett, Nr. 20, 1989 · Michael **Nash**, *Bill Viola*, in: Journal of Contemporary Art, Bd.3, Nr.2, Herbst/Winter, 1990 · Paul **O'Brien**, *Bill*

Viola Douglas Hyde Gallery Dublin, in: Circa Magazine, Nr. 45, Mai/Juni, 1989 · John **Rice**, *Conversation with Bill Viola*, in: Videography, Januar, 1988 · Stephen **Sarrazin**, *Bill Viola, la chaise et l'ordinateur*, in: Art Press, Nr. 12, 1991 · Marita **Sturken**, *Temporal Interventions*, in: Afterimage, Sommer, 1992 · Nadia **Tazi**, *L'image intérieure*, in: L'Autre Journal, Nr. 7, Dezember, 1990 · Pier Luigi **Tazzi**, *Bill Viola: Taormina Arte 1987, Parco Duca di Cesaro*, in: Artforum, Bd. 26, Nr. 4, Dezember, 1987 · Valentina **Valentini**, *Bill Viola: Un Osservatore Devoto*, in: Artics, Dezember, 1987/Februar, 1988 · Gene **Youngblood**, *Metaphysical Structuralism: The Videotapes of Bill Viola*, in: Millennium Film Journal, Nos. 20/21, Herbst, 1988/89 · Octavia **Zaya**, *Bill Viola Interview by Octavia Zoya*, in: El Peseante, Nr. 12, 1989

Filme Video | Films Video (Videography)
1972 *Instant Repaly*, s/w (60hz), Mono Sound, 20 Min. · *Wild Horses*, with Marge Munroe, s/w (60hz), Mono Sound, 15 Min. · *Tape I*, s/w (60hz), Mono Sound, 6:50 Min. 1973 *Passage Series*, s/w (60hz), Mono Sound, 7:50 Min. · *Composition ›D'*, s/w (60hz), Mono Sound, 9:42 Min. · *Vidicon Burns*, with Bob Burns, NTSC Farbe, Mono Sound, 8:02 Min. (30:00 Min. orig.) · *Information*, NTSC Farbe, Mono Sound, 30:00 Min. · *Polaroid Video Stills*, NTSC Farbe, Mono Sound, 2:36 Min. (10:00 Min. orig.) · *Level*, s/w (60hz), Mono Sound, 8:28 Min. · *Cycles*, s/w (60hz), Mono Sound, 7:07 Min. · *In Version*, NTSC Farbe, Mono Sound, 4:24 Min. (6:40 Min.) 1974 *Eclips*, s/w CCIR European Standard, Mono Sound, 22:00 Min. · *August ›74*, NTSC, Mono Sound, 11:22 Min. 1975 *Gravitational Pull*, s/w CCIR European Standard, Mono Sound, 10:00 Min. · *A Million Other Things*, s/w CCIR European Standard, Mono Sound, 8:00 Min. · *Red Tape (Collectd Works)*, NTSC Farbe, Mono Sound, 30:00 Min. 1976 *Migration*, NTSC Farbe, Mono Sound, 7 Min. · *Four Songs*, NTSC Farbe, Mono Sound, 33:00 Min. · 1977 *Memory Surfaces and Mental Prayers*, NTSC Farbe, Mono Sound, 29:00 Min. · *Memories of Ancestral Power (The Moro Movement in the Solomon Islands)*, NTSC Farbe, Mono Sound, 35:19 · *Palm Trees on the Moon*, NTSC Farbe, Mono Sound, 26:06 Min. 1979 *Chott el-Djerid (A Portrait in Light and Heat)*, NTSC Farbe, Mono Sound, 28:00 Min. · *Sodium Vapor (Including Constellations and Oracle)*, NTSC Farbe, Stereo Sound, 15:14 Min. 1977/80 *The Reflecting Pool – Collected Work 1977–80*, NTSC Farbe, Stereo Sound, 62:00 Min. 1981 *Hatsu-Yume (First Dream)*, NTSC Farbe, Stereo Sound, 56:00 Min. 1983 *Reasons for Knocking at an Empty House*, s/w (60hz), Stereo Sound, 19:11 Min. · *Anthem*, NTSC Farbe, Stereo Sound, 11:30 Min. · *Reverse Television – Portraits of Viewers*, Compilation Tape, NTSC Farbe, Stereo Sound, 15:00 Min. · *I Do Not Know What It Is I Am Like*, NTSC Farbe, Stereo Sound, 89:00 Min. 1989 *Angels's Gate*, NTSC Farbe, Stereo Sound, 4:00 Min. · *The Passing*, s/w, Mono Sound, 54:15 Min.

HENK VISCH

*Eindhoven (NL), 1950
Lebt/Lives in Eindhoven

Einzelausstellungen | One-man exhibitions

1981 *Getimmerde Tekeningen*, Apollohuis, Eindhoven 1982 The Living Room, Amsterdam 1983 Vereniging Aktuele Kunst, Het Gewad, Gent 1984 *Beelden en tekeningen*, Groninger Museum, Groningen · Galerie Paul Andriesse, Amsterdam · Galerie Joost Declercq, Gent 1986 Galerie Paul Andriesse, Amsterdam · Galerie Joost Declercq, Paris · *H.V. – Skulpturen 1980–86*, Städtische Galerie Nordhorn (Kat.: R. H. Fuchs, H.V.) 1987 Galerie Paul Andriesse, Amsterdam 1989 Stedelijk Van Abbemuseum, Eindhoven (Kat.: J. Debbaut, I. Veenstra) 1990 Kunstverein, Hannover (Kat.: I. Veenstra) · Galerie Joost Declercq, Gent · Kunstverein Ruhr, Essen (Kat.: P. Friese) · *Installation*, Kunstraum, Wuppertal · Gesellschaft der Freunde Junger Kunst, Baden-Baden 1991 *Dedicated to daily life*, Galeria Biala, Lublin (Kat.: L. Brijs) · *Multiples Henk Visch*, Galerie Van Esch, Eindhoven · Anny De Decker (zeefdrukmap) 1992 *I see I understand I know I do*, P.S. 1, New York (Kat.) · *Inédits de séjour, 9 artistes d'Europe*, L'espace Jules Verne, Bretigny-sur-Orge, Information Arts Plastiques en Ile-de-France, Paris

Gruppenausstellungen | Group exhibitions

1987 *R. Daniels, H. Visch, P. Veneman*, Galerie Van Rijsbergen, Eindhoven · *Beelden en Banieren*, Fort Asperen, Asperen a/ d Linge · *A priori sculptuur*, Stichting Makkom, Amsterdam · *Out of Holland/A l'heure de la Hollande*, Musée d'Art Contemporain de Montréal, Montréal · *Die große Oper oder die Sehnsucht nach dem Erhabenen*, Bonner Kunstverein, Bonn · *Im Gleichgewicht, Paul Klee und die Moderne, Nestler, Ruthenbeck, Visch*, Kunsthalle zu Kiel, Kiel · *Déconstruction*, Les Halles de Schaerbeek, Bruxelles · *Hedendaagse kunst in Uden, een kollektie werken van*

kunstenaars in Brabant 1964–1985, Toonkamer Stadhuis, Uden **1988** *Een collectie/a collection of the AMRO bank,* Stedelijk Museum, Amsterdam · *Linea Recta,* Centraal Museum, Utrecht · *Pyramiden,* Galerie Jule Kewenig, Frechen-Bachen · *La giovane scultura Olandese, Biennale,* Palazzo Sagredo, Venezia **1989** *Unbegrenzte Freyung,* Palais Harach, Wien · *6 Dutch artists,* The Fruitmarket Gallery, Edinburgh **1990** *Beeldenstorm (Iconoclasm),* Museum van Hedendaagse Kunst, Antwerpen · *Die Farbe Blau,* Kunstverein Heidelberg, Heidelberg · *Op een tafel in Maasstricht,* Jan Van Eyck Academie, Maastricht · *Multiple Choice,* Galerie Fons Welters, Amsterdam · *Beelden in Brabant na 1945,* Kasteel Heeswijk, Heeswijk · *Picturale,* Noord Brabants Museum, 's-Hertogenbosch **1991** *Little things mean a lot,* Momentany Modern, Amsterdam · *De verzameling in beeld,* Nederlands Textielmuseum, Tilburg · *As modern as bronze can be,* Galerie Van Esch, Eindhoven · *Nebeneinander II (Coexistent),* Galerie Schröder, Mönchengladbach · *Unter Null, Kunstes Kälte Kultur,* Centrum Industriekultur, Nürnberg/Münchner Stadtmuseum, München (et al.) · De Effenaar, Eindhoven · *Tentoonstellung/Stock. Kunst in oplage,* Galerie Tanya Rumpff, Haarlem · *De verbeelding,* Van Reekummuseum, Apeldoorn **1992** Galerie Wanda Reiff, Maastricht

Theaterproduktionen | Theatre Productions

1984 *Bedenk (alles is tussen twee)/Consider (everything is between two),* Theatre-performance in collaboration with F. van Keulen, R. Malasch, Shaffytheater, Amsterdam

Bibliographie | Bibliography

Texte und Bücher vom Küstler
Texts and books by the artist
Over het aangaan van een relatie met de dingen (About starting a relation with things), Apollohuis, Eindhoven, 1981 · Drawing booklet, 1981 · Drawing booklet, 1982 · *The silence is accessible,* in: Young art from the Netherlands, art 13, Sonderschau Kunstmesse Basel, Basel, 1982 · *Nu stil,* Amsterdam, Ed. Art Book, 1984 (translation *Ruhe Jetzt,* Gesellschaft der Freunde junger Kunst, Baden-Baden, 1990) · *Het gebaar waarmee men dieren voedt,* Ed. acompany the edition Reykjavik/Amsterdam, 1984 · *Artists pages,* in: Dutch + Architecture Today, Nr. 17, Mai, 1985 · *Kleur als verschijnsel in sculpture/Colour as phenomenon in sculpture* (Conference), Amsterdam, Ed. Gerrit Rietveld Academie, 1985 · *Wij ademen voortdurend elkaars adem in en uit.../We continiously breathe eachothers breath...),* Den Haag, HCAK, 1987; in: Kat. Beeldenstorm (Iconoclasm), Museum van Hedendaagse Kunst, Antwerpen; in: Kat. A priori Sculpture, Stichting Makkom, Amsterdam, 1987 · (Conference), technical University, Eindhoven, dd. 28. April, 1987 · (Conference), project *L'art sur l'art,* Centraal Museum Utrecht, dd. 14. März, 1987 (Text. in : Metropolis M, Nr. 3, Sommer, 1987) · *The problem of...,* in : (Ander Werk), teksten van kunstenaars in Nederland, Kunst actualiteiten Arnhem Produkties (Arnhem), 1988 · *Toen mij gevraagd werd.../When a question came to me...,* in : Kat. Munt en beeldende kunst,

Centraal Museum, Utrecht, 1989 · *Een galerie is een ruimte.../A gallery is a space...,* in : Kat. Galerie, Gallery Paul Andriesse, Amsterdam, 1989 · (Conference), van Abbemuseum, Eindhoven, dd. 2. April, 1989 · *De autonomie van het kunstwerk/De autonomie van de kunstenaar – The autonomy of the artwork/The autonomy of the artist,* in : De Rijksakademie, Nr. 10, 1990 · *Portrait of the artist or the man next door,* in: Another Look, new angles on contemporary artists from Holland, photobook of artists with texts, Stichting Maccacio Amsterdam, 1990 · *De openbare ruimte vertegenwoordigt de vrije mens in een open samenleving/The public space represents the free individual in an open society,* in: Metropolis M, Nr 3, 1990 · *Just beginning something...,* in: Kat. Facts and Rumours, Witte De With, Rotterdam, 1990 · *About the artmarket*(Conference), KunstRai, Amsterdam, 1991 · *Yes,* in: Kat. Dedicated to daily life, Galeria Biala, Lublin · *Nie bin ich gleich.../I'm never the same...,* in : Kat. Kunstverein Ruhr, Essen

Periodika | Periodicals

C. **Bierens**, *Henk Visch over Venetie,* in: Metropolis M, Nr. 4, 1988 · Ulrich **Bischoff**, *Henk Visch, Skulpturen 1980–86,* in: Das Kunstwerk, Februar, 1987 · J. **Bolten**, *Henk Visch in Venice,* in: Dutch Art + Architecture Today, Nr. 24, Dezember, 1988 · Jan **Braet**, *Kunst is altijd goed,* in: Knack, 18–24. September, 1991 · C. **Grout**, *Fonctions du regard,* in: Flash Art, Nr. 133, April, 1987 · Frank-Alexander **Hettig**, *Facts and Rumours,* in: Kunstforum, Bd. 115, September/Oktober, 1991 · A. **Jourdan**, *Henk Visch rhythme et poétique,* in: Art Press, Januar, 1989 · A. **Jourdan**, *Henk Visch,* in: Juliet Art Magazine, Januar, 1989 · S. **Pietsch**, *Henk Visch im Kunstverein Hannover,* in: Contemporanea, Nr. 2, 1990 · E. V. **Radziewky**, *Heitere Skeptiker aus Brabant,* in: Art Das Kunstmagasin, Nr. 1, Januar, 1987 · Irene **Veenstra**, *Henk Visch,* in: Nike, Mai/April, 1987 · P. **Winter**, *Henk Visch,* in: Das Kunstwerk, Juni, 1990

JAMES WELLING

*Hartford (USA), 1951
Lebt/Lives in New York

Einzelausstellungen | One-man exhibitions

1976 ARCO Center for Visual Art, Los Angeles **1981** Metro Pictures, New York (mit/with William Leavitt) **1982** Metro Pictures, New York (mit/with Walter Robinson) **1984** Cash Gallery, New York (mit/with Allan McCollum) · CEPA, Buffalo **1985** Metro Pictures, New York (mit/with Louise Lawler, Laurie Simmons) **1986** Coburg Gallery, Vancouver (mit/with Rodney Graham) **1987** Galerie Samia Saouma, Paris · Richard Kuhlenschmidt Gallery, Los Angeles · Feature, Chicago **1988** Galerie Nelson, Lyon · Jay Gorney Modern Art, New York · Johnen & Schöttle, Köln · Feature, Chicago · Christine Burgin Gallery, New York **1989** Beaver College Art Gallery, Glenside · *A Debate on Abstraction,* (mit/with Holly Wright) Leubsdorf Art Gallery, Hunter College, New York (Kat.: R. Krauss) · Galerie Nächst St. Stephan, Wien (Kat.: D. Joselit) **1990** *J.W. – Photographs*

1977–1990, Kunsthalle Bern, Bern (mit/with Vikky Alexander) (Kat.: U. Loock, W.B. Michaels, C. Queloz) · Galerie Samia Saouma, Paris · Maison de la Culture et de la Communication, St. Etienne (Kat.: J. W.) · *Sous-Sol,* ESDAV, Genève **1991** Jay Gorney Modern Art, New York · Galerie Nelson, Lyon (mit/with Christopher Williams) **1992** Galerie Samia Saouma, Paris · Donald Young Gallery, Seattle · Musée de Rochechouart/Musée de la Roche-sur-Yon, Limoges · Johnen & Schöttle, Köln (mit/with Candida Höfer) · *J.W.: Photographs,* Kunsternes Hus, Oslo (Kat.: D. Deitcher, A. Thorkildsen)

Gruppenausstellungen | Group exhibitions

1987 *Implosion,* Moderna Museet, Stockholm · *Malerei-Wandmalerei,* Stadtmuseum, Graz · *Skeptical Belief(s),* The Renaissance Society, Chicago **1988** *The BiNational,* Museum of Fine Arts, Institute of Contemporary Art, Boston · *Schlaf der Vernuft,* Museum Fridericianum, Kassel · *Photography and Art,* Museum of Contemporary Art, Los Angeles · *Utopia Post Utopia,* Institute of Contemporary Art, Boston **1989** *Une Autre Affaire,* Maison Fyot, Dijon · *A Forest of Signs,* Museum of Contemporary Art, Los Angeles **1990** *Le Diaphane,* Musée des Beaux-Arts, Tourcoing · *Perspective on Place,* University Art Gallery, San Diego State University, San Diego **1991** *Fabri Hajamadi, Hirsch Perlman, James Welling, Richard Kuhlenschmidt Gallery,* Santa Monica · *Balthasar Burkhard, Lynne Cohen, Didier Morin, Bernar Venet, William Wegman, James Welling,* Galerie Gokelaere & Janssen, Bruxelles · *Les Grandes Lignes,* Gare de l'Est, Paris · *Vom Verschwinden der Dinge aus der Fotografie,* Palais Liechtenstein, Wien **1992** *Skulpturen-Fragmente,* Wiener Secession, Wien

Bibliographie | Bibliography

Periodika | Periodicals
Alain **Cueff**, *Et Welling Aussi,* in: Beaux-Arts, 1989 · Ulrich **Loock**, *Meaning at our Disposal,* in: Parachute, November, 1990

FRANZ WEST

*Wien (A), 1947
Lebt/Lives in Wien

Einzelausstellungen | One-man exhibitions

1970 Galerie Hamburger, Wien 1977 Galerie Nächst St. Stephan, Wien 1978 Galerie Nächst St. Stephan, Wien 1979 *Semantik und Verblödung,* Galerie Forme, Frankfurt/M. 1980 Galerie Nächst St. Stephan, Wien · Galerie Krinzinger, Innsbruck · Galerie Forme, Frankfurt/M 1983 Kunsthandlung Hummel, Wien 1984 Im Klapperhof, Köln 1985 Kunsthandlung Hummel, Wien · Kunstzentrum der Engelhorn Stiftung, München (Kat.: R. Priessnitz, F. W.) 1986 *F. W. Legitime Skulptur 1950–85,* Neue Galerie am Landesmuseum Joanneum, Graz (Kat.: F. Schmatz, W. Skreiner, F. W.) · Galerie Max Hetzler · Galerie Peter Pakesch, Wien (Plakat) · Galerie Christoph Dürr, München (mit/with Heimo Zobernig) (Kat.: P. Pakesch, F. Schmatz, G. Schöllhammer, F. W., H. Zobernig) 1987 Galerie Eugen Lendl, Graz (Plakat) (mit/with Herbert Brandl) · *Ansicht,* Wiener Secession, Wien (Kat.: H. Amanshauser, E. Köb, A. Ruhs, F. Schmatz, G. Schöllhammer; Plakat) · De Lege Ruimte, Brugge (mit/with Heimo Zobernig) 1988 Kunsthalle, Bern (Kat.) · Galerija Studentskog kulturnog centra, Belgrado (mit/with Heimo Zobernig) (Kat., Plakat) · Galeria Giorgio Persano, Torino (mit/with Herbert Brandl) (Kat.) · *Schöne Aussicht,* Portikus, Frankfurt/M · Galerie Isabella Kacprzak, Köln (mit/with Heimo Zobernig) · Galerie Wilma Lock, St. Gallen · *Die Ernte des Tantalos,* Galerie Peter Pakesch, Wien (mit/with Herbert Brandl) · *Wiener Räume 2–5,* Galerie Peter Pakesch, Wien (Plakat) · Galleria Mario Pieroni, Roma (Kat.) 1989 Museum Haus Lange, Krefeld (Kat.: J. Heynen, F. Schmatz, Plakat) · *Possibilities,* P.S. 1, New York (Kat.) · Galerie Gisela Capitain, Köln · Galerie Grässlin-Ehrhardt, Frankfurt/M. (mit/with Herbert Brandl) (Kat.) · *Homemades,* Edition Julie Sylvester, New York · Galerie Giorgio Persano, Milano · Kunsthistorisches Museum, Wien 1990 *Otium,* Sala Boccioni, Milano (mit/with Michelangelo Pistoletto) · Galeria Juana de Aizpuru, Madrid · Kunstverein Horn (mit/with Heimo Zobernig) (Kat.) · *Defunctus,* Jänner Galerie, Wien · Galerie Ghislaine Husenot, Paris · Galerie Karl-Heinz Meyer, Karlsruhe · Galerie Bruges la Morte, Brugge · Rhona Hoffman Gallery, Chicago · Galleria Mario Pieroni, Roma · Galerie Peter Pakesch, Wien · Stichting De Appel, Amsterdam (mit/with Otto Zitko) (Kat.: S. Bos, E. Schlebrügge) · Standard Graphik, Köln 1991 Galerie Max Hetzler, Köln · Ealan Wingate, New York · Galerie Erika + Otto Friedrich, Bern (mit/with Vaclav Pozarek) · Villa Arson, Nice · Salzburger Kunstverein, Salzburg · Galerie Wilma Lock, St. Gallen · *Skulpturen für Krefeld,* Kaiser Wilhelm Museum, Krefeld · *Körper und Körper,* Grazer Kunstverein im Stadtmuseum Graz, Steirischer Herbst, Graz · *Rosa e Giallo,* Galleria Persano, Torino 1992 Galerie Grässlin – Ehrhardt, Frankfurt/M.

Gruppenausstellungen | Group exhibitions

1987 *Skulptur Projekte Münster,* Westfälisches Landesmuseum, Münster · *Anderer Leute Kunst,* Museum Haus Lange, Krefeld · Österreichisches College, Forum Alpach · *Aktuelle Kunst in Österreich,* Europalia, Museum van Hedendaagse Kunst, Gent · *Broken Neon,* Forum Stadtpark, Graz · *Various Artists, Vienna Austria 1987,* Unge Kunstneres Samfund, Oslo 1988 *Zeitlos,* Hamburger Bahnhof, Berlin · *Arbeiten mit/auf Papier,* Galerie Varisella, Nürnberg · *Broken Neon,* Galerie Christoph Dürr, München · *Broken Neon,* Galerie Sylvana Lorenz, Paris · *Körper,* Kunsthandlung Hummel, Wien · *Aperto,* Biennale di Venezia, Venezia · *Freizone Dorotheergasse,* Wien · Galerie Max Hetzler, Köln · *Skulpturenrepublik,* Messepalast, Wien · *Skulpturenrepublik,* John Hansart Gallery, Southampton 1989 *Open Mind,* Museum van Hedendaagse Kunst, Gent · *Günter Förg, Christina Iglesias, Ettore Spalletti, Jan Vercruysse, Franz West, Christopher Wool,* Galerie Joost Declercq, Gent/Max Hetzler, Köln /Luhring Augustine, New York/Peter Pakesch, Wien/Marga Paz, Madrid/Mario Pieroni, Roma · *Einleuchten,* Deichtorhallen, Hamburg · *Das Spiel des Unsagbaren,* Wiener Secession, Wien · Sigmund Freud Wohnung, Wien 1990 *Biennale di Venezia* · *Weitersehen,* Museum Haus Lange und Haus Esters, Krefeld · Koury-Wingate Gallery, New York · *The Shadow of Presence,* Galerie Charles Cartwright, Paris · *Bemalte Plastik I, II und III,* Kunsthandlung Hummel, Wien · Musée de l'Art Moderne de la Ville, Paris · Galerie Hubert Klocker, Wien · The Renaissance Society, Chicago · *Vienne Aujourd'hui,* Musée de Toulon, Toulon · *3 Tage Umhausen,* Umhausen · *Sammlung Rudi Molacek,* Neue Galerie am Landesmusum Joanneum, Graz · Institute of Contemporary Arts/Serpentine Gallery, London · Museum Haus Lange , Krefeld · *Le Diaphane,* Musée des Beaux-Arts, Tourcoing 1991 *Metropolis,* Martin-Gropius-Bau, Berlin · *Sensualité, sensibilité, purisme,* Couvent des Cordeliers, Paris · Christine Burgin Gallery, New York · *Junge Kunst aus Österreich,* Hamburger Kunstverein (et al.) · *Wien – 1900, Wien – 1990,* Liljevalchs, Stockholm · *Apt Art International,* Moskva

Bibliographie | Bibliography

Periodika | Periodicals
Helmut **Draxler,** *Franz West – Plastiker der Psyche,* in: Kunst und Kirche, Nr. 1, Januar, 1987 · Helmut **Draxler,** *Franz West, the antibody to anti-body,* in: Artforum, März, 1989 · Christian **Janecke,** *Franz West,* in: Vernissage, Nr. 8, Oktober, 1987 · Peter **Mahr,** *Franz West at Peter Pakesch,* in: Artscribe, Januar/Februar, 1987 · Francesca **Pasini,** *Franz West. Galleria Pieroni, Galleria Persano,* in: Artforum International, Nr. 5, Januar, 1992 · Martin **Prinzhorn,** August **Ruhs,** Franz **West**/Reinhardt **Priessnitz,** Ferdinand **Schmatz,** *Franz West,* in: Kunstforum, Bd. 89, Mai/Juni, 1987 · Alexandra **Reininghaus,** *Vom hohen Sockel an den Körper,* in: Art, Nr. 7, Juli, 1991 · Harald **Szeemann,** *Franz West ou le baroque de l'âme et de l'esprit en fragments séchés,* in: Art Press, Bd. 133, Februar, 1989

RACHEL WHITEREAD

*London (GB), 1963
Lebt/Lives in London

Einzelausstellungen | One-man exhibitions

1988 Carlile Gallery, London 1990 *Ghost,* Chisenhale Gallery, London 1991 Arnolfini Gallery, Bristol · Karsten Schubert Ltd., London 1992 *Recent Sculpture,* Luhring Augustine Gallery, New York · *Sculptures,* Fundació Caixa de Pensions, Barcelona

Gruppenausstellungen | Group exhibitions

1987 Whitworth Young Contemporaries, Manchester 1988 Riverside Open, London · Slaughterhouse Gallery, London 1989 *Concept 88 Reality 89,* University of Essex Gallery · Whitechapel Open, London · *Einleuchten,* Deichtorhallen, Hamburg 1990 *British Art Show,* touring Exhibition · *Mat Collishaw, Hanne Darboven, Angus Fairhurst, Günther Förg, Michael Landy, Rachel Whiteread,* Karsten Schubert Ltd., London 1991 *Katharina Fritsch, Robert Gober, Reinhard Mucha, Charles Ray, Rachel Whiteread,* Luhring Augustine, New York · *Marina Abramovic, Kate Blacker, Marie Bourget, Angela Bulloch, Leslie Foxcroft, Paola Pezzi, Tessa Robins, Kay Rosen, Yoko Terauchi, Marylin Weber, Rachel Whiteread,* Victoria Miro Gallery, London · *Metropolis,* Martin-Gropius-Bau, Berlin · *Kunst Europa (Großbritannien),* Kunstverein, Pforzheim (et al.) · *Broken English,* Serpentine Gallery, London · *Turner Prize Exhibition: Ian Davenport, Anish Kapoor, Fiona Rae, Rachel Whiteread,* Tate Gallery, London · *Confrontaciones 91,* Palacio Velasquez, Madrid 1992 *Doubletake: Collective Memory and Current Art,* Hayward Gallery, London · *Young British Artists,* Saatchi Collection, London

Bibliographie | Bibliography

Periodika/Periodicals
Marjorie Allthorpe-Guyton, *Made in Heaven: The 1991 Turner Prize*, in: Artscribe, Nr. 89, 1991 · Michael Archer, *Rachel Whiteread: Ghost Meat*, in: Artscribe, Nr. 87, Sommer, 1991 · Giles Auty, *British Art Show*, in: Art Line, Bd. 5, Nr. 2, Juli, 1990 · Patricia Bickers, *Rachel Whiteread at the Arnolfini, Bristol and Karsten Schubert Ltd., London*, in: Art Monthly, Nr. 144, März, 1991 · Liz Brookes, *Rachel Whiteread, Chisenhale*, in: Artscribe, November/Dezember, 1990 · Louisa Buck, *Rachel Whiteread's Space Craft*, in: Connoisseur Magazine, Bd. 221, Nr. 959, Dezember 1991 · Louisa Buck, *The Returns on the Turner Prize*, in: Art Monthly, Nr. 152, Dezember 1991 · Kate Bush, *British Art Show*, in: Artscribe, Frühling, 1990 · Emmanuel Cooper, *Pry Society: On Doubletake at the Hayward Gallery*, in: Time Out Magazine, Nr. 1124, März 1992 · Emma Dexter, *Rachel Whiteread at the Arnolfini in Bristol and at Karsten Schubert Ltd*, in: Sculpture Magazine, September/Oktober, 1991 · Mary Ann Francis, *Sculpture at Victoria Miro*, in: Art Monthly, Nr. 146, Mai, 1991 · David Galloway, *Metropolis – Crossroads or Cul-de-Suc?*, in: Art in America, Juli 1991 · Liam Gillick, *The British Art Show*, in: Art Monthly, März, 1990 · Liam Gillick, *Doubletake*, in: Art Monthly Magazine, Nr. 154, März 1992 · Andrew Graham-Dixon, *Great White Hopes: Young British Art at The Saatchi Collection*, in: The Independent, 10. März 1992 · Jürgen Hohmeyer, *Manie der Blauen Laube: Die Berliner Ausstellung Metropolis*, in: Der Spiegel, Nr. 18, 29. April, 1991 · Enrique Juncosa, *Rachel Whiteread, Karsten Schubert Ltd*, in: Lapis Magazine, Nr. 77, April, 1991 · Kay Larson, *Of Dogs and Man*, in: New York Magazine, 10. Februar 1992 · Marco Livingstone, *L'heritage du pop art anglais leurres: voir double*, in: Art Press, Nr. 160, Juli/August, 1991 · Stuart Morgan, *The Turner Prize*, in: Freeze Magazine, Nr. 1, Oktober 1991 · Alfred Nemeczek, *Metropolis*, in: Art Kunstmagazin, Nr. 6, Mai, 1991 · Andrew Renton, *Birth of th Cool: British Art Show*, in: Blitz Magazine, Januar, 1990 · Andrew Renton, *Ghost*, in: Flash Art, Bd. 23, Nr. 154, Oktober, 1990 · s.d., *The Returns on the Turner Prize*, in: Art Monthly, Nr. 152, Dezember 1991/Januar 1992 · Roberta Smith, *Rachel Whiteread at Luhring Augustine Gallery*, in: New York Times, 17. Januar 1992 · Sachiko Tamashike, *Ghost*, in: Nikkei Art, Japan, September 1990

CHRISTOPHER WOOL

*Chicago (USA), 1955
Lebt/Lives in New York

Einzelausstellungen | One-man exhibitions

1984 Cable Gallery, New York 1986 Cable Gallery, New York · Robbin Lockett Gallery, Chicago 1987 Luhring Augustine & Hodes Gallery, New York · 1988 Galerie Gisela Capitain, Köln (Kat.: C. W.) · Luhring Augustine & Hodes Gallery, New York · Galerie Jean Bernier, Athinai 1989 · Museum of Modern Art, San Francisco (Kat.) · *Monotypes*, Edition Julie Sylvester, New York 1990

Works on Paper, Luhring Augustine Gallery, New York · Galleria Christian Stein, Torino · Daniel Weinberg Gallery, Los Angeles 1991 Luhring Augustine Gallery, New York · Kölnischer Kunstverein, Köln (Kat.: C. W.) · Museum Boymans-van Beuningen, Rotterdam (Kat.: cfr. Köln) · Kunsthalle, Bern

Gruppenausstellungen | Group exhibitions

1987 *Ange Leccia, Christopher Wool*, Cable Gallery, New York · *New territories in art Europe/America*, Michetti Foundation, Chieti 1988 *Information as Ornament*, Feature Gallery, Chicago · *Robert Gober and Christopher Wool: an installation*, 303 Gallery, New York · *Six Americans: Bleckner, Halley, Levine, Taaffe, Wool, Welling*, Galerie Lelong, New York · *A »Drawing« show*, Cable Gallery, New York · *The Light from the other Side*, Monika Sprüth Galerie, Köln · *New Works by Bickerton, Gober, Halley, Koons, Prince, Vaisman, Wool*, Daniel Weinberg Gallery, Los Angeles · *The BiNational – American art of the late 80's*, Institute of Contemporary Art, Museum of Fine Arts, Boston 1989 *Gober, Halley, Kessler, Wool. Four Artists from New York*, Kunstverein, München · *Prospect*, Frankfurter Kunstverein, Frankfurt/M. · *Horn of Plenty*, Stedelijk Museum, Amsterdam · *Abstraction in Question*, John and Mable Ringling Museum of Art, Sarasota · *Herold, Oehlen, Wool*, The Renaissance Society, Chicago · *Günther Förg, Christina Iglesias, Ettore Spalletti, Jan Vercruysse, Franz West, Christopher Wool*, Galerie Joost Declercq, Gent/Max Hetzler, Köln/Luhring Augustine, New York/Peter Pakesch, Wien/Marga Paz, Madrid/Mario Pieroni, Roma · *Biennial Exhibition*, Whitney Museum of American Art, New York · 1990 *New Work. A New Generation*, San Francisco Museum of Modern Art 1991 *The Museum of Natural History*, Galerie Barbara Farber, Amsterdam · *Metropolis*, Martin-Gropius-Bau, Berlin · Galerie Max Hetzler, Köln · *Strange Abstraction*, The Touko Museum of Art, Tokyo · *51st Carnegie International*, Carnegie Museum of Art, Pittsburgh

Bibliographie/Bibliography

Texte und Bücher vom Künstler
Texts and books by the artist
93 Drawings of beer on the wall, ed. 5, 1984 · *Empire of the Goat*, ed. 33, 1985 · *(Ohne Titel/Untitled)*, in: WhiteWalls, Nr. 17, Herbst, 1987 · *Black Book*, New York/Köln, Thea Westreich Associates/Galerie Gisela Capitain, 1989

Periodika | Periodicals
Jennifer P. Borum, *Christopher Wool at Luhring Augustine*, in: Artforum, November, 1990 · Dan Cameron, *Unfixed States. Notes on Christopher Wool's New Editions*, in: Print Collector's Newsletter, März/April, 1990 · Joshua Dector, *Christopher Wool*, in: Arts Magazine, Nr. 6, Februar, 1989 · Reinhard Ermen, *Christopher Wool*, in: Kunstforum, Juli/August, 1991 · Steven Evans, *Robert Gober & Christopher Wool*, in: Artscribe, November/Dezember, 1988 · Bruce Ferguson, *Patterns of Intent*, in: Artforum, September, 1991 · Jutta Koether, Karen Marta, *Am Anfang war das Wort*, in: Noema Art Magazine, Nr. 30, 1990 · Cathérine Liu, *Christopher Wool. At the limits of image making and meaning production*, in: Flash Art, März/April, 1989 · Norbert Messler, *Christopher Wool*, in: Artscribe, März/April, 1989 · Kees Van der Ploeg, *The complexity of Form nd Meaning*, in: Flash Art, Bd. 24, Nr. 157, März/April, 1991 · Jerry Saltz, *Beyond boundaries: New York's New Art*, New York, Alfred van der Marck, 1987 · Jerry Saltz, *This is the end: Chistopher Wool's Apocalyps Now*, in: Arts Magazine, Nr. 1, September, 1988

KEUNBYUNG YOOK

*Jeun-Buk (ROK), 1957
Lebt/Lives in Seoul

Einzelausstellungen | One-man exhibitions

1988 Gallery Doll, Seoul 1990 Now Gallery, Seoul (Kat.: Kim Bok Young) · SamDuck Gallery, Seoul 1991 Now Gallery, Seoul · KumHo Museum, Seoul · Shoko Nagai Gallery, Tokyo

Gruppenausstellungen | Group exhibitions

1987 *Seoul, March of 1987*, Fine Art Center, Seoul · *Park Eun Soo, Yook Geon Byung*, Back-Song Gallery, Seoul 1988 *New Spirit Exhibition*, The 3 Gallery, Seoul · *Exhibition of Conciousness, Expression*, Back-Song Gallery, Seoul 1989 *Berlin International Contemporary Art Exhibition*, CMMA, Berlin · *'89 Exhibition of Korea Young Artists*, National Museum of Modern Art, Guachun · *Drawing 3 Members Exhibition*, Gallery Han, Seoul · *Art & Act & Human*, Now Gallery, Seoul · *Korea Art 80 year's situation*, Dong Sung Art Center, Seoul · *A small Work Exhibition*, Soo Gallery, Seoul · *Bienal São Paulo*, São Paulo 1990 *Mixed Medium Exhibition*, KumHo, Seoul · *The 64 Artists Born in the Fifties*, SoNa-Moo Gallery, Seoul · *The Exhibition for 21 Century*, Total Gallery, Seoul · *Eight Individual from the East*, Sagacho Exhibit Space, Tokyo 1991 *A View in the change of Art*, KumHo Museum, Seoul

Performances

1989 *Art & Act & Human,* Now Gallery, Seoul · *Message & Communication,* ChungNam Museum, Seoul · *Who Best Gentleman,* ShinSeiGai Department Front **1990** *I'm an Artist,* Sagacho Exhibit Space, Tokyo · *Everybody is an Artist,* University Road, Seoul

Bühnenarbeiten | Stage installation
Space design

1990 *Cave,* Lee Hae Soon Dance Composition, Duri D Theater, Seoul · *'90 Asia Olympic Game,* The Seoul Metropolitan Dance Theatre · *Glas City,* Chunkyo Theater, China · *Impact & Harmony,* ChoSun Daily News Art Museum, Seoul

HEIMO ZOBERNIG

*Mauthen (A), 1958
Lebt/Lives in Wien

Einzelausstellungen | One-man exhibitions

1983 Musikgalerie, Villach **1985** Galerie Peter Pakesch, Wien (Kat.) **1986** Galerie Borgmann-Capitain, Köln (Kat.) · Ausstellungsraum Fettstraße 7a, Hamburg · Galerie CC, Graz (Kat.: C. Besson) · Galerie Christoph Dürr, München (mit/with Franz West) **1987** Galerie Peter Pakesch, Wien (Kat.: A. Oehlen) · Galerie Ralf Wernicke, Stuttgart (Kat.) · De Lege Ruimte, Brugge (mit/with Franz West) **1988** Galerija Studentskog kulturnog centra, Beograd (mit/with Franz West) (Kat.) · Galerie Borgmann-Capitain, Köln · Galerie Christoph Dürr, München · *30.4.88,* Galerie Achim Kubinski, Stuttgart · Galerie Juana de Aizpuru, Madrid **1989** Galerie Juana de Aizpuru, Sevilla · Galerie Sylvana Lorenz, Paris · Galerie Christoph Dürr, München · Galerie Peter Pakesch, Wien (Kat.) **1990** Kunstverein Horn, Horn (mit/with Franz West) · Galerie Hlavniho mesta Prahy, Prag (mit/with Franz West) (Kat.) · Galerie Kubinski, Köln (Kat.: M. Prinzhorn) · Galerie Varisella, Frankfurt/M. · Forum Stadtpark,

Graz · Jänner Galerie, Wien (Folder) · Richard Kuhlenschmidt Gallery, Los Angeles · Robbin Lockett Gallery, Chicago · Galerie Christian Nagel, Köln **1991** Villa Arson, Nice (Kat.) · Galerie Sylvana Lorenz, Paris · Kunstraum Daxer, München (Kat.) · Andrea Rosen Gallery, New York · Galerie Holzer, Villach · Erste Allgemeine Generali – Foundation, Wien (Kat.) · Galerie Peter Pakesch, Wien · Hôtel des Arts, Paris · Fettstraße 7 A, Zürich · Architektur Forum, Zürich · Moderna Galerija, Ljublijana (Kat.)

Gruppenausstellungen | Group exhibitions

1987 Galerie Max Hetzler, Köln · *Acht österreichische Künstler,* Kunstverein, Aachen · *Aktuelle Kunst in Österreich,* Europalia, Museum van Hedendaagse Kunst, Gent · *Broken Neon,* Steirischer Herbst, Forum Stadtpark, Graz · *Siebdrucke,* Galerie Schilzer, Graz · *The Image in Singular,* Galerie Amer, Wien · *Various Artists,* Vienna Austria 1987, Unge Kunstneres Samfund, Oslo · *Im Rahmen der Zeichnung – Im Laufe der Zeichnung,* Wiener Secession · Galerie Peter Pakesch, Wien **1988** *Ein anderes Klima,* Städtisches Kunsthalle, Kunstverein für die Rheinlande und Westfalen Düsseldorf · *Arbeiten mit/auf Papier,* Galerie Varisella, Nürnberg · *Broken Neon,* Galerie Christoph Dürr, München (Galerie Sylvana Lorenz, Paris) · *Aperto '88,* Biennale di Venezia, Venzia · Galerie Kacprzak, Stuttgart · *Graz 1988,* Grazer Kunsterein, Graz · *Brennpunkt Wien,* Bonner Kunstverein, Bonn (Badischer Kunstverein, Karlsruhe) **1989** *Melancolia,* Galerie Grita Insam, Wien · *Kunst der letzten 10 Jahre,* Museum moderner Kunst, Wien · *60 Tage österreichisches Museum des 21. Jahrhunderts,* Institut für Museologie, Hochschule für angewandte Kunst, Wien · *Die Optik der Objekte,* Kunstsalon im Kulturhaus Graz · *Das Spiel des Unsagbaren,* Wiener Secession · Kunstraum Buchberg 1989, Schloß Buchberg am Kamp · *Popocatepetl,* Galerie Juana de Aizpuru, Madrid **1990** *Auf der Suche nach Eden – Wien 1950–1990,* Musée d'Art et d'Histoire de Fribourg, Fribourg · *Sub & Co,* Austrian Culture Institute, New York · *Raum annehmen III – das Zeichen,* Galerie Grita Insam, Wien · *Le désenchentement du monde,* Villa Arson, Nice · *Österreichische Skulptur,* Wiener Secession, Wien · *Summer in the City,* Achim Kubinski, Stuttgart · *3 Tage*

Umhausen, Umhausen · *Sammlung Rudi Molacek,* Neue Galerie am Landesmuseum Joanneum, Graz · *Materialita: ground of geometry,* Gallery ULUS, Belgrado **1991** *The Message as Medium,* Museum in Progress, Wien · *Transcendent Pop,* Trans Avantgarde Gallery, San Francisco · *Plastik Akut 2,* Kärtner Landesgalerie, Klagenfurt · *5 Skulpturen,* Akademie der bildenden Künste, Wien · *The Painted Desert,* Galerie Renos Xippas, Paris · *Apt Art International,* Moskva · *Can Yasargil, Marcus Geiger, Heimo Zobernig,* Fa Paro, Innsbruck · *Refleksy,* Galerie Zacheta, Warszawa

Bibliographie | Bibliography

Periodika | Periodicals
Jan Avgikos, *Heimo Zobernig,* in: Artforum, September 1991 · Helmut **Draxler,** *Aperto,* in: Noema, September/Oktober, 1988 · Robert **Fleck,** *New Austrian Art,* in: Flash Art, Nr. 153, Sommer 1990 · Goschka **Gawlik,** Heimo Zobernig, in: Tema Celeste, Juli/November 1987 · Isabelle **Graw,** Heimo Zobernig, in: Galeries Magazine, Juni/Juli 1990 · Isabelle **Graw,** *Der Fall des Prinzen,* in: Artis, 43. Jg., November, 1991 · Catherine **Grout,** *Heimo Zobernig,* in: Artefactum, Nr. 41, November-Dezember 1991/Januar 1992 · Peter **Pakesch,** *Artists in Vienna,* in: Journal: A Contemporary Art Magazine, Nr. 48, Herbst, 1987

Video | Film
1981 *De nada,* 67 Min. **1989** Nr. 1, 6 Min. · Nr. 2, 6 Min. · Nr. 3, 6 Min. · Nr. 4, 20 Min. **1991** Nr. 5, 30 Min. · Nr. 6, 30 Min. · Nr. 7, 30 Min. · VjB Ctexte für „Texte zur Kunst", 30 Min.

GILBERTO ZORIO

*Andorno Micca (I), 1944
Lebt/Lives in Torino

Einzelausstellungen | One-man exhibitions

1967 Galleria Sperone, Torino (Kat.: T. Trini) **1968** Centro Colautti, Salerno **1969** Galerie Sonnabend, Paris · Galleria Sperone, Torino **1970** Galleria Franco Toselli, Milano **1971** Galleria Flori, Firenze · Galleria Sperone, Torino · Modern Art Agency, Napoli · **1973** Galleria Sperone, Torino · Galerie MTL, Bruxelles **1974** Galleria Sperone, Roma · Galleria Toselli, Milano · Galleria Sperone, Torino **1975** Galleria dell'Ariete, Milano **1976** Nuovi strumenti, Brescia · Kunstmuseum, Luzern (Kat.: J.-C. Ammann, W. Lippert, U. Castagnatto) · Galleria Schema, Firenze · Studio Deambrogi/Cavellini, Milano **1977** Galleria del Tritone, Biella · Studio G7, Bologna · Studio Cesare Manzo, Pescara **1978** Piero Cavellini, Brescia · Galerie Eric Fabre, Paris (Galerie Albert Baronian, Bruxelles; 't Venster, Rotterdam) · Salone Annuciata, Milano · Piero Cavellini, Milano · Galleria Omar Aprile Ronda, Biella · Carlo Grosetti Studio **1979** Galleria Christian Stein, Torino · Galerie Jean & Karen Bernier, Athinai · Stedelijk Museum, Amsterdam (Kat.: J.-C. Ammann) **1980** Giuliana de Crescenzo, Roma · Studio G 7, Bologna · InK, Zürich · Galerie Albert Baronian, Bruxelles · Galerie Eric Fabre, Paris · Galerie Jean & Karen Bernier, Athinai **1981** Galleria S. Ala, Milano · Galerie Kiki Meyer-Hahn, Düsseldorf · Galle-

ria Biondi, Firenze · Galerie R. Schöttle, München · Sonnabend Gallery, New York · Stichting De Appel, Amsterdam/Galerie Fertsch, Frankfurt/M. (Kat.: W. Lippert) · Galleria De Crescenzo, Roma **1982** Galleria Cavellini, Brescia · Galleria Stein, Torino **1981** Galerie Meyer-Hahn, Düsseldorf · Gallery Sonnabend, New York **1982** Galerie Cavellini, Brescia · Galerie Stein, Torino · Loggetta Lombardesca, Pinacoteca Comunale, Ravenna (Kat.: B. Merz, D. Zacharopoulos) **1983** Galerie Müller-Roth, Stuttgart · Forum Kunst, Rottweil (Kat.: W. Storms) · Galerie Storms, München · Centro d'Arte Contemporanea, Siracusa **1984** *Au fond de la cour droite,* Galerie Pietro Sparta, Chagny (Kat.: B. Merz, P. Petit, D. Zacharopoulos, G. Z.) · Galerie Albert Baronian, Bruxelles · Galleria Plurima, Udine · *Differenti senzazioni,* ex Ospedale Psichiatrico, Torino **1985** Palazzina dei Giardini, Galleria Civica, Modena (Kat.: J.-C. Ammann, U. Castagnotto, C. David, B. Merz, T. Trini, D. Zacharopoulos, G.Z.) · Galerie Pietro Sparta, Chagny · Württembergischer Kunstverein, Stuttgart (Centre d'art contemporain Genève; Stedelijk Van Abbemuseum, Eindhoven) (Kat.: G.Z.) **1986** Galleria Christian Stein, Torino · Galerie Elisabeth Kaufmann, Zürich · Galerie Jean Bernier, Athinai · *Biennale di Venezia* · Centre Georges Pompidou, Paris (Kat.: A. Boatto, B. Ceysson, C. David, D. Zacharopoulos, L. Rogozinski) · Galerie Albert Baronian, Bruxelles · Galleria Rossana Ferri, Modena · Kunstnernes Hus, Oslo **1987** Galleria Christian Stein, Milano · The Tel Aviv Museum, Tel Aviv · G.F.T., Pitti Uomo, Fortezza da Basso, Firenze · Galerie Pietro Sparta, Chagny · Central Station, Limoges · Stedelijk Van Abbemuseum, Eindhoven (Kat.: G. Celant, R. H. Fuchs, G.Z.) · Galleria Spazio d'arte, Pozzuoli **1988** Sonnabend Gallery, New York · Tyler School of Art, Temple University, Philadelphia · Galleria Rossana Ferri, Modena · *Eventi Sorvegliati,* Palazzo Ruini, Reggio Emilia · Teatro Municipale Romolo Valli, Reggio Emilia **1989** Galeria Cómicos – Luis Serpa, Lisboa · Federazione Partito Comunista Italiano, Torino · Fiac 89, Galerie Albert Baronian, Bruxelles, Paris · Galerie Elisabeth Kaufman, Basel · Galleria Cesarea, Genova **1990** Galleria Stein, Milano · Fundação de Serralves, Oporto (Kat.: F. Pernes, D. Zacharopoulos, G.Z.) **1991** *Titoli Sospesi,* SteinGladstone, New York · IVAM, Centre del Carme, Valencia · Galleria Rossa-

na Ferri, Modena **1992** Institute of Contemporary Art, Amsterdam · Centro per l'Arte Contemporanea Luigi Pecci, Prato

Gruppenausstellungen | Group exhibitions

1987 *Paolino, Pistoletto, Zorio,* Galleria Giorgio Persano, Torino · *Sacred Spaces,* Everson Museum of Art, Syracuse, New York · *Turin 1965–1987 de l'Arte Povera dans les collections publiques françaises,* Chambery (et. al.) · Galleria Plurima, Udine · *Arte Moderna a Torino,* Promotrice delle belle arti, Torino · *Du Goutet, des Couleurs, en Médoc des Châteaux pour l'art contemporaine,* Bordeaux · *A Decade of Emerging Artists : selections from the Exxon Series,* The Solomon R. Guggenheim Museum, New York · *Ouverture, un musée d'art contemporain au Château de Rivoli,* Hall du CNAP, Paris · *Italie hors d'Italie,* Musée d'Art Contemporain, Nîmes · *Istanbul kültür ve sanat vakfi,* Saint Irene contemporary art in traditional spaces, Istambul · *Collection Sonnabend,* Reina Sofia, Madrid **1988** *Spazio hopefulmonster* ed., I Salone del Libro, Torino · *Collection Sonnabend,* Centre d'Art Plastique Contemporain, Bordeaux · *ROSC '88,* Royal Hospital, Dublin · *I Biennale della scultura,* Sassi di Matera · *Images & Mages,* Château de St. Géry-Rabastens, Alby · *Europa oggi,* Museo d'Arte Contemporanea Luigi Pecci, Prato · *Collection du Musée Van Abbe d'Eindhoven,* II part, Musée des Beaux-Arts, Nîmes · *Contemporanea,* Studio Noacco, Chieri · Festa dell'Unità »Sotto le antenne il cielo«, Pecetto · *L'art moderne à Marseille, la collection du Musée Cantini,* Musée Cantini, Marseille · *Fonds Régional d'Art Contemporain de Champagne-Ardenne,* Hôtel de la Région, Châlon sur Marne · *Images et mages,* Centre Culturel de l'Albigeois, Albi **1989** *Italian Art in the 20th Century,* Royal Academy of Arts, London · *Verso L'Arte Povera,* Padiglione d'Arte Contemporanea, Milano · *Materialmente scultori deggli anni ottanta,* Galleria d'Arte Moderna, Bologna · *Collezione Sonnabend,* Galleria Nazionale d'Arte Moderna, Roma · *Calzolari, Rückriem, Zorio,* Galeria Soledad Lorenzo, Madrid · *Viewpoints ; postwar painting and sculpture from the Guggenheim Museum and Mayor Loans,* The Solomon R. Guggenheim Museum, New York · *Hic sunt Leones,* Ex-Giardino Zoologico, Torino · *Anteprima,* Villa delle Rose, Galleria Comunal d'Arte Moderna, Bologna · *Les cent jours d'Arte Contemporain,* Centre International d'Art Contemporain, Montréal · *Verso L'Arte Povera,* Elac, Lyon · *La Collezione Sonnabend dalla Pop Art in poi,* Museo d'Art Moderna e Contemporanea, Trento · *Arte Contemporanea per un museo,* Padiglione d'Arte Contemporanea, Milano · *Spazio Umano, Portfolio,* Galeria Cómicos, Lisboa/Galleria Persano, Torino · *Aspetti dell'arte povera,* Willy d'Huysser Gallery, Knokke-Zoute **1990** *Terkel Threshold,* Musset for Samtidskunst, Oslo · *Je est un autre,* Galeria Cómicos – Luis Serpa, Lisboa/Fundaçao de Serralves, Porto · *Arte Povera,* Galleria In Arco, Torino · *Casino Fantasma,* Ex-Casino, Venezia · *Pontom Temse,* Museum van Hedendaagse Kunst Gent, Temse · *Hic Sunt Leones 2,* Ex-Giardino Zoologico, Torino · *Temperamenti, Contemporary Art from Italy,* Tramway, Glasgow · *Le Diaphane,* Musée des Beaux-Arts, Tourcoing **1991** *Espace Lulay,* Liège ·

Intersezione : Arte italiana 70/90, Mücsarnok, Budapest · *Antinomia per una nuova cultura di pace,* Castello del Valentino, Torino · *Il lavoro e le forme,* Sala ex-Sip, Modena · *20th Century Collage,* Margo Leavin Gallery, Los Angeles · *Coll. Peggy Guggenheim 1991,* Peggy Guggenheim Foundation, Venezia · *Arte Povera 1971 und 20 Jahre Danach,* Kunstverein, München · *Group Show,* Sonnabend Gallery, New York · *Ha um minuto do mundo que passa obras na colecçao da Fundaçao de Serralves,* Fundaçao de Serralves, Oporto, 1991

Bibliographie | Bibliography

Texte und Bücher vom Künstler
Texts and books by the artist
L'art pauvre, in: Le Quinzaine littéraire (Paris), Nr. 72, 1. Mai, 1969 · *Extra,* Nr. 5, (Köln), 7/1975· *Gilberto Zorio,* in: Data (Milano), Nr. 32, 1978 · *Gilberto Zorio,* in: New Art International, Nr. 3/4, Mai, 1987

Periodika | Periodicals
M. **Bertoni,** *Gilberto Zorio,* in: Segno, Februar, Nr. 2, 1987 · Y.A. **Bois,** *In Situ : Site-Specific Art In and Out of Context,* in: The Journal of Art, Januar, 1991 · S. **Chayat,** *Religious Imagery Colors Everson's ›Sacred Spaces',* in: Stars (Syracuse), 15. Februar, 1987 · Claudio **Ciavoliello,** *Gilberto Zorio,* in: Flash Art, Nr. 156, Juni/Juli, 1990 · E. **Daniel,** *Autour de Gilberto Zorio, Regards sur l'Arte Povera,* in: Artstudio, Nr. 13, 1989 · M. **Daniele,** *L'arte povera aujourd'hui, Entretien avec Gilberto Zorio,* in: +–, Nr. 56, Juni, 1990 · R. **Daolio,** *Materialmente (Scultori degli anni Ottanta),* in: Flash Art, Nr. 149, April, 1989 · Y. **Duvivier,** *L'étrange laboratoire de Gilberto Zorio,* in: Le Journal de Beaux-Arts, Nr. 3, Januar/ Februar, 1987 · S. **Evangelista,** *In 270 ad Arte Fiera divisa in due,* in: Il Giornale dell'Arte, Februar, 1989 · G. **Giachello,** *Gilberto Zorio,* in: Cimal Arte internacional (Valencia), Nr. 39, 1991 · G. **Gilsoul,** *Le Graal toujours,* in: Le Vif/L'express, Januar, 1987 · J. **Hall,** *Trilogy's offbeat final phase is shaped to center's oddity,* in: Visual Art (Columbus), 1991 · A. **Izzo,** *L'energia a stella,* in: Service, Jg. 1, Nr. 1, Dezember, 1987 · R. **Kleyn,** *Dopo il mito. Gilberto Zorio,* in: Tema Celeste, Juni/September, 1988 · Donald **Kuspit,** *Gilberto Zorio, Sonnabend Gallery,* in: Artforum, Oktober, 1988 · L. **Meneghelli,** *Gilberto Zorio,* in: Flash Art, Nr. 153, Dezember 1989/Januar 1990 · **M.L.R.F.,** *Lavori di Zorio su carta e pelle,* in: Arte, Januar, 1987 · U. **Palestina,** *Materialmente, scultori degli anni ottanta,* in: Segno, März, 1989 · Renate **Puvogel,** *Gilberto Zorio,* in: Kunstforum, Bd. 92, Dezember, 1987 · A.C. **Quintavalle,** *Torna a casa, scultura,* in: Panorama, 26. März, 1989 · **s.n.,** *I contemporanei a Raffaello,* in: A.E.I.U.O., Nr. 19, Januar, 1987 · A. **Sparks,** *New Works for New Spaces : Into the Nineties,* in: Dialogue, Januar, 1990 · Angela **Vettesse,** *Gilberto Zorio,* in: Flash Art, Nr. 138, April, 1987 · S. **Westfall,** *Gilberto Zorio, Sonnabend Gallery,* in: Flash Art International, Oktober, 1988 · M. **Winzen,** *Gilberto Zorio at Sonnabend,* in: Art in America, Oktober, 1988

CONSTANTIN
ZVEZDOTOCHOTOV

*Moskva, 1958
Lebt/Lives in Moskva

Einzelausstellungen | One-man exhibitions

1983 Galerie APT-ART, Moskva 1984 *Le décorateur et la vie,* Galerie APT-ART, Moskva 1992 Galerie Eric Franck, Genève · Association Musée d'Art Moderne, Genève

Gruppenausstellungen | Group exhibitions

1987 *Première exposition du Club des Avant-Gardistes CLAVA,* Salle d'exposition Avtozavodskaja, Moskva · *Exposition des cubistes du Club des Avant-Gardistes CLAVA,* Atelier privé de Dmitriy Vrubel, Moskva · *En enfer: exposition du Club des Avant-Gardistes CLAVA,* Parc près de la station de métro Kachirskaja, Moskva · *Répresentation de la culture visuelle,* Groupe Ermitage, Moskva · *Retrospective des artistes non-officiels de Moskva, 1957–1987,* Groupe Ermitage, Moskva · *Exposition de la 1ère union,* Maison du peintre Kuznetskiy, Moskva 1988 *Exposition du Club des Avants-Gardistes Clava,* Bains public Sandounovsky, Moskva · *Labyrinthe: exposition d'artistes informels de Moscou,* Palais de la Jeunesse, Moskva · *Ich Lebe-Ich Sehe: Künstler der 80er Jahre in Moskau,* Kunstmuseum, Bern · *Une habitation,* Groupe Ermitage, Moskva · *Imatra,* Festival d'art russe en Finlande, Helsinki · *Festival de Graz,* Graz · *Les nouveaux russes,* Palais de la Culture, Warszawa · *Iskunstvo: Moskva-Berlin,* DAAD:Westbahnhof, Berlin · *Les travaux inachevés,* Ateliers, Moskva 1989 *L'art cher: exposition du Club des Avant-Gardistes CLAVA,* Palais de la Jeunesse, Moskva · *Momentaufnahme,* Städtisches Museum, Münster-Köln-Bielefeld · *Jusqu'à 33,* Palais de la Jeunese, Moskva · *Moscou-MOMA,* San Francisco (et al.) · *10 + 10,* Maison du peintre Krimskiy Val, Albright-Knox Gallery, Buffalo · *L'art pas cher ou les petites créations,* First Gallery, Moskva · *Mosca Terza Roma,* Sala 1, Roma · *Rauschenberg à nous – nous à Rauschenberg,* First Gallery, Moskva · *Nouvelle Jérusalem:exposition du Club des Avant-Gardistes CLAVA,* Moskva · *Iskunstvo: Berlin-Moscou,* Salle d'exposition des constructions Frunzenskaja, Moskva · *Dialogue,* Centre Boris Vian, Paris · *Moskva-Wien-New York,* Wiener Festwochen Messepalast, Wien · *Furmanny Zaulek,* Vieille Usine, Warszawa 1990 *Du côté de l'objet,* Stedelijk Museum, Amsterdam (et al.) · *Schizo-Chine. Hallucination au pouvoir: exposition du Club des Avant-Gardistes CLAVA,* Salle d'exposition de construction Frunzenskaja, Moskva · *Pour le repos cultivé,* Salle d'exposition Kachirskaja, Moskva · *Art et Pénitence,* Jardin Zoologique, Moskva · *Book-Art,* Université, Riga · *Aperto,* Biennale di Venezia, Venezia · *Artisti Russi Conteporanei,* Museo d'Arte Contemporaneo Luigi Pecci, Prato · *Between spring and summer,* Art Museum, Tacoma · *Erosion: Sowjetische Kunst aus der Sammlung Perra Halosen,* Helsinki · *Iskonstvo,* Kulturhuset, Stockholm · *L'art de l'époque de la Perestroika,* Phyllis Kind Gallery, New York 1991 *Sowjetische Kunst um 1990,* Städtische Kunsthalle, Düsseldorf (et al.)

Bibliographie | Bibliography

Periodika | Periodicals
Maria Luisa **Frisa,** *Artisti Russi Contemporanei,* in: Flash Art, Nr. 156, Juni/Juli, 1990 · Alexei **Tarkhanov,** *Die entschlüpfende Kunst Zuezdotochotou,* in: Halle Sud (Genève), Nr. 28, 1991

SUPPORTING AND ACCOMPANYING PROGRAMME

JAZZ STORIES – AS SERIOUS AS YOUR LIFE

On 19 January 1974 Charles Mingus appeared with a ten-strong combo in a completely sold out Carnegie Hall in New York. The Mingus band: George Adams, tenor sax, Harriet Bluiett, alto sax, Don Pullen on piano, Dannie Richmond on drums. The wind section was a big line-up of other jazz celebrities.

In Duke Ellington's 'C Jam Blues' the soloists did their number one after the other: first John Handy on tenor sax, next Harriet Bluiett, George Adams and Rahsaan Roland Kirk on tenor, John Faddis trumpet and finally Charles McPherson with his alto sax. The critics said it was a not particularly inspired concert, a 'jam session on the concert stage'. And yet there was one of those rare moments that evening in the 'C Jam Blues' that you only get in jazz. After Charles McPherson's solo the piece seemed to be coming to an end. Drummer Dannie Richmond struck final beat after final beat, the piece was running down, but it didn't end, again the final drumbeat, the first applause. The musical structure had long since run its course; it sounded as if all of the musicians saw it was over, but couldn't let go. Then Roland Kirk suddenly escaped from this no-man's-land of indecision one more time, didn't stop playing, but imitated George Adams's solo, taking up the musical battle they had fought in their previous solos once more – they had tried to outdo each other on each other's terrain – they outdid themselves, played against and with each other, the rest of the band slowly pulled themselves together amidst the chaos, with Rahsaan Roland Kirk eventually literally having the last word, the last note. His final last statement was an indescribable and endless note, sustained by his special breathing technique. What had happened?
A magical musical moment.
It could not have been predicted.
A sudden explosion of music and emotion.
Jazz is all about moments like this. A thrust of muscial energy. A battle. A duel between two musicians. Provocation perhaps. Reaction to provocation. Amost a boxing match. Music happens. It makes the listener's heart stand still. What is going on? He watches music being made. He becomes an ear-witness, eye-witness. And he will never forget this heartbeat, will try and relive this moment, listening to the recording of the concert again and again.

Or he sees Roland Kirk suddenly leaving the stand, walking blindly and somewhat driven through the venue, pacing out a territory, until somebody leads him back to the band. He sees Thelonius Monk celebrating his almost ritual walk, only to be back in time at his seat for the one decisive touch on the piano. The wood above the keys has been scratched by his rings and fingernails. Making music is something very physical. You can see music.

Jazz always happens in this absolute present. It cannot be repeated. It happens in an intense and unthinkable collectivity. Perhaps in a state of trance and at the same time with inexplicable concentration. Dexter Gordon could hardly keep upright, but he was always superior with his music and at one with his instrument.

The musicians may have only just got off a plane or a bus a few hours or moments ago with their instrument cases, they step into the arena or the concert podium and carry on working on the project – music. Intensely, eager to take a risk. It is always a matter of life and death. As serious as your life. The audience is close to the action, as in a highly competitive sport, but outside the ring, involved, but out of danger.

The band are sworn to one another. The band is the basis, the basic structure for any further experiments. The members of the band know how far they can go with each other. They don't have to be in love with one another. Sometimes a musician looks for a new band for years, for a congenial leader. After the Coltrane's death McCoy Tyner for a long time had difficulties getting a new band together; some will never find the ideal constellation again. If you look at Bill Evans' search for 'his' trio over the years, you can get dizzy from all the different names who joined, left, tried again. Suddenly with Scott LaFaro on bass and Paul Motian on drums the right players seemed to be growing together, when LaFaro died in an accident. It was an eternity until Evans had tested a trio sufficiently to explore new musical territory.

Musicians playing classical music play consistently well, sometimes they play better. Jazz musicians may play badly once and then all of a sudden unbearably well. They break out of routine and mediocrity. A competition, competing with or against, rivalry, dialogue, euphoric understanding, or a battle begins. This sudden and amazing tension only exists in jazz. It is all about the personalities of the musicians with their emotions and intensity: human and musical energy is released. The musicians react to one another. They listen to one another. They rip the band apart or something completely different evolves. They will never play this particular piece in the same way again. It only happens this once and maybe only in one passage. Jazz is all about these moments.

Nothing is forseeable and everything is possible.

Who knows *when* a group of jazz musicians comes on stage what state of mind or physical state they are in. They may be exhausted from a long flight, a big tour, little sleep in uncomfortable hotel beds, unusual food. Where (the hell) are we anyway? And then they grab their instruments and play the first set.

And they play as they have never played before and will never play again.

They are travellers in an intercontinental jazz circuit, depending on tour organizers or club managers, to whom they are bound by contracts and who invariably only want commercial success. And the audience expects top performances every single night. If they are not performing in their favourite clubs the musicians often only play to themselves, trying to dim the specific geography or local colour of an evening. In moments like these they are truly extraterrestrial. They lead a life which for the majority of people in the venue is unimaginable. Jazz nomads, on the road, disorientated by jetlag. However, on the stages of the world, where jazz is played, they always meet in a variety of constellations. It is a lame comparison, but continuous work with the other musicians, no matter where – the music – is their home.

Jazz lives on its fanatics, too, music junkies who are waiting for each new release by their idols or who follow the bands around with their recording equipment. Jazz is the music of outsiders, of dissidents. Jazz is about spiritual options. The right-wing censor's eye speaks yet again of defining depth of focus. Le Pen does not like jazz, it is said, how could he?

Jazz musicians do not arrive on red carpets. Neither are they given royal receptions, jubilees or Orders of Merit, nor secure pensions. They perform until they are old (if they live so long) and are constantly faced with a financial (and health) risk. This they share with other artists. But careers look different. There are hardly any megastars, defined by earnings and presence in the jazz media. No Andy Warhol or Joseph Beuys. Miles Davis did not become a media event being a jazz avantgardist.

Jazz has always been ahead of rock music. It is a well-known fact: many rock themes have come from jazz (tunes), and only became successful (financially as well) as rock songs. But jazz has always been ahead. When free jazz developed, the Beatles had only just started singing their ballads. However, there was never a big audience for jazz. They chanted rock hymns (by heart) while remaining jazz illiterates.

And even in its aesthetics, jazz formed styles and was visionary. There are record covers from the 50s and 60s which are as modern today as they were revolutionary then. Today these aesthetics are being copied, not in a nostalgic fashion, but because the typefaces, the understanding of space, the way in which a person is arranged in his environment, are absolutely modern: cool, beautiful, clear, right. Jazz colours. Jazz aesthetics. Sense of style. Some find their way to jazz through these aesthetics. Some through a different awareness of life. Some begin to hear the music on these covers. Some want to paint the (sound of the) music. Some find their way to jazz via the battle of the musicians, via these inalienable moments. Some through the great personalities working in jazz. Some through a craving for presence, simultaneousness, something happening here and now, live! (And this only happens in jazz.)

There is a simple truth: jazz is absolutely linked to the experience of Afro-Americans. This music is a spiritual siting. Asked what influence Stockhausen or Cage had on his music, Cecil Taylor answered: 'They do not come from my community', and Archie Shepp said: 'Parker is my Bach and Coltrane my Beethoven'. Jazz becomes an existential and cultural experience. A subversive code for the search for spontaneity and feeling. For love, identity and opposition. A reason to stay alive.

Edek Bartz and Birgit Flos

(Translated into English by Michael Robinson)

FILMFESTIVAL OF DOCUMENTA IX
JAZZ – BOXING – BASEBALL

"…truth, 24 times a second…"
(Jean-Luc Godard)

Cinema book, archives of Marcel Broodthaers

For the first time in its history, documenta is to include an open-air film festival. This festival is part of the official programme of DOCUMENTA IX 1992 and will explore the basic themes of Jazz, Boxing, and Baseball through feature and documentary films.

The festival organizers attach a great deal of importance to the concept of documentation. The basic themes of the exhibition are presented in the context of film as concrete, objective themes of the medium, in a different way from art. Film does not interpret, it documents, it illustrates myth.

The selection of films is radically subjective, and this could not be otherwise, given the number of films and their varied subject matter, genres, and historical classification. Nevertheless we have tried to put films in the programme whose quality is shown through closeness to and presentation of the immanent myth.

The programme consists of exclusive premieres, classics of the genre, selected documentaries, a silent film programme and experimental, documentary and slapstick shorts as supporting programme. As serious cinematic entertainment, the programme is intended to be both popular and unusual, appealing to interested documenta visitors and the people of Kassel and the surrounding area. As well as this there will be special events in the form of combined concert and film programmes. Festival film directors include: Bruce Weber, Elia Kazan, Jean-Luc Godard, Bertrand Tavernier, Garret Linn, Clint Eastwood, John Badham, Martin Scorsese, Charlotte Zwerin, Dennis Hopper, Jacques Tati.

The festival site will be designed as a work of art by a DOCUMENTA IX artist. Franz West will design chairs for the event. The design of the festival area will be appropriate to this. This means that the festival site will itself be a work of art.

To take advantage of the warmest month of the year the film festival will take place from 31 July to 30 August 1992, five days per week from Wednesday to Sunday. A total of 23 films with appropriate supporting programme will be shown. The film festival is in the heart of Kassel at one of the central DOCUMENTA IX exhibition venues in the courtyard of the documenta press office in the Gerhart-Hauptmann-Schule.

Jürgen Fabritius, Til Radevagen, Klaus Steigmeier

Let's get lost, Chet Baker, Bruce Weber

Filmlist

Martin Scorsese: Raging Bull, Barry Levinson: Der Unbeugsame, Garret Linn: The Lounge Lizards Live in Berlin, Phil Aldin Robinson: Feld der Träume, Charlotte Zwerin: Straight, no chaser, David Leland: The big Man, *Boxen*: Die lange Nacht der kurzen Filme, am Piano: Willy Sommerfeld, Spike Lee: Mo Better Blues, David Ward: Die Indianer von Cleveland, Bruce Weber: Broken Noses, Dennis Hopper: Hot Spot, Rolf de Heer: Dingo, Louis Malle: Fahrstuhl zum Schafott, Michael Ritchie: Die Bären sind los, Bruce Weber: Let's get lost, Elia Kazan: Die Faust im Nacken, Jean-Luc Godard: Außer Atem/ Allemagne 90, B. Tavernier: Round Midnight, Stellan Olson: Sven Klang's Combo, Fred Frith: Step across the border and Fred Frith solo live, Robert Rossen: Body and Soul, John G. Avildson: The Power of One, Clint Eastwood: Bird.

PIERRE-ALAIN **HUBERT** FRANCE

LE CORPS ET SA VULNÉRABILITÉ L'HOMME PORTE LA LUMIÈRE VACILLANTE

LA MORT ET L'ULTRA-VIVANT à la fois

0 5 10 15 20 25 minutes

SPACE SHOWN AS WORKS OF ART

RAINBOWS HAVE NO SHADOWS AT NIGHT

"Slack and sleepy senses must be appealed to by thunderclaps and fireworks."
Friedrich Nietzsche

Fireworks combine the mythical power of fire with the refined aesthetics of baroque festivities. They come into being in a dazzling symbiosis of minerals and cosmos, and are at the same time a product of elemental, fundamental thought and advanced knowledge of chemical phenomena.

An ephemeral art, that destroys and is itself destroyed. Art that really can be seen in two lights is produced in this imaginary nocturnal world. Mercury and Jupiter together.

Fixed in the sign of light and fire, but still playing between the dimensions, this garden of dazzling light also unveils the dimensions of land and water, the latter becoming a liquid reflection. A pyrotechnician, or firework artist, tries to present the birth of the sun and the galaxies for us every evening. He is extremely emotional, and knows death and simultaneous pulsating life, intimate and universal, he knows tears and laughter. He embodies carnival and fasting: baroque and yet frugal. He seems to be destined to contradiction within himself. For all these reasons fireworks are an art that is an old tradition and yet eternally young.

And the firework artist makes this celebration material, and turns it into an ambiguous homage. Through the medium of the elements he can offer only a future of details in which rare minerals, precious metals and scientific effort are reduced to dust and ashes in a few moments… a poetic mineralogy of nothing.

Pierr-Alain Hubert

MÉLANCHOLIA
FEU D'ARTIFICE DE CLOTURE DE DOCUMENTA IX

First Performance

Franz Hummel

GESCHICHTE HINTER UNS. FONDS.
A symphonic fragment in memoriam Joseph Beuys

The words of this composition are derived from the unpublished manuscripts of
Joseph Beuys

14 June 1992 at the Staatstheater in Kassel
8 p.m.
in
"Tangents – Encounter '92"
a European Gala Event

The Orchestra of the Staatstheater of Kassel
Director: Bernhard Lang
Speaker: Sunnyi Melles

A composition commissioned by the Kulturförderkreis Nordhessen e.V.
(Artistic Director: Uli Heffner)

Jungfrau:
Und siehe, ich schaue dir zu
Wie du den Marmor schlägst
Wie du formst mit der fühlenden Hand.

Ja, Liebster forme mich in Stein
Wie ich deinen Geist in die Morgenröte lenkte
Bilde mich … O, bilde mich in Stein

Wie du Helden und Götter schufst
In Wäldergängen…
Hauche meine Seele in den kühlen Stein…

Mein Herz soll kühl und ernst werden
Und mädchenhaft wie der lichte Marmor

Doch aus den steintoten Herzen
Sollen die lebenden wachsen wie die blaue
Blume

Und jede Blüte soll wieder
Ein schlagendes Steinherz gebären…

Ewigkeit, Ewigkeit…
Ewigkeit…

Joseph Beuys

Undated Poem by Joseph Beuys.
Text for composition 'History
behind us. Fond'. (see page 70)

HISTORY BEHIND US. FONDS.
A symphonic fragment in memoriam Joseph Beuys

Even today the misconceptions about the artist Joseph Beuys have not been laid to rest. When the educated man of today asks himself whether or not the much-cited bathtub could indeed be called art, be it as found piece or invention, be it fraud or frivolousness, there has to be, in all honesty, a distinction made between the highly sensitive, talented individual and the loss of 'sound' common sense which not even the greatest effort of goodwill can cover up when devotion is missing.
My symphonic fragment *History behind us. Fonds.* is a requiem for Joseph Beuys. Few people know, that this unique artist was also a writer. There are his philosophical ideas beside his political creed. Next to touchingly simple and thoughtful poetry, you find daring linguistic constructions of genuine Beuysian dimensions; everything is always new and unpretentious. Beuys was also a poet. His family has kindly permitted me to use excerpts from these, so far unpublished, texts. As I am working on a Beuys-opera at present, I am well-acqainted with the material, and I am living under the spell of this vivacious man: Thus, this is not a requiem of grief but one of reminiscence and rapture. The music contains many harmonious and melodious 'twists' from the fund of history, which through transformation are brought into ever new relationships (interrelationships), thus escaping from their own background.
I have tried to newly organize musical fragments – found pieces – and to install them in new sound spaces. Music for the vivacious Beuys, a musical installation.

Franz Hummel

VAN GOGH TV – PIAZZA VIRTUALE
100 DAYS OF INTERACTIVE ART-TELEVISION

From the first day to the last night of documenta the European public will be presented with a TV transmitter based in Kassel and broadcasting only one thing: live transmissions of its own initiatives. The routes the spectators follow in these media networks, the discoveries they make as they wade through the electronic data flow, the interaction with other viewers, who have also entered the recording area of the broadcasted image: in the *Piazza virtuale* all that matters is the behaviour of the people, who have become active and take their own decisions as to what is to happen on the Piazza.

Van Gogh TV has developed a computer-controlled monitor surface, which makes it possible for everybody to intervene via telephone, computer, modem or fax machine. As starting points the station offers videophones and cameras which are securely installed in public places. The cameras are positioned at the entrance to the "Fridericianum", in an open studio near the "Fridericianum" and in open studios around the world. In Kassel, the Piazza virtuale is being broadcast continuously on the local cable network. The programme can be received nationwide at certain times of the day on 3Sat, for 350 hours in all. A satellite forms the link to the "Piazzettas", other cities in Europe, the United States and Japan where the broadcasting is again done by local TV stations. ISDN makes possible the transmission of images via colour videophones from nine German cities to Slovenia, Latvia, Estonia and Russia.

The transmitted image combines different media and their respective languages; live images, still video, drawings, type, sound, music, computer animation. From flashing disco lights to the weary daydream of a traffic monitoring system, from the words wandering out of a computer network to the voice coming out of a telephone, from a poster being reproduced by a fax machine to digitalized colour being slowed down by a videophone and flashing via satellites – the computer-generated configuration of the brodcast image wants to serve the construction of interaction and at the same time be an example of how communications channels can be transparent. Television is the material of this image.

To make it easier to find one's way through the architecture of the Piazza, Van Gogh TV have developed a timetable. This timetable consists of blocks (of topics) that recur at certain times of the day, structuring the course of the programme school, confessional, market square, speakers' corner, dictionary of art, interactive orchestra, contact exchange, diary, newspaper, hoarding. The topics are only meant to be a framework for the activity; they serve as a menu. More important is what happens between the viewers in this framework, how they use the networked communications channels in Kassel once the monitor surface, made up, for example, of four pictures from four different European cities, opens the virtual space between these cities as a communications field for the people there.

Only a few viewers can have access to the broadcast image at one time. That is why Van Gogh TV gives everybody on the Piazza a time limit. He (the viewer) can only keep in touch/hold the connection with the station for a few minutes and then must pass it on to the next person.

The artists at Van Gogh TV do not broadcast pre-produced videos and do not see the Piazza as their own forum. They see themselves as constructors of a new communicative structure, which designs an alternative to the ideas pursued by

Text: Roberto Ohrt, Ludwig Seyfarth

Van Gogh TV are:
Karl Dudesek, Benjamin Heidersberger, Mike Hentz, Salvatore Vanasco – Ponto European Media Art Lab Hamburg – and the Van Gogh TV Research Team:
Ole Lütjens, Jan Neversil, Christian Wolff, Gérard Couty, Christiane Klappert, Axel Roselius, Daniel Haude, Manuel Tessloff, Julian Knaak, Rainer Koloc, Tim Becker, Nicolas Anatol Baginsky, Hinnerk Schmitt, Holger Rix, Kathy Rae Huffman, Jan Holthusen, Rüdiger Hirt, Michael Ulrich, Fritz Groß

The Piazzettas and their contacts:
Van Gogh TV Berlin – Rudolf Stoert
Van Gogh TV Bremen – Ronald Gonko
Van Gogh TV Cologne – Bernd v. Brincken
Van Gogh TV France (Paris, Lyon, Montbeliard, Nantes, Poitiers, Bordeaux, Nancy) – Christian Vanderborgh / Canada (Quebec) – Richard Martell
Van Gogh TV Italy (Milan) – Giacomo Verde
Van Gogh TV Zürich – Peter Preissle
Van Gogh TV Geneva – Philippe Coeytaux
Van Gogh TV Prague – Michael Bielizky
Van Gogh TV Latvia – Baiba Ripa, Leila Jureneva
Van Gogh TV Moscow – Kirill Preobrazenskij, Leonid Bajanov
Van Gogh TV St. Petersburg – Arkakii Dragomoshchenko
Van Gogh TV Slovenia – Egon March Institute
Van Gogh TV Omaha
Van Gogh TV Tokyo

Piazza virtuale is sponsored by
(as known April 1992):

Main sponsors:
Dr. Robert Fleck – Curator for the Bundesminister für Kunst und Unterricht, Österreich
EDS – Electronic Data Systems Deutschland GmbH
Deutsche Telekom

Other sponsors:
Apple Germany, Lavazza Germany, Fast, Prisma, Miro, Zeck, Synthax, Commodore Germany, Amstrad Germany, Sharp Germany, PDO

Thanks to:
Proficomp, Steinberg, Wacom, Systematics, Systemhaus Uhlmann, Müller & Prange, Schuh Computer, Dr. Neuhaus, Synelec, Electronic Design, PBC Computerdesign, DP – Computing & Service D'Art, TSI, Niche, Philips Germany, Akai Germany, Roland Germany

Contact address: Ponton European Media Art Lab, Koppel 66, 2000 Hamburg 1,
Tel. 040-24 14 04, Fax 040-24 05 11

industry, and stay in the background servicing the machines. Van Gogh TV have erected a self-generating work of art, a communications automat functioning within and as a network. Piazza virtuale is an experiment, the result of which we do not know. Van Gogh TV do not want to be a forum for specialists, and are not looking for communication where it already exists. Normality is the stated field of experimentation, the construction of society where the emptiness of the cities is set out. The task of artists has changed. If they want to live in their time, they have to co-create the possibilities for experience and the imaginary worlds of everyday life. In contrast to those artists who confine themselves to merely determining the contents of a TV programme, Van Gogh TV puts forward an idea which has long been recognized in media theory, but which so far has never really been put into practice: The station is the artwork.

"Piazza virtuale" applies the idea of the square as a location for public discourse to the electronic network. Each monitor opens up a window to the square; television becomes the field of conversation, becomes publicity in virtuality. The Piazza virtuale is being erected against all the expectations that interactivity can be attained merely by connecting TV with PCs, and fulfilment found in the individual choice of programmes; as private media the mass media will finally come to a close. Ready-made information is to appear customized within the four walls of life. It is only logical then that people have invented the right for the sole protagonist on the stage of this private media to "stay in his pyjamas", and that this right is going to be further equipped with high-definition padding.

There is no doubt about the appalling quality of today's television; this view also determines the work at the Ponton European Media Art Lab, but it is not intended to enhance comfort. The viewer may stay in his pyjamas, but he should show himself in the virtual public streets. Why not ride on the wave of the programme range in a better and more selective way? It is more important, however, that the viewer takes over the functions of the station himself. In the slippers of privacy, man uses the function of the machine. The Piazza virtuale, however, is an offer to communicate with other people via machines. It is an artistic vision, the architecture of an atmosphere, and not the expression of one individual artist. The complex technological control goes straight through the signs of brave new illusionistic computer worlds, visualizing on a monitor surface what goes on between the users in the network. Work in progress cannot offer a finished product. Unlike many other documenta works, the Piazza virtuale will not be ready on the 13th June, neither will it be finished on the 20th September.

Van Gogh TV is a group at the Ponton European Media Art Lab. Founded in 1986 Ponton has been firmly installed in the Koppel 66 in Hamburg since 1989 and is a laboratory that functions also as a planning, production and broadcasting site. Artists and technicians experiment together there on new artistic possibilities as well as on innovations in media technology. Ponton and its study groups Van Gogh TV, Minus Delta t, Van Gogh Radio and Universcity TV have realized 20 different projects, among them a radio station at documenta in 1987, and television programmes at Arts Electronica in Linz in 1986, 1989 and 1990.

"let there be T.V."

*Die Hälfte
des Reichtums
für die Hälfte
der Schönheit* ©

© Vlado Kristel, Hymne der Postmoderne,

*Antennen
für den
Frieden*

Jeder hat Recht

For 100 days documenta will be the centre of a worldwide confrontation with contemporary art, of a willingness to accept the new and, also, to allow it to be created. The city of Kassel, comes to life during this time, experiencing the simultaneity of events that makes documenta possible.

This is matched by the media interest in this spectacular event – which is why, for the first time, we have tied the concept of documenta to television (and not only to video), as the most important medium of the new era.

The city, its citizens, the artists that reside here for a while and the visitors from around the world form a collage, a picture screen of art and urbanity. Everything is oriented to documenta 's daily schedule of events, its surroundings and the city – their joined pictures overlapping day and night. Pictures, sounds and texts, seemingly coming from everywhere, reacting to each other, shaping a new electronic ornament to be absorbed and further developed by the brain.

Real and at the same time fictional pictures and sounds, a hallucination, a rendering poetic of the everyday, and a transference of art into the humdrum of existence. When the essence of art is not to take itself so seriously, there will also be moments of quiet.

From June 13 until September 20, 1992 we will transmit via channel S-19 (of the cable-network of Kassel and Nordhessen) and, God willing, by satellite for 24 hours a day for 100 days from lower Karlstrasse (next to the Fridericianum).

Transmitting Team
Hartmut Bepler, Rafael Kinzig, Jin Plachy, Fregi Seidl, Rainer Schäfer, Thomas Scheffer, Tomislav Turina, Harald Werner
Other Co-workers
George Keller, Anne & Paul Haubrich, Thomas Kapielski, Harald E. Hohmann, Horst Ehrler
Pre- and Co-work
Frank Stukenbrock
Concept and Organization
Rolf Lobeck, Reinhard Franz
Administration
Prof. Peter Raacke
Graphics
Michael Simon, and art to use (for the people of the universe)
Representation
Karl von Grafenstein
Transmitting Technique
Werner Loose, Alfred Heiter, Georg Kolodziej
Robotics
Frank Faber
Aesthetic Direction
Prof. Rolf Lobeck
Credits
We thank the administration and the workshops of the GhK, the State Division for Private Radio in Hessia, the City of Kassel, Telecom, the 2nd. Tank Grenadier Division of Kassel and the German Defence Ministry, the Kulturkreis im BDI, Systematics Kassel, Fast Electronics Munich, Copyteam Kassel, Fulda Verpackungen, Stabernack, Apple Germany and Proficomp Karlsruhe

Program Plan

Shortly after sunrise, across from where the clean-up of the Friedrichsplatz is taking place, the Bundeswehr (German Military) starts its early P.E. program. In the studio, bleary-eyed artists breakfast while early risers jog through Karlsaue and the commuter traffic announces itself.

The curious stroll through the city. In front of documenta visitors line up and housewives begin to cook.

After the employed have taken their nap, the kids play on the screen.

'What is art?' live in the studio and on location, Artists in Dialogue, Art and Administration, Women's Art and colourful representations from around the world, something for everyone.

With the can of beer in front of the television. European soccer championships and Olympic Games *par excellence.*

Kassel at night; return to the studio. Art and the Erotic, melancholy piano music and signs of weariness.

LIEBE BESUCHER

Wir stellen das Projekt »ATLANTIS – Geschenk 2000« vor: Eine internationale, interdisziplinäre Begegnungsstätte für Kultur, Wissenschaft, Wirtschaft und Politik. Wir suchen zur Realisation dieses anspruchsvollen Unternehmens aktive Mitarbeiter und Sponsoren. Künstler und Kunstfreunde, die sich für eine bessere Zukunft engagieren wollen, sind eingeladen, mit uns über sinnvolle Wege und Aktivitäten nachzudenken.

DEAR VISITOR

We introduce the project "ATLANTIS – Donation 2000": An international meeting place and thinktank in the fields of culture, science, economy and politics. To implement this demanding enterprise, we are searching for active collaborators and sponsors. We invite all artists and friends of Art who are desirous to participate in the making of a better future, to reflect with us on the way to follow and the activities to be undertaken, in order to attain this objective.

AMI VISITEUR

Nous présentons le projet «ATLANTIS – Cadeau 2000»: Un lieu de rencontre international, qui sera un carrefour d'idées dans le domaine de la culture, de la science, de l'économie et de la politique. Pour mener à bien cette entreprise exigente, nous cherchons des collaborateurs actifs et des sponsors. Nous invitons tous les artistes et les amis de l'Art, désireux de participer à la création d'un futur meilleur, à réfléchir avec nous sur les chemins à suivre et les activités à entreprendre pour atteindre ce but.

AMIGO VISITANTE

Presentamos el proyecto «ATLANTIS – Regalo 2000»: Un lugar de encuentro internacional para el intercambio de ideas en el campo de la cultura, la ciencia, la economía y la política. Para llevar a cabo esta exigente empresa, buscamos combatientes activos y patrocinadores. Invitamos a todos aquellos artistas y amigos del Arte deseosos de participar en la creación de un futuro mejor, a reflexionar con nosotros sobre los caminos a seguir y las actividades a emprender para conseguir este objetivo.

ATLANTIS

Ostendstraße 106 7000 Stuttgart Telefon 0711-481066 Telefax 0711-484729

DOCUMENTA
The making of an Exhibition

The photo-project by Benjamin Katz documents the installation of many of the works of art in Kassel. These photographs will be exhibited from the middle of July in the Schloß Belvue. A documentation supported by the DG Bank.

Jimmie Durham, 1992

SPONSORS

Gegen die Schere im Kopf gibt's die documenta. Für die documenta gibt's die offizielle documenta-Packung von West. Und für alle, die auf der documenta keine documenta-Packung mehr kriegen, gibt's hier eine: zum Ausschneiden.

Movado The Museum Watch.
Ein zeitloser Klassiker.

Publica Press Swiss

Dies ist die legendäre Uhr, die dank ihres aussergewöhnlichen Designs dem Namen „Movado The Museum Watch" zu Weltruhm verhalf. Inspiriert von der Bauhaus-Bewegung, entwirft der Designer Nathan G. Horwitt im Jahre 1947 ein Zifferblatt, welches aufgrund seiner genialen Einfachheit Ende der fünfziger Jahre in die Sammlung des Museum of Modern Art, New York, aufgenommen wird.

Andy Warhol Times/5

Andy Warhol, amerikanischer Pop-Künstler (1931 - 1987) gestaltete als erster tägliche Objekte zu Kunstwerken. Er liebte auch Uhren, von denen er viele gleich doppelt oder dreifach sammelte. Seine eigene Kreation schuf er 1987 für Movado - die Andy Warhol Times/5.

MOVADO
SWITZERLAND
Movado Watch Deutschland GmbH
D-6540 Hanau 1 Kurt-Blaum-Platz 7 Tel. (06181) 32014

DOCUMENTA IX

Wir fördern die DOCUMENTA IX

Finanzgruppe Hessen
 Hessische Sparkassenstiftung

DIE ALTERNATIVE ZUM EINHEITSTREND

Wer Musik ungestört und frei von Netz und Kabel
in fantastischer Qualität erleben will, für den gibt es nur eins –
den tragbaren Philips CD-Player mit kabellosem Stereo-Kopfhörer.

Abseits von Effekthascherei kurzlebiger Modetrends
präsentiert sich dieser CD-Player aus der Philips Collection:

Innen zukunftsweisende Technik, außen ausgezeichnetes Design.

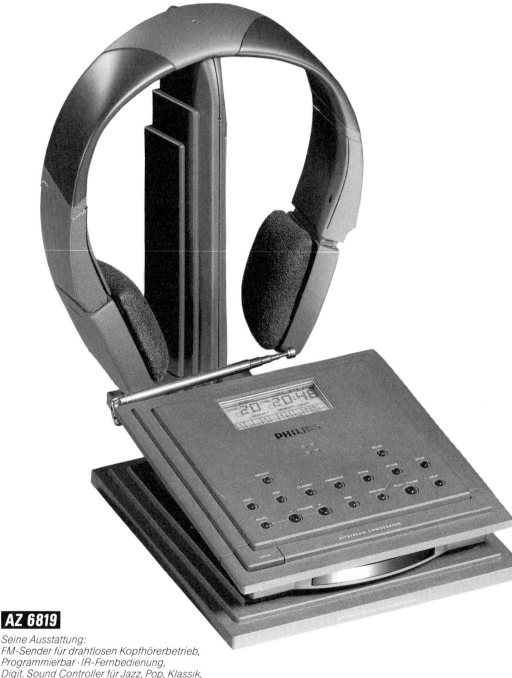

AZ 6819

Seine Ausstattung:
FM-Sender für drahtlosen Kopfhörerbetrieb,
Programmierbar · IR-Fernbedienung,
Digit. Sound Controller für Jazz, Pop, Klassik,
Dynamischer Bass Booster · Surround-Sound-Effekt-Schalter,
Wiederaufladbarer Akku für Player und Kopfhörer.

Der CD-Player aus der Philips Collection bekam 1991 den „Audio Design Award"
der HiFi-Fachzeitschrift Audio verliehen.

Philips Consumer Electronics Deutschland

rasch

DOCUMENTA IX

Parallel zur DOCUMENTA 92 in Kassel stellt Rasch die von internationalen Architekten und Designern entworfene Tapeten-Kollektion ZEITWÄNDE vor.

Die Kollektion ist das Ergebnis von 3 Jahren intensiver Entwicklungsarbeit der Designer BERGHOF/LANDES/RANG, DU PASQUIER, GINBANDE, LAUBERSHEIMER, MENDINI, SIPEK, SOTTSASS, SOWDEN, THUN mit Rasch in Zusammenarbeit mit design...connections.

Mit dieser Kollektion führt die Tapetenfabrik Rasch ihre bereits 1929 begonnene Pionierarbeit auf dem Gebiet des Designs fort, da zu diesem Zeitpunkt in Zusammenarbeit mit dem Bauhaus und dessen Abteilung Wandmalerei die Bauhaus-Tapeten entstanden.

An diese Tradition knüpfte Rasch an, als 1949 neben den neuen Bauhaus-Tapeten die ersten Künstler-Tapeten von Rasch vorgestellt wurden. In den 50er Jahren haben dabei international bekannte Künstler mitgewirkt, u. a. Bele Bachem, Arnold Bode, Salvadore Dali, Tea Ernst, Shinkichi Tajiri, Friedrich Vordemberge-Gildewart.

In den 80er Jahren hat der Faktor Design zunehmend an Bedeutung gewonnen. Rasch hat deshalb die internationale Avantgarde gebeten, das Produkt Tapete neu zu interpretieren. Das Ergebnis dieser gemeinsamen Arbeit wird im Beisein der Designer am 16. Juni 1992 der Öffentlichkeit im Tapetenmuseum Kassel vorgestellt.

DOCUMENTA IX

Parallel to the DOCUMENTA 92 Rasch will be introducing the ZEITWÄNDE wallcoverings collection created by internationally renowned architects and designers.

The collection is the product of 3 years of intensive development between the designers BERGHOF/LANDES/RANG, DU PASQUIER, GINBANDE, LAUBERSHEIMER, MENDINI, SIPEK, SOTTSASS, SOWDEN, THUN and Rasch in cooperation with design...connections.

With this collection, the Rasch company picks the pioneer work in the field of design started in 1929, when the Bauhaus wallpaper was first created in cooperation with Bauhaus and its Wall Decoration Department.

In 1949 Rasch joined this tradition by producing their first artistic wallpaper to accompany the Bauhaus collection. During the 50's, internationally known artists worked on the project, among them Bele Bachem, Arnold Bode, Salvadore Dali, Tea Ernst, Shinkichi Tajiri, Friedrich Vordemberge-Gildewart.

During the 80's, factor of design increased greatly in importance. Rasch has therefore requested the international Avantgarde to reinterpret the wallpaper product. The result of this mutual work will be introduced to the public by Rasch in the presence of the designers on June 16, 1992 in the Wallpaper Museum in Kassel.

TAPETENFABRIK GEBR. RASCH GMBH & CO · RASCHPLATZ 1 · POSTFACH 1255 · D-4550 BRAMSCHE · TELEFON 05461/810 · FAX 05461/81115

Die Vieldeutigkeit der Kunstwerke zeigt, daß Individualität immer eine herausragende Rolle spielt.

Individualität gepaart mit Begeisterung für das Automobil macht deutlich, daß in dieser Beziehung eine starke Verbindung zu einem sicheren Partner gefunden werden muß. Wir wollen dieser Rolle gerecht werden.

RENAULT
AUTOS
ZUM LEBEN

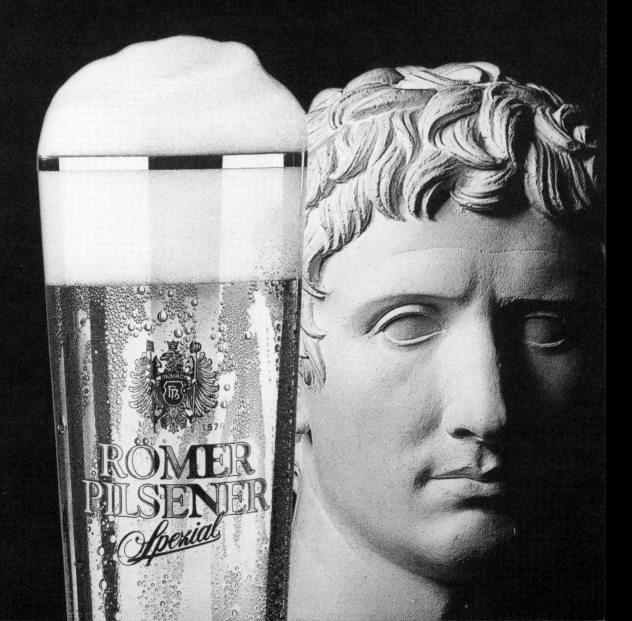

DAS KLASSISCHE RÖMER.

herbfrisch

»Gegenwartskunst ist eine Kommuni-
kationsweise, die auf den Informations-
charakter verzichtet und sich völlig
konzentriert auf die individuelle Erfah-
rung von und zur Realität. Genau das
wird in dieser documenta ausgedrückt
durch den Satz:

›VOM KÖRPER ZUM KÖRPER
ZU DEN KÖRPERN‹,

ein Satz, der durch die Arbeit von Max
Neuhaus dokumentiert wird. Deshalb
ist diese Arbeit, die RTL plus unter-
stützt, das Scharnier der ganzen Aus-
stellung DOCUMENTA IX.«

Jan Hoet
Künstlerischer Leiter der
DOCUMENTA IX

THE WORLD'S NEWSMAGAZINE

CIP-Titelaufnahme

Documenta ⟨ 09, 1992, Kassel ⟩
Documenta IX : Kassel, 13. Juni – 20. September 1992. –
[Engl. Ausg.]. – Stuttgart : Ed. Cantz.
ISBN 3-89 322-381-9
NE: HST

[Engl. Ausg.]
Bd. I (1992)

Library of Congress
Catalog Card Number: 92-72014